French Paintings
1500 - 1825

French Paintings
1500 - 1825

The Fine Arts Museums of San Francisco

by

Pierre Rosenberg
Conservateur en chef, Département des Peintures
Musée du Louvre, Paris

Marion C. Stewart
Assistant Curator, Department of European Paintings
The Fine Arts Museums of San Francisco

with the assistance of Thierry Lefrançois

1987

French Paintings
1500-1825
The Fine Arts Museums of San Francisco

This catalogue is made possible by a gift from Leslie J. and Marjorie
E. Kitselman, in memory of their parents, Donald C. and June H.
Kitselman. The catalogue was also supported in part by a grant from
the National Endowment for the Arts, a Federal agency.
Published by The Fine Arts Museums of San Francisco, 1987.

All translations by the authors. Biographical information and cata-
logue entries on pages 39, 41-43, 45, 47, 49, 52, 60-64, 65-68, 69-72,
79, 95, 97, and 100 have been published in somewhat different form
in *France in the Golden Age: Seventeenth Century Paintings in North
American Collections* by Pierre Rosenberg, New York: The Metropol-
itan Museum of Art, 1982, and on pages 317, 322-323, and 328 in
Watteau 1684-1721 by Margaret Morgan Grasselli and Pierre Rosen-
berg, Washington D.C.: National Gallery of Art, 1984.

Library of Congress Cataloging in Publication Data
Main entry under title:
French Paintings 1500-1825: The Fine Arts Museums of San Francisco
Bibliography: p. 356
Includes index.
1. Painting, French—Catalogs. 2. Painting, Modern—France—
Catalogs. 3. Painting—California—San Francisco—Catalogs.
I. Rosenberg, Pierre. II. Stewart, Marion C. III. Title.
ND544.F56 1987 759.4'074'019461 87-71444
ISBN 0-88401-055-4

Front cover: Detail, Jean-Antoine Watteau, *The Foursome* (*La partie
quarrée*), p. 326.

In memory of
Donald C. and June H. Kitselman

Contents

Preface

The publication of *French Paintings 1500-1825* is a proud moment in the history of The Fine Arts Museums of San Francisco. It is the first in a projected series of scholarly catalogues of the paintings in the permanent collection of these museums. In addition, it joins the previously published volumes *Four Centuries of French Drawings* and *Rodin's Sculpture* to document a significant portion of the objects housed in the California Palace of the Legion of Honor, a unique American museum devoted to the arts of France. The building was conceived as a tribute to the influence of French culture on America in general and San Francisco in particular, as well as to the friendship and cooperation that exists between these two nations.

In 1973 Pierre Rosenberg brought the exhibition *French Master Drawings of the 17th & 18th Centuries in North American Collections* to San Francisco. During his visit he recognized and praised the French seventeenth- and eighteenth-century paintings at the Legion of Honor as among the finest in America, and accepted an invitation to catalogue the collection. Marion C. Stewart was appointed his collaborator. A grant from the National Endowment for the Arts in 1977 was followed in 1982 by an exceedingly generous gift from Leslie J. Kitselman and Marjorie E. Kitselman in memory of their parents. We are extremely grateful for this support that provided the necessary funding for the research and publication of the catalogue.

It has been a privilege to work with Pierre Rosenberg, who undertook this project as a friend to The Fine Arts Museums of San Francisco, and with Marion C. Stewart, without whose research and commitment this book would not exist.

Ian McKibbin White
Director Emeritus

Harry S. Parker III
Director of Museums

Acknowledgments

This catalogue of *French Paintings 1500-1825* in the permanent collection of The Fine Arts Museums of San Francisco could not have been published without the contribution of many talented and generous people both in the United States and abroad.

For scholarly advice and information, we are extremely grateful to the following individuals: Daniel Alcouffe, Brian Allen, Alexandre Ananoff, Colin B. Bailey, Joseph Baillio, Gordon W. Batchelor, Michèle Beaulieu, Sylvie Béguin, Anna G. Bennett, Marie-Nicole Boisclair, Roland Bossard, Arnauld Brejon de Lavergnée, Dominique Brême, Thérèse Burollet, Jean Cailleux, Victor Carlson, the late David Carritt, Richard G. Carrott, Sylvie Chevalley, Marco Chiarini, Margaret Christian, Isabelle Compin, Philip Conisbee, Marguerite Coppens, Jean-Pierre Cuzin, Marie-Anne Dupuy, the late Yvonne Deslandres, Colin Eisler, Carol S. Eliel, John David Farmer, Roy Fisher, Jacques Foucart, Nadine Gasc, Serge Grandjean, Anne de Groer, Catherine Grodecki, Monique Halbout, Clarice Henry, J. G. von Hohenzollern, Edward L. Holt, Gérard Hubert, Donna Hunter, John A. S. Ingamells, Beverly Schreiber Jacoby, Geneviève Lacambre, Alastair Laing, Georges de Lastic, Alain Latreille, Pierre Lavayssière, Sylvain Laveissière, Marilyn Aronberg Lavin, Thierry Lefrançois, Sir Michael Levey, Nancy Little, Harald Marx, Jean M. Massengale, Suzanne Folds McCullagh, Alain Mérot, Dwight Miller, the late A. P. de Mirimonde, Elisabeth Mognetti, Jennifer Montagu, Edgar Munhall, the late Inna Nemilova, Pierre Nicolas, Konrad Oberhuber, Hal N. Opperman, Paola Bassani Pacht, Rodolfo Palluchini, Alain Pasquier, Isabelle du Pasquier, Alfonso E. Pérez-Sánchez, Mark Poltimore, Donald Posner, Gloria M. Ravitch, Nicole Reynaud, Marcel Roethlisberger, Marianne Roland Michel, Jean Rivière, Myra Nan Rosenfeld, H. Diane Russell, Marie-Catherine Sahut, Marc Sandoz, Sylvie Savina, Patricia A. Schindler, Erich Schleier, Antoine Schnapper, Regina Shoolman Slatkin, Martha Kellogg Smith, Edith A. Standen, Charles Sterling, Dominique Thiébaut, Jacques Thuillier, Colette Vasselin, Robert Wagner, the late Sir Ellis Waterhouse, Selby Whittingham, Eunice Williams, Nicole Willk, Gillian Wilson, Alan Wintermute, and Susan Wise. In addition, we were extremely fortunate to have the expertise of Dr. Robert A. Cockrell, Department of Forestry, University of California, Berkeley, in analyzing each of our panel paintings to determine its composition.

The resources of the following libraries and archives were vital in documenting our paintings. Special thanks are extended to:
Doe Library, University of California, Berkeley; The British Library, London; Christie, Manson, & Woods Ltd., London; The Library of The National Gallery, London; Sotheby Parke Bernet, London; Victoria and Albert Museum Library, London; The Wallace Collection Library, London; The Witt Library, Courtauld Institute of Art (University of London); the Frick Art Reference Library, New York; M. Knoedler & Co., Inc., New York; Thomas J. Watson Library, The Metropolitan Museum of Art, New York; Library of The Ashmolean Museum of Art and Archaeology, Oxford; Bodleian Library, Oxford University; Archives Nationales, Paris; Bibliothèque d'Art et d'Archéologie (Fondation Jacques Doucet), Paris; Cabinet des Estampes, Bibliothèque Nationale, Paris; the libraries and Service d'Etude et de Documentation, Musée du Louvre, Paris; Cecil H. Green Library, Art and Architecture Library, and Music Library, Stanford University; Library of the Achenbach Foundation for Graphic Arts and Library of The Fine Arts Museums of San Francisco; and the National Gallery of Art Library, Washington, D.C.

The staff of The Fine Arts Museums of San Francisco has changed considerably since the inception of this project. Among the many former colleagues who merit appreciation and gratitude are F. Lanier Graham, Curator in Charge, Paintings; William H. Elsner, Curator Emeritus, Paintings; Thomas P. Lee, Curator in Charge, Paintings; Edward T. Engle, Publications Manager; Teri Oikawa-Picante and Bruce Miller, Conservators; and Helen K. Crotty and Adrienne Horn, Docent Council.

The present staff has been extremely helpful as well. Special thanks are extended to Lamar Leland, Coordinator, Photographic Services; James Medley and Joseph McDonald, Photographers; Therese Chen, Paula March, and Ted Greenberg, Registrars; Sonya Knudsen, Data Entry Operator, Registration; William White, Technical Coordinator, and his team of technicians; Michael Sandgren, Packer; Jane Gray Nelson, Librarian; Pamela Forbes, Managing Editor, *Triptych*; Kristin Hoermann and Jim Wright, Conservators; Christopher Huson, Annette Holmes, and Helenjoy Pfaffenberger, Support Services; and many others who have offered their assistance in various ways over the years.

Production of this catalogue could not have been accomplished without the special talents of Rhonda Honorat and Peter Flagg, translators; Deborah Bruce, proofreader; Eileen Petersen and Cathy Kulka, secretaries; Barbara L. Mount, research assistant;

Ann Heath Karlstrom, Publications Manager of The
Fine Arts Museums, who has provided welcome conti-
nuity and good counsel; and Karen Kevorkian, Editor,
who has literally wrought miracles. To all we are
extremely grateful.

A grant from the National Endowment for the Arts and
a gift from Leslie J. Kitselman and Marjorie E. Kitsel-
man provided the funding for this catalogue. Without
this generosity, our dreams could not have come true.
 We are grateful to Director of Museums Harry S.
Parker III for his support in the completion of this
project.
 Finally, we wish to thank Ian McKibbin White, Direc-
tor Emeritus, for his long-standing interest and encour-
agement, and Charles S. Moffett, former Chief Curator,
for his efforts on our behalf.

Pierre Rosenberg
Marion C. Stewart

Introduction

Time-honored French painting is the poor relation of art history. This epigram may surprise some and merits a few words of explanation.

We are all familiar with Northern European painting of the seventeenth century; Rembrandt and Rubens are among the most well-known painters of all time. These prodigious old masters are studied by a multitude of specialists who are often torn over questions of date, attribution, and the meaning of key works. The little Dutch and Flemish masters are not forgotten either and have their monographs, exhibitions, and *catalogues raisonnés* like the great masters. Spanish art is very much in vogue. In the near future, there will hardly be a painting from the school of Seville that remains unpublished, or a still life that has not been repeatedly reproduced in color.

As for the Italian school, it has always been and will always be the field of choice for art historians. One need only draw up a list of articles, monographs, or events of all sorts which took place during the recent five-hundredth-birthday celebration of Raphael to justify this claim. In the last twenty years, the literature on Caravaggio has elevated this painter to legendary status on a par with Shakespeare or Beethoven. While it is difficult to give a precise figure, I think it is not an exaggeration to say that *quantitatively* there are a hundred times more publications on seventeenth-century Italian art than on French art of the same period, a point of great significance for the world of art history and one which I think my colleagues would be hard pressed to dispute. Eighteenth-century Venetian painting, an area to which I have devoted less attention than I would like, is represented in the literature by ten times as many publications as is French art of that century. Accordingly, while Nicola Grassi has been the subject of a colloquium and a number of exhibitions, and the discovery of an unpublished work by Bencovitch is a major event, there is no monograph of Hyacinthe Rigaud's work. Since Pierre de Nolhac, nothing has been written on Nattier (so well represented in San Francisco), but there are innumerable books and critical studies on Pietro Longhi. Even English art has enjoyed a well-deserved revival of interest thanks to The Paul Mellon Centre for Studies in British Art.

It might be argued easily that Impressionism is the most popular and the most frequently studied of all movements or stylistic currents in art history. Does not the recent exhibition, *The New Painting: Impressionism 1874-1886*, organized and presented with great success in San Francisco by Charles Moffett, offer incontrovertible proof? Or is it possible, as the saying goes, that we cannot see the forest for the trees? I would suggest that it is precisely because of Impressionism's half-century of fame and popularity, as well as the serious scholarship conducted in the United States, Germany, Italy, and England in the area of French Romanesque and Gothic art, that we have neglected two centuries of French art—which is far from wanting in interest.

Why this estrangement? There is of course no single answer, and a detailed analysis of the reasons for this lamentable state of affairs would go beyond the scope of this introduction. I can only point out a few facts that may help form the basis of an explanation.

Seventeenth- and eighteenth-century French art has been little studied in the classroom, this being as true in France as in the United States. There is no periodical devoted to this field as we have for Venice (*Arte Veneta*) or Milan (*Arte Lombarda*). No one in Montpellier or Grasse, the respective birthplaces of Sébastien Bourdon and Marguerite Gérard, ever thought of holding an exhibition in honor of his or her illustrious forebear. No local bank or savings and loan company is likely to sponsor the publication of a monograph on Claude Vignon of Tours, or on Duplessis, a native of Carpentras. American and German students are rather too familiar with the problems of access to French libraries and the difficulties of working in French archives and sometimes even in museums. Often discouraged by their professors, they choose to pursue their research in countries where the welcome is more forthcoming and where the needs of the fledgling scholar, often enthusiastic and naive, are more rapidly met.

What else can one say? Is it possible that French painting intimidates scholars? We cannot forget that to conduct research, it is necessary to be able to speak and read French, know something of French history, and have some familiarity with its abundant literary past. I suspect that it is impossible to complete a monograph on Patel or Perronneau—both represented in the collection at the California Palace of the Legion of Honor—without a knowledge of the inner workings of academic life in Paris, without access to the *Correspondance des directeurs . . .* or the *Procès-verbaux de l'Académie*.

At this point, the reader may rightly complain that I have not accounted for the success of exhibitions covering artists of the eighteenth century or for the prices commanded by the paintings of Boucher and Fragonard, the pastels of Chardin and Perroneau, or the drawings of Watteau and Vouet. Do my observations seem overly pessimistic or even cynical, considering the distinguished bibliography provided us by such historians as Sterling, Blunt, and Thuillier? Here too, the trees obscure the proverbial forest. Having myself organized exhibitions on Poussin, Chardin, Watteau, Boucher, Subleyras, and Fragonard, I am aware to what extent such painters remain unfamiliar. Collectors of French

painting of the period are easily counted on one hand, although there is now a marked increase of interest in the drawings of this period. It is also true that, due in great part to the activities of Arthéna publishers, a number of important studies on French art of the seventeenth and eighteenth centuries is now in print.

Thus, some years ago, when I was first asked to write the catalogue for the French paintings in The Fine Arts Museums of San Francisco, I felt bound to accept. Of all the branches of this discipline that for convenience's sake we call art history, the exhibition catalogue and the museum catalogue have seemed to me to be the most useful, and if I might say so, the most entertaining—at least for the one responsible for writing it.

I was well aware of the problems involved. I knew that the collection encompassed the best and the worst, that it was neither encyclopedic nor without substantial gaps. I was also aware that it was the most complete collection of its kind on the West Coast of the United States. Occasional uncertainty or lack of evidence sometimes prevented me from finding out as much as I would like to know about the provenance of certain works, and the distance between Paris and San Francisco did not always permit me to pursue a line of inquiry as I would have liked. Regrettably, there were times when I was forced to look at a photograph where an examination of the work itself would have been infinitely preferable. But *le challenge*, as we say in *franglais*, was worth the effort.

I could not have completed this task without the help of numerous individuals whose names can be found in the long list of acknowledgments. I would like to single out Marion C. Stewart, whose constant collaboration has been indispensable, as well as Thierry Lefrançois for his timely and valuable assistance. It is my sincere wish that this catalogue be followed by many others covering the French collections in so many other fine American museums, and that each provides the occasion for collaboration between parties on both sides of the Atlantic. Such endeavors can only further our understanding of the art of this neglected period and strengthen ties between the French and American people.

Pierre Rosenberg

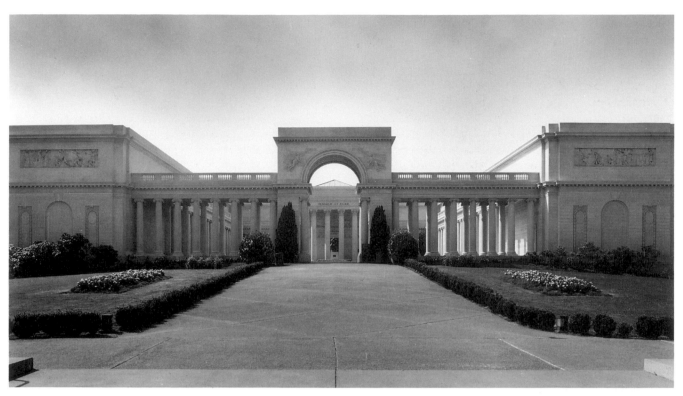

fig.1 California Palace of the Legion of Honor

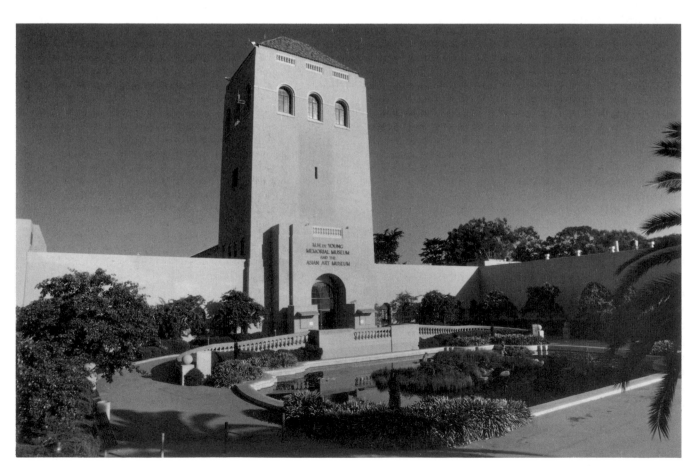

fig.2 M.H. de Young Memorial Museum

History of the Collections

In 1972 the voters of San Francisco approved the merger of two city-owned fine arts museums, the M. H. de Young Memorial Museum and the California Palace of the Legion of Honor, into The Fine Arts Museums of San Francisco. A plan was devised and implemented to present the combined collections according to national schools. American and European art, excluding the French, as well as the arts of Africa, Oceania, and the Americas, were installed at the de Young Museum. The Legion of Honor was devoted to the arts of France, thus becoming a unique French museum in the United States of America.

The California Palace of the Legion of Honor (fig.1) was presented to the City of San Francisco in 1924 by Mr. and Mrs. Adolph B. Spreckels, dedicated to the memory of Californians who gave their lives in World War I. The architecture of the building is based upon the Palais de la Légion d'Honneur in Paris, formerly the Hôtel de Salm, which was designed by Pierre Rousseau for Prince Frédéric de Salm-Kyrbourg and constructed between 1782 and 1787. Since 1804 it has been the headquarters of the Order of the Legion of Honor, established by Napoleon as a reward for civil and military merit.

The Hôtel de Salm is one of the rare Parisian neoclassic buildings that has been imitated in the twentieth century. It was the inspiration for the French pavilion at the 1915 Panama-Pacific International Exposition in San Francisco, as well as for the Château de Rochefort in the Yvelines, for which the architect doubled the proportions. Alma de Bretteville Spreckels, a passionate francophile, tried to persuade San Francisco to retain the pavilion after the fair, but it was constructed of impermanent materials. She then chose a dramatically beautiful site at Land's End in Lincoln Park and employed architect George Applegarth of San Francisco, assisted by Henri Guillaume of Paris, to adapt the original plan into functional museum space.

The California Palace of the Legion of Honor was formally dedicated on 11 November 1924, Armistice Day, with both French and American dignitaries in attendance. The inaugural exhibition of paintings, sculpture, and decorative arts was made up of loans from museums and private collectors and gifts from the French government. The art of France predominated from the beginning. The Spreckels collection of sculpture by Auguste Rodin, personally chosen by the artist himself, was one of the highlights. This collection was later given to the Legion of Honor. In addition to the munificence of Mr. and Mrs. Spreckels, substantial donations of French eighteenth-century art were made by Archer M. Huntington in memory of his father, Collis P. Huntington.

Mr. and Mrs. H. K. S. Williams established the nucleus of a permanent collection of paintings. They were persuaded by Mrs. Spreckels in 1929 to deed the contents of their Paris house to the Legion of Honor, retaining life interest, and to establish a substantial endowment to ensure the future growth of the collection. Mildred Anna Williams died in 1939. Despite the difficulties caused by the outbreak of hostilities in Europe, Mr. Williams was able to have their belongings shipped to California. In addition to their original collection of European masters, Mr. and Mrs. Williams's largesse was responsible for important acquisitions by such seventeenth-century French artists as Le Nain, Le Sueur, and Vouet, and such eighteenth-century masters as Watteau, Boucher, Nattier, Vanloo, and Gérard. The expanding collections took shape under Thomas Carr Howe, Director of the Legion of Honor from 1939 to 1968. It was he who encouraged the support of Albert C. Hooper, David David-Weill, Mrs. William Hayward, Mr. and Mrs. Louis Benoist, Mr. and Mrs. Prentis Cobb Hale, William H. Noble, and many other generous individuals.

Following the merger of the two museums, the French collection at the Legion of Honor was augmented by paintings from the de Young. The de Young (fig.2) originated in the California Midwinter International Exposition of 1894, which was conceived by Michael H. de Young, director general of the fair and owner and publisher of the *San Francisco Chronicle*. At the close of this successful venture, its Fine Arts building together with a sizable profit was turned over to the City of San Francisco to establish a permanent museum. This temporary building was eventually demolished after a new structure and various additions were erected in Golden Gate Park beginning in 1919, using funds given primarily by de Young as well as by other citizens and the city. The nucleus of the permanent collection was provided from some of the exhibits at the fair and from private donations. Established as a historical museum, a broad collection of art and artifacts was displayed. When Walter Heil, a German art historian, was named director in the 1930s, the collection emphasis shifted gradually to fine art.

A number of generous benefactors enabled the permanent collection of paintings at the de Young to grow. Samuel H. Kress, whose stores flourished in many American cities, presented a large collection of paintings by European masters to the museum in 1961. Mr. and Mrs. Roscoe F. Oakes provided a number of important loans over the years prior to their substantial gift to the Museums in 1975. In addition to giving works by artists such as Georges de La Tour, Boucher, and David, Mr. and Mrs. Oakes graciously endowed a fund for future

acquisitions. Clarence S. Postley and his brother, Brooke Postley, contributed works by Largillierre, Pater, and Greuze, and Mr. and Mrs. E. John Magnin's bequest of paintings in 1975 included a remarkable panel by Fragonard. The collection of Dr. T. Edward and Tullah Hanley was presented in 1969. Further growth of the collection has been fostered by The Museum Society in addition to many individual donors.

San Francisco and the entire Bay Area have been enriched profoundly by the vision of the founders of the California Palace of the Legion of Honor and the M. H. de Young Memorial Museum. From the initial construction of these buildings to the breadth and diversity of the collections on view today, the story is told not only of many generous donors, but also of dedicated museum directors and trustees. We salute them all.

Marion C. Stewart

Abbreviations

The following abbreviations are used in the catalogue:

AFGA	Achenbach Foundation for Graphic Arts, The Fine Arts Museums of San Francisco
advt.	advertisement
AN	Archives Nationales, Paris
Arch. de Paris	Archives de Paris
BM	*The Burlington Magazine*
BN	Bibliothèque Nationale, Paris
BSHAF	*Bulletin de la Société de l'Histoire de l'Art Français*
Bulletin CPLH	*Bulletin of the California Palace of the Legion of Honor*, San Francisco
Cab. des Dess.	Cabinet des Dessins, Musée du Louvre, Paris
Cab. des Est.	Cabinet des Estampes, Bibliothèque Nationale, Paris
Collection Deloynes	See list of References in back of catalogue.
CPLH	California Palace of the Legion of Honor, The Fine Arts Museums of San Francisco
de Young	M. H. de Young Memorial Museum, The Fine Arts Museums of San Francisco
GBA	*Gazette des Beaux-Arts*
LV	*Liber Veritatis*. See entry for Claude.
repr.	reproduced
s.d.	signed and dated
TFAMSF	The Fine Arts Museums of San Francisco

Note to the Reader

TITLES
Both English and French titles are given for paintings in the collection of TFAMSF. Titles of comparative works are given only in English, while titles of engravings and tapestry suites are given only in French.

DIMENSIONS
Height precedes width in all dimensions. Inches and centimeters are given for paintings, inches and millimeters for drawings, and feet and meters for tapestries. Approximate modern dimensions are cited where appropriate for French eighteenth-century *pieds* (feet) and *pouces* (inches), which were slightly longer than the modern equivalent.

PROVENANCE
Art dealers are noted by brackets.

FOOTNOTES
Correspondence with the Department of European Paintings of TFAMSF is cited in the footnotes as "letter," giving the name of the correspondent and the date of the communication. These sources are located in departmental files.

16th Century

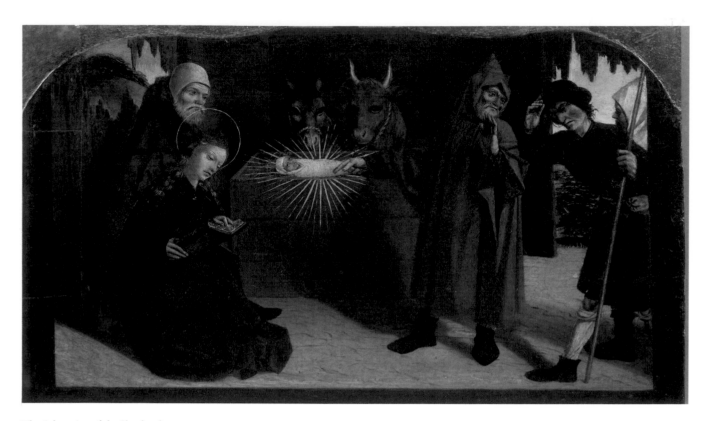

The Adoration of the Shepherds

Nicolas Dipre *Paris, active 1495-1532 Avignon*

Nicolas Dipre is a relatively recent discovery. Documents published by Léon-Honoré Labande in 1932, Hyacinthe Chobaut in 1940, and an article by Charles Sterling in 1942 established his identity and attributed an oeuvre to him. More recently, Michel Laclotte and Dominique Thiébaut (1983) have published their research on this artist.

Dipre, a late representative of the School of Avignon, was born in Paris, first recorded in Avignon in 1495, and married there in 1508. He created the decorations for the entry of Pope Julius II into Carpentras in 1508 and worked on the Church of Saint-Agricol in Avignon in 1509. He apparently received many commissions and had four apprentices between 1498 and 1508. However, all that appears to have been preserved of his work are seven or eight panels, primitive but powerful, which may have formed the predella of a large altarpiece devoted to the Life of the Virgin.

fig.1 Partial reconstruction of Dipre's altarpiece for Saint Siffrein, Carpentras. Reproduced from Eisler 1977, 246.

The Adoration of the Shepherds
L'adoration des bergers
Oil on walnut panel, cradled, 11½ × 18⅞ in.
(29 × 48 cm)
Gift of the Samuel H. Kress Foundation. 61.44.29
(de Young)

Provenance Private collection, Bergamo, before 1950; A. Contini Bonacossi, Florence; Samuel H. Kress, 1950; gift of the Samuel H. Kress Foundation to the de Young, 1961.

References Frankfurter 1955, 58; Neumeyer 1955, 282; Laclotte 1960, 115, repr.; W. Davenport et al., *Art Treasures of the West* (Menlo Park: Lane, 1966), 227, repr.; *European Works* 1966, 77, repr.; Eisler 1977, 246-248, no. K1821, fig.232; Sterling 1981, 11-13, fig.9; Laclotte and Thiébaut 1983, 268, no. 94-4, repr.; T. Lefrançois, "Les peintures provençales anciennes des Fine Arts Museums de San Francisco," *Bulletin Mensuel de l'Académie de Vaucluse*, January 1985, 3-4.

Exhibitions 1955 San Francisco, 74, repr.; 1978-1979 Denver-New York-Minneapolis, no. 13.

fig.2

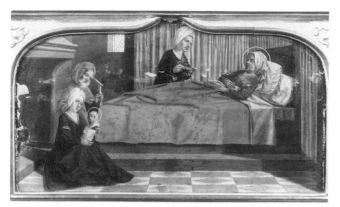

fig.3

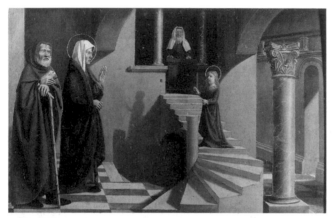

fig.4

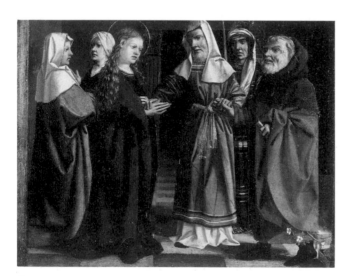

fig.5

Related Works

PAINTINGS

The Meeting of Joachim and Anne at the Golden Gate (before restoration), **fig.2**
Oil on panel, 10⁷⁄₁₆ × 20¹⁄₁₆ in. (26.5 × 51 cm)
Musée du Louvre, Paris. R.F. 1986-3
PROV: Private collection, France; [Galerie Pardo, Paris, in 1986].
REFS: *La Revue du Louvre et des Musées de France*, no. 6, 1986, 433; Compin and Roquebert 1986, 228, repr.

The Birth of the Virgin (before restoration), **fig.3**
Oil on panel, 11⁵⁄₈ × 20¹⁄₁₆ in. (29.5 × 51 cm)
Musée du Louvre, Paris. R.F. 1986-4
PROV: Private collection, France; [Galerie Pardo, Paris, in 1986].
REFS: *La Revue du Louvre et des Musées de France*, no. 6, 1986, 433; Compin and Roquebert 1986, 228, repr.

The Presentation of the Virgin in the Temple, **fig.4**
Oil on panel, 12¹⁄₂ × 19¹¹⁄₁₆ in. (32 × 50 cm)
Musée du Louvre, Paris. R.F. 1972.37
PROV: Ciprioli, Marseille; Pierre Landry, Paris, by 1949.
REFS: Ring 1949, no. 169, fig.139; Laclotte 1960, 115, repr. in color on 116.

The Marriage of the Virgin, **fig.5**
Oil on panel, 10⁵⁄₈ × 13³⁄₄ in. (27 × 35 cm)
Denver Art Museum. 1961.181
PROV: Monastery of the Trinitarians, Marseille; Comte Demandolx-Dedons, Marseille, by 1942; Samuel H. Kress, 1954.
REFS: Ring 1949, no. 267, fig.140; Eisler 1977, K1996, fig.233.

The Crucifixion, **fig.6**
Oil on panel, 11⁵⁄₈ × 17¹⁄₂ in. (29.5 × 44.5 cm)
The Detroit Institute of Arts, Founder Society Purchase, General Membership Fund. 50.57
PROV: Marquese Durazzo, Genoa; Breschi, Rome, by 1949; Vitale Bloch, Amsterdam.
REFS: Sterling 1942, 16; Ring 1949, no. 270, fig.142; Grigaut 1949-1950, 91, repr.

The Adoration of the Magi, **fig.7**
Oil on panel, 11 × 18¹⁄₂ in. (28 × 47 cm)
Private collection, Zurich
REF: Ring 1949, no. 168, fig.141.

The history of this work is closely connected to the rediscovery of Nicolas Dipre. In 1940 Hyacinthe Chobaut published a résumé of an original text of an archival document, unfortunately now lost, describing a commission:

11 March 1499, the priors of the Confraternity of the Conception of the Holy Virgin in the Church of Saint Siffrein in Carpentras gave him [Nicolas Dipre] the agreed price of 115 florins to paint their altarpiece. In the center of the altarpiece, the Virgin, blue and gold; on the same level at each side, two scenes: Joachim expelled from the Temple with his offering; Joachim in the fields with the shepherds and their flocks; Joachim and Saint Anne at the Golden Gate; the birth of the Virgin. On the renvers the Coronation of the Virgin, between two prophets, on a field of blue sprinkled with fine gold

stars. On the predella, five scenes relating to the Conception of the Virgin, not specified.[1]

The receipt for the altarpiece is dated 20 April 1500, and no other documents are known that relate to this work. After the publication by Chobaut of the commission for the altarpiece of the Life of the Virgin, Sterling identified *The Meeting of Joachim and Anne at the Golden Gate* (Musée Duplessis, Carpentras) as a fragment of one of the side panels and *The Marriage of the Virgin* (**fig.5**) as a panel from the predella. Sterling also indicated that René Huyghe had found a pendant to *The Marriage of the Virgin*, probably *The Crucifixion* (**fig.6**).

A few years later, Grete Ring published *The Presentation of the Virgin in the Temple* (**fig.4**), *The Adoration of the Magi* (**fig.7**), and *The Crucifixion*, attributing them to the Master of the Altarpiece of the Life of the Virgin.[2] In 1950 Roberto Longhi identified *The Adoration of the Shepherds* as part of the same altarpiece.[3] Later Colin Eisler reconstructed the altarpiece from the known panels (**fig.1**).

The Presentation of the Virgin in the Temple and *The Marriage of the Virgin* are both rectangular panels, while *The Crucifixion*, *The Adoration of the Shepherds*, and *The Adoration of the Magi* are curved at the top. X-ray examination of *The Presentation* proved that it was originally curved, but unfortunately the condition of Denver's panel made a similar analysis impossible.

In 1986 two panels previously unknown by specialists appeared in Paris, *The Meeting of Joachim and Anne at the Golden Gate* (**fig.2**) and *The Birth of the Virgin* (**fig.3**). Directly related in size, shape, and style to the previously identified panels, they are obviously the work of Nicolas Dipre.

Their appearance upset the previous solution to the problem of the altarpiece. Are they additional panels for the predella, and is the fragment at Carpentras no longer to be associated with the scheme? Dominique Thiébaut has found evidence of as many as ten or eleven scenes in the predellas of altarpieces of the period, and does not know of any other examples in Provence of panels with the double-curved line at the top. However, she finds the omission of a panel representing the Annunciation surprising, and wonders if there may be two sets of predellas by Dipre.[4] Further research or the discovery of additional panels may resolve this question.

The style of this work, which at first glance seems simple and even primitive, is delightful when examined in detail. As Michel Laclotte wrote, "The hasty, somewhat summary execution is, in fact, extremely effective. It is this mixture of the primitive and skillful that creates the exceptional charm of Dipre's art."[5] This effectively describes the late School of Avignon, which brings together a broad definition of forms and great attention to detail, such as that given to the ox and the ass behind

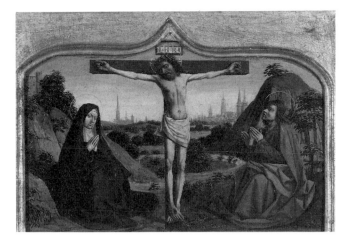

fig.6

fig.7

the manger. The northern origins of the artist are evident, as well as various Flemish influences common in southern French painting of the time. Although the School of Avignon soon fell into a naive and coarse style, popular in character, *The Adoration of the Shepherds* is one of its last masterpieces.

1. Chobaut 1940,101-102.
2. Ring 1949, cat. nos. 268, 269, 270; figs.139, 141, 142.
3. Kress Foundation Archives, letter, 20 March 1950.
4. Dominique Thiébaut, *Nouvelles acquisitions du Département des Peintures (1985-1987)*, Musée du Louvre.
5. Laclotte 1960,115.

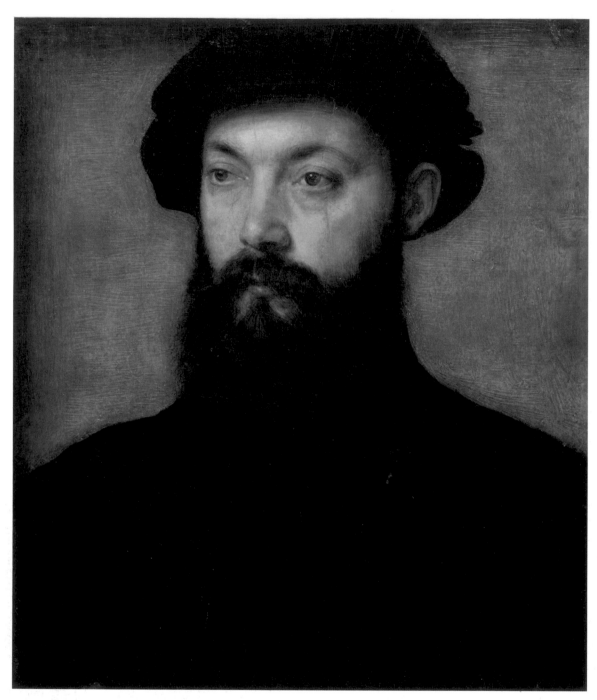

Portrait of a Man

Corneille de Lyon

The Hague ca. 1500/1510-1575 Lyon

A native of The Hague, Corneille de Lyon was so named because of long residence in the city of Lyon, where the poet Jean Second visited him in 1533. A court painter to Queen Eléonore in 1534, then to the dauphin (the future Henry II), Corneille de Lyon in 1547 became a naturalized French citizen and in 1551 bore the title *peintre et valet de chambre du roi*.

Little is known about the artist's beginnings, but the technique and the style of his paintings suggest Flemish training. In 1892 H. Bouchot reconstructed Corneille's work, starting with paintings attributed to him in the collection of François-Roger de Gaignières.[1] Some were found at the Château de Versailles (*Mme de Pompadour des Cars* and *Beatrice Pacheco*), at the Musée Condé, Chantilly (*Mme de Lansac*), and at the Musée du Louvre, Paris (*Charles de La Rochefoucauld, Comte de Randan*, and *Jacques Bertaut*). To these have been added paintings that bear on their reverse the seal of Colbert de Torcy, who sold the Gaignières collection for the king in 1715. Through comparison a few other paintings also have been attributed to Corneille de Lyon, such as the presumed *Portrait of Clément Marot* (Musée du Louvre, Paris).

The important discovery of *Portrait of Pierre Aymeric* (1534, Musée du Louvre, Paris), provides an essential piece to study the work of this artist because it is inscribed, signed, and dated, and remained in the sitter's family from its execution. Therefore the work previously attributed to the Master of Rieux-Châteauneuf, the Master of Brissac, and the anonymous artist Benson, hypothetical painters created by Louis Dimier[2] on the basis of limited and weak documentation, must be reassessed.

Traditionally, many small, meticulously executed portraits with green or blue backgrounds have been attributed to Corneille de Lyon. The abundance and difference in quality of these portraits might be explained by the existence of a flourishing workshop where works of the master were completed or copied. Corneille's son-in-law, Jean Maignan, his daughter, and his sons also were painters and presumably worked in the artist's studio.

The article on which Sylvie Béguin and Anne de Groër collaborated is considered the authoritative work on the artist.[3]

Portrait of a Man
(*attributed to Corneille de Lyon*)

Portrait d'un homme
Oil on softwood panel (perhaps fir), 7 × 6 in.
(18 × 15.5 cm)
Gift of The de Young Museum Society. 62.12.2
(de Young)

Handwritten on adhesive tape on the reverse of this panel: "By Corneille de Lyon (perhaps Odette Coligne) from the collection of King Ferdinand Spain 1413-59 [*sic*]." In addition, a red wax seal is affixed to the reverse of the panel bearing the word "Ferdinando" and two parallel rows of chains following the curve of what might be a crown, **fig.1**.

Provenance Possibly in the collection of King Ferdinand IV (1751-1825), the Bourbon king of Naples and the two Sicilies; [Mortimer Brandt, New York]; acquired for the de Young, 6 March 1962.

References *Apollo*, July 1963, 71, repr.; *European Works* 1966, 99, repr.; W. Wilson, *California Museums* (New York: Abrams, 1985), 69-70, fig.55.

Exhibition 1966 Bordeaux, no. 4.

fig.1 (detail with seal)

This fine portrait displays all the general stylistic features associated with Corneille de Lyon—acute visual perception, a lively handling of the brush, and the bust of a sitter posed in three-quarter view against a lightly shaded background. The face is solidly constructed; the arch of the eyebrows, the bridge of the nose and nostrils, the lips, and the ear are all firmly executed. This portrait can be compared with those of *Charles de la Rochefoucauld* or *Portrait of a Man*, also called *Chevalier d'Ambre* (both Musée du Louvre, Paris).

The undeniable presence of the model and the brilliance of the flesh tones could link this work with that which Louis Dimier assembled under the name of Master of Rieux-Châteauneuf. According to Dimier, the Master of Rieux-Châteauneuf was such an innovative artist that he might have been the initiator of this genre. Furthermore, as Dimier is inclined to believe, he may not have been French.

The "sure draftsmanship" and "free handling" of which Dimier writes are in evidence, although the simplicity and clarity of the composition suggest a French artist. Dimier also characterizes this Master by his "smooth and brilliant color, vigorous modeling, and spirited brushwork."[4] The intense expression and the penetrating gaze of the man in the San Francisco panel are similar to that of *Portrait of an Unknown Prelate* (Musée Ingres, Montauban, Inv. 351), which Dimier readily attributes to Rieux-Châteauneuf, not Corneille.[5]

Considering the great quality of this panel, in which the sitter's sharp, clear features are subtly highlighted by the black costume and green background, it is deplorable that no efforts were made until recently to discover the provenance or identity of the models in these French sixteenth-century portraits.

1. H. Bouchot, *Les Clouet et Corneille de Lyon* (Paris, 1892).

2. Louis Dimier, *Histoire de la peinture de portrait en France au XVI^e siècle*, vol. 2 (Paris and Brussels: Librairie Nationale d'Art et d'Histoire, 1925).

3. Sylvie Béguin and Anne de Groër, "A propos d'un nouveau Corneille: Le portrait de Pierre Aymeric," *La Revue du Louvre et des Musées de France*, no. 1 (1978): 28-41.

4. Dimier, *Histoire*, 2:73-77.

5. Dimier, *Histoire*, 2:75, no. 291.

School of Fontainebleau *16th Century*

The School of Fontainebleau, which flourished for about ninety years, began in 1530 when Francis I invited Italian mannerist painters and their assistants to the French court to decorate the Château de Fontainebleau. Rosso Fiorentino and Il Primaticcio, the earliest arrivals, worked on the decoration of the Galerie François I^{er}, which was notable for its frescoes and ornamental stucco. Niccolò dell' Abbate followed in 1552, introducing theatricality and fantasy to the decor. Rosso became an impresario at the Valois court, while Il Primaticcio was primarily responsible for the splendid artistic achievements. He assumed the role of director of fine arts upon Rosso's death in 1540, and for thirty years supervised the painters and craftsmen who embellished Fontainebleau.

These artists added a quality of sensuality to their mannered elegance, creating highly contrived mythologies, and distorting and elongating the nude figures that assumed primacy in their work. The elaborate and distinctive style of the School of Fontainebleau enjoyed great success, aided by the proliferation of engravings after the decorations there. These decorations often combined stucco ornament and painting, and the sculptors Goujon and Pilon made significant contributions. Little remains of this kind of work, but fortunately a number of paintings and drawings have survived.

After the death of Francis I in 1547, work continued on the château. In the so-called Second School of Fontainebleau, or the *bellifontain* movement of the late sixteenth and early seventeenth centuries, the style of painting became more academic with the work of such artists as Dubreuil, Fréminet, and Dubois, a native of Antwerp who became director of projects at Fontainebleau. By the end of the sixteenth century the mannerism of Fontainebleau had become an international style with extremely active centers in Lorraine and Bohemia.

The Triumph of Chastity
Le triomphe de la chasteté
Oil on canvas (transfer?), 34 ½ × 47 ¾ in.
(87.5 × 121.5 cm)
Mildred Anna Williams Collection. 1967.3 (CPLH)

Provenance Perhaps in the collection of a certain Read; Colonel Meredith, Albano, 1899; [Arnold Seligmann, Rey & Co., Inc., New York, 1940]; [Wildenstein & Co., Inc., New York 1950]; acquired for the CPLH, 1967.

References Frankfurter 1940, 30, repr. on 21; "New World Illustrated," *New York Herald Tribune*, December 1940, repr.; R. Cortissoz, "Old and Modern Art at the World's Fair," *New York Herald Tribune*, 2 June 1940, 7, repr.; *J. B. Speed Art Museum Bulletin* 11, no. 10, December 1950, n.p.; Friedlaender 1967, 51-52, fig.1, pl. 11; *Annual Report* [1967], CPLH, 1968, repr.; GBA, "La Chronique des Arts," February 1968, no. 219, repr.; Barret 1984, no. 68, repr.

Exhibitions 1940 New York World's Fair, no. 45, repr.; 1942 San Francisco, no. 24, repr.; 1950 New York, no. 7; Louisville, J. B. Speed Art Museum, *Women in French Painting*, December 1950, no cat.; 1973 Ottawa, 1:176, fig.164; *idem*, 2:69-70, , no. 1.

Variant
PAINTING
Education of Cupid, **fig.1**
Also called *Sleeping Cupid and Nymphs*
Oil on panel, 19 ¹¹⁄₁₆ × 25 ⅝ in. (50 × 65 cm)
The Wawel Castle State Art Collections, Krakow. Inv. 2170
NOTE: Sylvie Béguin observed that this painting is not by the same hand as the one in San Francisco, and is more Flemish in style and execution.[1]

Related Work
DRAWING
Attributed to Niccolò dell' Abbate, *Nymphs, Satyr, and Cupid*, **fig.2**
Red chalk, rubbed and lightly washed, pen and brown ink, 11 ¼ × 10 ½ in.(285 × 267 mm)
Signed on the verso in black chalk: *Ni del Abate*
Teylers Museum, Haarlem. B 25
NOTE: Béguin believes the drawing is by the same hand as the San Francisco painting and wrongfully attributed to dell' Abbate.[2] She also relates this drawing to a more decorative painting at the Heim Gallery, Paris, in 1980 (*Venus, Cupid, and the Graces*, attributed to the Master of Flora, 41 ¾ × 48 ½ in. [106 × 123 cm]).

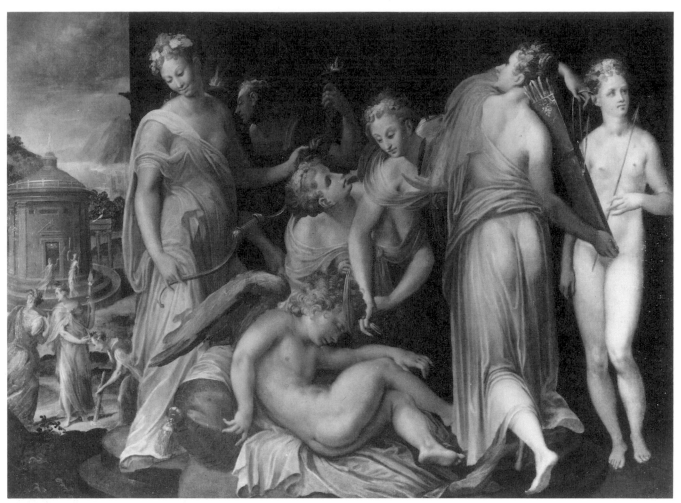

The Triumph of Chastity

The different titles given to this painting (*The Domestication of Cupid*, *The Vestal Virgins Taking the Vow of Chastity*, and *Love Disarmed*) reflect critical uncertainty about the subject. An important clue surely is the rotunda in the background at the left, a building evidently inspired by the Temple of Vesta in Rome, before which five modestly attired women carry torches.[3] Because six vestal virgins traditionally would be seen before their temple, the sixth may be the veiled woman who holds two torches at the center of the composition. Fire is the attribute of Vesta, goddess of chastity, who is also one of the personifications of Juno, the protector of marriage. A statue of Apollo in a classical pose, bearing warlike accoutrements of lance and shield, surmounts the temple-like building, and a peacock, symbol of Juno, perches on the colonnade to the right.

The scene is probably a sly and typically complex mannerist invocation of Petrarch's poem, *The Triumph of Chastity*, where both Apollo and Juno are mentioned in the first lines:

For if two arrows from a single bow
Can wound Apollo and the young Leander,
One called a god, the other but a man,
And if in a single snare Juno may fall,
And Dido, she whom love for her own spouse
(Not—as they say—for Aeneas) drove to her death,
I should not grieve if I be overcome
Being young, unarmed, incautious, and alone.
And if Love conquered not mine enemy
Not even that is cause enough for grief:
For in such plight that I could weep for him
I saw him soon, captive, and reft of his wings.[4]

At first glance, Juno does not appear to be present in the main scene of the picture. However, the woman holding the quiver may be Juno, for her braided coiffure and opulent appearance recall the Roman matrons for whom she was patron. The wife of Jupiter also was known for her impulsive nature and mercurial disposition. The woman in the painting certainly seems to be of a like mind; not only has she taken away Cupid's quiver of arrows, but she also has torn away his bowstring, which she holds in her left hand.

The young woman on the left with one breast exposed, holding the bow of love, evokes Diana, sister of Apollo and goddess of the hunt, the only one to resist the "snare" in Petrarch's poem. If the nude figure at right who holds an arrow for a scepter is Venus, as Béguin suggests,[5] the composition may subtly allude to *The Judgement of Paris* in reverse, providing a subtext that would have delighted the cultivated minds at European courts, especially the court of the last Valois. However, there is no Minerva present, unless the lady with the bow, an emblem of Diana, represents Minerva as well.

As for the two women bending over Cupid, one of

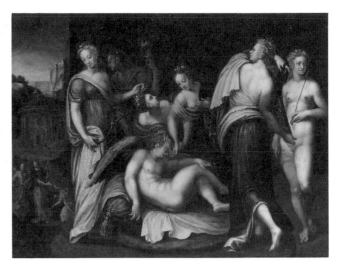

fig. 1

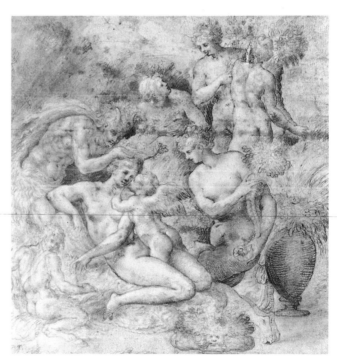

fig. 2

whom blindfolds him while the other pulls at his feathers, Petrarch writes:

I saw him bound, and saw him then chastised
Enough to wreak a thousand vengeances
And I was well content, and satisfied.
I could not fairly celebrate in rhyme,
Nor could Calliope and the Muses all,
The host of holy women who were there;
But I will tell of some in the forefront
Of truest honor; and among them all
Lucretia and Penelope were first,
For they had broken all the shafts of Love
And torn away the quiver from his side,
And they had plucked the feathers from his wings.[6]

The author of this picture may have been influenced directly or indirectly by a now lost painting by Primaticcio in the Galerie d'Ulysse at Fontainebleau, representing Diana, Apollo, Minerva, and Cupid.[7] Bringing together these divinities has no precedent in mythology, but may refer to a delightful excerpt from Lucian. There Cupid tells Venus, his mother, that he does not take aim at Diana, because she is already taken by a passion for the chase, but he has no such qualms about aiming his arrows at Apollo.[8]

The original adaptation of such a classical text to painting would presuppose an educated artist such as Ruggieri, who accompanied Il Primaticcio to Fontainebleau and became superintendent of paintings. However, the uneven quality of the picture makes this attribution tentative. The sure handling of the figure with the bow, and of the background, contrasts sharply with the heavier treatment of the vestal virgin, the supposed Juno with the quiver, and the slack figure of Venus on the right. In color and in style the San Francisco picture is closer to Fontainebleau than the version in Krakow (**fig.1**). The iconography is more subtle and complete and is probably a replica of a celebrated composition. Sylvie Béguin believes this painting is surely by a pupil of Il Primaticcio.[9]

1. Conversation with M. C. Stewart, 28 May 1977.

2. S. Béguin, exh. cat., 1973 Ottawa, 2:70.

3. Suzanne Boorsch, letters, 16 and 24 June 1987, suggests an allusion here to the story of the Wise and Foolish Virgins (Matthew 25:1-13).

4. *The Triumphs of Petrarch*, trans. Ernest Hatch Wilkins, "The Triumph of Chastity" (Chicago: The University of Chicago Press, 1962), 39.

5. S. Béguin, exh. cat., 1973 Ottawa, 2:69, no. 1.

6. *Petrarch*, 44.

7. Louis Dimier, *Le Primatice, peintre, sculpteur et architecte des rois de France* (Paris, 1900), 298.

8. Lucian, trans. M. D. Macleod, "Dialogues of the Gods" (London: William Heinemann, Ltd.; Cambridge: Harvard University Press, 1961), 7:343-345.

9. Conversation with M. C. Stewart, 28 May 1977.

Venus and Cupid

Vénus et l'Amour
Oil on panel, transferred to composition board,
37 3/4 × 27 3/4 in. (96 × 70 cm)
Roscoe and Margaret Oakes Collection. 1973.4 (CPLH)

Provenance Baron d'Albenas, Montpellier, ca. 1904; collection of the d'Albenas family until ca. 1958; [Wildenstein & Co., Inc., New York]; acquired by TFAMSF, 1973 (as *Triumph of Flora*, attributed to the Master of Flora).

References Lafenestre 1904, 138, repr. on 137; Robiquet 1938, 35, repr.; Rey 1939, 16, repr.; R. Huyghe, exh. cat., 1940 New York, mentioned on 13; Wehle 1942, 29-30; Sterling 1955, mentioned on 48 (Master of Flora); C. Sterling, exh. cat., 1955 Amsterdam, mentioned on 78; Béguin 1960, 73-74; Béguin 1961, 30; Held 1961, 201-218; S. Béguin, exh. cat., 1972-1973 Paris, mentioned under no. 130 on 120; Wilenski 1973, 28, pl. 14a; S. Béguin, exh. cat., 1973 Ottawa 2:54; GBA, "La Chronique des Arts," February 1974, 116, no. 381, repr.; Bordeaux 1977, 39; Richardson 1979, mentioned under no. 55.

Exhibitions 1904 Paris, no. 202 (School of Fontainebleau, ca. 1560); 1958 Montpellier, no. 18 (Master of Flora); 1978-1979 Denver-New York-Minneapolis, no. 29.

Variant

PAINTING
Triumph of Flora, fig.1
Oil on panel, 51 5/8 × 43 5/16 in. (131 × 110 cm)
Count Canera di Salasco, Vicenza
PROV: Dr. W. Feilchenfeldt, Zurich.
REFS: L. Venturi, *From Leonardo to El Greco* (Geneva: Skira, 1956), 244, repr. on 246; A. Châtelet and J. Thuillier, *French Painting from Fouquet to Poussin* (Geneva: Skira, 1963), 107, repr.; D. Sutton, "Letter from Paris, Fontainebleau: A Sophisticated School," *Apollo*, January 1973, repr. on 118.
EXHS: 1955 Amsterdam, no. 78; 1972-1973 Paris, no. 130, repr.

Related Work

PAINTING
Agnolo Bronzino, *Allegory*, fig.2
Previously entitled *Venus, Cupid, Folly, and Time*
Panel, 57 1/2 × 45 3/4 in. (146 × 116 cm)
The National Gallery, London. 651

DRAWING
School of Niccolò dell' Abbate, *Seated Woman*, fig.3
Cab. des Dess., Musée du Louvre, Paris. 8779

Acquired by the Museums as *Triumph of Flora*, attributed to the Master of Flora, this painting raises a few problems, particularly because of complex iconography. If the *Triumph of Flora* (fig.1), to which this picture is closely related, reveals its true theme by the explosion of putti surrounding the seated nude Flora, the relatively restrained San Francisco panel makes its subject less clear. Both works derive from the celebrated and often copied *Allegory* by Bronzino (fig.2), which belonged to the French royal collection in the sixteenth century. The

pose of the putto on the left in both the San Francisco and Vicenza pictures, for example, is similar to the putto in Bronzino's *Allegory*. However, this sort of contrapposto was a staple of mannerist painting that was often repeated with variations, as in the frescoes of the Galerie François I^er at Fontainebleau.

In any case, the painter or painters of the Vicenza and San Francisco works probably did not turn to Bronzino because of lack of inspiration. Rather they made allusions to his *Allegory* that could be appreciated and understood by a cultivated audience by enlarging or altering the original meaning. Such practices were common. Bronzino himself paid homage to Michelangelo with several figures in the Chapel of Eleanor of Toledo (Palazzo Vecchio, Florence). The authors of both the Vicenza *Flora* and the San Francisco picture portray the putto with bowed head, honoring the goddess at whose feet he places a garland. The themes of these two paintings stand in contrast to Bronzino's moralizing, satiric, and bitingly ironic work. There, as Vasari tells us, the putto is not a putto at all but an emblem of love at play, threatened by jealousy and deceit.[1] This explicit reference to Bronzino suggests that at least one variation may have been painted shortly after the *Allegory* entered the collection of Francis I. Sylvie Béguin has proposed this variation as the Vicenza *Flora*, which may also derive from a drawing attributed to the school of Niccolò dell' Abbate, *Seated Woman* (fig.3).[2]

Charles Sterling first attributed the San Francisco painting to the Master of Flora in the initial grouping of works given to this artist.[3] In fact, Sterling says it is the San Francisco painting that gives the artist his name.[4] Although several hands can be distinguished within the Master-of-Flora style,[5] this generic name refers to a well-defined, coherent, and very Italianate style in the manner of dell' Abbate or Il Primaticcio. While it is possible to date the Vicenza *Flora* ca. 1552,[6] or perhaps a little later, toward the end of the reign of Henry II, Sylvie Béguin believes the San Francisco picture was painted later, and by a different hand.[7]

It is useful to compare the Vicenza picture with San Francisco's. With only a few modifications, the author of the latter creates a different and original work. Having eliminated the winged putti in *Flora*, the painter lavishes attention on the putto with a horn, recalling Correggio's children in the *Room of Saint Paul* (Galleria Nazionale, Parma), and on the veil and the jewelry adorning the goddess. The transparence of the veil and the remarkable treatment of the nude forms signal an artist of great talent, even though he probably used shop assistants for decorative features such as the drapery, flowers, and crudely executed background. Having made use of the main details of a well-known composition, the painter subtly and discreetly modifies their allegorical significance. The pearls that adorn the goddess's

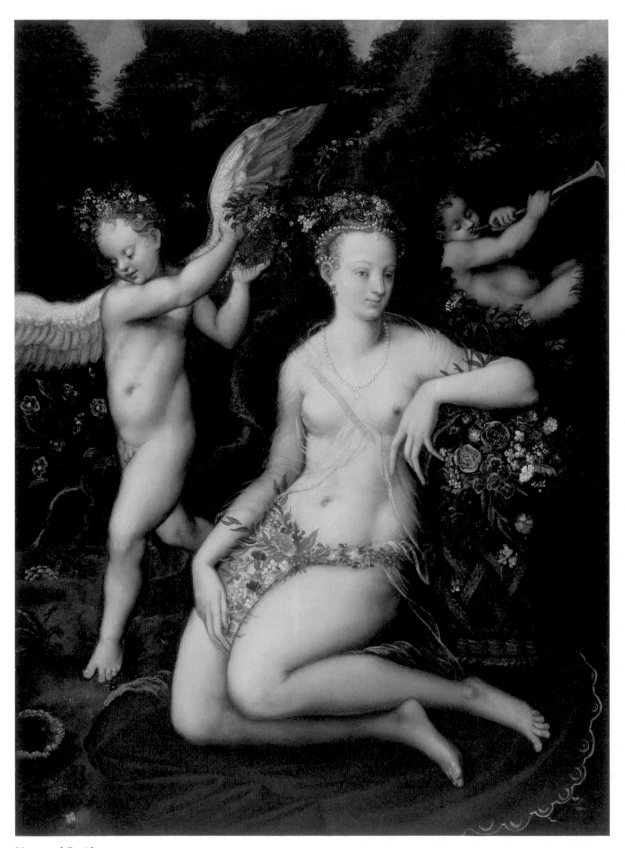

Venus and Cupid

neck are not attributes of Flora, but of Venus. And in contrast to the nudity of the Vicenza Flora, this Venus wears a veil that suggests the licentious nature of Aphrodite of Paphos. Other accessories, notably the girdle of flowers and the roses, another of Venus's attributes,[8] are mentioned by Athena at the Judgement of Paris as related by Lucian:

Athena: Do not let her undress, Paris, until she puts aside her girdle, for she is an enchantress; otherwise she may bewitch you with it. And indeed she ought not to appear before you made up to that extent and bedaubed with all those colours, as if she were a courtesan in earnest: she ought to show her beauty unadorned.[9]

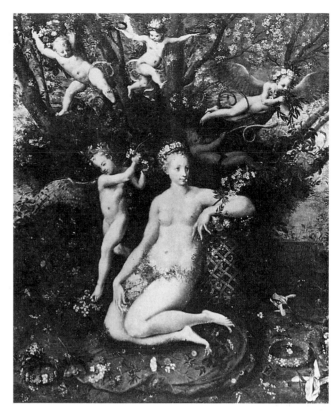

fig. 1

The original title of the San Francisco panel tells us the subject is Venus and Cupid, and this seems to be correct. Cupid, at left in the guise of a winged child, stands opposite the trumpeting putto at right, who proclaims the triumph of the earthly Venus and the divine nature of love. This is a rather playful and ironic variation on the *Triumph of Flora*, which connoisseurs of mythology can appreciate.

But another interpretation is possible for this painting, witty and allusive in the best mannerist tradition. The narrow strip of gauze that runs behind the goddess's neck appears connected to the flower basket, as a strap to a quiver. The jewel crowning her hair at center resembles the crescent moon, an emblem usually worn by the goddess Diana. Even the pearls, with their milky whiteness, might also be read as an attribute of the lunar goddess.[10] It is likely that this amalgam of Diana and Venus, who in the picture takes on the dual role of chaste divinity and goddess of love, was intended as an understated but pointed tribute to Diane de Poitiers. This would date the execution of the picture no later than 1559, the year of the death of Henry II, for whom Diane de Poitiers was both Diana and Venus.

Venus and Cupid in stylistic terms differs significantly from the more Italianate *Triumph of Flora*. Whether some of the decorative features were painted by another hand, the panel as a whole maintains a uniform appearance, and X-ray examination confirms that it was not reworked or painted in different stages. Unlike *Flora*, *Venus and Cupid* evokes a cold eroticism by its greens and pearly whites, for which the red drapery in the foreground hardly compensates. As both Italian and Flemish influences appear in this painting, it is difficult to determine a specific nationality for the artist. The same elegant draftsmanship and extravagant poses can be seen in *Allegory (of Water* or *of Love)* in the Musée du Louvre, Paris, particularly in the play of the elongated fingers. In both pictures we find a balance struck between the minute depiction of detail, a northern trait, and the rapid, free handling characteristic of Italian art. The synthesis of the two is specifically French, brought to fruition by the School of Fontainebleau.

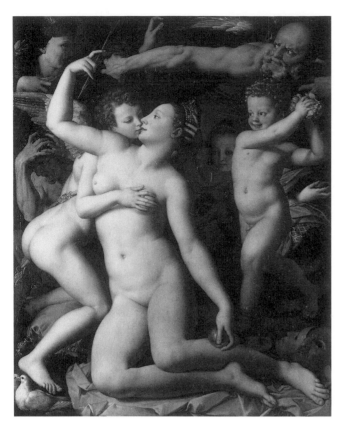

fig.2

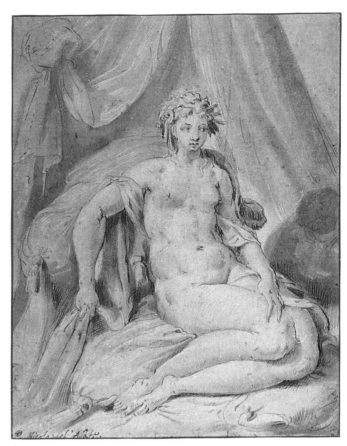

fig.3

The San Francisco panel, at close examination, reveals a few *pentimenti*, notably in the leg, the foot, the edge of Cupid's wing, and the left hand and arm of Venus. From a school where extant works of quality are rare, *Venus and Cupid* is a remarkable conflation of elegance and barbed wit, painted in a style that would soon spread throughout Europe.

1. Giorgio Vasari, *Lives of the Most Eminent Painters, Sculptors, and Architects*, trans. Gaston Du C. DeVere, 10 vols. (London: The Medici Society, Ltd., 1912-1915), 10:7.

2. Conversation with M. C. Stewart, 28 May 1977.

3. C. Sterling, exh. cat., 1955 Amsterdam, 77, under no. 78.

4. C. Sterling, letter, 27 November 1979.

5. S. Béguin, exh. cat., 1972-1973 Paris, 119.

6. C. Sterling, exh. cat., 1955 Amsterdam, 78.

7. Conversation with M. C. Stewart, 28 May 1977.

8. James Hall, *Dictionary of Subjects and Symbols in Art* (New York: Harper & Row, 1974), s.v. "girdle," "pearl," "rose."

9. Lucian, trans. A. M. Harmon, "The Judgement of the Goddesses" (London: William Heinemann; New York: G. P. Putnam's Sons, 1921), 3:399.

10. Hall 1974, s.v. "Diana."

17th Century

Landscape with a Shepherd Leading His Flock

Sébastien Bourdon *Montpellier 1616-1671 Paris*

The son of a master painter and glazier in Montpellier, Bourdon was raised a Protestant. At an early age he left his family, settling in Paris where he entered the studio of the painter Berthélémy. At fourteen he left the capital and probably traveled in the area of Bordeaux before entering military service in Toulouse. Four years later he went to Rome where he became distinguished as much for his skillful pastiches of Poussin, van Laer, Sacchi, and other painters, as for his *bambocciate* painted in the steel grays and vivid blues that he favored throughout his career.

Denounced by the Inquisition as a heretic, Bourdon fled Rome for France in 1637. Although he stopped only briefly in Venice, the influence of the Venetian painters determined his mature style. The *Adoration of the Magi* (Schloss Sanssouci, Potsdam) and the *Death of Dido* (Hermitage, Leningrad) show a new poetic spirit and a new use of space. With works such as *Beggars* (Musée du Louvre, Paris) Bourdon quickly established a reputation for *bambocciate* in the French manner, and by 1642-1643 works such as *Interior of a Cottage* (Musée du Louvre, Paris, at one time attributed to Kalf) show the incorporation of elements inspired by northern painting. The *Martyrdom of Saint Peter*, commissioned in 1643 by the goldsmiths of Paris for the cathedral of Notre-Dame, reveals a much more baroque style, characterized by powerful chiaroscuro, predominant oblique lines, and the use of partial figures.

Poussin's visit to Paris in 1640-1642 directed Bourdon's manner of painting toward geometric compositions with sharp planes and vivid, clear colors, exemplified by *Eliezer and Rebecca* (Musée d'Art Ancien, Blois). He was one of the twelve "elders" who were founding members of the Royal Academy of Painting and Sculpture in 1648. At the invitation of Queen Christina of Sweden he went to Stockholm in 1652, where he painted numerous portraits, including *Christina of Sweden on Horseback* (Museo del Prado, Madrid). The *Portrait of a Man* (The Art Institute of Chicago) illustrates the development of a formula that combined the official pomp appropriate to the status of the sitter with psychological insight. Bourdon returned to Paris in 1654, was appointed rector of the Academy the following year, and, upon Le Sueur's death, received a commission for the large tapestry cartoon *Decapitation of Saint Protasius* (Musée des Beaux-Arts, Arras) for the Church of Saint-Gervais. Around 1656-1657 he returned to Montpellier where he was commissioned to execute the *Fall of Simon the Magician* for the cathedral, and also to paint the *Seven Acts of Mercy* (John and Mable Ringling Museum of Art, Sarasota). The last years of his creative output were devoted to decorating the Hôtel de Bretonvilliers in Paris, unfortunately destroyed in 1840, and painting landscapes with and without religious scenes.

A versatile and prolific artist whose style changed considerably throughout his career, Bourdon excelled as an engraver and draftsman as well as a painter. Unfortunately he has been little recognized by subsequent generations. Geraldine Fowle's research is still essentially unpublished,[1] as is Pierre Rosenberg's in collaboration with Jacques Thuillier (from before 1971) for an exhibition proposed to commemorate the tercentenary of the death of the painter from Montpellier.

1. Geraldine Elisabeth Fowle, *The Biblical Paintings of Sébastien Bourdon*, 2 vols. (Ph.D. diss., Ann Arbor, University Microfilms, 1970).

Landscape with a Shepherd Leading His Flock
Paysage avec un berger conduisant son troupeau de moutons au son du flageolet
Oil on canvas, 19 1/2 × 24 3/4 in. (49.5 × 62 cm)
Mildred Anna Williams Collection. 1952.56 (CPLH)

Provenance Lord Berwick, 1862 (?); Sir Compton Gonville, 1888 (?); Rhind, Esq. (?); sale, London, Christie's, 23 July 1948, no. 158, repr. (as N. Poussin, "A Classical Landscape, with shepherd and sheep on a road"); acquired by "Bernard," according to Christie's list of purchasers, or by "Grayson," according to the annotated catalogue at the Witt Library, London; [W. M. Sabin & Sons, London, 1948 (?);] [P. & D. Colnaghi & Co., Ltd., London, 24 August 1951]; acquired by the CPLH, 2 October 1952.

References BM, February 1952, repr. on vii, advt.; P. Rosenberg, exh. cat., 1982 Paris-New York-Chicago, 348, no. 2, repr.; Wright 1985 (Boston), 149 (attr.), 285.

Related Work

ENGRAVING
Un berger dirigeant son troupeau vers la gauche, **fig.1**
Cab. des Est., BN, Paris. Da.32.b.59
REF: Weigert 1939-1968, 2:70, no. 34.

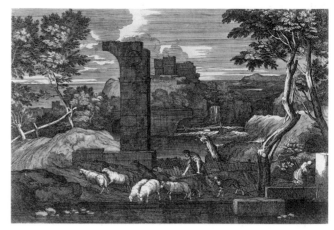

fig.1

This canvas poses numerous problems in provenance, iconography, date, and attribution. It cannot be confirmed that it ever belonged to Lord Berwick, Sir Compton Gonville, or to a Rhind, Esq., as noted in Christie's sale catalogue of 23 July 1948. However, a label glued to the back of the frame states that the work was in the collection of Lord Berwick, who perhaps had intended to sell the painting but withdrew it before the catalogue was printed. Although pictures from Lord Berwick's collection were sold twice at Christie's on 8 February 1862 and 6 February 1864, none of these works corresponds to the San Francisco painting. At best, this landscape might be linked with no. 79 from the latter part of the second sale, the property of Sir M. W. Ridley, "*Classical Landscape with Figures*, by N. Poussin," although neither the composition nor the dimensions are described.

Similarly, there does not appear to have been a sale for Sir Compton Gonville or Rhind, Esq., before 1948. The latter may have been John Rhind, Esq., of Edinburgh (d. 1892), the husband of Catherine Birnie (d. 1887) and the father of Thomas Duncan Rhind, who is mentioned in *County Families of the United Kingdom*.[1] A sale of items from the collection of a W. Birnie Rhind took place at Dowell's, Edinburgh, 27 November 1937, but San Francisco's picture is not included in that catalogue.

It has been proposed that Bourdon's landscapes are often scenes from the Old and New Testaments, but such an interpretation here is improbable. The herding of sheep could refer to Genesis 31:17-21 where Jacob takes the best of his father-in-law's flock, fleeing to his father, Isaac. However, it would be surprising if the belongings of the Hebrew patriarch and his entire family could be carried by the one weather-beaten donkey shown here. The text also states that Jacob's wives and children traveled on camels. Again, the shepherd in the painting, who leads his flock to the sound of his pipe, fails to fit the description of Jacob "pushing all his flock before him." It seems likely that the subject in this case is simply the kind of pastoral scene that Bourdon often painted.

The artist reveals a flair for *bambocciate* in his realistic depiction of the herd and other details—the urinating goat, broken arch and medallion, and little boat at the rear. Elements of composition, such as the shepherd and his flock in the foreground and the arch at mid-ground, are organized by a succession of horizontal planes. This recalls an original engraving by Bourdon, *Un berger dirigeant son troupeau vers la gauche* (**fig.1**). This engraving is part of a series of a dozen: the first four are landscapes; the second four illustrate the story of the Good Samaritan; and the final four depict scenes from the New Testament.[2] Nevertheless, the many differences between this painting and the engraving make it difficult to establish a direct relationship.

Landscape with a Shepherd Leading His Flock is a happy compromise between a *bambocciata* and a classical landscape, unlike the great biblical scenes Bourdon painted at the end of his career (i.e., *The Return of the Ark*, The National Gallery, London). Although its poor condition prevents full enjoyment and it lacks rigorous planar composition, the interlocking geometric forms and clear, refined color—particularly the beautiful, vivid blue—are typical of Bourdon from ca. 1650. However, weakness exists in the overall execution. Therefore, despite the inclusion of details typical of Bourdon, like the copper pot on the back of the donkey and the dog, the attribution to him must be proposed with caution.

1. *County Families of the United Kingdom* (London: Walford, 1920), s.v. "Rhind."
2. Robert-Dumesnil 1835-1871, 11:19.

The Candlelight Master *Active ca. 1620-1640*

In 1960 Benedict Nicolson attributed several Caravaggesque night scenes that formed a stylistically coherent oeuvre, but had been previously attributed to Honthorst, Stomer, and Georges de La Tour in turn, to a painter he called The Candlelight Master.[1] After further archival research, Jean Boyer identified this artist tentatively as a native of Aix living in Rome, Sandrart's mysterious "Trufemondi," Trophime Bigot.[2] Accepted for a time, this identification was problematic.

The case of the artist Bigot exemplifies some of the problems that confront the art historian. The paintings signed by Bigot in Provence after 1634 and those painted in Rome between 1620 and 1634 were completely different in style. A solution has been found in the creation of two Bigots.[3] Bigot the Elder, who was born 1579 in Arles and died after 1649, was responsible for the Provençal paintings; his son, active in Rome between 1620 and 1634, is the author of the group of works attributed to The Candlelight Master. This hypothesis has been challenged by Jean-Pierre Cuzin, who believes he can distinguish two hands in the group of Roman paintings attributed to Bigot the Younger—that of Trophime Bigot and that of an artist who remains to be identified—to whom the majority of the paintings by The Candlelight Master should be attributed.[4] Anthony Blunt, however, refused to accept the solution proposed by Cuzin and held to the standard attribution.[5]

Even if one accepts the view advanced by Boyer, who has devoted twenty years of archival research and several exhibitions and articles to this subject, it is still not known whether The Candlelight Master and Bigot are the same artist, whether he is French as is believed, or if he is a northern artist, as the strong influence of Honthorst, Stomer, or Adam de Coster on his work suggests. The link between his works and La Tour's remains confusing.

In any case, the artist exhibits an independent personality in his half-length figures of smokers, singers, and flea pickers, and in his secular paintings illuminated by the flame of a candle or a lamp. His more ambitious nocturnes of religious subjects—one of the best being *Saint Sebastian Cared for by Saint Irene* (Musée des Beaux-Arts, Bordeaux)—are weak in handling and cannot compete with those of Honthorst or, of course, La Tour. They represent the production of a good painter who worked within an established tradition without seeking to change it, and for whom the expressive use of luminism was an end in itself.

1. Nicolson 1960, 121–164.
2. Jean Boyer, "Un Caravagesque français oublié, Trophime Bigot," *BSHAF 1963,* 1964:35-51; in particular, "Nouveaux documents inédits sur le peintre Trophime Bigot," *BSHAF 1964,* 1965:153-158.
3. Nicolson 1972, 117; Jacques Thuillier, exh. cat., 1972 Paris, 47; Henri Wytenhove et al., exh. cat., 1978 Marseille, 4-9.
4. Jean-Pierre Cuzin, "Trophime Bigot in Rome: A Suggestion," *BM* 121, no. 914 (May 1979):301-305.
5. Anthony Blunt, "Trophime Bigot," *BM* 121, no. 916 (July 1979):444.

Young Boy Singing
Jeune chanteur
Oil on canvas, 26 ½ × 19 ½ in. (67.5 × 49.5 cm)
Gift of Archer M. Huntington in memory of Collis P. Huntington. 1946.2 (CPLH)

Provenance Heinigke collection, New York; [Arnold Seligmann, Rey & Co., Inc., New York, until 1946]; acquired by the CPLH, 1946 (as Georges de La Tour). (Cleaned by Teri Oikawa-Picante, 1973.)

References *Art News,* September 1946, 8, repr. (as La Tour); *Art Digest,* 15 September 1946, 7, repr. (La Tour); *Illustrated Handbook 1946,* 49, repr. (La Tour); Howe 1946, 34-43, repr. (*Young Girl Singing,* La Tour); Sterling 1951, 155 (note 10, La Tour); Pariset 1959; Nicolson 1960, 130 (and note 27), 143-144, 159-160, fig.20 (The Candlelight Master); Nicolson 1964, 121, 132, no. 40, pl. 36, 139 (The Candlelight Master); Nicolson 1965, 71, 94, 105, no. 40, pl. 19 (as T. Bigot); Thuillier 1973, 101, no. D18, repr. (Bigot); A. Brejon de Lavergnée and J.-P. Cuzin, exh. cat., 1973-1974 Rome-Paris, Ital. ed., 18, 240, French ed., 18, 248 (Bigot); H. Wytenhove et al., exh. cat., 1978 Marseille, mentioned on 164; Nicolson 1979, 22 (T. Bigot); "La peinture française du XVIIᵉ siècle dans les collections américaines, *Le Petit Journal des Grandes Expositions,* no. 116 (1982), fig.65; T. Lefrançois, "Les peintures provençales anciennes des Fine Arts Museums de San Francisco," *Bulletin Mensuel de l'Académie de Vaucluse,* January 1985, 3 (The Candlelight Master); Wright 1985 (Boston), 141, 285 (Bigot ?).

Exhibitions 1951 Santa Barbara, no. 3, repr.; 1951-1952 Ann Arbor-Grand Rapids, no. 37; Long Beach, Municipal Art Center, April 1952, no cat.; 1954 Fort Worth, no. 22; 1982 Paris-New York-Chicago, 65, repr. 130.

Related Works
PAINTINGS
Boy Singing, fig.1
Oil on canvas, 19⅞ × 15⅜ in. (50.5 × 39 cm)
Galleria Doria Pamphilj, Rome. FC 365
REF: Edward A. Safarik and Giorgio Torselli, *La Galleria Doria Pamphilj a Roma* (Rome: Fratelli Palombi Editori, 1982), 411, repr.

Boy Pouring Oil into a Lamp, fig.2
Oil on canvas, 18¾ × 15 in. (47.5 × 38 cm)
Galleria Doria Pamphilj, Rome. FC 351
REF: As above, 413, repr.

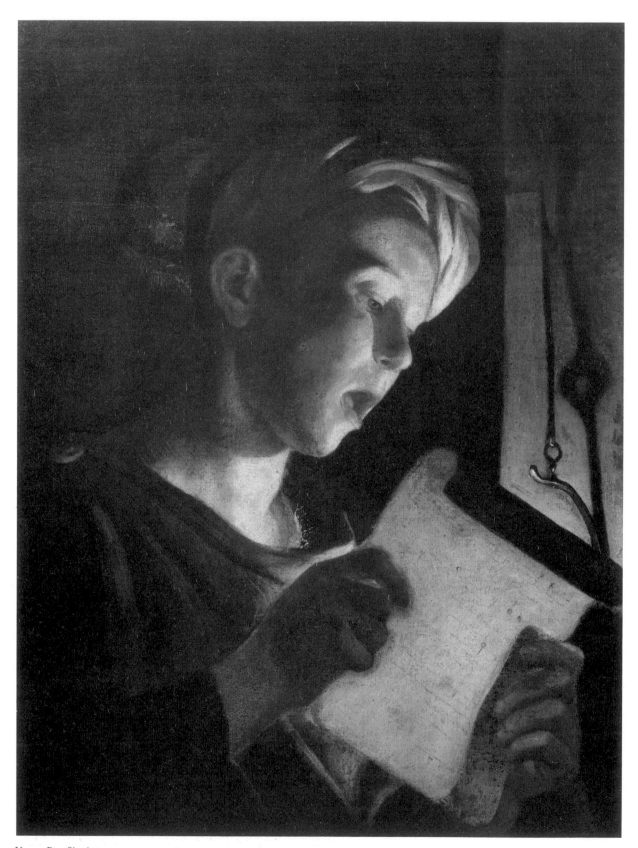

Young Boy Singing

This painting was acquired in 1946, attributed by Walter Friedlaender to Georges de La Tour.[1] This attribution was challenged in 1948 by F. G. Pariset and in 1951 by Charles Sterling ("Matthias Stomer?").[2] In 1960 Benedict Nicolson assigned the painting to The Candlelight Master.[3] As is true for all the works in this group, it was attributed in turn to Trophime Bigot, to Bigot the Younger, and then again to the mysterious Candlelight Master.

Although its condition is somewhat worn, this picture is one of the most charming the artist produced. A young boy sings by the light of an oil lamp, trying to read a sheet of music. The score is translucent in the light and a few of the notes show from the other side of the paper. This painting is related to a series of four remarkable small pictures in the Galleria Doria Pamphilj, Rome: *Boy Singing* (**fig.1**), *Young Girl Singing*, *Boy Holding a Bat*, and *Boy Pouring Oil into a Lamp* (**fig.2**).[4] As does San Francisco's painting, these pictures represent children in half-length and feature similar paint handling and nearly identical light effects. Rome's *Boy Singing* bears a striking compositional resemblance to our picture, and the same metal oil lamp hangs from the wall in both pictures. Called a *chaleuil* or *caleu*, it derives from antique terracotta lamps and is found throughout the Mediterranean, especially where olive oil is produced. The same lamp with its wick and long articulated handle reappears in *Boy Pouring Oil into a Lamp*.

The Candlelight Master obtains a range of exquisite light effects with the lamp. He accentuates shadows, distorts masses, and even introduces mystery with the shadow cast by the hanging lamp. The lamplight also illuminates the boy's face, neck, and sheet of music. His absorption in the score is emphasized by his fixed gaze and open mouth placed at the composition's center. The delicate modeling of the lips, nose, and eyelids brings out the subject's childlike grace, and a feathered turban adds an exotic touch. Dreamy and perhaps a bit melancholy, *Young Boy Singing* is proof that The Candlelight Master was capable of great invention and poetic inspiration and that he could, on occasion, rise to the level of Stomer or Honthorst as one of the finest luminist painters of his day.

1. Walter Friedlaender, certificate, January 1943.
2. F.-G. Pariset, letter, 14 April 1948; Sterling 1951, 155 (note 10).
3. Nicolson 1960, 130, 143, 159 (note 27), fig.20.
4. Exh. cat., 1973-1974 Rome-Paris, nos. 3-4, figs.1-4.

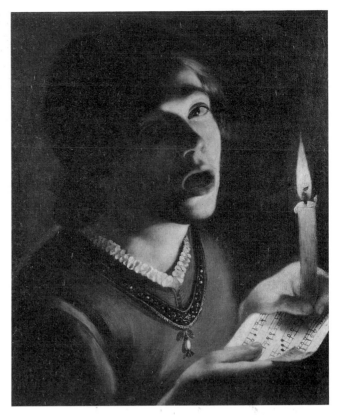

fig.1

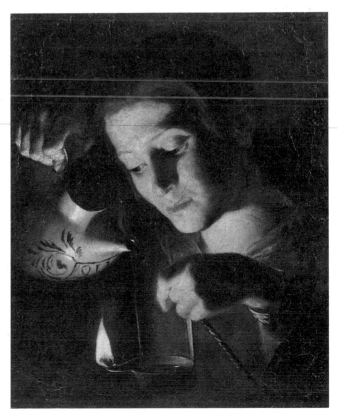

fig.2

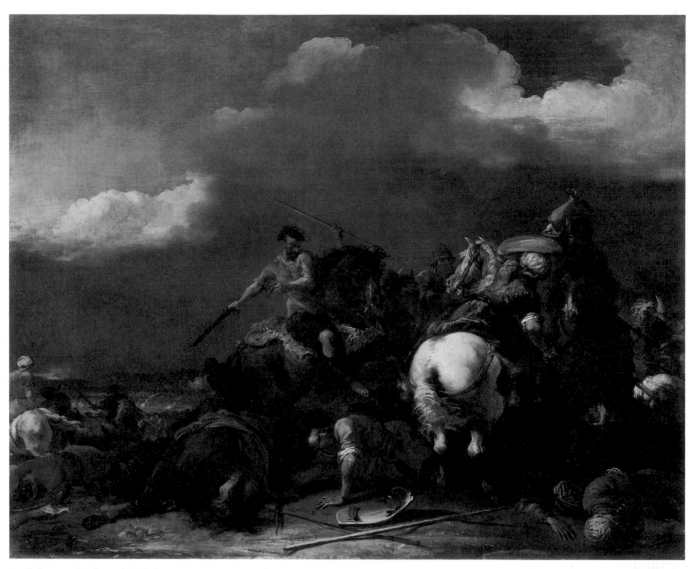

Battle between Turks and Christians

Jacques Courtois, called Le Bourguignon

Saint-Hippolyte 1621-1676 Rome

Courtois went to Italy at the age of fifteen and remained there for the rest of his life. Little is known about his early training in Bologna, Florence, and Siena. It is known that he was in Rome around 1640, where he painted a fresco on a ceiling of the Convent of Santa Croce in Gerusalemme. He frequented the company of *bambocciate* painters, and under the influence of Cerquozzi and probably Rosa soon began to specialize in battle scenes. After 1650 he was well known, traveling frequently. He received commissions from Mattia de' Medici, governor of Siena, in 1652 and 1656/1657 for four large *Battle Scenes* (Palazzo Pitti, Florence); visited Fribourg in 1654-1655; and Venice, where he executed paintings for the Palazzo Sagredo (some in the Derby collection, England, and in the Gemäldegalerie, Dresden).

In 1657 he joined the Jesuit order, thereafter signing his vigorous drawings with a cross in ink. Although a substantial number of his paintings and frescoes are religious (*Martyrdom of Forty Jesuit Fathers*, Palazzo Reale del Quirinale, Rome, and frescoes from 1658-1660 in the Collegio Romano), it is primarily his numerous and frequently enormous battle scenes that assured his reputation in Europe (several in the Alte Pinakothek, Munich). He became so famous that for the next three hundred years all paintings of this genre were attributed to Le Bourguignon. Courtois developed an innovative formula. Instead of panoramic and meticulously detailed topographical views or frieze-like battle scenes, which Renaissance artists had borrowed from the bas-reliefs of antiquity and which were still favored by artists such as Aniello Falcone and even Rosa, Courtois placed the spectator in the middle of a cavalry engagement. These works often depict Turks and Europeans in large landscapes dominated by broad, cloudy skies. The sense of movement and the delicate shades of color in these pictures, mingled with the smoke from firearms and the dust generated by the skirmishes, perfectly illustrate a struggle at its height.

Courtois had considerable influence on Italian painters, especially Monti and Simonini, as well as on French painters such as Joseph and Charles Parrocel. Francesco Alberto Salvagnini's book is now dated,[1] but the research of Edward L. Holt gives a fairly accurate idea of the evolution of the artist's style.[2] It is regrettable, however, that the personality of Jacques Courtois has been eclipsed by that of his brother Guillaume, who primarily painted religious scenes and was prominent among his fellow artists in Rome.

1. Francesco Alberto Salvagnini, *I Pittori Borgognoni Cortese* (Rome, 1936).
2. Edward L. Holt, "The Jesuit Battle Painter Jacques Courtois, le Bourguignon," *Apollo* 89, no. 85 (March 1969):212-223, in particular.

Battle between Turks and Christians
Combat entre turcs et chrétiens
Oil on canvas, 23 1/2 × 28 1/2 in. (59.5 × 72.5 cm)
Mildred Anna Williams Collection. 1974.4(CPLH)

After the Battle
Après la bataille
Oil on canvas, 23 3/4 × 28 1/2" (60 × 72.5 cm)
Mildred Anna Williams Collection. 1974.3 (CPLH)

Provenance [DeMotte, Paris and New York]; [Victor D. Spark, New York, by 1954]; acquired by the CPLH, 1974.

References *The Art Quarterly* 27, no. 1 (1964), *Battle between Turks and Christians* repr., advt.; Wright 1985 (Boston), 170 (*Battle between Turks and Christians*), 285.

Exhibitions Nashville, The Tennessee Botanical Gardens and Fine Arts Center, Inc., *Four Centuries of French Paintings*, 8 December 1961-17 January 1962, no cat.; 1967 New York, nos. 43-44, repr.; 1968-1969 Providence-Riverside, etc., nos. 34-35, repr.; 1969-1970 Florida, no. 19 (both paintings); 1982 Paris-New York-Chicago, nos. 22-23, repr.

Related Work
PAINTING
After the Battle, **fig.1**
Oil on canvas, 14 3/8 × 26 3/8 in. (36.5 × 67 cm)
Staatliche Kunstsammlungen, Dresden. 746

Although these two paintings have been exhibited many times, they were not discussed in print until 1982. They were attributed to Jacques Courtois by Hermann Voss,[1] an attribution that since has received the support of Edward Holt, Antoine Schnapper, and Anna Maria Guiducci.[2] Only Marco Chiarini, Rodolfo Pallucchini, and Jacques Thuillier express reservations because of the steel-blue of the palette and freedom of execution that is more characteristic of Italian painting.[3] Nonetheless, Holt and Guiducci persuaded Pierre Rosenberg to attribute the works to Courtois in the 1982 Paris-New York-Chicago exhibition. Since then, scholars have unanimously accepted this attribution.

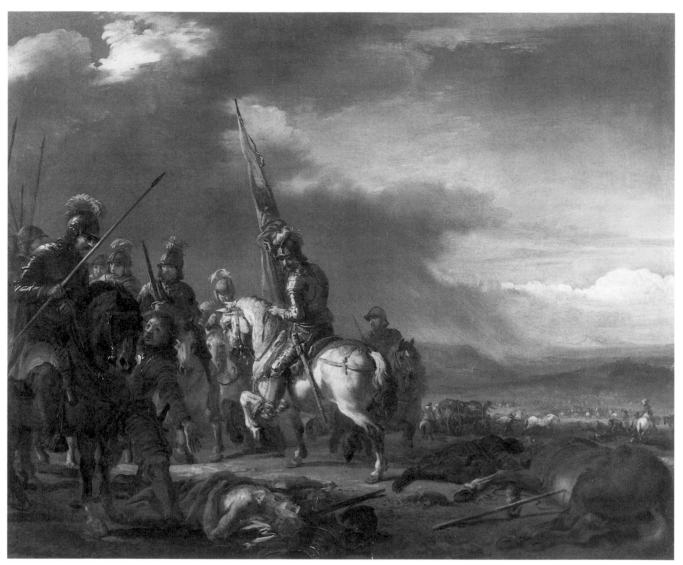

After the Battle

The first of these paintings, like so many of Courtois's works, depicts a battle between Christian and Turkish cavalrymen. One Turk wearing a turban seems about to be knocked off his horse by several adversaries. On the left, far into the distance, another skirmish takes place (fig.2). The heap of dead bodies in the foreground leaves little doubt that the Christians will be the victors. The second painting shows the battleground following combat. Dead horses, prostrate bodies, and a carriage and horses galloping across a desolate plain provide the counterpoint to the central scene in which a standard-bearer looks back at a fallen horseman stripped of his armor (fig.3).

Courtois painted many similar works. *Battle between Turks and Christians*, for example, is executed in the same manner as *Battle with the Turkish Cavalrymen* (Galleria Corsini, Florence) and two other paintings of the same subject in Rome (Galleria Spada and Palazzo Corsini). A drawing, *Combat between Cavalrymen* (Cab. des Dess., Musée du Louvre, Paris)[4] repeats the pose of the fallen warrior at the center in San Francisco's *Battle*. Holt and Guiducci agree that both these canvases were painted late in the artist's career, comparing them with Dresden's *After the Battle* (fig.1). The Dresden picture, according to Guiducci, dates from the early 1660s. Therefore, all three were painted shortly after Courtois entered the Jesuit order.

Like Falcone, Courtois offers battles without heroes. The battleground and scenes of combat are rendered with restraint and attempted objectivity. Courtois delighted in painting the animated gestures of the combatants, the turmoil of entangled bodies, and the clash of arms. In contrast, he also shows the same scenes in the throes of devastation, strangely calm in the wake of the battle. In each picture great dark clouds provide an ominous foil for the action. But the most arresting feature in these battle scenes is Courtois's quick and confident handling of the brush, sketching in the features of the combatants in nervous, fluttery strokes in the foreground and deftly executing silhouettes in the rear. The landscape at the left in *After the Battle* bears a decided resemblance to the work of Rosa. Unfortunately, the colors have not retained their original tones. The red ground has filtered through the paint, changing values. The clouds that once were gray, for example, have turned reddish, altering the light in both pictures, and with it the dramatic tension.

1. Herman Voss, letter, 11 November 1954.

2. Edward Holt, letter, 24 March 1978; Antoine Schnapper, letter, 22 January 1979; Anna Maria Guiducci, letter, September 1981.

3. Marco Chiarini, letter, 31 March 1978; Rodolfo Pallucchini, letter, 17 November 1978; Jacques Thuillier, conversation with M. C. Stewart, May 1977.

4. *French Drawings, Masterpieces from Five Centuries*, exh. cat., The Smithsonian Institution (New York: Platin Press, 1952), no. 51, pl. 18.

fig.1

fig.2 *Battle between Turks and Christians* (detail)

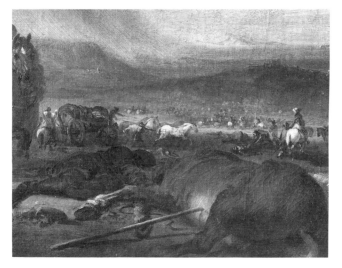

fig. 3 *After the Battle* (detail)

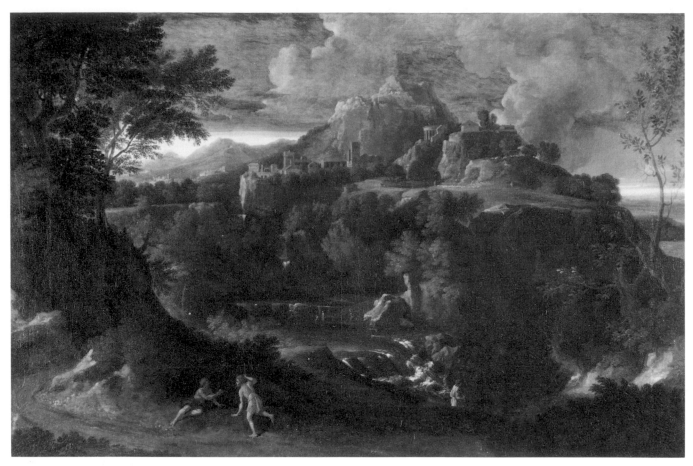

View of Tivoli

Gaspard Dughet, called Le Guaspre, or Gaspar Poussin *Rome 1615-1675 Rome*

In 1630 Nicolas Poussin married Anne Dughet, the daughter of a French pastry cook living in Rome. Her younger brother, Gaspard, probably entered Poussin's studio the next year, remaining until 1635. After several journeys he established himself in Rome, where his fame became assured by the execution of certain fresco cycles (Palazzo Mutti Bussi, San Martino ai Monti, Palazzo Pamphilj, Palazzo Reale del Quirinale, and Palazzo Colonna). A painter of the Roman *campagna*, Dughet, as well as Rosa and others, often asked Roman artists to paint the figures in his works. In advance of Poussin and Claude, who were almost his contemporaries, he distinguished himself by continuing the genre made famous by the great Bolognese artists. Although he limited himself to landscape, he knew how to exploit its possibilities by making use of all possible techniques. He was a very fine draftsman with a distinctive personality, but his originality has been appreciated only in recent years.[1]

Dughet had a poetic temperament. For example, in *The Tempest* (Denis Mahon collection, London) he depicted nature as wild, somber, and more sensitive to the changes of weather and to the seasons than is evident in the landscapes of Claude and Poussin. His works were soon in great demand, particularly by eighteenth-century English collectors, and many classical landscapes were falsely attributed to him as a result of his fame. In the article by Denys Sutton,[2] in the exhibition in Bologna,[3] and the recent Kenwood exhibition,[4] the artist's work has been examined with a more critical eye.

Above all it is to Marie-Nicole Boisclair that we owe our present understanding of the artist's life and his stylistic evolution.[5] The publication of her monograph with catalogue raisonné (1986) should restore Dughet to the place he deserves in the history of seventeenth-century painting.

The problem of Dughet's nationality remains, however. Although he was born and died in Rome without having lived in France, including him in a catalogue devoted to French painting follows a well-established tradition. It is no more unusual than referring to Picasso as a Spanish painter, despite his having lived and worked primarily in France.

1. Marco Chiarini, "Gaspard Dughet: Some Drawings Connected with Paintings," *BM* 111, no. 801 (December 1969):750-754; *Gaspard Dughet und die ideale Landschaft: Die Zeichnungen im Kunstmuseum Düsseldorf*, exh. cat. (Düsseldorf: Kunstmuseum, 1981).

2. Denys Sutton, "Gaspard Dughet: Some Aspects of His Art," *GBA* (July-August 1962): 269-312.

3. *L'ideale classico del Seicento in Italia e la pittura di paesaggio*, exh. cat. (Bologna: Palazzo dell' Archiginnasio, 1962).

4. *Gaspard Dughet, Called Gaspar Poussin*, exh. cat. (London: The Iveagh Bequest, Kenwood, 1980).

5. Marie-Nicole Boisclair, "Documents inédits relatifs à Gaspard Dughet," *BSHAF 1973*, 1974:75-85; "Gaspard Dughet: Une chronologie révisée," *Revue de l'Art*, no. 34 (1976):29-56.

View of Tivoli (*copy after Dughet*)
Vue de Tivoli
Oil on canvas, 30¼ × 46¾ in. (77 × 119 cm)
Mildred Anna Williams Collection. 1978.6 (CPLH)

Provenance F. T. Smith, London; sale, London, Christie's, 7 January 1882, no. 109 (as G. Poussin, *A Classical Landscape with Figures*); acquired by "Wallace," according to Christie's annotated catalogue; sale, Newbury, Berkshire, 1977, no cat.; [Thos. Agnew & Sons Ltd., 1977]; purchased by the CPLH, 1978. (When the picture was relined in 1978, Christie's old stock number 481N was discernible on the stretcher.)

References P. Rosenberg, exh. cat., 1982 Paris-New York-Chicago, 353, no. 4, repr.; Boisclair 1986, no. R. 87, mentioned under no. 152 (copy).

Exhibitions 1978 London (Agnew), no. 42, repr.; 1978-1979 Denver-New York-Minneapolis, no. 14.

fig.3

fig.2

fig.1

Variants

PAINTINGS

View of Tivoli , **fig.1**
Oil on canvas, 21½ × 327/8 in. (54 × 84 cm)
Staatliche Kunstsammlungen, Dresden. Inv. 737
PROV: Original composition acquired from Leplat for Frederick
Augustus III, elector of Saxony and king of Poland, ca. 1722.
REF: Boisclair 1986, no. 152, fig.190.
NOTE: Engraved by John Major, London, 1 March 1833.

Landscape with a Brushfire in the Hills above Tivoli , **fig.2**
Oil on canvas, 20½ × 26 in. (52 × 66 cm)
Musée Ingres, Montauban. Inv. 867.3. Gift to the city of Montauban
by Ingres, 1867
REFS: Museum cat. 1885, no. 137; Boisclair 1986, no. 153.
NOTE: Variant of the painting in Dresden. Engraving (not reversed),
The Conflagration, by W. Radclyffe (Boisclair 1986, G. 208, fig.652).

Landscape of Tivoli , **fig.3**
Oil on canvas, 18½ × 23¾ in. (47 × 60.5 cm)
Collection of Marquess of Exeter, Burghley House, England. No. 462
REF: Boisclair 1986, no. 344.
NOTE: A variant of the painting in Dresden, but probably a copy,
according to Marie-Nicole Boisclair (letter, 22 February 1984).

View of Tivoli , **fig.4**
Oil on canvas, 37 × 61 in. (94 × 155 cm)
Collection of Yannick Guillou, Paris
REF: Boisclair 1986, mentioned under no. 152 (copy), 319 (under
R. 87).
NOTE: Marie-Nicole Boisclair believes this is also a copy after
Dughet, but not by the same hand as the San Francisco painting (let-
ter, 22 May 1985).

DRAWING

Classical Landscape, **fig.5**
Black and white chalk, 1013/16 × 16¾ in. (273 × 425 mm)
National Gallery of Scotland, Edinburgh. Inv. 1720
REF: Boisclair 1986, mentioned under no. 152, fig.191.

Marie-Nicole Boisclair does not accept the attribution
of *View of Tivoli* to Gaspard Dughet, instead proposing
it as a copy of Dughet's painting of the same subject in
Dresden (**fig.1**):
*The more meticulous handling of the brush and the
utmost precision in the drawing, which is not usual for
Dughet, indicates a copy after the Dresden painting.
The rhythm and vivacity of the light effects that animate
Dresden's picture are lacking in San Francisco's. The
treatment of the sky also differs.*[1]
 This copy, which probably was painted toward the
end of the seventeenth century, lacks distinctly divided
planes and is executed with thick daubs of paint. It var-
ies significantly in other ways from its prototype. The
village in the center is dominated by the hills beyond,
which are brightly lighted in contrast to the stormy
clouds massed over the town. In the Dresden version
(which Boisclair dates ca. 1656-1657)[2] the village stands
out against a brighter sky and the treatment is lighter
throughout. Apparently it was a great success and

Dughet painted at least two other versions: *Landscape with a Brushfire in the Hills above Tivoli* (**fig.2**) and *Landscape of Tivoli* (**fig.3**). The former dates from the time of the Dresden picture; the latter, if it is indeed by Dughet, was painted much later.

Tivoli, which overlooks the verdant gorge of the Aniene, was a source of frequent inspiration for Dughet. To the above works we can add *Cascades at Tivoli* (Museo de Arte, Ponce) and its pendant, *View of Tivoli* (Seattle Art Museum), both painted from unusual viewpoints. In his full maturity, Dughet often painted the most famous sites in the Roman *campagna*, subjecting them to his own bold and singular vision. Over the next two centuries successive generations of painters came to Rome from all over Europe, painting these sites in the manner of Dughet's compositions.

Dughet loved the immensity of the outdoors and observed nature directly with a keen eye. The artist of San Francisco's *View of Tivoli* manifests a kindred feeling for the natural world. The figures—a lone wanderer, a group of peasants, two men in conversation, a shepherd and his flock—are placed in the composition in planes defined by the course of the river. The landscape is similarly punctuated by waterfalls, the village, greenery, and distant foothills of the Sabines. Of utmost interest to the artist are the beauty and variety of the Roman countryside, the density and diversity of its vegetation, and the play of water and light under a stormy sky.

1. Boisclair 1986, 319, under R. 87.
2. Marie-Nicole Boisclair, letter, 26 March 1980.

fig.4

fig.5

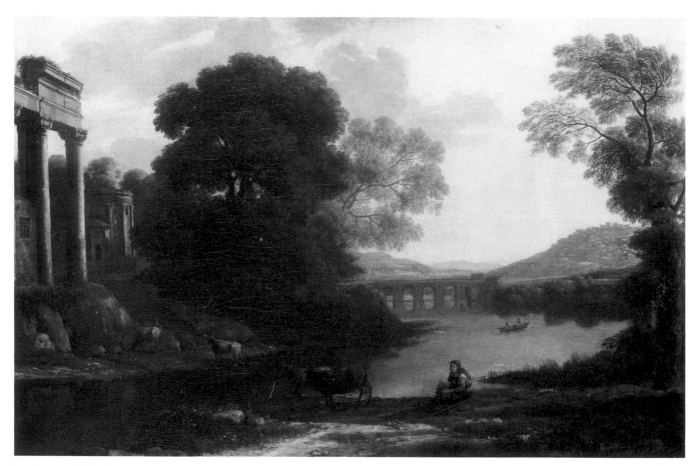

Landscape with Cowherd *or* Evening

Claude Gellée, called Claude Lorrain, or Claude

Chamagne 1600-1682 Rome

Claude Gellée, called Claude Lorrain, was orphaned at the age of twelve. The following year he went to Rome, probably in the company of a family member traveling on business. With the exception of a possible sojourn in Naples with the painter Wals between 1618-1622, and a brief journey to Nancy in 1625-1626 where he worked with Deruet, Claude did not leave Rome again. As a pupil of Tassi he was influenced by his contemporaries van Poelenburgh, Breenberg, and Swanevelt, and to a lesser extent, by the Bril brothers, Elsheimer, and the Bolognese landscape artists. Through the patronage of Cardinal Bentivoglio, Pope Urban VIII, and the king of Spain, he became famous around 1638, working for princes, cardinals, ambassadors, and foreigners visiting Rome. In order to keep a record of his works, but also to discourage forgery and imitation, in 1635 he began to copy each of his paintings into a book of two hundred sheets, the *Liber Veritatis*, now in the British Museum and published by Michael Kitson.[1] His last great patron, beginning in 1663, was Cardinal Colonna. Claude's life was relatively uneventful and he continued to paint until the eve of his death at the age of eighty-two.

Although he animated his canvases with small figures and stories, Claude devoted himself to landscape. He sought inspiration in the Roman *campagna*, but the subjects of his paintings are almost always imaginary, whether he depicts the sea with the reflection of the sun on the waves and the rigging of ships, or the rich foliage of verdant nature. His oeuvre can be studied only from 1629. The first available works are small paintings on copper, landscapes on canvas with genre figures, and seaport or pastoral scenes in the manner of van Laer, called Il Bamboccio (*Pastoral Landscape*, 1629, Philadelphia Museum of Art; *Landscape with Figures*, 1630, Cleveland Museum of Art). The influence of the classical landscapes of Annibale Carracci and Il Domenichino manifests itself around 1640 in compositions that are larger, stronger, and more serene in atmosphere. The artist was at the height of his creative powers in the 1650s when the influences of the previous decade culminated in a monumental and heroic style. His subjects were often taken from the New Testament, such as *Sermon on the Mount* (The Frick Collection, New York). Although his artistic vision became increasingly severe and grandiose, greater lyricism occurs in the last ten years of his career. Claude remains the painter par excellence of idealized landscape, faithfully observing the changing effects of sunlight throughout the day. His depiction of morning and evening light and the sun transforming all that it touches creates an idealized and timeless universe, a golden age of antiquity as yet undefiled by man.

Claude has had an important influence on generations of painters from Turner to Monet. The immense fame he enjoyed during his lifetime remains undiminished, especially in England. Marcel Roethlisberger, who has studied Claude with particular attention, has catalogued 1,200 drawings and 300 paintings. An exhibition organized in 1982-1983 celebrated the tercentenary of the painter's death and the richness of his talent.[2]

1. Kitson 1978. *Liber Veritatis* hereafter referred to as *LV*.
2. *Claude Lorrain 1600-1682*, exh. cat. (Washington: National Gallery of Art; Paris: Grand Palais, 1982-1983).

Landscape with Cowherd
or Evening (*copy after Claude*)

Paysage avec un bouvier or *Le soir*
Also known as *Paysage avec un berger et un pont au lointain*
Oil on canvas, 21 3/4 × 31 1/2 in. (55.5 × 80 cm)
Mildred Anna Williams Collection. 1947.13 (CPLH)

Provenance (Until 1839 with its pendant, *Morning*, whose present location is unknown.) Louis-François de Bourbon, prince de Conti (1717-1776), Paris; prince de Conti sale, Paris, 8 April 1777 (actually 10 May 1777), no. 545 (a pair representing *Morning* and *Evening*); Le Boeuf, Paris; [Le Boeuf] sale, Paris, 8 April 1783, no. 69 (a pair); both acquired by Rousseau de la Goispierre for 3917 francs; Gavin Hamilton, Sicily, ca. 1798; [according to the Smith suppl. 1842, 805-806, nos. 3 (*Evening*) and 4, Hamilton acquired the paintings in Messina ca. 1798; according to Redford 1888, 2:274, he acquired them in Palermo]; John Purling, London, 1798(?); Purling sale, London, 16 February 1801, nos. 50 (*Evening, A Warm Sunset*) and 49; James Forbes, London, 1801; Forbes sale, London, Christie's, 25 June 1839, nos. 160 (*Evening*) and 161; [John Smith, London, 1839]; G. H. Morland, 1840 (*Morning* disappears at this date); Morland sale, London, Christie's, 9 May 1863, no. 86; [John (?) Smith, London, 1863]; Beriah Botfield, Norton Hall, Daventry, 1863; Lord Alexander George Boteville Thynne (1873-1918), 1911; [according to Sir Ellis Waterhouse, Beriah Botfield (d. 1863) left his house and pictures to the Thynnes upon the death of his widow, later Mrs. Alfred Seymour, in 1911]; Lady Beatrice Thynne (1867-1941), Norton Hall, sister of Lord Alexander, by inheritance, 1918; Sir Henry Frederick Thynne, viscount Weymouth (b. 1905), nephew of Lady Beatrice, by inheritance, 1941; Weymouth sale, London, Sotheby's, 4 October 1944, no. 87 (as "Moucheron"); H. S. Round, London, 1944; Round sale, London, Sotheby's, 12 December 1945, no. 104, repr.; [S. & R. Rosenberg, Ltd., London, 1945]; [Rosenberg & Stiebel, New York, 1946]; acquired by the CPLH, 1947.

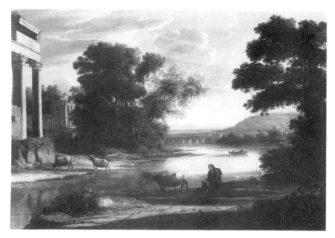

fig.1

fig.2

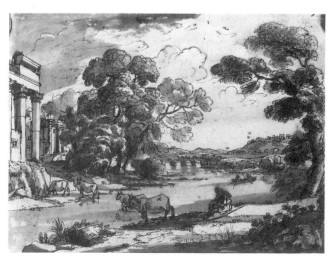

fig.3

References Smith 1837, 360, no. 351, 363, no. 361; Smith suppl. 1842, 805-806, no. 3; S. Bradshaw in Hall 1843-1845, 67, repr.; Redford 1888, 2:274; Howe 1948, 94-97, repr.; *Handbook* 1960, 54, repr.; L. Moore, *The First Book of Paintings* (New York: Watts, [1960]), repr.; Roethlisberger 1961, 1:238-239, fig.391; Roethlisberger 1968, 1:226 under no. 564; Roethlisberger and Cecchi 1975 and 1977, 104-105, under no. 148; Kitson 1978, 106-107, under *LV*85; J. D. Morse, *Old Master Paintings in North America* (New York: Abbeville Press, 1980), 52; Luna 1981, 108, 110 (note 47), fig.18; P. Rosenberg, exh. cat., 1982 Paris-New York-Chicago, 361, no. 11, repr.; Wright 1985 (Boston), 164, 285.

Exhibitions 1952 Vancouver, no. 19; 1962 Atlanta, no. 13.

Variants

PAINTINGS
Landscape with Shepherd, **fig.1**
Oil on canvas, 26¾ × 39 in. (68 × 99 cm)
Signed lower right: *CLAVDIO GELLE f ROMA 164* (?)
Madrid, Museo del Prado. Inv. 2257
REF: Roethlisberger and Cecchi 1975 and 1977, no. 148.
NOTE: This painting corresponds to *LV*85.

Classical Landscape, **fig.2**
Oil on canvas, 18⅞ × 26½ in. (48 × 67.5 cm)
PROV: Sold by Durand-Ruel to Charles H. Senff, 1894; Senff sale, New York, Anderson Galleries, 28 March 1928, no. 29, repr.; acquired by Mrs. L. Cameron; present location unknown.
REF: Roethlisberger 1961, 1:239, *LV*85.
NOTE: This is a small reversed copy of *LV*85, dating from the eighteenth or nineteenth century and offering variations such as the bridge and the seated shepherd, who is replaced by two people from *LV*52.

DRAWING
Pastoral Landscape (*LV*85), 1644-1645, **fig.3**
Pen, brown ink, and wash, 7⅝ × 10¼ in. (195 × 260 mm)
Inscription on verso: *quadro fact per Roma*; and at top: *Claudio fecit/in V.R.*
British Museum, London. Inv. BM 91
REF: Roethlisberger 1968, 1:226, no. 564.
NOTE: Engraved by Earlom in 1777 in England and by Caracciolo in 1815 in Rome, **fig.4**.

Related Work

ENGRAVING
Le bouvier, **fig.5**
REF: André Blum, *Les eaux-fortes de Claude Gellée, dit Le Lorrain* (Paris, 1923), no. 18, pl. 19.

Both this painting and one in the Museo del Prado (**fig.1**) correspond to Claude's *Liber Veritatis* 85 (**fig.3**). In that drawing the architecture is simplified and treated as a unit, the columns of the building on the left are slightly shorter, and the figures are missing in front of the temple. However, such differences between Claude's drawings and paintings are normal. The *LV* states that the

finished composition was painted "per Roma," perhaps for the agent of a Spanish collector. The Prado version was in the collection of Philip V at La Granja by 1746 (Inv. MS of 1746), but does not appear in inventories before that date. It was probably purchased sometime in the first half of the eighteenth century and does not come from the collection acquired by Philip IV.[1]

While the provenance of the San Francisco picture has been fairly well documented since the eighteenth century, its attribution to Claude remains problematic. Marcel Roethlisberger,[2] H. Diane Russell,[3] and Michael Kitson[4] all agree that the Prado picture is the original. A recent cleaning of the painting in Madrid leaves no doubt as to its authenticity. Because the San Francisco landscape appears to be a very good copy, Kitson does not exclude the possibility that it may come from Claude's studio; indeed, its high quality suggests that the artist worked from the original while it was still in Rome, or from his sheet in the *Liber Veritatis*. The San Francisco copy in some respects is closer to the LV drawing than is the original in the Prado, notably in the massing of the greenery and in the buildings at the left. Unfortunately, the Prado and San Francisco paintings have never been compared side by side.

Subtitled *Evening*, the painting in San Francisco apparently once had a pendant, *Morning*, which disappeared in 1840. Its composition is known to us by its description in the catalogue of the Le Boeuf sale of 8 April 1783, no. 69: "One represents a cool and pleasant morning; two women, one of whom presents flowers to a seated shepherd; behind the cows, some goats and other animals enrich the different planes," as well as in the Forbes sale catalogue of 25 June 1839, no. 161: "A landscape with a shepherd and shepherdess, sleeping cattle on a wooded bank and mountainous distance, a clear and brilliant effect of morning." In size and in appearance the lost pendant resembles a painting in the Howard collection, Yorkshire, but the latter's Roman provenance is clearly documented by Roethlisberger.[5] In any case, Claude painted sunrises and sunsets throughout his career, of which *Morning* and *Evening* are but two examples.

The setting for *Evening* is the Roman *campagna*. In the background, we see the Ponte Molle, a motif favored by Claude around 1645 as well as many other artists.[6] These compositions were prized as souvenirs by travelers in the region.

Roethlisberger dates the original composition by Claude ca. 1644, when the artist was at the height of his powers, but the principal elements in the picture are to be seen in Claude's oeuvre as early as 1636 in *Le bouvier*: a bend in the river, the same grouping of the trees, and even the cows ambling home at dusk (**fig.5**). Like its prototype, San Francisco's landscape benefits from the

best elements in Claude: a serene atmosphere, a hint of antiquity, and gentle but exquisite light effects in the water and the sky.

1. Alfonso E. Pérez Sánchez, letter, 18 February 1977.
2. Roethlisberger 1977, no. 148; and letters, 23 January 1979 and 8 June 1984.
3. H. Diane Russell, letter, 4 February 1981.
4. Kitson 1978, 106-107.
5. Roethlisberger 1961, 1:197; Roethlisberger and Cecchi 1975 and 1977, no. 120, repr.
6. See the following drawings: Claude, Cab. des Dess., Musée du Louvre, Paris, Inv. 26684; British Museum, London, Inv. 1895.9.15.912. Poussin, *Landscape with the Ponte Molle*, Cab. des Dess., Musée du Louvre, Paris, Inv. 32476.

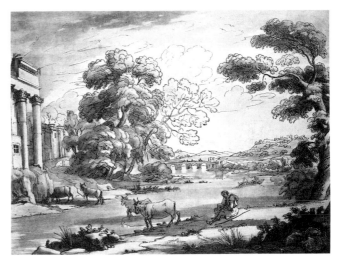

fig.4

fig.5

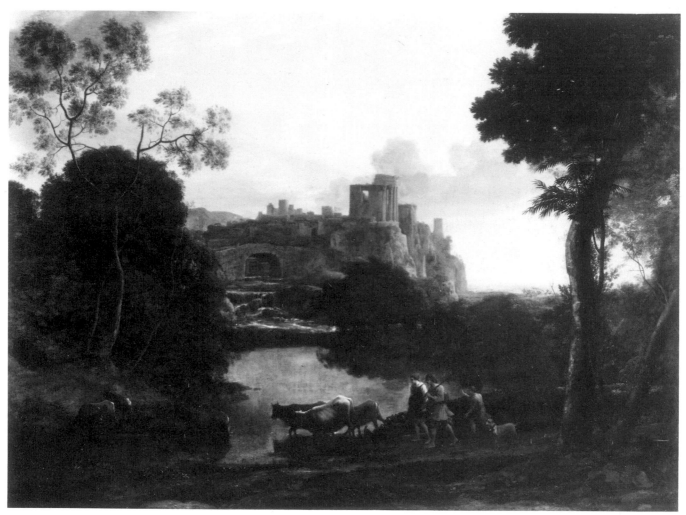

View of Tivoli at Sunset

View of Tivoli at Sunset
(copy after Claude)
Paysage avec un berger et un troupeau
Oil on canvas, 39 1/2 × 53 1/2 in. (100.5 × 136 cm)
Gift of the Samuel H. Kress Foundation. 61.44.31
(de Young)

Provenance Edward Adolphus, twelfth duke of Somerset (1804-1885); his sale, "The Stover Collection," London, Christie's, 28 June 1890, no. 50 (as Claude, "A View of Tivoli, with the Temple of the Sybil and the Palace of the Caesars in the background; two herdsmen with a female peasant and dogs, driving cattle through a ford. 37 1/2 × 51 1/2 in."); [Thos. Agnew & Sons Ltd., London, 1890; acquired for Sir James C. Robinson, according to W. G. Plomer, letter, 3 March 1981]; Sir Francis Cook (1817-1901), Doughty House, Richmond, Surrey, before 1901; Sir Frederick Lucas Cook (1844-1920), inherited 1901; Sir Herbert Frederick Cook (1868-1939), inherited 1920; [M. Knoedler & Co., Inc., ca. 1947]; Samuel H. Kress, New York, 1952; gift of the Samuel H. Kress Foundation to the de Young, 1961. (The painting was cleaned and restored by William Suhr, New York, ca. 1948; relined and revarnished in 1954 and retouched in 1959 by Mario Modestini, New York; and treated in the conservation laboratory of the Los Angeles County Museum of Art, 1973-1977.)

References Cook 1905, 20; Cook 1915, 3: no. 443, repr. opp. 61; Cook 1932, no. 443; Walker 1955, 18; Frankfurter 1955, 58; Larsen 1955, 175; Comstock 1955, 71; Neumeyer 1955, 279; *Architect and Engineer*, 5 July 1958, 5, repr.; Roethlisberger 1961, 1:231-232, fig.154; *European Works* 1966, 113, repr.; Kitson 1967, 147; Roethlisberger 1968, 1:224, under nos. 555-556; Kennedy 1969, 304, fig.1; Roethlisberger 1971, 81; Roethlisberger and Cecchi 1975 and 1977, no. 144, repr.; Eisler 1977, 284-285, no. K 1894, fig.254; Kitson 1978, nos. 65, 81 (1); Lee 1980, 214, 218, fig.5; C. Wright, *Italian, French, and Spanish Paintings of the 17th Century* (London: Frederick Warne Ltd., 1981), 13; P. Rosenberg, exh. cat., 1982 Paris-New York-Chicago, 361, no. 10, repr.; Rosenberg 1984, 42; C. P. Caraco, exh. cat., 1984 Orléans, 20.

Exhibitions 1902 London (The Royal Academy), no. 57; 1948 Baltimore, 42, 67, fig.101; 1951 Pomona, no. 62; 1951 Dallas, no. 49, repr.; 1951 Pittsburgh, no. 62, repr.; 1955 San Francisco, 24-25, repr.; 1961-1962 Washington, no. 18; 1978-1979 Denver-New York-Minneapolis, no. 19.

Variants
PAINTINGS
Ideal View of Tivoli, 1644, **fig.1**
Oil on canvas, 46 × 57 7/8 in. (117 × 147 cm)
New Orleans Museum of Art. Inv. 78.1
REF: Roethlisberger and Cecchi 1975 and 1977, no. 143.

Pastoral Landscape, 1644, **fig.2**
Oil on canvas, 37 1/2 × 50 in. (94 × 127 cm)
PROV: Formerly in the collection of earl of Harewood, Harewood House, England; sale of the princess royal, widow of sixth earl of Harewood, London, Christie's, 29 June 1951, no. 21 (acquired by "West"); present location unknown.
REF: Roethlisberger 1961, 231, fig.393.

Pastoral Landscape with Tobias and the Angel, 1642, **fig.3**
Oil on canvas, 39 3/8 × 50 3/4 in. (100 × 129 cm)
Private collection, Switzerland
PROV: Montribloud collection, Paris; sale, Paris, Paillet, 9 February 1784, no. 78; acquired by Lerouge; [Lebrun]; sale, London, Christie's, 18 March 1785, no. 87; [acquired by Dorset].
REFS: Roethlisberger 1961, mentioned under LV65; also letter, 8 June 1984; M. Kitson, "Claude Lorrain: Liber Veritatis," *Master Drawings*, 1978, 179, repr.

DRAWINGS
Pastoral Landscape with Tobias and the Angel (LV65), 1642, **fig.4**
Pen, brown ink, and wash on blue paper, 7 3/4 × 10 5/16 in. (197 × 262 mm)
British Museum, London. Inv. BM 71
REF: Roethlisberger 1968, 1:211, no. 511.
NOTE: This drawing corresponds to the painting of the same subject mentioned above.

Pastoral Landscape (LV81), 1644, **fig.5**
Pen, brown ink, and wash on blue paper, 7 13/16 × 10 7/16 in. (198 × 265 mm)
British Museum, London. Inv. BM 87
REF: Roethlisberger 1968, 224, no. 556.
NOTE: This drawing corresponds to the painting formerly in the Harewood collection, as well as to that in the New Orleans Museum of Art. It was engraved by Earlom in 1777 in England and by Caracciolo in 1815 in Rome.

Related Work
DRAWING
Three People and Two Dogs, **fig.6**
Preparatory drawing in black chalk and gray wash for the figures in the foreground of the painting, 7 1/8 × 10 1/4 in. (180 × 260 mm)
London, British Museum. Inv. BM 007-153
REF: Roethlisberger 1968, 224, no. 555.
NOTE: Engraved in reverse by F. C. Lewis III.

The vagueness of the citations make the early provenance of the several versions of this composition difficult to establish. For example, does the *Landscape, a View of Tivoli and St. Peter's*, attributed to Claude in the Dr. Bragge sale of 1754,[1] refer to this or to a similar work? It is equally impossible to determine whether the picture described by Smith as a bridge with two arches crossing

fig.1

fig.2

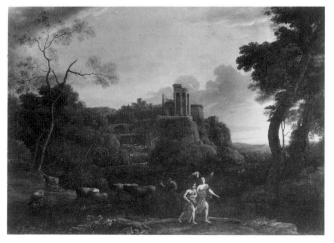

fig.3

a river in the background[2] is the painting in the New Orleans Museum of Art (**fig.1**) or another version formerly in the Harewood collection (**fig.2**).

This *View of Tivoli at Sunset* has also caused concern because its composition has no direct correspondent in the *Liber Veritatis*. Two drawings from the *Liber* possess many features in common with the Museums' painting. The architectural background, the massing of flora, and the arrangement of clouds in LV65 (**fig.4**) are practically identical with those in the San Francisco painting. However, LV65 differs in the manner in which the water cascades over the riverbed, the number of arches in the bridge, and especially the foreground animation, where LV65 illustrates the biblical scene of *Tobias and the Angel*. As a whole, the composition for San Francisco's *View of Tivoli* is similar to LV81 (**fig.5**). The mass of land in the first plane descends obliquely to the river beyond, and each area is animated by a bucolic scene. However, LV81 also corresponds in this way to the landscape in New Orleans and the one formerly in the Harewood collection. Although the three figures in the foreground of LV81 resemble those in a preparatory drawing in the British Museum (**fig.6**), they are not close enough to establish a direct link between the two. The pose of the shepherd in both cases is identical, but the poses of the woman and the young man, who in the drawing is accompanied by two dogs, are not.

Based on the resemblances, can one assume that Claude painted three variations of the same subject around 1644, as Roethlisberger and Eisler believe?[3] The absence of a sheet between pages 59 and 60 in the *Liber Veritatis* might offer a solution to this problem, as would a direct comparison between the three known versions. But there are additional problems with San Francisco's *View of Tivoli*: it is in poor condition, the perspective is clumsily handled in the wall of stone blocks forming the left side of the bridge, and the various landscape elements are organized less densely than might be expected, without poetry and in too minute detail, a miniaturist quality that extends to the treatment of the architectural features.

Despite the refined and beautiful palette, it is believed that the painting probably is not by Claude, but rather by a skillful imitator from the seventeenth or eighteenth century. All the master's familiar elements are there, but recombined to form a new composition. It was in order to protect himself against just such copyists that Claude took the precaution in 1635 of recording his compositions in the *Liber Veritatis*.

1. Dr. Bragge sale, London, Prestage, 24-25 January 1754, no. 64 (Victoria and Albert Museum, Forster Library, 86-00-18, 1:225).

2. Smith 1837, 8:234, no. 81.

3. Roethlisberger and Cecchi 1975 and 1977, nos. 129, 143, 144; Eisler 1977, 284-285.

fig.4

fig.5

fig.6

Georges de La Tour *Vic-sur-Seille 1593-1652 Lunéville*

The first mention of Georges de La Tour in documents dates from 1616 when he was still living in Vic, in the independent province of Lorraine. The son of a baker, in 1617 he married a wealthy woman, Diane Le Cerf. In 1620 he established himself at Lunéville and hired his first apprentice. Historical references mention him regularly in Lunéville, but a recently published document proves that La Tour went to Paris in 1639.[1] In that year he was designated *peintre ordinaire du roi*, a title that he probably owed to the patronage of Louis XIII, a great *amateur* of contemporary painting, and for whom he executed *Saint Sebastian Mourned by Saint Irene* (known through numerous copies, including one at The Detroit Institute of Arts and another in The Nelson-Atkins Museum of Art, Kansas City, Missouri). He continued to work in Lunéville, and during 1644-1651 received important commissions from the municipality intended for the collection of the maréchal de La Ferté, governor of Lorraine. Various court cases and police reports of the time reveal the artist's violent and arrogant nature and his pretensions to nobility. He died suddenly in 1652, leaving two daughters and a son, who was also a painter.

Nothing is known of La Tour's training, although the influence of Bellange has probably been underestimated. It should be noted that Rambervillers, an amateur artist, collector, and poet, was in Vic, and Fourier was in Lunéville during La Tour's early years. Little is known about the artist's travels, but he possibly was in Rome from 1610 to 1616. Several English scholars, however, believe that he also went to the Netherlands.

The story of La Tour's rediscovery is well known, and is obligated to the following: Alexandre Joly's archival research, the identification of works by Hermann Voss in 1915,[2] the exhibition in Paris in 1934,[3] and the monograph published by F.-G. Pariset.[4] However, since the La Tour exhibition in Paris in 1972, and the monographs by Jacques Thuillier, Pierre Rosenberg and François Macé de Lépinay, and Benedict Nicolson and Christopher Wright,[5] publications on the painter have multiplied, including those in Russian, Japanese, and Romanian. Unfortunately, these recent publications provide little new information.

The information contained in the three primary monographs of 1973-1974 has been recently updated. The date, which is difficult to see, for *The Payment of Dues* (Lvov State Picture Gallery) has been read incorrectly as 1634[6] or as 1641 or 1642.[7] In addition, changes in location have occurred. *Saint Philip*, from the series of the *Apostles*, at Albi, is today in The Chrysler Museum, Norfolk; *The Musicians' Brawl* is in the J.

Paul Getty Museum, Malibu; *The Cheat with the Ace of Clubs* is in the Kimbell Art Museum, Fort Worth; *Magdalene with the Flickering Flame* is in the Los Angeles County Museum of Art; *Magdalene with the Mirror* is in the National Gallery of Art, Washington; *Magdalene with Two Flames* is in The Metropolitan Museum of Art, New York; and finally, the upright version of *Saint Sebastian*, formerly in the Church of Bois-Anzeray, now hangs in the Grande Galerie, Musée du Louvre, Paris.[8] Only two new paintings have appeared: the *Pea Eaters* (Berlin Museum), published by Ferdinando Bologna (1975), and *The Choirboy* (Leicestershire Museum and Art Gallery), published by Christopher Wright (1984).

Scholarly opinion is divided over the chronology of La Tour's oeuvre, difficult to establish from the only two paintings that he dated, *The Repentance of Saint Peter* (1645, Cleveland Museum of Art) and *The Denial of Saint Peter* (1650, Musée des Beaux-Arts, Nantes). No one today, however, would deny the originality of an artist who, with an oeuvre of about forty compositions, has become one of the most popular painters of the seventeenth century. Rarely has an artist forgotten for over two centuries enjoyed such brilliant or well-deserved posthumous fame.

1. Michel Antoine, "Un séjour en France de Georges de La Tour en 1639," *Annales de l'Est*, no. 1 (1979): 17-26.

2. Hermann Voss, "Georges du Mesnil de La Tour: Der Engel erscheint dem hl. Joseph; Petrus und die Magd. . . ," *Archiv für Kunstgeschichte*, 2d year, 1915, fasc. 3-4, pls. 121-123 and one page of text.

3. *Les peintres de la réalité en France au XVIIᵉ siècle*, exh. cat. (Paris: Musée de l'Orangerie, 1934).

4. François-Georges Pariset, *Georges de La Tour* (Paris: Henri Laurens, 1948).

5. Thuillier 1973; Rosenberg and Lépinay 1973; Nicolson and Wright 1974.

6. S. Vsevolozhskaya and I. Linnik, *Caravaggio and His Followers* (Leningrad, 1975), 56-59.

7. Yvan Zolotov, *Georges de La Tour* (Moscow, 1979), in Russian with French résumé, 148-150.

8. As noted by Pierre Rosenberg, exh. cat., 1982 Paris-New York-Chicago, 253.

Old Man

Vieillard
Oil on canvas, $35\frac{7}{8} \times 23\frac{3}{4}$ in. (91 × 60.5 cm)
Roscoe and Margaret Oakes Collection. 75.2.9
(de Young)

Old Woman

Vieille femme
Oil on canvas, $36 \times 23\frac{5}{8}$ in. (91.5 × 60.5 cm)
Roscoe and Margaret Oakes Collection. 75.2.10
(de Young)

Provenance E. Holzscheiter, Meilen, Switzerland, ca. 1930 (purchased on the Swiss art market); recognized as La Tour by Kurt Meissner and Herbert Bier, ca. 1950; [Vitale Bloch, 1954]; [Galeries des Tourettes, Paris, by 1955]; [M. Knoedler & Co., Inc., New York, 1955]; Roscoe and Margaret Oakes, San Francisco, 1956; on loan to the de Young 1956-1972, and to the CPLH 1972-1975; gift to TFAMSF, 1975.

References (For the most important of the many references following their 1971-1972 Cleveland and 1972 Paris exhibitions, see Smith 1979.) Marzola 1949-1950, n.p.; Bloch 1954, 81-82, figs.16-17; Florisoone 1954, 253, figs.6-7; Fiocco 1954, 38-48, figs.20a-b; Pariset 1955, 86-87; Blunt 1957, 270 (note 165); Isarlo 1957, 2, repr.; Honour 1957, 34, repr.; *Time*, 4 March 1957, 74-75, repr. in color; Gendel 1957, 50; Cattaui 1957, 244-245, figs.5-6; Comstock 1957, 70-71, *Old Woman* repr.; Grossmann 1958, 91 (note 21); Isarlo 1958, 2; Pariset 1959; Pariset 1963, 56; *European Works* 1966, 110, repr.; Tanaka 1969, 181; Szigethi 1971, figs.6-7; Tanaka 1972; Nicolson 1972, 117; Blunt 1972, 519 (note 13) and 523, fig.1; Pariset 1972, 207; Held 1972, 43, *Old Man* repr.; Young 1972, 62, figs.7-8; Thuillier 1972, 26-27, repr.; Grossmann 1973, 579; Pariset 1973, 63, repr.; Rosenberg and Macé de l'Epinay 1973, 90-91, nos. 2-3, 15, *Old Woman* repr. in color; Thuillier 1973, 87, nos. 2-3 (color pls. 1-2); Held 1973, 86-87; Nicolson and Wright 1974, 17-18, 27, nos. 61-62 on 196-197, *Old Woman* repr. in color, pls. 4-7 and fig.11; Bologna 1975, 37-39, fig.7; Spear 1975, 120-122, repr., and 228; Schleier 1976 (G.S.M.), n.p., *Old Woman* fig.2; Schleier 1976 (G.M.), 236, *Old Woman* fig.88 on 232; Bordeaux 1977, 36, 38, repr.; Wright 1977, pls. 2-3 (color); Smith 1979, 288-293; Nicolson 1979, 65; *Art News*, April 1979, 5, *Old Woman* repr., advt.; Lee 1980, 218, 215, figs.6-7; L. Sherman, *Art Museums of America* (New York: William Morrow & Co., 1980), 36; B. Fromme, *Curator's Choice*, west. ed. (New York: Crown Publishers, 1981), 59, *Old Woman* repr. on 58; H. Langdon, *The Simon and Schuster Pocket Art Museum Guide* (New York: Simon and Schuster, 1981), 155; C. Wright, *Italian, French, and Spanish Paintings of the 17th Century* (London: Frederick Warne, Ltd., 1981), 26; F. R. Willis, *World Civilizations* (Lexington, Massachusetts: D. C. Heath and Company, 1982), 898, repr.; Mai 1982, 153; Cuzin 1982, 529; J. Russell, "French Masters at the Met," *New York Times*, 4 June 1982, 15, *Old Woman* repr.; P.-E. Barbier, "La peinture française du XVIIᵉ siècle dan les collections américaines," *Encyclopaedia Universalis*, 1983 ed., 514, *Old Man* repr.; W. Wilson, *California Museums* (New York: Abrams, 1985), 70, figs.56-57 (color); Wright 1985 (New York), 14, 15, repr.; Wright 1985 (Boston), 201 (both attr.), 285; T. Hoving, "The Grand Tour," *Connoisseur*, February 1987, 96.

Exhibitions 1956-1957 Rome, nos. 158-159; 1971-1972 Cleveland, nos. 40-41, repr.; 1972 Paris, nos. 1-2, repr.; Los Angeles County Museum of Art, *Georges de La Tour in California*, 15 December 1977-31 January 1978, no cat.; 1978-1979 Denver-New York-Minneapolis, nos. 25-26; 1982 Paris-New York-Chicago, nos. 35-36, repr.

First mentioned by Maria Marzola (1949-1950), then published by Vitale Bloch (1954), Giuseppe Fiocco (1954), and exhibited in 1956 in Rome by Charles Sterling, these two paintings came to San Francisco in 1956 on loan to the de Young Museum. Although they are in remarkable condition, the backgrounds may have been slightly retouched. An examination under ultraviolet light shows little loss of the original paint, but both may have been cut down by a few centimeters in their upper portions.[1]

While it is now generally conceded that *Old Man* and *Old Woman* are the work of La Tour, it was not always the case. Georges Isarlo (1957) and François-Georges Pariset (1963) rejected this attribution, hypothesizing that the paintings were fragments of a single composition. However, Richard E. Spear[2] and Benedict Nicolson (1972) attributed the works to La Tour, and critical opinion generally has been in agreement since the 1972 Paris exhibition. Only Isarlo and Hidemichi Tanaka (1972) continue to disagree, while Pariset has adopted a more moderate position. In our opinion these two paintings rank among La Tour's most ingenious works.

The two pictures clearly come from the early years of La Tour's production. Nicolson and Christopher Wright proposed ca. 1618-1619, shortly after the artist's marriage in 1617, but before he settled in Lunéville in 1620.[3] We find the same delicacy of workmanship and finished technique in La Tour's *Settling of Scores* (Lvov State Picture Gallery) and *The Pea Eaters* (Staatliche Museen Preussischer Kulturbesitz, Berlin). In *Old Woman*, the complex patterns formed by the folds in the subject's sleeves anticipate the art of Jean Leclerc, who returned to Lorraine in 1621 or early 1622.

The paintings pose two problems for art historians that in effect are the same. In question is the subject matter in each picture, and whether the costumes worn by the two peasants are from Italy or from Lorraine. Martha Kellogg Smith (1979), encouraged by suggestions from Blunt (1972) and F. Grossmann (1973), advances the idea that both are figures from popular North European theater. From sixteenth- and seventeenth-century engravings and plays Smith identifies *Old Woman* as Alison, the irascible and cantankerous wife, and *Old Man* as Père Dindon, the perpetually henpecked husband. She suggests that La Tour might have taken his costumes from engravings, but more likely painted what he had seen actors wearing in these popular farces. As these plays came out of folk tradition and were performed in the streets, La Tour need not have been to Italy or have known the inventions of the Caravaggesque painters, although this does not necessarily exclude the possibility. Smith notes the absence of close links between these pictures and the *commedia dell' arte*, and wonders if San Francisco's pendants, like *The Musicians' Brawl* (J. Paul Getty Museum, Malibu),

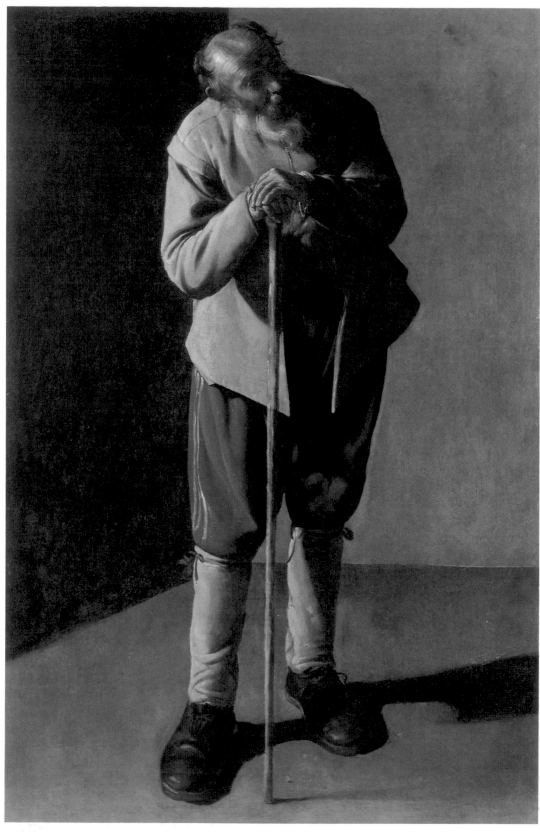

Old Man

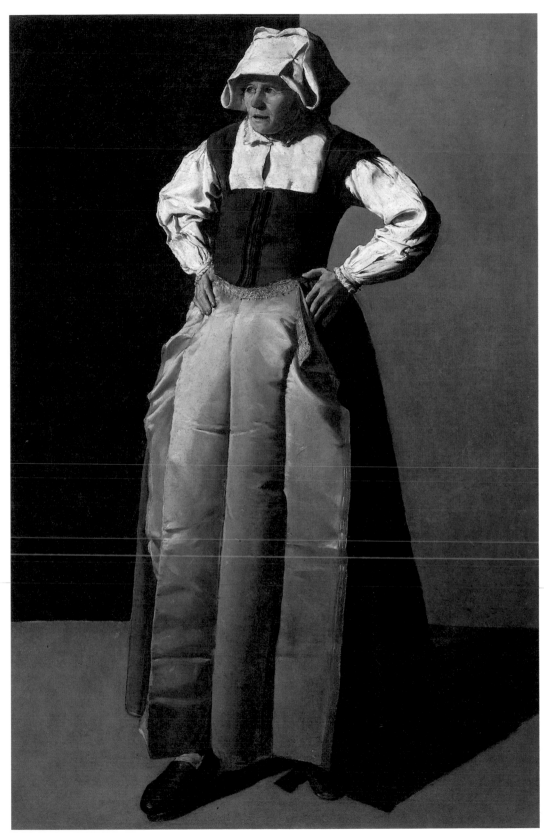

Old Woman

The Cheat with the Ace of Clubs (Kimbell Art Museum, Fort Worth), or *The Fortune Teller* (The Metropolitan Museum of Art, New York), should be accepted as illustrations of scenes from the theater.

Smith's analysis only partially tackles the problems in *Old Man* and *Old Woman*. The harsh light illuminating the figures and accentuating the shadows may be theater footlights, but what accounts for the diverging horizon lines and the illogical treatment of space in the background? In *Old Woman*, for example, opposing zones of shadow occupy the same plane. Possibly the artist simply wanted to emphasize contrasts of light and shade, however artificially. These figures might derive from northern prototypes, but we need look no further than the engravings of Callot for a precedent in the depiction of popular types. The extremely refined facture in La Tour's pictures may also owe something to Jacques Bellange. While it is true that only one composition, the nocturnal *Pietà* (Hermitage, Leningrad) can be attributed to Bellange with certainty,[4] there are similarities between this picture and La Tour's in the use of impasto and in the subtle range of colors.

The masterful treatment of the embroidery in the apron of the *Old Woman* and the expressive use of color, as in the vermillion of *Old Man*'s pantaloons, has been greatly admired. La Tour's touch is edgy and quick, relying on broken accents for nuance. Too often overlooked, however, is the presumably bitter exchange that takes place between the two figures, the woman derisive and haranguing, the man abject and humiliated. La Tour captures this dialogue with striking clarity, but without sentimentality or compassion.

1. Exh. cat., 1972 Paris, 119.
2. R. Spear, exh. cat., 1971-1972 Cleveland, nos. 40-41, repr.
3. Nicolson and Wright 1974, nos. 61-62, repr.
4. S. Vsevolozhskaya and I. Linnick, *Caravaggio and His Followers* (Leningrad, 1975), pls. 46-48.

Louis(?) Le Nain *Laon 1600/1610-1648 Paris*

After the monumental exhibition organized in 1978-1979 by Jacques Thuillier at the Grand Palais, Paris, it seems possible to divide the works of the Le Nain brothers, with rare exceptions, into three homogeneous groups. The brothers lived together until the two elder died in 1648. All three collaborated on certain works although probably less than has been suggested, signing their paintings without using their Christian names or initials. The paintings that today bear the name *Le Nain* are so different in quality and spirit, however, that each of the three brothers must be approached individually to find his artistic personality and originality.

One body of work can be attributed to Mathieu, who is the youngest and most documented, both for his military service and for his artistic activity. It is almost impossible to say to what extent Antoine or Louis is responsible for the other two groups of works. Du Bail and Claude Leleu appreciated Antoine "for the truth of his portraits executed from life." They also wrote that "he excelled in foreshortening in his miniatures and portraits," whereas Louis "made marvelous small paintings with a thousand different poses taken from life." They added that "he was successful with half-length and bust portraits."[1] These judgments are obviously too vague and too similar to make certain distinctions between Antoine and Louis; for example, it would be impossible to say which brother painted a group of small portraits on copper.

Louis, the second brother, is the most mysterious. He was in Paris with Antoine and Mathieu in 1629, and with them participated in the first session of the Royal Academy of Painting and Sculpture on 1 March 1648. He was buried the following 24 May, two days before Antoine, both presumably victims of some contagious disease. It is therefore arbitrarily that the name of Louis is assigned, or rather traditionally left, to the group of paintings that depict people with round and heavy faces and an air of melancholy (*Peasants in a Landscape*, National Gallery of Art, Washington; *Allegory of Victory* and *Peasant Meal*, Musée du Louvre, Paris). Louis, the genius of the family, appears to have been a somber artist, pensive and self-contained, who shunned elegance and relentlessly explored new horizons.

In addition to Jacques Thuillier's exhibition catalogue, an excellent source of information is the article by Marie-Thérèse de Roodenbeke.[2]

1. Louis Moreau du Bail, *Les galanteries de la cour* (Paris, 1644), 185-190; and Claude Leleu, *Histoire de la ville de Laon* (1632), MS dated 1632.

2. Marie-Thérèse de Roodenbeke, "Précisions nouvelles sur les oeuvres des Le Nain," *BSHAF 1979*, 1981:101-110.

Peasants before Their House
Paysans devant leur maison
Oil on canvas, 21 3/4 × 27 3/4 in. (55 × 70.5 cm)
Mildred Anna Williams Collection. 1941.17 (CPLH)

Provenance Probably acquired by Charles, fourth duke of Rutland (1754-1787), Belvoir Castle, England, in the last third of the eighteenth century; possibly identical with a painting entitled "Peasants at the door of a cottage, capital," sale, London, Christie's, 27-29 February 1772, no. 60, acquired by "May" for 25 guineas. (This sale, as well as the sale of 1818, mentioned below, was brought to our attention by Marie-Thérèse de Roodenbeke); [M. Knoedler & Co., Inc., New York, 1936]; acquired by the CPLH, 1941.

References Eller 1841, 209; Waagen 1854, 3:399; Thieme and Becker 1907-1950, 23:42; Jamot 1922, 232; Escholier 1923; Jamot 1923 (January), 32-33; Jamot 1923 (March), 158-160, repr. on 159; Michel 1923, 169, repr. on 168; Rey 1923, 5; J.-L. Vaudoyer, "L'exposition Le Nain," *Echo de Paris*, 18 January 1923; Vaillat 1923, 59, repr.; "L'actualité," *L'Art et les Artistes*, February 1923, 201; Thiis 1924, 304; Jamot 1929 (Paris), 40, 43, 48, repr. on 57; Jamot 1929 (*Pantheon*), 360; Weisbach 1932, 362 (note 33); Fierens 1933, 28-29, 60, pl. 26; Sambon 1934, 15; Sambon 1936, no. 6; Isarlo 1938, no. 246; Bloch 1939, 53; *The Art Quarterly*, Spring 1941, 154-155, repr. on 148; *Illustrated Handbook* 1942, 41, repr.; *idem*, 1944, 47, repr.; *idem*, 1946, 48-49, repr.; Howe 1944, 20, 21, repr.; Davisson 1946, 28, repr.; Leymarie 1950, fig.33; Bloch 1953, 367; Druart 1953, 9; *New York Times*, 20 February 1955, repr.; Fierens 1957, 550-551, repr. on 547; F. Fosca, "Trois peintres de la réalité au XVIIe siècle," *Tribune de Genève*, 22 August 1957, repr.; Wehle 1957, no. 14; *Handbook* 1960, 55, repr.; Sterling 1963, 115, pl. 69; Châtelet and Thuillier 1964, 21, repr. in color on 19; Bloch 1966, repr. in color pls. 8-9; W. Davenport et al., *Art Treasures in the West* (Menlo Park: Lane, 1966), 156, repr. on 144; Gébelin 1969, 72; Lough 1969, fig.7; Martinet 1971, 5; Bordeaux 1977, 33; Blunt 1978, 873; *Western European Painting* (Leningrad: Hermitage, 1978), mentioned under no. 49; Thuillier 1978-1979, 660; Cuzin 1979, 70 (note 14); Rosenberg 1979, 94, repr. on 95; Thuillier 1979, 159, 160, 163, 166 (note 1); Schleier 1979, 191-192; Lee 1980, 213, fig.2; C. Wright, *Italian, French, and Spanish Paintings of the 17th Century* (London: Frederick Warne, Ltd., 1981), 27; "La peinture française du XVIIe siècle dans les collections américaines," *Le Petit Journal des Grandes Expositions*, no. 116 (1982), fig.46; Blum 1982, repr.; Mai 1982, 153; W. Wilson, *California Museums* (New York: Abrams, 1985), 72, fig.58; Wright 1985 (Leicester), 1, 78; Wright 1985 (Boston), 106, fig.58, 214, 285.

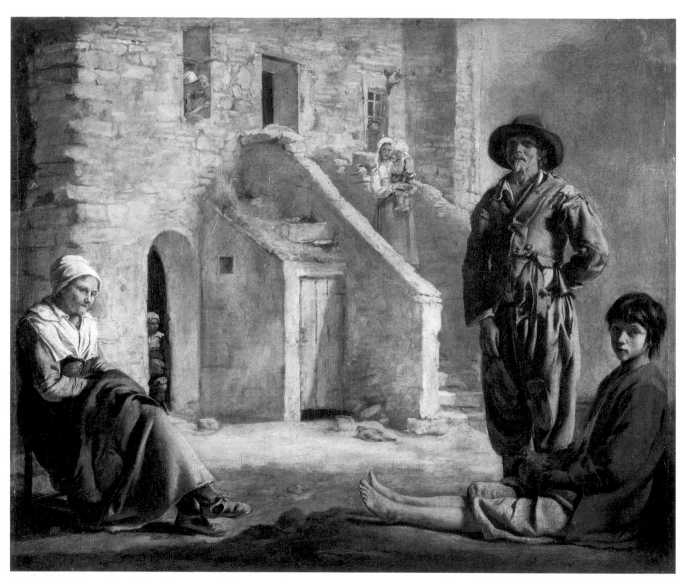

Peasants before Their House

Exhibitions 1910 London, no. 30, pl. 9; 1923 Paris, no. 1, repr.; 1936 New York, no. 14, repr.; 1946 New York (Wildenstein), no. 28, repr.; 1947 St. Louis, no. 26, repr.; 1950-1951 Philadelphia, no. 46, repr.; 1951 Pittsburgh, no. 52, repr.; 1951 Santa Barbara, no. 2, repr.; 1953 Reims, no. 7, pl. 5; 1955 Sarasota, no. 8, repr.; 1957 Buffalo, 10, repr.; 1958 Los Angeles-San Francisco, no. 16, repr.; 1961 New York, no. 12, repr.; 1961-1962 Canada, no. 42, repr.; 1966 The Hague-Paris, no. 20, repr.; 1978-1979 Denver-New York-Minneapolis, no. 24; 1978-1979 Paris, no. 35, repr. (details in color on 10 and 205); 1982 Paris-New York-Chicago, no. 46, repr. on 142.

Variant

PAINTING
Peasants before Their House (old copy), **fig.1**
Oil on canvas, 22¼ × 26 in. (57 × 66 cm)
Museum of Fine Arts, Boston, Clara Bertram Kimball Fund. 22.611
PROV: Earl of Carlisle, early nineteenth century; sale, Countess Rosalind Carlisle, London, Sotheby's, 10 May 1922, no. 88.
REFS: J. Thuillier, exh. cat., 1978-1979 Paris, mentioned under no. 35; P. Rosenberg, exh. cat., 1982 Paris-New York-Chicago, 356, no. 3, repr.; A. Murphy, *European Paintings in the Museum of Fine Arts* (Boston: Museum of Fine Arts, 1985), 164, repr.
NOTE: Possibly identical with a painting from the sale of the late "Michallon portrait sculptor, premier coiffeur du Roi and of S. A. R. the duc d'Angoulême," 30 March-4 April 1818, no. 351: "Nain (L. le). Family of villagers at the door of their house. From all points of view the painting merits restoration. . . . Canvas, h. 22; l. 28 in. (59.5 × 75.5 cm)."

fig.1

Related Work

PAINTING
The Cart, **fig.2**
Oil on canvas, 22 × 28⅜ in. (56 × 72 cm)
S.d. lower left: *Le Nain fecit 1641*
Musée du Louvre, Paris. RF 258

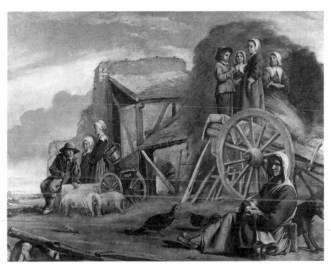

fig.2

The Le Nain exhibition of 1978-1979 in Paris brought together two versions of *Peasants before Their House*, the San Francisco picture and one from the Museum of Fine Arts, Boston. The Boston picture long had been thought to be the work of Le Nain, but is now considered a copy. Nonetheless, by seeing the two paintings together we have a better idea of the San Francisco picture's probable appearance before its borders were extended slightly at either side. The old woman at the left, who conceals her hands inside her apron, once had her back against the picture's frame; the boy with the rooster who sits on the ground at the right was originally shown leaning against a chair.

The attribution of this painting to the Le Nain brothers has never been in question, and this remarkable canvas can only have come from the genius of the family. As early as 1854, Waagen observed that *Peasants before Their House* contained "all the most esteemed qualities of the master, great truth, clearness of colour, and a

careful execution."[1] Many similarities exist between this painting and *The Cart* (**fig.2**). Both reveal the same confident brushwork—restrained in the treatment of the figures, appropriately chalky in the depiction of the stone masonry, and deft and sure in the rendition of the hay and plant growth on the rooftops. The rough texture of the painted surface perfectly and realistically captures the appearance of a Laon farmhouse. Its huge stone blocks, the stair at the right leading up to the living quarters, the storeroom on the ground floor, and the generally dilapidated condition are typical of the living conditions in Picardy during this troubled era. As in *The Cart*, the figures in *Peasants before Their House* look out from the painting as if surprised by the sudden arrival of a visitor. Even those in the background, the women carrying children and the little girl with a dog, seem to pause in silent expectation.

The painter employs a nearly monochromatic palette of grays and ochres to describe the peasants' clothing, the earth, and the sky, and uses subdued yellow tones to bring out the weathered quality of the old stones. Only a few bold strokes of red, in the jacket of the dispirited-looking boy in the foreground and the sleeve of the girl under the arch, break this atmosphere of unrelieved sobriety. The air of stability and the serenity pervading *Peasants before Their House* can also be credited to the network of straight and oblique lines that unify the composition. In the case of the man and the boy at right, these lines intersect quite sharply, contributing to the unusual and highly abstract composition of this painting.

The figure of the man in the hat occupies a pivotal position between the oblique line of the stair and the figure of the boy at right. Against an overcast sky, this figure "in his tattered clothes, one of the most beautiful figures of a peasant in all of French art,"[2] suggests a quiet dignity in contrast to the squalor of his surroundings. The gravity and peculiar allure of this work derive from this sense of another presence just beyond the picture frame and from the way the painter treats his models—without irony, idealization, or condescension, but with great respect and sympathy. Rarely have poetry and realism been combined with such telling results.

1. Waagen 1854, 3:399.
2. Jacques Thuillier, exh. cat., 1978-1979 Paris, 206, under no. 35.

Eustache Le Sueur *Paris 1616-1655 Paris*

Le Sueur was better known and appreciated in his lifetime and during the nineteenth century than he is now. However, Alain Mérot's work (1987) should restore the artist to his rank among the most original painters of a decade that witnessed the birth of Mignard, Bourdon, and Lebrun.

The son of a woodworker, Le Sueur remained in Paris all his life. Around 1632 he began his apprenticeship in the studio of Simon Vouet, where he remained until 1643-1644. He completed his training by studying the works of Raphael, the drawings in the royal collection, the engravings of Raimondi, and the decorations for the Château de Fontainebleau. At the beginning of his career he was helped by Vouet, who gave him a commission in 1637 for eight paintings illustrating the *Dream of Polyphilus* by F. Colonna. Le Sueur soon distinguished himself from his teacher by a more sensual approach to his subjects and greater refinement in the use of color. Several important canvases dating from this period often have been attributed to Vouet, such as *Tobias and the Angel Raphael* (Musée des Beaux-Arts, Grenoble) and the *Resurrection of the Son of Nain's Widow* (Church of Saint-Roch, Paris). Poussin was in Paris from 1640 to 1642; primarily through the influence of his works and those of Raphael, Le Sueur's paintings became increasingly classical but did not lose the elegance, grace, harmony, and freshness of tone characteristic of his art. In this period are found the decorative works he executed between 1644-1650 for the *hôtel* of the president of the Chambre des Comptes, Lambert de Thorigny, *Cabinet of Love* and *Cabinet of the Muses*, of which many parts are preserved at the Musée du Louvre, and *Cabinet of the Bath*.

His series of twenty-two paintings depicting the major episodes in the life of Saint Bruno (Musée du Louvre, Paris) brought him immense fame. Rapidly executed from 1645-1648 to decorate the cloister of the Charterhouse of Paris, these works reveal a personal style that was the fruit of his sustained reflection on Poussin's classical example. In 1648 he was asked to join the founding members of the Royal Academy of Painting and Sculpture. He painted an *Allegory of the French Monarchy* for the king's room at the Louvre, treated the theme of *The King's Authority*, and decorated the queen mother's bathroom. All of these works, unfortunately, disappeared during the eighteenth century.

After 1650 Le Sueur began to use subjects borrowed from the Old and New Testaments as well as Greek history. Impressed by Raphael's tapestry cartoons and his paintings in the Vatican loggia, he developed a formula that was cold, monumental, and controlled by a delicate palette refined to the point of preciousness.

The death of this "French Raphael" at the age of thirty-eight, one year before La Hyre and two years before Stella, removed the major obstacles for Lebrun, who established himself as his country's foremost painter.

Sleeping Venus
Vénus endormie surprise par l'amour
Oil on canvas (octagonal), 48 × 46 in. (122 × 117 cm)
Mildred Anna Williams Collection. 1977.10 (CPLH)

Provenance Perhaps in the collection of Sir Peter Gleane, sale, London, Prestage, between 1745 and 1755, second day, no. 132: "A Sleeping Venus, Cupid, etc.—Le Sueur," (*Catalogue of Picture Sales in England 1711-1759*, MS, 1:373, Victoria and Albert Museum, Forster Library 86-00-18); probably in the collection of the prince de Conti; his first sale, 8 April 1777 (actually 10 May 1777), no. 621: "Vénus endormie surprise par l'amour" (no dimensions given); acquired by "Vautrin" for 201 *livres*, according to the annotated cat., Bibliothèque d'Art et d'Archéologie, Paris; Marguerite Sapin (1986, no. 5) suggests the following provenance for the years 1793-1795: anonymous sale, Paris, 96 rue de Cléry (expert: J.-A. Lebrun), 13 February 1793, no. 72 (50 × 45 *pouces* [ca. 136 × 122 cm]); perhaps in the inventory made by J.-A. Lebrun after the seizure of the collection of Deville, former *fermier général*, 17 place des Piques, Paris, with an attribution to Simon Vouet, as no. 8 (ca. 145 × 129 cm); deposited with the rest of the Deville collection at Nesle, Paris, 27 or 28 December 1794; returned to the "widow Deville" with the rest of her husband's collection, 21 October 1795; [O'Dwyer, Salisbury, ca. 1940-1968]; [Johannes Thermes, Dublin, 1969-1975]; [Art Associates Partnership, Bermuda, 1975]; acquired by TFAMSF, 1977.

References Dussieux 1852-1853, 118, engraving on 122; Rouchès 1923, 53 (lost); GBA, "La Chronique des Arts," March 1978, 44, fig.198; Cohn and Siegfried 1980, 116; Lee 1980, 214, pl. 29 on 217; Rosenberg 1982 (*La Revue du Louvre*), 74; Rosenberg 1982 (*Connaissance des Arts*), 80, repr. in color, 82; "La peinture française du XVIIᵉ siècle dans les collections américaines," *Le Petit Journal des Grandes Expositions*, no. 116 (1982), fig.51; Mérot 1983, 8, 13; Rosenberg 1984 (*Metropolitan Museum Journal*), 30, no. 51; W. Wilson, *California Museums* (New York: Abrams, 1985), 73; Wright 1985 (Boston), 220, 285; Sapin 1986, 57, no. 5; Mérot 1987, no. 14, repr.

Exhibitions 1978-1979 Denver-New York-Minneapolis, no. 27; 1982 Paris-New York-Chicago, no. 51, color repr. on 148.

Variants
PAINTINGS
Venus, Cupid, and Vulcan (old copy)
Oil on canvas, 49 5/8 × 50 in. (126 × 127 cm)
PROV: Anonymous sale, Paris, Hôtel Drouot, salle 1, 17 May 1974, no. 96, repr., as "School of Simon Vouet."

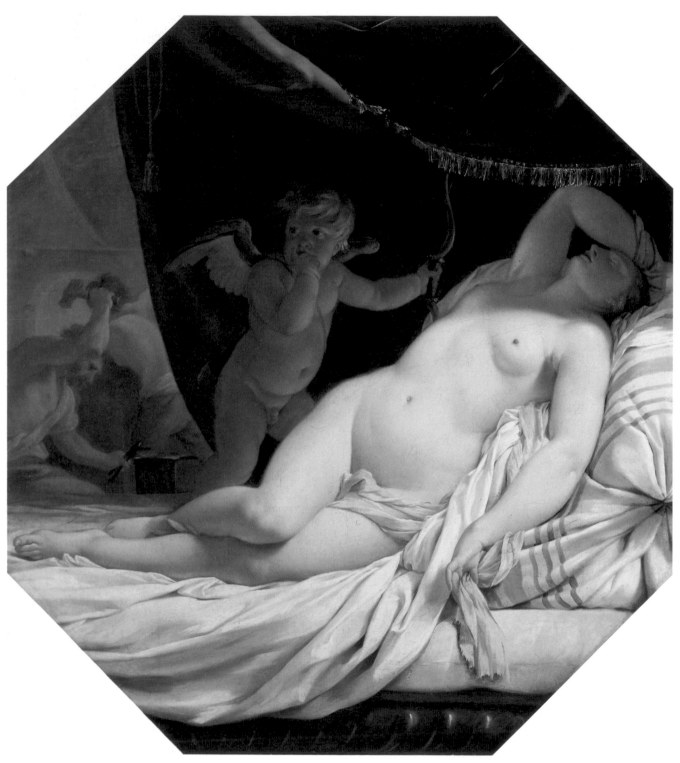

Sleeping Venus

Venus and Cupid, **fig.1**
Oil on canvas, 30 × 33 ½ in. (76 × 80.5 cm)
PROV: Anonymous sale, *Catalogue d'une belle collection de tableaux
originaux des trois écoles*, Paris, 10 December 1778, no. 100: "Eu-
stache Le Sueur. Love has just surprised a half-nude woman sleeping
on a bed hung with a crimson curtain, H. 27 × 32 *pouces*"; sale, New
York, Christie's, 15 January 1986, no. 110a, repr. in color; Matthiesen
Gallery, London.

ENGRAVINGS
Pierre Daret, *Vénus endormie*, **fig.2**
Octagonal, and in counterproof, 10 ⅝ × 8 ½ in. (270 × 217 mm)
A print is held in the AFGA, TFAMSF, 1977.1.300
REFS: Cab. des Est., DA 7 fol., 45; not catalogued by Weigert 1939-
1968; P.-J. Mariette, *Notes manuscrites sur les peintres et graveurs*
(MS, BN, Paris 1740-1770), Cab. des Est., Ya²4 pet. fol., 3:fol. 3 and 9.

Pierre-François Basan, *Le député de Mars*
Square format, a reissue in the eighteenth century of Pierre Daret's
Vénus endormie
REFS: Paris, Bibliothèque de l'Arsenal, no. 102.40; Georg Caspar
Nagler, *Neues Allgemeines Künstler-Lexikon* (1835-1852; reprint,
Vienna, 1924), 20:110.

NOTE: Louis Dunand ("Les estampes dites 'découvertes' et 'cou-
vertes,'" *GBA*, April 1967, 229) has shown that editors often executed
a supply of engravings designed to be glued onto the proofs so that the
censor's attention would not be attracted by excessive nudity.

Emma Landon Soyer, *Le sommeil de Vénus*
Line engraving after the print by Daret
REF: C. P. Landon, *Galerie des peintres les plus célèbres: Vie et
oeuvres . . . d'Eustache Le Sueur* (1803-1817; reprint, Paris, 1844),
12:pl. 92. (Also *Sammtliche Werke von Eustache Le Sueur*, Paris, n.d.,
pl. 92).

Pierre-Joseph Challamel
Lithograph in rectangular format
REF: L. Vitet, *Eustache Le Sueur: Sa vie et son oeuvre* (Paris, 1849),
pl. 61.

fig.1

fig.2

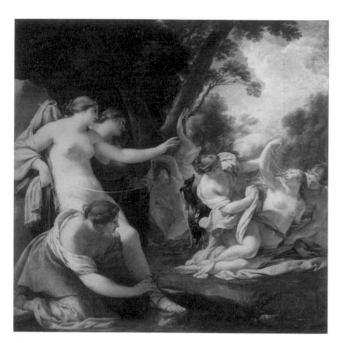

fig.3 Le Sueur, *Diana and Callisto*, oil on canvas, 53⅛ × 51¼ in. (135 × 130 cm), Musée Magnin, Dijon.

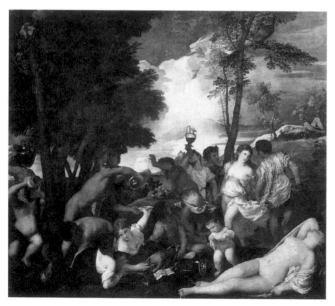

fig.4 Titian, *The Andrians (Bacchanal)*, 1523-1525, oil on canvas, 68⅞ × 76 in. (175 × 193 cm), signed: *Ticanvs F.* (restored), Museo del Prado, Madrid.

Long a celebrated picture, the *Sleeping Venus* in San Francisco was the subject of numerous engravings during the seventeenth, eighteenth, and nineteenth centuries. Yet nothing is known about the picture's origins and details of its provenance before the Second World War remain sketchy. It might have belonged to Sir Peter Gleane, probably passing into the collection of the prince de Conti in the eighteenth century.

There is no ambivalence about the subject or in the frankly erotic way it is treated. Although the artist portrays a divine couple, Vulcan, the god of fire, and Venus, the goddess of love, the mythological subject is merely a pretext for the artist's main objective, the depiction of a beautiful female nude. Le Sueur creates a sense of drama, contrasting the illuminated form of the sleeping goddess with the figure of Cupid, who holds a finger to his mouth, and Vulcan at the forge in the background. The artist relegates the face of Venus to the shadows, thereby throwing emphasis on the voluptuous curves of her body. Other details—the rosiness of the goddess's lips and the play of light and shadow that highlights the boy's expression and genitals—intensify the licentious character of the painting, but at the same time maintain a certain standard of decorum.

Sleeping Venus is not the only work of this type in Le Sueur's oeuvre. Another such picture is *Bacchanal with Sleeping Nymph*, a picture now lost but known by an engraving by Dorigny (ca. 1638-1639). The pose of the nymph, for which there also exists a preparatory study in a private collection in Paris, is particularly close to that of Venus in the San Francisco painting. The brilliant color and free handling of the paint in *Sleeping Venus* also resemble that of *Diana and Callisto* (fig.3). That picture, formerly attributed to Vouet, surely dates from the 1638-1639 period in which *Sleeping Venus* was executed. The artist also may have been inspired by an engraving by Daret, based on Vouet's painting of *Cupid and Psyche*, dated 1637.[1] It therefore can be assumed that *Sleeping Venus* was painted shortly before 1640, a period in which Le Sueur began to assert his independence from his master, adopting a range of colors such as these extraordinary blue-violets, cold whites, and the generally lighter palette for which he is now known. The highly decorative color scheme of this canvas is certainly one of its principal attractions. The pearly flesh of the goddess stands out admirably against the red curtain; the color plays against the gray shadows on the bedclothes practically tone for tone, a harmony subtly reinforced by the cascade of the scarf against the blue bands of the pillow. This same juxtaposition is repeated in Cupid's wings and quiver. In sharp contrast to the foreground, Vulcan and his assistant are rendered in pastel shades.

The pose of Venus owes much to the *Sleeping Ariadne* in the Vatican (Pio-Clementine Museum), subsequently

repeated in Titian's *The Andrians* (*Bacchanal*, **fig.4**), Poussin's *Bacchanals*, and many other pictures. Ingres's various *Odalisques*, as Cohn and Siegfried have recently pointed out, may also have been inspired by the Vatican *Ariadne*.[2] It should hardly come as a surprise that Le Sueur was widely admired throughout the nineteenth century, and Ingres was prompted to write of him: *Eustache Le Sueur, that gentle offspring of the works of Raphael who, without ever leaving Paris, was able to conceive Ideal Beauty and give birth to numerous marvels of grace and sublime simplicity.*[3]

1. Weigert 1939-1968, 3:247, no. 10.
2. Cohn and Siegfried 1980, 116.
3. Henri Delaborde, *Ingres: Sa vie, ses travaux, sa doctrine* (Paris, 1870), 163.

The Month of October

Pierre-Antoine Patel, called Patel the Younger

Paris 1646-1707 Paris

Little is known about the life of Pierre-Antoine Patel, called Patel the Younger. The pupil of his father, Pierre-Antoine also specialized in landscape painting. The similarity of their first names and their genre has made the confusion of their works inevitable. The great *amateur* Pierre-Jean Mariette, referring to Patel the Elder as the "Claude Lorrain of France," said in effect that the formula he created for the rhythm of his landscapes was continued so faithfully by his son that "sometimes a painting is attributed to the father that, in fact, belongs to the son."[1]

Both artists delighted in painting clear, composed landscapes with broad horizons and bushy trees. However, Patel the Elder, strongly influenced by the sure classical style of La Hyre, bathed his compositions in a milky light and punctuated them with colonnades and ruins. Patel the Younger, turning to the northern tradition, plunged the spectator into wilder, more expansive nature, giving his landscapes a touch of fantasy and the bizarre. Although his paintings are signed and dated only from the last fifteen years of his career, the number of gouaches attributed to him is steadily growing. In addition to the San Francisco painting, American museums own several good examples of Patel's work. Among these are *Landscape with a Fisherman* (Norton Simon Museum, Pasadena), *Landscape with the Flight into Egypt*, and *Landscape with Pan and Syrinx* (both Brown University Museum, Providence). Stylistically midway between Flanders and Italy, Patel is closer to Claude than to Poussin. His acute observation and understanding of light give him a distinguished position among the numerous landscapists of the second half of the seventeenth century.

1. Mariette 1851-1860, 4:89.

The Month of October
Le mois d'octobre
Oil on canvas, 17 ¼ × 25 ¾ in. (44 × 65.5 cm)
S.d. lower left, on the side of the stone: *PATEL / 1699*,
fig.1
The stone bears a medallion with a scorpion in bas-relief (the appropriate sign of the zodiac), under which appears the inscription: *Octobre*.
Mildred Anna Williams Collection. 1952.73 (CPLH)

Provenance Executed in 1699 as one of a series of twelve paintings illustrating the months of the year for the headquarters of the Jesuit order in Paris on the rue Saint-Antoine (Saint-Louis-de-la-Couture, also called Saint-Louis-de-la-Culture), now called Saint Paul-Saint Louis; the series remained there until 1790; [L. G. H. Freeman, Brighton, by 1952]; [P. & D. Colnaghi & Co., Ltd., London, 13 March 1952]; acquired by the CPLH, 3 December 1952.

References Thiéry 1786-1787, 1:702; *Archives du Musée* 1883-1897, 2:252; Stein 1890, 121; P. Rosenberg, exh. cat., 1982 Paris-New York-Chicago, 368, no. 9, repr.

Exhibition 1978 New York, no. 50, fig.16.

fig.1 (detail with inscription)

fig.2

fig.3

fig.4

Related Works

PAINTINGS (from the same series)

The Month of January, **fig.2**
Oil on canvas, 17 ¼ × 25 ⅝ in. (44 × 65 cm)
S.d. lower left: *Janvier PA Patel 1699*
Musée du Louvre, Paris. Inv. 7133
REFS: Rosenberg, Reynaud, and Compin 1974, no. 622, repr.; Compin and Roquebert 1986, 126, repr.

The Month of February, **fig.3**
Oil on canvas, 18 ¾ × 26 ⅜ in. (47.5 × 67 cm)
S.d. lower right: *PATEL/1699*
Galerie "A l'enseigne des arts, art et patrimoine," Paris, early 1984

The Month of April, **fig.4**
Oil on canvas, 17 ¼ × 25 ¼ in. (44 × 64 cm)
S.d. lower middle: *Avril PA Patel 1699*
Musée de Louvre, Paris. Inv. 7134
REFS: Rosenberg, Reynaud, and Compin 1974, no. 623, repr.; Compin and Roquebert 1986, 126, repr.

The Month of June, **fig.5**
Oil on canvas, 17 ½ × 26 in. (44.5 × 66 cm)
S.d. lower left: *PATEL/1699*
John Mitchell & Son, London
PROV: Sale, London, Sotheby's, 24 October 1973, no. 87, repr.

The Month of August, **fig.6**
Oil on canvas, 17 ¾ × 25 ⅝ in. (45 × 65 cm)
S.d. lower right: *AOVST PA PATEL 1699*
Musée du Louvre, Paris. Inv. 7135; on loan to the Château de Maisons-Laffitte

The Month of September, **fig.7**
Oil on canvas, 17 ¾ × 25 ⅝ in. (45 × 65 cm)
S.d. lower right: *SEPTEMBRE PA PATEL 1699*
Musée du Louvre, Paris. Inv. 7136; on loan to the Château de Maisons-Laffitte

The Month of November, **fig.8**
Oil on canvas, 17 ½ × 25 ⅝ in. (44.5 × 65 cm)
S.d. lower middle: *PATEL/1699*
Staatliches Museum, Schwerin. Inv. G.271

The Month of December, **fig.9**
Oil on canvas, 17 ½ × 26 in. (44.5 × 66 cm)
S.d. lower left: *PATEL/1699*
Staatliches Museum, Schwerin. Inv. G.273

fig.5

fig.8

fig.6

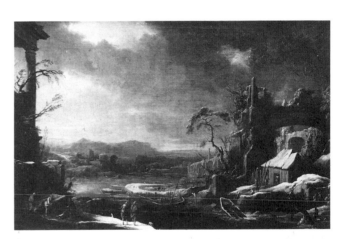

fig.9

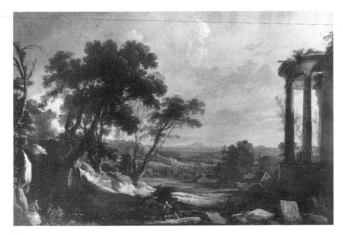

fig.7

San Francisco's painting belongs to a series representing the twelve months of the year, probably the only commission ever received by the artist, and executed for Saint-Louis-de-la-Culture. Built in the second quarter of the seventeenth century, this church and its dependencies were rich in the works of artists of the day. In addition to famous sculptures by Jacques Sarrazin, above the altar could be seen the *Presentation in the Temple* (Musée du Louvre, Paris) and *Saint Louis Ascending to Heaven* (Musée des Beaux-Arts, Rouen) by Simon Vouet, and *Souls in Purgatory* (Musée des Augustins, Toulouse) by Philippe de Champaigne. Charles Lebrun decorated one of the chapels with a *Holy Family*, also known as *The Benediction* (Musée du Louvre, Paris).

According to Luc-Vincent Thiéry, the series of twelve landscapes hung in "a salon to the left of the garden" in 1786-1787.[1] They were still there in their entirety on 24 September 1790, the date of a state inventory in which the ensemble was described as "the twelve months of the year, small landscapes by *Patel*, gilded frames."[2] The group of pictures was soon dispersed, suffering the vicissitudes common to most works of art from Paris churches during the Revolution. In 1795 Alexandre Lenoir mentioned "six *Months* of the year, painted by Patel *the Elder* [sic]; medium-sized pictures" from Saint-Louis-de-la-Culture.[3] He did not specify which months, but it is likely that the four pictures now in the Louvre were among them. Of the nine extant paintings, four are published here for the first time.

Like all the paintings in this series, San Francisco's contains the appropriate sign of the zodiac. Representing October, a scorpion rests on top of a stone stela inscribed with the name of the month. Nothing suggests that this stela is a tombstone, however, which would give the painting religious or moral significance. In spite of the small scenes in the foreground that illustrate various activities related to the grape harvest, the picture is not anecdotal. Rather, the artist is concerned primarily with the representation of landscape.

A northern sensibility is suggested by the way Patel dwells on figures, at work and in nature, beneath a vast, open sky. Similar to a composition by Paul Bril, *October* is remarkable for placing a twisted clump of trees surmounting rocks in the middle of the canvas. The distant mountains delineate a horizon in three successive masses. However, Patel evidently looked closely at Claude as well. The symmetry of the composition, the framing devices of the trees at either side, the evocative use of ruins, and the effects of changing light demonstrate Patel's reliance on the master. What is peculiar to Patel is the strange and contradictory juxtaposition of the gigantic trees against the tiny village below, the contrast of awesome nature against a peaceful evening sky. Thus, while partaking of the traditions of the French classical landscape, Patel did not hesitate to add a personal touch of fantasy and reverie.

1. Thiéry 1786-1787, 1:702.
2. Stein 1890, 121.
3. Alexandre Lenoir, *Inventaire général des objets se trouvant provisoirement déposés au Musée des Petits-Augustins*, 2 vols. (1795; reprint, Paris: IGRAF, *Archives du Musée des Monuments Français*, 1886), 2:252.

Nicolas Poussin *Les Andelys 1594-1665 Rome*

Problems are posed by any attempt to condense into a few lines the life of Poussin, the greatest French painter of the seventeenth century and perhaps the greatest French painter of all time. These problems are all the more acute because his work constantly evolved and all its secrets have not yet been revealed.

Poussin was born in Les Andelys (Normandy) in 1594 and trained in Rouen and Paris. After two unsuccessful attempts he finally established himself in Rome in 1624. Except for a brief and unhappy stay in Paris from 1640 to 1642, where he was summoned by Louis XIII, he never again left the Eternal City. In 1630 he married Anne-Marie Dughet, the daughter of a French cook and the sister of the painter Gaspard Dughet. After a few years of financial difficulty, Poussin achieved fame primarily as a result of the commissions for *Death of Germanicus* (The Minneapolis Institute of Arts) and the *Martyrdom of Saint Erasmus* (Pinacoteca, Vatican). He was renowned and admired by the most discriminating literati of the era.

Poussin primarily produced easel paintings, usually prepared by pen and wash drawings. While depicting scenes from the Bible and classical mythology, he concentrated more and more on landscape. His oeuvre consists of scarcely more than two hundred fifty paintings. The majority of these are known, although sometimes only through engravings or contemporary copies. There are distinct periods in his career: the years before he went to Rome, from which many works are lost; the prolific first years in Rome, to which Konrad Oberhuber's forthcoming book is dedicated; the decade from 1630 to 1640 when the artist, in full possession of his powers, created some of his most lyrical and perfectly composed works; the brief Parisian episode (1640 to 1642); the years of his maturity from 1642 to 1652, which were marked by increasing classicism and a preference for reflection over spontaneity of execution; and finally, his old age, dominated by the *Seasons* (Musée du Louvre, Paris), which are meditations on the fecundity of nature and the meaning of life and death, and constitute the spiritual testament of this painter-philosopher.

Scholars such as Walter Friedlaender, Charles Sterling, Anthony Blunt, Denis Mahon, and Jacques Thuillier have attempted to isolate Poussin's paintings from those of his many imitators, an especially difficult task for works executed before 1630. They have also tried to identify the works by his own hand from among the different known versions of the same composition. Many of the artist's works have been assembled in exhibitions in order to confront these problems, such as the exhibitions in Paris (1960) and Rome and Düsseldorf.[1] Some specialists are still searching for old inventories, but a greater number are analyzing the known works. The painter, whose erudition was considerable, liked to invent new compositions in order to make the great myths of antiquity visible and moving. There are only a few issues of *The Art Bulletin* or the *Journal of the Warburg and Courtauld Institutes* that do not offer some new interpretation of Poussin's masterpieces as scholars attempt to give him his proper place in European painting.

Although Poussin established his reputation in Rome by reacting against fashionable trends and by refusing, in turn, to follow Caravaggio and Cortona, during the last years of his life he voluntarily isolated himself, creating works that had no equal in contemporary painting. A stoic and pantheist, Poussin never placed his ideas above his métier; the evocation of ideal beauty remained the ultimate goal of his art.

1. *Nicolas Poussin 1594-1665*, exh. cat. (Rome: Accademia di Francia, Villa Medici, 1977-1978; Düsseldorf: Städtische Kunsthalle, 1978).

Bacchanal before a Temple (*copy after Poussin*)
Bacchanale devant un temple
Oil on canvas, 29 ½ × 39 ⅞ in. (75 × 101.5 cm)
Roscoe and Margaret Oakes Collection. 52.30
(de Young)

Provenance Private collection, England; [art market, Los Angeles, indicating an English provenance]; Roscoe and Margaret Oakes, San Francisco, 1951; gift to the de Young, 1952.

References *Art Digest*, July 1953, 28; Friedlaender and Blunt 1939-1953, 3:26, no. 5; Blunt 1958, 1:144, 261, 325, repr., and 2:pl. 205; Blunt 1960 (BM), 400; *The Connoisseur*, September 1960, 43; Blunt 1960 (*Revue des Arts*), 63-65, fig.13 on 66; Mahon 1962, 119; Blunt 1966, 100, under no. 140 (copy no. 4 repr.); Thuillier 1974, 106, under no. 167; Wild 1980, 1:46, 50, 199, and 2:no. 48, repr.; P. Rosenberg, exh. cat., 1982 Paris-New York-Chicago, 371, no. 4, repr.; Wright 1985 (London), 238, under A2, 93.

Exhibition 1960 Paris, no. 98, repr.

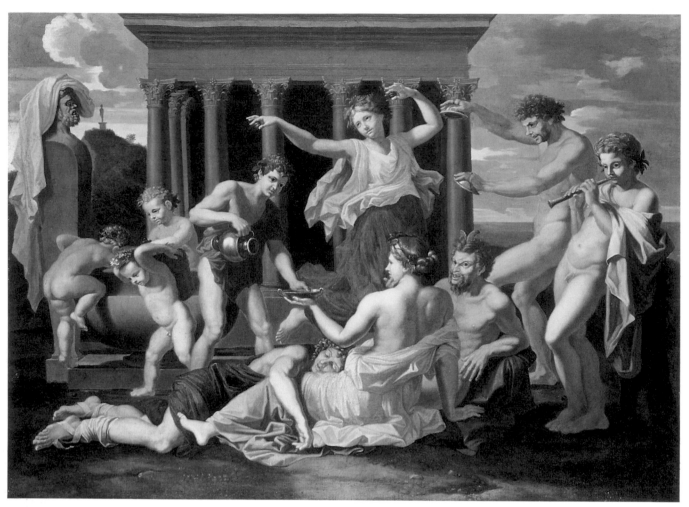

Bacchanal before a Temple

Variants

PAINTINGS

Bacchanal before a Temple (lost original)
PROV: Executed for du Fresne.
REFS: Félibien 1725, 4:146; A. Blunt, exh. cat., 1960 Paris, no. 98; Blunt 1966, 100-101, no. 140; Thuillier 1974, 106, no. 167.

Known copies of *Bacchanal before a Temple* are listed below and follow the numbering in Blunt 1966, under no. 140, with augmented information:

Copy no. 1, *Bacchanal*, **fig.1**
Oil on canvas, 72⅞ × 102¾ in. (185 × 266 cm)
Musée des Beaux-Arts, Besançon. Inv. 896.1.210
Bequest of Jean Gigoux. 1894 (given in 1896)
NOTE: Blunt: "A free variant." Triangular pediment.

Copy no. 2, *Bacchanal before a Temple*
Oil on canvas, 41 × 59⅛ in. (104 × 150 cm)
Musée des Beaux-Arts, Caen. Inv. 60
Bequest of Bernard Mancel. 1872 (destroyed in World War II)
REF: Mus. cat. 1928, no. 57.

Copy no. 3, *A Bacchanal*, **fig.2**
Oil on canvas, 38³⁄₁₆ × 51¼ in. (97 × 130 cm)
Musée des Beaux-Arts, Orléans. Inv. 720
PROV: Collection of Frémont, adviser to the Court of Appeals of Orléans, who gave this picture to Dr. Vaussin, Orléans; bequest of M. and Mme Petit-Vaussin, 5 September 1888.
REF: Mary O'Neill, *Les peintures de l'école française des XVIIᵉ et XVIIIᵉ siècles*, 2 vols. (Musée des Beaux-Arts d'Orléans, 1980), no. 140, repr.
NOTE: Pediment cropped.

Copy no. 4
TFAMSF. 52.30
NOTE: According to the late Ellis Waterhouse, this painting is possibly the same as Blunt no. 17, slightly cut down at the top (letter, 18 March 1981). Pediment cropped.

Copy no. 5, *Bacchanal in front of a Temple*
PROV: Collection of M. G. M. Bevan, Longstowe Hall, Cambridge (inherited from his uncle, R. G. Briscoe); lent to the exhibition at the Burlington Fine Arts Club, 1930-1931, no. 2, repr. (according to Blunt, the dimensions given, 48 × 60 in., include the frame or are inaccurate); sale, London, Sotheby's, 20 November 1957, no. 107, repr., 37¾ × 47¾ in. (96 × 121 cm); acquired by L. Adamson.
NOTE: The temple is seen in its entirety with the triangular pediment.

Copy no. 6
"87 × 115 cm"
Mme Cocquel-Trehu, Paris

Copy no. 7
"24 × 30 cm"
Maurice Helles, Château de Vieiza (Gironde)

Copy no. 8
Mme Labbé, Paris

Copy no. 9, *Bacchanal in front of a Temple*
G. A. Morancé, Paris
REF: Friedlaender and Blunt 1939-1953, 3:26, no. 6, fig.18.
NOTE: Pediment cropped.

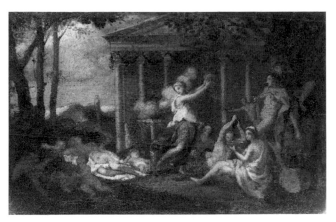

fig.1

fig.2

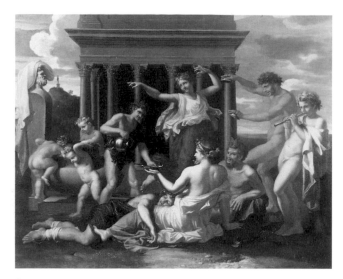

fig.3

fig.4

Copy no. 10
"73.5 × 98.5 cm"
M. Souviron, Valenciennes

Copy no. 11
"31 × 43 in." [*pouces?*]
PROV: Fraula sale, Brussels, de Vos, 21 July 1738, no. 59.

Copy no. 12, *Some Satyrs, Bacchantes, and Infants*
3 × 4 *pieds*
PROV: Marquis de Lassay sale, Paris, 17-22 May 1775, no. 44.
NOTE: According to Blunt, probably the *Bacchanal* mentioned by
Dézallier d'Argenville in the Hôtel de Lassay among the pictures
acquired by the marquis (d. 1738).

Copy no. 13, *A Bacchanalian Scene*
PROV: J. Bayley sale, London, Sotheby's, 29-30 May 1865, no. 83
(with the provenance of *Bacchanal with a Term of Pan*, The National
Gallery, London).

Copy no. 14, *A Bacchanal*
Oil on canvas, 33⅞ × 44⅞ in. (86 × 114 cm)
PROV: Aguado collection; Duguit sale, Bordeaux, 30 April 1912, no.
31.
EXH: Millenaire Normand, 1911.
NOTE: Pediment cropped.

Copy no. 15, *Homage to a God*
Oil on canvas, 31⅞ × 39⅜ in. (81 × 100 cm)
PROV: G. von Osmitz, C. E. Meyers et al. sale, Berlin, Lepke, 11 Feb-
ruary 1913, no. 121, repr.
NOTE: Pediment cropped.

Copy no. 16, *Bacchanal*
Oil on canvas, 31 × 38⅝ in. (79 × 98 cm)
PROV: Sale, Paris, Hôtel Drouot, 3 June 1913, no. 52, repr.
NOTE: Pediment cropped.

Copy no. 17, *Bacchanalians Dancing*
Oil on canvas, 31 × 40 in. (78.5 × 101.5 cm)
PROV: Sale, London, Christie's, 10 March 1939, no. 73; acquired by
Roland; sold to a dealer, New York.

Copy no. 18
Oil on canvas, 30 × 39 in. (76 × 99 cm)
PROV: Commandant E. Culme-Seymour sale, London, Christie's, 21
November 1952, no. 13, repr.; acquired by Tonken.
NOTE: Pediment cropped.

Copy no. 19, *Bacchanal before a Temple*, **fig.3**
Oil on canvas, 31½ × 39¾ in. (80 × 101 cm)
PROV: Earl of Liverpool; David Bevan (Smith 1837, 115, no. 217);
Lady Lane, Carlton Hall, Suffolk; [F. Kleinberger & Co., New York,
ca. 1940, who probably loaned the picture to the *Golden Gate Inter-
national Exposition*, San Francisco, 1940, no. 24, and to the Portland
Art Association, 28-30 November 1941]; [Arnold Seligmann, Rey and
Co., Inc.]; sale, New York, Parke-Bernet, 23 January 1947, no. 241,
repr.; [Aram Galleries, New York, 1950]; W. P. Chrysler, Jr., 1950,
who loaned the picture to the 1956-1957 exhibition organized by the
Portland Art Museum, *Paintings from the Collection of Walter P.
Chrysler, Jr.*, no. 54, repr.; according to The Chrysler Museum (letter,
31 March 1980) the painting remained in Walter Chrysler's possession
through 1962 and was subsequently sold; [Foscan Fine Art, Hobart,
Australia, 1981]; [Joseph Guttman, Los Angeles, October 1983];
[Arnoldi Livie, Munich, July 1985].

NOTE: This painting, slightly squarer than San Francisco's, with the cropped pediment raised a little higher, does not vary notably from the engraving by Mariette and can be considered a faithful copy.

Copy no. 20
"Ca. 2 × 3 ft."
PROV: Claudine Bouzonnet Stella in 1693-1697.

Copy (no number)
Lord Radstock sale, London, 13 May 1826, no. 17
PROV: Prince Carignan collection.
REF: A. Blunt, exh. cat., 1960 Paris, 126.

Related Works

DRAWINGS

Bacchanal before a Temple, ca. 1635, **fig.4**
Pen and bistre wash, 8¼ × 12½ in. (210 × 316 mm)
Royal Library, Windsor Castle. Inv. 11910
REFS: Anthony Blunt, *The French Drawings in the Collection of His Majesty the King at Windsor Castle* (Oxford: Phaidon Press; New York: Oxford University Press, 1945), no. 198, pl. 49; Blunt 1958, 1:144, 261, fig.213; Blunt 1966, 100, under no. 140, drawing no. 1.

fig.5

Bacchanal before a Temple, **fig.5**
Pen and dark bistre wash, 6¼ × 8¼ in. (155 × 210 mm)
Musée Condé, Chantilly. Inv. 178
PROV: Formerly in the collections of Mariette, Lagoy, Dimsdale, Cunningham, and Reiset.
REFS: Friedlaender and Blunt 1939-1953, 3:no. 195, pl. 153; Blunt 1966, under no. 140, drawing no. 2.
NOTE: Both drawings above (**figs.4-5**) are first thoughts which present some variants in relation to the final composition. Both show a temple with a triangular pediment.

ENGRAVINGS

Jean Mariette, after Poussin, *Fête de Bacchus devant un temple*, 1688, **fig.6**
REFS: Le Blanc 1854-1890, 2:605; A. Andresen, *Nicolas Poussin, Verzeichniss der nach seinen Gemälden gefertigten gleichzeitgen und späteren Kupferstiche* (Leipzig, 1863), no. 367 (reprinted in G. Wildenstein, GBA, July-August 1962, 188); G. Wildenstein, "Les graveurs de Poussin au XVIIᵉ siècle," GBA, September-December 1955, 276, no. 131, repr.
NOTE: The San Francisco painting is faithful to Mariette's engraving with the pediment cropped.

fig.6

Jacques-Philippe Le Bas, line engraving (Witt Library)
NOTE: Pediment cropped.

If we are to believe Félibien, the original *Bacchanal* was painted for a M. du Fresne, probably Raphael Trichet du Fresne, director of the Imprimerie Royale in Paris, or perhaps Nicolas de Fresne Hennequin.[1] The San Francisco canvas, along with Mariette's engraving (**fig.6**), is an important record of this lost composition. Numerous other extant copies testify to the success of the original (**figs.1, 2, 3**). However, the only early citations corresponding to the dimensions of the San Francisco *Bacchanal* are those of the Fraula sale in Brussels, 21 July 1738, and the Osmitz et al. sale in Berlin, 11 February 1913.

The loss of the original canvas makes this painting difficult to date. Blunt and Thuillier agree, however, that the execution of the work can be placed ca. 1650.[2] We know that de Fresne Hennequin was in Rome in 1649, and that in February of that year Poussin planned "a pleasing bacchanal" for the comic novelist Paul Scarron. Scarron, author of the *Roman Comique*, *Jodelet*, and *Virgile Travesti*, was the first husband of Mme de Maintenon. Possibly du Fresne bought the picture originally intended for Scarron, and Poussin then executed *The Conversion of Saint Paul* (Musée du Louvre, Paris) for Scarron, although this is pure conjecture.

We know of Poussin's fondness for the theme of the bacchanal. According to the reliable Félibien, Poussin may have taken up the subject in Cheverny before departing for Italy. Arriving in Rome, Poussin found numerous sources on which to elaborate this theme. His *Bacchanal of Infants* (Incisa della Rocchetta collection, Rome), *Bacchus and Apollo* (Nationalmuseum, Stockholm), *Infancy of Bacchus* (Musée du Louvre, Paris), *Bacchanalian Revel before a Term of Pan* (The National Gallery, London), and other works depicting nymphs and satyrs were inspired by close observation of the mannerists, particularly the engravings of Giulio Romano and, above all, Titian, although the general theme often served as a pretext for eroticism. Titian's *Bacchanal* in the Museo del Prado, more than Philostratos's text, was the source for *Bacchanal with a Lute Player* (ca. 1627-1628, Musée du Louvre, Paris), although Titian's treatment of the theme was relatively discreet by comparison. In addition, Poussin looked to antiquity for his Dionysiac revels. Sarcophagus reliefs were always on hand, and many of Poussin's drawings clearly come from altar fragments with figures.[3] Poussin also studied the writings of archaeologists, keeping notes. Sheets preserved at the Musée Condé, Chantilly, prove that Poussin had read the *Discourse on the Religion of the Ancient Romans* by du Choul in its Italian edition.[4] He also read *Images of the Gods* by Cartari.[5]

Two drawings, at Windsor Castle (fig.4) and the Musée Condé (fig.5), have compositions similar to our *Bacchanal*. The drawing at Windsor Castle bore the title *Li misteri di Priapo* in the manuscript catalogue of drawings belonging to Cardinal Camillo Massimi, Poussin's close friend. Nonetheless, the drawing represents a festival in honor of Bacchus, god of inebriation, rather than the potent deity of the garden. San Francisco's painting does not give the feeling of ripe nature as seen in Poussin's early bacchanals or in the more tranquil landscapes painted for Cardinal Richelieu (*Triumph of Pan*, *Triumph of Bacchus*, *Triumph of Silenus*, and *Triumph of Neptune*, 1636-1637). The temple in the San Francisco version is of the Corinthian order; the Doric or Ionic would not have conveyed the notion of Roman virtues in their decadence. Before it, a nymph dances to the sound of cymbals and fife. A young man crowned with grape leaves pours wine for a reclining nymph, the object of the satyr's lustful gaze. Three nude children replenish the vat with grapes and stir them in at the foot of a herm of Bacchus.

Blunt and Thuillier date two preparatory drawings for this composition ca. 1635-1650, when Poussin was at work on the *Bacchanals* for Richelieu. The idea was dropped and then taken up again ca. 1649-1650, perhaps for the painting promised to Scarron. As the most striking aspect of this composition is its persistent literary and archaeological character, it is worth noting that by 1649-1650 Poussin had begun to unload this sort of cultural baggage and submit himself to the laws of nature. The result was a series of great moral landscapes: *Diogenes* (1648, Musée du Louvre, Paris), *Landscape with Polyphemus* (1649, Hermitage, Leningrad), *Landscape with a Woman Washing Her Feet* (1650, National Gallery of Canada, Ottawa), and *Landscape with Orpheus and Eurydice* (1649-1651, Musée du Louvre, Paris).

1. Félibien 1725, 4:146.
2. Blunt 1966, 101, no. 140; Thuillier 1974, 106, no. 167.
3. Works in Musée Bonnat, Bayonne; Musée Fabre, Montpellier; Ecole des Beaux-Arts and Musée du Louvre, Paris; and Blunt Collection (see Blunt 1960 [*Revue des Arts*], 56-66).
4. Du Choul, *Discours sur la religion des anciens Romains* (Fr. ed. [Lyon], 1556; Ital. ed., 1569, was used by Poussin).
5. Cartari, *Le Imagini degli dei* (Venice, 1587).

The Holy Family with Ten Figures
(*copy after Poussin*)
La Sainte Famille aux dix figures
Oil on canvas, 33⅛ × 43 in. (84 × 109 cm)
Roscoe and Margaret Oakes Collection. 75.2.4
(de Young)

Provenance Collection of the Routier family, France, until 1935; examined by M. Clavière, expert at the Court of Appeals, Paris, whose document mentions a certificate of authenticity by Grautoff; acquired in Paris by Frederic Carroll, 7 October 1955; Roscoe and Margaret Oakes, San Francisco, 1955; on loan to the de Young, 1955-1972, and to the CPLH, 1972-1975; gift to TFAMSF, 1975.

References Comstock 1956, 74; *The Art Quarterly*, Winter 1956, 421, repr. on 420; P. Wescher, "Neuerwerbungen des De Young Museums in San Francisco," *Kunstchronik*, October 1957, 311; Blunt 1960 (*BM*), 400; Mahon 1962, 116; Blunt 1966, 43, under no. 59 (copy no. 1); Thuillier 1974, 105, under no. 164; Thuillier and Mignot 1978, 49; Wild 1980, 2:140, under no. 150; P. Rosenberg, exh. cat., 1982 Paris-New York-Chicago, 371, no. 3, repr.; Wright 1985 (London), 206, under no. 143, 93.

Exhibitions 1960 Paris, no. 86, repr.; 1965 Riverside, no. 18; Eureka, Art and Music Festival, *Gloria in Excelsis Deo*, 8 December 1965, no cat.

Variants
PAINTINGS
The Holy Family with Ten Figures (lost original)
Oil on canvas, 30 × 36 in. (76 × 91.5 cm)
PROV: Executed for Pointel, 1649; seen by Bernini in Paris in the collection of M. Cérisier, 9 August 1665 (Paul Fréart de Chantelou, *Journal du voyage du Cavalier Bernin en France* [Paris: Ludovic Lalanne, 1885], 90; reprint, *idem*, 1960, 127).
REFS: Félibien 1725, 4:59; for the essential information see Blunt 1966, 43-44, no. 59; Thuillier 1974, 105, no. 164; Thuillier and Mignot 1978, 41, 43, 48-49.

The Holy Family with Ten Figures (copy), **fig.1**
Oil on canvas, 31⅛ × 41¾ in. (79 × 106 cm)
National Gallery of Ireland, Dublin. Inv. 905
PROV: Collection of earl of Milltown, 1847; gift from Countess Geraldine of Milltown, 1902.
REF: J. White, *National Gallery of Ireland* (New York: Frederick A. Praeger, 1968), fig.48.
NOTE: Anthony Blunt (1966, no. 59) considered this the original with some repainting and some weaknesses; for Jacques Thuillier (1974, under no. 164) the painting was "too weak in draftsmanship and too harsh in color to be considered the original." In any case, following the 1960 exhibition in Paris, the quality of the Dublin version is considered generally superior to that of San Francisco's.

Thomas Bodkin ("Nicolas Poussin in the National Gallery, Dublin," *BM*, April 1932, 179) erroneously mentions a copy in the Musée des Beaux-Arts, Tours, according to M.-N. Pinot de Villeclenon, letter, 25 March 1981.

Repose of the Holy Family (copy)
Oil on canvas (oval), 14⅛ × 18⅛ in. (36 × 46 cm)
Musée des Augustins, Toulouse. Inv. 126. Consignment from the state, 1803
REF: Mus. cat. 1806, no. 312.

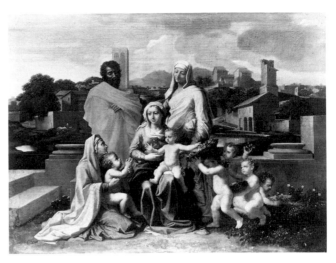

fig.1

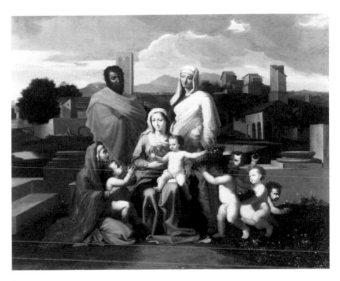

fig.2

The Holy Family (copy)
Oil on canvas, 30¾ × 39⅜ in. (78 × 100 cm)
PROV: Formerly in the Abbey of Ferté-sur-Crosne (Seine et Loire); acquired by the mayor of Creusot in 1793; sold by his descendants before 1914; private collection, Paris; present location unknown.
REFS: Blunt 1966, 43, under no. 59; Thuillier and Mignot 1978, 49.

The Holy Family with Ten Figures (copy), **fig.2**
Oil on canvas, 32 × 41¼ in. (81 × 105 cm)
PROV: Sale, New York, Sotheby Parke Bernet, Inc., 28 November 1978, no. 56, repr. (attributed to school of Poussin).

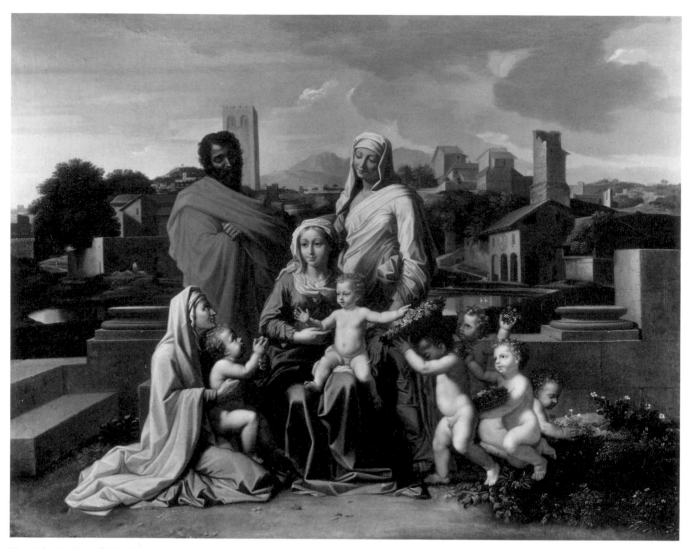

The Holy Family with Ten Figures

DRAWING

The Holy Family, fig.3
Pen and bistre wash, 9 ³⁄₈ × 10 ¹⁄₈ in. (238 × 258 mm)
Musée Condé, Chantilly. Inv. 304
REFS: Blunt 1966, under no. 59, "copy, probably after a lost drawing"; Friedlaender 1968, 1:22, D2(a), 27, A8, pl. 74.

ENGRAVINGS

Claudine Bouzonnet Stella, after Poussin, *Ego Mater pulchrae dilectionis*, 1668, fig.4
REFS: Le Blanc 1854-1890, 3:589, no. 14; Blunt 1966, under no. 59, engraving no. 1; Thuillier and Mignot 1978, 49, repr.
NOTE: Claudine Bouzonnet, the niece of Jacques Stella, whom we know was a friend of Poussin, owned the plate and thirty prints of this engraving at her death. Georges Wildenstein ("Les graveurs de Poussin au XVIIᵉ siècle," *GBA*, September-December 1955, 173, no. 55) mentions that Mariette owned a print ca. 1673.

Louis Moreau, *La Sainte Famille*, copy after a proof owned by P. Mariette in 1669, fig.5
REF: Blunt 1966, under no. 59, engraving no. 2.
NOTE: Published by Etienne Gantrel.

This *Holy Family* is a copy of a lost original painted for Jean Pointel in 1649.[1] An article by Jacques Thuillier and Claude Mignot offers more information about the personality of Pointel,[2] whose letters to his friend Poussin are now lost. Pointel was a native of Lyon, where he had contacts with bankers and merchants. He later moved to Paris and rapidly built a sizable fortune (ca. 1641-1651). He bought a number of pictures from Poussin, including *Moses Saved from the Waters*, *Eliezer and Rebecca*, and *Landscape with Orpheus and Eurydice* (Musée du Louvre, Paris),[3] *The Storm* (Musée des Beaux-Arts, Rouen), and *Calm Weather* (Morrison Collection). In 1649 he also bought the celebrated *Self-Portrait* (Bode Museum, East Berlin). On Pointel's death on 5 November 1660, Philippe de Champaigne made an inventory of his estate. He describes the original composition, on which San Francisco's picture is based, as *Item 6: another painting likewise on canvas without frame three feet long by two and one-half feet wide upon which is the subject of the Virgin holding the Infant Jesus, Saint Joseph, Saint Anne with the baby Saint John, appraised at the sum of four hundred livres, this work being by the said Poussin . . . IIIIᶜ lt.*[4]

The inventory shows that Pointel owned twenty other paintings by the master and about eighty drawings. Thuillier and Mignot state that the original *Holy Family* was certainly among those acquired by the silk merchant Jacques Cérisier at the Pointel estate sale in 1660. It was at Cérisier's Paris home that Bernini saw the picture on 9 August 1665.[5] Cérisier already owned Poussin's *Funeral of Phocion* (1648) and *Esther before Ahasuerus* (Hermitage, Leningrad), which Bernini greatly admired. (Bernini was less enthusiastic about *The Holy Family*.) Nonetheless, this "Lysidor" of the *Banquet of the Curious*[6] seems to have been content to

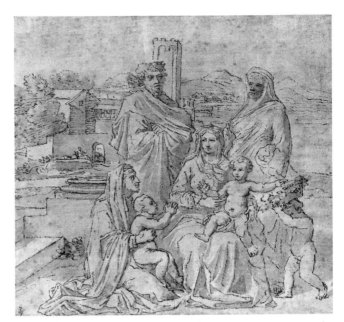

fig.3

Ego Mater pulchrae dilectionis

fig.4

fig.5

acquire the most modest works of the Pointel sale, including *Holy Family with Ten Figures*, the Berlin *Self-Portrait*, and two small unidentified landscapes. The history of the original version of *The Holy Family* from the time of its purchase by Cérisier remains unknown.

In the preface to the catalogue of the Poussin exhibition of 1977-1978, Thuillier remarks that the artist's treatment of religious subjects followed contemporary trends, and was as much French as Roman.[7] He left the glorifications and the martyrdoms to his rival Pietro da Cortona. He drew from antiquity for his works, but not in a nostalgic or poetic sense. Poussin's idea of the antique constituted a way of thinking and of living. The landscape of *The Holy Family* is composed of strong and stable buildings rather than ruins, giving the composition weight and balance.

Poussin's antique sources were given greater depth and amplitude by the artist's own profound religious faith. In *The Holy Family* with nine figures (1650, Fogg Art Museum, Cambridge), the *Madonna Roccatagliata* with three figures (The Detroit Institute of Arts), the eleven-figure composition jointly owned by the J. Paul Getty Museum, Malibu, and Norton Simon Museum, Pasadena, and the paintings with Saint John (John and Mable Ringling Museum of Art, Sarasota, and Toledo Museum of Art), the themes of antiquity and religious belief are united in contemplation of the nature of divine grace, of the "elect." The spiritual tenor of *The Holy Family* did not escape the attention of Claudine Bouzonnet Stella, who inscribed beneath her engraving of the painting (**fig.4**), "Ego Mater pulchrae dilectionis."[8]

Poussin emphasizes the noble and pensive figure of Joseph, marking his isolation from the group of women and children by placing a tower at his back. The artist's ordinary working method was to throw himself body and soul into his subject. A *Crucifixion* he once painted is known to have exhausted him to the point of illness. In *The Holy Family* all is carefully thought out and carefully composed. Every stone and leaf, every expression and gesture contributes to the ensemble. Poussin the stoic, the humanist, as Thuillier would call him, mastered his awesome powers of concentration in a demonstration of his belief in the Word and Divine Grace.

1. Félibien 1725, 4:59.

2. Thuillier and Mignot 1978, 39-58.

3. Rosenberg, Reynaud, and Compin 1974, nos. 669, 670, 675; Compin and Roquebert 1986, Inv. 7272, Inv. 7270, Inv. 7307.

4. Thuillier and Mignot 1978, 48.

5. Thuillier and Mignot 1978, 48-49.

6. *Banquet des curieux* [1676-1677]; the only known copy is in Paris, Bibl. de l'Arsenal; reprinted by P. Lacroix in *Revue Universelle des Arts* 4, annotated.

7. Jacques Thuillier, *Nicolas Poussin*, exh. cat. (Rome: Accademia di Francia, Villa Medici, 1977-1978; Düsseldorf: Städtische Kunsthalle, 1978).

8. Ecclesiasticus 24:18: "I am the mother of fair love, and fear, and knowledge, and holy hope: I therefore, being eternal, am given to all my children which are named of him."

Adoration of the Golden Calf

Adoration of the Golden Calf
(*pastiche in the style of Poussin, attributed to Andrea di Lione*)
L'adoration du veau d'or
Oil on canvas, 38 × 52 in. (96.5 × 132 cm)
Inscription on the right: *NP. 1629* (or *1626?*), fig.1
Gift of the Samuel H. Kress Foundation. 61.44.30
(de Young)

Provenance [Sackville Gallery, London, 1919]; Ernest May, Paris (Blunt 1947, 269); [Durlacher Brothers, New York, 1940]; [Rudolf J. Heinemann, New York (Blunt 1966, 21)]; acquired by Samuel H. Kress, 1952; gift to the de Young, 1961.

References Johnstone 1919, 91, repr.; W. Friedlaender, in Thieme and Becker 1907-1950, s.v. "Poussin"; Friedlaender 1940, 10, repr. on 8; Blunt 1947, 269, detail pl. 1, fig.B; Bertin-Mourot 1948, 45-46, pl. 5; Suida 1955, 76-77, repr.; Larsen 1955, 175, fig.4; Comstock 1955, 71; Neumeyer 1955, 279-280; Davies 1957, mentioned under no. 5597, note 5; P. Wescher "Neuerwerbungen des De Young Museums in San Francisco" *Kunstchronik*, October 1957, 311; Blunt 1958, 1:62-63, 70, 92, 94, and 2:pl. 10; A. Blunt, intro. exh. cat., 1959 Toledo-Minneapolis, 6; Blunt 1960 (*Colloque*), 163, fig.148; A. Blunt, exh. cat., 1960 Paris, 222-223; Mahon 1960, 290-291 (notes 16-19), 296-297 (note 71); Blunt 1960 (BM), 396; Mahon 1962, 3, 6 (note 16), 38 (note 113), 49 (note 149), 50 (note 151), 132 (note 391); Friedlaender 1964, 138-139, fig.105; Blunt 1966, 21, no. 25, repr.; *European Works* 1966, 111, repr.; Friedlaender 1968, 12, no. 22; Badt 1969, 1:293; Cocke 1969, 715; P. Rosenberg, exh. cat., 1973 Paris, 19, 22, fig.37; Blunt 1973, 533-534; *Encyclopaedia Britannica*, 15th ed., s.v. "golden calf," repr.; Thuillier 1974, 92-93, no. 63; Blunt 1974, 761, 763; exh. cat., 1975 London (Agnew), 29, mentioned under no. 29; Eisler 1977, 269-271, no. K 1876, fig.249; Blunt 1977, 392; Blunt 1979, 160, 162, 177; Wild 1980, 1:38 (note 13), 45 (note 6), 80, 82, 182, 188, 197, 203, and 2:no. 23, repr.; Lee 1980, 214, fig.4; P. Rosenberg, exh. cat., 1982 Paris-New York-Chicago, 371, no. 5, repr.; Blunt 1982, 706; M. C. Stewart, "16 Paintings in Search of an Artist," *Triptych*, October-November 1982, 10, repr.; A. Brejon de Lavergnée 1984, 2:669-270, pl. 656; N. Spinosa, exh. cat., 1984-1985 Cleveland-Fort Worth-Naples, mentioned on 40-41; Wright 1985 (London), 247, under L4-5, 253, 279; Wright 1985 (New York), 139-144, repr. on 140.

Exhibitions 1940 New York (Durlacher), no. 1; 1978-1979 Denver-New York-Minneapolis, no. 34; San Francisco, de Young, *16 Paintings in Search of an Artist*, 28 August-14 November 1982, no cat.

Variants
PAINTINGS
Adoration of the Golden Calf (lost)
PROV: Sale, Quiryn van Biesum, Rotterdam, 18 October 1719, no. 12: "De Kinderen Israëls, het gulde Kalf aenbiddende, door Nikolas Poussyn, h. 3 v. 2 d., br. 4 v. 2 d. 220-0" (113.5 × 135 cm); seen by Jonathan Richardson in the Flinck collection, Amsterdam, before 1722; sale, Amsterdam, 4 November 1754, no. 14.
REFS: Gerard Hoet, *Catalogus of Naamlyst van Schilduyen met derzelven Pryzen* (The Hague, 1752-1770), 1:227; Jonathan Richardson, *An Account of the Statues, Bas-Reliefs, Drawings, and Pictures in Italy, France, etc.* (London, 1722), 1; Smith 1837, 19-20, no. 34.
NOTE: The dimensions of the painting mentioned by Smith (4 ft. 5 in. by 5 ft. 8 in.) are larger than those of the composition in the van Biesum sale, but Smith sometimes included the frame in his measure-

fig.1 (detail with inscription)

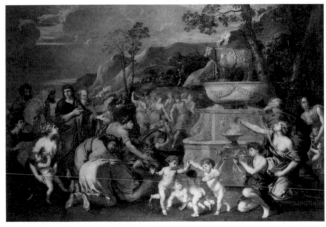

fig.2

ments. The description corresponds perfectly to the version in San Francisco, which was probably executed after this painting. The author mentions the engraving by Poilly, but not the location of the work.

Adoration of the Golden Calf (copy), **fig.2**
Oil on canvas, 49 × 70 in. (124 × 177 cm)
The New-York Historical Society. Inv. 1882.34
PROV: Brought from Italy by James Benkard, before 1882; collection Louis Durr, New York; gift of Louis Durr to The New-York Historical Society.
REFS: *Catalogue of the Gallery of Art of The New-York Historical Society* (New York: printed for the Society, 1915), 106, no. D34; P. Rosenberg, exh. cat., 1982 Paris-New York-Chicago, 370, no. 7, repr.

fig.3

fig.4

fig.5

DRAWING
Adoration of the Golden Calf, **fig.3**
Black chalk, 5 ¼ × 7 ⅛ in. (134 × 180 mm)
Windsor Castle, Royal Library. Inv. 11884, verso
REFS: W. Friedlaender et al., *The Drawings of Nicolas Poussin* (London: Warburg Institute, 1939), 1:12, no. 22, pl. 13; A. Blunt, *The French Drawings in the Collection of His Majesty the King at Windsor Castle* (Oxford: Phaidon Press; New York: Oxford University Press, 1945), 38, no. 180.

ENGRAVINGS
Jean-Baptiste Poilly, *L'adoration du veau d'or*, **fig.4**
REFS: A. Andresen, *Nicolas Poussin, Verzeichniss der nach seinen Gemälden gefertigten gleichzeitgen und späteren Kupferstiche* (Leipzig, 1863), no. A74; Le Blanc 1854-1890, 3:223; G. Wildenstein, "Catalogue des graveurs de Poussin par Andresen . . . ," *GBA*, July-August 1962, no. A74, repr. on 144; Thuillier 1974, 92-93, no. 63a, repr.; Eisler 1977, 269.

Louise-Charlotte Landon Soyer, line engraving after the Poilly print
REFS: C. P. Landon, *Galerie des peintres les plus célèbres: Vie et oeuvres . . . de Poussin* (1803-1817; reprint, 3:pl. 5, and 4:table on 2-3 and pl. 24.

H. Robinson (Witt Library)

Related Work
PAINTINGS
Two Female Heads (fragment of *Adoration of the Golden Calf?*), 1627-1629 (?), **fig.5**
Oil on canvas, 13 ¼ × 19 ½ in. (33.5 × 49.5 cm)
Private collection, England
EXH: 1975 London (Agnew), no. 29, repr.

Adoration of the Golden Calf, **fig.6**
Oil on canvas, 60 ⅞ × 84 in. (154 × 214 cm)
The National Gallery, London. 5597

Poussin treated the theme of the adoration of the golden calf many times. The artist was inspired by the fresco from the school of Raphael in the Vatican loggia, which illustrates the famous episode from Exodus where Moses left his people to meditate on Mount Sinai. In his absence his brother Aaron forged a golden calf for the Israelites who wanted to worship their ancestral idols. Armed with the tablets given to him by God, Moses descended the mountain:
And it came to pass, as soon as he came nigh unto the camp, that he saw the calf and the dancing: and Moses' anger waxed hot and he cast the tables out of his hands and brake them beneath the mount.[1]

A drawing at Windsor (**fig.3**), faded, stained, and barely decipherable, is surely a preliminary study for the painting formerly in the van Biesum collection. The recto of the Windsor drawing depicts *Gideon's Victory over the Midianites*, a study for the painting in Rome (ca. 1625, Pinacoteca, Vatican). Accordingly, the van Biesum picture was probably painted then.[4] The paint-

ing at The New-York Historical Society (fig.2), which is related to the San Francisco painting in composition although with many variants, may be a souvenir of the van Biesum picture by an unknown hand.

The attribution of San Francisco's *Adoration of the Golden Calf* to Poussin was accepted by Friedlaender, Blunt, Mahon, and Eisler.[2] It was rejected in 1973 by Rosenberg, Thuillier, and subsequently by Blunt.[3] Oberhuber, Harris, Epstein, Bridgstocke, and Wright all refused, in turn, to accept this painting by the hand of Poussin.[4] Miller took the same position, but noted that the painting was an excellent copy after a lost original of ca. 1628-1629.[5]

The ongoing controversy over the date inscribed on the canvas, 1626 or 1629, the last digit having been erased during restoration, has tended to mask the real problem of the painting's authenticity. Certain details— such as the kneeling figure with dirty feet in the foreground, a Caravaggesque touch that Poussin would have held in horror—and an overall triviality in the execution suggest the possibility that the picture is a pastiche inspired by the work of Poussin. The artist may well be the Neapolitan Andrea di Lione, whose oeuvre includes *Tobias Burying the Dead* (Paul Ganz collection, New York) and *Shepherds and Their Flock* (Kunsthistorisches Museum, Vienna). Brother-in-law of Falcone, with whom his works share an affinity, di Lione was also a formidable imitator of his contemporary Castiglione. This hypothesis has claimed the attention of Arnauld Brejon de Lavergnée, who recently published this new attribution.[6] It will be instructive to view the San Francisco painting in the context of the exhibition *Poussin's Early Years in Rome*,[7] which will attempt to resolve definitively individual questions of attribution such as this one.

The engraving by Poilly (fig.4) presents no major differences with the San Francisco painting and has tended to support the theory that this painting is by Poussin. Poilly undoubtedly believed that the San Francisco painting was an original, which proves that forgeries or clever pastiches of Poussin's work were not only in existence at the time, but apparently accepted as by the hand of the master. Jacques Thuillier observed that "the composition certainly appears to be the work of Poussin and belongs to the 1629-1630 period. The sequence of figures, the various types, and the way the distant landscape is organized and animated by small figures hardly leaves room for doubt."[8]

A fragment, *Two Female Heads*, has been considered an early work by Poussin, perhaps from an *Adoration of the Golden Calf* (fig.5).[9] The head at left in this work is close to that of the young mother leaning over her child in the San Francisco painting. The head at the right may be an idolator of the calf. However, there is no proof that this interpretation is correct. The most famous is

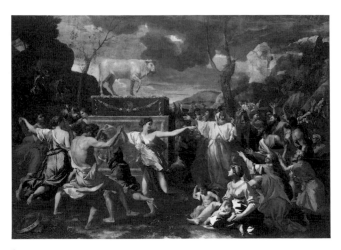

fig.6

probably the painting in The National Gallery, London (fig.6), dated by Thuillier ca. 1633-1635,[10] which has little in common with the San Francisco composition except the theme.

A comparison of the versions of this subject reveals different interpretations. San Francisco's pastiche provides a biblical scene in which the pagan veneration of the calf is treated with great dignity, emphasizing the rite's religious aspect. In contrast, the version in The New-York Historical Society is much more ambitious, stressing the popular dances and pagan ritual as much as the prayers. Finally, the London picture is animated by a great number of figures whose joyous bacchanal seems to have set in motion even the golden calf.

1. Exodus 32:19, King James Version.
2. Friedlaender 1940, 10; Blunt 1947, 269; *idem*, 1966, 21, no. 25; Mahon 1960, 290-291; Eisler 1977, 269-270.
3. P. Rosenberg, exh. cat., 1973 Paris, 22, 66, no. 56; Thuillier 1974, no. 63; Blunt 1973, 533-534.
4. Konrad Oberhuber, letter, 2 April 1975; Ann S. Harris, letter, 29 March 1979; Suzanne Epstein, letter, 7 May 1979; Hugh Bridgstocke, letter, 5 December 1979; Christopher Wright, letter, 8 February 1982.
5. Dwight Miller, letter, 10 April 1984.
6. Brejon de Lavergnée 1984, 669-670, fig.655.
7. Fort Worth, Kimbell Art Museum, *Poussin's Early Years in Rome*, September-November 1988.
8. Thuillier 1974, 92, no. 63.
9. Blunt 1966, 22, no. 27; Thuillier 1974, no. 64; Wild 1980, 2:no. 24; Wright 1985 (London), 247, under L4.
10. Thuillier 1974, no. 83.

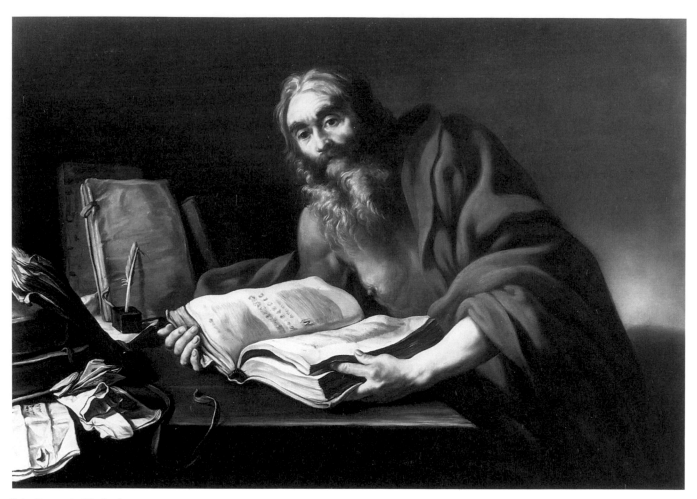

Saint Jerome in His Study

Claude Vignon *Tours 1593-1670 Paris*

Among French artists of the first half of the seventeenth century, Vignon's style is most easily recognized. Paradoxically, he is also among the painters who seem to have been open to varied influences. Among these were the Paris mannerists Bunel and Lallemant, Caravaggio, Manfredi and Terbrugghen, who were Rembrandt's masters, and Borgianni, Serodine, Fetti, Guercino, Simon Vouet, and others.

The life of this great traveler, a native of Tours, could be the subject of a novel. After training in Paris Vignon went to Rome from 1616 to 1623, according to the *Stati d'anime*. There he painted the *Martyrdom of Saint Matthew* (1617, Musée des Beaux-Arts, Arras) and the *Adoration of the Magi* (1619, Dayton Art Institute), both revealing a knowledge of Venetian painting. Between 1621 and 1623 he won a competition organized by Prince Ludovisi with *Marriage at Cana* (destroyed 1945 in Berlin). *Saint Andrew*, engraved in 1623, which is close in style to Ribera, suggests he may have gone to Naples. However, he also traveled to Florence, Bologna, and made two adventurous journeys to Spain in 1623-1624 and 1625-1628 as an adviser to Marie de' Medici. In Paris on 21 January 1623 he signed a marriage contract with Charlotte de Leu, his first wife. From his two marriages Vignon purportedly had a total of thirty-four children, although it is true that Jal counted only twenty-four.[1] His monumental painting of *Saint Ambrose* (1623, The Minneapolis Institute of Arts) marks the beginning of increased production by him and his studio of secular and religious paintings, genre scenes, history paintings, allegories, mythological scenes, and portraits. This production is confirmed by the discovery almost every year of several new paintings. By the time he was admitted to the Royal Academy of Painting and Sculpture in 1651, his patrons Richelieu and Louis XIII had died, and his style of painting with thick impasto and glints of gold on somber backgrounds must have seemed out-of-date.

While Vignon may be accused of being too prolific and often facile, uncontestably he was a great painter during his Roman sojourn and in the first years after his return to Paris. His work in this period is imbued with imagination, verve, and a sense of humor.

Following the works of Charles Sterling,[2] Wolfgang Fischer (1962 and 1963), and others, Paola Bassani Pacht has devoted her studies to this artist.[3] A monograph would certainly be welcome.

1. Jal 1867, s.v. "Claude Vignon."
2. Charles Sterling, "Un précurseur français de Rembrandt: Claude Vignon," *GBA* 2 (1934):123-136.
3. Paola Bassani Pacht, "Claude Vignon," *Storia dell'Arte*, no. 28 (1976):259-283; and "Qualche inediti di Claude Vignon," *Ricerche di Storia dell'Arte*, no. 7 (1979):85-98.

Saint Jerome in His Study
(*studio of Vignon*)
Saint Jérôme lisant
Oil on canvas, 40½ × 58½ in. (103 × 148.5 cm)
Mildred Anna Williams Collection. 1976.6 (CPLH)

Provenance Probably in the sale, Paris, Hôtel Drouot, 18 January 1970, no. 115, pl. 4 ("School of Guercino"); acquired by Dumont for 7,000 francs; [Sestieri, Rome, who bought the picture in France at an unknown date]; [Somerville & Simpson, Ltd., London, 1975]; acquired by TFAMSF, 1976.

References "Current and Forthcoming Exhibitions," *BM*, December 1975, 819, fig.40 on 817; Theodore Crombie, *Apollo*, December 1975, 470, fig.1; *GBA*, "La Chronique des Arts," March 1978, 44, no. 199, repr.; P. Rosenberg, exh. cat., 1982 Paris-New York-Chicago, 374, no. 11, repr.; W. Wilson, *California Museums* (New York: Abrams, 1985), 73.

Exhibition 1975 London (Somerville & Simpson), no. 7, repr.

Variant
PAINTING
Saint Jerome in His Study, fig.1
Oil on canvas, 41 × 56⁵⁄₁₆ in. (104 × 143 cm)
Present location unknown
PROV: Henri Baderou, Paris; perhaps the painting examined in December 1977 in a private collection, Rome, by Paola Bassani Pacht (letter, 29 May 1984).
REF: Fischer 1963, 163-164, fig.45 (?), 179, no. 44. (While this is presumably the original composition, there is some confusion regarding which version Fischer actually reproduced under fig.45 on page 164.)

fig.1

Related Work

PAINTING

Saint Augustine, formerly attributed to Mattia Preti, **fig.2**
Museum of the Abbey of Cava dei Tirreni, Italy
REF: A. Brejon de Lavergnée and J.-P. Cuzin, "A propos de Carava-gesques français," *La Revue du Louvre*, no. 1 (1974):16, fig.3.

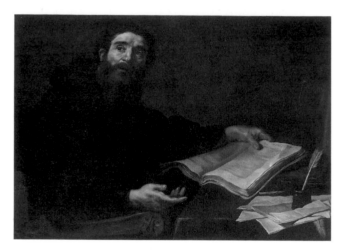

fig.2

Alfred Moir,[1] Arnauld Brejon,[2] and Dwight Miller[3] concur in their belief that this painting is by Claude Vignon. They base their opinions on the stylistic similarities of many documented works by this artist. Pierre Rosenberg, however, believes this picture was executed in Vignon's studio after the composition formerly in the Baderou collection (**fig.1**), based on the feeble handling of the brush, inconsistencies in the painted surface, and the absence of a secure touch. The picture has been relined and flattened in appearance. As a theme repeatedly taken up by the Caravaggesque painters, Saint Jerome was depicted by Vignon at least fifteen times, in both horizontal and vertical format. Sometimes Vignon portrayed the saint with a lion (s.d. 1626, Nationalmuseum, Stockholm), sometimes with the dove of the Holy Spirit that he shares with Saint Gregory, or sometimes with a cardinal's hat, although Saint Jerome was never a cardinal.

Saint Jerome (347-ca. 420), a doctor of the Latin church, was the confidant of Pope Damasus and the abbot of a religious group in Bethlehem. He passed his life in study and, as a hermit in the desert, is often portrayed in prayer, repentance, and beating his breast. He was a remarkable biblical scholar and wrote the lives of Saint Paul the Hermit and Saint Hilary as well as treatises and letters. His major accomplishment, however, was the translation of the Scriptures into the Vulgate.

The traditional attributes of the intellectual saint are not visible in the San Francisco picture: the hermit's skull, the spectacles, and the hourglass, which are anachronisms in the latter two cases. Instead, the composition shows Saint Jerome at work consulting a large volume bound in vellum, presumably the Bible, a number of books nearby. Dressed in a simple cloak, he appears lost in reflection, although nothing in the painting clearly indicates his religious character. Vignon adopted similar solutions in *Saint Jerome Reading* (private collection, The Hague; a copy in the Church of Moutier-Saint-Jean, Côte d'Or) *Saint Paul* (Museo Civico, Turin),[4] and *Saint Augustine* (**fig.2**). Paola Bassani Pacht believes the rich and theatrical arrangement of the still life on Saint Jerome's desk dates the original composition ca. 1620-1630, the period of Vignon's *Saint Jerome* (1626, Nationalmuseum, Stockholm) and *Cresus* (1629, Musée des Beaux-Arts, Tours).[5]

Like Simon Vouet, Vignon borrowed from Caravaggio and his school, but only superficially. For example, his use of half-length figures, seated like Saint Jerome at a table, gives the composition a feeling of spaciousness. Vignon also uses chiaroscuro to add interest to his backgrounds, against which his colors stand out in relief. The pleasure he takes in placing a jumble of books and manuscripts in the foreground is reminiscent of Fetti.

1. Letter, 15 October 1976.
2. Conversation with M. C. Stewart, 16 March 1984.
3. Conversation with M. C. Stewart, March 1984.
4. Pierre Rosenberg, "A Vignon for Minneapolis," *The Minneapolis Institute of the Arts Bulletin* 57 (1968):16, fig.8.
5. Letter, 29 May 1984.

Simon Vouet *Paris 1590-1649 Paris*

Simon Vouet's career can be divided easily into two periods—the Italian sojourn that ended in 1627 when the artist returned to France, and the Parisian period that lasted from then until the painter's death twenty-two years later.

The son of an obscure painter, Laurent Vouet, Simon Vouet seems to have traveled to England while still quite young, to Constantinople between 1611-1612, and to Venice between 1612-1613. He was in Rome in 1614, where he remained until 1627, except for a brief trip to Genoa and Milan between 1620-1621.[1] In 1617 he received a *brevet* from the king of France and, the following year, a royal pension. He also maintained a relationship with the colony of foreign artists living in Rome as well as with the most prominent Italian painters. In 1624 the artist was elected president of the Academy of Saint Luke. That same year his reputation was assured by a commission for Saint Peter's in Rome.[2] It was at this time that he undertook the decoration of the church of San Lorenzo in Lucina. Vouet's Italian work is well known through church paintings, which are often still in the original churches (San Francesco a Ripa and the Alaleoni Chapel, Rome; Sant' Ambrogio, Genoa; Sant' Angelo a Segno and San Martino, Naples; and others). During this time he also painted several easel pictures and portraits characterized by great freedom of handling and moving spontaneity.

One of the most celebrated artists in Rome, upon his return to Paris Vouet became the foremost painter of his country and the reorganizer of its artistic life. However, Vouet's oeuvre in France is less well conserved and studied than that in Italy. Many of his large decorations have been destroyed, although those for the Château de Colombes were later rediscovered at the town hall of Port-Marly.[3] Nearly all his paintings in churches were removed during the Revolution and some are still missing.

Vouet surrounded himself with a large team of collaborators, including Dorigny, Tortebat, Aubin Vouet, and Poerson. His studio trained the best painters of the next generation, Le Sueur and Lebrun, the latter succeeding him as the leader of French artistic life. Vouet's position was threatened in 1640 by Poussin's return to France, eliciting Louis XIII's famous remark, *"Voilà Vouet bien attrapé"* ("There's Vouet nicely trapped"), but Poussin's hasty and final departure for Rome left Vouet an open field. Vouet played an active role in the founding of the Royal Academy of Painting and Sculpture in 1648, but he died the following year.

In Italy Vouet demonstrated his sensitivity not only to Caravaggesque painting, but also to the Bolognese school and contemporary trends in Italian painting. Even before he returned to France, his palette had become lighter, he used more vivid colors, and his style was more decorative and elegant (*Time, Venus, Mars, and Love*, John and Mable Ringling Museum of Art, Sarasota). A first-rate draftsman and a great decorator and easel painter, Vouet was undeniably the most influential French artist of his generation. Without him Paris would never have become one of the artistic capitals of Europe.

Crelly's monograph on Vouet remains indispensable.[4] Together with numerous articles, the 1973-1974 Rome-Paris exhibition provides insight, particularly into Vouet's Roman sojourn. However, a serious study of his Parisian period cannot be undertaken until the style and artistic personalities of the painter's principal assistants are better defined.

1. Arnauld Brejon de Lavergnée, "Simon Vouet à Milan en 1621. . . ," *Revue de l'Art*, no. 50 (1981):58-64.

2. For surviving fragmentary sketches, see Jean-Patrice Marandel, exh. cat., *French Oil Sketches from an English Collection* (Houston: The Museum of Fine Arts, 1973-1975), nos. 92-93.

3. J. Féray and Jacques Wilhelm, "Une oeuvre inédite de Simon Vouet: Le décor d'une chambre à alcôve du château de Colombes remonté à la mairie de Port-Marly," BSHAF 1976, 1978: 59-79; and Barbara Brejon de Lavergnée, "Contribution à la connaissance des décors peints à Paris et en Ile-de-France au XVIIᵉ siècle: Le cas de Michel Dorigny," BSHAF 1982, 1984: 69-83.

4. William Crelly, *The Painting of Simon Vouet* (New Haven: Yale University Press, 1962).

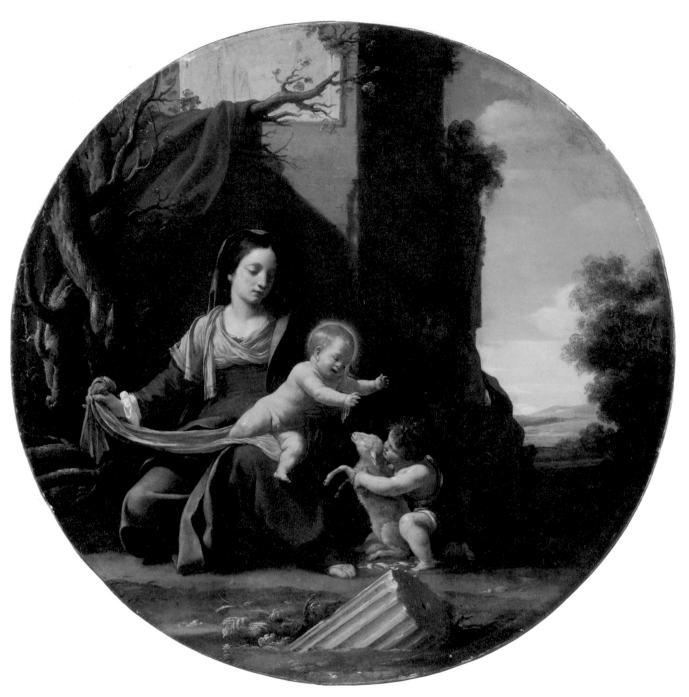

The Holy Family with the Infant Saint John the Baptist

The Holy Family with the Infant Saint John the Baptist

La Sainte Famille avec Saint Jean-Baptiste

Oil on panel, transferred to composition board (round),
d. 29½ in. (75 cm)
Inscribed at the base of the column (difficult to read):
SMON VOV./et P.C. Vol . . . , **fig.1**
Mildred Anna Williams Collection. 1974.8 (CPLH)

Provenance Mentioned for the first time in the inventory of Cardinal Francesco Barberini (1597-1679), 6 January 1627 (the painting had belonged to a "Bastiano Pasetti"); collection of Cardinal Francesco and Prince Taddeo Barberini, his brother, 1627-1640; mentioned again in the collection of Francesco Barberini, Palazzo della Cancelleria, Rome, October 1649; inventory after the death of Prince Maffeo Barberini, 1686; inherited by his son, Urbano (Lavin 1975); remained in the Barberini collections until they were dispersed between 1812-1816; Corsini, Florence; [P. & D. Colnaghi & Co., Ltd., London, July 1966]; [Wildenstein & Co., Inc., New York, May 1968]; acquired by TFAMSF, 1974.

References Orbaan 1920, 497; B[enedict] N[icolson], *BM*, May 1968, 292; Schleier 1971, 70, 72, fig.10, 73 (notes 44-46); A. Brejon de Lavergnée and J.-P. Cuzin, exh. cat., 1973-1974 Rome-Paris, Ital. ed., 198, 248, Fr. ed. 204, 255; Lavin 1975, 13 (doc. 102), 44 (doc. 354b), 84 (Inv. 26-31.242), 99 (*coppiere* 27-40, no. 1), 106 (Barb. Lat. 5635, fol. 58, no. 242), 241 (Inv. 49, 184, no. 650), 398 (Inv. 86, fol. 186 right, no. 87), 533, 625; Bordeaux 1977, 36, 38; P. Rosenberg, exh. cat., 1977 Florence, mentioned under no. 105; Lee 1980, 212-214, fig.1; *Triptych*, Summer 1980, fig.1, on 13; *Triptych*, December 1982-January 1983, repr. in color on the cover; Wright 1985 (Boston), 220, 285.

Exhibitions 1968 London, no. 7; 1978-1979 Denver-New York-Minneapolis, no. 44; 1982 Paris-New York-Chicago, no. 120, repr. on 71.

fig.1 (detail with inscription)

fig.2

Variants

PAINTINGS
The Holy Family with Saint John the Baptist, **fig.2**
Oil on canvas (round), d. 28 in. (71 cm)
Musée Magnin, Dijon
REF: Mus. cat. 1938, no. 996 ("French School. Middle of the 17th century").
NOTE: According to Arnauld Brejon de Lavergnée (letter, 5 June 1979), the picture is a seventeenth-century copy by an unknown artist. It is faithful to the original in San Francisco, with only minor variations.

The Holy Family with Saint John the Baptist
Oil on canvas (round), d. 28 in. (71 cm)
Private collection, Rome
PROV: This studio copy of a painting by Vouet (with halos suggested around the heads) was sold in London, Sotheby's, 26 June 1974, no. 159 repr., attributed to Jean Tassel, and again on 1 June 1977, no. 112, repr.

Mariano Vecchi, 1638, copy
Present location unknown
REF: Lavin 1975, 13, 44, doc. 354b.
NOTE: Executed for the Church of Santi Apostoli, Rome.

fig.3

ENGRAVINGS
Jean Lenfant, *La Sainte Famille*, fig.3
First state, inscribed: *Stella pinxit. Lenfant sculpsit*
REFS: Cab. des Est., Ed. 31. LL 22; Colette Lamy-Lassalle, *Jean Lenfant (1615-1674), graveur abbevillois* (Amiens, 1938), 48, no. 22.

Jean Lenfant, *La Sainte Famille*
Second state, inscribed: *S. Vouet pinxit. Lenfant sculpsit. E. Gantrel exc*
REF: Cab. des Est., Ed. 31. LL 22*bis*.
NOTE: This engraving, published by Etienne Gantrel, is a new state of the preceding, and was executed after Jean Lenfant's death in 1674. His widow, Marguerite Boudan, married Etienne Gantrel. This version has slight variations from the painting in San Francisco, but the composition is faithful to the original.

This painting entered the Barberini collection on 6 January 1627 and must have attained rapid renown, as Pietro da Cortona in 1634 used it in a theater production. In 1638 a copy was made for the Church of Santi Apostoli in Rome by the little-known Mariano Vecchi, a painter from Radicofani.[1] The San Francisco picture is of utmost importance, and there is every reason to believe it was painted shortly before it entered the Barberini collection, therefore ca. 1626.

In their attitudes and gestures, the Virgin and Child here bear undeniable affinities with the Virgin and Child in *Vision of Saint Bruno* (s.d. 1626, Carthusian Monastery of San Martino, Naples). In the words of Erich Schleier, "the background landscape is greatly inspired by Tassi . . . Breenbergh, and by Poelenburgh."[2] It is also very similar to that of the *Madonna of the Hamper* in Florence (Galleria Uffizi), which is also painted on wood.[3] With the superb *Time Vanquished by Hope, Love, and Beauty* of 1627 (Museo del Prado, Madrid), these paintings help clarify the evolution of Vouet's style toward a lighter palette before he departed for Venice and Paris. Vouet's new style owed much more to the school of Bologna than to the school of Caravaggio, which had gone out of fashion. The lighter palette would soon triumph in Rome where it was taken up by artists like Andrea Sacchi, the master of Carlo Maratta, and Andrea Vaccaro, the future director of the new *congregazione* of painters. It should be noted, however, that in spite of the new trend in painting, Valentin's *David* (Michael and J. Ellen Brunner, Fountain Valley, California) was added to the Barberini collection a few months after the Vouet.

Although contemporary with Poussin's *Death of Germanicus* (The Minneapolis Institute of Arts) and Valentin's *Allegory of Rome* (Finnish Institute, Rome), Vouet's *Holy Family* is unlike either of them in style. The standard pyramidal composition is placed off-center and the oblique light from the left reinforces a strong axis that aligns the heads of the protagonists. The shaft of light in the foreground also clearly delineates the receding space at right. The transition from foreground to background is eased by the placement of Saint Joseph, admirably modeled in half-tones, in a shadowed area behind the main group of figures. Vouet is concerned with rhythm and balance in his selective distribution of colors, the cold blue tones warmed by neighboring tones of ochre and red. Although the theme is hardly novel, Vouet manages to renew its appeal with his sensitive coloring, use of light, the shimmering effect on the tree branches and the boy's hair, and with the happy, pensive expression of his Virgin. The charm and elegance of the painting prove that even before he had settled in Paris in 1627 Vouet had found a style that would assure him success and important commissions.

1. Lavin 1975, 13, 44.
2. Schleier 1971, 70.
3. Exh. cat., 1977 Florence, no. 105, repr.

18th Century

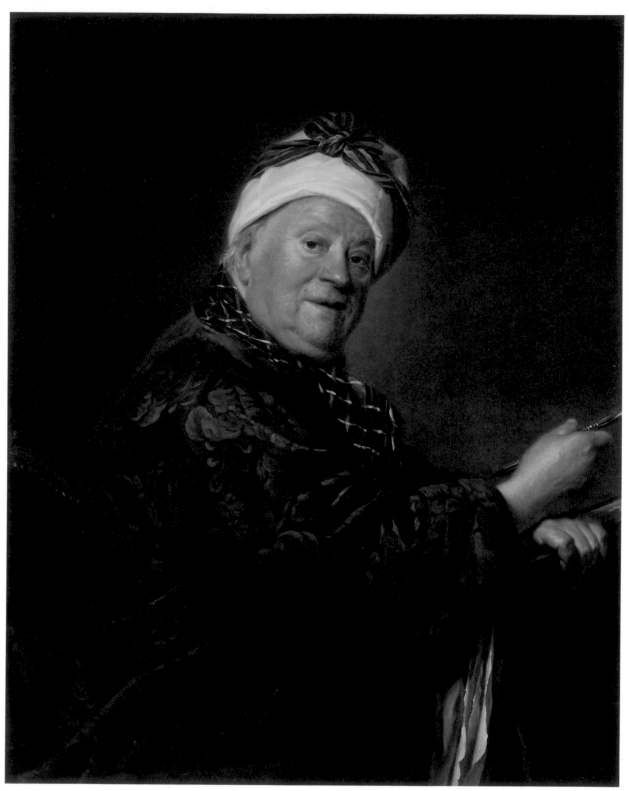

Etienne Jeaurat

Etienne Aubry *Versailles 1745-1781 Versailles*

Among the painters of the second rank in the latter half of the eighteenth century, Etienne Aubry was one of the best. Unfortunately, only Florence Ingersoll-Smouse has devoted a few pages to him (1925) and this excellent artist still awaits his biographer.

Studying first under J.-A. Silvestre, the drawing master to the royal children of France, then under Vien, Aubry began his career by painting portraits. It was in fact as a portraitist that he was accepted in 1771 by the Royal Academy of Painting and Sculpture and elected to membership four years later with his likenesses of *Vassé* and *Hallé* (Château de Versailles). His portraits, although quite rare, probably constitute the most original part of his work.

His genre paintings are much better known, with the most important exhibited in the Salons of 1775, 1777, and 1779. The majority, such as *The Curious Lover* and *The Good News*,[1] *The Shepherdess of the Alps*,[2] *Paternal Love* (The Barber Institute of Fine Arts, Birmingham), *Farewell to the Nurse* (Pushkin Museum, Moscow; and Sterling and Francine Clark Art Institute, Williamstown), and *First Lesson in Fraternal Friendship* (D. A. Hoogendijk Gallery, Amsterdam, in 1929), are infused with the smiling sentimentality characteristic of Aubry.

However, under the patronage of Comte d'Angiviller, director of the Bâtiments du Roi, Aubry soon aspired to paint in the *grand genre*, and he produced such melodramatic works as *The Broken Marriage*[3] and *The Repentant Son Returned Home* in which Greuze's influence is evident. His desire to be known as a history painter drew him to Rome in 1777, in the company of A.-F. Silvestre, Aubry's pupil and the son of his first teacher. However, despite hard work and the execution of several history paintings, including *Diogenes Asking for Alms* for Comte d'Angiviller, his inaptitude for the *grand genre* became apparent and he left Rome abruptly in 1780. His ambitions disappointed and his health ruined, he died ten months later, leaving behind as the only realization of his Roman dream *Coriolanus's Farewell to His Wife before Leaving to Give Up Himself to the Volsii* (lost), which was shown at his posthumous exhibition in the Salon of 1781. On his death, it was written of him:

When one considers at what point he began and to what extent he managed to rise through the sheer force of his genius, and the hopes generated by his first attempts in a genre he had hardly time to study, this artist merits the regrets of anyone who loves the arts. He excelled in drawing; he applied himself to it from his youth; he had acquired the habit of working hard. In addition to his talents, he possessed the advantages of a pleasant and open personality; his sensitivity, which hastened his death, might have helped make him one of the great painters of the French School.[4]

1. Sale, Paris, Palais Galliera, 21 March 1977, no. 27.
2. E. Leonino sale, Paris, Galerie Jean Charpentier, 18-19 March 1937, no. 10.
3. Sale, Paris, Hôtel Drouot, 10 June 1963.
4. Reprinted from a contemporary obituary in "Nécrologe des artistes et des curieux," *Revue Universelle des Arts* 13 (1861):50-51.

Etienne Jeaurat (*attributed to Aubry*)
Oil on canvas, 36 × 28 3/4 in. (91 × 73 cm)
Roscoe and Margaret Oakes Collection. 75.2.1
(de Young)

Provenance Probably the presumed self-portrait of Jeaurat mentioned in the inventory after his death, 1789 (Puychevrier 1862, 32); certainly the presumed self-portrait of Jeaurat in the possession of Mme Richer, his niece, ca. 1862 (Puychevrier 1862, 27); Noël Bardac, Paris, 1910; Colonel and Mme Jacques Balsan, Paris, ca. 1924; [Arnold Seligmann & Rey Co., Inc., Paris, ca. 1934]; [Rosenberg & Stiebel, New York, 24 February 1953]; Roscoe and Margaret Oakes, San Francisco, 1953; on loan to the de Young 1953-1972, and to the CPLH 1972-1975; gift to TFAMSF, 1975 (as Greuze).

References Puychevrier 1862, 27, 32; Osborn 1929, 614, no. 218, repr.; *Art Digest*, July 1953, 14; *The Art Quarterly*, Winter 1953, 352, 355, fig.1; *European Works* 1966, 195, repr.; Wescher 1969, 153-154, 157, repr.; Bordeaux 1977, 36; J. H., "Prächtige Leibgaben aus San Francisco," *Aufbau*, 20 April 1979, 12, repr.; W. Wilson, *California Museums* (New York: Abrams, 1985), 76, pl. 64.

Exhibitions Perhaps exhibited in the Salon of 1771, no. 226; 1910 Berlin, no. 58, repr.; 1924 London, no. 18; The Minneapolis Institute of Arts, *French Eighteenth Century Painters*, 5 October-2 November 1954, no cat.; 1954 New York, no. 12; 1965 Indianapolis, no. 3, repr.; 1966 Bordeaux, no. 27; 1978-1979 Denver-New York-Minneapolis, no. 21.

fig.1

Variants

PAINTINGS

Etienne Jeaurat, **fig.1**
Oil on canvas (oval), 22½ × 18½ in. (57 × 47 cm)
Rau Collection, Zurich and Marseille
PROV: Louis Fournier collection; sale, Amsterdam, 24 June 1924, no.
38, repr.; C. J. Austin, England; [Mortimer Brandt, ca. 1967]; sale,
London, Christie's, 20 July 1973, no. 257, repr. (attributed to J.-S.
Duplessis); [Dr. Eisenbeiss, St. Gallen, Switzerland, 1973].

Etienne Jeaurat (copy), **fig.2**
Oil on canvas, 23⅝ × 18⅞ in. (60 × 50 cm)
Musée Carnavalet, Paris. P. 186
PROV: Acquired in 1899 from the Sortais collection.

Etienne Jeaurat (copy)
Oil on canvas, 23⅝ × 18⅞ in. (60 × 48 cm)
Present location unknown
PROV: Sale, Milan, Gallerie Salamon Agustoni Algranti, 26 November 1984, no. 3, repr. (attributed to Johann Kupezky).

fig.2

Related Work

ENGRAVING
Louis-Simon Lempereur, after Alexandre Roslin, *Etienne Jeaurat*,
fig.3

fig.3

This portrait raises a number of questions. The only thing certain is that this is definitely a portrait of Jeaurat at about seventy years of age. A comparison with portraits of Etienne Jeaurat by Greuze and especially by Alexandre Roslin, where even the pose of the sitter is similar, leaves no doubt.

Originally a student of Vleughels, Jeaurat had an unusual career. Elected to membership by the Royal Academy of Painting and Sculpture in 1733 with *Pyramus and Thisbe*, he vacillated among history painting (including several good religious pictures), village scenes inspired by northern art, and scenes of Parisian life. Rector of the Academy in 1765 and Guardian of the King's Pictures at Versailles two years later, he was appointed chancellor of the Academy in 1781.

The portrait seems to have remained in the family of the sitter for a long time, and it is interesting to relate it to the portrait of Jeaurat belonging to Marie-Jeanne Quatremère, widow of Nicolas-François Richer (Jeaurat's nephew), noted by Puychevrier:

We should also mention a portrait of Jeaurat that this lady claims is a self-portrait; he is depicted in three-quarter profile, a cap tied with a ribbon on his head, and clad in a dressing gown, a scarf casually knotted around his neck. In this portrait, Jeaurat seems to be about seventy years old; it is one more similarity that he wished to have with Chardin; the arrangement of the clothing is strikingly similar to Chardin's self-portrait, which can be seen in the pastel gallery of the Louvre.[1]

Although this description corresponds perfectly to our portrait, it is difficult to accept it as a self-portrait by Jeaurat. The quality of the picture distinguishes it quite clearly from Jeaurat's heavier, infinitely less subtle handling. The traditional attribution to Greuze is improbable as well. The precise treatment here is rather different from Greuze's more synthetic technique; more important, Greuze exhibited his *Etienne Jeaurat* (Musée du Louvre, Paris) in the Salon of 1769. It would have been unusual for him to paint two different portraits of the same person within two years.

There remains a tempting hypothesis. We know that Etienne Aubry exhibited *M. Jeaurat, Painter to the King, Guardian of Pictures and Maps in the Cabinet of His Majesty* at the Salon of 1771 (no. 226). Unfortunately, the dimensions and location of this painting are unknown. The apparent age of the sitter and the close similarity in technique between the San Francisco portrait and Aubry's portrait of the composer *Christoph*

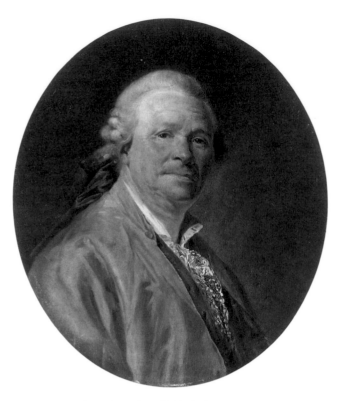

fig.4 Etienne Aubry, *Christoph Willibald Gluck* (1714-1787), oil on canvas (oval), 24 3/8 × 20 1/2 in. (62 × 52 cm), s.d. lower right: *Greuze 1777* (doubtful), Musée du Louvre, Paris, R.F. 1715.

Willibald Gluck (**fig.4**), as well as that of Gluck's wife (s.d. 1773, formerly Galerie Cailleux, Paris), suggest the possibility that Aubry might be our artist.

The quality of this skillfully composed and beautifully painted portrait—perhaps directly inspired by Roslin's reception piece, which had been in the Academy's collection since 1753—is not surprising, as Aubry's work was favorably noticed at the Salon. Already celebrated in the *Lettre de M. Raphaël le jeune . . . à un de ses amis architecte à Rome*,[2] this painting was also the subject of the following lines in *La muse errante au salon*:
Jeaurat strikes my eyes: his interesting face
Speaks, announces genius.
Everyone knows his wonderful paintings
The most beautiful cabinets shine from his brushes.
While paying tribute to this skillful artist
We marvel at one who renders our likeness.[3]

Should this attribution be confirmed by new documentation, there is no doubt that a portrait of such brilliant execution and psychological insight would be considered one of Aubry's major works.

1. Puychevrier 1862, 27.
2. Collection Deloynes 9, no. 141.
3. Collection Deloynes 9, no. 145.

François Boucher *Paris 1703-1770 Paris*

François Boucher, the son of an obscure painter, entered the workshop of François Le Moyne around 1720 and quickly assimilated the new style of the period. He also executed drawings for the engraver J.-F. Cars. In 1723 he won the *Prix de Rome* at the Royal Academy of Painting and Sculpture with *Evilmirodach Delivers Jehoiachin from Imprisonment* and in 1725 became familiar to connoisseurs through the Exposition de la Jeunesse. One of these connoisseurs was Jean de Jullienne, who asked Boucher to make etchings from many of Watteau's drawings from *Figures de différents caractères, de paysages, et d'études.* In 1728 Boucher went to Italy at his own expense, where he became influenced by Roman painting, possibly also studying the works of Castiglione in Genoa, Correggio in Parma, and the sumptuous compositions of the Venetian painters.

Boucher returned to Paris in 1731 and two years later married Marie-Jeanne Buseau, who is supposed to have served often as his model. In 1734 he began his long official career, becoming a member of the Academy with *Rinaldo and Armida* (Musée du Louvre, Paris). He was named professor in 1737, subsequently becoming director and *premier peintre du roi* in 1765 upon the death of Carle Vanloo.

From 1734 to 1736 he illustrated several books and collections, including a handsome *Oeuvres de Molière* in collaboration with Oppenordt and Blondel and a series of *Cris de Paris*, and etched a number of drawings of Bloemaert, which perhaps influenced his own later pastoral scenes and landscapes. However, his paintings with mythological or biblical themes, such as *Venus Asking Vulcan for Arms for Aeneas* (1732, Musée du Louvre, Paris) and *The Rape of Europa* (Wallace Collection, London), long attributed to François Le Moyne, reveal a more brilliant artistic personality.

After the Salon of 1737 Boucher intensified his artistic production and his fame continued to grow. He executed many cartoons for the royal tapestry factories at Beauvais and the Gobelins, becoming chief inspector of the Gobelins from 1755 to 1765. In these cartoons he transformed with originality the grandiose art of Charles Lebrun, decentralizing the composition, making use of curves and counter-curves, and employing pastel colors with which he produced effects similar to silk. His designs for the Vincennes and later for the Sèvres porcelain factories, as well as the numerous sets he designed for the theater and opera, contributed to his reputation as the most inventive decorative artist of the century.

Boucher worked for the king and queen at Versailles, painting parts of a ceiling *en camaïeu* for the queen's bedroom in 1735 and a *Tiger Hunt* (1736) and a *Crocodile Hunt* (1738) for the Petits Appartements (Musée de Picardie, Amiens). In 1738 he painted several overdoors for the Hôtel de Soubise; between 1741 and 1746 he executed four overdoors for the Royal Library. Some time after 1756 he also painted two landscapes for the dauphin. Above all, however, he worked consistently for Mme de Pompadour, the king's official mistress and his principal patron.

While visiting Paris in 1768, Reynolds found Boucher overloaded with commissions. The artist told him that he was working mostly from memory, drawing on some ten thousand sketches he had accumulated over the years. Diderot was quick to criticize the painter's facile technique and his palette in his reviews of the biennial Paris salons. Boucher continued this amazing productivity until his death, despite the public's changing taste and his own failing eyesight. This brilliant and indefatigable imagination, celebrator of women, and painter of *bonheur* left his mark on the entire century until the rise of David.

André Michel (1906), Pierre de Nolhac (1907), and Maurice Fenaille (1925) are among the authors of monographs on Boucher in the early twentieth century. More recently, Alexandre Ananoff with Daniel Wildenstein compiled a catalogue raisonné of Boucher's work (1976), and Alastair Laing and others prepared an excellent catalogue for the 1986-1987 Boucher exhibition (New York-Detroit-Paris).

fig.1 (detail with signature)

Virgin and Child
La Vierge et l'Enfant
Oil on canvas (oval), transfer, 17 × 13¾ in. (43 × 35 cm)
Signed lower right, on the arm of the chair: *F. Boucher PX* (partially effaced), **fig.1**
Gift of Brooke Postley. 57.2 (de Young)

Provenance Probably in the [La Ferté] sale, Paris, 20 February 1797, no. 91 ("F. Boucher. The Virgin seen waist-length holding in her arms the infant Jesus. H. 15 *pouces* × L. 13 *pouces* [ca. 40.5 × 35 cm]. Canvas in oval form"); [acquired for 27 *livres* 1 *sou* by J.-B.-P. Le Brun, according to the annotated catalogue, Bibliothèque Doucet (18b/4)]; anonymous sale, Paris, 22-23 February 1850, no. 40; [René A. Trotti, Paris, early twentieth century]; Brooke Postley, Stamford, Connecticut; gift to the de Young, 1957.

References Michel 1906, 41, no. 740; *The Art Quarterly*, Summer 1957, 205, fig.2 on 212; *European Works* 1966, 182, repr.; Ananoff and Wildenstein 1976, 2: no. 662, fig.1732; Ananoff 1976, 23; exh. cat., 1978 London (Artemis), mentioned under no. 20; Ananoff and Wildenstein 1980, no. 700, repr.; C. Bailey, exh. cat., 1985-1986 New York-New Orleans-Columbus, 135, no. 92, repr.

Exhibition 1987 Rochester-New Brunswick-Atlanta, no. 5, repr.

Variants
PAINTINGS
The Virgin Holding the Infant Jesus in Her Arms, **fig.2**
Oil on canvas (oval), 21⅝ × 17⁵⁄₁₆ in. (55 × 44 cm)
S.d. upper left: *F. Boucher/1768.*
Frank Valle, Houston, Texas, 1981
PROV: Sale of an artist [Fabre or Le Brun], Paris, 11 January ff. 1773, lot 87; bought by Monnet for 310 *livres*; Boyer de Fonscolombe sale, Paris, 18 January ff. 1790, lot 82; bought by Le Brun for 48 *livres*; Robert de Saint-Victor sale, Paris, 26 November 1822 and 7 January 1823, lot 615, sold for 5 [*livres* ?] 5 [*sous* ?]; A. M. Hollond; [Galerie Cailleux, Paris]; Ernest Mansurel, Paris; sale, Paris, Nouveau Drouot, salles 5 and 6, 19 June 1981, no. 52, repr.
REF: Jean-Richard 1978, mentioned under no. 746.

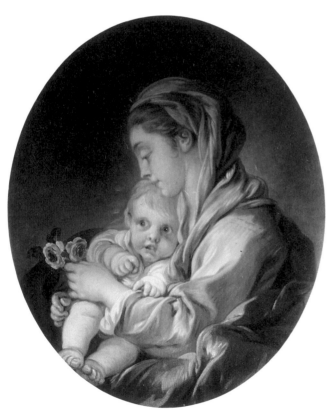

fig.2

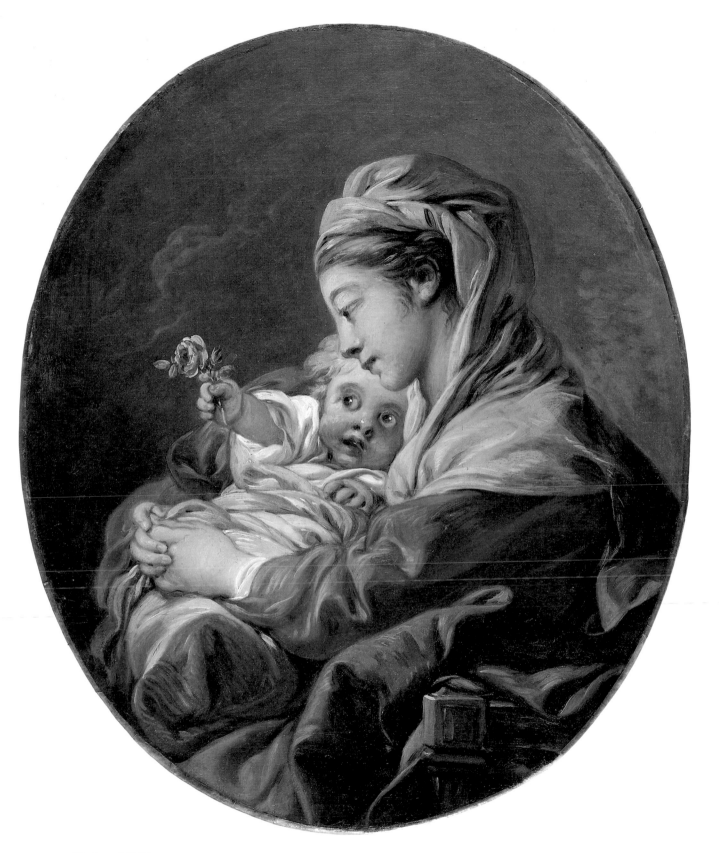

Virgin and Child

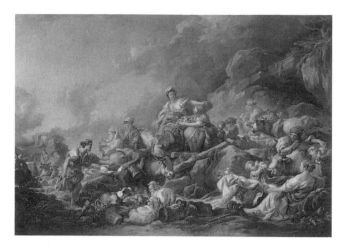

fig.3

Related Works

PAINTINGS
Returning from Market, **fig.3**, and detail, **fig.4**
Oil on canvas, 82 ½ in. × 114 ⅜ in. (209.5 × 290.5 cm)
S.d. lower left: *F. Boucher/1767*
Museum of Fine Arts, Boston, Gift of the Heirs of Peter Parker. 71.3

Education of the Virgin, **fig.5**
Oil on canvas (oval), 14 × 16 in. (35.5 × 40.5 cm)
S.d. lower right: *F. Boucher, 1768*
Phoenix Art Museum. 64.41

ENGRAVING
Gilles Demarteau, after Boucher, *Groupe de deux têtes de femme et d'une tête d'enfant*
Crayon manner engraving, print in sanguine, no. 178
REF: Jean-Richard 1978, no. 746, repr.
NOTE: A drawing in black chalk after this engraving is in the Cab. des Dess., Musée du Louvre, Paris, Inv. 24783.

The difficulty in citing the full provenance of this work is twofold. First, at least one other painting of similar composition exists (**fig.2**). Second, descriptions in old sale catalogues do not always make clear to which painting they refer. Only the dimensions given by the writers of these catalogues permit the equation of San Francisco's *Virgin and Child* with one sold in the La Ferté sale (1797), and the Valle version with the picture in the Fabre and Boyer de Fonscolombe sales.[1] The description "the Holy Virgin, seated in a chair, holding in her arms her divine son who bears a rose in his hand"[2] surely corresponds to the San Francisco painting. On the other hand, the version in the Valle collection may well be the "Virgin holding a bouquet in her hand, and in her arms the infant Jesus" described in the catalogue of the Robert de Saint-Victor sale.[3]

The San Francisco *Virgin and Child* is not dated, although the Valle picture bears the date 1768. The motif of the Virgin and Child also appears in the left portion of *Returning from Market* (**fig.4**), dated 1767, and the head of the Virgin is almost identical to that of Saint Anne in *Education of the Virgin* (**fig.5**), dated 1768. In addition, Demarteau engraved a sheet by Boucher of two female heads and an infant's with similar poses.[4] Thus it seems reasonable to assign a date of 1765-1770 to the Museums' painting.

Boucher's signature appears on both of these works, although the facture is unremarkable. The painter's eyesight was failing toward the end of his life, and he frequently relied on the help of his studio to satisfy numerous requests for his work. The Museums' painting contains a few weaknesses, particularly in the treatment of the hands and in the details of the drapery, and

fig.4 *Returning from Market* (detail)

the position of the Virgin's head has been modified. However, the San Francisco painting appears to be of better quality than the Valle version, and its hasty brushwork may reflect the aesthetic encyclopedism in Boucher's studio, especially the master's fondness for Venetian painting, particularly Tiepolo and the gentle Correggio.

The iconography here is conventional. The rose, which sometimes symbolizes what Pope Pius IX would later define as the dogma of the Immaculate Conception, is seen frequently in representations of the Virgin. The concept of "Santa Maria della rosa," where the Virgin or the Christ child holds a rose, appears very early in Italian painting. This *Virgin and Child* is in the tradition of the "Mater amabilis" in which the Virgin is shown in half-length dressed in a blue cloak over a red robe. Boucher attempted religious themes in paintings and drawings throughout his life. However, critics have not always taken them seriously, finding his madonnas too worldly and his treatment too casual.

1. See fig. 2, provenance.
2. Sale, Paris, 22-23 February 1850, no. 40.
3. See fig. 2, provenance.
4. See Related Work, engraving by Demarteau.

fig.5

Companions of Diana

Companions of Diana
(*Boucher and studio*)
Les compagnes de Diane
Pendant to 75.2.3
Oil on canvas (oval), 46 ⅛ × 36 ⅛ in. (117 × 92 cm)
S.d. lower left: *F. Boucher/1745*, **fig.1**
Roscoe and Margaret Oakes Collection. 75.2.3
(de Young)

fig.1 (detail with signature)

Provenance One of four overdoors from a suite of five pastoral
scenes perhaps acquired at the sale, Paris, Hôtel des Ventes Mobi-
lières, 28-29 November 1834, lot 15, by Gregory Williams (1786-
1854), who took the surname Gregory when he succeeded to the
estates of his father and his uncle in 1822, Harlaxton Manor, Gran-
tham, Lincolnshire; inherited by his cousin, George Gregory (d. 1860),
1854; inherited by the family solicitor, John Sherwin, who added
Gregory to his name, 1860-1869; inherited by his widow, Catherine
Sherwin-Gregory, who acted as Squire of Harlaxton from 1869-1892;
inherited by Thomas Sherwin Pearson (1851-1935), cousin and god-
son of Sherwin-Gregory, who added Gregory to his name, 1892;
inherited by his son, Major Philip Pearson-Gregory (d. 1936), 1935;
Pearson-Gregory estate sale (the contents of Harlaxton Manor), Lon-
don, Christie's, 18 June 1937, no. 12; [acquired by Duveen Brothers,
New York, in half-share with Wildenstein & Co., Inc., 1937, and the
four overdoors were transformed by Duveen into rectangular format];
Roscoe and Margaret Oakes, San Francisco, 13 April 1954; on loan to
the de Young 1954-1972, and the CPLH 1972-1975; gift to TFAMSF,
1975. (Restored to original oval format, 1978.)

References R. Cortissoz, "Decorations by François Boucher in New
York," *New York Herald Tribune*, 24 October 1943; Cortissoz 1944,
pl. 15; *Art News*, February 1946, repr. in color; *Art News*, December
1946, 8; *Time*, 2 August 1954, 58, repr. in color; P. Wescher, "Neuer-
werbungen des De Young Museums in San Francisco," *Kunstchronik*,
October 1957, 311; *European Works* 1966, 180, repr.; C. Hibbert,
Versailles (New York: Newsweek, 1972), 170, repr. on 90; R. S. Slat-
kin, exh. cat., 1973-1974 Washington-Chicago, mentioned under no.
48 on 63, fig.25; Ananoff and Wildenstein 1976, 1:400, no. 290,
fig.846; Bordeaux 1977, 36; Jean-Richard 1978, 341; Slatkin 1979,
120; Ananoff and Wildenstein 1980, no. 300, repr.; D. Sutton, exh.
cat., 1980 New York, mentioned under no. 50 on 48; B. Fromme,
Curator's Choice, west. ed. (New York: Crown Publications, 1981),
59; C. Bailey, exh. cat., 1985-1986 New York-New Orleans-
Columbus, 135, no. 90, repr.; A. Laing, exh. cat., 1986-1987 New
York-Detroit-Paris, mentioned under nos. 49-50 on 221, fig.153 on
222.

Exhibitions 1943 New York (Duveen); 1947 Detroit, 3; 1952 New
York, no. 5; 1952-1953 Palm Beach, no. 2; 1978-1979 Denver-New
York-Minneapolis, no. 2.

Variants
PAINTINGS
Diana and Nymph, **fig.2**
Oil on canvas, 31½ × 51 in. (80 × 129.5 cm)
PROV: Sale, London, Christie's, 18 July 1947, no. 76; Martin
McCormack, Bletchingdon Park, Oxford, 1973; sale, London, Chris-
tie's, 26 November 1976, no. 90, repr.; sale, Amsterdam, Christie's, 7
September 1983, no. 331, repr.

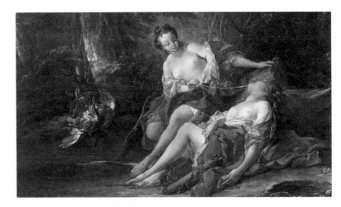

fig.2

fig.3

fig.4

Companions of Diana, **fig.3**
Oil on canvas, 34 ½ × 45 ¼ in. (87.5 × 115 cm)
Private collection, London
PROV: Rohoncz Castle, Hungary, 1949; Thyssen-Bornemisza collection, Villa Favorita, Castagnola, until 1968; [Rosenberg & Stiebel, Inc., New York, 1968]; sale, London, Christie's, 7 July 1978, no. 156, repr.; acquired by the Alexander Gallery, London.

Two Nymphs of Diana Returning from the Hunt
Oil on canvas (curved), 4 *pieds* × 2 *pieds 6 pouces.*
PROV: Executed in 1748 for the king's dining room at the Château de Fontainebleau; possibly the picture in the ninth catalogue of the Sedelmeyer Gallery, Paris, 1905, no. 61, which was last recorded in the collection of Dr. Henry Barton Jacobs, Baltimore.
REFS: Ananoff and Wildenstein 1976, 2:8, no. 312; A. Laing, exh. cat., 1986-1987 New York-Detroit-Paris, 26.

Related Works
DRAWINGS
Reclining Nude, **fig.4**
Black and red chalk heightened with white on blue-green paper, 9 × 12 ⅝ in. (227 × 320 mm)
PROV: Mr. and Mrs. Donald S. Stralem, New York; sale, *Old Master Drawings from the Collection of Mrs. Donald S. Stralem*, London, Christie's, 13 December 1984, no. 155, repr.

Two Followers of Diana Sleeping
PROV: Boucher sale, Paris, 18 February 1771, no. 381.
REF: Ananoff and Wildenstein 1976, 2:8, no. 312/1.

Reclining Nymph, After Returning from the Hunt
Black chalk
PROV: D'Azincourt sale, Paris, 10-27 February 1783, no. 179.

ENGRAVINGS
Gilles Demarteau, after Boucher, *Female académie*
Crayon manner engraving, print in sanguine
REF: Jean-Richard 1978, 186, no. 567.

J.-B. Michel, after Boucher, *Le repos de la volupté*
Etching and engraving
REF: Jean-Richard 1978, no. 1423.

Bacchantes (*Boucher and studio*)

Pendant to 75.2.2
Oil on canvas (oval), 46³/₁₆ × 38¹/₈ in. (117 × 97 cm)
Signed at the right: *F. Bouch[er]*, **fig.5**
Roscoe and Margaret Oakes Collection. 75.2.2
(de Young)

Provenance The same as *Companions of Diana*; sale, London, Christie's, 18 June 1937, no. 11.

References R. Cortissoz, "Decorations by François Boucher in New York," *New York Herald Tribune*, 24 October 1943; Cortissoz 1944, pl. 8; *San Francisco Chronicle*, 16 May 1954, 10, repr.; P. Wescher, "Neuerwerbungen des De Young Museums in San Francisco," *Kunstchronik*, October 1957, 311; *European Works* 1966, 181, repr.; C. Hibbert, *Versailles* (New York: Newsweek, 1972), 170, repr. on 90; Ananoff and Wildenstein 1976, 1:400, no. 288, fig.843; Bordeaux 1977, 36; Slatkin 1979, 120; Ananoff and Wildenstein 1980, no. 298, repr.; M. A. Morris, *European Paintings of the 18th Century* (London: Frederick Warne, Ltd., 1981), 10; C. Bailey, exh. cat., 1985-1986 New York-New Orleans-Columbus, 135, no. 91, repr.; A. Laing, exh. cat., 1986-1987 New York-Detroit-Paris, mentioned under nos. 49-50 on 221.

Exhibitions 1943 New York (Duveen); 1978-1979 Denver-New York-Minneapolis, no. 1.

Related Works

PAINTINGS
The Love Letter, **fig.6**
Oil on canvas, 30 × 65 in. (76 × 165 cm)
S.d. at the right: *f. Boucher, 1745*
Wildenstein & Co., Inc., New York, in 1975
REF: Ananoff and Wildenstein 1976, 1:no. 286, fig.846.

Four overdoors in their gilt and white Georgian frames from Harlaxton Manor (1937), **fig.7**, left to right:

Pomona
Oil on canvas, 41 × 31 in. (104 × 78.5 cm)
Wildenstein & Co., Inc., London or Geneva, in 1976
REF: Ananoff and Wildenstein 1976, 1:no. 289, fig.845.

Flora
Oil on canvas, 41 × 36 in. (104 × 91.5 cm)
Wildenstein & Co., Inc., London or Geneva, in 1976
REF: Ananoff and Wildenstein 1976, 1:no. 287, fig.842.

Bacchantes
TFAMSF. 75.2.2

Companions of Diana
TFAMSF. 75.2.3

fig.5 (detail with signature)

These two paintings belong to a series of five decorative canvases with mythological and pastoral themes. The group consists of four oval overdoors and a rectangular panel that may not have been associated with these originally. All five are signed and three are dated 1745. Besides San Francisco's *Companions of Diana* (formerly and incorrectly called *Diana and Callisto*) and *Bacchantes*, the overdoors include *Flora* and *Pomona*. The oblong picture is entitled *The Love Letter*.

Alexandre Ananoff suggested that either *The Love Letter*, *Pomona*, or *Companions of Diana*, which he called *Nymphs of the Hunt*, might be the painting Boucher added at the last minute to the Salon of 1745 (no. 172), described as "a picture with rounded edges, representing a pastoral subject."[1] However, no evidence for this hypothesis is provided by the few extant accounts of the Salon.[2] Tradition has it that the decorative series was painted for Mme de Pompadour and placed in her Château de Bellevue. However, Boucher was not painting for Mme de Pompadour as early as 1745; the pictures could not have been commissioned for Bellevue as the château was not built until 1748-1749; and there is no trace of these paintings in the many descriptions and inventories of Bellevue,[3] nor in the inventory made upon the death of Mme de Pompadour in 1764.[4] The paintings and other furnishings of Bellevue were distributed among several residences following the acquisition of the château in 1757 by Louis XV.[5]

Certainly the series was intended as a room decoration and appears to have been a success. At least two other versions of *Pomona* are known from sales[6] and there are several versions of *Companions of Diana*. Those formerly in the McCormack and Thyssen collections are merely copies from Boucher's studio (**figs.2-3**). Engravings by Demarteau and Michel, with a few variations in the landscape and the accessories, and several

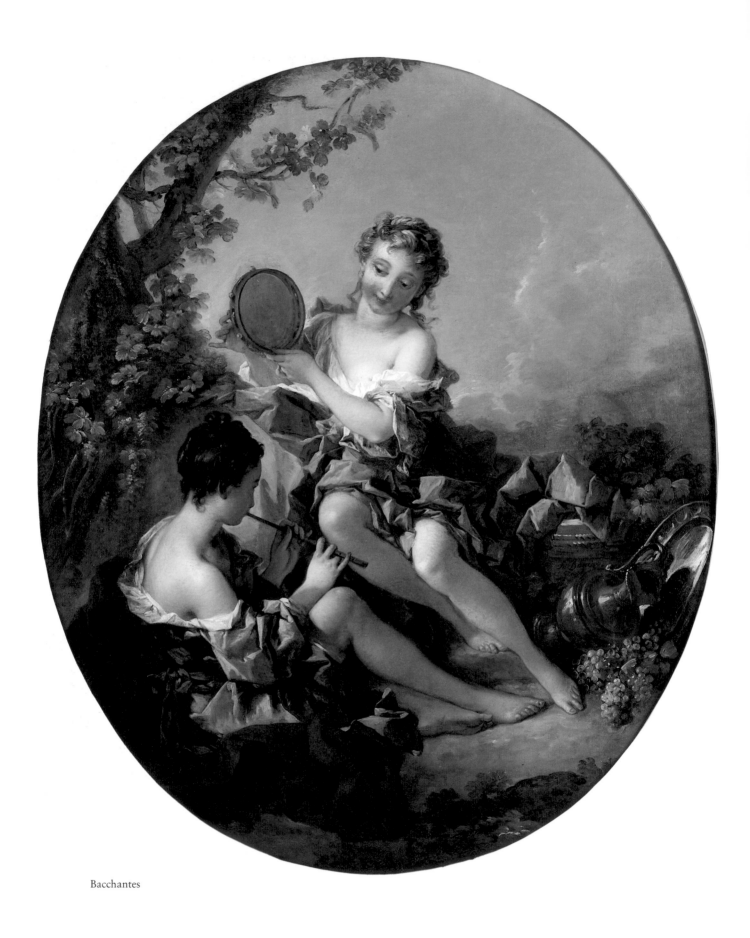

Bacchantes

related drawings, such as the superb sheet formerly in the Stralem collection (**fig.4**), underline the importance of this nymph in Boucher's oeuvre. The Stralem drawing might be a preparatory study for the reclining nymph, but it could also be a highly finished study after it.

Each figure in the four overdoors is placed to achieve a desired effect as the viewer looks up. *Pomona* and *Flora* form pendants, both in iconography and in composition, as do the two San Francisco paintings. In the latter pair, the torsos are symmetrically placed, and the positions of the nymphs' legs are reversed. By a subtle play of curves and countercurves Boucher suppresses vertical and horizontal axes in his compositions, admirably adapting them to the oval format.

Regrettably, the two paintings are in fragile condition; alterations are especially noticeable in *Companions of Diana*. The faces of the women are excessively sweet, suggesting retouching to conform to contemporary taste during the nineteenth century. San Francisco's version is superior to those formerly in the McCormack and Thyssen collections in modeling, the brilliant effects of light and color, and treatment of landscape and still life. The facture appears somewhat mechanical, raising the likelihood that collaborative hands intervened in Boucher's studio. Despite this qualitative restriction, these paintings can be grouped with such works as *Diana Rising from Her Bath* (1742, Musée du Louvre, Paris) and *Diana Returning from the Hunt* (1745, Musée Cognacq-Jay, Paris), which are among the most beguiling female figures Boucher ever created.

1. Ananoff and Wildenstein 1976, 1:400, no. 290.
2. Collection Deloynes 47, no. 1223.
3. Biver 1933.
4. Cordey 1939.
5. Biver 1933, 144.
6. Sale, Paris, Galerie Georges Petit, 27-29 May 1903, no. 556, repr. (as J.-B.-M. Pierre); Sedelmeyer estate sale, Paris, 16-18 May 1907, no. 178, repr. *(Pastorale)*.

fig.6

fig.7

Vertumnus and Pomona
(*studio of Boucher*)

Vertumne et Pomone

Oil on canvas, 123¾ × 72½ in. (314 × 184 cm)
Mildred Anna Williams Collection. 1967.11 (CPLH)

Provenance Mme Munroe Ridgway, 5 rue François Iᵉʳ, Paris, ca. 1900; sold by Mme Ridgway to Reginald Vaile, London, July 1902 (letters, Marquis de Ganay, 2 January 1968 and 6 August 1980); Reginald Vaile sale, London, Christie's, 23 May 1903, no. 56, repr.; [bought by Arthur Tooth] for Sir Joseph B. Robinson, Bt.; installed in the ballroom of Dudley House, Park Lane, London, 1903-1910; in storage with the Robinson collections in a house on Bayswater Road, 1910-1923; Robinson sale, London, Christie's, 6 July 1923, no. 105/2, repr. (bought in); Princess Ida Labia (Robinson's daughter), South Africa, 1929; inherited by her two sons, South Africa, 1961; Princess Labia sale, New York, Parke-Bernet Galleries, 3 November 1967, no. 61B, repr.; acquired by the CPLH, 1967.

References Frappart 1903, 34; Foster 1906, 2:pl. 35; Macfall 1908, 155, repr. on 119; Badin 1909, 91, 105; Marillier 1926, 103, 209; Townsend 1940, 86; Scharf 1958, 304; Shipp 1958, 43; *BM*, October 1967, xxxvi, repr., advt.; *Art at Auction*, 1967-1968, Sotheby's & Parke-Bernet, New York, 58, repr.; *Annual Report for the Year 1967*, CPLH, 1, 4,1968, repr.; Howe 1968, fig.1; P. Jean-Richard, exh. cat., 1971 Paris, mentioned under no. 100; R. Slatkin, exh. cat., 1973-1974 Washington-Chicago, mentioned under no. 84; Ananoff and Wildenstein 1976, 2:no. 385, fig.1120; Bordeaux 1977, 39; P. Cannon-Brookes, exh. cat., 1978 London (Wildenstein), mentioned under nos. 15-16; exh. cat., 1978 London (Artemis), mentioned under no. 2; Jean-Richard 1978, mentioned under no. 1550; Standen 1978, 107, also note 7; Slatkin 1979, 118; Ananoff and Wildenstein 1980, 119, no. 407, repr.; B. Fromme, *Curator's Choice*, west. ed. (New York: Crown Publications, 1981), 59; E. Zafran, exh. cat., 1983 Atlanta, mentioned under no. 13; C. Bailey, exh. cat., 1985-1986 New York-New Orleans-Columbus, 135, no. 89, repr.; Standen 1985, 2: mentioned under no. 80 on 545, fig.62 on 547; A. Laing, exh. cat., 1986-1987 New York-Detroit-Paris, mentioned under nos. 55-56, analogy no. 2, fig.161; Standen 1986, 133, fig.12.

Exhibitions 1902 London (Guildhall), no. 39 lent by Mme Ridgway (as *The Fortune Teller*); 1958 London, no. 31, repr.; 1959 Capetown, no. 102, pl. 59; 1962 Zurich, no. 46; 1976-1977 San Francisco, no cat. no., mentioned on 7, fig.3.

Variants

TAPESTRIES
Known examples of *Vertumnus and Pomona* from *Fragments d'Opéra*, Beauvais:

fig.1
10 ft. × 6 ft. 9 in. (3.05 × 2.06 m)
S.d. lower left: *F. Boucher/1757*
The Metropolitan Museum of Art, New York, Bequest of Benjamin Altman, 1913. 14.40.708
REF: Standen 1985, 2:no. 80, repr.

11 ft. 6 in. × 11 ft. (3.50×3.35 m)
S.d. lower left: *F. Boucher/1757*, with royal arms
PROV: Henri Léonard Bertin, 1762; Camille Groult, 1925; sale, Galerie Jean Charpentier, Paris, 24 May 1955, no. 108, repr.; private collection, New York, 1985.

10 ft. 6 in. × 9 ft. 10 in. (3.2 × 3.0 m)
S.d. lower left: *F. Boucher/1757*
PROV: Casimir Périer; Veil Picard; private collection, Paris, 1974; private collection, Italy, 1983.

9 ft. 10 in. × 5 ft. 9¾ in. (3.0 × 1.77 m)
PROV: Théodore Reinach, 1921; Charles Ephrussi; sale, Hôtel Drouot, Paris, 29 May 1929, no. 10, repr.; sale, Galerie Jean Charpentier, Paris, 25 June 1937, no. 104, repr.

10 ft. 6 in. × 11 ft. (3.2 × 3.35 m)
Signed lower left: *F. Boucher*
PROV: Alfred de Rothschild; Countess Alarina of Carnarvon; sale, London, Christie's, 2 May 1935, no. 120, repr.

fig.1

PAINTINGS

Earth: Vertumnus and Pomona, **fig.2**
34³/₁₆ × 53⁵/₈ in. (87 × 136 cm)
S.d. lower right: *f. Boucher/1749*
Columbus Museum of Art, Ohio, Museum purchase, Derby Fund.
80.27
EXH: 1986-1987 New York-Detroit-Paris, no. 56, repr. in color.

Copy, **fig. 3**
Oil on canvas, 24 × 33⁷/₈ in. (61 × 86 cm)
Alte Pinakothek, Munich. Inv. 2863

Copy
Oil on canvas, 45¼ × 52¾ in. (115 × 134 cm)
PROV: H. L. Bischoffsheim; sale, London, Christie's, 7 May 1926, no.
12, repr.; L. Cotnaréanu; sale, Paris, Palais Galliera, 14 December
1960, no. 2, repr.

Gouache, 7¼ × 8¼ in. (18.5 × 20.5 cm)
PROV: Sale, Paris, Hôtel Drouot, 4 March 1931, no. 70, repr. (as
François Le Moyne, *Cérès et Pomone*).

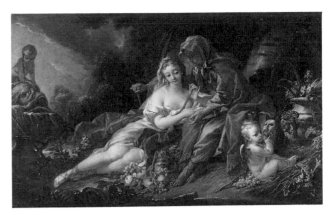

fig.2

Related Works

PAINTINGS
The Birth of Venus (partial analogy, the pose of Pomona), **fig.4**
Oil on canvas, 32¹¹/₁₆ × 55¹/₈ in. (83 × 140 cm)
S.d. lower left: *Boucher 1754*
Wallace Collection, London. P. 423

Vertumnus and Pomona, **fig.5**
Oil on canvas (oval), 58¹/₈ × 48 in. (147.5 × 122 cm)
S.d. lower right: *F. Boucher 1763*
Musée du Louvre, Paris. Inv. 2710*bis*
NOTE: A later composition with important variants that was used as
a tapestry design for the Gobelins' series, *Tentures de Boucher*.

DRAWINGS
Hands and Limbs (of Pomona), **fig.6**
Black chalk heightened with white, 9½ × 12¾ in. (24 × 32.5 cm)
Private collection, Geneva
REF: Ananoff and Wildenstein 1976, 2: no. 385/9, fig.1122.

Vertumnus and Pomona
Red, black, and white chalks, 8⁵/₈ × 13³/₈ in. (22 × 34 cm)
PROV: Alphonse Trézel; Trézel sale, Paris, Galerie Jean Charpentier,
17 May 1935, no. 21, repr.

Vertumnus and Pomona, **fig.7**
Brown chalk, 13⁵/₈ × 8⁷/₈ in. (34.5 × 22.5 cm)
The Metropolitan Museum of Art, New York, Gift of Mrs. O'Donnell
Hoover, subject to Life Estate. 60.176.2
PROV: Alphonse Trézel; Trézel sale, Paris, Galerie Jean Charpentier,
17 May 1935, no. 24, repr.

Vertumnus and Pomona, **fig.8**
Black chalk heightened with white on buff paper (oval), 11³/₈ × 10 in.
(29 × 25.5 cm)
The Hyde Collection, Glen Falls, New York. 1971.61
REF: Ananoff and Wildenstein 1976, 2:158, no. 482/3, fig.1350.

fig.3

fig.4

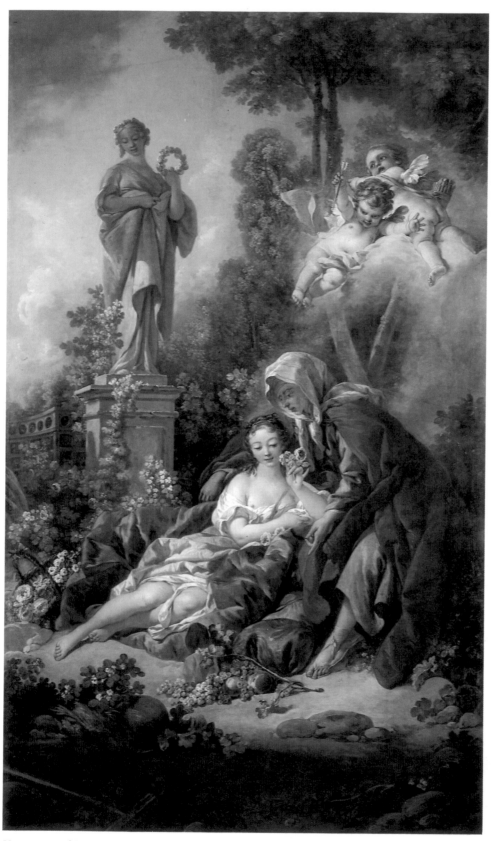

Vertumnus and Pomona

Reclining Venus or *Venus with Doves*, **fig.9**
Signed lower right: *F. Boucher*, with an unidentified collector's mark
Three crayons, 11½ × 17⁵⁄₁₆ in. (29 × 44 cm)
Private collection, New York
PROV: M. E. M. Hodgkins sale, Galerie Georges Petit, Paris, 30 April
1914, no. 9, repr.; Lucien Kraemer, Paris.
REF: R. S. Slatkin, "Some Boucher Drawings and Related Prints,"
Master Drawings 10, no. 3 (1972):271, pl. 35.

ENGRAVINGS
Augustin de Saint-Aubin, after Boucher, *Vertumne et Pomone*, 1765
Dedicated to Laurent Cars
REF: Jean-Richard 1978, no. 1550-1554, repr.
EXH: Salon of 1771, no. 312.

L.-M. Bonnet, after Boucher, *Le Repos de Vénus*, 1769
Announced in the *Mercure de France*, June 1774.
REF: Jean-Richard 1978, no. 384, repr.

DECORATIVE ARTS
Snuff box, enamel with gold cover, **fig.10**
Musée du Louvre, Paris. OA.6831
REF: Jean-Richard 1978, mentioned under no. 1550.

Miniature, attributed to P.-A. Baudouin, *The Fortune Teller*
PROV: Mme A. H.; sale, Paris, Hôtel Drouot, salles 7 and 8,
19-20 December 1913, no. 51, repr.

fig.6

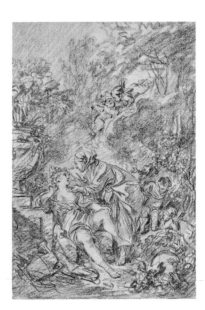

fig.7

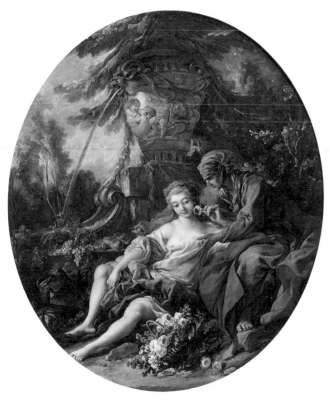

fig.5

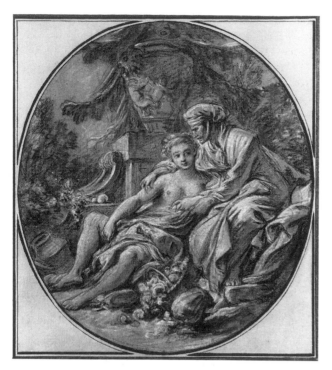

fig.8

fig.9

The recent history of this picture is well documented; unfortunately the same cannot be said of its early provenance. From the late nineteenth century until 1967 it was considered part of a series of four large decorative canvases with identical frames and similar dimensions. Three of these, including *Vertumnus and Pomona*, are closely related to tapestries manufactured at Beauvais after cartoons by Boucher. *Vertumnus and Pomona* served as the model for a tapestry from the series *Fragments d'Opéra* (**fig.1**), undertaken in 1752. *The Love Letter*[1] contains figures that appear in two pieces from the Beauvais suite *La noble pastorale*, *The Fountain of Love* and *The Fisherman*. The third picture, *The Interrupted Sleep* or *Evening*,[2] also shows figures from *The Fountain of Love*. The fourth panel, *Love's Offering*,[3] although signed and dated, does not appear to have any relationship to drawings, engravings, or tapestries by or after Boucher. Perhaps, as has been suggested, this panel is the work of another artist such as Huet.[4]

How can the relationship of these four pictures be explained? It is possible that they were all used as cartoons or models at Beauvais. *Vertumnus and Pomona* corresponds to all the tapestries in its basic composition (reversed), but not in its dimensions. The wider tapestries have additional decorative elements at each side. The San Francisco painting has been retouched in several places, particularly at the edges, and a horizontal band has been added to the bottom below five vertical bands that are clearly delineated. The painting for *Vertumnus and Pomona* is listed by Badin in a 1794 inventory at Beauvais,[5] and the cartoon for the tapestry is recorded in five bands at Beauvais in 1820.[6] If the San Francisco canvas is the cartoon, reassembled and repainted, it was prepared at Beauvais after a painting by Boucher, and cut into strips for use by the weavers under the *basse-lisse* (horizontal) looms.[7]

The painting's early provenance cannot be proven, although Alexandre Ananoff believes that it was sold in Paris on 22 August 1829 by order of Vicomte de La Rochefoucauld for the benefit of the Veterans' Fund.[8] Unfortunately, the Beauvais archives are incomplete. While there is a record of such a sale on 31 August 1829, the list of paintings is not in the dossier.[9] Neither is it correct that the four paintings belonged to Marquis de Ganay at the end of the nineteenth century.[10] Mme Munroe Ridgway, who exhibited and sold the paintings in 1902, was born Miss Willing of Philadelphia. Her daughter, Emily Ridgway (1839-1921), married Anne Etienne de Ganay (1833-1903) in 1858, thus uniting two families of notable collectors. In 1902 Mme Ridgway lent the panels to her son-in-law, who placed them in his state dining room.[11]

The story of Vertumnus and Pomona, popularized by Ovid's *Metamorphoses*, has been a favorite theme with artists.[12] Vertumnus, the Roman god of fertility, had the

power to assume any shape he wished. Unsuccessful in his attempts to seduce Pomona, the goddess of fruit trees and gardens, he assumed the disguise of an old woman and came to visit Pomona in her garden. As they talked he told her the sad story of Iphis, a Cypriot youth who hanged himself in despair for love of Anaxarete, a noble lady. As Vertumnus finished his tale he dropped his disguise and Pomona was conquered.

Because this work was initially conceived for the suite *Fragments d'Opéra*, Boucher probably based the composition on a stage design. He would have had several sources of inspiration. *Pomone*, a musical pastorale by Robert Cambert and Abbé Pierre Perrin, was first performed in 1671. There is no record of revivals, but a manuscript and fragments of the score survive. *Les saisons*, an opera-ballet in four acts by the Abbé Picque, Louis de Lully, and Pascal Collasse, was first produced in 1695 and revived during the next twenty-seven years. The second act, *L'été*, represented Vertumnus and Pomona. The most likely source however is *Les éléments* by Lalande and Destouches, which was first produced at the Tuileries in 1721.[13] The four acts represented air, water, fire, and earth (*Vertumnus and Pomona*), and were subsequently performed separately as "fragments" with acts from other opera-ballets, which became the vogue for musical evenings. The frequent revivals of *Les éléments*, including a performance of the fourth act in 1749 at Versailles, coincide with Boucher's activities at the Opéra, at Beauvais, and at the court.[14]

Unlike Coypel, whose *Fragments d'Opéra* served earlier as models for the Gobelins factory, Boucher did not worry about absolute fidelity to a text, and a picture like *Vertumnus and Pomona* probably reflects a number of memorable trips to the theater. The presence of the overhead putti aiming their arrows at Pomona was certainly motivated by aesthetic considerations rather than strict adherence to an iconographic prototype.

The subject of Vertumnus and Pomona appears frequently in Boucher's oeuvre with few variations. The version of 1749 in Columbus (fig.2), which was apparently painted for Louis XV's Château de la Muette, was engraved by Augustin de Saint-Aubin in 1765 and served as the forerunner of several paintings, including San Francisco's. The 1763 model for the Gobelins now in the Louvre (fig.5) clearly resembles the San Francisco picture, and Boucher's entire series of drawn or painted Venuses either precedes or repeats Pomona's attitude here. However, the illustration from the Abbé Banier edition of *Metamorphoses* departs slightly from this initial conception of the theme.[15]

In comparing the 1749 version (fig.2) with San Francisco's, the difference between Boucher's concept of an easel picture and a tapestry cartoon can be seen. In the first version Boucher focuses on the two protagonists,

presenting them on a large scale in the center of the composition. In the second he stresses the abundant decorative elements such as gardening tools and fruits, flowers, and vegetation in the garden, subordinating the figures to the decorative whole. This focus is intended to allow the weavers to demonstrate their skill in an art that stresses detail and strongly contrasts areas of light and shadow.

1. Signed; last known sale, London, Sotheby's, 1 November 1978, no. 31, repr.

2. S.d. 1757, Natale Labia collection on loan to The South African National Gallery, Cape Town, 1976; another version dated 1750 is at The Metropolitan Museum of Art, New York, 49.7.47.

3. S.d. 1757, Natale Labia collection, on loan to The South African National Gallery, Cape Town, 1976.

4. Marquis de Ganay, letter, 2 January 1968.

5. Badin 1909, 91, no. 13, "Etat des tableaux remis à la nation par M. de Menou. . . ."

6. Badin 1909, 14, no. 31, "Modèles existant en 1820."

7. E. Standen, exh. cat., 1986-1987 New York-Detroit-Paris, 328.

8. Ananoff and Wildenstein 1976, 2:no. 385.

9. Jean Coural, letter, 2 June 1978.

10. T. C. Howe, *Bulletin CPLH*, March-April 1968.

11. Exh. cat., 1902 London (Guildhall), 13, under no. 5.

12. Ovid, *Metamorphoses*, book 14, lines 623-771.

13. Exh. cat., 1978 London (Artemis), under nos. 1-2.

14. Louis César de La Baume-le-Blanc Lavallière, *Ballets, opéra, et autres ouvrages lyriques* (1760; facs. ed., London: H. Baron, 1967), 163-165; Théodore de Lajarte, ed., *Bibliothèque musicale du théâtre de l'opéra*, vol. 1 (Paris: Librairie des Bibliophiles, 1878), 137-139.

15. Augustin Saint-Aubin and Jean-Jacques André Le Veau, *Les Métamorphoses d'Ovide* (Paris: Abbé Banier, 1767-1771), 4:opp. 219; Jean-Richard 1978, nos. 1564 (repr.), 1565-1567.

fig.10

Are They Thinking of Grapes?

Are They Thinking of Grapes?
(*old copy after Boucher*)

Pensent-ils au raisin?
Oil on canvas, 30 × 35 ½ in. (76 × 90 cm)
Inscription lower left, partially legible: *F B 1749*, **fig.1**
Gift of Mr. and Mrs. Clarence Sterling Postley in memory of Mrs. George T. Cameron. 72.15 (de Young)

Provenance Perhaps in the anonymous sale, Paris, Hôtel des Ventes Mobilières, 20-21 February 1843, no. 1; perhaps in the anonymous sale, Paris, Hôtel des Commissaires Priseurs, 12-14 April 1843, no. 57; Eugène Piot, Paris, prior to 1874; Piot estate sale, Paris, Hôtel Drouot, 21-24 May 1890, no. 547 (*Pastorale*, school of François Boucher); [René A. Trotti, Paris, early twentieth century]; Mr. and Mrs. Clarence S. Postley, Long Island, New York; gift to the de Young, 1972.

References Michel 1906, no. 1554 (3); Ananoff and Wildenstein 1976, 2:no. 309/6 (copy); A. Bennett, exh. cat., 1981 San Francisco, 115, under no. 8, repr.; exh. cat., 1984 Manchester, mentioned under P6; A. Laing, exh. cat., 1986-1987 New York-Detroit-Paris, mentioned under no. 53, copy no. 1.

Exhibition 1874 Paris (Hôtel de Lassay), no. 722 (suppl.).

Variants

PAINTINGS
Are They Thinking of Grapes? **fig.2**
S.d. lower right: *f. Boucher 1747*
Oil on canvas (oval), 31⅞ × 27 in. (81 × 68.5 cm)
The Art Institute of Chicago, Martha E. Leverone Bequest. 1973.304
EXH: 1986-1987 New York-Detroit-Paris, no. 53, repr.

Are They Thinking of Grapes? **fig.3**
S.d. lower right: *f. Boucher 1747*
Oil on canvas, 30 × 35 in. (76 × 89 cm)
Nationalmuseum, Stockholm. NM 722, LU 70
EXH: 1984 Manchester, no. P6, repr.

ENGRAVING
J. P. Le Bas, after Boucher, *Pensent-ils au raisin?* **fig.4**
Etching and engraving, after the Stockholm painting
Example in The Metropolitan Museum of Art, New York. Gift of Mr. and Mrs. Charles B. Wrightman. 1970.522.2
REF: Jean-Richard 1978, nos. 1344-1346, repr.

Related Works

A large number of related works in a variety of media repeat the principal figures of this composition. A listing of these works, including paintings, drawings, tapestries, snuff boxes, an enamel casket, porcelains, and a fan (TFAMSF 1964.91), is in our files.

fig.1 (detail with inscription)

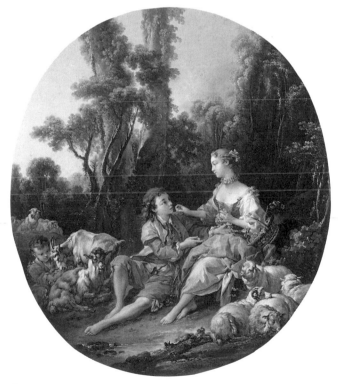

fig.2

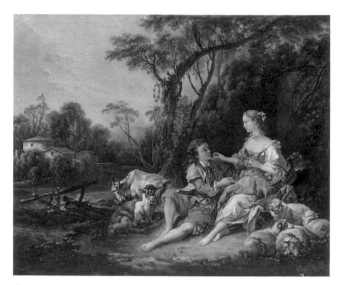

fig.3

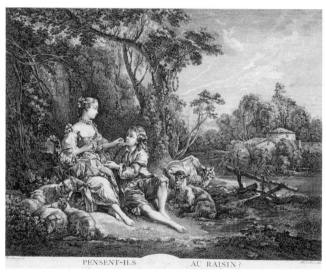

PENSENT-ILS AU RAISIN?

fig.4

This composition is an outstanding example of a genre in which Boucher excelled. As the Goncourt brothers wrote:

When Boucher descended Olympus, his imagination found refreshment in pastoral subjects. These he painted in the only manner that was then permitted: he banished from his idylls that particular crudity that is always somewhat distasteful. He presents them in the most chivalrous disguise, in the vesture of the masked balls of the court. Rustic life at his touch became . . . an allegory of pleasures and loves, virtues subsisting remote from city and society. . . . These delightful shepherds, these adorable shepherdesses are all satin, paniers, beauty spots, necklets of ribbon; their cheeks are painted, their hands fit only for the task of embroidery, and their feet, escaping from their slippers, are the feet of aristocrats; their sheep are silken and the crooks flowered; and these peasants posed like a salutation by Marcel and their ladies seem to have issued from the hands of a wardrobe mistress of the Menus Plaisirs du Roi. . . .[1]

Boucher places his characters in a bucolic setting with a stream in the foreground and a little hollow to the side, allowing a glimpse of a few buildings and a shaded riverbed. The setting not only identifies the characters, but also serves as a foil to their pearly flesh tones and the rich color of their costumes. In these seductive but highly artificial settings, the dreamy and vaporous landscapes of Watteau have been replaced by ripe vegetation and pictorial details reminiscent of opera or stage decor.

This grouping of figures seized Boucher's imagination very early in his career. In the 1730s he executed *The Tender Pastoral* with a similar scheme, notably in the pose of the shepherd.[2] There are also a number of related drawings, for example, *Young Shepherd Leaning on His Elbow* and *The Repose of the Shepherds*,[3] which was engraved in 1736 by Huquier as *La pastorale*.

In 1747 Boucher executed two canvases with variations on the earlier theme. The Chicago painting (**fig.2**), a presumed pendant to *The Flute Player* (s.d. 1726),[4] is apparently the older of these two compositions. The rectangular version in Stockholm (**fig.3**) differs slightly in the landscape at the rear and in the subtraction from the left of a child and several sheep. The success of these two 1747 paintings is borne out by the engraving of Le Bas (**fig.4**); two prints by Gilles Demarteau after drawings by Boucher showing the goat standing at left,[5] the sheep and the ram lying in the foreground at right,[6] and other animals; and the repetition of the composition in many media (see Related Works). The San Francisco picture is clearly an old copy of the Stockholm version, perhaps executed by a Swedish artist, and in comparison with the Stockholm canvas appears dry in modeling, draperies, details, and color.[7]

Many have puzzled over the reason for Boucher's use of the elegiac motif of the bunch of grapes. However,

because Boucher's inspiration often came from the theater or opera, Gisela Zick has suggested a piece called *Les vendanges de Tempé* by Charles-Simon Favart as the probable source.[8] First a pantomime in 1745, it was revived at the Théâtre Italien in 1752 as a more elaborate ballet-pantomime called *La Vallée de Montmorency*, with a setting among cherry orchards rather than vineyards.[9] In any event, the floral crown hanging on a branch above the shepherd indicates that his declaration of love is not going to be rejected by his companion.[10]

1. Goncourt 1873-1874, 1:204-205; Goncourt 1948, 67.
2. Ananoff and Wildenstein 1976, 1:no. 54, fig.274.
3. Virginia Museum of Fine Arts, Richmond, 82.139.
4. Sale, Paris, Pavillon Gabriel, 17 June 1977, no. 5, repr.
5. Ananoff and Wildenstein 1976, 2:under no. 310/1, fig.890.
6. Ananoff and Wildenstein 1976, 2:under no. 310/2, fig.891.
7. Hal Opperman, conversation with M. C. Stewart, 11 November 1986.
8. Gisela Zick, "D'après Boucher: Die Vallée de Montmorency und die europäische Porzellanplastik," *Keramos* 29 (July 1965):3-47.
9. A. Laing, exh. cat., 1986-1987 New York-Detroit-Paris, no. 53.
10. See Anne Betty Weinshenker, "'The Lover Crowned' in Eighteenth-Century French Art," *Studies in Eighteenth-Century Culture*, vol. 16 (Madison: The University of Wisconsin Press, 1986), 271-294.

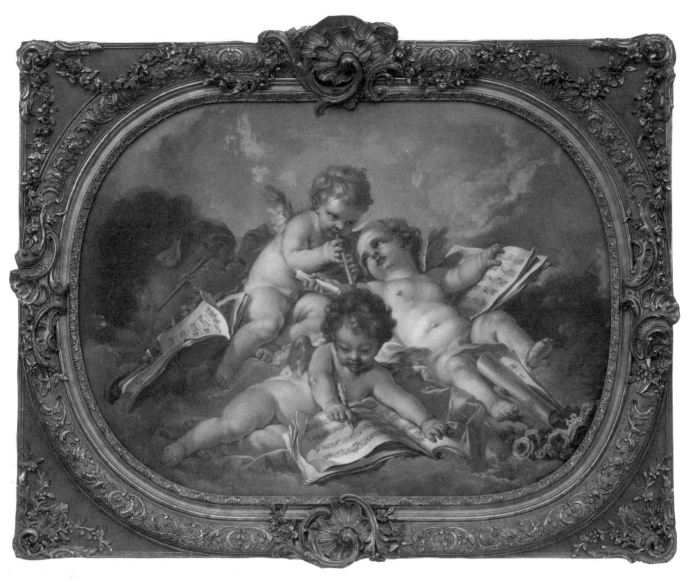

Music

Music (*copy after Boucher*)

La musique
Oil on canvas (oval), 36⅛ × 48 in. (92 × 122 cm)
Gift of Archer M. Huntington through Herbert Fleish-
hacker. 1929.6 (CPLH)

Provenance The sale catalogue of 13 July 1922, incorrectly attribut-
ing this painting to Boucher himself, indicates that it constitutes "One
of a set of four panels, known as *The Arts*, painted for Mme de Pom-
padour, and brought over to England at the end of the eighteenth cen-
tury by one of the French nobility, who resided at Twickenham. He
gave it to Dr. Michael Barry, of Cairn Lodge, Twickenham, in return
for medical services rendered. Dr. Barry gave it to the late Joshua
Field, Esq., father of the present owners." This information cannot be
verified.
 Sale, London, Willis's Rooms (Robinson, Fisher, & Harding), 13
July 1922, no. 139, repr.; [Frank T. Sabin Gallery, London, 1922?];
acquired by the CPLH, 1 August 1929.

References *Illustrated Handbook* 1946, 54, repr.; Ananoff and Wil-
denstein 1976, 2:no. 470/1 (copy); Ananoff and Wildenstein 1980,
no. 496 (copy).

Variant

PAINTING
Music, fig.1
Oil on canvas, 39⅜ × 69 in. (100 × 175 cm)
Amalienborg Palace, Copenhagen
PROV: One of a series of seven allegories of the arts and sciences com-
missioned from Boucher in 1756, and installed in 1757 as an overdoor
in the Banqueting Hall.
REFS: Krohn 1922, 103-113, fig.28; Ananoff and Wildenstein 1976,
2: no. 470, fig.1310; Ananoff and Wildenstein 1980, no. 496, repr.

Shortly after 1750 Count Adam Gottlieb Moltke built a
palace outside Copenhagen, which later became the
Amalienborg Palace, seat of the Danish kings. In 1756
he commissioned seven allegories of the arts and sci-
ences from Boucher: five overdoors to illustrate the arts
(*Sculpture*, s.d. 1756) and two paintings to represent the
sciences, *Geography* and *Astronomy*, which were
designed to hang above two fireplaces in the Banqueting
Hall. The suite was installed in 1757 by the architect N.
Jardin.
 San Francisco's painting is a copy of *Music* (**fig.1**), one
of the five overdoors dedicated to the arts. The width of
this version is reduced more than fifty centimeters, so
the artist was compelled to omit the harpsichordist and
the Basque tambourine at right, as well as the conductor
at left. The relative mediocrity of the facture, the heavy
touch in many of the details, and the shapelessness of
the flesh make it unlikely that the copy was executed in
Boucher's studio.

As is true of its composition, the iconography of this
painting is characteristic of the school of Boucher. The
artist had a particular interest in painting children.
Although faithful to the Renaissance pyramidal scheme,
he took great liberties with allegorical tradition. Here
plump and mischievous putti symbolize the genii of
poetry and the arts. These are indeed
*the spoilt children of Boucher's brush . . . they appear
everywhere in Boucher's work . . . they amuse them-
selves at the feet of the Muses by playing with the attri-
butes of the Arts and Sciences . . . they are always a
charming spectacle, with their little fat hands, their
rotund stomachs and navels like dimples, their cupid's
bottoms, their chubby calves . . . and what games, the
sport of elves and infant gods, they play amid these alle-
gorical scenes.*[1]

 1. Goncourt 1873-1874, 1:202-203; Goncourt 1948, 66.

fig.1

Louis-Antoine de Bourbon, Duc d'Angoulême

Joseph Boze *Martigues 1744/1745-1825 Paris*

The son of Captain Jean-François Boze, who was a commandant of the West Indies and then consul in Malta, Joseph Boze studied painting in Marseille in 1762, then in Nîmes, Montpellier, and finally Paris, probably with the pastelist M.-Q. de La Tour. Having an inquiring, technical mind, Boze invented not only a process for fixing pastel colors but also systems for instantaneously unhitching runaway horses and braking carriages on steep slopes. He even devised gauges for measuring a ship's speed and drift for the navy.

Presented to Louis XVI by Abbé de Vermont, who was the queen's confessor, Boze was appointed *peintre breveté de la guerre* and had an active, although semi-official, court career. His account book for the years 1783-1788 shows that he spent his time painting and copying portraits of the royal family for a large clientele.[1] From 1782 he exhibited miniatures and pastels at the Salon de la Correspondance (*Portrait of Vaucanson*, Académie des Sciences, Paris; *Self-Portrait*, Cab. des Dess., Musée du Louvre, Paris). Several pastels from these years, most of them oval, have been preserved; some show remarkable vigor (*Portrait of the Physician Charles*, Bibliothèque de Versailles; *Mme Campan*, 1786, Château de Versailles).

Because he was not a member of the Royal Academy of Painting and Sculpture, Boze did not exhibit at the Salon until 1791. At this time his portraits, notably of *Robespierre* and *Mirabeau* (Musée Granet, Aix-en-Provence), drew such criticism that he did not return. His position also grew difficult when he was implicated in the preparations for the flight to Varennes in 1791 of Louis XVI and the royal family. After testifying in the queen's favor at her trial in October 1793, he was arrested. Following his release on 9 Thermidor, year II (27 July 1794), scarce commissions forced him to emigrate. He then led an obscure life in Belgium, Holland, and England. In London he received a pension from the future Louis XVIII. In France again after 18 Brumaire, year VIII (9 November 1799), Boze was accused by the painter Lefèvre of having employed him to execute full-length oil portraits under Boze's name. The matter was never satisfactorily resolved.

Boze's loyalty to the ancien régime was rewarded in 1816 when he received the title of count. His later production was probably small, but is completely unknown. The only important work that can be cited is his *Portrait of the Late Marshall Berthier, Prince of Neufchâtel*, exhibited at the Salon of 1817.

Although a minor pastelist, Boze was admired for the striking likenesses of his portraits. His style is characterized by a range of cool tones and skillful draftsmanship. Because of a certain dryness in his work, however, Boze has been judged a bit severely although unjustly. Nothing major has been published on this artist since the works of Volcy-Boze[2] and A. Foulon de Vaulx.[3]

1. "Le livre de Comte de Boze, 1783-1788," MS 72, Bibliothèque d'Art et d'Archéologie, Paris, entries for March-April 1785, 12-17.
2. Volcy-Boze, *Le Comte Joseph de Boze, peintre de Louis XVI, Roi de France* (Marseille, 1873).
3. André Foulon de Vaulx, "Un pastelliste du XVIIIᵉ siècle: Joseph Boze," *Le carnet historique et littéraire*, 8-9 (June-August 1901).

Louis-Antoine de Bourbon, Duc d'Angoulême

Oil on canvas, 21½ × 18 in. (54.5 × 45.5 cm)
Signed lower right: *Boze FT*, **fig.1**
Gift of Grace Hamilton Kelham. 1962.18 (CPLH)

Provenance Probably executed in 1785; acquired in Paris by Grace Spreckels Hamilton, ca. 1920; inherited by Grace Hamilton Kelham, 1936; gift to the CPLH, 1962.

Reference T. Lefrançois, "Les peintures provençales anciennes des Fine Arts Museums de San Francisco," *Bulletin Mensuel de l'Académie de Vaucluse*, January 1985, 4.

Exhibitions San Francisco, CPLH, *Bedecked with Lace*, April-June 1982, no cat.; San Francisco, de Young, *Gentlemen's Finery*, 16 July-14 August 1983, no cat.

fig.1 (detail with signature)

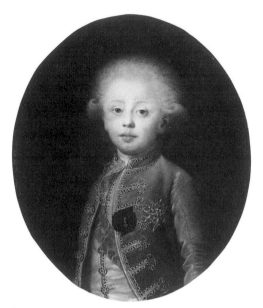

fig.2

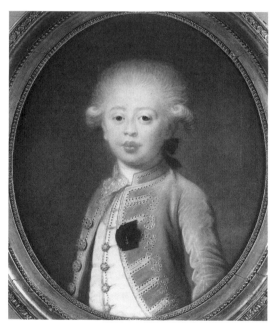

fig.3

Variants

PAINTINGS

Duc d'Angoulême, copy, **fig.2**
Oil on canvas (oval), 21 × 17 ½ in. (53.5 × 44.5 cm)
Rau Collection, Zurich and Marseille
PROV: [Jacques Seligmann & Co., New York, 1930]; McCann sale,
New York, Parke-Bernet, 21 February 1945, no. 42, repr.; Barney sale,
New York, Parke-Bernet, 8 May 1948, no. 66, repr.; anonymous sale,
London, Christie's, 30 November 1973, no. 76, repr.; [acquired by Dr.
Eisenbeiss, St. Gallen, Switzerland].
NOTE: The sitter wears the blue ribbon and enameled gold cross of
the Order of Saint-Esprit and is dressed in a light blue suit and pink
waistcoat.

Duc d'Angoulême, miniature
Cab. des Dess., Musée du Louvre, Paris. Inv. RF 30671
PROV: Château de Frohsdorf, residence-in-exile of the royal family
after 1830; from the collection of Duchesse de Berry; collection of D.
David-Weill, no. 634.

DRAWINGS

Duc d'Angoulême, **fig.3**
Pastel (oval), 21 ½ × 18 in. (54.5 × 46 cm)
S.d. lower left: *1785*
Cab. des Dess., Musée du Louvre, Paris. Inv. 25040

Duc d'Angoulême
Pastel (oval), 22 × 18 ½ in. (56 × 47 cm)
S.d. 1785
Musée National de Versailles. MV 5357

Duc d'Angoulême, copy
Pastel (oval), 22 × 19 in. (56 × 48 cm)
Joseph R. Messina, New York
PROV: Sale, New York, Parke-Bernet, 10 September 1969, no. 69.

French school, eighteenth century, *Portrait of a Boy, Possibly the Old-
est Son of Louis XVI*
Pastel, 21 × 18 in. (53.5 × 45.5 cm)
PROV: Sale, New York, Sotheby's, 9 June 1987, no. 219, repr.

Louis-Antoine de Bourbon (1775-1844), the older son of Comte d'Artois (later Charles X) and Marie-Thérèse de Savoie, is shown here at the age of ten. The portrait may have been executed on his baptism, as it was not until 28 August 1785 that Louis XVI and Marie-Antoinette stood as godparents to the child. Little is known of the prince's childhood except that he was raised by his mother, who lived in seclusion at the Temple, and by his tutor, Duc de Sérent. He was barely fifteen months old when he was given the title of Grand Prior of the Order of Malta on 24 November 1776; in this portrait the cross of the Order of Malta is suspended on a black cockade pinned to his coat. At twelve, Louis XVI and Marie-Antoinette decided to marry him to their daughter and his cousin, Marie-Thérèse-Charlotte de France, called Mme Royale, who was nine at the time. However, the laws of the monarchy and then the Revolution delayed the wedding ceremony, which finally took place in Mitau (Latvia) on 10 June 1799. The last dauphin of France after the coronation of his father Charles X, he renounced the throne in 1830 in favor of Duc de Bordeaux, and lived in exile in Göritz under the title Comte de Marne.

This fine but rather unremarkable work is an original of good quality after the pastel (fig.3) that was executed as a pendant to *Charles-Ferdinand de Bourbon, Duc de Berry* (1783, Cab. des Dess. Musée du Louvre, Paris), younger brother of Duc d'Angoulême. These works are characteristic of Boze's oeuvre in that they were copied and recopied for clients numerous times by the artist himself in pastel, oil, and miniature. We know from his account book that while the original portraits of the royal children of France were delivered to Comte d'Artois in March 1785 for 600 *livres* each, in the following April his wife, his aunt (Mme Victoire), and his sister-in-law (Comtesse de Provence) each received copies of these portraits at a price of 360 *livres*.[1] As Boze's distinction between oil and pastel works is far from systematic in his account book, it is possible that the San Francisco painting, the one in Versailles, or perhaps the one in the Messina Collection in New York might correspond to one of these various commissions.

Despite the attractive depiction of youth and the freshness of the sitter, it is obvious that such a painting cannot be ranked among the masterpieces of an artist who, paradoxically, seems to have been particularly famous for his portraits of revolutionary orators, and who remains essentially for many the author of *Portrait of Mirabeau* (Musée Granet, Aix-en-Provence).

1. "Le livre de comte de Boze, 1738-1788," MS 72, Bibliothèque d'Art et d'Archéologie, Paris, entries for March-April 1785, 12-17.

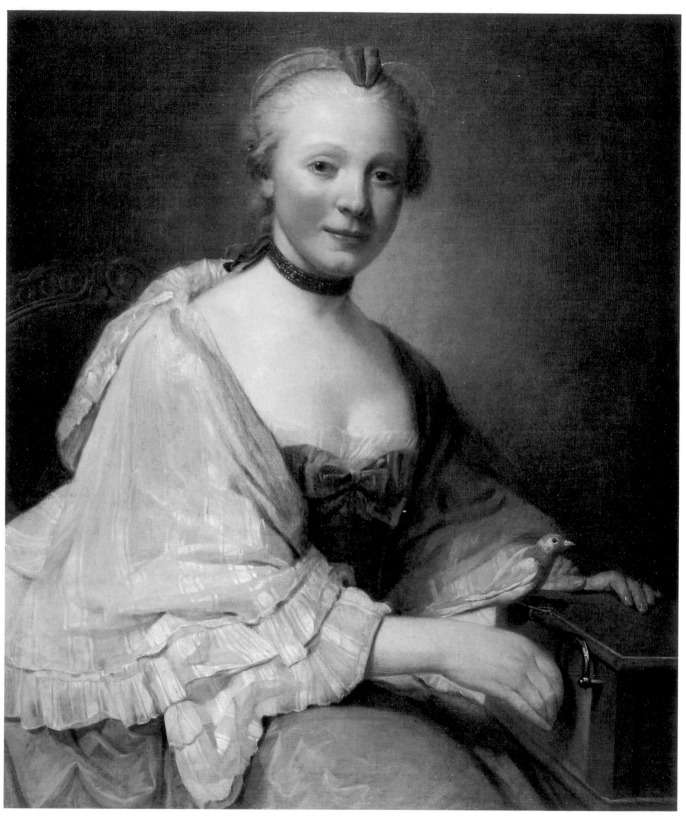

Lady with a Serinette

Jean-François Gille, called Colson

Dijon 1733-1803 Paris

The son of the miniaturist and pastelist Jean-Baptiste Gille, called Colson, Jean-François Gille, also called Colson, first studied with his father and then with Brother Imbert in Villeneuve-lès-Avignon. He moved with his family to Grenoble and enrolled as an independent auditor in the school of engineering, particularly interested in mathematics and geometry. He probably finished his artistic training in Lyon under the painter Nonnotte, later entering the workshop of Despax in Toulouse. By 1759 he appears to have established himself in Paris, where he quickly specialized in portraiture and acquired a diverse clientele that included musicians, actors, and soldiers.

Most important, however, Colson was the *directeur et ordonnateur du Bâtiments* for Charles-Godefroy de La Tour d'Auvergne, duc de Bouillon, and Godefroy-Charles-Henry de Bouillon, prince de Turenne, who entrusted him for forty years with the construction of their residence, Château de Navarre near Evreux (demolished in 1834). Acting as engineer, architect, and decorator, Colson constructed a temple on the Isle of Love, conceived models for statues, and even designed the enlargement of the park. In addition to this he taught classes on perspective in Paris during 1765 and 1766 and at the Lycée des Arts from 1797. Colson also was interested in literature, and in 1775 anonymously published *Observations sur les ouvrages exposés au Salon du Louvre: Recueil de poésies legérès* (a collection of poems), and left behind several manuscripts, one entitled *Introduction à la connaissance des arts de goût et d'imitation en général et de la peinture en particulier.*

Colson exhibited at the Salons of 1793, 1795, and 1797. In the year XI (1803), shortly before his death, he became a member of the Academy of Sciences, Arts, and Letters of Dijon. Several of his works have been engraved and a number of them are preserved in the museums of Besançon, Rennes, and Dijon. A charming and skillful artist, Colson was included in the 1969 exhibition *Trois peintres bourguignons du XVIIIᵉ siècle: Colson, Vestier, Trinquesse* (Musée des Beaux-Arts, Dijon) organized by Pierre Quarré.

Lady with a Serinette (*attributed to Colson*)

La leçon de serinette or *La charmeuse*
Oil on canvas, 26 ¼ × 22 ½ in. (66.5 × 57.5 cm)
Mildred Anna Williams Collection. 1964.113 (CPLH)

Provenance Henry Didier, Paris, before 1860; Didier sale, Paris, Hôtel Drouot, 15-17 June 1868, no. 46 (attributed to Chardin as *The Serinette*); Baron Henri de Rothschild, Paris, ca. 1907-1933; René Fribourg, New York, 1 February 1957; Fribourg sale, London, Sotheby's, 26 June 1963, no. 77, repr.; acquired by "Mrs. G. H. Dixter"; sale, London, Sotheby's, 2 December 1964, no. 117; [F. Kleinberger & Co., Inc., New York, 1964]; acquired by the CPLH, 1964 (as Chardin).

References Bürger, 15 September 1860, 337 (attributed to Chardin); Dayot and Vaillat [1907], III-IV, no. 11, pl. 11 (Chardin); Guiffrey 1908, 85, no. 184 (Chardin); Ridder 1932, 85, pl. 38 (Chardin); Wildenstein 1933, 178, no. 266, pl. 125, fig. 202 (Chardin); Wilson 1963, 23, repr. (Chardin); Wildenstein 1969, 235 (Chardin); J. D. Morse, *Old Master Paintings in North America* (New York: Abbeville Press, 1980), 47; Rosenberg 1983, 115, no. 14, repr.

Exhibitions 1860 Paris, no. 97 (Chardin); 1907 Paris, no. 41 (Chardin); 1929 Paris, no. 14 (Chardin).

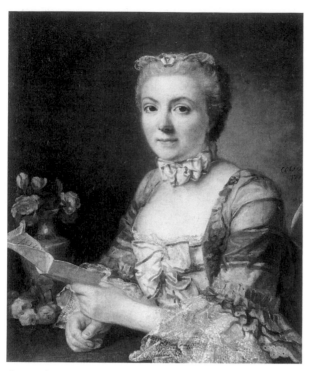

fig.1 Colson, *Portrait of Mme Véron de Forbonnais*, oil on canvas, 25⅝ × 21¼ in. (65 × 54 cm), s.d. 1760, Musée des Beaux-Arts, Dijon, 4066.

fig.2 Colson, *The Repose*, oil on canvas, 36⅝ × 28¾ in. (83 × 73 cm), Musée des Beaux-Arts, Dijon, CA.252.

All the experts today agree that this painting cannot be by Chardin, to whom it was attributed when purchased by the Museums. A comparison with any of the three known versions of Chardin's *The Serinette* or *Lady Varying Her Amusements* makes their conviction clear.[1]

The style of the painting is certainly close to that of the painter Aved (*Portrait of Mme Crozat*, 1741, Musée Fabre, Montpellier), and even closer to that of an artist from Franche-Comté, Nonnotte (*Portrait of Mme Nonnotte Reading*, 1758, Musée des Beaux-Arts, Besançon). However, despite their lively, minute execution, neither of these painters are characterized by the general softness of style of this picture, where the soberly harmonizing blue-gray tones are more reminiscent of Chardin or Greuze. It seems possible to attribute this painting to Jean-François Gille, called Colson, who was a student of Nonnotte for some time, and whose work has been rediscovered only in the last fifteen years. It is especially revealing to compare the treatment of the eyes, fabrics, and details of costume with Colson's *Portrait of Mme Véron de Forbonnais* (fig.1), as well as with Colson's most famous painting, *The Repose* (fig.2).

The pictorial and luminous quality of the painting is remarkable, as is the evocation of bourgeois charm. The young woman, whose attire indicates provincial dress ca. 1750-1760,[2] turns the handle of a *serinette*, a hand organ that reproduces the songs of birds. *L'Avant-Coureur* informs us that "a certain M. Joubert has some of these *serinettes* for which he has adapted the latest and most popular melodies. . . . All one has to do is turn the handle in an even movement. He also makes some that can spin silk by means of a small wheel driven by the handle when one plays a tune."[3]

Colson's dependence on Chardin is seen in the sober, composed manner with which he treats his subject, and in the constrained, less assertive style of conception and execution. This indicates that *Lady with a Serinette* probably was painted before *The Repose*, perhaps around 1755. Although at this time the twenty-two-year-old Colson was provided with sitters from the provincial bourgeoisie, he had not yet completely mastered the genre of portraiture.

1. See P. Rosenberg, exh. cat., *Chardin 1699-1779* (Paris: Grand Palais, 1979), no. 93. The three known versions of *The Serinette* (Musée du Louvre, Paris; The Frick Collection, New York City; and Ball State University, Muncie, Indiana) are discussed and reproduced.

2. Yvonne Deslandres, conversation with M. C. Stewart, 12 May 1977.

3. *L'Avant-Coureur*, 7 August 1769, 500-501; Mirimonde 1975, 58-60.

Michel-François Dandré-Bardon

Aix-en-Provence 1700-1783 Paris

Son of Honoré André, third consul of Aix in 1698 and 1699, Michel-François Dandré-Bardon took the last name of a maternal uncle in order to receive his inheritance. His father sent him to Paris some time before 1720 to study law. Of this stage in the artist's life Mariette wrote,

The plague, which was desolating his country at that time, forced him to stay in Paris longer than planned, and finding himself idle, with nothing to feed his impetuous and fiery genius, he remembered that he had been born with a flair for drawing.[1]

He entered the studios of his compatriots J.-B. Vanloo and J.-F. de Troy. In 1725 he was awarded the second *Grand Prix* of the Royal Academy of Painting and Sculpture and left for Rome, at his own expense, after a stop in his native city where he received a large and important commission to decorate the audience hall for the *Chambre des Comptes de Provence*. He remained in Italy for five years, stopping for six months in Venice before returning to Aix where he executed various decorations for the Hall of Justice and the City Hall. Accepted by the Royal Academy of Painting and Sculpture in Paris in 1734, he was elected to membership the following year with *Tullia Allowing Her Chariot to Ride over the Body of Her Father* (Musée Fabre, Montpellier; sketch in Musée Bertrand, Châteauroux).

Dandré-Bardon for a time played a leading role in his own region, where from 1748-1752 he was inspector of paintings for the king's ships and galleys in Marseille. Founder of the Academy of Marseille, he became director in 1754. From 1755 to 1775 he took a secondary position in Paris, serving as a professor of history at the Ecole Royale des Elèves Protégés, and was appointed rector of the Academy in 1778. From around 1740 he also attempted a literary career, writing poems and treatises on painting and art history, notably an excellent *Eloge de Carle Van Loo*. In 1770 a stroke left him partially paralyzed, but he continued to draw if not to paint. A draftsman of inexhaustible verve, Dandré-Bardon worked in all genres of painting. He compensated for some apparent clumsiness in his compositions with a preference for glaucous colors, "a free style . . . more abrupt than measured,"[2] and dynamic execution, which explains why his works have at times been attributed to Austrian painters.

Except for Daniel Chol's thesis,[3] no comprehensive study has been published since the eighteenth century on this versatile artist.[4]

1. Mariette 1851-1860, 2:55.
2. Pierre Rosenberg, "Dandré-Bardon as a Draughtsman: A Group of Drawings at Stuttgart," *Master Drawings* 12 (1974): 137-151.
3. Daniel Chol, *M.-F. Dandré-Bardon* (thesis, Université de Provence, 1975).
4. M. d'Ageville, *Eloge historique de Michel-François d'André Bardon* (Marseille, 1783), 32-34.

Diana and Endymion
Diane et Endymion

Oil on canvas (curved), 78½ × 52 in. (199.5 × 132 cm)
S.d. at the left, on the quiver: *D'André. F/1726*, **fig. 1**
Gift of Albert C. Hooper. 1943.214 (CPLH)

Provenance Painted in 1726 for Henri-Raynauld d'Albertas, first president of the *Chambre des Comptes de Provence*; gift to the CPLH, 1943.

References D'Ageville 1783, 33; MacAgy 1944, 91-93, repr. on 90; *Illustrated Handbook* 1946, 50, repr.; D. Chol, "Michel-François Dandré-Bardon" (thesis, Université de Provence, 1975), 190, no. 3, fig.1; Hattis 1977, 346, mentioned under no. 359; Lee 1980, 221-222, fig.16 on 219; T. Lefrançois, "Les peintures provençales anciennes des Fine Arts Museums de San Francisco," *Bulletin Mensuel de l'Académie de Vaucluse*, January 1985, 4.

fig.1 (detail with signature)

Diana and Endymion

In the list of paintings by d'André Bardon [sic], drawn up by d'Ageville the year of the painter's death, the following citation is found: "Diana and Endymion, for M. le Président d'Albertas."[1] There can be no doubt that this refers to the San Francisco painting. Mariette observes that "his capabilities were already known in Aix, and when he arrived M. d'Albertas asked him to paint the pictures which were to decorate the audience hall in the *Chambre des Comptes de Provence*, of which this magistrate was the president."[2] For this purpose, the great canvas depicting *Augustus Punishing the Conspirators* was completed in 1729 in Rome, and today hangs above the great staircase in the city hall of Aix. This painting was followed by other official commissions destined for the Palais Comtal, which housed the Revenue Court, as well as for the council chamber and the concert hall in the city hall.

It is obvious that such important commissions could not have been given to the young painter on the basis of an established reputation. It is tempting to believe that Dandré-Bardon was asked to demonstrate more tangible proof of his talent during his stay in Aix. This is probably the reason why he painted *Diana and Endymion* for d'Albertas. This work is even more important as it seems to be the first painting signed and dated by the artist.

A love story from classical mythology, notably popularized by the Carracci, the theme of Diana and Endymion inspired many artists at the beginning of the eighteenth century.[3] Among them was Jean-Baptiste Vanloo, Dandré-Bardon's friend and first teacher, who painted the story at least twice, in particular for his reception piece at the Academy in 1731 (Musée du Louvre, Paris; the other picture is in the Musée Royal des Beaux-Arts, Brussels). The hunter Endymion was condemned to perpetual youth and perpetual sleep by Jupiter, perhaps as a punishment for Endymion's interest in Juno. The goddess Diana fell in love with him as he slept on Mount Latmos in Caria and came down from the heavens each night to watch over him. Here Diana is represented upon her arrival on Mount Latmos with the first rays of moonlight appearing against a still blue evening sky. A cupid is about to shoot an arrow of love into the young man as he sleeps.

The handling in this youthful work shows some hesitation, particularly in the background with its pentimento in the crescent moon at left. The painting is academic in composition, the canvas stiffly divided into two parts by an oblique line intended to increase the dramatic effect. Diana is placed nicely inside the crescent of the moon, but the diagonal beneath her is placed artificially and obviously juxtaposed to the polygonal group formed by the putto, the dog, and Endymion. The painting also reveals the influence of the artist's teach-

ers. The figure of Endymion is an adaptation of the *Apollo* painted by Vanloo in 1711 for the Pavillon de Lenfant in the countryside near Aix. The cupid, the goddess, and the dog are progeny of the repertory of J.-F. de Troy. A comparison of the San Francisco painting with works like de Troy's *Armida Disarmed upon the Sight of the Sleeping Rinaldo* (1725) or *Diana at Rest* (1726) (Musée des Beaux-Arts, Nancy), measures the extent of this influence.

Trained in Paris, this young *provençal* grew up among artists with Italian affinities. His first works manifest this dual character, in turn conforming to academic principles, then giving way to the fervor of the baroque.

1. D'Ageville 1783, 33.
2. Mariette 1851-1860, 2:56.
3. See Henry Rubin, "Endymion's Dream as a Myth of Romantic Inspiration," *The Art Quarterly* 1, no. 2, Spring 1978, 47-84.

Jacques-Louis David *Paris 1748-1825 Brussels*

Jacques-Louis David was born on 30 August 1748 to a family of masons and building contractors. He studied under Vien, to whom he had been recommended by Boucher, a relative by marriage. He received the *Grand Prix* from the Royal Academy of Painting and Sculpture on his fourth attempt in 1774 with his painting *Erasistrates Discovering the Cause of Antiochus's Illness* (Ecole des Beaux-Arts, Paris). It was not until his first Roman sojourn (1775-1780) that David found his way, establishing himself as the foremost painter of his generation with some academic studies (Musée Thomas Henry, Cherbourg; Musée Fabre, Montpellier), *Funeral of Patroclas* (1778-1779, National Gallery of Ireland, Dublin), *Saint Roch* (1780, Musée des Beaux-Arts, Marseille), *Portrait de Potocki* (1780, Museum Narodowe, Warsaw), and *Belisarius* (1781, Musée des Beaux-Arts, Lille). Young artists began to frequent his studio, among them Fabre, Hennequin, Wicar, Girodet, and Drouais.

David was elected to membership in the Academy in 1783 with *The Grief of Andromache* (Musée du Louvre, Paris, on loan from the Ecole des Beaux-Arts). He soon abandoned both religious painting and his somber style, which had drawn its influence from Italian art of the seventeenth century, in favor of a lighter palette. From 1784 to 1785 he lived in Rome, where he painted the work that remains the manifesto of the neoclassic movement, *The Oath of the Horatii* (Musée du Louvre, Paris). After his return to Paris, he painted such important works as *The Death of Socrates* (1787, The Metropolitan Museum of Art, New York) and, notably, *Brutus* (Musée du Louvre, Paris). Completed in 1789, this work idealizes contemporary political events.

During the Revolution David played an important role in French artistic life. He led the attack against the Academy, which was abolished in 1793. Elected a deputy to the Convention in 1792, he became one of the most influential members of the Committee for Public Instruction as well as the principal organizer of Revolutionary pageants. Caught up in the turbulent times he voted for the death of Louis XVI and became a close associate of Robespierre as well as a member of the Committee for Public Safety, and painted *The Death of Marat* (Musée des Beaux-Arts, Brussels), perhaps his masterpiece. His political activities probably limited the number of portraits he was able to paint, among them the remarkable *Mme Trudaine* (Musée du Louvre, Paris)

and *Marquise de Pastoret* (The Art Institute of Chicago). He left unfinished the portrait of young *Joseph Barra Dying* (Musée Calvet, Avignon) as well as his famous *Oath of the Tennis Court*. Arrested after 9 Thermidor, year II (27 July 1794), David was imprisoned for a short time. He was a founding member of the Institute of France in 1795, and then divided his time between portraiture and work on his great painting of the *Sabines* (Musée du Louvre, Paris), which was completed in 1799.

David was an early supporter of Bonaparte and often portrayed him, beginning with the heroic allegory *Crossing of the Alps* (1801, Château de Versailles), an eloquent testimony of his admiration. In addition, David was commissioned to paint enormous canvases commemorating the great festivities of the Empire, such as *The Coronation of Napoleon and Josephine* (1806-1807, Musée du Louvre, Paris) and *The Distribution of Eagles* (1810, Château de Versailles). In these, realism of detail is subordinated to grandiose design. Having remained loyal to Napoleon, David was forced into exile when the Bourbons returned to power. He established himself in Brussels in 1816, painting such superb portraits as *Sieyès* (1817, Fogg Art Museum, Cambridge) and mythological paintings that had not even limited success. Works such as *Cupid and Psyche* (1817, Cleveland Museum of Art) or *Mars and Venus* (1821-1824, Musée des Beaux-Arts, Brussels) are representative of David's desire near the end of his life to reconcile drawing with color and to use a bold palette while introducing reality into the ideal. Experiments such as these baffled his viewers then and continue to do so today.

The catalogue for the 1948 Paris exhibition *David*, monographs by J.-L.-J. David (1880-1882), Richard Cantinelli (1930), Louis Hautecoeur (1954), Antoine Schnapper (1980), Anita Brookner (1980), and texts gathered by Daniel and Guy Wildenstein[1] give us further insight into the life and oeuvre of this fascinating painter. Nevertheless, there is no definitive catalogue raisonné of the paintings and drawings of this artist who, along with Goya, dominated European painting in the last quarter of the eighteenth and the first quarter of the nineteenth centuries.

1. Daniel Wildenstein and Guy Wildenstein, *Recueil de documents complémentaires au catalogue complet de l'oeuvre de l'artiste* (Paris: Fondation Wildenstein, 1973).

Laure-Emilie-Félicité David, Baronne Meunier

Laure-Emilie-Félicité David, Baronne Meunier

Oil on canvas, 29 × 23⅝ in. (73.5 × 60 cm)
Roscoe and Margaret Oakes Collection. 75.2.6
(de Young)

Provenance Painted ca. 1812, according to J.-L.-J. David (1880-1882, 1:648), grandson of the artist; Baronne Laure-Emilie Meunier, Calais, after 1812; Baronne J. Meunier, Calais, ca. 1880; Mme Marius Bianchi, née Mathilde Jeanin, great-granddaughter of J.-L. David, by 1913; Comtesse Joachim Murat, ca. 1930-1940; Marquis de Ludre-Frolois, March 1947; [Galerie Cailleux, Paris, by 1948]; [M. Knoedler & Co., Inc., New York, 1954]; Roscoe and Margaret Oakes, San Francisco, 4 October 1955; on loan to the de Young 1956-1972, and to the CPLH 1972-1975; gift to TFAMSF, 1975.

References Alexandre Lenoir, *Etude inédite sur David* in *Traité philosophique des arts . . .* , vol. 3 (MS coll., Fondation Wildenstein, Paris), 93, opposite 93; David 1880-1882, 2:487, 648, repr. vol. 2; Saunier [1903], 107-108; Rosenthal 1905, 130, 166; Saunier 1913, 279; Möller 1914, 2:158; Cantinelli 1930, 113, no. 129, pl. 74; Holma 1940, 129, no. 135; Maret 1943, pl. 87; Hautecoeur 1954, 230; *The Art Quarterly*, Winter 1956, 421; Comstock 1956, 74; P. Wescher, "Neuerwerbungen des De Young Museums in San Francisco," *Kunstchronik*, October 1957, 311; Leymarie 1962, 25; *Cailleux 1912-1962* (Paris: Cailleux, 1963), repr. (n.p.); *European Works 1966*, 216, repr.; Maxon 1967, 46, fig.4 on 45; Brookner 1980, 169-170; Schnapper 1980, 266; W. Wilson, *California Museums* (New York: Abrams, 1985), 76, pl. 68 (color).

Exhibitions 1913 Paris (Petit Palais), no. 54; Copenhagen, Statens Museum for Kunst, *Exposition des peintures*, 1914, no cat.; 1948 London-Manchester, no. 25; 1948 Paris, no. 65; 1950 Paris, no. 25b; 1952 Paris, no. 17; 1978-1979 Denver-New York-Minneapolis, no. 9.

Variant

ETCHING
J.-L.-J. David, after David, *Baronne Meunier*
REF: David 1880-1882, vol. 2 (plates).

Related Works

PAINTINGS
Baronne Pauline Jeanin, **fig.1**
Oil on canvas, 28¾ × 23⅝ in. (73 × 60 cm)
Sammlung Oskar Reinhart, Winterthur

Baron Claude-Marie Meunier, **fig.2**
Oil on canvas
Present location unknown

Marguerite-Charlotte Pécoul, Madame David, **fig.3**
Oil on canvas, 28¾ × 23⅜ in. (73 × 59.5 cm)
Inscribed lower left: *L. David. 1813*
National Gallery of Art, Washington, D.C. Samuel
H. Kress Collection, 1961.9.14

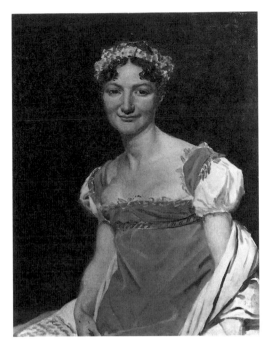

fig.1

fig.2

fig.3

Around 1812-1813 David painted portraits of several members of his family, including his twin daughters, Laure-Emilie-Félicité and Pauline (fig.1); his son-in-law, Baron Meunier (fig.2); and his wife, Marguerite-Charlotte Pécoul (fig.3), whom he married in 1782.

David had two sons (1783 and 1784) before the twins were born 26 October 1786 and baptized the following day at the Church of Saint-Germain-l'Auxerrois. Emilie's godfather was Marcel Germonière de Villoiseau, treasurer of the navy at Rochefort, and her godmother was her aunt, Emmanuelle-Emilie Pécoul.[1] The two sisters were very different in personality, Pauline's boldness contrasting with Emilie's more tranquil nature. According to J.-L.-J. David, the painter's grandson, Emilie loved flowers and grew them on the windowsill of her room at the Louvre against the regulations of the architect in charge of the maintenance of the building. It is said that one morning by accident she watered the First Consul while tending her hydrangeas, a flower then new to France.[2]

On 27 March 1805, Emilie married Claude-Marie Meunier (1770-1846), a colonel in the light infantry regiment, Ninth Regiment, and officer of the Legion of Honor.[3] This valiant soldier was a native of Franche-Comté. Born in Saint-Amour (Jura), he joined the Tenth Battalion of the Jura as a volunteer in 1792 and was named captain by his comrades-in-arms. Meunier participated in campaigns of the Rhine (1792-1794) and in Italy (1794-1798). In Egypt with Bonaparte, he held the dying Kléber in his arms. With the rank of battalion commander earned during the campaign in Egypt, the First Consul appointed him to the light infantry of the Consular Guard upon his return to France. In 1803 he was given command of the Ninth Regiment, called *L'incomparable*. His exploits during the Austrian and Bohemian campaigns earned him the cross of commander of the Legion of Honor in 1806 and the title Baron of the Empire by an official proclamation of 26 October 1808.[4] Wounded twice at the Battle of Talavera during the war with Spain, he earned the rank of brigade general in 1810.[5]

When Emilie's father began her portrait around 1812,[6] her son, Charles-Louis-Alfred (1806-1896), had been born six years earlier and her second son, Jean-Albert-Claude-Jules (1813-1867), the future mayor of Lille, was to be born a few months later. Therefore it is possible that in contrast to the lively Pauline Jeanin David wanted to portray a certain maternal tenderness in the features of his other daughter. As a result, one sees less the proud wife of a general, comfortably seated in an armchair, than a young woman of twenty-six, perhaps concerned with the care of her home and the education of her children.

For whatever reasons, this painting appears to be unfinished, although the sketchy technique highlights the spontaneous freedom of the brushwork and appears as a "sort of liberation from the more methodical manner he employed during the years 1795-1805."[7] Going beyond the pictorial sensitivity of his unfinished portraits of the Revolutionary period such as *Mme Trudaine* (Musée du Louvre, Paris) and *Mme de Pastoret* (The Art Institute of Chicago), David juxtaposes the vermillion of the velvet dress, the lemon yellow of the back of the armchair, and the beautiful white and gray impasto of the sitter's sleeves against a dappled brown background. This happy but bold play of colors announces the art of Matisse nearly a century later.

1. Arch. de Paris, V2E.638.

2. David 1880-1882, 1:507.

3. Arch. de Paris, V2E.8192.

4. A. Révérend, *Armorial du Premier Empire*, vol. 3 (Paris, 1894-1897), 238-239.

5. David 1880-1882, 1:508-509.

6. David 1880-1882, 1:648.

7. Hautecoeur 1954, 230.

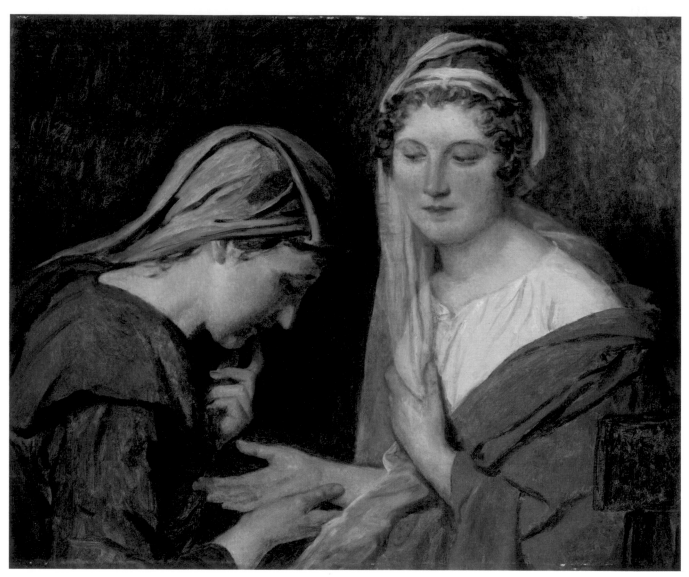

The Fortune Teller

The Fortune Teller

La bonne aventure
Oil on canvas, 24½ × 29½ in. (62 × 75 cm)
Gift of David David-Weill. 1947.3 (CPLH)

Provenance Painted in Brussels in 1824, according to all authorities; Baron Charles-Louis-Jules David (1783-1854), elder son of the painter, Paris, 1825-1854; Baron Jérôme-Frédéric-Paul David (1823-1882), son of the preceding and grandson of the painter, Paris, 1854-1882; [Galerie Goupil, Paris, 1909, according to Georges Wildenstein, 1963]; David David-Weill, before 1925; in storage with other paintings from the David-Weill collection, Wildenstein & Co., Inc., New York, 1937-1946; gift to the CPLH, 1947.

References Thomé de Gamond 1826 (Paris), 165; Thomé de Gamond 1826 (Brussels), 238; Coupin 1827, 57; Du Seigneur 1863-1864, 366; David 1880-1882, 1:651, repr. vol. 2; Saunier [1903], 115; Henriot 1925, 6; Henriot 1926, 73-74, repr.; Cantinelli 1930, 116, nos. 161 ("La bonne aventure," 1824), 163 ("Bohémienne et Romaine," 1825); Holma 1940, 130, nos. 167 ("La bonne aventure," 1824), 169 ("Bohémienne et Romaine," 1825), fig.17, on 98; Howe 1947, 10-13, repr. on 10; Hautecoeur 1954, 272; *Handbook* 1960, 64, repr.; Cuzin, exh. cat., 1977 Paris, 48, no. 127, repr.; J. D. Morse, *Old Master Paintings in North America* (New York: Abbeville Press, 1980), 96.

Exhibitions 1937 New York, no. 6; 1940 Los Angeles, no. 15, repr.

Variant

ETCHING
J.-L.-J. David, after David, *La bonne aventure*
REF: David 1880-1882, vol. 2 (plates).

Traditionally dated 1824, the year before David's death, this painting is documented as having belonged to his family. The slightly larger dimensions (75 × 90 cm) noted in 1880 by Jacques-Louis-Jules David, the artist's grandson and biographer, may be the result of an error or may refer to the dimensions of the framed canvas.

After the painter's death in Brussels, the picture was brought back to Paris where it became the property of David's elder son, Charles-Louis-Jules (1783). The latter's older son Eugène suffered from mental disorders and was sent to the Asylum of Charenton.[1] Therefore, the painting eventually reverted to his younger son, Jérôme-Frédéric-Paul, Baron David. Unfortunately, it is not known what became of the painting after his death, as his two children, Jérôme (1854-1874) and Marie-Thérèse (1856-1872), predeceased him,[2] although the family certainly sold the picture before David David-Weill eventually bought it.

The theme of *The Fortune Teller* unarguably enjoyed widespread success in European painting, especially after Caravaggio and his followers popularized it by multiplying its possible interpretations and meanings. French artists of the eighteenth century such as Watteau, Pater, and Lancret generally retained only the aspect of

promised good fortune, thus stripping the gypsy of her picturesque accoutrements and her power.[3]

Paradoxically, David's painting continues this thematic tradition while at the same time breaking with it. With its horizontal composition presenting two half-length figures, the work is reminiscent of Caravaggio's *Fortune Teller* (Musée du Louvre, Paris). However, David's painting departs vigorously from Caravaggio's model by depicting only the faces of the two women without making any concessions to picturesque detail. Despite the evocation of antiquity, David substitutes an almost timeless composition compared to the realism of the Italian master. According to the artist's grandson, "This rough sketch depicts an older woman, her head covered by a shawl such as those worn by Italian peasant women, examining the lines in the hand of a Roman lady."[4] The reference to Roman costume is superficial, however, as the younger woman's curly and banded hairstyle is the coiffure so fashionable during the Empire and the beginning of the Restoration in France.

David boldly contrasts the dark green dress, brown mantle, and blue shawl of the peasant woman with the white dress, blue-gray veil, and orange mantle of the younger woman. This contrast and the affectedly elegant design are consistent with other works painted during the painter's exile in Brussels that are just as disconcerting in their mannerist language: *Cupid and Psyche* (Cleveland Museum of Art), *The Farewell of Telemachus and Eucharis* (1818, J. Paul Getty Museum, Malibu), and *Mars Disarmed by Venus and the Three Graces* (Musées Royaux des Beaux-Arts de Belgique, Brussels). *The Fortune Teller* reflects some of David's artistic preoccupations toward the end of his life. Strongly influenced by the light of Flanders and its masterpieces, the artist's ideal united the composition and drawing of the Italian Renaissance—the seated woman is reminiscent of a fifteenth-century Italian madonna—with Flemish color of the sixteenth century.

The Fortune Teller belongs to the series of David's later paintings which, dismissed until recently by critical opinion, are beginning to interest contemporary historians. It is possible that if this work were more finished, it would possess an even more intense color scheme as well as the smooth, enamel-like surface of the Romanists that so appealed to David during his time in Brussels.

1. Arch. Paris, DQ⁷ 10013, *Déclarations des Mutations par décès*, fol. 8V°, no. 144.
2. A. Révérend, *Titres et confirmations de titres, 1830-1908* (Paris: H. Champion, 1909), 269-270.
3. See F. de Vaux de Foletier, "Iconographie des 'Egyptiens': Precisións sur le costume ancien des Tsiganes," *GBA* 68, no. 1172 (September 1966), 165-172.
4. David 1880-1882, 1:651.

The Performing Dogs

Philibert-Louis Debucourt *Paris 1755-1832 Belleville*

Philibert-Louis Debucourt was the son of a bailiff at the Châtelet in Paris. By the age of thirteen he was enrolled in the Ecole du Modèle de l'Académie as a protégé of Allegrain, the sculptor. The registers of the Academy reveal that in 1774 he was a pupil of Vien, who was to become director of the French Academy in Rome the following year. As Vien's style is not apparent in Debucourt's work, it is likely that he was Vien's student for only a short time.

The first reference to Debucourt's paintings dates from 1779. Small genre scenes on panel can be found mentioned in public sales under the name Debucourt from this time. These paintings are related in style to Teniers and van Ostade. Indeed, it was as a "painter of small subjects in the style of Flemish painters" that he was accepted by the Royal Academy of Painting and Sculpture in 1781.[1] At the Salons of 1781, 1783, and 1785 he successfully exhibited works such as *The Judge* and *The Broken Pitcher* (formerly collection of Achille Fould) and *The Village Dance* (formerly collection of Baron Robert de Rothschild). At the Salon of 1785, however, the critics were not content to reproach him solely for lack of solidity in his compositions and inadequate draftsmanship, but they also accused him of a tendency to pass off sketches as paintings. Above all they emphasized his lack of personal style. Was Debucourt offended? In any case, he needed no further encouragement to take up engraving. He did not exhibit paintings again for twenty-five years, until the Salons of 1810, 1814, 1817, and 1824, and then without having greatly modified his style.

While there may be little variation in his choice of themes, there are some differences in his manner of interpreting them. At first his imitation of Flemish subjects, figures, costumes, and settings is evident. Later he focused on his surroundings, giving his small compositions a more unconventional flavor. His figures became individualized, costumes and settings were contemporary, brushwork was agile, and his palette was dazzling.

Much more than his paintings (which, incidentally, are quite rare), Debucourt's drawings reveal astonishing diversity. He made use of all techniques and worked in all genres. But it is chiefly by his original engravings chronicling contemporary Parisian elegance and its evolution that Debucourt made his mark. In 1785 he learned the delicate new technique of color engraving. The following year he became a master of color-plate engraving, and in 1792 executed his masterpiece, *The Public Promenade*. By 1800 Debucourt had produced only sixty-four works. In spite of the healthy influence of prints by Hogarth and Rowlandson, he habitually made reproductions, multiplying works of often mediocre quality. At the time of his death he had produced approximately five hundred fifty-eight prints.

Even though he was appointed corresponding member of the Institute of France in 1817, Debucourt experienced hardship at the end of his career. In addition to the dissipation of his talent and the growing scarcity of commissions, he suffered financial setbacks and had to give up his comfortable existence. He died in poverty in his seventy-seventh year.

Debucourt was the subject of an outstanding study by Maurice Fenaille in a monograph devoted primarily to the engraver,[2] while an exhibition organized in 1920 by the Musée des Arts Décoratifs in Paris revealed the painter and the draftsman to the public.[3]

1. *Procès-Verbaux 1875-1892*, 9:71.
2. Maurice Fenaille, *L'oeuvre gravé de P. L. Debucourt (1755-1832)* (Paris: Librairie Damascène Morgand, 1899).
3. *Exposition Debucourt* (Paris: Musée des Arts Décoratifs, 1920).

The Performing Dogs (*attributed to Debucourt*)
Les chiens savants
Oil on walnut panel, 8 × 5¼ in. (20 × 13 cm)
Gift of Albert E. and James H. Schwabacher. 46.10
(de Young)

Provenance [Probably the painting 9 × 5⅞ in. (23 × 15 cm) attributed to J.-B. Le Prince at the Galerie Charles Brunner, Paris, 1910]; perhaps in the sale, Collection Madame X . . . , Paris, Hôtel Drouot, salle 6, 25-26 February 1924, no. 47 (as "N. Taunay, *Les chiens savants*, peinture sur bois"); presumably acquired in South America by Maria Saenz, ca. 1944; gift to the de Young, 1946. (Cleaned by William Suhr, New York, 11 July 1944.)

Reference *Illustrations of Selected Works* 1950, 76, repr.

fig.1

fig.2 Debucourt, *Interior of a Farmhouse: Peasant Dance*, oil on canvas, 14½ × 11 in. (37 × 28 cm), s.d. lower right: *Debucourt, 1824*, former collection Achille Fould.

Variant

DRAWING
Attributed to N.-A. Taunay, *Le chien savant*, **fig.1**
Watercolor over black chalk indications, 8¾ × 6 in. (223 × 152 mm)
Inscribed on the back: *Un dessin de Taunay (Nicolas-Antoine, 1755-1830)/à été gravé*
Wildenstein & Co., Inc., New York, in 1985
NOTE: The inscription on this watercolor might be erroneous, as the composition is identical to the painting in San Francisco.

The author of this small panel remains a mystery. It was attributed to Le Prince while with a dealer at the beginning of the century. In 1944 Georges Wildenstein suggested the hand of Philibert-Louis Debucourt, whose work is characterized by similar genre subjects, although he is most famous for his engravings in aquatint. The existence of an identical composition in watercolor attributed to Taunay (**fig.1**) further complicates the situation. Taunay's considerable oeuvre also includes genre subjects (parades, jugglers, and charlatans) in the northern style, usually small in format and often painted on wood.[1] He is known, however, to have executed another composition on pasteboard, also entitled *Les chiens savants*,[2] which was engraved by C.-M. Descourtis under the title *Le tambourin*.[3]

The witty, lively brushstrokes, large crumbling sections of wall, decaying woodwork, and heavy masses of greenery are consonant with some of Debucourt's late paintings, ca. 1815-1825. However, stylistic comparison with *Interior of a Farmhouse: Peasant Dance* (s.d. 1824, **fig.2**) is not convincing because the figures are executed quite differently from those in the San Francisco panel. The choice of contemporary subject, taken from daily life in the outskirts of Paris, dress of the figures, and picturesque details are found in the works of both Debucourt and Taunay.

In spite of the artificial and conventional character of the composition, this little painting is an interesting record of the activities of jugglers, strolling players, street comedians, and minor entertainers in early nineteenth-century France.

1. J.-P. Cuzin, "Nicolas-Antoine Taunay," exh. cat., 1974-1975 Paris-Detroit-New York, 626.
2. Photograph 520-24b at the Frick Art Reference Library, New York.
3. Photograph 517-1a at the Frick Art Reference Library, New York.

Jean-Baptiste-Henri Deshays, called Deshays de Colleville

Rouen 1729-1765 Paris

This painter, in my opinion, is the nation's foremost painter; he has more warmth and genius than Vien; he rivals Van Loo in drawing and color. . . . There is strength and austerity in his palette; he conceives [the most] striking subjects.[1]

So wrote Diderot in his *Salon of 1761*, seeing Deshays as the "Rising Sun of French Painting."

Jean-Baptiste-Henri Deshays was born in Colleville, near Rouen, and the early stages of his career were molded in Normandy. He first studied with his father, an obscure local painter, who in 1748 sent him to study with Collin de Vermont, a student of Jouvenet, who introduced him to drawing. Shortly before 1750 he became an apprentice to Jouvenet's principal disciple in Rouen, his nephew Restout. Restout's influence was decisive, as he trained Deshays in religious painting, his great speciality. The Ecole Académique awarded the *Second Prix* to Deshays in 1750 and the *Grand Prix* the following year. He then spent three years at the Ecole Royale des Elèves Protégés directed by Carle Vanloo. He began four years of study in 1754 at the French Academy in Rome, at that time directed by Natoire. After his return to Paris he was greatly influenced by Boucher, whose eldest daughter he married in 1758, the same year he was accepted by the Royal Academy of Painting and Sculpture. The following year he was elected to membership with his painting *Venus Rendering Hector's Body Immortal* (Ecole des Beaux-Arts, Paris) and was appointed adjunct professor in 1760. He exhibited his works at the Salon only four times—in 1759, 1761, 1763, and 1765—always with immense success. His last exhibition was posthumous.

Diderot wrote in his *Salon of 1765*:
This painter is no more—he who had fire, imagination, and verve; he who knew how to set a tragic scene; he who was truly a poet.[2]

The diversity of training received by the young painter, whose works echo the art of Le Sueur, Lebrun, and the Carracci, makes stylistic analysis difficult. In Deshays's work there is an ease, vivacity, and freedom of handling that announces Delacroix. These qualities were somewhat in opposition to contemporary trends, and permit the comparison of his work to Fragonard. The majority of Deshays's oeuvre are religious compositions, along with a few mythological scenes, that illustrate the artist's notable powers of expression. In addition, he executed two series of cartoons for the tapestry factory at Beauvais, *Iliade d'Homère* (1761) and *Histoire d'Astrée* (1763).

Marc Sandoz's monograph and catalogue raisonné (1978) together with several articles[3] form the basis of our current knowledge of this artist who died at age thirty-five, his talent in full bloom as his last brilliant sketches testify.

1. Diderot 1957-1967, *Salon of 1761*, 1:120.
2. Diderot 1975-1983, *Salon of 1765*, 2:96.
3. Marc Sandoz, "Etudes et esquisses peintes ou dessinées de Jean-Baptiste Deshays (1729-1765)," *GBA*, no. 38 (1951):129-146; "J.-B. Deshays, peintre d'histoire (1729-1765)," *BSHAF 1958*, 1959:7-21.

The Abduction of Helen

The Abduction of Helen
L'enlèvement d'Hélène
Oil on canvas, 21¼ × 34½ in. (54 × 87 cm)
Gift of Rudolf H. Heinemann. 54.4 (de Young)

Provenance Sketch painted ca. 1761 for the first piece of the Beauvais tapestry suite, *Iliade d'Homère*; Deshays collection, Paris, 1761-1765; Deshays sale, Paris, 26 March 1765, no. 113 (with the sketch of *Venus Wounded by Diomedes*); both acquired by Abbé Gruel, according to the annotated sale catalogue, Bibliothèque Doucet, Paris, call no. 1765/4; [Rudolf J. Heinemann, New York, before 1953]; gift to the de Young (attributed to François Boucher) in two parts, 1953 and 1954.

References *The Art Quarterly*, Autumn 1954, 299, fig.2 on 303 (as Boucher); *European Works* 1966, 183, repr. (Boucher); Sandoz 1978, 84, no. 70-4Bb, 135, 150, pl. 4; Lee 1980, 221, pl. 20 on 217; Sandoz 1981, 47, fig.1; M. Small, "Four Oil Sketches: The Artist at Work," *Triptych*, Winter 1981, 9, fig.3.

Exhibitions 1976-1977 San Francisco, not in cat.; 1978-1979 Denver-New York-Minneapolis, no. 12.

Variants
PAINTINGS
Mythological Scene, copy, **fig.1**
Oil on canvas, 20⅛ × 34¼ in. (51 × 87 cm)
Musée des Beaux-Arts, Le Havre, Bequest of Gutzwiller. Inv. A.56-26
NOTE: Erroneously attributed to Charles Natoire.

Perhaps a duplicate or copy of the cartoon
Oil on canvas, 48½ × 70⅛ in. (123 × 178 cm)
PROV: Sale, Paris, Hôtel Drouot, salle 11, 17 December 1934, no. 14.

TAPESTRY CARTOON
Tapestry cartoon of very similar composition (lost) supplied to the Beauvais factory in 1761 for the first piece of the suite *Iliade d'Homère* mentioned in 1794 at Beauvais by De Menou; and listed as "cut in 5 bands" at Beauvais in 1820.
REFS: Badin 1909, 62, 91, 106; Sandoz 1978, 134.

TAPESTRIES
Known examples of *The Abduction of Helen*, from *Iliade d'Homère*, Beauvais:

First weaving, ca. 1761, for Duc de Praslin, 41 Faubourg Saint-Honoré, Paris (residence of the United States Ambassador, since 1972), **fig.2**
REF: Charles Emmons, letter, 8 February 1984.

Second weaving, ca. 1762-1765, for Vicomte de Choiseul, location undetermined (perhaps Berlin)

Third weaving, ca. 1769-1771, for the Ministry of Foreign Affairs, Madrid, Spanish Crown Collection
REFS: Paulina Junquiera, letter, 26 June 1976; Sandoz 1978, 131-135.

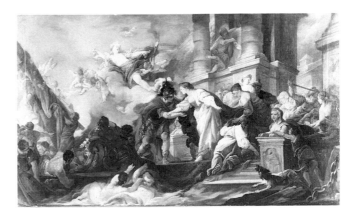

fig.1

fig.2

Greek mythology tells the story of the beautiful Helen, daughter of Leda and Jupiter, who married Menelaus, the king of Sparta. He was one of some hundred suitors who had fought for her hand, swearing to revenge himself on the chosen one should he fail to win her. The Trojan Paris (protégé of Venus who appears in the sky with a dove, one of her favorite companions) had fallen madly in love with Helen. He took advantage of the absence of Menelaus to abduct the half-willing young woman and flee with her to Troy. In honor of the oath all had sworn, the suitors decided to avenge this outrage against the Greeks by the Trojans, and thus began the interminable Trojan War. It should be noted that the abduction of Helen is not chronicled in the *Iliad*. It is mentioned only by allusion in book 3 in an exchange between Menelaus and Paris during their preparations for single combat. A very strong iconographic tradition has existed, however, in depictions of the story since the sixteenth century among literary illustrators and painters.

The abduction of Helen by Paris is the subject of Deshays's sketch in preparation for the first tapestry cartoon of the series *Iliade d'Homère* (in six pieces), undertaken at the Beauvais factory in 1761. The suite was woven three times by order of the king, presumably planned as diplomatic gifts, because the great arms of France and Navarre are prominent in the upper center of each tapestry. *Iliade d'Homère* followed two suites by Boucher (*Fragments d'Opéra*, 1752, and *La noble pastorale*, 1755) at Beauvais, and represents a radical departure in style from rococo decoration to heroic subjects reminiscent of seventeenth-century history painting.

A scientific analysis by Teri Oikawa-Picante has shown that the sketch originally might have been painted on paper and then glued onto canvas. It has been transferred several times. X-ray and infra-red photography further reveal that at some time the sketch was cut horizontally and vertically into eight irregular sections, either from vandalism or accident. There is also evidence of repainting in the central part of the picture, where the head and shoulders of Helen were first placed slightly higher.

Comparison of the tapestry (**fig.2**) with the sketch (reversed in the weaving) shows that although the general structure of the composition was already fixed in the sketch, many details were later modified, including the figures, the ship, and the background decor. The rea son for these changes is clearly to increase the legibility of the composition. The artist achieves this through simplification of the architectural decor, suppression of the excess ornamental sculpture, and reduction in the number of figures (from forty-four to twenty-seven), which lays stress on the protagonists. He also makes an effort to disseminate the decorative elements throughout the work, not only giving the tapestry greater force and clarity, but also facilitating the work of the weavers.

It is regrettable that by this evolution Deshays's initial concept loses much of its tumultuous verve and lively effervescence. For example, the loss of the two Rubenesque nymphs in the foreground, as well as the diagonal line created by the mast of the ship, lessen the impact of the work. Although the young artist owed an immense debt to his father-in-law, François Boucher, especially evident in the details of execution, and to his Roman teacher Natoire, evident in the expression of the principal figures, Deshays also looked back to Rubens, Veronese, and Titian.

With a free brush and a subtle, brilliant palette (notably blue and pink), Deshays falls within a decorative tradition that originated in the designs of Le Moyne and Boucher and continued with Natoire, Pierre, and other leaders of the eighteenth-century French school of grand interior decoration. Judging by this work, it is clear that Deshays might have become one of the major artists of his time had he lived longer. Stylistically closest to Boucher, he differed from all the decorative painters of the era by his imaginative and vigorous approach to history painting and by his innate sense of the epic.

Joseph-Siffred (or Siffrein) Duplessis

Carpentras 1725-1802 Versailles

Joseph-Siffred Duplessis was the son of a surgeon from Carpentras and was educated locally by Brother Imbert of the Carthusian monastery of Villeneuve-lès-Avignon. In 1745 he went to Rome and became acquainted with Pierre Subleyras, whom he copied. Duplessis returned to Carpentras in 1749, then traveled to Paris in 1752. He did not become famous until 1764 when he exhibited *Portrait of Mme Lenoir* (Musée du Louvre, Paris) at the Salon of the Academy of Saint Luke. Accepted by the Royal Academy of Painting and Sculpture in 1769, Duplessis was elected to membership in 1774 with *Portrait of Allegrain*. Ten years later he painted *Portrait of Vien* (both Musée du Louvre, Paris).

As the official court painter to Louis XVI, Duplessis was in vogue as a portraitist (*Marie-Antoinette*, 1771, Musée du Louvre, Paris; *Louis XVI*, 1775, Château de Versailles; *Gluck*, 1775, Kunsthistorisches Museum, Vienna; *Benjamin Franklin*, 1778, The Metropolitan Museum of Art, New York; *Doctor Lassone*, 1785, replicas in Musée Calvet, Avignon, and the Faculté de Médecine, Paris; *M. de Chabanon*, 1785, Musée des Beaux-Arts, Orléans). Appointed director of the galleries of Versailles, he fell into disfavor during the Revolution and virtually abandoned painting. He returned to Carpentras in 1792 and remained there until 1796, compiling an inventory of works of art that had been confiscated during the Revolution. In 1796 he was appointed curator of the Musée de Versailles with Durameau, Roland, and Le Roy. He died in 1802, destitute and forgotten.

A leading portraitist of his generation and recognized as such by Pierre, the *premier peintre du roi*, as well as by unanimous critical opinion of the day, Duplessis was rivaled only by Alexandre Roslin. A critic at the Salon of 1783 wrote, "If only Roslin painted flesh tones like Duplessis and Duplessis painted fabrics like Roslin!"[1]

Duplessis liked to outline forms, avoiding the hazy and the vague. His sitters, whose social status is clearly evident, pose before us, smiles on their lips. No artifice or false elegance, but rather finesse and a taste for the truth characterize Duplessis's art. It is marked as well by the painter's modesty before his sitter, whom he wished to serve.

Jules Belleudy's excellent monograph (1913) remains the primary work on this artist.

1. Belleudy 1913, 250.

Portrait of a Gentleman (Jean-Baptiste-François Dupré?)
Portrait d'un gentilhomme
(*Portrait présumé de Jean-Baptiste-François Dupré*)
Oil on canvas, 57³⁄₄ × 44³⁄₄ in. (147 × 114 cm)
Mildred Anna Williams Collection. 1966.46 (CPLH)

Provenance Perhaps in the collection of Comte d'Arjuzon (but not in his sale of 2-4 March 1852); [Wildenstein & Co., Inc., Paris, ca. 1913, according to Jules Belleudy; in the United States from 1920]; acquired for the CPLH in 1966.

References Belleudy 1913, 340-341; *The Arts Magazine*, February-March 1921, 3, repr.; Bazin 1965, 187, repr. on 186; *GBA*, "La Chronique des Arts," February 1967, 91, no. 323, repr.; *Bulletin CPLH*, March-April 1967; Bellaigue 1974, 1:431, 433, repr.; Abromson 1981, 8, 10, fig.3; T. Lefrançois, "Les peintures provençales anciennes des Fine Art Museums de San Francisco," *Bulletin Mensuel de l'Académie de Vaucluse*, January 1985, 4.

Exhibitions 1920 San Francisco, 94, repr. on 41; 1923 New York, no. 5, pl. 5; 1931 New York, no. 13; 1948 New York, no. 12, pl. 12; 1974-1975 Paris-Detroit-New York, no. 54, pl. 19; 1978-1979 Denver-New York-Minneapolis, no. 15.

Related Works
DECORATIVE ARTS
Pair of wall lights, Paris, ca. 1715-1720, **fig.1**
Gilt bronze, 20¹⁄₁₆ × 14 × 9¹³⁄₁₆ in. (51 × 35.5 × 25 cm)
J. Paul Getty Museum, Malibu. 83.DF.195.1-2

Joseph Baumhauer, writing table, 1770, with Sèvres plaques, 1760, **fig.2**
30¹⁄₈ × 45⁵⁄₈ × 23¹⁄₄ in. (76.5 × 116 × 59 cm)
The National Trust, Waddesdon Manor, Aylesbury. P/754
REF: Bellaigue 1974, 1:428-433, no. 89.

Jules Belleudy (1913), who described the colors in this painting, attributed the work to Duplessis and called the sitter "unknown." Seven years later in an exhibition in San Francisco this portrait was called *Marquis de Chillon*, and in 1931 the sitter became *André Dupré de Billy*. Recent archival research and inquiry among the latter's descendants, who still own several family portraits, suggest the possible identification of this sitter as Maître Jean-Baptiste-François Dupré (1747-1837), son of Marie-Madeleine Caron and Maître Jean-Baptiste-Alexandre Dupré, a Paris notary and counselor to the king.

It is known that after serving as first clerk to his father, whose office was located "at the corner of rue Saint Honoré and rue du Coq," Dupré took over the

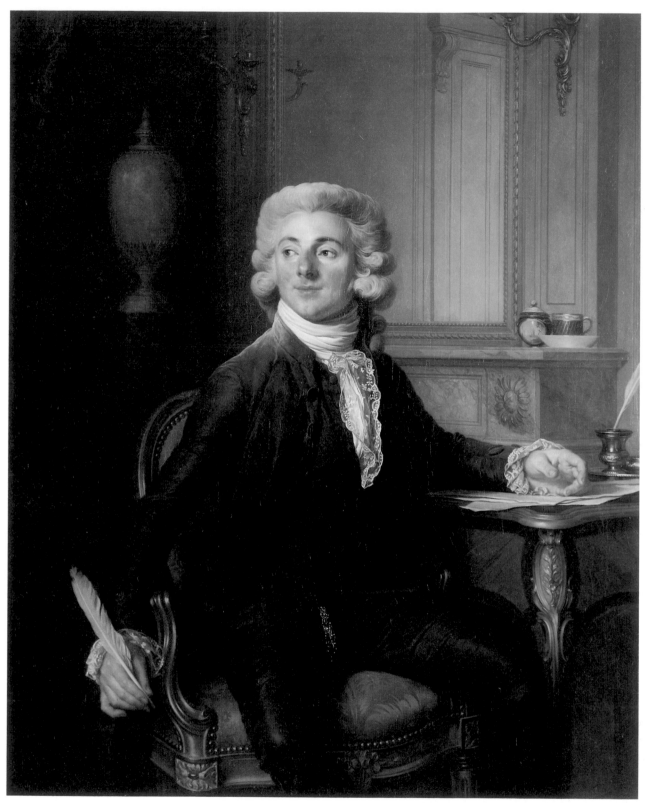

Portrait of a Gentleman

practice on 26 October 1779,[1] moving his office in 1782 to 234 rue Saint-Thomas-du-Louvre. He married Emilie Levacher-Duplessis on 13 November 1780. Perhaps a distant cousin of the painter from Carpentras, she was born in 1765 in Paris and died in 1795,[2] leaving four children, Alphonse, Jean-Baptiste-Alcime, Marie, and Sophie.[3] Dupré took a second wife, Antoinette-Bérénice Homberg (1769-1845), from a wealthy family of Le Havre, less than three years later in December 1797.[4] She bore him another child, Marie-Anthime. His business was then so successful that he was able to live on his private income. He sold his office on 3 August 1798; documents show that he lived at 14 rue de l'Université, then 88 rue de Grenelle, in the wealthy district of the Faubourg Saint-Germain.[5] If Duplessis's portrait depicts Dupré, he is about thirty years of age, dressed with sober elegance in a dark gray suit highlighted by the gleam of his gold watch chain, perfectly in keeping with his position as a man of law.

The furniture of the study, meticulously reproduced by the artist, reveals that the sitter was obviously able to pay the sum of more than six hundred *livres* that was Duplessis's asking price for portraits from the 1770s.[6] The heterogeneous mixture of the Louis XV and Louis XVI furnishings—certainly not from the painter's studio—confirms that the sitter came from a family that had lived affluently for several decades. The rococo sconces in gilt bronze (fig.1) are fastened to wood paneling dating from about 1770. The wall clock dates from the middle of the century, and the armchair from around 1760. The marquetry desk, ornamented with gilt bronze mounts, was rightly compared by Geoffrey de Bellaigue to a writing table with a similar profile and an identical set of corner mounts in gilt bronze made by Joseph Baumhauer and now at Waddesdon Manor (fig.2). The most modern objects appear to be the ovoid vase in marble shown at the back of the room on a column, the Sèvres porcelain on the mantel, a Hébert sugarbowl (ca. 1770), and a Litron cup and saucer from about 1780.

The various objects in the room, composition, sitter's pose and dress, and decor can be compared to Duplessis's famous portrait of *Necker* (s.d. 1781, Château de Coppet, Switzerland), which was exhibited at the Salon of 1783. Possibly the San Francisco picture was painted in 1779, the year the presumed Dupré took over his father's practice, or in 1782, when he moved his office.

Regardless of the identity of the sitter, the solid qualities of this portrait—the rendering of materials, keenness of observation, brilliance of flesh tones, completeness and balance of the composition, and devices such as the mirror that introduces another painting within the painting—are full measure of Duplessis's talent and skill. In addition to the intrinsic qualities of the painting, the work serves as a revealing document of taste in the decorative arts among the Parisian bourgeoisie at the end of the eighteenth century.

fig.1

fig.2

1. AN, Minutier Central, LXXXIII-595, 17 September 1779.
2. Arch. de Paris, V2E.299 and 10690.
3. AN, Minutier Central, CXIII-918, 27 November 1837.
4. AN, Minutier Central, CXIII-798, 1 May 1822.
5. AN, Minutier Central, VCXIII-917, 28 August 1837.
6. Belleudy 1913, 195.

Portrait of a Lady

Portrait of a Lady (*studio of Duplessis*)

Portrait d'une dame
Oil on canvas, 24 × 19 ¾ in. (61 × 50 cm)
Bequest of M. H. de Young. 41.1.3 (de Young)

On the back, on the lower horizontal stretcher, is written: "Port^r de Mlle Dumesnil Actrice du Théâtre Français(e) au 17^e par Mme Lebrun."

Provenance M. H. de Young, San Francisco; gift to the de Young, 1941. (Cleaned and restored in lower part by William Suhr, 1943.)

References "Rediscovery of a Duplessis," *Art News*, 15 May 1942, 7; "Duplessis Uncovered," *Art Digest*, June 1942, 8, repr.; Wildenstein 1944, 1-15, figs.1-2; Benisovich 1946, 292; *Illustrations of Selected Works* 1950, 75, repr.; P. Wescher, "Neuerwerbungen des De Young Museums in San Francisco," *Kunstchronik*, October 1957, 311; J. Herold, *Mistress to an Age* (New York: Bobbs-Merrill, 1958), 84, repr.; *European Works* 1966, 194, repr.; Marandel 1976, 2; T. Lefrançois, "Les peintures provençales anciennes des Fine Arts Museums de San Francisco," *Bulletin Mensuel de l'Académie de Vaucluse*, January 1985, 4.

Exhibitions 1946 New York (Knoedler), no. 11, repr.; 1956 Kansas City, no. 30; 1966 Bordeaux, no. 25.

fig.1

Variants

PAINTINGS
Portrait of a Woman, **fig.1**
Oil on canvas (oval), 28 ¾ × 23 ¼ in. (73 × 59 cm)
The Art Institute of Chicago, Mrs. Arma Wyler Restricted Gift.
1975.137
EXH: 1976 Chicago, cat. no. 12, repr. (as *Mme de Staël*).

Portrait of a Woman, **fig.2**
Oil on canvas, 28 ⅜ × 22 ½ in. (72 × 57 cm)
PROV: Camille Groult sale, Paris, Galerie Jean Charpentier, 21 March 1952, no. 75, repr. (as H.-P. Danloux).

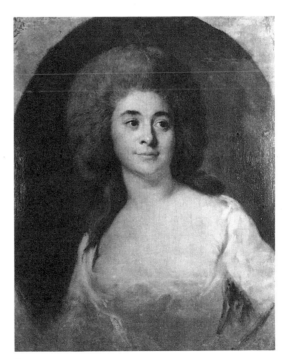

fig.2

Both the sitter and the artist were unknown when this painting entered the Museums' collection. In 1944 Georges Wildenstein proposed Mme de Staël as the sitter and Joseph-Siffred Duplessis as the artist. While the attribution to Duplessis seems probable,[1] the portrait is not a likeness of Germaine Necker, baronne de Staël-Holstein (1766-1817). This woman does not resemble any of the known portraits of this famous writer by artists such as Baron F. Gérard (collection of Duc de Broglie), Vigée Le Brun (Musée d'Art et d'Histoire, Geneva), Massot and Bouvier (Château de Coppet) or M.-F. Godefroy (Château de Versailles).

Unfortunately the inscription on the frame (see above) does not provide a real clue to the identity of the painter or the sitter. The expressiveness of the lady's face might indicate that she is an actress, although she is not Mme Dumesnil, a tragedienne whose portrait can be seen at the Comédie française. A theatrical note is provided in

the more finished portrait at The Art Institute of Chicago (**fig.1**), where the drapery of the costume takes on heroic fulness, and a large knotted ribbon crowns the lady's leonine hair. There is also another unidentified portrait of this woman, attributed to Danloux (**fig.2**), in which the sitter appears somewhat younger. Two proposed actresses—Marie-Thérèse Davoux Maillard (1766-1818), who was known particularly for her incarnations of Liberty,[2] and Mlle Mars—do not really resemble this sitter.

In comparing the San Francisco version with the other two known portraits, it is obvious that the lower portion has been completely repainted. Only the face and the neck are intact and of good quality. A detailed examination of the canvas reveals rounded edges in the upper corners, indicating that it might have been originally an oval painting similar to Chicago's, with only the face finished and the rest hastily sketched in before being reduced to a smaller rectangular format. In addition, the technique of this piece is similar to that of *Portrait of a Young Woman* (formerly in the collection of Mme Rogers-Doucet), signed "Duplessis pinxit,"[3] and the suppleness of the modeling relates it directly to *Portrait of Gluck* (1775, Kunsthistorisches Museum, Vienna).

Of the three versions of this portrait, it would appear that the San Francisco painting is weakest in execution, and may have been prepared by an artist working under Duplessis as a copy of the Chicago version, or as a sketch preceding it. As for the attribution of the third version to Danloux, there is no proof. Unfortunately, this interesting lady remains unidentified.

1. Joseph Baillio, letter, 28 July 1977; although Susan Wise, letter, 24 February 1982, accepts this attribution with some reluctance.
2. Sylvie Chevalley, letter, 7 March 1978.
3. Belleudy 1913, 336, no. 151, repr. on 256.

Jean-Honoré Fragonard *Grasse 1732-1806 Paris*

After arriving in Paris Jean-Honoré Fragonard worked as a notary clerk but soon showed great enthusiasm for painting. While still quite young he was rejected by the studio of Boucher, served a brief apprenticeship with Chardin that seems to have left little impression on his work, and returned to Boucher, revealing his genius and becoming the master's favorite pupil. Fragonard won the *Grand Prix* of the Royal Academy of Painting and Sculpture in 1752 with his *Jeroboam Sacrificing to Idols* (Ecole des Beaux-Arts, Paris). Having completed his training at the Ecole Royale des Elèves Protégés under Carle Vanloo, he left for Rome in 1756. He stayed in Italy until 1761, where he became a close friend of Hubert Robert and the Abbé de Saint-Non. There he looked at the work of a variety of masters, including the Carracci, Veronese, Solimena, and Tiepolo.

After his return to Paris Fragonard was accepted by the Academy with the immense *Corésus and Callirhoe* (Musée du Louvre, Paris), exhibited at the Salon of 1765. The Academy never elected him as a full member, however, because he did not submit a reception piece. From then on Fragonard rarely exhibited at the Salon, and quickly abandoned history painting and large interior decorations in favor of cabinet pictures soon coveted by *amateurs*. His *Fantasy Portraits* (eight in the Musée du Louvre, Paris) date from 1769, and the series now called *The Progress of Love* (The Frick Collection, New York) from 1771-1773. Mme du Barry commissioned this latter series for the Pavillon de Louveciennes, but subsequently refused to accept it. In spite of his overwhelming success, Fragonard's art became passé as neoclassicism began to captivate Parisian audiences. Under sharp critical attack, he spent much of 1773 and 1774 in the Midi of France, Italy, and Austria, traveling with his wife, Marie-Anne Gérard, also a native of Grasse, whom he had married in 1769.

If many facts about the rest of Fragonard's life are well known, the works he produced during this period are much less so. The monograph by Georges Wildenstein (1960) catalogues approximately four hundred fifty paintings before 1776 and hardly more than one hundred after that date. The painter, whose celebrity diminished daily, withdrew into the intimacy of his family and friends. David secured a post for him as curator of the Muséum National des Arts in 1792. While his works were less and less in demand, those of his sister-in-law and pupil, Marguerite Gérard, had an increasing number of admirers, and the reputation of his son Alexandre-Evariste, who was trained by David, also steadily rose. In examining pictures like *The Bolt* (Musée du Louvre, Paris) and *The Stolen Kiss* (Hermitage, Leningrad), it appears that even before 1780 Fragonard attempted to revise his style and his poetic language. In his own way, by use of allegory and elegiac motifs, Fragonard contributed to the elaboration of the new aesthetic, bypassing David and directly anticipating romanticism.

Although he was a prolific draftsman and painter, Fragonard rarely signed or exhibited his works, and did not always have them engraved. It is difficult therefore to distinguish them from those of his many talented imitators and to assign correct dates. Beyond his amazing virtuosity, his freedom with the brush, and his explicitly erotic themes, which are never trivial or vulgar, Fragonard distinguishes himself by his extraordinary powers of invention that are on the level of Rubens, Rembrandt, Veronese, Hals, and Boucher. He was also a great poet, an artist who did not resort to formulas but constantly varied his style, adapting to variations in taste and at times playing the innovator.

In addition to the catalogue by Georges Wildenstein, Fragonard has been the object of studies by many scholars, including Jacques Thuillier,[1] Alexandre Ananoff (1961-1970), and Pierre Rosenberg, the organizer of the 1987-1988 Paris-New York exhibition.

1. Jacques Thuillier, *Fragonard* (Geneva: Skira, 1967); "Le Verrou," in *Le Petit Journal des Grandes Expositions* (Paris: Editions de la Réunion des Musées Nationaux, 1974), no. 10.

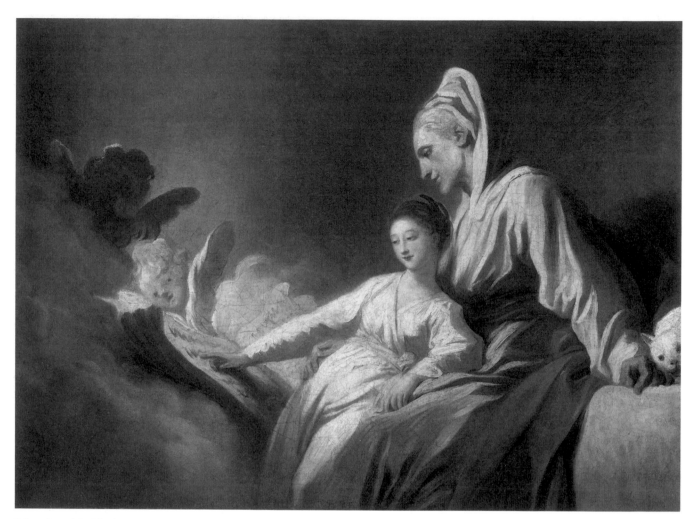

Education of the Virgin

Education of the Virgin
L'éducation de la Vierge
Oil on canvas, 33 ⅛ × 45 ¼ in. (84 × 115 cm)
Gift of Archer M. Huntington through Herbert
Fleishhacker. 1929.2 (CPLH)

Provenance Probably in the sale of a painter, Folliot, Paris, 15 April
1793, no. 48 (5 *pieds* 10 *pouces* × 4 *pieds* 10 *pouces* [ca. 165 × 133
cm]), after which the canvas must have been cut down; perhaps in the
[Aubert] sale, Paris, 17-18 April 1806, no.13; acquired by "Brunot"
for 20 francs, according to the annotated sale catalogue at the BN, 8°
V³⁶2165; Henri Walferdin sale, Paris, Hôtel Drouot, 12-16 April 1880,
no. 65; acquired by M. de Siéhen for 650 francs (Wildenstein 1960,
no. 19); sale, Collection de M. de X⁺⁺⁺, 16-21 April 1883, no. 632;
Clément Bayard, Paris; [Wildenstein & Co., Inc., New York];
acquired by the CPLH, 1929. (Cleaned by Teri Oikawa-Picante, 1973).

NOTE: Three paintings entitled *Education of the Virgin* appeared in
nineteenth-century sales with no dimensions and no support specified:
Paris, 17 March 1852, no. 37; Paris, Hôtel des Ventes Mobilières, 27
January 1853, no. 6, sold for 45 francs, according to the annotated
sale catalogue at the Bibliothèque Doucet (1853/18); and sale, Cabinet
de feu M. le Comte⁺⁺⁺ et l'atelier de M⁺⁺⁺, Paris, 107 rue de Gre-
nelle, 13-15 December 1853, no. 28. It is impossible to determine to
which versions these refer.

References Goncourt 1894-1895, 3:321; Portalis 1889, 276; Nolhac
1906, 164; *Illustrated Handbook* 1942, 44, repr.; *idem*, 1944, 48,
repr.; *idem*, 1946, 52, repr.; *Handbook* 1960, 56, repr.; Wildenstein
1960, 196, no. 19, pl. 2; Wildenstein and Mandel 1972, 86, no. 18,
repr.; Young 1977, 413, fig.5; exh. cat., 1978 London (Artemis), men-
tioned under no. 6; Lee 1980, 219, fig.11 on 216; J. D. Morse, *Old
Master Paintings in North America* (New York: Abbeville Press, 1980,
128; M. A. Morris, *European Paintings of the Eighteenth Century*
(London: Frederick Warne, 1981), 22; exh. cat., Los Angeles County
Museum of Art, *Selections from The Armand Hammer Collections*,
22 May-26 August 1984, mentioned under no. 7; T. Lefrançois, "Les
peintures provençales anciennes des Fine Arts Museums de San Fran-
cisco," *Bulletin Mensuel de l'Académie de Vaucluse*, January 1985, 4;
D. Rosenthal, exh. cat., 1987-1988 Rochester-New Brunswick-
Atlanta, 34, fig.24 on 35; P. Rosenberg, exh. cat., 1987-1988 Paris-
New York, mentioned under no. 232, fig.2.

Exhibitions Cambridge, Fogg Art Museum, *Loan Exhibition of
Eighteenth-Century French Art*, 16 February-9 March 1931, no cat.;
1937 Los Angeles, no. 83; 1954 New York, no. 10; 1958 Los Angeles-
San Francisco, no. 20, repr.; 1962 Seattle, no. 37; Oberlin, Allen
Memorial Art Museum, *Youthful Works by Great Artists*, 10-30
March 1963, no cat. (Ref: *Bulletin*, Spring 1963, no. 18, repr.); 1977
New York, no. 35, fig.41; 1980 Japan, no. 2, repr.

Variants
PAINTINGS
Education of the Virgin, fig.1
Oil on panel, 11 ¹³⁄₁₆ × 9 ⅝ in. (30 × 24.5 cm)
The Armand Hammer Foundation, Los Angeles
EXHS: 1984 Los Angeles, no. 7, repr. in color.; 1987-1988 Paris-New
York, no. 232, repr.

fig.1

fig.2

Education of the Virgin, unfinished version
Oil on canvas, 35 1/2 × 28 3/8 in. (90 × 72 cm)
Private collection, Paris, 1960
PROV: Walferdin sale, Paris, 12-16 April 1880, no. 66; Beurnonville sale, Paris, 9 May 1881, no. 73; Grimelius; Baron A. de Turckheim, ca. 1907; Comtesse de Pourtalès; Marquise de Loys-Chandieu, Paris, 1921; Mme Maurice Bérard, Paris.
REF: Wildenstein 1960, 195, no. 17, fig.11.

Abbé de Saint-Non, after Fragonard, *Education of the Virgin*
Oil on canvas
REF: G. Wildenstein, "L'Abbé de Saint-Non: Artiste et Mécène," *GBA*, November 1959, 239.

DRAWINGS
Education of the Virgin, fig.2
Bistre wash, 15 3/4 × 11 3/8 in. (400 × 290 mm)
St. Louis Art Museum. 146.1986
PROV: Sale, collection Camille Groult, Paris, Palais d'Orsay, 23 February 1978, no. 1, repr.; [Galerie Cailleux, Paris].
REF: Ananoff 1961-1970, 3:no. 1769, fig.441.
EXH: 1987-1988 Paris-New York, no. 233, repr.

Education of the Virgin, fig.3
Black chalk, 19 1/4 × 15 3/4 in. (490 × 400 mm)
Musée des Beaux-Arts, Rouen, Gift of Victor Loutrel in 1891
REFS: Ananoff 1961-1970, 3:no. 1771; exh. cat., 1987-1988 Paris-New York, fig.2 under no. 233.
NOTE: This drawing may be a nineteenth-century copy.

Education of the Virgin, fig.4
Charcoal, 10 15/16 × 8 9/16 in. (280 × 215 mm)
The Armand Hammer Foundation, Los Angeles
REF: Exh. cat., 1987-1988 Paris-New York, fig.3 under no. 233.
EXH: 1984 Los Angeles, no. 77, repr.
NOTE: This is a weak drawing, perhaps not by Fragonard.

Related Work
DRAWING
After G. B. Tiepolo, *Saint Anne Teaching the Virgin to Read*, 1760-1761, fig.5
Black chalk, 11 1/2 × 8 in. (290 × 205 mm)
Norton Simon Foundation, Pasadena. F.70.3.113.D

NOTE: A number of drawings entitled *Education of the Virgin* were catalogued by Ananoff (1961-1970, 3: 1767, 1768, 1769, 1770, 1771, 1772, 1788, 1813). Many passed through sales with no dimensions cited. For a discussion of these versions attributed to Fragonard, see P. Rosenberg, exh. cat., 1987-1988 Paris-New York, no. 233.

This painting, with its traditional hagiography, is based on a composition Fragonard reworked a number of times over the years.

Of the three known paintings of *Education of the Virgin*, the San Francisco picture seems most likely to have been the large oil sketch mentioned in the Folliot sale of 1793 ("The Education of the Virgin, a sketch very freely painted on canvas by Fragonard"). However there is no ready explanation for the drastic reduction in dimensions between 1793 and 1880 when the work was documented in the Walferdin sale in Paris.

Another smaller painting also appeared in the Walferdin sale of 1880 (no. 66) showing the composition in its original full length, which includes the feet of the two saints. In this picture, as well as in the panel in the Armand Hammer collection (fig.1), the Virgin looks at Saint Anne, rather than at the book. Additional comparisons between these pictures and the San Francisco version include a different treatment of Saint Anne's drapery, and there is no cat. Two drawings, one in St. Louis (fig.2), and another formerly in the Norblin and Walferdin collections, show compositions similar to the Hammer and former Bérard paintings, whereas the drawings in Rouen (fig.3) and in the Hammer collection (fig.4) are similar to the work in San Francisco.

The most difficult question concerns the dating of this picture. Fragonard was surely inspired by Tiepolo's treatment of the same subject (1732, Chiesa della Fava, Venice), which he saw in 1761 when he visited Venice with Abbé de Saint-Non and after which he made a drawing (fig.5). Fragonard's Virgin and Saint Anne are the same physical types as their correspondents in the Tiepolo, and in both paintings the Virgin points with one finger at the book which rests on a bank of clouds supported by putti. The atmosphere and even the facture in both paintings are similar.

As *The Education of the Virgin* series may well have been elaborated and pursued over a number of years, it seems probable that the San Francisco picture was painted just before Fragonard's second trip to Italy in 1773. After returning from Italy in 1774, Fragonard probably produced the Hammer and former Bérard paintings, as well as the St. Louis drawing, all part of a second group of works on this subject.

Fragonard manifests great economy of means in this *Education of the Virgin*, handling the paint with large easy strokes in keeping with an oil sketch. Yet the hands of Saint Anne are incisively and squarely depicted, and there is an amazing diversity in the range of yellows the artist produces. The result is a work practically purified of its drawing, the finesse of its modeling and lighting effectively communicating the artist's classicizing ambitions.

fig.3

fig.5

fig.4

The Good Mother

The Good Mother

La bonne mère
Oil on canvas, 18½ × 22¼ in. (47 × 56.5 cm)
Gift of Mrs. Herbert Fleishhacker. 54.2 (de Young)

Provenance Probably in the Le Dart de Caen sale, Paris, Hôtel Drouot, 24 April–4 May 1912, no. 111 (presumably the dimensions are reversed in the catalogue); acquired by M. Cordonnier (Wildenstein 1960, no. 8); [Wildenstein & Co., Inc., Paris]; anonymous sale, Paris, Hôtel Drouot, salle 1, 12 December 1925, no. 95, repr. (*The Virgin at the Cradle*); Mr. and Mrs. Herbert Fleishhacker, San Francisco, by 1934; gift to the de Young, 1954.

References Réau 1932, 101; *The Art Quarterly*, Autumn 1954, 299; P. Wescher, "Neuerwerbungen des De Young Museums in San Francisco," *Kunstchronik*, October 1957, 311; Wildenstein 1960, no. 8, fig.3; *European Works* 1966, 192, repr.; Wildenstein and Mandel 1972, no. 8, repr.; M. A. Morris, *European Paintings of the Eighteenth Century* (London: Frederick Warne, 1981), 22; exh. cat., 1982 New York, 55, mentioned under no. 16; T. Lefrançois, "Les peintures provençales anciennes des Fine Arts Museums de San Francisco," *Bulletin Mensuel de l'Académie de Vaucluse*, January 1985, 4; exh. cat., 1987-1988 Paris-New York, mentioned under no. 10, fig.9.

Exhibitions 1934 San Francisco, no. 31; 1977 Cincinnati, no cat. no.; 1980 Japan, no. 1, repr. in color.

Variants

PAINTINGS
The Holy Family, copy after Rembrandt
Oil on canvas, 37⅞ × 29½ in. (91 × 75 cm)
Private collection, 1960; present location unknown
PROV: Boucher sale, Paris, 18 February 1771, no. 111; exhibited for the last time in Paris, Arnold Seligmann & Co., Inc., 1934, no. 27.
REF: Wildenstein 1960, no. 7, fig.2.

The Young Mother, partial copy after Rembrandt
Oil on canvas, 19¼ × 23¼ in. (49 × 59 cm)
PROV: H. R. Stirlin Oboussier, Saint-Prex, Switzerland, 1960.
REF: Wildenstein 1960, no. 9, fig.4.
NOTE: Probably the painting of the same dimensions, present location unknown, reproduced by K. E. Maison, *Themes and Variations* (London: Thames and Hudson, 1960), pl. 149.

The Cradle, partial copy after Rembrandt
Oil on canvas, 19¼ × 23¼ in. (49 × 59 cm)
Private collection, England, 1960
PROV: Gow sale, London, Christie's, 28 May 1937, no. 90, repr.; acquired by Watelin.
REF: Wildenstein 1960, no. 10, fig.5.

Mother and Child, partial copy after Rembrandt
Oil on canvas, 16½ × 22 in. (42 × 56 cm)
PROV: F. Kleinberger sale, New York, American Art Association, 18 November 1932, no. 28, repr.

The Young Mother, partial copy after Rembrandt
Oil on canvas, 19¾ × 23⅝ in. (50 × 60 cm)
Private collection, 1960
REF: Wildenstein 1960, no. 11, fig.6.

Related Work

PAINTING
Rembrandt, *The Holy Family with Angels*, fig.1
Oil on canvas, 46⅛ × 35⅞ in. (117 × 91 cm)
S.d. at bottom left: *Rembrandt f. 1645*
Hermitage, Leningrad. 741
REF: Lacurne de Sainte-Palaye, *Catalogue des tableaux du cabinet de M. Crozat, baron de Thiers* (Paris: De Burl l'Aîné, 1755), 15.

During Fragonard's apprenticeship with Boucher (ca. 1748-1752) he made a number of copies after the master; *Hercules and Omphale*, now lost, is just one example. But Fragonard also showed a great interest in and appreciation of artists from the northern school such as van Mol, the Wouwermans, van Ostade, and particularly Rembrandt, whose works he studied in the cabinets of the great Parisian *amateurs* of the period. From the collection of Baron Crozat de Thiers, which was bought by Catherine the Great in 1772, he copied three paintings by Rembrandt: *The Sweeper*, *Danae*, and *The Holy Family with Angels* (fig.1). Rembrandt's celebrated *Holy Family* was copied scrupulously by Fragonard (at an unknown date) in a canvas that his master Boucher

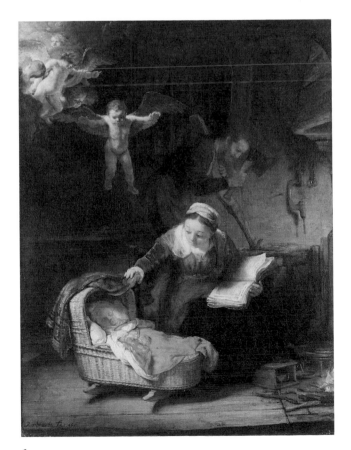

fig.1

kept until his death. Presumably Fragonard later executed a series of smaller pictures based on the Virgin and Child in Rembrandt's composition, including San Francisco's *The Good Mother*, but these are difficult to date.

A comparison of Rembrandt's painting with Fragonard's version in San Francisco shows that Fragonard not only reduced the subject to two figures, but took other liberties with the composition as well. He places the Virgin and Child closer together, necessarily modifying the position of the right arm of the young woman; the presence of Joseph is evoked only by the representation of a few carpenter's tools, which hang on the wall above the book. By these means he focuses on a secular mother with her child, suppressing the religious character of the Rembrandt painting.

What distinguishes Fragonard's rendition from Rembrandt's is the former's extraordinary ease and brio in the handling of the brush. Instead of a meticulous depiction of the interwoven ribs of the cradle, Fragonard offers only a suggestion of composition, not substance. Drapery is merely sketched, and the play of the brush is evident throughout, rendering the effects of light by creamy white pigment. Even more stunning is Fragonard's ability to recreate the atmosphere of his model, skillfully managing the chiaroscuro and masterfully producing the half-tones and shadows so much admired in the Dutch painter's work. This canvas shows none of the weaknesses of the young Fragonard's work in Boucher's studio, but rather the technique of a more mature artist, perhaps ca. 1762-1763, after Fragonard's return from his first Italian sojourn. *The Good Mother* exemplifies a popular theme treated by Fragonard and other late eighteenth-century artists.[1] However, Fragonard's rendition of this subject varies widely, from the wholesome nature of *The Cradle* (Musée de Picardie, Amiens) to the risqué *The Good Mother* (private collection, Switzerland).[2]

1. See Carol Duncan, "Happy Mothers and Other New Ideas in French Art," *The Art Bulletin* 55, no. 4 (December 1973): 570-583 (in particular, 572, note 6).

2. Exh. cat., 1987-1988 Paris-New York, no. 159, repr.

The Useless Resistance

La résistance inutile

Oil on panel (an exotic tropical wood, probably of the mahogany family), 9½ × 12¾ in. (24 × 32.5 cm)
Mr. and Mrs. E. John Magnin Gift. 63.33 (de Young)

Provenance Probably in the anonymous sale, Paris, Hôtel de Bullion, 8 July 1793, no. 16; G. Muhlbacher, Paris; Muhlbacher sale, Paris, Galerie Georges Petit, 13-15 May 1907, no. 20, repr.; David David-Weill, Paris, 1907-1939; [Wildenstein & Co., Inc., New York]; Mr. and Mrs. E. John Magnin, New York, 31 October 1939; gift to the de Young, 1963, but remained with Mr. and Mrs. Magnin in New York until 1975.

References Guiffrey 1907, 105; Grappe 1913, 2:72, repr.; Henriot 1925, 5; Henriot 1926, 141-142, repr.; Wilenski 1936, 163, pl. 72a; Guimbaud 1947, 53; Réau 1956, 159, 251; Wildenstein 1960, 262, no. 278, pl. 47; Ananoff 1961-1970, 2:53; Wildenstein and Mandel 1972, no. 296, repr.; Lee 1980, 219, fig.10 on 216; T. Lefrançois, "Les peintures provençales anciennes des Fine Arts Museums de San Francisco," *Bulletin Mensuel de l'Académie de Vaucluse*, January 1985, 4; W. Wilson, *California Museums* (New York: Abrams, 1985), 73-74, pl. 63; T. Hoving, "The Grand Tour: Rating California Art Museums and Their Contents," *Connoisseur*, February 1987, 96, repr. in color, 97; P. Rosenberg, exh. cat., 1987-1988 Paris-New York, mentioned under no. 146, fig.2.

Exhibitions 1907 Paris, no. 144; 1937 New York, no. 21; 1942 New York, no. 21; 1978-1979 Denver-New York-Minneapolis, no. 18.

Variants

PAINTING
Attributed to Abbé de Saint-Non, *The Resistance* or *The Dispute*, copy after Fragonard, **fig.1**
Oil on canvas, 9⅞ × 13 in. (25 × 33 cm)
Wadsworth Atheneum, Hartford. 1960.262
PROV: [Wildenstein & Co., Inc.]; Robert Lehman, New York.
REF: Wildenstein, "L'Abbé de Saint-Non: Artiste et Mécène," *GBA*, November 1959, 239, no. 16 (inventory after Saint-Non's death).

ENGRAVINGS
N.-F. Regnault, after Fragonard, *La résistance inutile*, **fig.2**
REF: Portalis 1889, 330, no. 144.

Gérard (or Géraud) Vidal, after Fragonard, *La résistance inutile*
REF: Le Blanc 1854-1890, 4:120, no. 9; Portalis 1889, 330, no. 143.
NOTE: This is pendant to a print after Borel entitled *Il a cueilli ma rose*, and shows a boy behind the woman and a cupid at the foot of the bed.

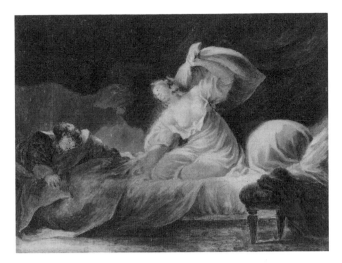

fig.1

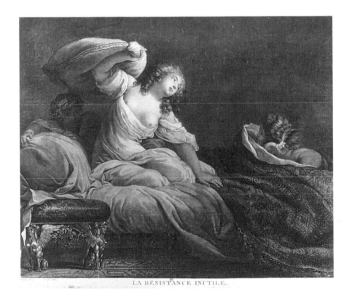

fig.2

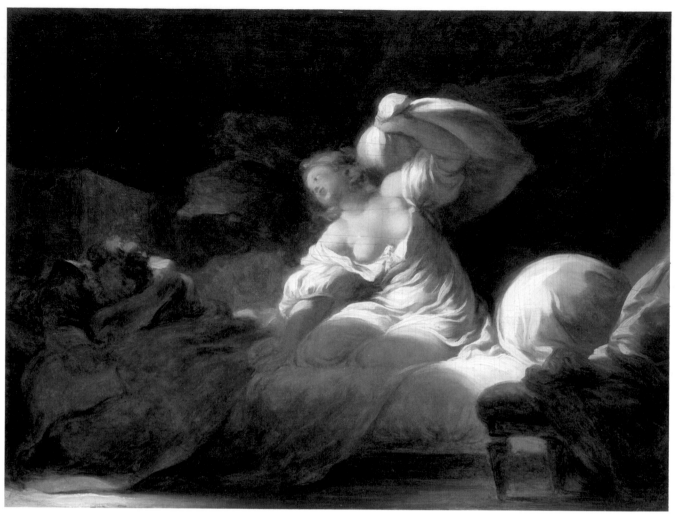

The Useless Resistance

Related Works

PAINTINGS

The Useless Resistance, fig.3
Oil on canvas (oval), 17 ¾ × 23 ⅝ in (45 × 60 cm)
Nationalmuseum, Stockholm. NM 5415

The Resistance, lost
Oil on canvas, 17 5/16 × 15 in. (44 × 38 cm)
PROV: Baron de [Saint-Julien] sale, Paris, 14 February 1785, no. 108.
REF: Wildenstein 1960, no. 277.

DRAWING

The Useless Resistance or *The Happy Moment*
Black crayon, brush and brown wash, heightened with watercolor,
9 1/16 × 13 ⅝ in. (230 × 347 mm)
George M. Cheston, Philadelphia
EXH: 1987-1988 Paris-New York, no. 146, repr.

fig.3

Fragonard's oeuvre includes a number of compositions entitled *The Useless Resistance* or *The Resistance*. In those that are aptly titled, such as the Stockholm painting (**fig.3**), a playful struggle between a young man and young woman in various stages of dishabille amid bed-sheets and pillows is usually depicted. The outcome of these struggles is never in doubt, as Love inevitably triumphs. These *sujets galants* were popular with eighteenth-century *amateurs* and Fragonard treated these themes with zest and flair, as well as with the consummate skill of a draftsman and colorist.

In the San Francisco panel, however, the recipient of the young woman's pillow attack is not a young man, but a boy, and we cannot be sure of their relationship. The picture was engraved by Regnault (**fig.2**) and Vidal with some embellishments, notably the cupid at the foot of the bed, which immediately gives an erotic meaning to the composition. It is probable that from these engravings the picture received the title *The Useless Resistance*, although originally it might have been called simply *Young Woman Attacking a Boy with a Pillow*.

While the provenance of this painting cannot be traced during the nineteenth century, it is probable that it is the picture (9 × 12 *pouces*, no support given) "representing a young girl on a bed playing with her pillow," which was sold in Paris 8 July 1793, no. 16. The artist's longtime friend, Abbé de Saint-Non, made a rather heavy, uninspired copy after the San Francisco panel (**fig.1**).

This little painting is of stunning quality. The brushwork is lively and purposely imprecise; the vaporous atmosphere augments the ardently sensual conception of the artist, imbuing the work with poetry. The light is hot and amber, a characteristic feature in the work of Fragonard, which mitigates any hint of acidity in the delicate strokes of green and pale red in the figure of the boy and in the cushion at right behind the bolster. Through-

out the composition, repeated touches of green and off-red create an overall harmony. Equally remarkable is the spontaneity of movement that Fragonard captures on a diagonal in the cascade of draperies and the brilliant motif of the young woman. Chiseled in thick impasto, this figure seems like the subject of a precocious oil sketch, but is more convincing and real than many a finished work.

The panel is difficult to date exactly, but its facture is similar to that of Fragonard's *All in a Blaze* and *The Stolen Shift* (both Musée du Louvre, Paris), and *The Desired Moment*, also called *The Happy Lovers* (private collection, Switzerland). Perhaps it can be placed in the late 1760s or early 1770s before Fragonard returned to Italy for the second time. This charming and imaginative work is a remarkable example of a genre in which Fragonard excelled. He painted more audacious subjects, but always in the bright and expansive manner of this irresistible little picture.

Baron François-Pascal-Simon Gérard

Rome 1770-1837 Paris

Baron François-Pascal-Simon Gérard spent his early childhood in Rome. There his father, who had married an Italian, was administrator of the household of Cardinal de Bernis, the French ambassador to the Holy See. When his family returned to Paris, Gérard demonstrated his gifts as a draftsman as early as 1782, apprenticed to the sculptor Pajou, and then in 1784 with the painter Brenet. Two years later he entered David's studio. He was awarded second place in the *Prix de Rome* in 1789 with his painting *Joseph Recognized by His Brothers* (Musée des Beaux-Arts, Angers), but had to renounce competition the following year because of his father's death. In an era when revolutionary turmoil was not favorable to artistic activity, Gérard supported his family by illustrating editions of *Virgil* and *Racine* published by Didot Frères. He already had exhibited at the Salons of 1791 and 1793, but it was not until the Salon of 1795 that *Belisarius* (formerly in the Leuchtenberg Gallery, Munich) won him public recognition. His first portraits date from this period. He won fame for the elegance and psychological insight of such portraits as *The Painter Isabey*, which was exhibited at the Salon of 1796, and *Comtesse Regnault de Saint-Jean d'Angély*, which was much admired at the Salon of 1799 (both Musée du Louvre, Paris).

Gérard achieved true success the following year when Bonaparte asked him to execute official portraits and the Ossian decor for Malmaison. His portraits of the imperial family, dignitaries of the Consulate and the Empire, and nobles from all over Europe left him little time to devote to new history paintings. Nevertheless, he exhibited the *Battle of Austerlitz* in 1810 (Château de Versailles). The fall of the Empire did not hinder Gérard's career. Presented to Louis XVIII by Talleyrand, he executed a standing *Portrait of Louis XVIII* (1814, Château de Versailles). He received a commission for *Henry IV Entering Paris* (Château de Versailles; smaller version in Musée Municipal, Chartres), a monumental canvas exhibited at the Salon of 1817 that celebrated the return of the Bourbons to power. In addition to numerous portraits, in 1819 Gérard painted *Corinne at Cape Misène* for Augustus of Saxony (Musée des Beaux-Arts, Lyon) and exhibited *Daphnis and Chloe* (Musée du Louvre, Paris) at the Salon of 1824. To illustrate the resurgence of religious sentiment in royalist circles, Châteaubriand commissioned *Saint Theresa* (1827, Infirmerie-Sainte-Thérèse, Paris).

From 1820 Gérard's portraiture shows a decline. Although handicapped by failing health and eyesight, under the July Monarchy of 1830 Gérard painted four colossal figures for the History Gallery of Versailles. He also resumed decoration of the four pendentives of the cupola of the Panthéon, commissioned in 1820 but not completed until 1836.

At his death in 1837 Gérard had long since obtained all possible honors. Chevalier of the Legion of Honor since the creation of the order in 1802, he became an officer in 1824, *premier peintre* for Empress Josephine in 1806, professor at the Ecole des Beaux-Arts in 1811, member of the Institute of France in 1812, chevalier of the Order of Saint Michael in 1816, *premier peintre* to the king in 1817, and baron in 1819. In addition, he was a member of most of the academies of Europe.

Not a single study of his complete works has been done in the twentieth century, although his portraits have been the subject of a thesis by Alain Latreille (1973).

Comtesse de Morel-Vindé and Her Daughter *or* The Music Lesson

Comtesse de Morel-Vindé et sa fille
Oil on canvas, 79 × 56¼ in. (200 × 143 cm)
Museum purchase, Mildred Anna Williams Fund and William H. Noble Bequest Fund. 1979.8 (CPLH)

Provenance Charles-Gilbert More, vicomte de Morel-Vindé, Paris, 1799-1842; legacy to his granddaughter, Claudine-Renée-Christine Terray, comtesse de Narcillac, "the large painting by Gérard representing all that I have had most dear in the world, my wife and my daughter" (codicil to his will, 12 October 1835; AN, Minutier Central, III-1529, 5 January 1843), 1843-1872; legacy to her elder son, Comte Ernest de Narcillac, "the large painting by Gérard representing my grandmother and my mother," in accordance with her will dated 22 April 1865, recorded by Me Jean Dufour (notary), Paris, 27 August 1872 (étude de Me Léon Dufour, 15 boulevard Poissonnière, Paris 2ᵉ); Comte Ernest de Narcillac, Bellevue, 1872-1911; sold to his nephew, Comte Alain de Maingard, for 8,000 francs, 15 January 1911 (Museums' files); private collection, branch of the family outside of France; [Galerie Brame and Lorenceau, Paris, ca. 1978]; acquired by the CPLH, 1979.

References *Mercure de France*, Frimaire, year IX [November 1800], 2:361-362; Blanc 1862-1863, 3:8, s.v. "Gérard"; Gérard 1886, 1:9, and 2:404; Thieme and Becker 1907-1950, s.v. "Gérard"; Latreille 1973, 151-152, no. 126, fig.12; A. Temko, "The New Legion Look—Very French," *San Francisco Sunday Examiner and Chronicle*, "World," 9 December 1979, 38, repr.; S. Blair, "TFAMSF: Tilting the Balance," *Triptych*, Spring 1980, 3, fig.1 on 2; *Apollo*, March 1980, 247, fig.5; GBA, "La Chronique des Arts," no. 1346, suppl., March 1981, 38, no. 206, repr.

Exhibition Salon of 1799, no. 716.

Comtesse de Morel-Vindé and Her Daughter *or* The Music Lesson

fig. 1

Variants

PAINTING

Comtesse de Morel-Vindé and Her Daughter, studio reduction of the portrait, fig. 1

Oil on canvas, 12 3/16 × 8 5/8 in. (31 × 22 cm)

Musée National de Versailles. MV 4856

PROV: Gérard sale, Paris, "in his house, rue Saint-Germain-des-Prés, no. 6," 27-29 April 1837, no. 26 (collection of 84 portraits in small format "of which many have been made under the eye of M. Gérard and touched up by him"). The entire collection was acquired by the Musée National de Versailles.

REFS: Bénézit 1976, s.v. "Gérard"; Constans 1980, no. 1881.

ENGRAVING

Pierre Adam, after Gérard, 1825

REFS: Gérard 1852-1857, 1:n.p.; Henri Béraldi, *Les graveurs du XIXᵉ siècle* (Paris: L. Conquet, 1885-1892), 1:14.

The execution of this important painting can be dated from a letter written by Gérard on 21 Nivôse, year VII [10 January 1799] to the Citizen de Vindé. The painter requested of the latter "that these ladies leave their home to come and pose in the studio in spite of the cold of January."[1] Charles-Gilbert de Morel-Vindé (1759-1842), who commissioned the work, had come out of a clandestine life only a few years earlier. Member of the Parliament of Paris since 1778, he had adopted the Revolutionary principles with moderation and in 1790 had been asked to preside over one of the six tribunals of the capital. After the king's flight to Varennes the following year, he resigned and retired from public life. As much from inclination as from caution, and to divert the suspicions aroused by the considerable fortune he had inherited in 1789 from his maternal grandfather, Paignon-Dijonval, he devoted himself exclusively to agricultural research, literature, and his collections of

books and paintings begun by his grandfather. We know that he enriched considerably the Paignon-Dijonval library and also acquired at the sales of Destouches (21 March 1794), Godefroy (2 April 1794), and Tolozan (23-26 February 1801) a great number of seventeenth-century paintings, which are found in the catalogue of the sale of his collection, 17 December 1821. By 1797-1798 he had just published an essay, *Les révolutions du globe*, and his novels, *Primerose* and *Clémence de Lautrec*, and was still to publish a great number of books on agriculture and animal husbandry. He came out of private life only after the Bourbons returned to power. Peer of France and hereditary baron in 1815, member of the Conseil Supérieur de l'Agriculture in 1818 and hereditary vicomte in 1819, he was elected member of the Academy of Sciences in 1824.[2]

In 1780 he married Marie-Renée-Elisabeth Choppin d'Arnouville (1763-1835), the daughter of the first president of the Cour des Monnaies, portrayed here at the age of thirty-six.[3] J.-A. Barral reports that this young magistrate

understood that happiness does not lie in the excessive satisfactions of pride and affluence. He proved it, upon his entry into society, by resisting the advice of those who wanted to arrange a successful marriage for him which would lead to high positions of Court and State. He . . . took as his wife the woman he loved; he could have contracted a wealthier alliance, but none which better matched his rank nor held more pledges of affection and devotion. . . . Through this union he obtained fifty years of the sweetest felicity.[4]

An act of guardianship of 2 April 1784 tells us that the young couple had two daughters, Claire-Marie and Cécile-Louise, and that apparently one of them died while very young.[5] Family tradition identifies the young girl in San Francisco's painting as Claire de Morel-Vindé (1782-1806). However, if we believe Vicomte A. Révérend, who is generally well informed, it could be only "Cécile-Louise, born in Paris on 18 December 1782, died . . . ; married on . . . January 1800 to Claude-Hippolyte Terray, *préfet*."[6] Whether it is Claire-Marie or Cécile-Louise, it is easy to recognize this young girl of about seventeen as the only Mlle de Morel-Vindé mentioned by all the biographers, who had four children from her marriage to a nephew of Abbé Terray: a son, Charles-Louis Terray, vicomte Terray de Morel-Vindé (1803-1866); and three daughters—Marquise de Belboeuf, Vicomtesse de Merinville, and Comtesse de Narcillac, who inherited this painting from her grandfather.[7]

Family tradition also reports that the canvas represents a salon in the Hôtel de Vindé, boulevard de la Madeleine in Paris, at the place where the Cité Vindé stood in the past. Charles-Gilbert de Morel-Vindé was living at 11 boulevard de la Madeleine at the time of his

death on 19 December 1842.[8] According to Barral, *he engaged in various successful speculations with which he rapidly increased his wealth. He had predicted that all the properties along the boulevards from rue Richelieu to the Madeleine were to gain in value in the near future. Thus he acquired the* hôtel *where the Passages de l'Opéra and the Hôtel de Paris are today, where the Cité Vindé has been built.*[9]

It appears probable that Gérard scrupulously reproduced the salon of the home of the Morel-Vindés, and also represented the boulevard, as it was then, through the window. In a letter of January 1799 addressed to Citizen de Vindé, Gérard added as a postscript: "Please send me one of the turned-back chairs which are in your cabinet."[10] The modern character of the furniture should be noted. The mahogany chair mentioned above with a turned-top crosspiece, an openwork design on the back, and two saber-shaped back legs is indeed characteristic of the work of the Jacob brothers, ca. 1800. It is particularly close to a chair in the antique style at Malmaison that bears the stamp *Jacob Frères* of the rue Meslée (1796-1803).[11]

The subject of the painting corresponds perfectly to the sentimentality of the era. The title of the sheet of music placed on the pianoforte, "to my mother," seems to indicate that the young girl, accompanying herself, has just finished singing a melody composed for her mother. The performance over, she turns toward her mother to judge the effect. Mme de Morel-Vindé only moderately expresses her satisfaction, even though her daughter affectionately presses her hand. The work was not overlooked during its exhibition at the Salon of 1799. The publisher of the *Mercure de France* wrote:

In the painting which depicts a young girl turning from her piano to take the hand of her mother, it is impossible not to be struck by the manner in which the head of the young girl is lighted; her pose is perhaps not very natural, but it is an apt choice for making the figure stand out, and this figure is full of expression and life. I do not like the strong colors that dominate the mother's clothing, and I find it difficult to believe that the painter was not embarrassed by the choice.[12]

Charles Blanc, sixty years later, noted that "through his skill, the painter has been able to preserve the grace in the constrained movement" with which the young girl turns toward the viewer. He adds,

one senses immediately in front of this portrait, as before so many others that Gérard painted subsequently, that it is not only a faithful image that he wished to produce, but also a composition that does honor to the acuity of his intellect. We see only too well that he has taken great care to express at the same time the tender affection that unites mother and daughter, the studious tastes and talents of the young lady, and to make a complete painting with these two figures. Later, he would use

with less discretion this art of compositional organization, of which he was the master par excellence, and he would give even more importance to the external aspect of his composition, at the expense of sentiment and truthfulness.[13]

This painting is perhaps somewhat stilted, with the studied spontaneity and affected grandeur that characterize many of the portraits Gérard painted in his maturity. But the subdued expression of the figures and the elegance and balance of the composition prevent it from falling into preromantic melodrama. The color scheme is based on a combination of ochre and white, which is found again, for example, in *Portrait of Josephine* (Hermitage, Leningrad), and is representative of the taste of portraitists under the Consulate and the Empire. Great faithfulness in the rendering of the materials, an expressive and sensitive analysis of faces, extraordinary refinement of the facture, and technical virtuosity as demonstrated in the treatment of the landscape seen through the muslin curtains make this ambitious portrait a masterpiece.

1. Bibliothèque d'Art et d'Archéologie, Paris, *Autographes des peintres*, carton 14.

2. A. Révérend, *Titres, anoblissements et pairies de la Restauration 1814-1830* (Paris: H. Champion, 1901-1906), 5:191-193.

3. M.-R.-E. Choppin d'Arnouville's birth certificate, Arch. de Paris, V2E, 278, 23 February 1763.

4. J.-A. Barral, *Eloge historique de Charles-Gilbert de Morel-Vindé* (Paris: La Maison Rustique, 1860), 7.

5. Arch. de Paris, DC⁶28, fol. 10.

6. Révérend, *Titres*, 5:193.

7. Révérend, *Titres*, 5:193.

8. AN, Minutier Central, III-1529, 5 January 1843.

9. Barral, *Morel-Vindé*, 11-12.

10. Barral, *Morel-Vindé*, 11-12.

11. Serge Grandjean, *Empire Furniture 1800-1825* (London: Faber & Faber, 1966), pl. 8a; Guillaume Janneau, *Les sièges* (Paris: Jacques Tréal, 1974), no. 329.

12. *Mercure de France*, Frimaire, year IX [November 1800]:2:361-362.

13. Blanc 1862-1863, 3:s.v. "Gérard."

General Rapp Reporting to Napoleon the Defeat of the Russian
Imperial Guard, Austerlitz (2 December 1805)

General Rapp Reporting to Napoleon the Defeat of the Russian Imperial Guard, Austerlitz (2 December 1805) (*studio of Gérard*)

Général Rapp annonce à Napoléon la défaite de la Garde Impériale Russe, Austerlitz (2 décembre 1805)
Oil on canvas, 18 ½ × 39 ½ in. (47 × 100 cm)
Mildred Anna Williams Collection. 1965.27 (CPLH)

Provenance Perhaps the "reduction made under the eyes of Baron Gérard, and in which the figures added to enlarge the original, are entirely by his hand," sale of Gérard's studio, "at his house, rue Saint-Germain-des-Prés, no. 6," Paris, 27-29 April 1837, no. 28 (sold for 690 francs); [F. Kleinberger & Co., New York]; acquired by the CPLH, 1965.

Reference GBA, "La Chronique des Arts," February 1967, 95, no. 335.

Exhibitions 1969 Kansas City, no. 30; 1974 Santa Barbara, no. 11.

Variants
PAINTINGS
The Battle of Austerlitz, fig.1
Oil on canvas, 16 ft. 8 ½ in. × 31 ft. 5 in. (5.10 × 9.58 m)
Galerie des Batailles, Musée National de Versailles. MV 2765
PROV: Napoleon wished the painting to constitute the ceiling of the Conseil d'Etat, Palais des Tuileries, so Gérard added four allegorical figures at the sides to hold the canvas as if it were a tapestry being unrolled; taken down in 1815; King Louis-Philippe asked Gérard in 1832 to increase the height by 82 cm, and placed it in the Musée du Louvre, Room of the Seven Chimneys, as pendant to another work by Gérard, *Henry IV Entering Paris*; eventually placed in Versailles.
REFS: Gérard 1886, 2:122-123, 416; P. de Nolhac and A. Pératé, *Le Musée National de Versailles* (Paris, 1896), 42, 315; A. Pératé, *La Galerie des Batailles du Musée de Versailles*, 2d ed. (Paris: Henri Laurens, 1930), 18, repr. on 58; Constans 1980, no. 1866.
EXH: Unfinished at the Salon of 1808, but listed as no. 239; exhibited at the Salon of 1810, no. 347.

The Battle of Austerlitz, fig.2
Oil on canvas, 54 ½ × 122 in. (141 × 310 cm)
Present location unknown
PROV: Perhaps the reduction executed for General Rapp; perhaps in the inventory of General Rapp's house on rue Plumet, 15 January 1822, no. 890; acquired by Jean-Jacques Regis Cambacérès (1753-1824), duc de Cambacérès; by family descent to Comte de Cambacérès; Calvin Bullock Collection, New York, 1937; sale, London, Christie's, 8 May 1985, no. 126, repr. in color.
REF: Gérard 1886, 2:122-123.

The Battle of Austerlitz
PROV: Original sketch in the Paillet collection, 1846.
REF: Constans 1980, mentioned under no. 1866.

ENGRAVINGS
Jean Godefroy, after Gérard, 1813
REFS: Gérard 1852–1857, 2:n.p.; Henri Béraldi, *Les graveurs du XIX^e siècle* (Paris:L. Conquet, 1885-1892), 7:168; Gérard 1886, 2:416.

C.-M.-F. Dien, after Gérard
REF: Gérard 1886, 2:416.

A.-F. Pannemaker, after a drawing by G.-A. Harang
REF: Blanc 1862-1863, 3:9, s.v. "Gérard."

Related Works
DRAWINGS
Portrait of Maréchal Duroc (1772-1813)
Graphite, 10 ¼ × 7 ½ in. (260 × 190 mm)
On the verso (in French): *Maréchal Duroc, duc de Frioul, study drawn by Gérard for his painting of the Battle of Austerlitz*. Annotated at the bottom: *after nature September 1810*. This may be an erroneous date as *The Battle of Austerlitz* was exhibited at the Salon of 1810 from 5 November, and preparatory studies probably would have been completed earlier.
PROV: Formerly coll. P.-F.-L. Fontaine; sale Mme Gustave Meunié, Paris, Galerie Jean Charpentier, 14 December 1935, no. 19.

General Rapp
Black chalk, 9 ^13/16 × 11 ⅜ in. (250 × 290 mm)
Cab. des Dess., Musée du Louvre, Paris
EXH: Paris, *Napoléon et la Légion d'honneur*, June 1968, no. 212.

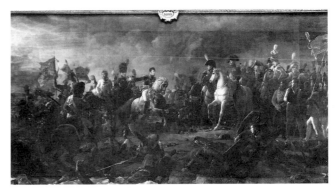

fig.1

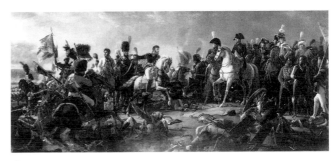

fig.2

In this important composition Gérard chose to illustrate the decisive moment in the battle of Austerlitz, which took place on 2 December 1805 near a small town in Moravia. Having to pit his strength against the combined forces of the Emperors Francis I of Austria and Alexander I of Russia, Napoleon did not hesitate at the peak of the battle to enlist the help of the Mamelukes and the light cavalry of his Imperial Guard. He entrusted their command to his aide-de-camp, General Comte Jean Rapp, who already was famous for his bravery at Szeiskam, and especially at Sediman and Samanhout during the German and Egyptian campaigns. Soon Rapp was engaged in battle with Alexander's horse guard, but with the aid of Napoleon's horse grenadiers he succeeded in scattering the enemy. The colonel of the Russian horse guard, Prince Repnin, and two hundred under his command were taken prisoner. The entire artillery of the Russian imperial guard also was captured, and more than five hundred lay dead on the field. The moment of the painting occurred when, *surrounded by his general staff, Napoleon received Rapp, returning wounded and covered with blood, followed by the prisoner Prince Repnin, and made a great display of satisfaction. . . . It was one o'clock in the afternoon and victory was no longer in doubt.*[1]

In Gérard's work the emperor is on horseback among twelve of his generals, among whom the Maréchaux Bessières and Berthier and Generals Duroc and Junot are meticulously represented. Thus one would be tempted to identify the saber hanging from Rapp's right wrist, clearly evident in the center of the painting, as "a curved blade of damascene steel, handle and scabbard richly decorated with gilt silver and engraved, of beautiful workmanship," which was given to the general by the Mameluke chieftain Mourad Bey and used "at Austerlitz where he covered himself with glory."[2] But the painter does not limit himself here to a simple juxtaposition of portraits. Depicting the end of the battle in the distance, a vanquished and fleeing army is seen. With the perspicacity of a cold and discerning mind and a clarity of order admired by Guizot at the Salon of 1810, Gérard paradoxically succeeds in portraying Napoleon on his white horse as the principal actor. The artist contrasts the excitement of General Rapp, who rushes in to announce the victory, with the impassivity of the supreme commander who already knows the outcome he has planned and foreseen.

General Rapp's personal art collection of twenty-eight modern paintings and forty-two older works included seven canvases by Gérard, among them the famous *Cupid and Psyche* from the Salon of 1798. It is known that Gérard promised to make a copy of his famous *Battle of Austerlitz* for General Rapp because of a letter he wrote to the artist from Danzig on 6 December 1810: *The* Moniteur, *my dear Gérard, has given your painting*

of Austerlitz well-deserved praise. . . . Some time ago you promised a copy that could serve as a family memorial for me. I have no doubt that a beautiful replica will come out of your studio, and I am sure that it will be worthy of you; but I would like to know when I will have it. Tell me how you are progressing and what size it will be. If you need an advance of money, do not hesitate to ask. . . .[3]

In a subsequent letter dated 12 June 1811, also written from Danzig, the general reminded the painter: "As for the painting of Austerlitz, I am awaiting your price. I am ready to pay at any time."[4]

Although the catalogue of the Rapp estate sale does not mention this work,[5] nor is it found in the estate sale of his widow,[6] the 1822 inventory made after General Rapp's death describes a copy of Gérard's *Battle of Austerlitz.*[7] Thus we know that the commission was completed and delivered to the General. The dimensions cited in the inventory (175×350 cm, which possibly included the frame) are comparable to the reduction later owned by the Cambacérès family. Pierre Lavayassière believes this painting was bought by Duc de Cambacérès from General Rapp's estate (fig.2).[8] Because only one other reduction is known from the sale of the artist's studio in 1837 (without dimensions), it is probably the San Francisco version. However, it is impossible to be certain.

1. Adolphe Thiers, *Histoire du Consulat et de l'Empire* (Paris: Paulin, 1845-1874), 6:324.

2. Comtesse Rapp estate sale, Paris, 15 June 1830, no. 31.

3. Gérard 1886, 2:122.

4. Gérard 1886, 2:123.

5. General Comte Rapp estate sale, Paris, "in his *hôtel*, rue Plumet, no. 29, at the corner of boulevard Mont-Parnasse," 11 March 1822.

6. Comtesse Rapp estate sale, Paris, "in her *hôtel*, rue Pigale, no. 18," 15 June 1830.

7. Inventory made after the death of General Rapp, Paris, at his *hôtel*, rue Plumet, 15 January 1822, no. 890. (AN, Minutier Central, M. C.-Etude I-787.)

8. Letter, 2 October 1986.

Jean-Baptiste Greuze *Tournus 1725-1805 Paris*

Jean-Baptiste Greuze studied in Lyon with Grandon, the town's official painter, then went to Paris about 1750. A protégé of J.-A. de Silvestre, he was Natoire's pupil at the Royal Academy of Painting and Sculpture, but did not follow the official path of the *Grand Prix* or of an academic career. Nevertheless, he was made an associate of the Academy in 1755, which enabled him to exhibit at the Salon. Critics acclaimed his work, original for the middle of the century—moralizing family scenes brightened by sensuality, even daring. From the beginning of his career, Greuze appeared to be an attentive observer, a disciple of the Dutch masters with a love for his subject matter, but with a more "delicate spirit and sensibility," according to Diderot. In 1755 he left for Naples with Abbé Gougenot, then went to Rome for about one year. From this Italian sojourn he absorbed less of the lesson of antiquity than he did a taste for the picturesque. This taste was manifested in works he exhibited at the Salon of 1757, such as *The Lazy Italian Girl* (Wadsworth Atheneum, Hartford) and *The Neapolitan Gesture* (Worcester Art Museum).

With *The Village Betrothal* exhibited at the Salon of 1761 (Musée du Louvre, Paris), Greuze started a new trend which was to have great success—genre painting elevated to the level of history painting. Encouraged by his friend Diderot, he aspired to the *grand genre* and executed *Emperor Severius Reproaching His Son Caracalla for Wishing to Assassinate Him* (1769, Musée du Louvre, Paris). This painting earned Greuze membership in the Academy, not as a history painter as he had hoped, but as a painter of genre scenes. The artist was so embittered that he did not exhibit again at the Salon until 1800. He continued to show his paintings in his studio, however, and earned the support of the most enlightened minds of the time in Russia as well as in France. Diderot did not cease praising Greuze until the Salon of 1771, although by 1769 it was apparent that he no longer felt as warmly toward the artist's work. Fluctuating in style between Chardin and Hogarth, Greuze's genre paintings grew unfashionable by 1780 and he began to devote himself to portraiture, for which he had demonstrated a talent as fine as that of M.-Q. de La Tour, and a feeling for the immediate that was reminiscent of Rembrandt. But portraits such as *Bonaparte* (Château de Versailles), *Fabre d'Eglantine* (Musée du Louvre, Paris), or *Citizen Bernard Dubard* (page 182) probably show less technical virtuosity than emotion and sincerity.

Greuze's art is by no means sentimental. Rather it is sensual, troubling, and at times ambiguous. Perhaps better than any other artist of his generation, he understood the ideals of Poussin and wished his art to uplift the soul. He tried to introduce the teachings of the Bible into his scenes of contemporary life, an attempt that foreshadowed David by twenty years, although David used technical means diametrically opposed to those of Greuze.

Despite Diderot's reasoned analysis, Greuze has fallen in critical estimation and popularity since the eighteenth century. Regardless of the excellent works of Louis Hautecoeur,[1] Edgar Munhall,[2] and Anita Brookner (1972), the artist has never regained the position with the general public that was rightly his during his lifetime. The 1976-1977 Hartford-San Francisco-Dijon exhibition organized by Edgar Munhall was the first comprehensive showing of Greuze's work.

1. Louis Hautecoeur, *Greuze* (Paris, 1913).
2. Edgar Munhall, "Greuze and the Protestant Spirit," *The Art Quarterly* 27, no. 1 (1964):1-21; "Les dessins de Greuze pour 'Septime Sévère'," *L'Oeil* (April 1965):22-29, 59; "Quelques découvertes sur Greuze," *La Revue du Louvre*, no. 2 (1966): 85-92.

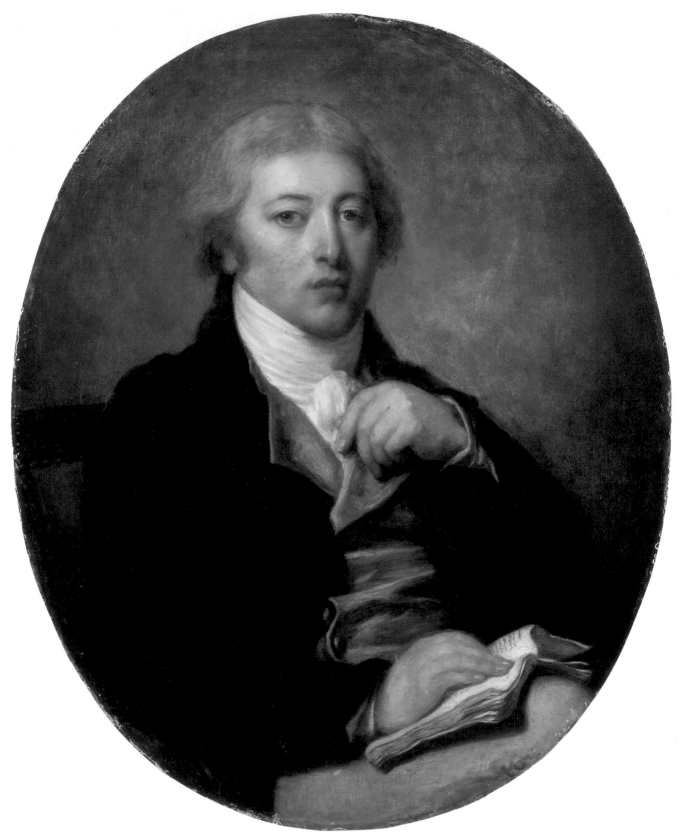

Citizen Bernard Dubard

Citizen Bernard Dubard

Citoyen Bernard Dubard
Oil on elm panel (oval), 26 ¼ × 21 ¼ in. (67 × 54 cm)
S.d. on the back: *Peint par J. B. Greuze 1799*, **fig.1.**
Museum purchase, Archer M. Huntington Fund. 1935.3
(CPLH)

The original text (in French) of a torn label has been
reconstructed thanks to the entry in the exh. cat., 1913
Paris (Galerie Philipon), no. 17:
Bernard Dubard, born at Dijon
in 1767
He became successively Paymaster to the Division of
Marine
at Besançon and at Rouen.
He was nominated 16 Floréal year VII [5 May 1799]
Private Paymaster to the First Consul.
21 Messidor of the same year [9 July 1799]
he became General Treasurer of the contributions
for the Italian Army.
On 21 May 1808 Paymaster for the 18th
Military Division at Dijon
and later Paymaster at
Limoges and Mâcon.
He died at Montfort-l'Amaury (Seine and Oise)
1 June 1829.

Provenance Perhaps in the Leyland collection, England, ca. 1833,
according to Wildenstein & Co., Inc. (but not in the Leyland sale,
London, Christie's, 28 May 1892, nor in previous Leyland sales); Val-
court collection, also according to Wildenstein; [Wildenstein & Co.,
Inc., New York, 1913-1935]; acquired by the CPLH, 23 March 1935.

References *Illustrated Handbook* 1942, 47, repr.; *idem*, 1944, 51,
repr.; *idem*, 1946, 55, repr.; Davisson 1944, 98-100, repr. on the
cover; *Handbook* 1960, 62, repr.; Brookner 1972, 132, pl. 92; M. A.
Morris, *European Paintings of the Eighteenth Century* (London: Fred-
erick Warne, Ltd., 1981), 33.

Exhibitions 1913 Paris (Galerie Philipon), no. 17, repr.; 1923 New
York, no. 10, repr.; 1923 St. Louis, no. 11, repr.; 1934 San Francisco,
no. 32; 1943 New York (Wildenstein), no. 11, repr.; 1963 Cleveland,
no. 61, repr.; 1976-1977 Hartford-San Francisco-Dijon, no. 111, repr.

fig.1 (detail with signature)

This remarkable portrait, the exact provenance of which
is far from established, constitutes a major late work by
Greuze. Curiously, what we know about the sitter
comes primarily from a short manuscript biography in
French, pasted on the back of the panel, but now par-
tially torn (see above). The *Imperial*, then *Royal*,
Almanachs permit us to follow the career of this "field
agent of the Public Treasury" at Dijon until 1817.[1] The
Almanach Royal of 1818 informs us that Dubard, a
knight of the Legion of Honor and one of the "field pay-
masters for the Royal Treasury charged with the acquit-
ting of public expenses in the departments and the
ports," held the post of second class (out of four classes)
at Dijon until 1822.[2] He held the same position in
fourth class at Limoges for the Haute Vienne in 1823
and 1824,[3] and then at Mâcon for the Saône and Loire
regions from 1825 to 1829.[4] He died June 1829 and the
Almanach Royal from the following year informs us
that Dubard *fils* had replaced Dubard at his post in
Mâcon in the third class.[5]

Greuze painted this successful accountant at the age
of thirty-two when he was a rising figure in the new
society and the future treasurer of Napoleon Bonaparte.
We know that the artist benefited from the goodwill of
David and from the friendship of Mme Roland and
other highly influential persons, so that his old, aristo-
cratic clientele was soon replaced by members of the
new generation of the Revolution.

Although dated 1799, this portrait is quite close in its
conception to the *Portrait of Napoleon Bonaparte*
(1792, private collection, Paris) in rigor and austerity. In
its simple, coldly elegant drawing, it is related to an
important contemporary portrait in Saint-Omer (Musée
des Beaux-Arts)[6] that arguably represents Talleyrand,

Bonaparte, or Barbaroux. The clothing, the position of the torso, and the crossed legs are practically identical, which would seem to indicate that in his final years Greuze tended to repeat attitudes or motifs that had been successful. Ingres was inspired by this same prototype for his famous *Portrait of Philibert Rivière* (ca. 1804-1805, Musée du Louvre, Paris).

Dubard's portrait shows all the characteristics of Greuze's later work, already noticeable in his portraits of the convention members *Armand Gensonne, Fabre d'Eglantine* (Musée du Louvre, Paris), and *Jurisconsul Cambacérès* (Musée de Chartres)—a somber but not brownish palette, the play of whites and blacks against a neutral background, vivid and colorful flesh tones highlighted with bluish shadows in the lower part of the face, and a use of the medium that is both thick and somewhat chalky. In this and similar paintings, Greuze breaks with the seductive virtuosity and shimmering colors of the eighteenth century in favor of a more sober art that aims at depicting the essential. His old manner is recalled only in the delicate harmony of Dubard's almond green vest against the violet back of the chair. *Dubard*, with its simplified composition, large and solid facture, and the candid melancholy expression of the young man who retains something of adolescent ingenuousness, appears to directly foreshadow the masterworks of Géricault and Delacroix.

1. *Almanach Imperial* 1809, 590; 1810, 610; 1811, 659; 1812, 686; 1813, 680; 1814-1815, 581; *Almanach Royal* 1816, 656; 1817, 695.

2. *Almanach Royal* 1818, 704; 1819, 668; 1820, 690; 1821, 702; 1822, 711.

3. *Almanach Royal* 1823, 715; 1824, 755.

4. *Almanach Royal* 1825, 681; 1826, 680; 1827, 690; 1828, 215; 1829, 217.

5. *Almanach Royal* 1830, 237.

6. Mauclair [1906], no. 1251.

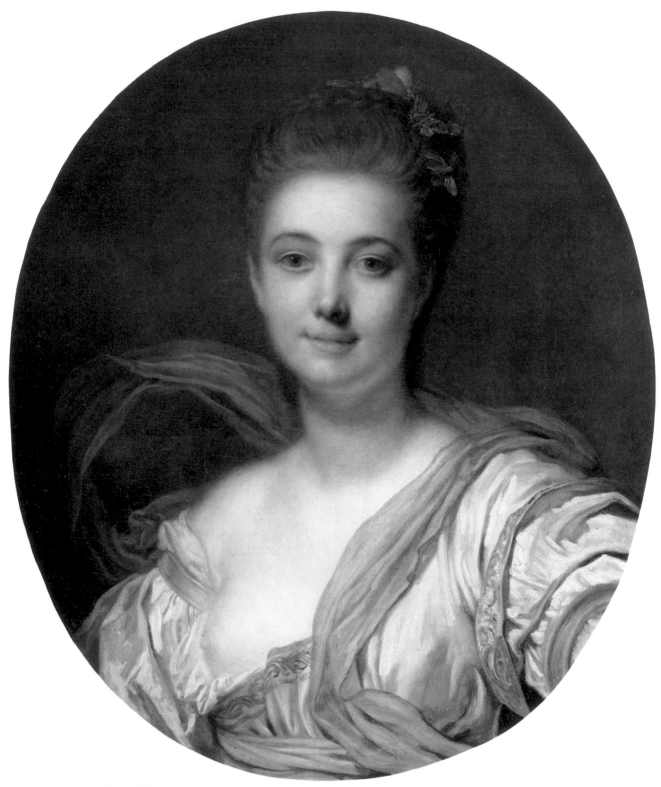

Portrait of a Young Woman

Portrait of a Young Woman

Portrait d'une jeune femme
Oil on canvas (oval), 22¼ × 18¾ in. (56.5 × 47.5 cm)
Gift of Brooke Postley. 61.49 (de Young)

Provenance Adolphe de Rothschild, Paris, after 1880-1885 (Dacier 1911, 260); (a label on the back of the painting says "Salon Rouge, Greuze," and may refer to its location in the house of Adolphe de Rothschild); [René A. Trotti, Paris, ca. 1900]; Mrs. Clarence Postley, Paris, then New York, by 1911; included in the Andriesse, Bergmann, etc., sale, New York, Parke-Bernet, 24 February 1949, no. 83, repr. (as "La Marquise d'Avricourt"), but was returned to its owner; inherited by Brooke Postley, Greenwich, Connecticut; on loan to the de Young, 24 April 1956; gift to the de Young, 1961.

References Dacier 1911, 259-260; *The Art Quarterly*, Winter 1961, 402, fig.1 on 399.

Variant

ENGRAVING
E.-M.-L. Chiquet, after Greuze, *Portrait de jeune fille*
REFS: Dacier 1911, repr. opposite 260; Thieme and Becker 1907-1950, s.v. "Greuze"; and Bénézit 1976 s.v. "Greuze."

This beautiful young woman has been called Marquise d'Avricourt (1949) and Mlle de Ménars (1961) in sales catalogues, but her true identity remains unknown. As she wears a loose white robe trimmed with gold, her right breast exposed, and her hair dressed with butterflies, it is tempting to think of her as an actress. However, research at the Bibliothèque de l'Opéra and the Comédie française has proved that she is not Mme Dugazon or any of the famous leading ladies of the Parisian theater in the latter half of the eighteenth century.

The oval format was a favorite of Greuze, who found it a flattering and graceful shape for his portraits of young women. The facture in this portrait envelops its subject, especially in the treatment of the flesh, attenuating to a degree the physical flaws. This helps date the picture ca. 1775-1780, halfway between *Portrait of Marie-Jeanne Bécu, Comtesse du Barry* (ca. 1771)[1] and *Portrait of Comtesse Schuvalov* (before 1781, Hermitage, Leningrad). Other characteristics of Greuze's style are a taste for crisp but rounded drapery, which is visible in such paintings as *Wavering Virtue* (Alte Pinakothek, Munich) and *The Broken Jug* (Musée du Louvre, Paris). Greuze's *Young Woman with a Spaniel*, a presumed portrait of *Mme de Porcin* (Musée des Beaux-Arts, Angers),[2] reveals a Raphaelesque manner in the use of flying veils and scarves, as does the San Francisco portrait.

This admirable portrait, which has suffered from unsuccessful relining, reveals a surprising lightness, fluidity, and delicacy. It is the work of an artist who knows how to paint the curve of a young woman's shoulder and bosom to best effect. Greuze employs a refined palette, balancing a harmony of grays against the brilliance and rosiness of flesh. One might reproach the artist for the absence of psychological depth. He seems to have been content merely to look at the sitter's face, rendering her youth and grace, but also, perhaps, her superficial character. Whatever the case, this portrait provides an interesting contrast with Greuze's portrait of *Citizen Bernard Dubard* (page 182). The former is the incarnation of charm; the latter is freer in technique and more austere in composition, but perhaps greater in its psychological understanding of the sitter.

1. Exh. cat., 1976-1977 Hartford-San Francisco-Dijon, no. 74, repr.
2. Exh. cat., 1976-1977 Hartford-San Francisco-Dijon, no. 72, repr.

The Painter Jean-Baptiste Greuze

The Painter Jean-Baptiste Greuze
(*school of Greuze*)

Le peintre Jean-Baptiste Greuze
Oil on canvas (oval), 25 × 20½ in. (63.5 × 52 cm)
Mr. and Mrs. E. John Magnin Gift. 75.18.11 (de Young)

Provenance Jules Duclos, according to Mauclair [1906], no. 1135 (but not in his sales of 19 December 1853; 14 February, 23 March, 20-21 November, and 23 December 1878); Gustave Rothan, Paris; Rothan sale, Paris, Galerie Georges Petit, 29-31 May 1890, no. 154; acquired by M. Foinard for 3,150 francs (Mauclair [1906], no. 1135); anonymous sale, Paris, Hôtel Drouot, salle 6, 10 June 1893, no. 24, repr.; Léopold Goldschmidt, Paris, according to the Stern sale cat. (but not in his sale of 14-17 May 1898); Comte A. Pastré, Paris, according to the Stern sale cat.; [Wildenstein & Co., Inc., 1929]; Mrs. Benjamin Stern, New York; Stern sale, New York, American Art Association, Anderson Galleries, Inc., 4-7 April 1934, no. 837, repr.; acquired by H. E. Russell for Mr. and Mrs. E. John Magnin, New York; gift to the de Young, 1975.

Reference Mauclair [1906], 70, no. 1135.

Exhibitions 1939 San Francisco, no. 117, repr.; 1942 New York, no. 24.

This portrait is particularly enigmatic. The only fact of which we can be sure is that it represents the painter Greuze. Although the pose of the sitter is identical to the major known self-portraits of the artist—the model shown at bust-length in three-quarter profile turning to the right—we know of no other self-portrait of this type by the artist, and the style seems unlike the hand of Greuze. The features are nearly identical to those of the superb self-portraits dated 1785 (Musée du Louvre, Paris) and 1804 (Musée des Beaux-Arts, Marseille). While Greuze appears somewhat younger in the Museums' painting than in the other works, he is older than in the self-portrait ca. 1745-1750 (Musée Greuze, Tournus). A wash drawing showing him in profile (The Ashmolean Museum, Oxford), which was engraved in 1763 by Flipart, seems to have been executed at about the same time. Greuze is represented here in all the arrogance of his forty years, and he looks out at the spectator in a proud and almost ironic manner, clearly a man who is sure of himself. The studied carelessness of his dress, a white cravat hastily knotted around the neck, is typical of portraits of artists, but the painter also is elegantly attired in a violet dressing gown over a blue waistcoat trimmed in yellow, and his hair is curled and powdered.

While similarities in the brushwork in the treatment of the face and in the overall conception of the work relate this canvas to the *Self-Portrait* in the Musée du Louvre, Paris, in which the artist is about sixty years old, this canvas may not be by the same hand. The palette is less austere than Greuze's, less Rembrandtesque, and the general effect is more luxuriant. This fine work was probably painted by one of Greuze's best students or followers. In particular, it resembles the portrait of *Jean-Baptiste Greuze* (Musée des Beaux-Arts, Dijon), attributed to Ledoux, whom we know was a talented student of the painter. In both paintings there is the same contrast of the face, delicately described and carefully observed, with the clothing so broadly sketched that it appears almost unfinished.

As Ledoux was born only in 1767, it is improbable that she could have painted this portrait unless it was a later version of an unknown self-portrait lost today. The attribution to Mayer, another fine student of Greuze who was also a close friend, is even less likely. The true author of this canvas may never be identified.

Portrait of a Man

Johann-Ernst Heinsius

Hildburghausen (?) 1740-1812 Orléans

Although this artist belongs to the German school by birth, it is appropriate to include him among the French painters with whom the essential part of his career developed and whose example he followed. Nothing is known about his early training. Johann-Ernst Heinsius began his profession as a painter around 1767 in the court of Charles Augustus, grand duke of Saxony-Weimar. He then worked in the Weimar Palace (destroyed by fire in 1774), executed six allegories of the fine arts for overdoors in the Green Salon in the Castle of Heidecksburg, Rudelstadt, and painted portraits of princes and princesses. In 1772 he replaced Löber as first court painter at Weimar and as curator of the grand duke's picture gallery.

Between 1770 and 1775, in spite of his official duties in Germany, Heinsius also received commissions in the north of France. In Lille in 1771 he executed the portraits of *M. and Mme Charles Lenglart*,[1] and four years later in Douai he drew portraits of *Laurent Venant Desmolins* and his wife, *Françoise Rémy de Campeau* (Musée Municipal, Douai). It is probable that at the same time he executed the *Portrait of François de Bérenger*, Commissioner General of the Artillery in Douai (formerly in the collection of Mme Rieffel). Heinsius exhibited three canvases at the Salon in Lille in 1774, then came to Paris where he met the pastelist Boze, with whom he collaborated for a time. "Fait à Paris" appears on the back of some of his canvases around 1779, the same year he exhibited the *Portrait of Faujas de Saint-Fond* at the Salon de la Correspondance.[2] His fame as a portraitist soon spread in the capital and at Versailles, and he became acquainted with members of the households of the king and queen, the d'Ossun and the Bazin families, and had the honor of painting portraits of Louis XVI's aunts (*Mme Adélaïde*, 1785 and 1788, and *Mme Victoire*, 1786, Château de Versailles). The number of existing replicas testifies to their success. At the beginning of the Revolution Heinsius took refuge in Orléans, painting miniatures in 1790. Although traveling frequently to Paris, he lived there until his death in 1812.

His oeuvre can be divided easily into three periods. Until about 1775 Heinsius's style was marked by a dry and awkward manner (*Portrait of a German Lady*, Musée des Beaux-Arts, Troyes). From his contact with French artists, Heinsius's handling became more supple and graceful, and his psychological insight more truthful, while he retained both his vigor and love of realism. The charming portrait of *Mlle Françoise Bazin* (1793, formerly in the collection of Gordon Bennett) is perhaps his masterpiece. In the last phase of his production, the painter endeavored successfully to satisfy with creative austerity the desires of a new clientele, evident in the portrait of *Maréchal Augereau* (Musée Carnavalet, Paris).

Charles Oulmont, whose richly illustrated monograph on Heinsius (1913; 1970) has not been replaced, has rightfully emphasized the importance of this highly uneven artist. With Ducreux and Duplessis, Heinsius is certainly one of the more visible figures in a small group of portraitists prior to David whose innovative role has been underestimated in the history of eighteenth-century French painting.

1. E. Kraemer sale, Paris, Galerie Georges Petit, 28-29 April 1913, no. 29.
2. Sale, Paris, Hôtel Drouot, 5 February 1947, no. 24.

Portrait of a Man
Portrait d'homme
Oil on canvas, 24 × 20⅛ in. (61 × 51.5 cm)
Museum purchase, Archer M. Huntington Fund. 1933.9
(CPLH)

Provenance [Paul Cailleux, Paris (sold as Heinsius)]; [Dr. Siegfried Aram, New York, by 1932]; acquired by the CPLH, 1933 (as Duplessis).

Despite the inscription on a label on the stretcher of this painting, "J[oseph]-S[iffred] D[uplessis] 1725-1802. Portrait de M. du They," there is every reason to agree with the late Paul Cailleux, who sold this painting as by Heinsius. The palette of pale, grayish tones in which the colors blend as in a pastel is characteristic of this artist, and is found again, with the same blurred treatment of the batiste cravat, in *Portrait of a Man* (s.d. 1779, formerly in the Trézel collection).[1] The dark brown shadow under the nose is a true tic of the painter. The studied hairstyle of the sitter, in contrast to the vaporous rendering of costume and background, reappears in *Portrait of M. Riau* (s.d. 1777, Musée des Beaux-Arts, Rouen).[2] The simplicity of the pose, in which the sitter's torso is turned at a three-quarter angle, the absence of any superfluous ornamentation, and the concentration of the painter's efforts on the expression of the eyes and mouth are all arguments favoring this attribution.

The traditional identification of the sitter as a "M. du They" is difficult to accept. Research has failed to locate such a family. Perhaps there was a connection with the old du Teil family of Provençal origin, which might explain the former attribution to Duplessis, a painter born in Carpentras. However, in the absence of any further information, we must label the sitter of this vibrant portrait unknown.

While Heinsius primarily executed portraits of women, it is his portraits of men that more often hold the viewer's attention. An attempt at sincerity, tempered by soft brushwork and a muted palette, constitutes the appeal of this canvas. It was probably painted near the peak of Heinsius's career, somewhere between the *Portrait of Abbé Calonne* (1773, formerly in the Pollien collection),[3] where one notes a similar modeling of the face, and *Portrait of a Man* (1784, formerly in the Jaffé collection in Hamburg).[4] The latter work is similar to the Museums' portrait not only in pose, but also in treatment of clothing, especially the rendering of the small parallel pleats at the top of the sleeve.

1. Oulmont 1970, 62-63, no. 47, pl. 26.
2. Oulmont 1970, 58, no. 41, pl. 23.
3. Oulmont 1970, 42-44, no. 25, pl. 14.
4. Oulmont 1970, 81-82, no. 66, pl. 45.

Jean-Baptiste Huet *Paris 1745-1811 Paris*

The son of a painter in the king's household, Jean-Baptiste Huet spent his childhood among the artists lodged at the Louvre. He first studied under Dagomer, a painter of animal scenes. He then entered the studio of Le Prince and his career developed rapidly. Accepted by the Royal Academy of Painting and Sculpture in July 1768, he was elected to membership the following year as a painter of genre scenes with *Mastiff Attacking Geese* (Musée du Louvre, Paris). He exhibited regularly at the Salon from 1769 to 1787 (except 1783) and from 1800 to 1802 with pastorals, shepherd scenes, and animal subjects. In 1779 he tried unsuccessfully to be accepted by the Academy as a history painter.

A prolific draftsman and primarily a painter of animals, Huet was admired also as a decorator. A number of his drawings were engraved by G.-A. Demarteau, Bonnet, Jubier, and others. It is interesting to note that the Revolutionary period had little influence on his style. Although he often imitated Boucher and Le Prince, continuing to work in their style under the Empire, Huet was much more inventive in his animal paintings. While certainly influenced by Oudry, they demonstrate a vivid palette and remarkable boldness of execution.

When his painting became unfashionable after 1789, Huet devoted his time to engraving, publishing his sketchbooks in 1796. His series of prints intended for teaching sold easily. He ended his days, however, in almost total obscurity.

The study by Claude Gabillot (1892) is still the most important source for Huet.

fig.1 (detail with signature)

fig.2

Fox in a Chicken Yard

Un renard dans un poulailler or *Un renard qui fait fracas dans un poulailler*
Oil on canvas, 38 × 51¾ in. (96.5 × 131.5 cm)
S.d. lower left: *J. B. huet. 1766*, **fig.1**
Gift of Mrs. Frank Wilkins in memory of Charles Le Gay. 50558 (de Young)

Provenance Mrs. Frank Wilkins, San Francisco, before 1923; gift to the de Young, 1923.

References Des Boulmiers 1769, 196; Bachaumont 1780, 62; Gabillot 1892, 48, 50-51, 150; Dacier 1909, 89, repr.; *Illustrations of Selected Works* 1950, 74, repr.; Diderot 1957-1967, 4:103; *European Works* 1966, 193, repr.; Bordeaux 1977, 36; Bellier and Auvray 1979, 2:787; Lee 1980, 222, fig.18 on 221; exh. cat., 1984 Langres, no. 17, repr.

Exhibitions Salon of 1769, no. 138; 1975-1976 Toledo-Chicago-Ottawa, no. 48, pl. 104; 1978-1979 Denver-New York-Minneapolis, no. 22.

Variant
ETCHING
J.-B. Huet, **fig.2**
S.d. *1780*, with an annotation in drypoint needle: *Letronne*. The reverse of the plate contains four etchings by Huet: three pastorals and *Mastiff Attacking Geese* (*Un dogue se jetant sur des oies*) after his reception piece.
REF: Roux et al. 1931–1977, 11:430, no. 15.
NOTE: Contrary to Gabillot (1892, 50), it is not the artist's son who executed the etching of the painting, but Huet himself. The date of the etching makes the attribution to Huet *fils* impossible, as he was born in December 1772. The annotation by drypoint, "Letronne," remains unexplained.

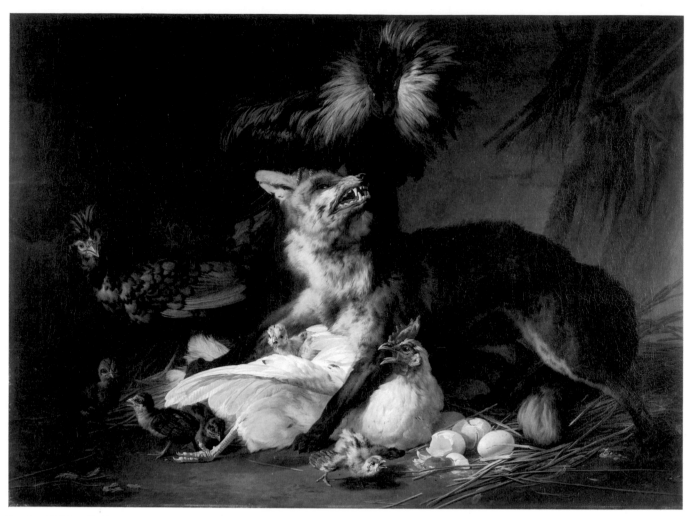

Fox in a Chicken Yard

Related Work

DRAWING

G. de Saint-Aubin, after Huet, in his *livret* of the Salon of 1769, **fig.3**
Cab. des Est., BN, Paris
REF: Dacier 1909, 2:89.

Huet exhibited at the Salon for the first time in 1769, presenting about fifteen works. These included animal scenes, notably his reception piece, *Mastiff Attacking Geese* (Musée du Louvre, Paris), as well as *The Dairy Maid, Moonlight*, some flower paintings, and some drawings including one religious subject. San Francisco's painting was indeed shown at this time, as confirmed by the sketch that Gabriel de Saint-Aubin made at the end of his copy of the *livret* (**fig.3**).

The paintings Huet exhibited there enjoyed some success. The publisher of *L'Avant-Coureur* on 25 September 1769 remarked that the artist's animal paintings "are treated with all the fury of the brush combined with good compositional principles. His color is true and thickly applied."[1] However, some contemporary viewers were critical. Bachaumont wrote:
Huet, who has devoted himself particularly to animals, charms the crowd with a Fox in a Chicken Yard, *etc. This demonstrates, Sir, that there is some truth in these paintings nevertheless criticized by connoisseurs, but then what isn't criticized? Some think . . . that the hens look like bats.*[2]
Diderot, after having mentioned several of Huet's paintings, including San Francisco's, added: "Out of all this there is only one thing to say. There is not enough draftsmanship, and what there is is so discordant that the vigor of the brushwork makes it even more offensive. Without harmony there is no salvation."[3] Nevertheless, at the same time Des Boulmiers wrote in the *Mercure de France* that "his *Fox in a Chicken Yard* is the painting that honors him most and that could rank him among the most skillful painters in this genre."[4]

This opinion was not entirely shared at the end of the nineteenth century. Gabillot, the biographer of the Huets, knew the composition only from the engraving. He found that "the hens accept the visit of the intruder with far too much calm; it is as if they were afraid to disturb the economy of the composition; this painting is not as good as his reception piece."[5] Perhaps Huet might be reproached for a lack of forceful expression that would have more strongly rendered the brutality of the action. However, while the painter remains obviously dependent on Oudry's teaching in such a work, he shows his knowledge in the rendering of the animals and succeeds in creating a colorful and animated composition, full of picturesque details and vitality. The canvas also indicates the quasi-historical conception of animal paintings by Huet's contemporaries who, in their zeal, at times looked for the feelings, passions, and suffering of man in these inferior beings.

1. Collection Deloynes 9, 137.
2. Bachaumont 1780, 61-62.
3. Diderot 1957-1967, 4:103.
4. Des Boulmiers 1971, 97:279.
5. Gabillot 1892, 50.

fig.3

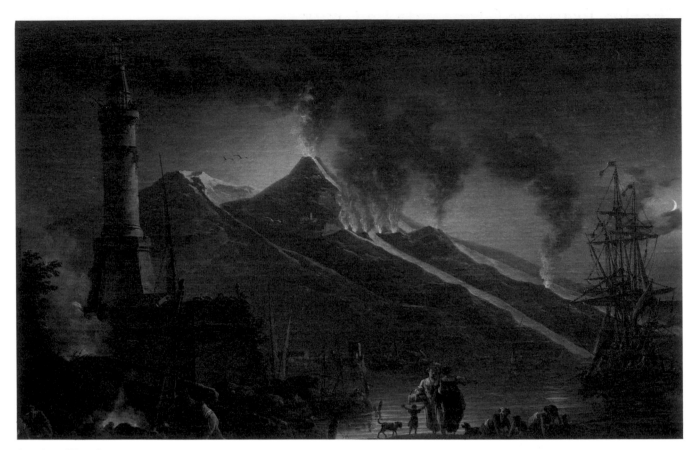

Eruption of Vesuvius

Charles-François Grenier de La Croix, called Lacroix de Marseille

Marseille ca. 1700-1782 Berlin (?)

Little is known about Charles-François Grenier de La Croix, whom the Italians called *della Croce*, and who has never been the subject of a major study. His first known paintings are two pendant seascapes, signed and dated 1743, *Italian Port at Sunrise* and *Italian Port at Sunset*.[1] He was certainly in Rome in 1754, where he met Marquis de Vandières, and in Naples in 1757 where he painted Vesuvius and the local countryside. He exhibited his painting *View of the Bridge and the Castle of Sant'Angelo* at the Salon du Colisée in Paris in 1776. In May 1780 the following advertisement appeared in Paris: "M. Delacroix, painter of Architecture, of Marines, and of Landscapes, who has long resided in Italy, proposes to take pupils at his home, rue de Vaugirard, by the Luxembourg."[2] He participated in the Salon de la Correspondance in Paris in 1780 and 1782. After spending many years in Italy as well as working in France, La Croix died in Berlin in November 1782, according to Pahin de la Blancherie, a contemporary of the artist. He was never a member of the Royal Academy of Painting and Sculpture.

In Rome La Croix undoubtedly knew Manglard, a renowned seascape painter from Lyon, as well as Claude-Joseph Vernet, whom he sometimes copied and whose style he often imitated. Although La Croix may have borrowed the subjects of his landscapes from Vernet—seascapes, seaports, storms—his style and manner differ appreciably. Vernet is generally more realistic than La Croix, who distinguishes himself from the Avignon master by a taste for fantastic architecture, *capricci*, and compositions that are more ambitious and often more descriptive, linking him sometimes to Gaspard Dughet and sometimes to Rosa. It seems, however, that La Croix must have come under another influence—no less important than the first—that of the Italian landscape painters such as Ricci and Zuccarelli. This influence is particularly noticeable in his treatment of figures. Finally, it should be noted that all the known works of this artist are open-air views where the sea or waterfalls are strongly emphasized. His numerous works were popular in the eighteenth century, as the engravings of Le Veau and Le Mire attest.

1. *Tableaux de maîtres anciens*, exh. cat. (Paris: Galerie Heim, 1956), nos. 15-16.
2. *Annonces, Affiches et Avis Divers*, 3 May 1780, 1021.

Eruption of Vesuvius
Eruption du Vésuve
Oil on canvas, 20¾ × 33½ in. (53 × 85 cm)
S.d. lower left: [*La*] *croix*/1762, **fig.1**
Gift of Mr. and Mrs. Prentis Cobb Hale. 1958.1 (CPLH)

Provenance Perhaps in the Dennoor sale, 14 March 1797, no. 82 ("view of an eruption of Vesuvius, view of the Château de l'Oeuf, H. 19 *pouces*: L. 30 *pouces*" [ca. 51 × 81 cm]); gift to the CPLH, 1958.

Reference T. Lefrançois, "Les peintures provençales anciennes des Fine Arts Museums de San Francisco," *Bulletin Mensuel de l'Académie de Vaucluse*, January 1985, 4.

fig.1 (detail with signature)

fig.2

fig.3

fig.4

Related Works

PAINTINGS

View of Vesuvius at Night, 1767, **fig.2**
Oil on canvas, 19 ½ × 29 ⅛ in. (49.5 × 74 cm)
Galerie Cailleux, Paris
PROV: Colonel Charles Brocklehurst, sale, London, Christie's, 2 December 1977, no. 83, repr.
EXHS: Paris-Geneva, Galerie Cailleux, *Des monts et des eaux, paysages de 1715 à 1850*, 1980-1981, no. 12, repr.; Paris, Galerie Cailleux, *Rome 1760-1770, Fragonard, Hubert Robert et leurs amis*, 1983, no. 36, repr.

Vesuvius, **fig.3**
Oil on canvas
PROV: The Leger Galleries Ltd., London

Vesuvius
Oil on canvas, 13 ¾ × 17 ⁵/₁₆ in. (35 × 44 cm)
S.d. *1758*
PROV: Sale, Lucerne, Galerie Fischer, 16 and 17 June 1972, no. 247, repr.

ENGRAVING

N. le Mire, after Lacroix's painting *Vue du Mont Vézuve tel qu'il étoit en 1757*, 1762, **fig.4**
PROV: Cabinet of M. Duboccage, 1762.

The view of Vesuvius rising above the bay of Naples has long been a favorite subject for painters. During the eighteenth century Vesuvius was extremely active and the drama of its frequent eruptions and incandescent lava flows fascinated artists such as Lacroix de Marseille, who depicted the erupting volcano many times (see Related Works). San Francisco's painting is very similar to *View of Vesuvius at Night* (**fig.2**), notably in the handling of the landscape and the figures, although the lighthouse and the bastion on which it stands have changed sides, and some other details have been modified. These variations indicate the experiments La Croix made in composing his landscapes, while the difference in the number of craters on Vesuvius probably reflects the volcano's change in configuration over the years. In the San Francisco version, the artist seems to have been dissatisfied with the balance of the masses, moving the architectural motif to the right to achieve a more harmonious counterbalance with the mountain in the Cailleux version. The rearrangement of the composition places greater emphasis on the body of water in the foreground, and the sea is animated by reflections from the blazing volcano. In this luminist atmosphere only the mast of the ship stands out.

Eruption of Vesuvius is characteristic of La Croix's style. Typical are the slight bends in the figures of the women, their corseted full-sleeved décolleté dresses,

kneeling figures seen from behind revealing the soles of their feet, and meticulous rendering of the foliage. The little dog crossing the foreground with his tail in the air is virtually a signature device of this painter from Marseille. These elements appear frequently in his many paintings of Mediterranean ports with ships at anchor and fishermen and other workers in the foreground.

Of course, La Croix was only one of many painters attracted to this sublime spectacle.[1] Another Frenchman, Volaire, who arrived in Rome in 1764 and established himself permanently in Naples five years later, made it his speciality. His treatment is more fantastic and more visionary than La Croix's, as is evident in his large paintings in The Art Institute of Chicago and Nantes (Musée des Beaux-Arts), while La Croix's treatment of Vesuvius is more classical. The high quality and beauty of many of his canvases fully justifies the success the artist enjoyed during his lifetime.

1. See Raffaello Causa, "Foreign View-Painters in Naples," in exh. cat., *The Golden Age of Naples, Art and Civilization under the Bourbons 1734-1805*, 2 vols. (The Detroit Institute of Arts and The Art Institute of Chicago, 1981), 1:183-212.

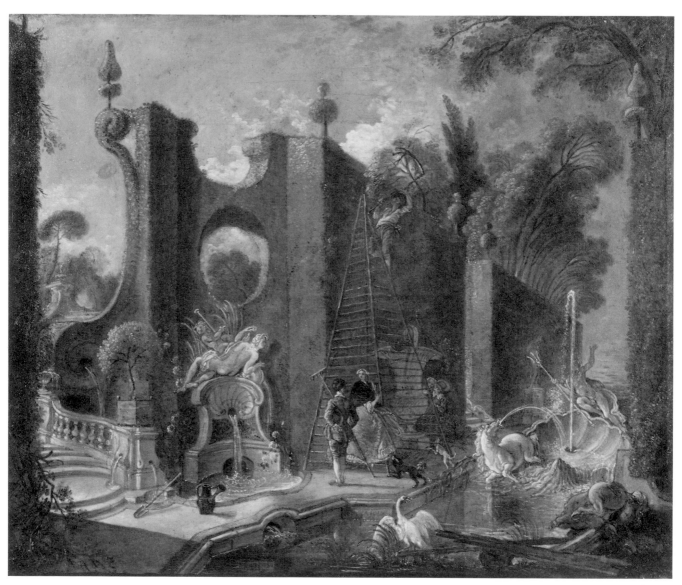

Garden Scene

Jacques de Lajoue *Paris 1686-1761 Paris*

Trained exclusively in Parisian studios, Jacques de Lajoue owes his taste for architectural landscapes to his father, an architect and master mason. In 1721 he was accepted and elected to membership in the same meeting of the Royal Academy of Painting and Sculpture with the presentation "of two paintings, each representing a perspective in a landscape."[1] At the Salon of 1725 he exhibited "three easel paintings, of a pleasing shape and composition representing architecture, landscape, and figures."[2] He acquired a reputation as a craftsman-decorator. In 1745 or 1747 he probably worked with Boucher on the fireworks for the dauphin's wedding, and around 1730 the Bâtiments du Roi commissioned three paintings intended for the comte de Toulouse. At about the same time he was also entrusted with the decorations for the Bibliothèque Sainte-Geneviève where, in spite of the difficult layout of the building, he skillfully used all the resources of perspective. This important commission assured his fame, as did his allegorical decorations *The Sciences* and *The Arts* for the cabinets of Duc de Picquigny and Bonnier de la Mosson. He participated in every Salon from 1737 to 1753.

Lajoue was primarily a painter of architectural landscapes and decorative designs in the fashionable rococo style of the age of Louis XV, which Cochin the Elder characterized as "all sacrificed to the sensation of vertigo."[3] Lajoue also painted seascapes, allegories, portraits—including one of himself and his family (Musée du Louvre, Paris)—and even religious compositions. Unfortunately, in the absence of any detailed descriptions of the paintings he exhibited in the Salons, or any mention from critics of the time, it is practically impossible to identify these paintings among his numerous extant works. We do know that *Allegory to the Glory of the King*, exhibited at the Salon of 1753, was either commissioned or purchased by Mme de Pompadour for Bellevue. The figures in his decorative canvases often drew their inspiration from engravings after Lancret, Boucher, and, above all, Watteau. His own creations—fanciful pieces, architecture, landscapes, and perspectives—were gathered together in books of cartouches and decorative designs and were known all over Europe through engravings made by Cochin the Younger, Guélard, Desplaces, and especially Huquier. Lajoue was one of the first painters whose inventiveness inspired craftsmen in the rococo. This art, which was essentially the fleeting expression of an era, went out of fashion about the middle of the century. According to Mariette, Lajoue died "disdained and unemployed" at over seventy-four years of age.[4]

The artist's works are numerous, of uneven quality, and seldom dated, which makes their chronology extremely difficult to establish. In addition to the few pages devoted to Lajoue by Marie-Louise Bataille[5] and the analysis of the relationship between Watteau and Lajoue by Jean Cailleux,[6] Marianne Roland Michel's study (1984) has answered many questions, returning this long-neglected artist to the rank he deserves.

1. *Procès-verbaux* 1875-1892, 26 April 1721, 4:313.
2. *Mercure de France*, September 1725, 2:2268.
3. C.-N. Cochin, *Mémoires inédits* (Paris: Ch. Henry, 1880), 140.
4. Mariette 1851-1860, 2:267.
5. Marie-Louise Bataille, in Dimier 1928-1930, 2:347-361.
6. Jean Cailleux, "Personnages de Watteau dans l'oeuvre de Lajoue," BSHAF 1956, 1957: 101-111.

Garden Scene
Le jardin aux fontaines et statues
Oil on canvas, 21½ × 25½ in. (54.5 × 65 cm)
Signed lower center, on the rim of the pool: *LA JOÜE*, fig. 1
Mildred Anna Williams Collection. 1960.21 (CPLH)

Provenance Count Greffulhe, London; Greffulhe sale, London, Sotheby's, 22 July 1937, no. 68; [Durlacher Bros., New York, ca. 1955-1960]; acquired by the CPLH, 1960.

References Rambo 1960, 3-6, repr.; *The Art Quarterly*, Autumn 1960, 307, repr. on 314; Ekhart Berckenhagen, *Die französischen Zeichnungen der Kunstbibliothek Berlin*, 1970:213, mentioned under no. 2473/15; Roland Michel 1984 (*Lajoue*), no. P 138, fig.129.

Exhibition 1959 Baltimore, no. 16, repr. on 46.

fig.1 (detail with signature)

fig.2

fig.3

Related Works

PAINTING
The Sleeping Gardener, **fig.2**
Oil on canvas, 12⅝ × 15¾ in. (32 × 40 cm)
Galerie Cailleux, Paris, in 1930
REF: Roland Michel 1984 (*Lajoue*), no. P 141, fig.132.

DRAWING
Garden with an Arbor, **fig.3**
Pen and gray wash on dark ground
8¹⁵⁄₁₆ × 9⅞ in. (227 × 250 mm)
Staatliche Museen Preussischer Kulturbesitz, Berlin. No. 2473 15 recto.
REF: Roland Michel 1984 (*Lajoue*), no. D 220, fig.310.

The works of Lajoue, one of the great decorators of his time, are representative of the rococo style. The spirit of fantasy in this composition is evidenced by the characteristic profusion of fountains and the complex play of their waters, the dream-like appearance of the vegetation, the massive hedges trimmed like stone walls (one pierced by a bull's-eye), a monumental scroll, and curious topiary finials. The fanciful ornamental statuary on the right is taken from Neptune's Basin at Versailles, and the Ceres at left is reminiscent of the creations of Michelangelo for the tombs in the Medici Chapel in Florence. Abundant sculptural groups seem to dominate their setting, the basin's contours are overly elaborate, and the flight of stairs has steps alternately convex and concave. In the lower right corner of the canvas, a horse sprawls over a heap of boards. All these elements demonstrate the artist's rich imagination. One is almost at a loss to tell where reality ends and ornamentation begins. This fundamental and intended ambiguity is even more pronounced in the numerous fantastic engravings after Lajoue.

The depiction of frenzied horses on the edge of rococo fountains surmounted by gesturing tritons is found again in a plate by Huquier.[1] The numerous decorative details are also very close to the motifs engraved by Lucas, Cochin the Younger, Guélard; and Desplaces.[2] Marianne Roland Michel has noted other similarities, such as the tritons, found in at least four other paintings,[3] as well as more general affinities with other works. Notable among these are *Rest in a Park*,[4] *The Sleeping Gardener* (**fig.2**), and a drawing, *Garden with an Arbor* (**fig.3**). Like these works, San Francisco's painting evokes gardening by tools such as the rake, spade, scythe, and watering can. Its composition shows the opening of the staircase on the left and lines of trees on the right that underline the deep perspective. In addition, Roland Michel finds "a mixture of naiveté and stiffness, an awkward use of various elements that had become clichés, the quasi-caricatural aspect of figures and sculptures," which lead her to place these works

late in Lajoue's oeuvre, after 1745.[5] The figures here are sketched rapidly, similar to the drawing in Berlin, and their gestures comically exaggerated as for the gardener at the top of the ladder.

Lajoue reserves his most vivid touches of color for the figures, illustrated by the red of the lady's dress in the center and the breeches of the gardener perched on the ladder. The highly decorative palette of this work is based on the contrast between the somewhat yellow vegetation and the azure sky animated with fleecy white and rosy clouds. The estimated depth of perspective suggests that this painting might have been conceived as a design for the theater. Indeed the high pillars of foliage forming boundaries on each side are similar to the wings of a stage. While a number of questions are raised by this painting, Lajoue's purpose remains primarily decorative.

1. J. G. Huquier, *Livre de divers morceaux d'architecture paysages et perspectives inventés par J. de la Joue peintre ordinaire du roi* (Paris, 1740), 2d part, 4th plate.

2. J. de la Joue, *Livre nouveau de douze morceaux de fantaisie utile à divers usages* (Paris, 1736).

3. Roland Michel 1984 (*Lajoue*), nos. P 26, 44, 98, and 165.

4. Roland Michel 1984 (*Lajoue*), no. P 139, fig.131.

5. Roland Michel 1984 (*Lajoue*), 210 (under no. P 138).

Nicolas Lancret *Paris 1690-1743 Paris*

Although little is known of the early training of Nicolas Lancret, who came from a humble family of artisans, he studied under the history painter Dulin and was expelled in 1708 from the school of the Royal Academy of Painting and Sculpture as a result of a dispute with his classmates. He then worked in the studio of Gillot, Watteau's master, who was at that time director of scene designs and costumes for the Opéra. On the advice of Watteau, whom he greatly admired, Lancret left Gillot to take nature for his master.[1] In 1711 he failed to win the *Grand Prix* as a history painter, but he was elected by the Academy in 1719 as a painter of *fêtes galantes*. His slavish imitation of Watteau soon caused a rift between the two artists.

After Watteau's death, however, Lancret benefited from the success his rival did not live to enjoy. In fact, as early as 1723 the *Mercure de France* referred to Lancret as the "student of the late M. Gillot and emulator of the late M. Watteau."[2] He participated in the Exposition de la Jeunesse from 1722 to 1725, and regularly in the Salon beginning in 1737. In 1725 he received his first commission from the Bâtiments du Roi, and his fame earned him the patronage of many *amateurs*, including Duc d'Antin, Count Tessin, Prince de Carignan, Pierre Crozat, and even Frederick II of Prussia.

Gradually Lancret broke away from Watteau's influence and developed his own style, more decorative and less poetic, although he was capable of great color intensity and a certain lyricism. He executed over seven hundred paintings, according to Georges Wildenstein (1924), producing a number of portraits and history paintings including *The Seat of Justice Held by Parliament until the King's Majority* (1723, Musée du Louvre, Paris) and *The Awarding of the Order of the Holy Spirit* (Musée du Louvre, Paris). Upon J.-B. Pater's death he finished a series of paintings after the *Contes* of La Fontaine. However, he was primarily a painter of outdoor scenes or scenes of comedy where dance, music, and, of course, the *fête galante* played a major role.

More robust than Pater, more varied in his subjects and in his search for new settings for his figures, Lancret employed a limited repertory of physiognomic types and psychological situations. "His work, a perfect and charming reflection of the spirit and customs of our eighteenth century," has been for a long time "one of the most appealing expressions of French art."[3]

1. Ballot de Sovot, *Eloge de Lancret, peintre du roi . . . , accompagné de diverses notes sur Lancret, de pièces inédites et du catalogue de ses tableaux et de ses estampes (November 1743)*, ed. J.-J. Guiffrey (Paris: Rapilly, 1874), 18.
2. *Mercure de France*, June 1723, 1175.
3. Wildenstein 1924, 37.

Suite of Four Overdoors:
The Bathers
Les baigneuses
Oil on canvas (lunette), 24 × 51 in. (61 × 129.5 cm)
Gift of Mrs. William Hayward. 52.29.1 (de Young)

End of the Hunt
Hallali
Oil on canvas (lunette), 23¾ × 53³⁄₁₆ in. (62 × 135 cm)
Gift of Mrs. William Hayward. 52.29.2 (de Young)

The Music Party
Concert champêtre
Oil on canvas (lunette), 24 × 50¾ in. (61 × 129.5 cm)
Gift of Mrs. William Hayward. 53.2.1 (de Young)

Breakfast before the Hunt
Le petit déjeuner avant la chasse
Oil on canvas (lunette), 24 × 52½ in. (61 × 133.5 cm)
Gift of Mrs. William Hayward. 53.2.2 (de Young)

Provenance Traditionally said to have been in the Château de Marly (but no document confirms it); perhaps in the Prousteau de Montlouis sale, Paris, Hôtel des Ventes, 5-6 May 1851, no. 10, backed to four Boucher canvases, now in the Wallace Collection, which formed a screen (acquired by Lord Hertford for 10,600 francs); perhaps in the collection of Lord Richard Seymour Conway, Count Yarmouth, fourth marquess of Hertford, 1851-1870; perhaps inherited by Sir Richard Wallace, Paris, 1870-1890; perhaps inherited by his widow, Amélie-Charlotte de Castelnau, 1890-1897; Sir John Murray Scott, Paris, 1897 (former secretary to Sir Richard Wallace, a legatee of Lady Wallace); inventory of Scott's belongings, 2 rue Laffitte, Paris, drawn up between 16 February and 13 March 1912, 87, no. 1136, on the third floor, Appartement Jacquemin (John Ingamells, letter, 10 May 1979); Lady Victoria Sackville, London, 1913; [Jacques Seligmann, Paris, 1914]; [M. Knoedler & Co., Inc., Paris and New York, 14 June 1914]; Morton F. Plant, New York, 1916; Mrs. William Hayward (formerly Mrs. M. F. Plant), New York, 1917-1952; gift to the de Young in two parts, 1952 and 1953.

References Yriarte 1903, 407; Duchesne 1909, 204; Wildenstein 1924, 120, nos. 743-746, figs.178-181; Seligman 1961, pl. 22a; *European Works* 1966, 178-179, repr.; *Wallace Collection Catalogues* 1968, mentioned under no. P429 on 34, 171; Ananoff 1976, 2:121 (note regarding nos. 428-431); Bordeaux 1977, 36; *Summary Illustrated Catalogue of Pictures* 1979, mentioned under P429; Mallett 1979, 199.

Exhibitions Perhaps 1888 Paris, no. 18 ("set of four pastoral subjects overdoors"); 1934 San Francisco, nos. 36-39.

Related Works

DRAWINGS
Sheet of studies, **fig.1**
Red chalk, 8 × 10⅝ in. (205 × 270 mm)
PROV: F. Bobler sale, Paris, 23 February 1906, no. 25 (attributed to Pater); Louis Deglatigny sale, Paris, Hôtel Drouot, salle 1, 4-5 November 1937, no. 224, repr.
NOTE: Directly related to *Breakfast before the Hunt* with studies of the seated man and his hands.

Man Holding a Rifle, **fig.2**
Red chalk, 7⅛ × 5⅛ in. (180 × 130 mm)
Musée Atger, Montpellier
NOTE: Preparatory drawing for the standing hunter in *Breakfast before the Hunt*.

fig.1

The provenance of this suite remains highly problematic. Traditionally the four overdoors were considered as part of the decoration at the royal Château de Marly, but this assumption appears unfounded. Engerand makes no mention of them, and they appear neither in Bailly's *Inventory* nor in later inventories.[1]

In 1851 Lord Hertford acquired from the Prousteau de Montlouis estate four important canvases by Boucher: *Venus with Vulcan, Cupid Imprisoned, Venus and Mars Surprised by Vulcan*, and the *Judgment of Paris*—all painted in 1754 and now in the Wallace Collection, London. The sale catalogue notes that the Boucher pictures "were arranged in the form of a screen, and behind each there is a pastoral landscape by Lancret."

The Paris exhibition catalogue of 1888 mentions, under the name of Lancret, no. 18, a "suite of four pastoral subjects (overdoors) belonging to Sir Richard Wallace Bar." Henri-Gaston Duchesne described the Pavillon de Bagatelle during the time it was inhabited by Sir Richard, noting "a charming ceiling by Boucher ornaments the west bedroom, and on the walls, four panels by Lancret from Marly which seem to have been created for this room."[2] The four Lancret canvases presumably remained at Bagatelle until 1904 when the pavillon was sold to the City of Paris. In 1912, they were listed among the holdings of Sir John Murray Scott in Paris.

fig.2

The Bathers

End of the Hunt

The Music Party

Breakfast before the Hunt

None of these early citations indicates clearly that these four Lancrets are the ones now in San Francisco. Moreover, the four Bouchers in the Wallace Collection are vertical paintings, only ca. 33½ in. (85 cm) wide, while the Lancret overdoors are horizontal, measuring ca. 51¼ in. (130 cm) wide. How then could these four Lancrets have been placed on the backs of the Bouchers? Either the Hertford provenance is correct, but these Lancrets were not attached to the Bouchers, or the provenance of these four works, prior to their acquisition by Sir John Murray Scott, remains unknown.

A laboratory examination of these paintings under ultraviolet light by Teri Oikawa-Picante and Bruce Miller of TFAMSF reveals considerable wear and some retouching, some of it quite old. X-rays disclose a few pentimenti and important modifications. In *The Bathers* a standing figure was originally positioned behind the young woman at right, and the woman at left was once further removed from the center of the composition. In *End of the Hunt* the head of the deer was placed higher, and the left hand of the hunter and the two hands of the woman previously hung a little lower. The left hand and foot of the hunter seated at table in the *Breakfast before the Hunt* were similarly displaced, and a second young woman originally was at the center of the composition, behind the dog between the seated woman and the standing male figures. Some of the decorative elements at the sides are cropped (such as a fountain and a pedestal), which suggests that the canvases were cut down after their execution. Perhaps they were originally rectangular or rounded to fit into the outline of a panel or an overdoor.

San Francisco's canvases are related to a series of small paintings on copper representing *The Four Times of Day*, executed before the Salon of 1741, when engravings of these four subjects by de Larmessin were exhibited. It is interesting to observe how Lancret reemploys certain motifs. There are two extant preparatory drawings for *Breakfast before the Hunt* (**figs.1-2**), which are similar in composition to *After Dinner* from the series *The Four Times of Day*. The pose of the seated young man, for example, is nearly the same in both, and the motif of the two figures at table (a gaming table in *After Dinner*) is also similar.[3] The dead deer with the hound at its side in *End of the Hunt* reappears in a picture of the same name (formerly J. Tabourier collection, Paris).[4] The seated woman in *Outdoor Concert* appears once again with a book in her lap without modifications in *The Evening Player* (formerly Baron Maurice de Rothschild collection, Paris).[5] *The Bathers* is very close in conception to a small picture engraved by Moitte, which repeats both the motif of the women, with the same half-length figures in half-tones amid the foliage in the middle ground,[6] as well as to *The Party* from *The Four Times of Day*.[7] All of these works present the same

shallow conception of space, where the vegetation in effect forms a screen behind the foreground. Thus it seems reasonable to date the San Francisco suite to Lancret's mature years (ca. 1740), and perhaps even toward the end of his career.

The subjects of these four paintings do not have any particular iconographic link, and their choice by the artist probably rests on a desire for diversity and decorative harmony. Somewhat facile in their conception, they are a long way from the poetry of Watteau's work. However, because of the naive charm of their execution and coloring, they admirably fulfill their decorative purpose.

1. Engerand 1900; N. Bailly, *Inventaire des tableaux du Château de Marly*, 1733 (AN O¹1956⁵, O¹1965 and 1966).

2. Duchesne 1909, 204.

3. Wildenstein 1924, no. 36, fig.25.

4. Wildenstein 1924, no. 442, fig.106.

5. Wildenstein 1924, no. 115, fig.30.

6. P.-E. Moitte, *Recueil d'estampes d'après les tableaux de la galerie de S.E.M. le Comte Bruhl* (Dresden, 1754), pl. 36.

7. Wildenstein 1924, no. 37, fig.36.

Nicolas de Largillierre *Paris 1656-1746 Paris*

Nicolas de Largillierre spent his youth in Antwerp where his father was a hat merchant, in 1668 becoming a student of Goubau, a painter of still-life and genre scenes. He was received as a master at the Guild of Saint Luke in 1672. He soon left for England where he worked on portraits, although it is not certain that he frequented the studio of Lely as tradition would have it. As a Catholic Largillierre encountered difficulties in England in 1678 and the next year returned to Paris where he was welcomed by the large Flemish colony.

In 1686 he was elected to the Royal Academy of Painting and Sculpture with his large *Portrait of Charles Lebrun* (Musée du Louvre, Paris). Although the major part of his work was devoted to portraiture, he occasionally tried his hand at history painting (*Moses Saved from the Water*, 1728, Musée du Louvre, Paris). A few landscapes and still lifes, probably executed early in his career, are broadly treated with simple color harmonies (Petit Palais, Paris; Musée de Picardie, Amiens; Musée de Dunkerque; Musée de Peinture et de Sculpture, Grenoble). He vied for court commissions with Rigaud, but his clientele also included members of parliament, financiers, and other wealthy bourgeois. In addition, he was asked to commemorate various events of Parisian life. For this he drew on the Dutch tradition of group portraiture (*City Council Deliberating . . . in 1687*, now lost; sketches in Musée du Louvre, Paris, and Hermitage, Leningrad) and portrayed Parisian aldermen in association with a divine apparition (*Offering to Saint Genevieve*, 1696, Church of Saint-Etienne-du-Mont, Paris). His artistic production was immense.

Largillierre was Rigaud's rival in the aesthetic domain as well. While Rigaud preferred cool hues, straight lines, and rigorous clarity of composition, it is to his Flemish training that Largillierre owed his taste for warm tones, bold, thick brushwork, and curved lines, which give his canvases an intended dynamism.

Mariette believed there were between twelve and fifteen hundred portraits by Largillierre's hand in Paris around 1750.[1] The chronology of his work, spread over sixty years, is poorly established, but some stages of his evolution emerge. The simple compositions of his youth are linked to French portraiture of the preceding generation with a distinct element of English portraiture derived from van Dyck (*A Young Man with His Tutor*, 1685, National Gallery of Art, Washington). This traditional realism, interpreted with a subtle sense of movement, is also found in his bust portraits of artists with their scaled-down and simply treated decors (*Norbert Roettiers*, Fogg Art Museum, Cambridge, or *Thomas Germain and His Wife*, 1736, Gulbenkian Foundation,

Lisbon). It is expressed as well in certain of his portraits of women where he uses a dominant chromatic—black for *The Beautiful Woman of Strasbourg* (1703, Musée des Beaux-Arts, Strasbourg) or white for the portrait of *Elizabeth Throckmorton* (1729, National Gallery of Art, Washington).

Georges de Lastic's research should lead to a better appreciation of this great painter, insufficiently addressed by Georges Pascal (1928) and by the monumental catalogue of the 1981 Montreal exhibition.

1. Mariette 1851-1860, 3:61.

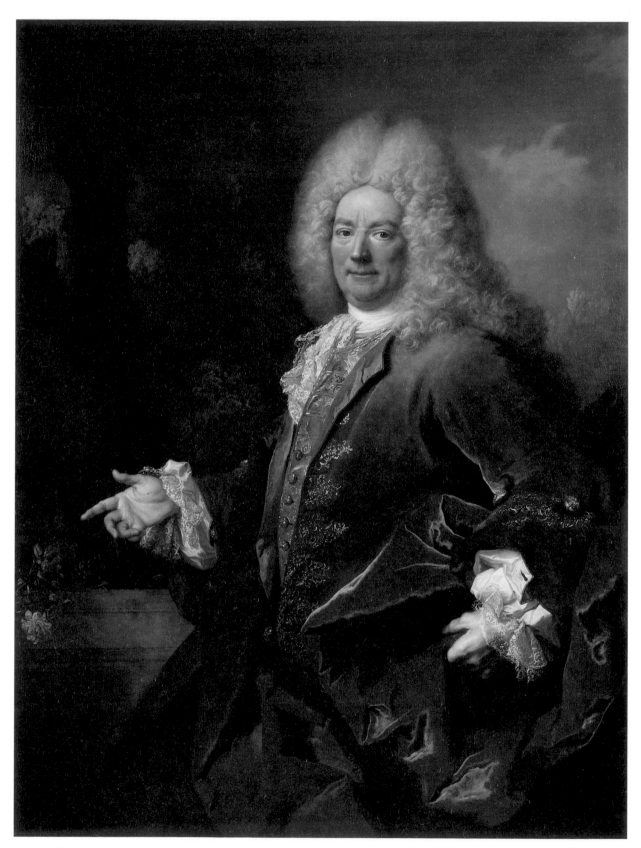

Portrait of a Gentleman

Portrait of a Gentleman
Portrait d'un gentilhomme
Oil on canvas, 53 3/8 × 41 3/8 in. (135.5 × 105 cm)
S.d. lower left on the parapet: *Peint par N./De Largillierre 1710*, fig.1
Gift of Archer M. Huntington through Herbert Fleishhacker. 1929.1 (CPLH)

fig.1 (detail with signature)

Provenance Georges de Lastic (letter, April 1985) suggests the following provenance through 1890: Sigismond Radziwill sale, Paris, Hôtel Drouot, salle 7, 16-24 May 1865, no. 336, as "Unknown" (although the dimensions given in the catalogue, 240 × 140 cm, and the absence of more precise documentation, appear to contradict this); Prince S. Radziwill's sale, Paris, Hôtel Drouot, salle 5, 26 February 1866, no. 37, as *Portrait of Robert de Cotte*; anonymous sale, Paris, Hôtel Drouot, salle 2, 15 April 1868, no. 36, as *Portrait of a Man*; estate sale of M. Marquiset, Paris, Hôtel Drouot, salle 3, 28-29 April 1890, no. 22, as *Portrait d'un Gentilhomme*; Comte André Ganay, after 1890 (according to MS notes by Georges Sortais, Cab. des Est., DA 58, 4: no. 116, but there is no trace of this portrait in the Ganay sales of 14 May 1881, 4 June 1903, 11 June 1904, 24 April 1906, and 16 April 1907); Comte Jean de La Riboisière, Paris; Lord Edgar Vincent d'Abernon, Foley House, Portland Place, London, ca. 1928; [Duveen Bros., Paris, on consignment from Lord d'Abernon]; acquired by the CPLH, 3 May 1929. (Cleaned and relined by Teri Oikawa-Picante, January 1979.)

References Gronkowski 1928 (*GBA*), 330; Pascal 1928, 74, no. 183; *Kansas City Journal Post*, 17 December 1939, repr.; N. Tietze, *Masterpieces of European Painting in America* (New York: Oxford University Press, 1939), 326, no. 254, repr.; *Illustrated Handbook 1942*, 43, repr.; *idem*, 1944, 47, repr.; *idem*, 1946, 51, repr.; Davisson 1947 (April), 99-103, repr. on 98; *Handbook 1960*, 57, repr.; Smith 1964, 238, fig.77, pl. 20; W. Davenport et al., *Art Treasures in the West* (Menlo Park: Lane, 1966), 154-155, repr. on 155; N. Mitford, *The Sun King* (New York: Harper & Row, 1966), 10, repr. on 47; E. Christensen, *A Guide to Art Museums in the United States* (New York: Dodd, Mead, 1968), no. 465, repr.; Bordeaux 1977, 39; B. Fromme, *Curator's Choice*, west. ed. (New York: Crown Publications, 1981), 59; Lastic 1982, 30; Lastic 1983 (*GBA*), 37; Lastic 1983 (*La Revue de l'Art*), 78.

Exhibitions 1928 Paris, no. 29 (1st ed.), no. 32 (2d ed.); 1934 San Francisco, no. 10, repr.; 1935-1936 New York, no. 2, repr.; William Rockhill Nelson Gallery of Art, Kansas City, *French Painting*, 1 December 1939-15 January 1940, no cat.; 1952 Minneapolis, no. 15, repr.; 1978-1979 Denver-New York-Minneapolis, no. 23; 1981 Montreal, no. 23, repr.

Variant
PAINTING
La Live de Bellegarde, fig.2
Oil on canvas, 55 1/8 × 43 5/16 in. (140 × 110 cm)
S.d. lower left: *1710*
PROV: Louis Bringnant, Paris; private collection, Paris.

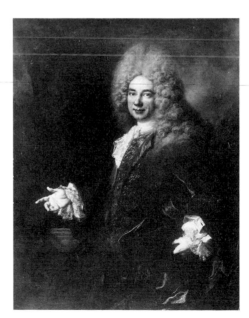

fig.2

Related Work

ENGRAVING

J. Audran, after Largillierre, *Victor-Marie, Marquis de Coeuvres, Duc d'Estrées, and Maréchal de France* (1660-1737), **fig.3**
REF: Roux et al. 1931-1977, 1:259, no. 45.

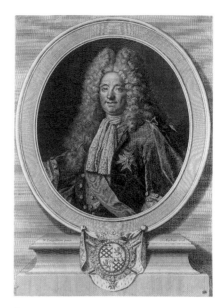

fig.3

The identity of this affluent sitter has yet to be determined. After the 1928 Paris exhibition it was suggested that his features resembled those of Louis-Henri de Pardaillan de Gondrin, marquis de Montespan, husband of Louis XIV's celebrated mistress. But the marquis died in 1702, eight years before this portrait was painted. In the Montreal exhibition of 1981 the sitter was identified as Victor-Marie, marquis de Coeuvres, duc d'Estrées, maréchal de France, based on a resemblance to an engraving of a lost portrait of the maréchal (**fig.3**). However, Georges de Lastic has pointed out that
the replica of the maréchal's portrait (Versailles) shows that the sitter's eyes are blue, whereas the unknown's are brown. It seems unthinkable that in this official portrait, the maréchal, so "glorious" according to Saint-Simon, would have himself painted without the ribbon and the badge of the Holy Spirit (of which he was a chevalier since 1705), which are quite visible in the copy and the engraving.[1]

This *Portrait of a Gentleman*, with its proud subject gesturing toward a mass of flowers with one hand while holding back a velvet mantle with the other, is not unique in Largillierre's oeuvre. There is another portrait, also signed and dated 1710, which was identified in the 1928 Paris exhibition as the portrait of a rich tax farmer named La Live de Bellegarde (**fig.2**). This painting is strikingly similar to San Francisco's except for the face, the floral background, and the flower hanging over the parapet. It is surprising that Largillierre would repeat the pose, the costume, the wig, and the landscape in the two pictures, but Georges de Lastic notes that this period was one of intense activity for the artist, and Largillierre accordingly worked in a manner that allowed him maximum speed and minimal expense. In addition, Myra Nan Rosenfeld cites a number of letters addressed to M. and Mme de Gueidan around 1730-1731 revealing that standardization was adopted to a far greater extent than previously supposed in the Largillierre studio.[2] Types, clothing, and accessories, based on the same scrupulously preserved studies, were constantly reused. In addition to *La Live de Bellegarde*, a number of other portraits bear close compositional similarities with the one in San Francisco: *Comte de Noirmont* (Museu Nacional de Arte Antigua, Lisbon), *M. de Puiséjour* (Barzin collection, Paris), *François-Jules du Vaucel*

(1724, Musée du Louvre, Paris), and *Portrait of a Man* (Musée des Beaux-Arts, Cherbourg).

Despite the repetition of a formula, San Francisco's painting is of exceptional quality. According to Georges Sortais, "the painting is admirable and powerful, the flesh tones are stunning, and although painted on a coarsely grained canvas, the execution of the face has all the finesse of a beautiful portrait by Philippe de Champaigne."[3] The penetrating analysis of the sitter's features is in no way diminished by the sumptuous treatment of the fabrics, the delicate rendering of the lace, the embroideries in which arabesques of gold are traced on the coat and waistcoat, or the full-bottomed, powdered wig that falls in waves of tiny curls. The palette is warm and mellow, and the brown tones of the suit and the red of the cloak are subtly echoed in the landscape behind. San Francisco's *Portrait of a Gentleman* ranks with Largillierre's celebrated *Portrait of Jean Pupil de Craponne* (Musée des Beaux-Arts, Grenoble) in its brilliant effect and in its profound analysis of its subject.

1. Lastic 1983 (*GBA*), 37.
2. M. N. Rosenfeld, exh. cat., 1981 Montreal, 198-199.
3. MS notes, Cab. des Est., Da 58, 4:no. 116.

Portrait of a Gentleman
(Pierre van Schuppen?)

Portrait présumé de Pierre van Schuppen
Oil on canvas (oval), 28 ½ × 23 ½ in. (72.5 × 60 cm)
Mildred Anna Williams Collection. 1961.23 (CPLH)

Provenance Duc de Talleyrand, Valençay and Sagan, Château de Valençay; Talleyrand sale, Paris, Galerie Georges Petit, 29 May-1 June 1899, no. 13, repr.; Georges Boin sale, Paris, Hôtel Drouot, salle 6, 17-18 December 1918, no. 19, repr.; Duchâteau collection, Paris; Dodge collection, New York, ca. 1928; [Wildenstein & Co., Inc., New York]; acquired by the CPLH, 1961. (Cleaned by Teri Oikawa-Picante, 1981.)

References Gronkowski 1928 (*Le Figaro*), 467, repr.; Gronkowski 1928 (*GBA*), 327-328, repr. on 327; Pascal 1928, 71, no. 151; Howe 1961, 13-14, fig.8 on 12; *The Art Quarterly*, Winter 1961, 402, fig.3 on 399; *GBA*, "La Chronique des Arts," February 1962, 32, no. 124, repr.; Smith 1964, 77, fig.29, pl. 7; Lastic 1979 (*BSHAF*), 156, fig.6 on 158; Lastic 1979 (*Connaissance des Arts*), 17, fig.b on 18; "Bedecked with Lace," *Triptych*, March-April 1982, 11, fig.1; Lastic 1983 (*GBA*), 37; Lastic 1983 (*La Revue de l'Art*), 75; Rosenfeld 1984, 69, notes 19 and 22.

Exhibitions 1928 Paris, no. 32 (1st ed.), no. 35 (2d ed.); Florida, Pensacola Art Center, 1959 (no details); 1981 Montreal, no. 17, repr. on 117; San Francisco, CPLH, *Bedecked with Lace*, April-June 1982, no cat.

Variants

PAINTINGS
Portrait of a Man, replica
Oil on canvas (oval), 26 × 20⅞ in. (66 × 53 cm)
National Museum, Warsaw, 1964. Inv. 231643
REFS: J. Michalkowa, "New Acquisitions of the Department of European Painting, 1963-1969," *Bulletin de Musée National de Varsovie* 11 (1970): nos. 2-3, 59-60, fig.32a on 59; M. N. Rosenfeld, exh. cat., 1981 Montreal, 118, fig.17a.

Vincent de Lesseur-Lesserovitch, miniature after Largillierre, *Portrait of a Man*
Monogrammed and dated 1789 on the recto; on the verso the inscription in French: *President de Thou after Largilieur* [sic] *by Lesseur*
Museum Narodowe, Krakow
REFS: H. Kaminska-Krassowska, "Wincenty de Lesseur-zycie i dzialalnosé," *Rocznik Muzeum Narodowego w Warszawie* 13, no. 2 (1969):164-165, fig.6; J. Michalkowa, cited above, fig.32b on 59; M. N. Rosenfeld, exh. cat., 1981 Montreal, 118.

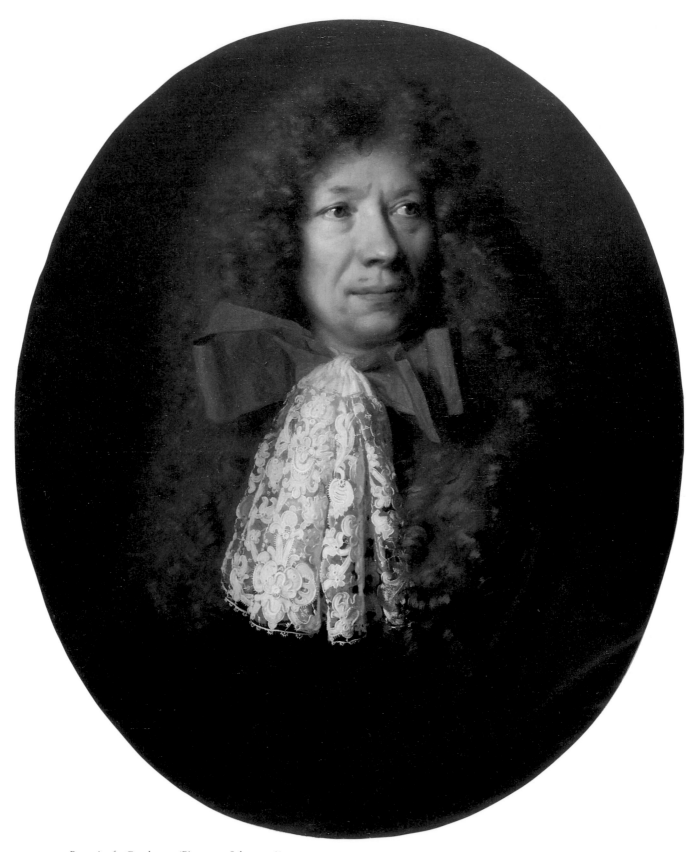

Portrait of a Gentleman (Pierre van Schuppen?)

214 Largillierre

Identification of the sitter in this portrait poses a real problem for the art historian, but an examination of the painting offers a few valuable clues. The sense of immediacy and psychological analysis of the sitter excludes the possibility of a posthumous portrait; this vibrant likeness was certainly executed directly from the model. The facial features are those of a man about fifty years old. Similarly, his clothing can be precisely dated. Maurice Leloir informs us that

cravats were first worn in the army, where it was difficult to find starchers and ironers. . . . They soon spread to civilian costume. . . . A bow of ribbons in three or more layers was attached underneath the hanging ends of the lace cravat and spread out on each side. These ribbons were attached and sewn, and were sold ready made as are our pre-knotted ties. In 1678, the ribbons were always very wide. This cascade of muslin or batiste trimmed in lace seemed to come from a knot under the chin made by the ends of the cravat which encircled the neck twice. It fell straight below the double bow of loops and ribbons arranged underneath and spread out on either side.[1]

The author also reproduces a picture of a "Gentleman in military dress after Jean de Saint-Jean 1678-1680,"[2] whose cravat and knot are identical to those of the sitter in our portrait. Soon thereafter ribbons became narrower and the loops in the bows more numerous, as seen in Largillierre's *Portrait of King James II of England* of 1686 (National Maritime Museum, Greenwich) and in the 1689 engraving of *The Reception of James II at Saint-Germain-en-Laye*.[3]

According to Georges de Lastic, a date of 1678-1680 is confirmed by the style of the work.[4] The predominantly Flemish character of the picture relates it to the first portraits executed by the painter upon his arrival in Paris in 1679-1680, and not to works of the 1685-1690 period, as suggested by Myra Nan Rosenfeld.[5]

It is tempting to compare these findings with a now lost inscription in French, mentioned in the sales catalogues of Talleyrand (1899) and Boin (1918): "according to the information on the back, this portrait should be that of Monsieur Pierre van Schuppen, engraver, painted in 1680." Unfortunately, the painting has been relined and no investigative means, even the most modern, enable us to read that inscription. An annotation on the frame indicates the portrait is of "Pierre van Schuppen, Painter to the Court of Vienna from 1670-1729." This inscription is erroneous, and stems from a confusion of Pierre van Schuppen with his son Jacques van Schuppen, the official painter of the Viennese court in 1723 and director of the Academy there three years later.

According to A.-J. Dezallier d'Argenville, Jacques van Schuppen was a pupil of Largillierre and therefore could have been painted by his master.[6] But Jacques was only ten years old in 1680, and a comparison between his *Self-Portrait* in the Academy of Vienna[7] and the San Francisco painting completely negates this hypothesis. Equally wrong is the identification of the sitter as Jacques-Auguste de Thou, based on an inscription on the back of the miniature in Warsaw by Vincent de Lesseur.

The Albertina in Vienna holds roughly one hundred forty engravings and seventeen drawings by van Schuppen, but none of these is a self-portrait, nor are any extant portraits of the engraver known. Thus, positive identification of the sitter in the San Francisco painting is impossible. We know that van Schuppen was trained at Antwerp in 1639, became a master in the Guild of Saint Luke in 1651, was active in Paris from 1655, and became a member of the French Royal Academy of Painting and Sculpture in 1663. The quality of his engravings earned him the sobriquet "Petit Nanteuil," after one of his masters. In 1680 he was fifty-three years old.

Unfortunately, the portrait appears to have been cut down at the top, but its pictorial quality is remarkable. The assurance in the handling of the brush and the restrained use of the palette anticipate the *Portrait of Charles Lebrun* (1686). Both works are conceived in the same harmony of browns. Largillierre modeled the background, the highlights of the wig, and the chiaroscuro of the face with extreme dexterity; the contrast of the sitter's dark coat with the orange bow and white lace cravat—a true piece of bravura—is treated with unimaginable precision and fidelity. This painting reveals a sense of reserve and elegance as well as balance and harmony that makes it a true masterwork.

1. Maurice Leloir, *Histoire du costume de l'antiquité à 1914*, vol. 10 (Paris, 1935), 8.

2. Leloir, *Histoire*, 10:fig.1.

3. M. N. Rosenfeld, exh. cat., 1981 Montreal, fig.17c and no. 16, repr.

4. Lastic 1983 (*GBA*), 37.

5. M. N. Rosenfeld, exh. cat., 1981 Montreal, no. 17, repr.

6. D[ezallier d'Argenville] 1762, 3:252-253.

7. M. N. Rosenfeld, exh. cat., 1981 Montreal, fig.17b.

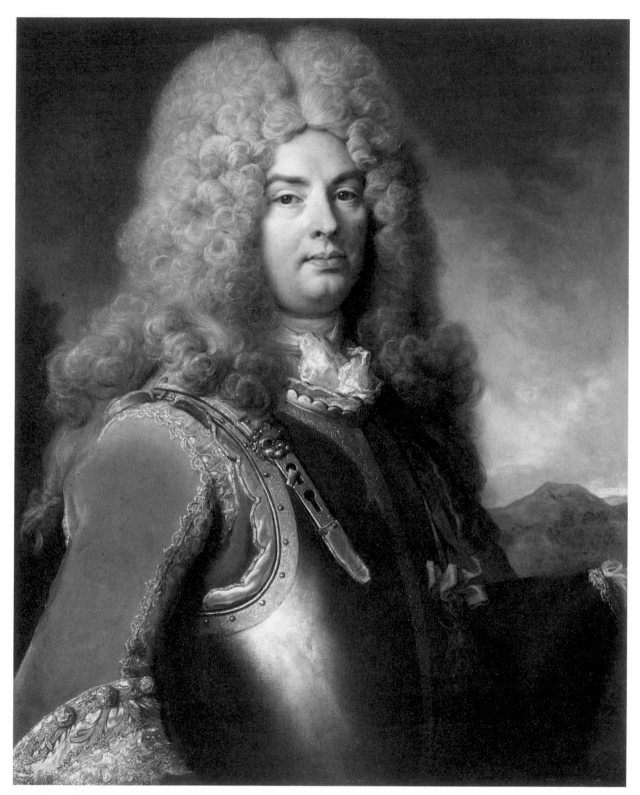

Portrait of a Gentleman

Portrait of a Gentleman
Portrait d'un gentilhomme
Oil on canvas, 32 × 25 ½ in. (81 × 65 cm)
Gift of Clarence Sterling Postley in memory of his
father, Sterling Postley. 61.10 (de Young)

Provenance [René A. Trotti, Paris]; Sterling Postley, New York, ca.
1912; Clarence Sterling Postley, New York; gift to the de Young, 1961.

References *The Art Quarterly*, Autumn 1961, 310, fig.3 on 301;
Fahy 1973, 5:132.

Related Works
PAINTINGS
André-François Alloys de Theys d'Herculais (1692-1779), **fig.1**
Oil on canvas, 54 ¼ × 41 ½ in. (138 × 105.5 cm)
S.d. on back: *peint par N. de Largillierre/1727*
The Metropolitan Museum of Art, New York
Gift of Mr. and Mrs. Charles Wrightsman. 1973.311.4

Jacques-François Lénor Grimaldi, Duc de Valentinois (1689-1751),
1718, **fig.2**
Oil on canvas, 57 ⅛ × 43 ⁵⁄₁₆ in. (145 × 110 cm)
Palais du Prince, Monaco

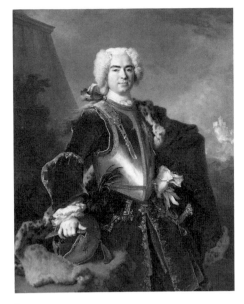

fig.1

The identity of this sitter remains unconfirmed. As did
the previous portrait, this picture entered the Museums'
collection with an inscription at the top, subsequently
erased during cleaning and restoration, that read "Louis
Lamorélie des Biars 1688." According to Georges de
Lastic the date possibly refers to the year of death of the
sitter's father. Lastic believes that the model for this por-
trait is Pardoux de La Morélie, Seigneur des Biards,
born in 1667, son of Louis de La Morélie and Suzanne
de Gondinet.[1] Sub-lieutenant, lieutenant, and then cap-
tain of the de la Serre regiment, Pardoux served under
Maréchaux Catinat and de Luxembourg during the
wars at the end of the reign of Louis XIV. He married
Catherine de Villoutreys in 1694 and received the cross
of the military Order of Saint-Louis, which appears dis-
tinctly on the cuirass he wears in the portrait. Lastic
believes the painting might be a pendant to the *Portrait
of a Lady* (page 218), whom he identifies as Catherine
de Villoutreys.

Despite the restoration this work has undergone, and
a presumably severe reduction in format, it appears
indeed to be by Largillierre. The description of the cui-
rass is remarkable, its metallic brilliance skillfully high-
lighted by the blue lining and the ochre sleeve. Certain
weaknesses in execution might have been the contribu-
tion of a member of Largillierre's studio. The pose of the
sitter and the style and composition are closely related
to other portraits of military figures by the painter, such
as *André-François Alloys de Theys d'Herculais* (**fig.1**) or
Jacques-François Lénor Grimaldi, Duke of Valentinois
(**fig.2**), suggesting a date of 1718-1725 for this work.

1. Letter, April 1985.

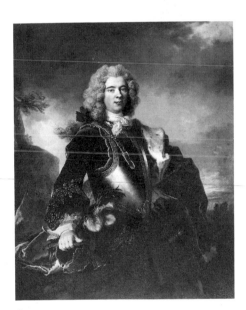

fig.2

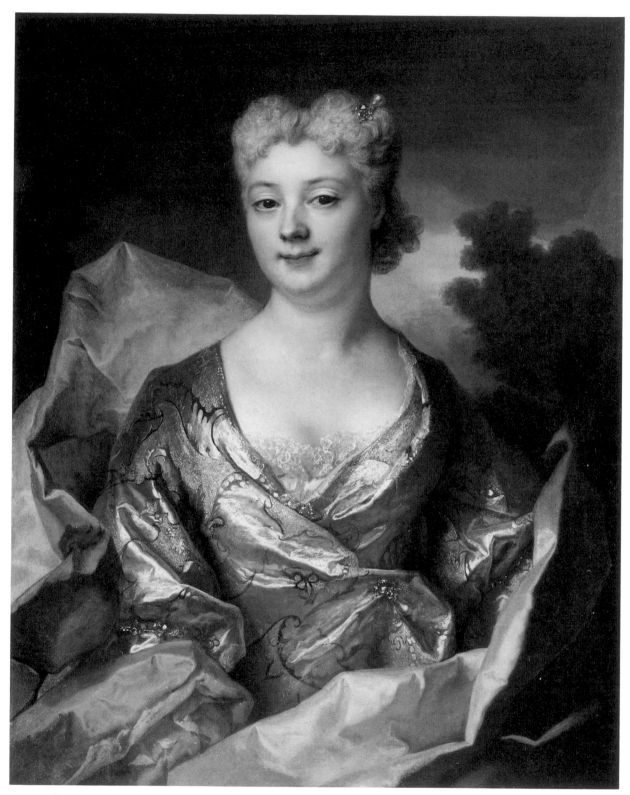

Portrait of a Lady

Portrait of a Lady

Portrait d'une dame
Oil on canvas, 32 × 25 ¾ in. (81 × 65 cm)
Gift of Brooke Postley. 56.14 (de Young)

Provenance [René A. Trotti, Paris]; Sterling Postley, New York, ca.
1912; Brooke Postley, Connecticut; gift to the de Young, 1956.
(Restored by Henry Rusk in 1958.)

Reference *The Art Quarterly*, Spring 1957, 95.

Despite the difference in composition, Georges de Lastic
believes this portrait is pendant to the *Portrait of a
Gentleman* (page 216).[1] When the painting entered the
Museums' collection, it also bore an inscription in
French on its upper portion, which was lost in restora-
tion in 1958, stating that the sitter was "Catherine de
Vilotreix, wife of Louis Lamorélie des Biars 1668."
According to Lastic, Catherine de Villoutreys married
Pardoux de La Morélie in 1694, and the date of 1668
given in the inscription is presumably the date of her
birth. Another French inscription appears on the back
of the canvas: "Nicolas de Largillierre. Painted by
1638." Lastic believes this is simply an error, and the
picture should be dated around 1718.

Although in rather poor condition and probably cut
down from its original size, the portrait shows excep-
tional brushwork and an extraordinarily bold range of
colors. The treatment of the pink mantle, turning
almond green at the bottom left, is noteworthy for its
subtle play of reflected light. Similarly, the execution of
the silver brocade of the dress, with its green and red flo-
ral motifs, is stunning. The use of complementary colors
in this work demonstrates Largillierre's full command of
the palette.

This portrait bears a number of stylistic and composi-
tional similarities to *Portrait of a Woman* (s.d. 1703,
Alte Pinakothek, Munich) and *Portrait of a Woman* (s.d.
1714, Musée Cognacq-Jay, Paris), although the San
Francisco model's dress and coiffure would seem to date
the picture somewhat later, around 1718-1720.

1. Letter, April 1985.

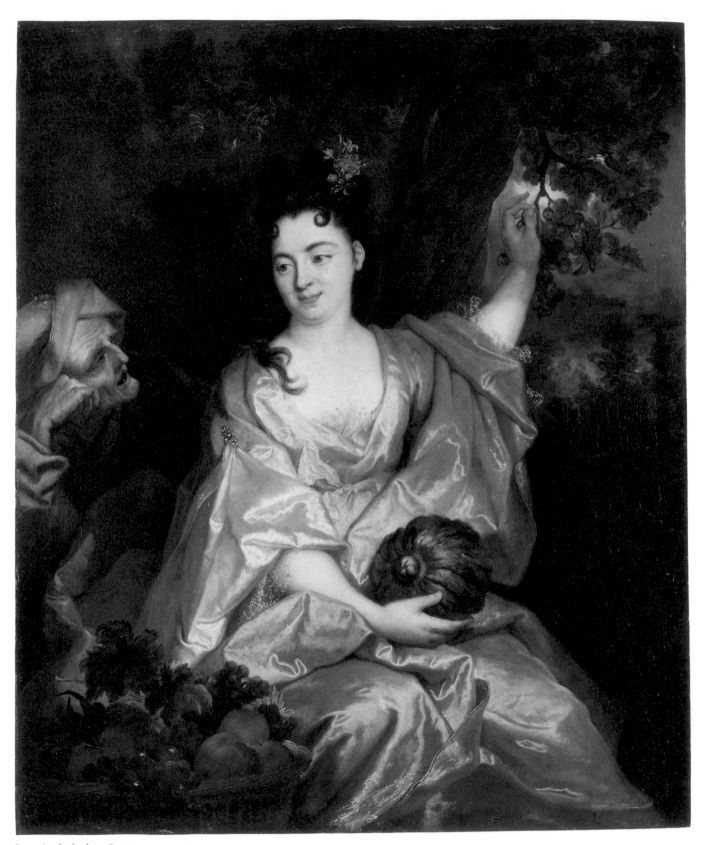

Portrait of a Lady as Pomona

Portrait of a Lady as Pomona
(*copy after Largillierre*)

Portrait d'une dame sous la figure de Pomone
Oil on canvas, 25 ½ × 21 ½ in. (65 × 53.5 cm)
Gift of Clarence Sterling Postley in memory of his
mother, Ethel Cook Curran. 1950.1 (CPLH)

Provenance Anonymous sale, Paris, Hôtel Drouot, salle 6, 8 April
1908, no. 12, repr.; acquired by Georges Sortais for 6,000 francs;
[René A. Trotti, Paris, ca. 1908-1912]; acquired by Mrs. Sterling Pos-
tley (later Mrs. Ross Ambler Curran), ca. 1912; inherited by Clarence
Sterling Postley; gift to the CPLH, 1950.

References Howe 1950 (May) 4-7, repr. on 5; M. N. Rosenfeld, exh.
cat., 1981 Montreal, 219, fig.44b.

Exhibition 1958 Santa Barbara, no. 16.

Variant
PAINTING
Presumed Portrait of Mme de Motteville as Pomona, **fig.1**
Oil on canvas, 53 ¾ × 41 in. (136.5 × 104 cm)
Donald A. Kullman, M.D., West Hollywood, Florida, in 1977
PROV: Krakau Sale, Berlin, Lepke Galleries, 12 November 1918, no.
49, repr.; probably brought to the United States before World War II;
David Kramarsky, New York, by 1959; [Robert Draper, Mirrell Gal-
lery, Miami, early 1960s]; acquired by Donald A. Kullman before
1971; anonymous sale, New York, Sotheby Parke-Bernet, 2 December
1976, no. 66, repr. (returned to owner).

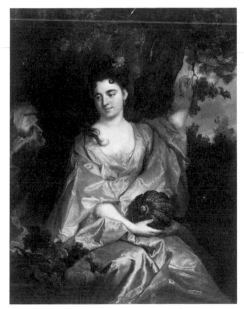

fig.1

Related Works
PAINTINGS
Portrait of a Lady Disguised as Pomona
Oil on canvas, 57 ⅛ × 41 ⅜ in. (145.5 × 105 cm)
Staatliche Kunstsammlungen, Dresden
REF: M. N. Rosenfeld, exh. cat., 1981 Montreal, 216, fig.43a.

Vertumnus and Pomona
Oil on canvas, 56 × 45 in. (142 × 114 cm)
PROV: Lynde sale, New York, Parke-Bernet, 24 February 1938, no.
69, repr.

Like Boucher (page 122), Largillierre treated the theme
of Vertumnus and Pomona[1] a number of times. The
young god Vertumnus, symbolizing the changing sea-
sons, falls in love with the nymph Pomona, goddess of
gardens and orchards. He visits her disguised as a
laborer, a harvester, and then a vintner. Finally, in the
guise of an old woman, symbolizing winter, he is able to
plead his case successfully.

The practice of using a mythological context for
portraits of women enjoyed considerable vogue in
eighteenth-century France, particularly in the portraits
by Jean-Marc Nattier (pages 226, 230, 234). Here the
artist flatters his subject by giving her the attributes of a
goddess and contrasting her more youthful face with
that of the old crone, but making no effort at real psy-
chological analysis. Largillierre's Flemish training is
apparent in the depiction of grapes, apples, peaches, and
the vegetation in general, as well as in the almost carica-
tured depiction of the old woman's head.

Georges de Lastic, studying this painting from a pho-
tograph, called it "an original, or better still an auto-
graph replica in small format," and suggested a date of
1690-1700.[2] However, after careful examination of the
picture, it does not appear to be by the hand of Largil-
lierre. The relative mediocrity of treatment suggests it is
a copy in smaller format of the painting in the Kullman
collection (**fig.1**). The composition is identical, although
the faces of the two sitters are different. The lady in the
Kullman portrait has been traditionally identified as
Mme de Motteville, but she is neither the lady-in-
waiting to Anne of Austria and author of celebrated
Mémoires, nor Hélène Lambert, wife of François-Marie
de Motteville, first president of the Chambre des
Comptes of Normandy, whose portrait by Largillierre
was subsequently engraved by Pierre Drevet.[3]

While the name of the sitter remains unknown, this
portrait seems to have been conceived as a decorative
tribute to a woman whose opulent charms are comple-
mented by the rich and ripe evocation of nature.

1. Ovid, *Metamorphoses*, book 14, lines 623-771.
2. Letter, 13 August 1974.
3. M. N. Rosenfeld, exh. cat., 1981 Montreal, 122, fig.18b.

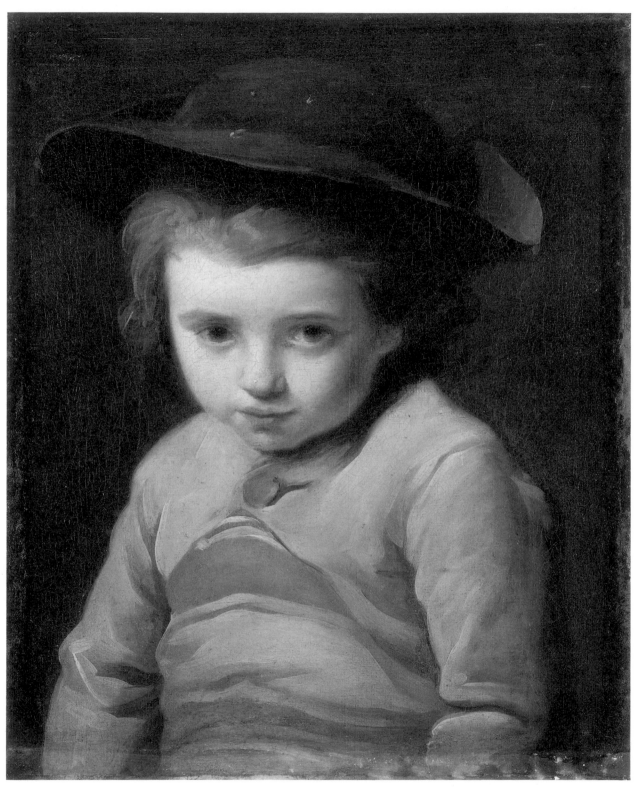

Portrait of a Little Boy

Nicolas-Bernard Lépicié *Paris 1735-1784 Paris*

Nicolas-Bernard Lépicié was born to François-Bernard Lépicié, secretary of the Royal Academy of Painting and Sculpture, and Renée-Elisabeth Marlié, both of whom were engravers. He studied under Carle Vanloo. Having received the second *Grand Prix* in 1759, he was accepted by the Academy in 1764 with *William the Conqueror* (Lycée Malherbe, Caen) and elected to membership in 1769 as a history painter with *Achilles Instructed by the Centaur Chiron* (Musée des Beaux-Arts, Troyes). He exhibited regularly at the Salon from 1765, was appointed adjunct professor in 1777 and professor three years later.

Until 1773 Lépicié devoted himself to history painting, particularly to large, rather unconventional religious scenes. His first great canvases were characterized by a pale palette, bold impasto with luminous highlights, and dynamic diagonal compositions learned from Carle Vanloo, which were also similar to works by Doyen (*The Martyrdom of Saint Andrew*, 1771, Abbaye de Saint-Riquier). Later, the strained attitudes of his subjects became more relaxed and his compositions more reminiscent of neoclassical trends (*Regulus Leaving Rome to Return to Carthage*, 1779, Musée des Beaux-Arts, Carcassone). His purely decorative works, however, such as *Narcissus* (1777) or *Adonis* (1782), executed for the Petit Trianon, are more faithful to the lesson of Boucher.

During the last ten years of his life he concentrated on portraiture and genre scenes. In his small, meticulously executed paintings he demonstrates a talent for observation, then much admired by the French public, who delighted in the works of the seventeenth-century Dutch little masters. Paradoxically, it is in this genre that Lépicié reveals his interest in new ideas.

He favors simple compositions, a flat surface without effect, and a sober range of gingerbread hues. With tranquil realism, delicate color harmonies, and plasticity of figures and objects, his works recall Chardin although they tend more toward anecdote and to a luscious modeling of forms (*Raising of Fanchon*, 1773, Musée de l'Hôtel Sandelin, Saint-Omer). Some are marked by excessive sentimentality, which links them to Greuze (*The Penitent Child*, Musée des Beaux-Arts, Lyon). However, his less ambitious works exude simple charm and poetic discretion that make his depiction of contemporary family scenes especially appealing. Toward the end of his life Lépicié also enjoyed painting rustic and urban scenes (*In the Courtyard of the Customs-House*, s.d. 1775, Thyssen-Bornemisza collection, Castagnola, and *The Farm Yard*, 1784, Musée du Louvre, Paris), which seem to have been influenced in spirit by Teniers.

Philippe Gaston-Dreyfus's remarkable catalogue raisonné (1923), and the articles by Florence Ingersoll-Smouse,[1] although inadequately illustrated, have not been replaced.

1. Florence Ingersoll-Smouse, "Nicolas Bernard Lépicié," *Revue de l'Art Ancien et Moderne* 43 (1923):39-43, 125-136, 365-378; *idem*, 46 (1924):122-130, 217-228; *idem*, 50 (1926):253-276; and *idem*, 54 (1927):175-186.

Portrait of a Little Boy (*attributed to Lépicié*)
Portrait d'un garçonnet
Oil on canvas, 18½ × 15½ in. (47 × 39.5 cm)
Museum purchase, M. H. de Young Art Trust Fund.
50.35.3 (de Young)

Provenance Perhaps *Portrait of a Little Boy*, anonymous sale, Paris, Hôtel Drouot, salle 6, 15 November 1905, no. 52 (oil on canvas, 46 × 38 cm), sold for 450 francs according to the annotated sale catalogue, Bibliothèque Doucet; [Alex Popoff & Cie, Paris]; [Thos. Agnew & Sons, Ltd., London, July 1929]; [Isabella Barclay, New York, September 1929]; Mrs. Gordon Dexter, Massachusetts and New York; [French & Company, New York]; anonymous gift to the de Young, 1950.

References *Art News*, April 1930, repr., advt.; *Art Digest*, July 1953, 28.

Related Works

PAINTINGS

The Penitent Child, fig.1
Oil on panel, 16⅛ × 11¹³⁄₁₆ in. (41 × 30 cm)
Musée des Beaux-Arts, Lyon. Gift of Jacques Bernard, 1876. No. 40
REF: Gaston-Dreyfus 1923, no. 231.

The Sullen Boy
Oil on canvas (oval), 27¾ × 22¼ in. (70.5 × 56.5 cm)
EXH: New York, William H. Schab Gallery, Inc., *Master Paintings of
the 16th to the 18th Century*, 7 October-19 November 1983, no. 14,
repr.

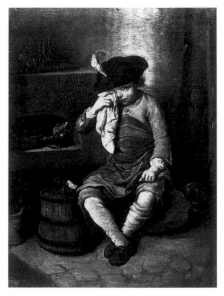

fig.1

This composition illustrates perfectly Florence Ingersoll-
Smouse's opinion that
*Lépicié was always a genre painter. One might even say
that he saw every subject from this point of view. His
portraits are often no more than genre paintings, just as
his genre paintings are often portraits . . . and it is per-
haps the complex character of these small paintings,
with their keen accent of intimacy and truth, their firm
and tight draftsmanship, and their discreet palette that
gives them a great part of their charm.*[1]

This picture appears to have had an unfortunate
physical history. Before 1930 the canvas was cut down,
notably in the lower part, probably to create a pendant
for *Portrait of a Boy* (page 342) with which it was
acquired for the Museums. X-rays have revealed a suspi-
cious triangular area near the right shoulder of the boy,
although whether a change was made in composition
remains undetermined. While both these portraits were
sold as by Lépicié, only *Portrait of a Little Boy* appears
directly related to that artist because of its similarity to
the securely attributed *The Penitent Child* (fig.1). In
addition to the extremely sober palette, in which the
warm brown tones are cut with gray, the faces of the
two boys are also alike. They wear the same black hat
with a wide brim (turned up in the back, San Francisco,
and in the front, Lyon) and the same blue painter's
smock, closed near the neck by a single large button.
There may have been other similarities before the San
Francisco painting was reduced in size.

Can the hand of the artist himself be recognized in
this painting? The quality of the modeling in the boy's
face is worthy of Lépicié, and the densely applied pig-
ment of the shirt also suggests his hand, as the painter
often resorted to the use of thick impasto. However, the
heavy treatment of the clothing does not exclude the
possibility of a skillful pastiche.

This sentimental work is certainly closer to Greuze
than to Chardin. It is comparable in style to *Portrait of a
Boy* (Mauritshuis, The Hague), *Little Draftsman*
(Musée du Louvre, Paris), and portraits of Vernet's chil-
dren at various ages and François Gounod at the age of
ten, all executed by Lépicié for the most part between
1769-1772.[2] Thus we believe that the San Francisco
painting can be attributed to Lépicié.

1. Florence Ingersoll-Smouse, "Nicolas Bernard Lépicié," *Revue de
l'Art Ancien et Moderne* 46 (1924):122.
2. See Gaston-Dreyfus 1923, nos. 68-71, 77-79.

Jean-Marc Nattier *Paris 1685-1766 Paris*

The son of a long-forgotten portraitist, Marc Nattier, and younger brother of the history painter Jean-Baptiste Nattier, Jean-Marc Nattier began his career under the sponsorship of his godfather, Jouvenet. He made a drawing from the portrait of Louis XIV by Rigaud that, according to his eldest daughter, who later married Tocqué, earned from the king the comment, "Sir, continue to work like that and you will become a great man."[1] Nattier also copied Lebrun's *Battle Scenes* and Rubens's *Life of Marie de' Medici*, the latter for an engraving.

In 1717 he left for Holland where he worked for Tsar Peter the Great (*Battle of Poltava*, Pushkin Museum, Moscow). The following year he was elected to the Royal Academy of Painting and Sculpture with *Perseus Changing Phineas into Stone* (Musée des Beaux-Arts, Tours). He then sketched pictures of the king and regent in 1721 for Pierre Crozat, financier and *amateur*.

Early in his career Nattier specialized in portraiture. His first portraits were reminiscent of the luminous, shimmering art of Raoux, although more deftly drawn, but he soon began to paint portraits in which he transposed the majestic character of Rigaud's figures to a more human, approachable dimension. He endowed his sitters with sweet, effeminate expressions, treating the modeling of the faces with extreme delicacy and highlighting his compositions with masses of silk draperies and decorative elements. Already the favored painter of the House of Orléans in the 1740s, Nattier became painter to the royal family, executing portraits of Louis XV's daughters. He used the formula of mythological portraiture in an entirely different spirit from the sixteenth century, endowing his sitters with the attributes of Olympian goddesses. However, Nattier is remarkable for the great sensitivity with which he portrays human physiognomy. Rather than suggesting the grandeur of a court personage, his paintings portray the natural elegance and frivolity, tinged with melancholy, that reflect women's expanding role in society, and anticipate the sentimentality of portraits by Greuze and Vigée Le Brun.

The artist's later days were saddened by the death of his son, who drowned in Rome in 1754 a few months after his arrival at the French Academy. He was beset also by financial troubles and illness, which prevented him from painting after 1762.

His daughter, who was his first biographer, wrote: *He utilized these two great genres so well in his work that the enlightened public often did not know what to admire most in him: the history painter or the portraitist. Moreover, one will wonder less about the success with which Nattier was able to combine these two genres when one recalls that his first and major studies were done with the intention of following the fashion of composition, and it was only the circumstances in which he later found himself that caused him to change his objectives.*[2]

Since the works by Pierre de Nolhac (1905; 1910; 1925) and Georges Huard,[3] no major study has been devoted to this painter, who is very well represented in American museums. Portraits such as *Mme de Marsollier and Her Daughter* (The Metropolitan Museum of Art, New York), *Joseph Bonnier de la Mosson*, and *Mme de Caumartin as Hebe* (both National Gallery of Art, Washington) are among the best of his oeuvre.

1. *Mémoires inédits* 1854, 2:356-357.
2. *Mémoires inédits* 1854, 2:354.
3. Georges Huard, in Dimier 1928-1930, 2:93-133.

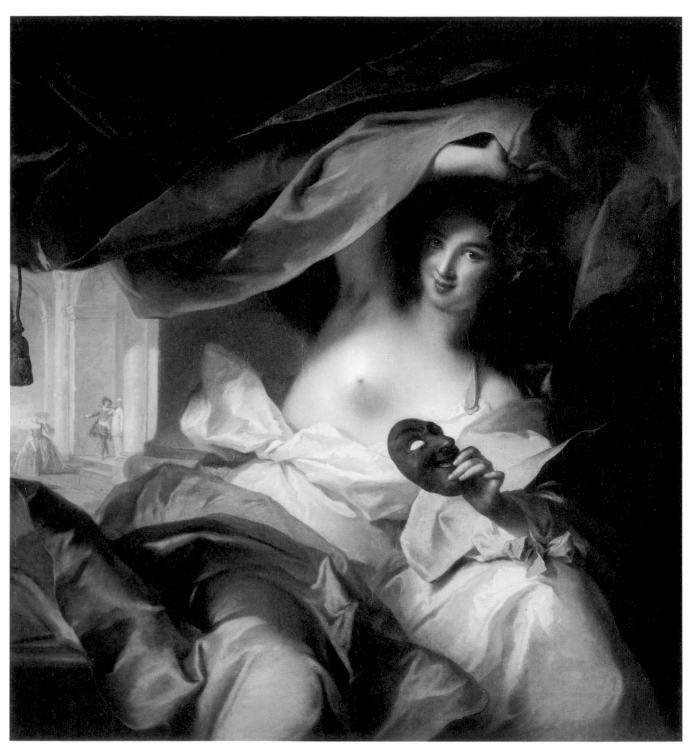

Thalia, Muse of Comedy (Silvia Balletti?)

Thalia, Muse of Comedy (Silvia Balletti?)

Thalie, muse de la comédie (Portrait présumé de Silvia Balletti)

Pendant to *Terpsichore, Muse of Music and Dance*
Oil on canvas, 53½ × 49 in. (136 × 124.5 cm), upper corners previously curved
S.d. at the left on the column: *Nattier pinxit 1739*, **fig.1**
Mildred Anna Williams Collection. 1954.59 (CPLH)

Provenance Baron Albert de Rothschild, Vienna; Baron Louis de Rothschild, Vienna; [Rosenberg & Stiebel, New York]; acquired by the CPLH, 16 April 1954.

References *The Art Quarterly*, Autumn 1954, 299, fig.3 on 302; Howe 1955, n.p., repr.; Davies 1957, mentioned under no. 5586; *Handbook* 1960, 59, repr. in color; W. Davenport et al., *Art Treasures of the West* (Menlo Park: Lane, 1966), 155, 159; E. Christensen, *A Guide to Art Museums in the United States* (New York: Dodd, Mead, 1968), 466, repr.; Bordeaux 1977, 40, repr.

Exhibition 1986-1987 Houston, no. 7, repr., repr. in color on 20, detail on 127.

Variants

PAINTINGS

Thalia, replica, **fig.2**
Oil on canvas, 30¾ × 37⅜ in. (78 × 95 cm)
Private collection, Paris
PROV: Eugène Kraemer sale, Paris, Galerie Georges Petit, 5-6 May 1913, no. 60, repr.; M. E. M. Hodgkins sale, Paris, Galerie Georges Petit, 16 May 1927, no. 32, repr., sold for 51,000 francs; sale of the collection of M. P . . . , Paris, Hôtel Drouot, salle 6, 7 March 1935, no. 10, repr.; acquired by its present owner.
REFS: Nolhac 1925, 227-228 (with wrong identification of sitter); G. Huard, in Dimier 1928-1930, 2:129, no. 148; Courville 1943-1958, 2:341-342; *idem*, 3:297 (attributed to Jean Raoux); Davies 1957, mentioned under no. 5586.

Thalia or *Comedy*, studio copy, some restoration
Oil on canvas, 31⅞ × 39¼ in. (81 × 99.5 cm)
PROV: Anonymous sale, Versailles, Palais des Congrès, 3 March 1985, no. 60.
EXH: Paris, Galerie Jean Charpentier, "Figures nues de l'Ecole française," 1953, no. 95 *bis*.

Thalia, Muse of Comedy, copy
Oil on canvas, 26½ × 32 in. (67.5 × 81 cm)
PROV: Sale, New York, Sotheby's, 17 April 1986, no. 93, repr. ("Follower of Jean-Marc Nattier").
NOTE: This painting is possibly the same as school of J.-M. Nattier, *La comédie*, oil on canvas, 26¾ × 31⅛ in. (68 × 79 cm), Georges Sortais sale, Paris, Hôtel Drouot, 22 May 1925, no. 65.

Dr. Hippolyte Mireur, *Dictionnaire des ventes d'art faites en France et à l'étranger pendant les XVIIIᵉ et XIXᵉ siècles* (Paris: Maison d'Éditions d'Oeuvres Artistiques, 1901-1912), mentions an "Allegory in the guise of a woman holding a mask and raising a curtain. In the background three comedians," by Nattier, sold for 1,000 francs in the Hoche sale of 1895 (5:374-375). However, a painting of this description was not in the Gustave Hoche sales of 22-23 February 1895 or 18 March 1898.

fig.1 (detail with signature)

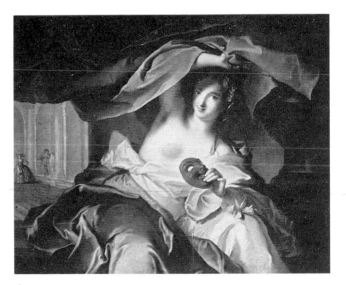

fig.2

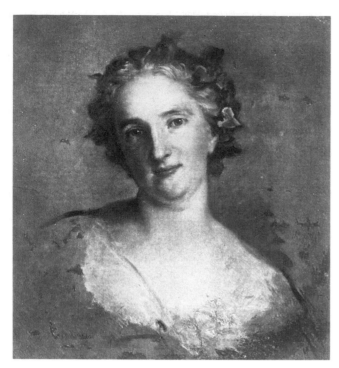

fig.3

Related Work

PAINTING

J.-M. Nattier, *Mlle Sylvia of the Opéra*, ca. 1745, fig.3
Oil on canvas, 18½ × 16⅛ in. (47 × 41 cm)
PROV: Defer-Dumesnil collection; sale, Paris, Hôtel Drouot, 10-12
May 1900, no. 17, repr.
REF: G. Huard, in Dimier 1928-1930, 2:no. 121.

This composition is well-known. A version in smaller format, also entitled *Thalia* (fig.2), was identified erroneously by Nolhac and Huard as Marie-Madeleine (Manon) Balletti (1740-1776).[1] This beautiful young lady, whose portrait by Nattier was exhibited at the Salon of 1757 (no. 25) and is now in The National Gallery, London, was a friend of the famous Casanova. Nolhac and Huard probably confused *Thalia* with Manon Balletti's portrait. Another presumed portrait of Manon appeared in a 1950 sale in London.[2]

However, at the time of its acquisition by the Museums, this portrait was proposed as the likeness of Marie-Anne de Mailly-Nesle, duchesse de Châteauroux (1717-1744), who was a mistress of Louis XV, while its pendant (page 230) was identified as the duchess's sister, the marquise de Vintimille. Both identifications are easily disproved by comparison with documented portraits of the Nesle sisters.

It is highly probable that the sitter of *Thalia, Muse of Comedy* is Silvia Balletti, mother of Manon and popular actress of the Comédie italienne. She was the subject of many portraits by artists such as Raoux,[3] François de Troy,[4] Carle Vanloo,[5] Watteau,[6] Lancret,[7] and Maurice-Quentin de La Tour,[8] as well as Nattier. In Nattier's portrait of *Mlle Sylvia of the Opéra* (fig.3), Silvia appears older than in the San Francisco painting, but she wears the same ivy crown upon her head.

The daughter of itinerant Italian comedians who practiced their art in the Midi, Zanneta-Rosa-Guionna Benozzi (1701-1758), called Silvia, was engaged by Luigi Riccoboni in 1716 as a member of the troupe of Italian actors formed by order of the regent of France. She was chosen to play the *amoureuse* or love interest, and at the theater met Giuseppe Antonio Balletti (1692-1762), Riccoboni's brother-in-law, who played leading male roles under the name of Mario. The two were married in June 1720 and had three children. During the first half of the eighteenth century, Silvia was the leading actress of the Comédie, the idol of Paris, and a godsend for a number of playwrights whose mediocre works were made bearable by her great talent. In his *Mémoires*, Casanova writes:

They have never found an actress capable of replacing her; in order to do so, she would have to combine all of Silvia's qualities in the difficult art of the theater: action, voice, feeling, physiognomy, bearing, and a great knowledge of the human heart. Everything in her was natural, and the art which perfected it was always hidden.[9]

Nattier might well have chosen to represent Thalia, Muse of Comedy, in the guise of Silvia Balletti. The ivy wreath encircling her head and the dark mask in her left hand are traditional attributes of this muse, and the nudity of the actress admirably suggests Thalia's youth and beauty. Thalia lifts a heavy velour curtain with her right hand, revealing to the viewer three figures whose costumes indicate that they are playing a piece from the repertory of the Comédie italienne (fig.4). Perhaps the scene represents *Arlequin poli par l'Amour* or *La surprise de l'Amour*, two very Italianate plays by which Marivaux made his debut in 1720-1722, and in which Silvia created the female leads. The actress liked to appear in the works of Marivaux, giving the playwright "the feeling of satisfaction, so rare for a dramatic author, to see reality in the theater fulfilling the dream of his imagination."[10] Silvia remained extremely youthful in appearance and continued successfully to create the illusion of the soubrette both on and offstage beyond the age of fifty.[11]

Xavier de Courville, who did not know there was a San Francisco canvas signed and dated 1739, rather hastily attributed the version in Paris to Raoux, "the master of Nattier in the genre of mythological portraiture."[12]

He based this attribution on Georges Bataille's mention of a lost portrait by Raoux entitled *Mlle Silvia of the Theater as Thalia*.[13] The style in this portrait is in many ways like that of Raoux with the same luminist quality and attention to drapery details as in his *Portrait of Mlle Prévost in the Role of a Bacchante* (Musée des Beaux-Arts, Tours). However, the superb decorative fullness of the drapery in *Thalia*, the innovative palette dominated by the highly characteristic cold blue, the sure handling of the design, and the light dexterity with which the secondary scene is treated are all clearly the work of Nattier. Interestingly, this picture and its pendant are not unlike the style and composition of two theater scenes, *Cleopatra* and *Portia* (s.d. respectively 1712 and 1714), by Jean-Marc Nattier's older brother, Jean-Baptiste.[14]

Whether these San Francisco canvases come from a larger series or are a pair will be discussed in the following entry.

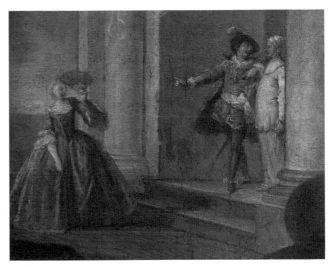

fig.4 (detail)

1. Nolhac 1925, 227-228, 278; G. Huard, in Dimier 1928-1930, 2:no. 148.

2. Sale, London, Sotheby's, 29 November 1950, no. 55.

3. G. Bataille in Dimier 1928-1930, 2:274 (lost); Courville 1943-1958, 2:341-342.

4. Formerly collection of Duke of Portland; copy in the foyer at the Comédie française. Jules Truffier, "Un musée de l'art dramatique," *L'art et les artistes* 1 (April-September 1905), repr.

5. Exhibited Paris, Bagatelle, *La mode à travers trois siècles*, 1911. S. G. Endore, *Casanova, His Known and Unknown Life* (New York, 1929), repr. opp. 108.

6. National Gallery of Art, Washington, no. 789.

7. Wildenstein 1924, no. 580, fig.210.

8. Formerly collection of Marquis de la Coste-Messelière, Château des Ouches. Courville 1943-1958, 3:297, pl. 8.

9. Casanova, *Mémoires* (Paris: Garnier, n.d.), 3:116-117.

10. N.-M. Bernardin, *La Comedie italienne en France* (Paris, 1902), 198.

11. Emile Compardon, *Les comédiens du roi de la troupe italienne* (Paris, 1880), 1:11-19.

12. Courville 1943-1958, 3:297.

13. See note 3 above.

14. Sale, London, Sotheby's, 6 April 1977, no. 50, repr.

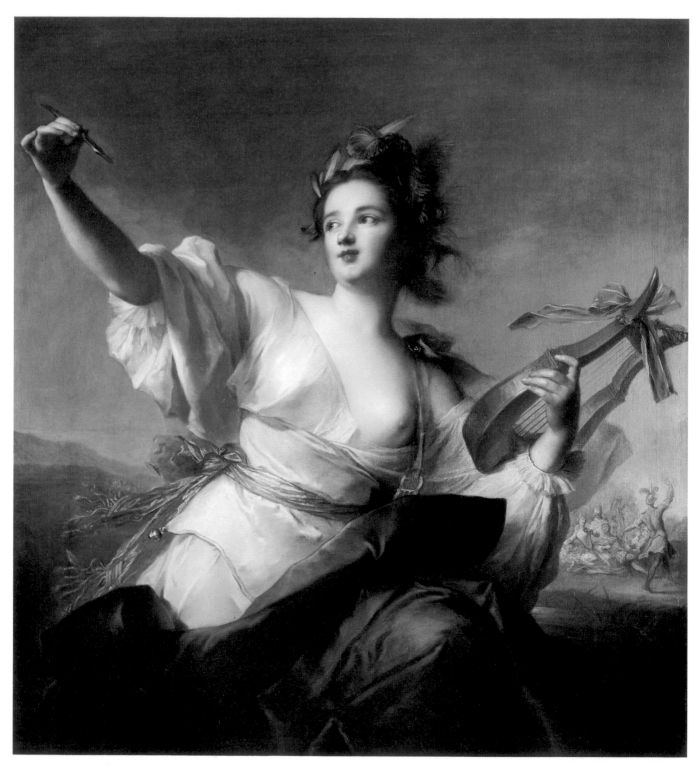

Terpsichore, Muse of Music and Dance

Terpsichore, Muse of Music and Dance

Terpsichore, muse de la musique et de la danse
Pendant to *Thalia, Muse of Comedy*
Oil on canvas, 53½ × 49¼ in. (136 × 125 cm), upper
corners previously curved
Mildred Anna Williams Collection. 1954.60 (CPLH)

Provenance Perhaps in the Edouard Weibel collection, ca. 1909;
Baron Albert de Rothschild, Vienna; Baron Louis de Rothschild,
Vienna; [Rosenberg & Stiebel, New York]; acquired by the CPLH,
16 April 1954.

References *The Art Quarterly*, Autumn 1954, 299, 302, fig.1 on
303; Howe 1955, n.p., repr.

Variants

PAINTINGS
Attributed to Charles-Joseph Natoire, presumed *Portrait of Mlle
Clairon*
REF: Armand Dayot, "Les peintres de la femme au XVIIIᵉ siècle:
Ecole française," *L'Art et les Artistes* (April-September 1909) 75, repr.
(collection of Edouard Weibel).

Euterpe or *Music*, studio copy, some restoration
Oil on canvas, 31⅞ × 39¼ in. (81 × 99.5 cm)
PROV: Anonymous sale, Versailles, Palais des Congrès, 3 March
1985, no. 61.
EXH: Paris, Galerie Jean Charpentier, "Figures nues de l'Ecole fran-
çaise," 1953, no. 95.

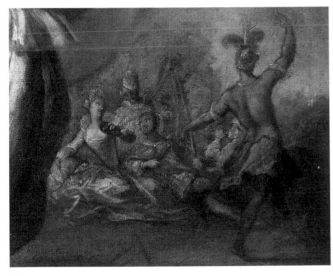

fig.1 (detail)

Certainly executed around the same time as its pendant,
Thalia, Muse of Comedy, this painting is perhaps even
more in keeping with Nattier's style. The broad flat-
tened areas of drapery with their light folds and the
mastery with which the aerial space is described fore-
shadow Nattier's *Portrait of the Duchesse de Chaulnes
as Hebe* (1744, Musée du Louvre, Paris).

The provenance of this work is complicated by the
reproduction in 1909 of a similar composition in the
Edouard Weibel collection. Whether this is San Francis-
co's painting or another version, it is certain that the
painter of *Terpsichore* is not Natoire, as proposed by
Armand Dayot (see Variants). A comparison of the
Museums' painting with three large canvases Natoire
exhibited in the Salon of 1745, *Thalia, Calliope*, and
Terpsichore, which were painted for the Cabinet of
Antiquities of the Royal Library (now the BN), illus-
trates that Natoire is not the author of the present pic-
ture.[1] In addition, the model for *Terpsichore* cannot be
Mlle Clairon (1723-1803), a tragic actress of the Théâ-
tre français, whose likeness is well known through her
portrait by Carle Vanloo.[2] The identification of the sitter
as Marquise de Vintimille, proposed when the work was
acquired by the Museums, has as little basis in fact as
the proposed identification of the duchesse de Château-
roux as *Thalia*. Although the sitter remains anonymous,
it is quite possible that the painting was not conceived
as a portrait.

The painting represents Terpsichore, one of the nine
muses, and not Euterpe as had been thought previously.
Euterpe, whose principal attribute is the flute, is the
musical muse par excellence and traditionally is shown
wearing a crown of flowers, presiding at festivals and
entertainments. She also is seen accompanying the cor-
tege of Dionysus. However, the lyre, played with a plec-
trum as held in the right hand of the woman here, is the
principal attribute of the Muse Terpsichore. With this
instrument and in the guise of a vivacious girl, she
marks the rhythm of songs and the choral dance. In the
broader sense, Terpsichore is considered the muse of
both dramatic chorus and dance, and it is to this dual
theatrical role that the small scene at right refers. In this
little scene a figure dances to the music of an improvised
orchestra (fig.1), a motif that recalls the frontispiece
designed by Lancret for the musical compositions of
Jean-François Dandrieu.[3] The bell hanging from Terp-
sichore's tunic is intended to accompany the rhythm of
the dance and is also an attribute of this muse.

Undoubtedly conceived as pendants, *Thalia, Muse of
Comedy* and *Terpsichore, Muse of Music and Dance*
originally may have been overdoors. A curved outline is
visible in their upper corners. Unfortunately we do not
know whether they were painted as a pair or as part of a
larger decorative program illustrating the nine muses.
After the death of Raoux in 1734 Nattier was chosen by

the chevalier d'Orléans to complete the decoration of the gallery in the Hôtel du Temple. Nattier's daughter confirms that he painted "six pictures of the muses remaining to be done for the decoration of the great priory."[4] Did the two paintings in San Francisco belong to this series? If we are to believe Nattier's daughter, *everything was destroyed upon the death of Chevalier d'Orléans, Prince de Conti (his successor) having sold all the paintings and other effects belonging to the grand prior for the benefit of the Order of Malta. It is not irrelevant to add that Nattier, upset at seeing the paintings which had cost him infinite care and work sold under his very eyes at auction, bid for them and bought them back. They are today in the hands of his family.[5]*

Whatever the case, this painting of great quality holds the viewer's attention through the charm of its colors and dynamic composition, conveying the personification of the Muse Terpsichore and imbuing this decorative canvas with a timeless lyricism.

1. Jean Babelon, *Les trésors du Cabinet des Antiques, Le Cabinet du Roi ou le Salon de Louis XV de la Bibliothèque Nationale* (Paris, 1927), 31-32, pl. 14.

2. Exh. cat., 1977 France, no. 165, repr.

3. Albert P. de Mirimonde, letter, 17 February 1977.

4. *Mémoires inédits* 1854, 2:356-357.

5. *Mémoires inédits* 1854, 2:357.

Madame Boudrey as a Muse
(*studio copy after Nattier*)

Portrait de Madame Boudrey, représentée en muse
Oil on canvas, 51¼ × 38⅛ in. (130 × 97 cm)
Formerly inscribed (before cleaning) lower left: *Nattier Pinxit/1752*
Museum purchase, M. H. de Young Art Trust Fund.
50.35.1 (de Young)

Provenance Henri Germain, Paris, ca. 1905-1925; André Germain, Paris; sale, M. L . . . , Paris, Galerie Charpentier, 21 December 1937, no. 21, repr.; Baronne Seidlitz sale, Paris, Galerie Jean Charpentier, 26-27 June 1951, no. 13, pl. 10 (sold for 1,700,000 francs); anonymous sale, New York, Plaza Art Gallery, 31 October 1953, sold for $4,000 according to Georges Wildenstein, letter, 21 December 1956; [French & Company, New York, 1953]; acquired by the de Young in exchange for another painting, 1956. (Restored by William Suhr, New York, April 1953, and Gertrude Blumel, New York, December 1955.)

References Nolhac 1925, 248; *The Art Quarterly*, Winter 1956, 421, repr. on 427; P. Wescher, "Neuerwerbungen des De Young Museums in San Francisco," *Kunstchronik*, October 1957, 311; *European Works* 1966, 184, repr.; Burollet 1980, mentioned under no. 74.

Variants
PAINTINGS
Portrait of Mme Boudrey as a Muse, fig.1
Oil on canvas, 48¹³⁄₁₆ × 38 in. (124 × 96.5 cm)
S.d. lower left: *Nattier pinxit/1752*
Private collection, New York
PROV: Joseph Bardac, Paris, ca. 1905-1910; Luis Bemberg, Paris; Otto Bemberg, Paris, ca. 1925-1930; anonymous sale, Paris, Nouveau Drouot (Ader-Picard-Tajan), 5 December 1985, no. 15, repr. in color.
REFS: Nolhac 1925, 206, 209-210, 248, 277, repr. opp. 206; G. Huard, in Dimier 1928-1930, 2:124, no. 59; Burollet 1980, mentioned under no. 74.
EXH: Salon of 1753, no. 48.

Portrait of Mme Boudrey (bust), perhaps autograph, after the portrait from the Bardac and Bemberg collections, fig.2
Oil on canvas, 15¾ × 12¾ in. (40 × 32.5 cm)
Inscription on the back: *Marie Victoire Talon âgée de 22 ans, Dame du palais de Madame la comtesse d'Artois, épouse du marquis de Ste Croix, ambassadeur, gentilhomme de la chambre de Monseigneur le Duc d'Angoulême.*
Musée Cognacq-Jay, Paris. Inv. 80
PROV: M. J.[acques D.[oucet] sale, Paris, Hôtel Drouot, salle 6, 16-17 May 1906, no. 75, repr.
REF: Burollet 1980, no. 74, repr.

Portrait of Mme Boudrey (half-length), after the portrait from the Bardac and Bemberg collections
Oil on canvas, 25⅜ × 20⅞ in. (64.5 × 53 cm)
Present location unknown

Erroneously entitled *Portrait of Rosalba Carriera* (bust), copy, with the right hand holding a paintbrush
Rectorate of Paris
REF: Burollet 1980, mentioned under no. 74.

Although signed and dated before cleaning, this canvas appears to be a studio copy, perhaps retouched by Nattier, after the original *Portrait of Mme Boudrey as a Muse* (fig.1). There are only a few variations between this and the San Francisco version: the sitter's face, the positions of the fingers of the sitter's left hand, and the absence of a fold in the drapery on the left arm. Otherwise, the differences are qualitative. The San Francisco version appears weaker in execution, lacking the nervous energy of the first painting in description of the drapery, and revealing general dryness in handling.

The *livret* of the Salon of 1753 describes no. 48 as a "Portrait of Mme Boudrey, depicted as a muse, drawing. In the background of the picture Mount Parnassus can be seen." In fact the background shows the muses and Apollo, holding the lyre and the laurel crown, on Mount Helicon. The winged Pegasus is behind this group, kicking a rock from which the Hippocrene, a sacred spring, gushes forth (fig.3). The allegorical nature of this mythological picture is vague, as the muses preside over poetry, song, and other arts, but none of them serves specifically as the genius of graphic art. Among the muses Polyhymnia is easily recognized at left, her arm outstretched in an oratorical gesture; Erato plays the violin; Urania is near a globe, and Clio reads. The motif of Apollo and the muses also appears with some variations in the *Portrait of Nattier* by Voiriot (1759, Musée du Louvre, Paris), which shows the artist at work in his studio.

Who was Mme Boudrey? According to the marquis d'Argenson, she had at the time of this portrait been enjoying some success at court. In an entry of 4 August 1750, the marquis writes in his journal that
the dauphin has fallen in love with the wife of a finance broker named Boudrey. She is in effect the most beautiful woman of the day, but if the rumor of this gallantry is true, we can see that our sovereigns today prefer the shepherd's crook to the scepter. The dauphin is in truth a devout person, but nature is strong and he is a man of great temperament. The dauphine, being pregnant, requires periods of rest, and during these periods he might have conceived ambitious designs at the sight of such a woman; presently, he has no personal agent to help him with his amorous affairs. Nonetheless, he knew no better than to write to this lady; she gave the letter to her husband; the latter is a man of honor and brought the letter to Mme de Pompadour. We know no more than this.[1]

It is not until September 1753 that the marquis d'Argenson mentions the affair once again in his journal, giving a few more details:
The king and the dauphin coveted her at the same time. The day she had a rendezvous with the king she received a letter from the dauphin, asking for a rendezvous. She

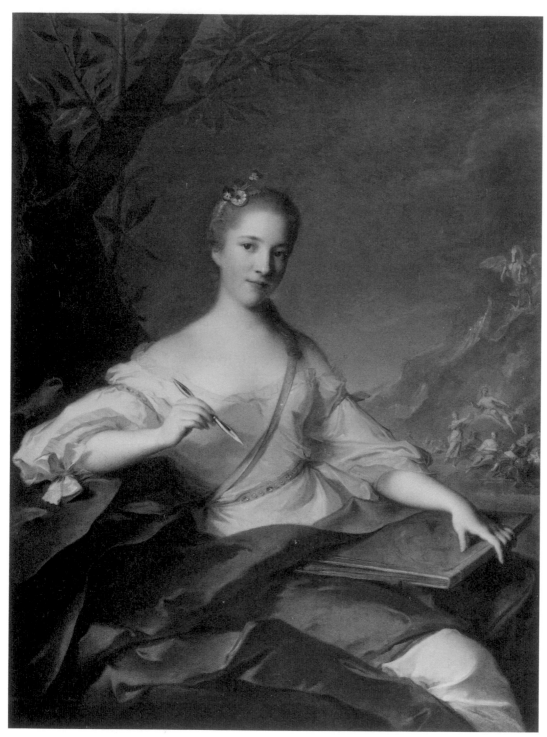

Madame Boudrey as a Muse

was quite embarrassed and gave her husband the dauphin's letter, asking him to answer it. The husband offered his excuses as one can readily understand, and from then on, held his wife in great admiration, as one can also readily understand. However, she kept the rendezvous with the king, as he was capable of paying her more; but the king stood the lady up. Since then, he has asked again and succeeded; but since the fulfillment of his plans he has not sent for her, and the poor woman, seeing herself thus scorned, is dying of shame.[2]

It is likely that the husband of this lady was Jean-François Boudrey, first agent to the controller general, and sole inheritor in 1738 from his brother, Paul Boudrey de Pingé, tax farmer to the king.[3] The sitter was Marie-Geneviève Radix, daughter of Claude-Mathieu Radix, squire and lord by acquisition of Chevillon and La Ferté-Loupière, honorary lands that had belonged to the house of Courtenay. Her mother was Marie-Elizabeth-Geneviève Denis. During her life at the court Mme Boudrey was also romantically attached to one of the most handsome men of the day, Nicolas-Augustin de Malbec de Montjoc, marquis de Briges and first squire and captain of the King's Guard. After she was widowed, Mme Boudrey married him on 14 December 1760 by contract "with the agreement and the signature of their Majesties the King, the Queen, and the Royal Family."[4]

The original *Portrait of Mme Boudrey* was received with diverse opinion at the Salon of 1753. Abbé Garrigues de Froment observed that "the Portraits of Nattier are hung above those of [M.-Q.] de la Tour," and went on to remark that

several of these last, according to the others, are not pleasing when viewed from up close. The former [Nattier's portraits] are all pleasing: the accoutrements moreover very flattering; it is a pity that the flesh tones are a little dark and that the Lady's head, painted as a Muse, and her pose, which has already been found affected and unnatural, should be subject to such criticism, and that we have grounds for suspecting that several heads on which this Author seems to have worked the most, are also dark.[5]

Abbé Leblanc was more positive in his appraisal:
The works of Nattier have what it takes to please the Public. Truth, finesse, graceful brushwork, great skill in the manner of draping his figures, consistent attention to making his Portraits Paintings. This is what characterizes him and what one finds in the five he has shown this year at the Salon, which merit the highest praise. . . . In that of Mme Boudrey he has rendered all the feeling and grace of the Original.[6]

The problem posed here by the fusion of a society portrait with a mythological allusion is neatly resolved in

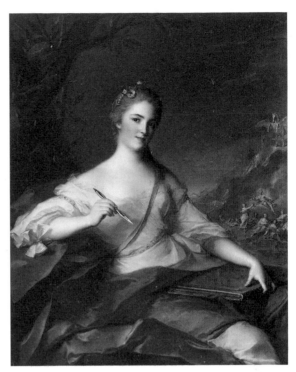

fig.1

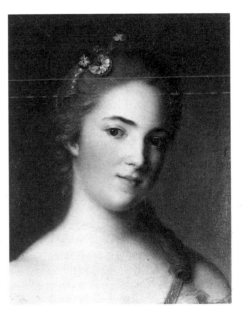

fig.2

the construction of the composition. Seeking to maintain an overall sense of balance, the artist relegates the mythological scene to the background, using a forceful series of diagonals to focus attention on the sitter. The end result is a portrait of great refinement and rare harmony.

1. *Journal et mémoires du Marquis d'Argenson* (Paris: E. J. B. Rathery, 1859-1867), 6:242.

2. *Journal*, 8:119-120.

3. The will of Paul Boudrey de Pingé, AN, Minutier Central, XXIX-439, 17 May 1738.

4. De la Chenaye-Desbois and Badier, *Dictionnaire de la noblesse*, 1868 ed., 12:col. 978; and 1869 ed., 15:col.685.

5. Collection Deloynes 5,23, no. 58.

6. Collection Deloynes 5,32, no. 63.

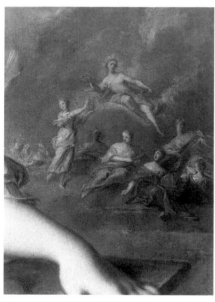

fig.3　(detail)

Jean-Baptiste Oudry *Paris 1686-1755 Paris*

Jean-Baptiste Oudry's father, Jacques Oudry, was director of the Academy of Saint Luke in 1706. The younger Oudry received his first lessons from Serre, *peintre des galères du roi* in Marseille, who visited Paris in 1704. Around 1705-1707 he began a five-year apprenticeship in the studio of Largillierre, where he copied Flemish and Dutch works and studied color. He was elected to membership by the Academy of Saint Luke in 1708. While Oudry devoted himself primarily to portraiture, he painted several religious works between 1709 and 1717, when he was accepted by the Royal Academy of Painting and Sculpture. He was elected to full membership two years later as a history painter with *Abundance with Her Attributes* (Château de Versailles). An adjunct professor in 1739, he was appointed professor in 1743.

From the beginning of his career Oudry was interested in still life, and was very quickly considered an imitator of Desportes, who inspired Oudry's brilliant compositions combining animals, flowers, and musical instruments. Around 1721-1722 he painted his first compositions of the hunt, which had enormous success. He was appointed official painter of the royal hunt and given lodgings at the Louvre. Under the patronage of Louis Fagon, the finance minister, he was named painter to the Royal Tapestry Factory at Beauvais in 1726, where he assumed artistic direction in 1734. In 1736 he became inspector at the Gobelins factory as well.

At Beauvais Oudry executed tapestry cartoons for *Chasses nouvelles* (1727), *Amusements champêtres* (1730), *Comédies de Molière* (1732), *Métamorphoses d'Ovide* (1734), *Verdures fines* (1735), and *Fables de La Fontaine* (1736). However, it was for the Gobelins that he created his finest tapestry suite, *Chasses royales de Louis XV* (1733-1746). Concurrently, Oudry made decorative panels and overdoors for various royal residences, including *The Fables of La Fontaine* for the cabinet of the dauphin at Versailles.

The patronage of *amateurs* such as Marquis de Beringhen and Count Tessin brought numerous private commissions to the painter. As a result of Duke of Mecklenburg-Schwerin's admiration for Oudry's work, the museum at Schwerin today houses an incomparable collection of paintings and drawings representing all the genres in which the artist worked. In addition to portraiture, history painting, allegory, still life, hunting pictures, "portraits" of the king's dogs (Fontainebleau), and exotic animals, Oudry also painted outstanding landscapes (*The Farm*, 1750, Musée du Louvre, Paris). Although less moving than Chardin's, Oudry's work aims toward virtuosity (*The White Duck*, 1753, collection of Dowager Marchioness Cholmondeley, Houghton Hall), illusion, and stunning effects. His son, Jacques-Charles, continued in his father's style.

Oudry's oeuvre is enormous. Hal N. Opperman has catalogued more than six hundred paintings and one thousand drawings. His monumental work (1977) and the catalogue he compiled for the 1982-1983 exhibition[1] provide current knowledge of the artist, eclipsing the outdated monographs by Jean Locquin (1912) and Jean Vergnet-Ruiz.[2]

1. *J.-B. Oudry 1686-1755*, exh. cat. (Paris: Grand Palais, 1 October 1982-3 January 1983; Fort Worth: Kimbell Art Museum, 26 February-5 June 1983; and Kansas City, Missouri: The Nelson-Atkins Museum of Art, 15 July -4 September 1983).
2. Jean Vergnet-Ruiz, in Dimier 1928-1930, 2:135-192.

The Pâté

The Pâté

Le pâté
Oil on canvas (curved), 69 ¾ × 49 in.
(177 × 124.5 cm)
S.d. lower left, below the ledge in the niche: *J. B. Oudry
1743*, **fig.1**
Mildred Anna Williams Collection. 1956.91 (CPLH)

Provenance Dr. Mallez, Paris; Dr. Mallez sale, Paris, Hôtel Drouot, salle 8, 30 May 1885, no. 30 (sold for 1,600 francs, according to the annotated sale cat., Bibliothèque Doucet, 1885/177); A. Veil-Picard, Paris, 1889-1955; [Galerie Feilchenfeld, Zurich, 1955]; acquired by the CPLH, 1956.

References Locquin 1912, 23, no. 115; J. Vergnet-Ruiz in Dimier 1928-1930, 2:173, no. 313; Howe 1957, repr.; *The Art Quarterly*, Spring 1957, 95; *Handbook* 1960, 58, repr., repr. in color on 85; "L'ébéniste Joseph Baumhauer," *Connaissance des Arts*, March 1965, 82, repr. in color; Faré 1976, 129, fig.202; C. Constans and M.-D. Bascou, *Le Larousse des grands peintres*, 1976 ed., s.v. "J.-B. Oudry"; Bordeaux 1977, 38, repr. in color; Opperman 1977, 1:553-554, no. P.511, fig.289, and 2:945, no. P.511; H. W. Woodward, Jr., *Eighty Works in the Collection of The University of Michigan Museum of Art*, 1980, mentioned under no. 52; Lee 1980, 222, fig.17 on 220; L. Blanch, "Paintings of the Table," *Architectural Digest*, March 1987, repr. in color on 30.

Exhibitions 1955 Zurich, no. 223; 1978-1979 Denver-New York-Minneapolis, no. 32.

Variants

PAINTING
Buffet with Dead Game, a Ham Pâté, and Bread
REF: Opperman 1977, 1 and 2:no. P.559.
EXH: Salon of 1753, no. 35: "A painting five *pieds* by three and one-half *pieds* showing a pheasant with a hare; a pâté of ham, bread, turnips, etc., make up the rest of the composition. This painting is in the dining room of M. Roettiers, goldsmith in ordinary to the king."

DRAWING
The Pantry, **fig.2**
Black chalk heightened with white on gray-blue paper, 13 ⅝ × 10 1/16 in.
(345 × 255 mm)
S.d. lower left, below the ledge in the niche: *J. B. Oudry 1743*
The University of Michigan Museum of Art, Ann Arbor, given by Friends of the Museum in honor of Miss Helen B. Hall. Inv. 1971/2.5
PROV: Edmond and Jules de Goncourt, Paris; Brothers Goncourt sale, Paris, Hôtel Drouot, 15-17 February 1897, no. 221; Georges Bourgarel, Paris; Bourgarel sale, Paris, Hôtel Drouot, 15-16 June 1922, no. 168, repr.; Mrs. James W. Johnson; [Faeber and Maison, Ltd., London].
REF: Hiram W. Woodward, Jr., *Eighty Works in the Collection of The University of Michigan Museum of Art*, 1980, no. 52, repr.

fig.1 (detail with signature)

fig.2

In 1743, the year this painting was executed, Oudry was appointed professor at the Royal Academy of Painting and Sculpture. He began to diversify his production and in 1739 painted *Still Life with a Pheasant and a Rabbit* (Drottingholm Castle, Art Collections of the Swedish State), the first in a series of white backgrounds so characteristic of his later work. As a young man he had already painted several studies of this kind. These paintings, of which the San Francisco picture is an excellent example, met with considerable public acclaim.

The composition of *The Pâté* is well balanced, simple and classic in its austerity. The long stems of the cardoons, a garden vegetable with edible stalks related to the artichoke, help unify the composition at the bottom of the picture by forming a link between the pâté on the silver platter and the basket of fruit. In apposition to one another on a diagonal are two bottles of wine and two game birds, a mallard and a red partridge, which have been tossed on top of the cardoons. The hare and the pheasant that hang from their feet complement the verticality of the composition. The pheasant's open wings add a horizontal axis, subtly echoed by the pieces of cut stone forming the niche. The trompe l'oeil is effective although the canvas is in poor condition. Oudry handles the fur and the plumage with flair, rendering both their thickness and soft texture with virtuosity. The intensity of the shadows is graduated, indicating an artist with absolute control over the use of color values. With such skill, Oudry creates a work of art where a less gifted artist might have produced an unappealing decorative picture.

What relationship does this canvas have with the drawing of similar composition, also dated 1743, at The University of Michigan Museum of Art (**fig.2**)? There are some modifications in the lower portion: the pâté has been replaced by a fowl, a leg of lamb has been substituted for the duck and partridge, and the basket in the second plane is empty. Hal Opperman admits that it is impossible to determine whether the drawing is a preparatory study for this painting, or for another painting with a similar theme and slightly smaller dimensions shown at the Salon of 1753.[1] The drawing might be a study for an unknown or lost variant, or it could actually have been done following execution of the San Francisco painting, a habit of Oudry's.

Although unfortunately the whereabouts of the painting exhibited in the Salon of 1753 is unknown (see Variants), probably both it and San Francisco's painting served similar functions as a simulated buffet in the dining room of a bourgeois or an aristocrat. The arched format, which was easily adaptable to a panelled wall, and the motif of the niche are not at all unusual. They are found in the still lifes of Largillierre, Oudry's master, and in the work of Jacques-Charles Oudry, the son and pupil of the artist.[2]

The same *pâté en croûte* with a removable pastry lid decorated with fleurs-de-lys is found also in other paintings (*Still Life with a Rifle, a Pâté, and a Dead Rabbit*, called *Le feu*, 1720, Nationalmuseum, Stockholm; and *The Dead Wolf*, 1721, Wallace Collection, London), which suggests that this might have been a standard pastry-mold design of the day.

Executed in a light palette with its fresh tonalities delicately distributed, this beautiful painting—perhaps the most beautiful Oudry in the United States—demonstrates the extreme care the artist took in his later works. The picture merits admiration not only for its illusionism, but also for the fine quality of its composition. The arrangement of the animals and foodstuffs appears simple and natural, but in fact represents careful reflection. No detail has been left to chance, and one cannot help but compare this extraordinary work with the last still lifes of Chardin.

1. Letter, 7 February 1973.
2. Michel Faré, *La nature morte en France*, 2 vols. (Geneva: Pierre Cailler, 1962), 2:nos. 192, 194, 293, 294, 355-357.

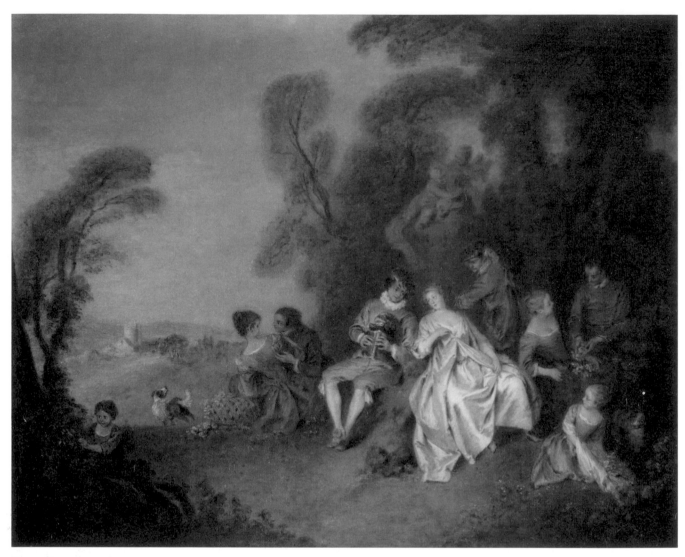

Country Party

Jean-Baptiste-Joseph Pater *Valenciennes 1695-1736 Paris*

Jean-Baptiste-Joseph Pater's father was the sculptor-dealer Antoine-Joseph Pater, who was a friend of Watteau. Jean-Baptiste received his first lessons in 1706 from Guidé, a painter in the Guild of Saint Luke. He was one of the few students of Watteau in Paris in 1713, and worked with him again in 1721. It was not until 1728 that Pater was elected to membership by the Royal Academy of Painting and Sculpture as a painter of modern subjects with *Country Party* (Musée du Louvre, Paris). In the eighteenth century Pater was almost as renowned as his teacher, and like him remained out of the mainstream of official painting, working for dealers and *amateurs* such as Duc de La Force. After Pater's death Frederick II of Prussia became one of the artist's most ardent admirers, eventually owning more than forty of his paintings.

Pater drew many of his subjects from the theater, such as Florent Carton Dancourt's work (*Village Orchestra*, Frick Collection, New York), and the works of La Fontaine, Molière, and Paul Scarron. His village and military scenes, such as *The Vivandières of Brest* (Wallace Collection, London) or *The Fair at Bezons* (The Metropolitan Museum of Art, New York), display a personal talent; the happy and anecdotal subjects, on the other hand, are more reminiscent of Dutch genre painting. The same pleasing descriptiveness contributes to the charm of his pastorals and bathers.

Pater painted prolifically, if unimaginatively, to assure a comfortable existence, and in the process prematurely ruined his health. While Watteau's *fêtes galantes* were his constant inspiration, he also copied his own work. Light brushwork, the sharpness of blue and pearly pink hues, the rococo mannerism of draperies, and the frank and witty gaiety with a hint of realism make his works easy to recognize. Pater is the epitome of the "little master" who benefited from Watteau's immense fame, excessively so when one considers the obscurity of so many artists of the era.

The largest collections of Pater's works are in Berlin (Schloss Charlottenburg) and London (Wallace Collection), but major paintings are preserved also in the United States, notably in New York, Washington, Pittsburgh, St. Louis, Indianapolis, and Jacksonville.

Florence Ingersoll-Smouse (1928) published an exemplary and richly illustrated catalogue of his work.

Country Party
Fête champêtre
Oil on canvas, 25 3/4 × 32 3/16 in. (65.5 × 82 cm)
Gift of Brooke Postley. 59.36 (de Young)

Provenance [René A. Trotti, Paris]; [M. Knoedler & Co., Inc., Paris, by 1925]; Jeanne G. Postley, New York; Brooke Postley, Greenwich, Connecticut; gift to the de Young, 1959.

References Ingersoll-Smouse 1928, 41, no. 44, fig.163 on 191; *European Works* 1966, 177, repr.

Exhibitions 1948-1949 Paris, no. 164; 1961 Los Angeles, 11, repr.

Variant
PAINTING
Country Party, fig.1
Oil on canvas, 24 3/8 × 29 1/2 in. (62 × 75 cm)
PROV: Duke of Marlborough, Blenheim Palace (attributed to Lancret); Duke of Marlborough sale, London, Christie's, 24 July 1886, no. 205; Marquis de Barron; anonymous sale, London, Christie's, 24 March 1972, no. 80, repr.

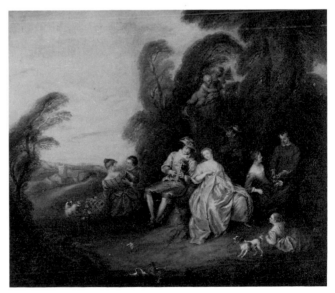

fig.1

In this typical work by Pater, it is easy to see the influence of Watteau, whose style and subject matter Pater knew so well. The young woman at center rests her elbow on the embankment with the same graceful attitude as the exquisite lady who leans on the counter in *The Shop Sign of Gersaint* (Schloss Charlottenburg, Berlin). The couple seated at left, particularly the male figure, seem related to *The Faux Pas* (Musée du Louvre, Paris). Many other details, such as the little girl at left, the blurred outline of the trees, the fountain composed of two putti embracing a dolphin, and the familiar presence of small dogs, evoke the work of the master from Valenciennes.

The relationship between the two artists goes even further, as Pater also borrowed from Watteau the dolphin's erotic significance as well as the use of the musette as the musical instrument of pastoral lovers, omitting the ribald double entendre that Flemish painters often gave the bagpipe. This prosaic *Country Party* lacks both the wistful charm and the refined sense of arabesque of Watteau's figure grouping. The personages in this painting are linked by a play of glances and series of inclinations toward one another, but they are not really well-integrated into the landscape and lack a sense of intimacy. The element of fantasy here is conventional. Pater's talent, however assured, cannot rival Watteau's genius.

A second version of this composition exists with a few variations (**fig.1**). In the background there is a pond in which ducks and ducklings swim, the little girl on the right reclines on her elbow on the grass and the small dog has moved to her left, the child picking flowers is absent, and a number of details have been modified. A qualitative comparison is not possible as the other version is known only through a mediocre reproduction in a sale catalogue.

In his haste to paint, the prolific Pater often copied himself. For example, the little girl kneeling at right reappears in reverse at left in *The Offer of Flowers* (page 245).

The Offer of Flowers *or* Springtime

L'offre des fleurs or *Le printemps*
Oil on canvas (oval), 16 × 21 ½ in. (40.5 × 54.5 cm)
Mr. and Mrs. E. John Magnin Gift. 75.18.3 (de Young)

Provenance Collection of Earl of Pembroke (according to Ingersoll-Smouse 1928, 42, no. 56); perhaps Earl of Pembroke sale, Paris, 19 place Vendôme, 27-30 June, 1-10 July 1862, no. 10 ("Reunion in a park"); Mme Pauper, Paris; Mme P+++ Pauper sale, Paris, Hôtel Drouot, salle 8, 12-15 March 1873, no. 14; acquired for 8,500 francs by "M. le duc de Narbonne, 21 rue de Varennes [*sic*]" (according to the sale catalogue annotated by Seymour de Ricci, Cab. des Est., Yd. 2589, vol. 4); Maurice Kann, Paris, before 1909; Edouard Kann, Paris; [Thos. Agnew & Sons, London, 1925-1926]; anonymous sale, London, Christie's, 9 July 1926, no. 136, repr.; acquired for 800 guineas by "Smith" (according to the Witt Library, London); [Wildenstein & Co., Inc., New York, 1926]; Mrs. Benjamin Stern, New York, 1927-1934; Stern sale, New York, American Art Association, Anderson Galleries, 4-7 April 1934, no. 839, repr.; acquired by Mr. and Mrs. E. John Magnin, New York; gift to TFAMSF, 1975.

References Marguillier 1909, 4, repr. on 2; *BM*, April 1925, repr., advt.; *BM*, July 1926, advt.; Ingersoll-Smouse 1928, 42, no. 56, 124, fig.46 on 124; Lee 1980, 218, fig.9 on 215.

Exhibitions 1942 New York, no. 44; 1978-1979 Denver-New York-Minneapolis, no. 33.

Variant

PAINTING
The Offer of Flowers, **fig.1**
Oil on canvas, 17 ¾ × 21 ¹/₁₆ in. (45 × 53.5 cm)
PROV: Henry Cousin sale, Paris, Hôtel des Ventes Mobilières, salle 1, 21 March 1853, no. 64, repr.; Baron Henri de Rothschild, Paris; Baron James de Rothschild, Paris; Baron James de Rothschild sale, Paris, Palais Galliera, 1 December 1966, no. 131, repr. (attributed to J.-B. Pater).
REF: Ingersoll-Smouse 1928, 45, no. 93.

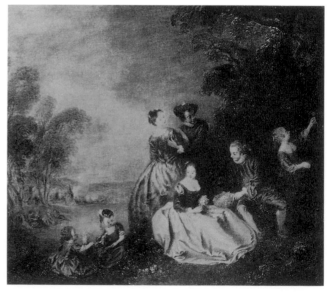

fig.1

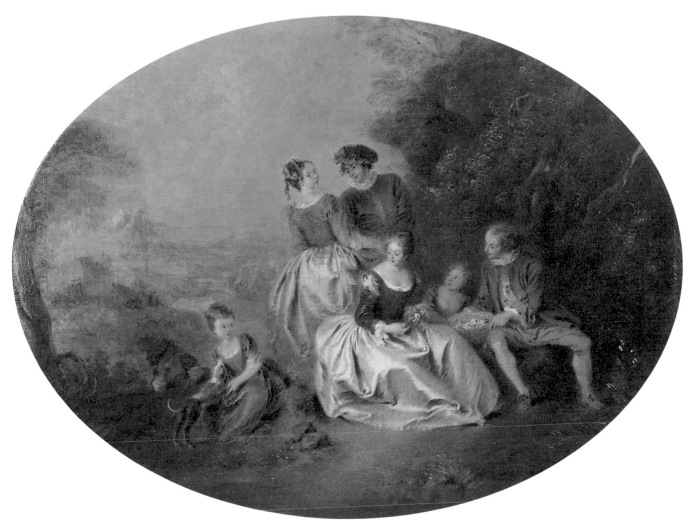

The Offer of Flowers *or* Springtime

This canvas also reveals Watteau's influence on his student and disciple. The background landscape with a mill and various country buildings is very similar to that of Watteau's *The Love Lesson* (Nationalmuseum, Stockholm), engraved in 1734 by Dupuis, and the pose of the couple standing in the center is reminiscent, although reversed, of the central couple in *Pilgrimage to the Island of Cythera* (Musée du Louvre, Paris, and Schloss Charlottenburg, Berlin). Even the theme of roses offered and accepted, signifying the young woman's favorable response to the overtures of the young man, is borrowed from Watteau (*Fête in a Park* and *Elysian Fields*, both Wallace Collection, London). Pater emphasizes the moral implications of this amorous intrigue by directing the eyes of the couple toward a young girl, the image of innocence, which allows him to assemble in a rather surprising manner three stages of youth: the innocence of childhood, the awakening of amorous desire, and the choice of a lover. In fact all the figures in this composition are related through an exchange of glances. Certain details of the costumes, such as the large beret and the linen ruffs worn by the men, show Watteau's influence, but these clothes are closer to contemporary reality than to theatrical fantasy.

The original rectangular shape of this charming painting was certainly changed to an oval before 1873. Unfortunately, the painting has suffered in cleaning and some of the details have been almost erased, such as the pond in the foreground. Pater's palette is colder and more silvery in tone than Watteau's, but the delicacy of his brushwork is remarkable, as demonstrated by the light treatment of the foliage and the aerial perspective in the landscape background.

A second version with a number of variations exists (**fig. 1**). The couple seated at the right on an embankment is practically identical in both paintings, but a little girl sits between them in the San Francisco picture; in the other version a young girl placed behind them picks roses. The children on the left are in different poses; the face of the young man standing in the middle is turned in the opposite direction, and his hand appears on his companion's back. Several couples variously grouped have been introduced in the distance, and details differ in the drapery as well as in the landscape background. It is extremely difficult to determine which version was executed first, but San Francisco's painting seems to be of higher quality.

Jean-Baptiste Perronneau *Paris 1715-1783 Amsterdam*

Jean-Baptiste Perronneau, a student of the engravers Aveline and Laurent Cars, whose portrait he painted in 1750 (The University of Michigan Museum of Art, Ann Arbor; another version in pastel at the Musée du Louvre, Paris), was primarily a pastelist. His first works in this genre date from 1744, although he was less exclusive in this medium than his great rival, M.-Q. de La Tour. Initially he was strongly influenced by Nattier, as one of his masterpieces, *Mme de Sorquainville* (1749, Musée du Louvre, Paris), attests. In 1753 he was elected to membership by the Royal Academy of Painting and Sculpture with his portraits of *L.-S. Adam* and *J.-B. Oudry* (Musée du Louvre, Paris). Nevertheless, Perronneau led a difficult life. In spite of several requests he never obtained lodgings at the Louvre, and had to be content with a bourgeois clientele consisting mostly of provincials and foreigners. His career was based on interminable travels—to Italy in 1759, England in 1761, Russia in 1781, Poland in 1782, and especially Holland in 1754, 1755, 1761, 1771, 1772, 1780, and 1783, where he died.

Largely unknown during his lifetime, Perronneau was rediscovered in the nineteenth century. His portraits are usually half-length, on a neutral background with minimal accessories. He accorded his sitter greater importance than did La Tour, who was more nervous, technically skilled, capricious, full of feeling, and perhaps more irritating. Unfortunately Perronneau did not blend his colors well. The harsh contrasts he sometimes created on the faces of his sitters are curiously reminiscent of the art of contemporary English portraitists. The slightly coarse appearance of his figures explains not only the reluctance of aristocratic clients to sit for him, but also the preponderance of masculine portraits, which are the best of his work (for example, the remarkable *Abraham Van Robais*, 1767, Cab. des Dess., Musée du Louvre, Paris). Here the pastelist approaches Chardin's style, feeling of intimacy, use of chiaroscuro, and play of reflections between different colored masses, making him in this instance a colorist more brilliant than La Tour. This personal sense of realism in Perronneau's work is combined with a need to serve and understand the sitter, in contrast to La Tour, who used his sitters to his own advantage.

Perronneau's art is well represented in French museums (notably Musée du Louvre, Paris; Musée des Beaux-Arts, Orléans; and Musée des Beaux-Arts, Tours), as well as by major works in the United States (Museum of Fine Arts, Boston; The Art Institute of Chicago; The Detroit Institute of Arts; and J. Paul Getty Museum, Malibu). Léandre Vaillat and Paul Ratouis de Limay published an excellent monograph on this artist (1909; 1923), which is still the authority.

Portrait of a Woman (Madame Braun?)

Portrait présumé de Madame Braun
Pendant to *Portrait of a Man* (*Monsieur Braun?*)
Oil on canvas, 28¾ × 23½ in. (73 × 59.5 cm)
S.d. upper right: *Perronneau./1773,* **fig.1**
Gift of Archer M. Huntington through Herbert Fleishhacker 1929.8 (CPLH)

Provenance Presumably with the descendants of the Brauns until the beginning of the twentieth century; [Galerie Boussod, Valadon & Cie, Paris]; [M. Knoedler & Co., Paris, then New York, 1916-1929]; acquired for the CPLH, 1 August 1929.

References Vaillat and Ratouis de Limay 1923, 120-121, 229, pl. 38 opposite 150; Robinson 1921, 113, repr. on 114; *Illustrated Handbook* 1942, 45, repr.; *idem*, 1944, 49, repr.; *idem*, 1946, 53, repr.; Davisson, August 1947, 26-28, repr. on 27.

Exhibitions Perhaps in the Salon of 1773, no. 65; 1934 San Francisco, no. 48; 1959 Baltimore, no. 28; 1961-1962 Canada, no. 63, repr. on 133; 1963 Cleveland, no. 65, repr.; 1977 New York, no. 50, fig.50.

Portrait of a Man (Monsieur Braun?)

Portrait présumé de Monsieur Braun
Pendant to *Portrait of a Woman* (*Madame Braun?*)
Oil on canvas, 29 × 23½ in. (73.5 × 59.5 cm)
S.d. upper right: *Perronneau./1773.*
Gift of Archer M. Huntington through Herbert Fleishhacker. 1929.7 (CPLH)

Provenance The same as the preceding work.

References Vaillat and Ratouis de Limay 1923, 120-121, 229, pl. 37 opposite 146; Robinson 1921, 113; *Illustrated Handbook* 1942, 45, repr.; *idem*, 1944, 49, repr.; *idem*, 1946, 53, repr.; Davisson, August 1947, 26-28, repr. on 29; *Handbook* 1960, 62, repr.

Exhibitions Perhaps in the Salon of 1773, no. 65; 1934 San Francisco, no. 47, repr.; 1940 New York World's Fair, no. 218, repr.; 1963 Cleveland, no. 64, repr.; 1977 New York, no. 49, fig.49.

Portrait of a Woman (Madame Braun?)

Portrait of a Man (Monsieur Braun?)

fig.1 (detail with signature)

The identification of the sitters of these two portraits poses a problem. In the first published reference to the works David Robinson observed:
The Knoedler Galleries of New York have recently brought from France typical portraits by Jean-Baptiste Perronneau. . . . The subjects are M. and Mme Braun, who lived during the second half of the eighteenth century at Strasbourg. She was a lady of honor and he a chamberlain at the court of Fürstenberg. The portraits were obtained from their direct descendants.[1]
This information was repeated by Vaillat and Ratouis de Limay,[2] as well as by the publishers of all relevant exhibition catalogues. While the name Braun was very common in the Germanic provinces of France, and notary archives of the region list several bourgeois families by that name who lived in Strasbourg during the second half of the eighteenth century, none have been proven to be the sitters of these portraits. Intensive local research might one day solve this dilemma.

Vaillat and Ratouis de Limay mention that Perronneau visited Lyon briefly in 1773.[3] The "Brauns" might have been in that city at the same time, or perhaps the painter, who was always on the move, spent some time in Strasbourg that year as well. The same authors also suggest that these two pictures might have been exhibited at the Salon of 1773. Although at the end of the list of works by Perronneau the *livret* for the Salon mentions for no. 65 "additional portraits under the same number," no article or description of these works permits verification that the Museums' works were among them.

The two pendants are reminiscent of the art of Gainsborough, although unsatisfactory relining and poorly done restoration have diminished their effect. One sitter is in a frontal pose, the other in a three-quarter profile, and both are framed with trompe l'oeil ovals cropped on all sides by the rectangular canvas. This interesting procedure combines the then-fashionable and graceful oval form with the more monumental and ennobling rectangular frame. Perronneau thus skillfully fulfills the requirements of good taste while placating the desire of his rich bourgeois patrons to appear in a certain way before society. The uniform appearance of the works is assured by the identical treatment of the backgrounds, subtly modulated by the play of light and shadow in gray and brown tonalities. The presumed M. Braun wears a suit of pale beige velvet over a blue waistcoat that captures the passing reflections of light. Both garments are ornamented with gold braid. A jabot of fine lace falls across his chest and a black tricorn hat is tucked under one arm. The pose resembles that in *Portrait of a Man from the Journu Family* (1757, formerly in the Demotte collection)[4] and especially the *Portrait of a Man* (1765, formerly in the René Benjamin collection).[5] The presumed Mme Braun wears a bodice of

pink pleated silk ornamented with a multi-layered bow and a scarf of white muslin trimmed with pink wrapped around her shoulders. Her hair is coiffed high and lightly powdered. Her pose is related to the *Portrait of the Marquise de Courcy* (pastel, 1772),[6] which for a long time remained in the sitter's family, and to the *Portrait of Mme Schuyt* (1778, formerly in the collection of J. van Weede van Dijkveld).[7] From these similarities we can conclude that Perronneau was not an innovator in devising poses, and that the models did not attempt to distinguish themselves by wearing other than what was normally worn by good society at the time.

Of much greater interest is the execution of the two paintings with rather loose brushwork that evokes the technique of pastel drawing. This is not surprising for a master of that medium. The treatment of the lady's face is remarkable for its delicate coloring and the flat but serene expression, but less so for the interpretation of the model's personality. Most likely ill-at-ease as reputedly he was while painting female portraits, Perronneau glossed over the features of his sitter, concentrating on the shimmering silks of her dress and the airy transparence of her scarf. His ambition did not go beyond producing an irreproachably faithful likeness and a suitably elegant setting. For his male sitter, Perronneau uses a more audacious palette and more incisive tonalities, making the flesh tones vibrate under strong lateral illumination and emphasizing every line in the sitter's florid face. The painter appears to have enjoyed analyzing his model and made more of an effort to penetrate his character. Thus, while the supposed M. Braun is less attractive than his wife, his portrait appears more sincere and truthful.

Perronneau painted many pendant portraits of couples, but few are more characteristic of the ambiguity of his art. Drawing on inexhaustible decorative skill, he oscillates between the conventions of portraiture with its facile attractions, and a realistic conception that stresses the essentials.

1. Robinson 1921, 113.
2. Vaillat and Ratouis de Limay 1923, 120.
3. Vaillat and Ratouis de Limay 1923, 119-120.
4. Vaillat and Ratouis de Limay 1923, pl. 19.
5. Vaillat and Ratouis de Limay 1923, pl. 26.
6. Vaillat and Ratouis de Limay 1923, pl. 36.
7. Vaillat and Ratouis de Limay 1923, pl. 39.

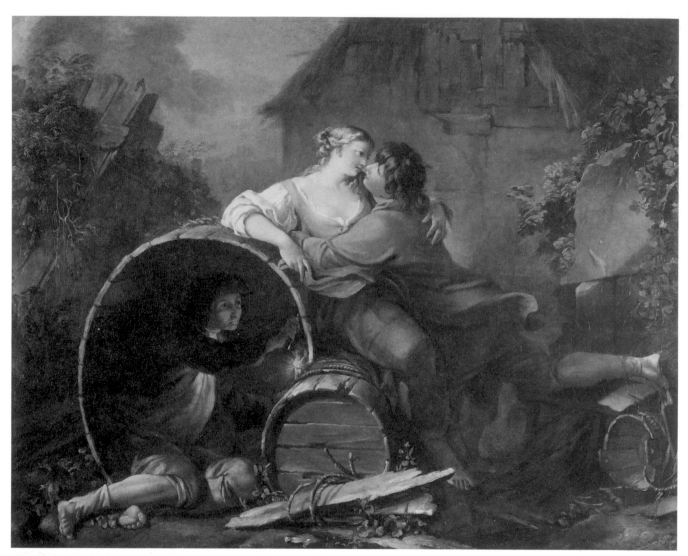

The Tale of the Cooper's Wife

Jean-Baptiste-Marie Pierre *Paris 1714-1789 Paris*

After studying with Natoire, Jean-Baptiste-Marie Pierre was awarded the *Grand Prix* by the Royal Academy of Painting and Sculpture in 1734. He arrived in Rome in 1735 where he studied Italian painting for five years at the Palazzo Mancini, which was then under the directorship of Vleughels and J.-F. de Troy. Accepted as an associate in 1741, he was elected to membership by the Academy the following year with *Diomedes Killed by Hercules and Eaten by His Own Horses* (Musée Fabre, Montpellier) in which he appears to have perfectly mastered his style. He rapidly climbed the various steps of an academic career: adjunct professor in 1744, professor in 1748, adjunct rector in 1768, and director in 1770. In addition, he was chosen by Duc d'Orléans as *premier peintre* and curator of his picture gallery in 1752, received the title *premier peintre du roi* in 1770, and was ennobled. Pierre then more or less ceased painting. It is not too much to say that, with Comte d'Angiviller, Pierre played the principal role in the administration of French artistic life under the reign of Louis XVI, forcefully imposing his ideas. He was notably responsible for the absence of Chardin from any official function and for promoting history painting almost exclusively.

Before the middle of the century Pierre painted a few genre scenes and fanciful *bambocciate* (*Grandmother's Lesson*, 1741, Musée d'Art et d'Histoire, Auxerre, and *Return from the Market*, Musée des Beaux-Arts, Dijon), which are as brilliantly executed as his sketches (*Venus on the Waters*, Musée des Beaux-Arts, Caen). While working for the king (on the Council Chamber at Fontainebleau with Boucher and Carle Vanloo), he executed several history and religious paintings, replacing the tumultuous style of his earlier production by a flatter, more linear, and more classic mode. From this time his works evidence marked sobriety and restraint, a reaction against the art of Boucher and his followers, as seen in *The Flight into Egypt* (Salon of 1751, Church of Saint-Sulpice, Paris), *The Death of Harmonia* (Salon of 1751, The Metropolitan Museum of Art, New York), *Descent from the Cross* (Salon of 1761, Cathedral of Saint-Louis, Versailles), and *Mercury, Herse, and Aglore* (Salon of 1763, Musée du Louvre, Paris). Pierre's role in the history of great interior decoration cannot be denied. *The Assumption*, which was painted from 1749-1756 on the ceiling of the chapel of the Virgin in the Church of Saint-Roch, was considered a masterpiece by his contemporaries. Equally admired was *Apotheosis of Psyche* for the ceiling of Duchesse d'Orléans's salon at the Palais-Royal, and the *Story of Armida*, painted in 1769 for Duc de Chartres on one of the ceilings of the Château de Saint-Cloud. Pierre, an outstanding draftsman, also did approximately forty etchings.

It is hoped that Monique Halbout's research will produce a publication devoted not only to Pierre the artist, often misunderstood during his lifetime and virtually forgotten today, but also to Pierre as the most influential figure in artistic life in France during an era when a new aesthetic was evolving.

The Tale of the Cooper's Wife (*studio of Pierre*)
Le cuvier
Oil on canvas, 29 × 35 3/4 in. (73.5 × 91 cm)
M. H. de Young Memorial Museum purchase. 49.1

Provenance Mrs. Louisa Bradbury, San Francisco; acquired by the de Young, 7 February 1949.

References *Illustrations of Selected Works* 1950, 74, repr.; Bordeaux 1985, 77, mentioned under no. 17, fig.13a.

Related Work
ENGRAVING
P. Filloeul, after Le Mesle, *Le cuvier*, 1737, **fig.1**
REF: *Contes de la Fontaine: Suite d'estampes après Lancret, Pater, Eisen, Boucher, etc.*, Jules Lemonnyer, ed. (Paris, 1885).

fig.1

The subject of this canvas was borrowed from a licentious tale by La Fontaine, *Le cuvier*,[1] which was inspired by Boccaccio's *Decameron* (seventh day, second story), which in turn was influenced by the *Fables* of Apuleius (book 9). Pierre's painting does not seem based on the Italian writer, however, as the latter set the action at the house of a mason in Naples and not at a cooper's in the French provinces. The story is as follows: Nan, hearing her husband returning, hides her lover in a large barrel that the cooper has just sold. She tells her husband that in his absence she has sold the barrel to another, who is inside to see if it is sound. The husband, not wanting to lose a more advantageous deal than the one he had concluded, exclaims:

Come, come, sir, leave the tub, there's naught to dread;
When you are out, I'll ev'ry quarter scrape,
Then try if water from it can escape;
I'll warrant it to be as good as nice,
And nothing can be better worth the price.
Out came the lover; in the husband went;
Scraped here and there, and tried if any vent;
With candle in his hand looked round and round,
Not dreaming once that LOVE without was found.
But nothing could he see of what was done; . . .
A very diff'rent work from that within
The husband had, who scraped with horrid din,
And rubbed, and scrubbed, and beat so very well,
Fresh courage took our gay gallant and belle;
They now resumed the thread so sadly lost,
When, by the cooper's coming, all was crossed.[2]

The attribution to Pierre is based on stylistic comparisons. In this canvas is found the same illustrative sense of composition and the same rustic figures and accessories as in the *Vegetable Market*, engraved by Pelletier, or the house in the background in an original etching entitled *Village Market*. The lingering over details and the supple handling of the draperies in highly colored, rich impasto, appear once again in a securely attributed work by Pierre, the *Sheep Enclosure* (Musée des Beaux-Arts, Dijon). Monique Halbout finds that "the sobriety in the accessories and the treatment of the foliage make one think immediately of this artist. In the 1750s one finds profiles similar to that of the lover, as well as the fluid treatment of the couple."[3]

Pierre demonstrated his interest in the *Contes* of La Fontaine on another occasion. He made four etchings inspired by the tales *Brother Luce*, *The Geese of Brother Philippe*, *The Falcon*, and *The Courtesan in Love*, subjects which Pierre Subleyras painted around 1732-1735 in Rome for the duc de Saint-Aignan and which may be the four paintings in the Musée du Louvre, Paris.[4]

La Fontaine's *Contes* were published in several beautifully illustrated editions during the eighteenth century, including Pierre Filloeul's *Contes de La Fontaine*. These editions show that *Le cuvier* in particular (**fig.1**) enjoyed great popularity throughout the eighteenth century.

1. J. de La Fontaine, *Contes et Nouvelles* (Paris: Gallimard, 1965), part 4, sec. 13.
2. J. de La Fontaine, *Tales and Novels* (London: Lancret Edition, n.d.), 229-230.
3. Letter, 15 May 1978.
4. See exh. cat., 1987 Paris-Rome, nos. 18, 23, 26, 28, repr.

Pierre-Paul Prud'hon *Cluny 1758-1823 Paris*

Pierre-Paul Prud'hon, son of a stonecutter, was sent in 1774 to the Ecole de Dessin in Dijon, which was directed by Devosge. Thanks to the patronage of Baron de Joursanvault, he was able to stay in Paris from 1780 to 1783 where he met Wille and Pierre. He won the *Prix des Etats de Bourgogne*, which allowed him to go to Rome (1784-1788). Rather than follow the style of David, he preferred the approach brought into Italy at that time by Mengs and Kauffmann.

In Paris and in Gray (Franche-Comté) during the Revolution, Prud'hon was an ardent republican. After his return to Paris in 1796 he supported himself by executing drawings—for Didot Frères and other publishers—for the illustration of works such as *L'art d'aimer*, *Paul et Virginie*, and *La nouvelle Héloïse*. After the turmoil of the Revolution, the new society was eager to enjoy itself and welcomed Prud'hon's revival of the decorative tradition of the eighteenth century. Josephine, the wife of General Bonaparte, commissioned him to decorate the ceiling of her salon on rue Chantereine. Even more important, in 1799 he executed allegorical decorations for the banker Lanoy's *hôtel* (sketch at Musée Fabre, Montpellier; fragments of these decorations in Musée du Louvre, Paris). After the great success at the Salon of 1801 of *Triumph of Bonaparte* (1800, drawing in Musée du Louvre, Paris), Prud'hon began to receive government commissions. In 1803 he was asked to paint *Diana Imploring Jupiter* on the ceiling of the gallery of Greek sculpture at the Louvre, to be followed by portraits of the imperial family. On many occasions he was chief decorator for official celebrations given by the City of Paris, including the commemoration of the emperor's coronation, the Treaty of Tilsitt, and the wedding of Napoleon and Marie-Louise of Austria.

The years 1808 to 1815 mark the height of Prud'hon's career and it was during this period that he painted his masterpieces: *Justice and Vengeance Pursuing Crime*, *The Abduction of Psyche* (both 1808, Musée du Louvre, Paris), *The Meeting of Napoleon and Francis II* (1812, Château de Versailles), *Young Zephyr Swaying* (1814, Musée du Louvre, Paris, on loan to the Musée des Beaux-Arts in Dijon as of 1983), and remarkable portraits such as the *King of Rome* (1811), *M. Vallet* (1812, both Musée du Louvre, Paris), and *Count Sommariva* (1815, Brera, Milan). He designed the empress's furniture and became her drawing master. As a target of hostility from David's circle, Prud'hon did not receive critical acclaim until late in his career. He was elected to the Institute only in 1816, and the paintings that he then sent to the Salon already seemed out of fashion. The end of his life was further saddened by the suicide in 1821 of his student, Constance Mayer. Although he continued to paint portraits, his history paintings became more rare (notably *Christ on the Cross* and *The Assumption*, 1822, Musée du Louvre, Paris). Prud'hon left several unfinished works at his death in 1823.

This admirer of Correggio manifests the cultural complexity typical of his era. As a neoclassicist and a precursor of romanticism, yet still tied in many respects to the eighteenth century, Prud'hon worked in opposing directions. He was truly a loner, the epitome of the tormented romantic artist. These conflicting tendencies in his work are tempered by freshness and personal charm, but often betrayed by the use of technical processes that hastened the deterioration of his works.

No recent comprehensive works have been published on Prud'hon. Jean Guiffrey's excellent catalogue (1924), following the books by Charles Clément (1872) and Edmond de Goncourt (1876), is now outdated. It is hoped that Sylvain Laveissière's catalogue raisonné, currently in preparation, will fill this gap.

Venus Bathing *or* Innocence

Venus Bathing *or* Innocence
Vénus au bain or *L'innocence*
Oil on canvas, 10⅝ × 8½ in. (27 × 21.5 cm)
Memorial Gift from Dr. T. Edward and Tullah Hanley,
Bradford, Pennsylvania. 69.30.166 (de Young)

Provenance Probably in the collection of Charles Boulanger de Bois-
fremont, Paris; M. de Boisfremont *fils*, Paris; Boisfremont *fils* sale,
Paris, Hôtel Drouot, salle 8, 9 April 1870, no. 21; Alexandre Dumas
fils, Paris, before 1874 to 1892; Dumas *fils* sale, Paris, Hôtel Drouot,
salles 8 and 9, 12-13 May 1892, no. 83; Alphonse Kann, Paris; Kann
sale, Paris, Galerie Georges Petit, 6-8 December 1920, no. 57, repr.;
David David-Weill, Paris, before 1922 to 1959; David-Weill sale, Lon-
don, Sotheby's, 10 June 1959, no. 122, repr.; Dr. T. Edward and Tullah
Hanley, Bradford, Pennsylvania; gift to the de Young, 1969.

References Goncourt 1876, 101-102; Forest 1913, 158, no. 59; Guif-
frey 1924, 66-67, no. 179; Henriot 1925, 6; Henriot 1926, 2:321-322,
repr. on 323; Guiffrey 1933, 4-5.

Exhibitions 1874 Paris (*Prud'hon*), no. 59; 1912 St. Petersburg, no.
496 ("La Nymphe"); 1922 Paris, no. 6; 1937 New York, no. 41; 1969
Buffalo, no. 181, repr.; 1970 San Francisco, no. 127.

Variants
PAINTINGS
Venus Bathing or *Innocence*, unfinished painting, **fig.1**
Oil on canvas, 52¾ × 40⁹⁄₁₆ in. (134 × 103 cm)
Musée du Louvre, Paris. R.F. 3696
PROV: Last owned by Edouard Desfossés; sale, Paris, Hôtel Drouot,
23-24 November 1932, no. 41, repr.; acquired by the Musée du
Louvre.
REFS: Guiffrey 1924, no. 178; Compin and Roquebert 1986, 151,
repr.

The Bath of Flora, unfinished painting with some variations on the
paintings in the Musée du Louvre and in San Francisco
Oil on canvas, 51¼ × 38¼ in. (130 × 97 cm)
PROV: At the dealer Duclos, according to Edmond de Goncourt, who
mentions a "doubtful sketch" (1876, 101, note 1); Laurent Richard,
Paris; Richard sale, Paris, 26 May 1886, no. 38 ("attributed to
Prud'hon"); Edouard Latil sale, Paris, Hôtel Drouot, 14 December
1931, no. 32, repr. ("Ecole de Prud'hon. Baigneuse").
REF: Guiffrey 1924, 66, mentioned under no. 178.
EXH: 1874 Paris (*Prud'hon*), no. 511.
NOTE: Gigoux made a lithograph after this painting, according to
Edmond de Goncourt.

fig.1

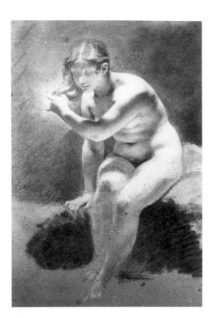

fig.2

DRAWINGS
Venus Bathing, with a single cupid
Black chalk heightened with white and color on bluish paper,
8 ¼ × 5 ¾ in. (210 × 145 mm)
PROV: Alphonse Kann sale, Paris, Galerie Georges Petit, 6-8 December 1920, no. 137.
REF: Guiffrey 1924, no. 186.

Study of a Female Nude for *Venus Bathing*, 1814, **fig.2**
Black chalk heightened with white on gray paper, 20 ¼ × 13 ³/₁₆ in. (515 × 335 mm)
Musée des Arts Décoratifs, Paris. Inv. 16423
REFS: Guiffrey 1924, no. 187; Raymond Régamey, *Prud'hon* (Paris: Rieder, 1928), 50, fig.48.

Study of Arms for *Venus Bathing*
Black chalk heightened with white on bluish paper
PROV: Collection Mahérault.
REF: Guiffrey 1924, no. 188.

Venus Seated
Black chalk
PROV: Collection Julien Gréau, 1864.
EXH: Troyes, May 1864, no. 1233.
NOTE: Perhaps identical with one of the two previous drawings.

PRINTS
After Prud'hon's painting in the Musée du Louvre:

Léopold Flameng, *Innocence*, engraving
REF: Léon Lagrange, "La Galerie de M. le Duc de Morny," GBA, 1863, 395.

Langlumé, *Venus Bathing*, lithograph
REF: Guiffrey 1924, 65, mentioned under no. 178.

Jules Boilly, *Venus Bathing*, lithograph
REFS: *L'Artiste*, 1866, 1:72, no. 79; Guiffrey 1924, 65, mentioned under no. 178.

Pellicot, lithograph, reproducing the same female figure, but with a single cupid on each side
REF: Guiffrey 1924, 65, mentioned under no. 178.

While the original owner of this charming oil sketch is unknown, it was in the collection of M. de Boisfremont *fils*, who owned a considerable number of paintings and drawings by Prud'hon. His father, Charles Boulanger de Boisfremont, was a painter and admirer of Prud'hon who acquired *Andromache* (The Metropolitan Museum of Art, New York) at Prud'hon's estate sale in 1823, and finished it for the Salon of 1824. It is therefore possible that the San Francisco sketch and many other works sold on 9 April 1870 from the collection of M. de Boisfremont *fils* belonged previously to his father.

This work is a preparatory sketch for the unfinished canvas now in the Musée du Louvre (**fig.1**). The variations between the compositions on this theme are few and insignificant. For example, *The Bath of Flora* (see Variants) differs from San Francisco's picture chiefly in the omission of the three cupids in the background and

in the addition of a garland of flowers placed upon the thighs of the goddess.

Jean Guiffrey somewhat arbitrarily concludes that all drawings depicting Venus are connected to our composition.[1] While the composition of four of these drawings, including the superb *Study of a Female Nude* (fig.2), is obviously related to the painting, others are similar only in subject. Prud'hon may have envisioned a composition like that of the drawing in the Musée Bonnat, Bayonne,[2] or those exhibited around 1950 at the Mathiessen Gallery, London (no. 70),[3] or in 1966 at Thos. Agnew & Sons, London (no. 136).[4] Perhaps a second painting of this subject was planned. The fact that the painting in the Musée du Louvre is no more than a rough sketch suggests this may be true.

In any case, all these studies reveal Prud'hon's interest in a work classical in subject, simplicity, and scope, but completely modern in interpretation. Except for the cupids gathering flowers, nothing indicates that this young woman is a goddess. The intimate and profane grace with which she holds back her abundant hair in a movement of the most charming invention is that of a rustic nymph, or simply a young woman preparing to bathe. It is an amusing paradox that Prud'hon chose to portray one of Olympus's most libertine goddesses as a young woman so naive that the painting was soon called *Innocence*. If this is indeed Venus, rather than an anonymous nymph, it is quite likely that Prud'hon intended here through a restrained balance of harmony, simplicity, and purity to give love a more elevated and moral interpretation.

Charles Clément places *Venus Bathing* at the end of the artist's career, between 1812 and 1823.[5] The relationship with *Young Zephyr Swaying* is striking. In each we find the same desire to blend antique inspiration with contemporary sensibility and the same manner of creating directly from the nude model, situating the natural bend of the body within a network of oblique lines. This work is representative of the artist in his full maturity, which he reached around 1815. The oil sketch in San Francisco is more ethereal and charming than the Louvre's painting. Except for the upper portions of the canvas, Prud'hon largely spared the San Francisco work from excessive use of bitumen and varnishes. In a fine, smooth impasto, underneath which can still be seen some of the initial squaring of the composition, Prud'hon manages to translate pictorially the full power of the model in the drawing at the Musée des Arts Décoratifs. In this painting we also find a childlike rosiness and elegant arabesques, inspired by the art of Leonardo and Correggio, delicately brought to completion. The light emanates from the figures and its nocturnal quality heightens the work's erotic allure. Having a keen sense of values and a restrained palette, Prud'hon makes the most of the play of light and shadow. With broad strokes he sketches in the suggestion of a landscape behind the loosely contoured putti, the product of a creative spirit and a sure hand.

1. Guiffrey 1924, nos. 180-188.
2. Guiffrey 1924, no. 18.
3. Guiffrey 1924, no. 180.
4. Guiffrey 1924, no. 182.
5. Clément 1872, 396.

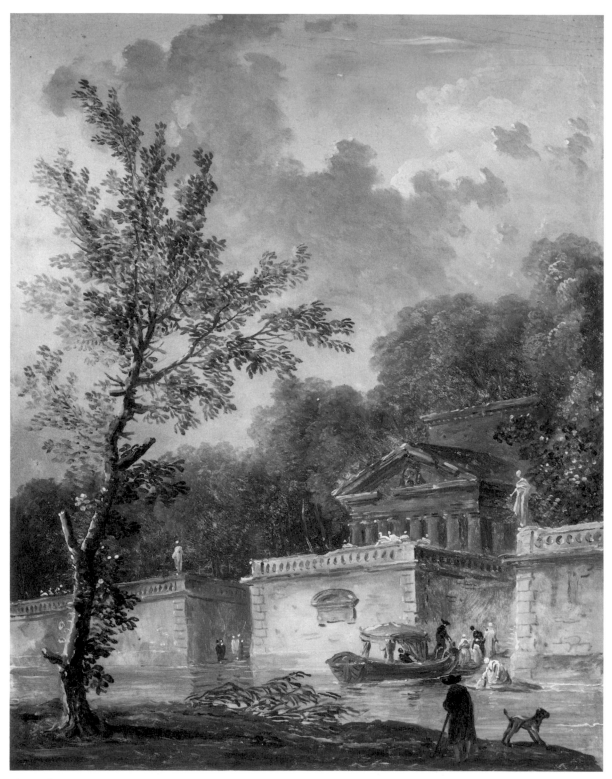

The Landing

Hubert Robert *Paris 1733-1808 Paris*

Son of a *valet de chambre* to the marquis de Stainville, Hubert Robert was destined originally for a career in the church. While little is known of his early training as an artist, he studied with the sculptor and architectural designer Slodtz, and exhibited at the Salon de la Jeunesse in 1752 and 1753. Under the patronage of the comte de Stainville, the future duc de Choiseul, Robert went to Rome in 1754 to study at the Palazzo Mancini (at that time the location of the French Academy in Rome). In 1759 he won a pension; Natoire, the director, deemed him a promising pupil whose style was influenced by Panini[1] and by the engravings of Piranesi as well. He went to Naples with Abbé de Saint-Non in 1760 and visited Pompeii and Herculaneum. During his eleven years in Rome he traveled extensively, compiling a portfolio of drawings and paintings of the city and the *campagna* that inspired his future work. Thanks to the generosity of Bailli de Breteuil, he was able to spend some time in Florence in 1763.

Successful and well-known when he returned to Paris in 1765, Robert was accepted as a member of the Academy of Painting and Sculpture in 1766 with *Port of Rome* (Ecole des Beaux-Arts, Paris). He exhibited in the Salon of 1767, eliciting the praise of Diderot.[2] In 1778 he was appointed designer of the king's gardens and given lodgings at the Louvre. His fascination with Italian architectural ruins soon earned him the sobriquet "Robert des Ruines" (1773, *The Discovery of the Laocoön*, Virginia Museum of Fine Arts, Richmond), but he also chronicled the urban renewal of Paris (1786, *Demolition of Houses on the Nôtre-Dame Bridge*, Musée du Louvre, Paris), the *Grand Gallery of the Louvre* (a number of versions, Musée du Louvre, Paris), and sites and landscape in the French countryside.

Robert was imprisoned in 1793-1794 because of his links with the ancien régime. Upon his release he was appointed to a select committee that organized the Muséum National des Arts, the forerunner of the Musée du Louvre. Vigorous and productive until the end, Robert's inventive and charming depictions of ruins reflect the revival of archaeological interest in mid-eighteenth-century France.

Claude Gabillot's monograph (1895) and Pierre Nolhac's studies (1910 in particular) remain the most complete sources on the life and work of the artist. More recently, Victor Carlson[3] and Jean Cailleux with Marianne Roland Michel[4] have used their considerable research to organize exhibitions of Robert's paintings, drawings, and watercolors. Certainly a catalogue raisonné of this superb draftsman's oeuvre would be welcome.

1. *Correspondance des directeurs de l'Académie de France à Rome avec les surintendants des bâtiments*. 13 vols. Ed. Jules Guiffrey and A. de Montaiglon (Paris: Noël Charavay, 1896-1908), 11: letter 5331 (28 February 1759), 262, and letter 5521 (8 July 1761), 388.
2. Diderot 1957-1967, 3:228-229.
3. Victor Carlson, exh. cat., *Hubert Robert, Drawings & Watercolors* (Washington: National Gallery of Art, 1978-1979).
4. Jean Cailleux and Marianne Roland Michel, exh. cats., *Hubert Robert (1733-1808): Dessins et peintures* and *Un Album de croquis d'Hubert Robert (1733-1808)* (Geneva: Galerie Cailleux, 1979).

The Landing
Le débarcadère or *Le retour d'une promenade en barque*
Oil on walnut panel, cradled with mahogany, 11 1/2 × 9 1/8 in. (29 × 23 cm)
Mildred Anna Williams Collection. 1953.40 (CPLH)

Provenance Perhaps in the collection of Lord Sackville (Lionel Sackville-West, 1867-1928), Knole, Kent, England; "Monsieur X.," Paris, 1933; Mrs. Mabelle McLeod Lewis, Burlingame, California; acquired by the CPLH, December 1953.

Reference Perhaps Charles J. Phillips, *History of the Sackville Family (Earls and Dukes of Dorset) together with a Description of Knole, Early Owners of Knole, and a Catalogue Raisonné of the Pictures and Drawings at Knole*, 2 vols. (London, [1929]), 413, 442 ("A River Scene Near Versailles").

Exhibitions 1933 Paris, no. 91; San Francisco, de Young, April-August 1947, no cat.

Variants

PAINTINGS
Park Scene, **fig.1**
Oil on canvas, 13½ × 15½ in. (34.5 × 39.5 cm)
The Detroit Institute of Arts. 28.93
REF: *Bulletin of The Detroit Institute of Arts of the City of Detroit,*
October 1928, repr. on the cover; Museum cat. 1930, no. 190, repr.;
Museum cat. 1944, no. 190.

Departure for a Boat Ride
Oil on canvas, 63 × 41⅜ in. (160 × 105 cm)
S.d.: *H. Robert 1786*
PROV: Sale, Paris, Hôtel Drouot, 18 November 1893, no. 10, repr.;
Ernest Gouin, by 1922; Arthur Veil-Picard, Paris, by 1933.
REF: Nolhac 1910, 149 (*The Boat Ride*).
EXHS: Paris, Galerie Jean Charpentier, *Exposition Hubert Robert et
Louis Moreau*, 1922, no. 12, repr.; 1933 Paris, no. 81.

The same composition, as above, but in smaller format, appears in the
following sales:
Boating Party in a Park
Oil on canvas, 58¼ × 38⅝ in. (148 × 98 cm)
PROV: Sale, Berlin, Lepke, 6-7 March 1928, no. 83, repr. (as Robert);
sale, Berlin, Lepke, 5 February 1929, no. 87, repr. (as Jean Pillement).

DRAWING
Sketch, red chalk, 1786
Moreau-Nélaton Album, Cab. des Dess., Musée du Louvre, Paris. Inv.
11.582
NOTE: This appears to be a study for *Departure for a Boat Ride*
above.

fig.1

Hubert Robert often repeated motifs, and this small
panel is related to a number of similar works by the art-
ist (see Variants). In each there is a park-like setting with
a columned temple facing a river or a lake, flanked by
wide stairs from which men and women are embarking
on or disembarking from a boat ride. A tree, male fig-
ures, and a cow or dog appear in the foreground. This is
a typical composition by Robert in which contemporary
activities are conducted amid the architecture of
antiquity.

While not the best of the renditions of this theme, the
San Francisco picture appears to be authentic. Jean
Cailleux, who examined it in 1977, finds the white
undertone similar to that in other small, late paintings
by the artist, and notes that this special preparation by
Robert achieved a smooth surface with close texture
and no cracks. Cailleux dates the panel after 1794, and
has published it.[1]

1. Jean Cailleux, letters, 2 March and 30 March 1987; and *Hubert
Robert et les jardins* (Paris: Editions Herscher, 1987).

Alexandre Roslin *Malmö 1718-1793 Paris*

Born in Malmö, Sweden, Alexandre Roslin developed an early passion for painting. He studied under Schröder in Stockholm, lived in Bayreuth from 1745 to 1747, and then spent four years in Italy (Venice, Bologna, Naples, Parma, and Florence, where the Academy received him among its members). He arrived in Paris in 1752 and became friendly with Vien, Pierre, and Boucher, whose portrait he painted in 1760 (Château de Versailles). He was a Protestant, but the Royal Academy of Painting and Sculpture admitted him in 1753 with portraits of two other artists, *Collin de Vermont* (also Versailles) and *Etienne Jeaurat* (Musée du Louvre, Paris), although the king's confirmation was not received until 1754. As a protégé of the court and of Boucher, he soon acquired a substantial reputation as a portraitist, which brought him a large clientele among aristocratic and worldly circles. A regular salon exhibitor from 1753 to 1791, he contributed portraits of architects (*Adelcrantz*, 1754, Nationalmuseum, Stockholm; *Rehn*, 1756, private collection, Bellinga), painters (*Vernet*, 1767, Nationalmuseum, Stockholm), sculptors (*Pajou*, 1767, private collection, Stockholm), scholars and writers (*Marmontel*, 1767, Musée du Louvre, Paris; *Carl von Linne*, 1775, Vetenskapsakademien, Stockholm).

In 1759 he married the pastelist and miniaturist Marie-Suzanne Giroust, a student of Vien's who was admitted to the Royal Academy in 1770 and whom he often portrayed. The arrival in Paris of the young crown prince of Sweden, the future King Gustav III, was an important event for the painter, who was then exhibiting his great painting of the king and his brothers in the Salon of 1771 (Nationalmuseum, Stockholm). It was at this point that he changed his signature from "Roslin-le-Suédois" to "Chevalier Roslin." In 1774, two years after the death of his wife, he made a short triumphal tour of Sweden and in 1775 he went to the court of Catherine II in Saint Petersburg where he painted numerous portraits. In 1778 he returned to Paris via Poland and Vienna, and remained there until his death.

A first-rate portraitist, Roslin certainly considered himself Swedish. His career, however, was essentially Parisian; his oeuvre, comparable to that of Duplessis or Danloux, belongs to the French portrait tradition, which was so brilliant in the second half of the eighteenth century. His early style, inspired by Boucher, utilized the clear, fresh palette of the rococo. Later his style became more austere and his colors more strongly accentuated. The sitters of his later works, such as *Portrait of Daubenton* (1791, Musée des Beaux-Arts,

Orléans), give an impression of profound melancholy.

Gunnar W. Lundberg's catalogue (1957) includes approximately six hundred twenty-five works, the majority of them portraits.

Charles-Antoine de la Roche-Aymon, Archbishop of Reims (*studio of Roslin*)

Oil on canvas, 40 × 31½ in. (101.5 × 80 cm)
Inscription at the top and right: *CH. ANT. DE LA ROCHEAYMON ARCH. DUC DE REIMS / I. PAIR ET G. AUM. DE FRANCE ABBE DE FECAMP CERCAM / ET BEAULIEU COM.^{deur} DE L'ORDRE DU S^t. ESPRIT. & C.*
Gift of Edward W. Carter. 1964.76 (CPLH)

Provenance Partial replica of the portrait in the Salon of 1769; probably with the comtes de la Roche-Aymon until 1961; [F. Kleinberger & Co., Inc., New York, 1961-1964]; acquired by the CPLH, 23 July 1964. (Cleaned by Teri Oikawa-Picante, August 1973.)

References Diderot 1957-1967, 4:25, fig.30; Howe 1964, 3-7, repr.; *The Art Quarterly* 27, no. 4 (1964): 496, repr. on 493; GBA "La Chronique des Arts," no. 1153, February 1965, 46-47, no. 200, repr.

Exhibitions 1978-1979 Denver-New York-Minneapolis, no. 37; San Francisco, de Young, *16 Paintings in Search of an Artist*, 28 August-14 November 1982, no cat.

Variants
PAINTINGS
Portrait of the Archbishop of Reims, Grand Aumonier of France (lost)
Oil on canvas, 6 × 4 *pieds* (ca. 195 × 130 cm)
REF: The complete bibliography is given by Lundberg 1957, 3:49, no. 273.
EXH: Salon of 1769, no. 39. G. de Saint-Aubin made a sketch in his *livret* for the Salon of 1769, **fig.1**.

Standing Portrait of the Archbishop of Reims
Oil sketch, 1768
Signed: *Esquisse de Roslin*
Private collection, Paris
REF: Lundberg 1957, 3:50, no. 273a, and *idem*, 1:repr. on 113.

Portrait (bust), but dressed as a Prince of the University, a title belonging to the Archbishop of Reims, wearing on his left shoulder "la chausse" of the graduates of theology, **fig.2**
Oil on canvas (oval), 25⅝ × 21¼ in. (65 × 54 cm)
Musées de Reims
REF: Lundberg 1957, 3:49, no. 272.

Charles-Antoine de la Roche-Aymon, Archbishop of Reims

Copy of the painting in the Salon of 1769
S.d.: *Pinson 1767* (?), probably a collaborator of Roslin
Private collection, Paris

ENGRAVING
L.-J. Cathelin, after Roslin, 1773, **fig.3**
REF: Lundberg 1957, 3:49.

fig.1

The biography of Cardinal Charles-Antoine de la
Roche-Aymon (1697-1777) is well documented. He was
appointed to the archbishopric of Reims by brevet 5
December 1762, given this office by papal bull 24 Janu-
ary 1763; gave his oath of loyalty to the late King (Louis
XV) 7 February; took possession of the archbishopric 5
March; and was received in Parliament the 14th as Duke
of Reims and Premier Pair ecclésiastique de France.
Appointed next to the abbey of Cercamp in the diocese
of Amiens 1 November 1765, he was given charge of the
list of benefices 13 April 1771; made Cardinal the fol-
lowing 16 December, and given the abbey of St.
Germain-des-Prés 13 February 1772, relinquishing
those of Cercamp and Beaulieu; consecrated and
crowned the King (Louis XVI) at Reims on Trinity Sun-
day, 11 June 1775, having previously had the honor of
administering to His Majesty the sacraments of Bap-
tism, Confirmation, First Communion, and Matrimony.
Finally, he presided over all the assemblies of the French
clergy, from 1760 to 1775 inclusive, after having
attended all the previous assemblies since 1735, first as
deputy then as second president, with the exception of
that of 1750.[1]
La Roche-Aymon died in 1777 while dean of the French
episcopate.

His personality is less well known. Although the city
of Reims owed to him the conservation of its traditional
form of government and the repurchase of its municipal
offices in 1773, his contemporaries did not always spare
him their criticism. For example, François Barrière, in
annotating the *Mémoires de Duclos*, spoke of
the ambitious la Roche-Aymon . . . ignorant, but
encouraged from childhood by a scheming mother
[Françoise-Geneviève de Baudry, the wife of Renaud-
Nicolas de la Roche-Aymon] to aspire to great honors.
The mother made a living from business; the son was an
abbé of quality who lived well after receiving his licen-
tiate. He traveled to Rome accompanied by Abbé
d'Aydie, who eclipsed him in society, but remained well
behind in fortune. Abbé de la Roche-Aymon was named
. . . coadjutor to the Bishop of Limoges, who demanded
so insistently to be relieved of him that la Roche-Aymon
was sent to Tarbes. . . . When Louis XV died, he aspired
to add the title of duke to the family name.[2]
The astonishing career of the prelate appears to confirm
this opinion of him.

fig.2

fig.3

The bold and fluent brushwork, great truthfulness, and the virile draftsmanship generally found in the works of M. Roslin have been brought together in the portrait of M. the Archbishop of Rheims; the lace and the gilded ornaments seem to jump right out of the canvas.[8]

For Bachaumont,

the portrait of the archbishop . . . is outstanding. The stern likeness of his countenance and the details of the vestments attract all the connoisseurs in turn. The fire which leaps from the eyes of the prelate mirrors marvelously the burning zeal of the house of God which certainly consumes him and which illuminates his face with emaciation and mortification.[9]

Less laudatory is the author of the *Lettre adressée au journal encyclopédique*, who finds the portrait "a good likeness, well composed, but rather harsh in color."[10] Diderot admits that the portrait "is handsome, very vigorous" and constitutes "a work of great patience," but adds that, while Roslin "possesses firmness in brush and in color, . . . his poses are stiff, his heads are without soul, his accessories are awkwardly placed and rendered without taste. . . ."[11]

The San Francisco version, unknown by Lundberg in 1957, is not a fragment of the original painting. One certainly finds here Roslin's taste for large somber eyes where the cornea is almost covered by the eyelids and animated only by a miniscule white dot, but the fabrics lack suppleness, the modeling of the face is unnatural, and the hair, treated in a systematic manner, is not rendered in the skillful disarray with which Roslin coiffed his sitters. Comparison to another ecclesiastical portrait of similar composition by Roslin, *Abbé Terray* (1774, Château de Versailles), is very telling. It can be concluded that San Francisco's painting is a good workshop replica after the original portrait and therefore valuable as our best evidence of an important lost work by Roslin.

1. *Généalogie historique et critique de la Maison de la Roche-Aymon, pour servir de supplément ou continuation de l'histoire généalogique et chronologique de la Maison de France et des grands officiers de la Couronne* (Paris: Vve Ballard & Fils, 1776), V-VII.
2. F. Barrière, *Mémoires de Duclos: Bibliothèque des mémoires rélatifs à l'histoire de France pendant le XVIII^e siècle*, (Paris, 1846), 2:420-421.
3. Lundberg 1957, 3:49, no. 272.
4. Cab. des Est.; Dacier 1909, 11 and 75.
5. Charles Loriquet, mus. cat. 1881, no. 128.
6. Henri Jadart, *Les portraits rémois du Musée de Reims* (Paris: E. Plon, Nourrit et Cie, 1894), 20.
7. Lundberg 1957, 3:50, no. 273b; *idem*, repr. on 51.
8. Collection Deloynes 9, 25-26, no. 120.
9. Diderot 1957-1967, 4:25.
10. Collection Deloynes 19, 9, no. 133.
11. Diderot 1957-1967, 4:89.

His iconography, on the other hand, poses some problems that Gunnar W. Lundberg does not resolve in an entirely satisfactory manner. For instance, in comparing costume details, the engraving by L.-J. Cathelin (**fig.3**) bearing the date 1773 could not have been executed, as Lundberg advances,[3] after the oval portrait in the Musée de Reims (**fig.2**), but only after the painting executed in 1768 and exhibited at the Salon of 1769 (of which Gabriel de Saint-Aubin made a sketch on the margin of his copy of the *livret* [**fig.1**]).[4] In addition, the original of 1768 cannot be identified as the painting destroyed during the bombing of the archiepiscopal palace of Reims in 1914. Charles Loriquet, while compiling his catalogue of the collections of the Musée de Reims, stated that the oval painting "probably differs only by its medallion shape from the one which was exhibited in 1769, awaiting the later execution of the magnificent portrait of the prelate dressed in Roman purple which can be seen at the archiepiscopal palace."[5] Henri Jadart clarifies this reference a few years later, mentioning that "a magnificent full-length portrait of him in his Cardinal's robes, attributed to the same painter [Roslin], can be found in the assembly room of the Academy at the Archbishopric."[6] The large copy painted in 1862 by Maillot after Roslin remains in the archbishop's palace in Reims, where the sitter's pompous likeness can still be seen.[7]

On the whole, the original portrait was favorably received upon its exhibition at the Salon of 1769. The anonymous author of the *Lettre sur l'exposition des ouvrages de peinture et de sculpture au Sallon du Louvre 1769* analyzed the painting thus:

Jean-Frédéric Schall *Strasbourg 1752-1825 Paris*

Jean-Frédéric Schall began his apprenticeship in Strasbourg about 1763 in the public drawing school where he received lessons from the brothers Haldenwanger. He then went to Paris and in 1772 was admitted to the Ecole Royale des Elèves Protégés, which was under the directorship of Vien. After that institution was closed, he became the student of Jollain in 1775, then of Lépicié from 1776 to 1779. He aspired to the academic distinction reserved for history painters, but as a Protestant he was prevented from being a candidate for the French Academy in Rome.

The patronage of the Alsatian painter Meyer, whom he replaced for a time in the service of Christian IV, duke of Zweibrucken, and of M. Godefroy, the comptroller of the navy, soon introduced Schall into the courtly society that enlivened Paris during the final years of the ancien régime. His work, especially during the prerevolutionary period, was derived from the increasingly passé rococo, in which *fêtes galantes* and erotic allegories were presented in a manner that sometimes seems awkward and provincial, especially when compared to Fragonard. He owed much of his fame to depictions of dancers (examples in Musée des Beaux-Arts, Nantes; Musée des Beaux-Arts, Strasbourg; and Musée Nissim de Camondo, Paris) and ballerinas from the Opéra and Italian theater. Numerous small, light-hearted compositions, such as *Love Surprised*,[1] *The Pretender Accepted* (1788),[2] and *The Demanding Soubrette*[3] assured his success. His works were popularized by English and French engravers, notably Bonnet, Descourtis, Legrand, and Chaponnier.

The Revolution, which he supported, led him temporarily to more politically suitable subjects, such as *The Heroism of William Tell* (1793, Musée des Beaux-Arts, Strasbourg). This patriotic composition is the exception in his overall production, however, as he primarily exhibited love scenes at the Salons of 1793 and 1798. He was able to adapt himself to the current fashion for literary illustration by publishing prints based on events in stories about Christopher Columbus, Mme de Lavallière, and Don Quixote. His style changed, probably owing to the influence of Marguerite Gérard, and his free handling of the brush gave way to a more laborious, narrative manner that was closer to Dutch genre painting. Under the Empire and the Restoration, when his former clientele returned to France, Schall again took up his favorite themes, sometimes with a neoclassical and romantic accent, as in *Thoughts on the Brevity of Life* (Salon of 1806, Musée du Louvre, Paris). Somewhat forgotten at the time of his death, Schall's art soon afterward became a major source of the rococo revival among the younger romantics, in particular the brothers Devéria.

André Girodie published an excellent monograph on this appealing artist (1927). The major problem in studying Schall's oeuvre is that many of his works passed directly between the private cabinets of *amateurs* rather than through public auction sales, and therefore their locations remain unknown.

1. Formerly in the collection of Franklyn Laws Hutton, New York.
2. Charles E. Dunlap sale, New York, Parke-Bernet, 4 December 1975, no. 378, repr.
3. Baron Cassell estate sale, Paris, Galerie Jean Charpentier, 9 March 1954, no. 42, repr.

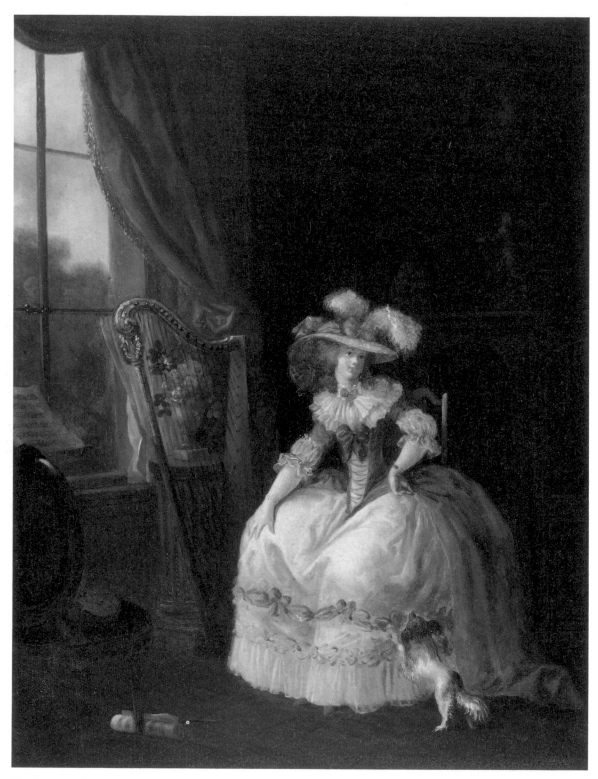

The Young Musician

The Young Musician

La jeune musicienne
Oil on panel (camphor?), 12 × 9¼ in. (30.5 × 23.5 cm)
Signed left, on the back of the chair: *Schall* (faint), **fig. 1**
Mr. and Mrs. E. John Magnin Gift. 75.18.18 (de Young)

Provenance Sale, Paris, Hôtel Drouot, salles 7 and 8, 2 December 1910, no. 21, repr.; acquired for 16,100 francs by Mme Brasseur, according to the annotated sale catalogue, Bibliothèque Doucet; Mme J. Brasseur, Lille, 1910-1928; Mme Brasseur sale, Paris, Galerie Georges Petit, 1 June 1928, no. 20, repr.; Mr. and Mrs. E. John Magnin, New York, before 1933; gift to TFAMSF, 1975.

Reference Bénézit 1976, s.v. "Schall."

This small painting, executed on a panel of fragrant wood imported from the Orient, is thoroughly characteristic of Schall's oeuvre in the 1780s. Closely related in composition to *The Pretty Visitor*[1] as well as another painting of the same title,[2] this picture shows the artist's predilection for a certain female type, graceful and elegant, but lacking in personality.

In order to emphasize the sitter's charms, Schall uses a number of characteristic devices. The fingers and feet are tapered and tiny, and the waist is extraordinarily slender, contrasting with the then-fashionable fullness of the hat, the collar, and especially the dress. The refinement of the young woman's pose and costume is complemented by the appropriate decor. Furniture and accessories have little diversity in Schall's oeuvre. For example, a violin rests on the Louis XVI chair at the lower left of the San Francisco painting. This chair reappears with a cat lying on the seat at the lower right of *The Pretty Visitor*. Similarly, the veneered or marquetry bookcase with glass doors appears in the background of both works. The painter, as was his custom, enriches the composition with art objects prized at the time by *amateurs*: a *magot* (a Chinese porcelain grotesque figure) and another Chinese or Japanese statuette appear on the bookcase under an oval painting depicting a young woman reading. The small dog, a King Charles spaniel, which at the time was called "the faithful friend" (in contrast to lovers who were less faithful), and the harp, an instrument that was much in vogue about 1780, both frequently appear in Schall's works. A violin, bow, music stand, and another rolled sheet of music carelessly thrown on the floor indicate the young woman's occupation.

The artist paints with feeling and skill, delighting in the description of every ornament. While not one of his major works, this composition is well balanced, and each object, perfectly placed, contributes to its harmony. The colors are fresh and lively, and the delicate finish and the chiaroscuro used to describe the lighting from the left reveal a debt to the northern tradition of small, intimate paintings. The overall conception is modern in that the young woman is not unlike the fashionable types popularized in engravings. This picture's sense of immediacy is almost naive in its faithful documentation of an era that, perhaps more than any other, cultivated the art of *savoir vivre*.

1. Former collections Sigismond Bardac, sale, Paris, Galerie Georges Petit, 10-11 May 1920, no. 40, repr.; and Mme André Saint, sale, Paris, Galerie Jean Charpentier, 20-21 May 1935, no. 50, repr.

2. Former collections Edouard Jonas, Paris, 1927; and Mrs. Joseph Heine, sale, New York, Parke-Bernet, 24-25 November 1944, no. 240, repr.; sale, New York, Sotheby's, 17 May 1972, no. 100, repr.

fig. 1 (detail with signature)

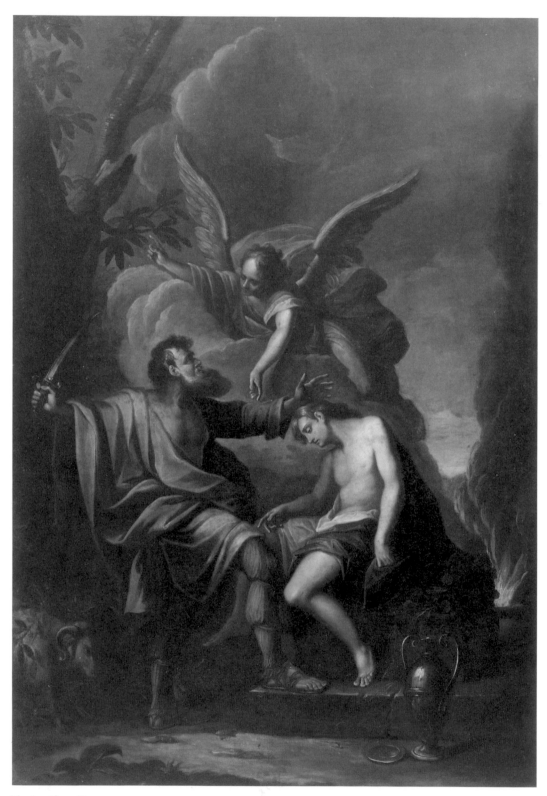

The Sacrifice of Isaac

Jean-Jacques Spoede

Antwerp ca. 1680-1757 Paris

Very little is known about this artist, whose entire career took place in France. After studying at the Academy in Antwerp, Jean-Jacques Spoede went to Paris where he became the student and close friend of Watteau. He married there in 1721, was an art dealer, and took part in the Expositions de la Jeunesse, exhibiting "several paintings of animals" in 1725.[1] Appointed rector of the Academy of Saint Luke, he participated in their exhibitions in 1751, 1752, and 1753, presenting mythological works, allegories of the seasons, still lifes of game, hunting pictures, and battle scenes.

His rare works are marked by the influence of Watteau, from whom he frequently borrowed his figures although his handling is somewhat clumsy. In addition to oval pendants at the Museum Ridder Smidt van Gelder in Antwerp, also known are a painting of *Game with a Hare, a Rabbit, and a Partridge* (1724, private collecton, Béziers) and two mythological canvases forming pendants, *Bacchic Scene* and *Invocation to Flora*, both signed and dated 1724.[2] A delightful element of caricature can be seen in the portrait of *Nicolas Bolureau*, dean of the master painters of Saint Luke, a drawing of which was engraved in 1743 by Guélard. Several paintings copied after the engraving also exist.

1. *Mercure de France*, June 1725, 2:1402.
2. Sale, Paris, Galerie Jean Charpentier, 5 December 1955, nos. 54-55.

The Sacrifice of Isaac

Le sacrifice d'Isaac
Oil on canvas, 41 1/2 × 28 1/2 in. (105.5 × 72.5 cm)
Signed on the bottom ledge: *J. J. Spoede* (difficult to read), fig. 1
Gift of Henrietta Gassner in memory of her husband, Louis Gassner. 1940.105 (CPLH)

Provenance Henrietta Gassner, before 1940.

The theme of the sacrifice of Isaac is a favorite subject in painting because of its dramatic intensity, offering the artist many rich possibilities of expression and form. Isaac, the second of the Hebrew patriarchs, was the only son of Abraham and Sarah. To test Abraham's faith, God ordered him to offer his son Isaac in sacrifice: *And they came to the place which God had told him of: and Abraham built an altar there, and laid the wood in order; and bound Isaac his son, and laid him on the altar upon the wood. And Abraham stretched forth his hand, and took the knife to slay his son. And the angel of the Lord called unto him out of heaven, and said Abraham, Abraham: and he said, Here am I. And He said Lay not thine hand upon the lad, neither do thou anything unto him: for now I know that thou fearest God, seeing thou hast not withheld thy son, thine only son, from me. And Abraham lifted up his eyes, and looked, and, behold, behind him a ram caught in a thicket by his horns; and Abraham went and took the ram, and offered him up for a burnt-offering in the stead of his son.*[1]

Although the artist has remained faithful to the biblical text and his composition is vigorous, his interpretation is not of exceptional quality. The rendering of the perspective of the vase in the foreground is awkward, the expressions of the faces are insipid, and here again is the same stiff, dry execution of draperies as in the two oval pendants, *Bacchus and Ariadne* and *The Rape of Europa* (s.d. 1723, Museum Ridder Smidt van Gelder, Antwerp).

This very conventional canvas is remarkable only in that it is, to our knowledge, one of the few extant religious paintings by the artist. It also represents his style, which despite his friendship with Watteau is more in keeping with the historical tradition of the seventeenth century than with the art of the Master of Valenciennes.

1. Genesis 22:9-13.

fig.1 (detail with signature)

The Miracle of Saint Benedict *or*
Saint Benedict Reviving a Dead Child

Pierre Subleyras *Saint-Gilles 1699-1749 Rome*

Pierre Subleyras, a painter's son from Uzès, was trained in Toulouse in the studio of Rivalz. He arrived in Paris in 1726, presumably with a scholarship from the city of Toulouse. The following year he won the *Grand Prix* from the Royal Academy of Painting and Sculpture with *The Brazen Serpent* (on loan from the Musée du Louvre to the Musée des Beaux-Arts, Nîmes, since 1954). This admitted him in 1728 to the French Academy in Rome, which was then under the directorship of Vleughels. He lived at the Palazzo Mancini until 1735, justifying this long sojourn with projects for clients such as the duc de Saint-Aignan, French ambassador to Rome (various *Contes* by La Fontaine, Musée du Louvre, Paris; Musée des Beaux-Arts, Nantes). Subleyras remained in Rome after 1735, however, and in 1739 married the miniaturist Maria Felice Tibaldi, daughter of the musician (a portrait of her by her husband is in the Worcester Art Museum).

His reputation was assured from 1737 by paintings such as *Prince Vaini Receives the Order of the Holy Spirit from the Duc de Saint-Aignan* (Musée de la Légion d'Honneur, Paris) or *Feast in the House of Simon* (Musée du Louvre, Paris), commissioned by the Order of Saint John Lateran for the refectory of the convent in Asti. He worked for numerous churches and religious orders throughout Italy as well as in France. Around 1740 he came to the attention of Cardinal Valenti Gonzaga, who recommended him to Pope Benedict XIV. Subleyras executed his official portrait in several versions, notably that in the Musée Condé, Chantilly. Through the patronage of the Pope, Subleyras received a commission in 1743 for Saint Peter's (*Saint Basil Celebrating Mass*, Santa Maria degli Angeli, Rome), the highest of tributes for the painter. Not since Simon Vouet, Poussin, and Valentin in the seventeenth century had a French painter received a commission for this basilica. Before he completed this monumental canvas in 1748 he executed his finest paintings—*Saint Benedict Reviving a Dead Child* (fig.1) and *Saint Ambrose Absolving Theodoris* (Galleria Nazionale, Perugia) for the Olivetans in Perugia, and his masterpiece, *Saint Camille de Lellis Conjuring the Flood* (Museo di Roma, Rome). With the triumph of *Saint Basil*, Subleyras became a painter of the first rank in the Roman school alongside J.-F. de Troy, then director of the French Academy. In spite of a trip to Naples in 1747 to regain his health, he died in Rome two years later at the age of fifty, leaving as his heir apparent the younger Pompeo Batoni.

Although primarily a history painter, Subleyras produced still lifes (Musée des Augustins, Toulouse), genre scenes (*The Painter's Studio*, Akädemie der Bildenden Künste, Vienna), portraiture (*Dom Cesare Benvenuti*, Musée du Louvre, Paris; *Saint John of Avila*, City Art Gallery, Birmingham), mythology, and nudes (*Female Nude*, Galleria Nazionale d'Arte Antica, Rome). In whatever genre he worked Subleyras composed his paintings with rigor, calm, strength, and neoclassic simplicity. His brushwork is delicate and meticulous and his palette, dominated by black, white, and especially pale pink, is characteristically refined.

An exceptional painter who is often moving, whose glory did not diminish during the second half of the eighteenth century, Subleyras merits attention. Odette Arnaud's excellent study is over fifty years old.[1] Pierre Rosenberg is preparing a monograph with catalogue raisonné on this painter, who is as French and as Roman as Poussin. Together with the major exhibition in Paris-Rome (1987), Subleyras should regain the rank that he held during his lifetime.

1. Odette Arnaud, in Dimier 1928-1930, 2:49-92.

The Miracle of Saint Benedict *or* Saint Benedict Reviving a Dead Child (*studio of Subleyras*)
Le miracle de Saint Benoît or *Saint Benoît ressuscitant un enfant*
Oil on canvas, 18¾ × 12½ in. (48 × 31.5 cm)
Gift of Dr. and Mrs. Walter Heil. 51.38 (de Young)

Provenance Dr. and Mrs. Walter Heil, San Francisco.

References *European Works* 1966, 164, repr.; P. Rosenberg and O. Michel, exh. cat., 1987 Paris-Rome, mentioned under no. 91(B), fig.3.

Variants
PAINTINGS
Saint Benedict Reviving a Child, **fig.1**
Pendant of *Saint Ambrose Absolving Emperor Theodosius* (1745, Galleria Nazionale dell' Umbria, Perugia)
Oil on canvas, 10 ft. 8 in. × 7 ft. ¾ in. (3.25 × 2.15 m)
S.d. lower center: *Petrus Subleyras Pinxit Romae/1744*
Church of Santa Francesca Romana, Rome
PROV: Painted in 1744 for the Olivetans of Perugia; 1822, placed in Santa Francesca Romana, Rome.
EXH: 1987 Paris-Rome, no. 91, repr.

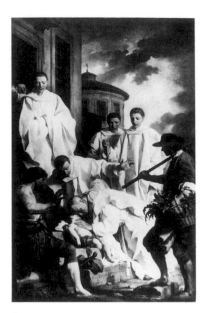

fig.1

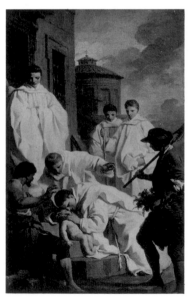

fig.2

Saint Benedict Reviving a Child, autograph reduction of the preceding painting, **fig.2**
Oil on canvas, 19¹¹/₁₆ × 12⁵/₈ in. (50 × 32 cm)
Musée du Louvre, Paris. Inv. 8006
PROV: Collection of Comte d'Angiviller, Paris; seized in the Revolution for the Musée Central des Arts, the future Musée du Louvre, 2 December 1794.
EXH: 1987 Paris-Rome, no. 92, repr.

DRAWINGS
Saint Benedict Reviving a Child, preparatory study for the painting in Rome, **fig.3**
Black chalk heightened with white on gray-green paper, squared in black chalk, 8⁷/₈ × 6⅛ in. (222 × 156 mm)
The Metropolitan Museum of Art, New York. 1974.354
PROV: Sale, London, Christie's, 27 November 1973, no. 276, repr.
REF: Jacob Bean and Lawrence Tŭríc, *15th-18th Century French Drawings in The Metropolitan Museum of Art* (New York: The Metropolitan Museum of Art, 1986), no. 285, repr.
EXH: 1987 Paris-Rome, no. 93, repr.

A Standing Monk, preparatory study, **fig.4**
Black chalk heightened with white on blue paper, 15 × 9⁷/₈ in. (380 × 250 mm)
Musée de la Faculté de Médecine, Montpellier. Collection Atger
EXH: 1987 Paris-Rome, no. 94, repr.

NOTE: A discussion of the many variants of the original composition, together with numerous reproductions, may be found in the exhibition catalogue *Subleyras, 1699-1749*, 1987 Paris-Rome, nos. 91-95.

The miracle of Saint Benedict of Nursia (ca. 480-547) is not mentioned in Jacques de Voragine's *The Golden Legend*, a primary hagiographic source, but is included in *Dialogues of Saint Gregory* (book 2, chap. 32). The episode takes place after 528, the year Saint Benedict founded the famous monastery of Monte Cassino, halfway between Rome and Naples, where he formulated the Rule of the Benedictine Order. One day when he had gone to work in the fields with the brothers, a gardener brought his dead son to the monastery and asked to see Father Benedict. Learning that he was not there, the man left the child's body and ran looking for the holy man, whom he begged with great insistence to bring his son back to life:
God's servant asked: "Where is he?" "Here," answered the father, "see his body lying before the door of the monastery." When the man of God arrived there with the brothers, he knelt and bent over the small body as the prophets Eli and Elisha had done. Then, straightening up, he prayed; according to the legend, no sooner had he finished than the body of the child trembled and returned to life.

In this composition Subleyras has scrupulously followed the text that was undoubtedly given to him by the Olivetans of Perugia who commissioned the original work (**fig.1**). The monks of the Order of Monte Oliveto, created in Ancona in 1316 as a preaching brotherhood, followed the Rule of Saint Benedict. It was certainly in

compliance with their wishes that the artist replaced the Benedictines' traditional black vestments with the Olivetans' white frocks. Although the text of Saint Gregory mentions no steps, the painter has resorted to this device in order to arrange his figures on a diagonal, which lends a sense of immediacy to the action. Accordingly, the masses of drapery cascade from upper left to lower right, and the saint bending over the child is given a more elegant pose. The invention of the figure on the right is perhaps less successful. A dark silhouette against the backlighting and a foil for the group of monks clad in white, this figure could be confused with the actual father of the resuscitated child at left. The rustic attire and gardener's implements of this figure also add a picturesque element that breaks with the otherwise timeless quality of the whole.

Although this composition was conceived in the middle of the eighteenth century, its powerful serenity is related to the grand tradition of religious painting of the preceding century, evoking the work of Le Sueur or Jouvenet. It is interesting to note that Louis de Silvestre painted a picture of the same subject only a few years earlier for the refectory of the priory Saint-Martin-des-Champs in Paris (Musée du Louvre, Paris). Odette Arnaud, writing about the original composition in Rome, stresses Subleyras's marvelous handling of Saint Benedict's features and the truthfulness of his expression, as well as

the surprising monochrome of warm whites which pose no difficulty for the painter in his métier. Firm draftsmanship and clearly defined shadows tinged with blue sustain the fragile nuances. The half-tones, barely perceptible, are lost in charming delicacies. Vivid splashes of color distributed among the assistants serve to reinforce this harmony, and strong structures are profiled with an extreme vigor against a tragic sky. This is Subleyras's masterpiece.[1]

The many reductions with variations of this composition were produced in order to satisfy the demand of collectors who desired a smaller version of a magisterial work. Only the versions in the Musée du Louvre (**fig.2**) and in Munich (Alte Pinakothek) could possibly be considered from the hand of the master, but neither constitutes a preparatory study for the great picture in Rome. On the other hand, the drawings in The Metropolitan Museum of Art (**fig.3**) and the Atger collection (**fig.4**) are clearly studies for the composition and for the figure of the standing monk.

The San Francisco painting appears to be an excellent copy of one of Subleyras's finest works, executed by a member of his studio or by one of his students. Above all, as a composition *Saint Benedict* is remarkable for its ascending constructive scheme, its refined palette, its effects of light and shadow, and its vigorous but subtle opposition of blacks and whites.

1. Odette Arnaud, in Dimier 1928-1930, 2:67.

fig.3

fig.4

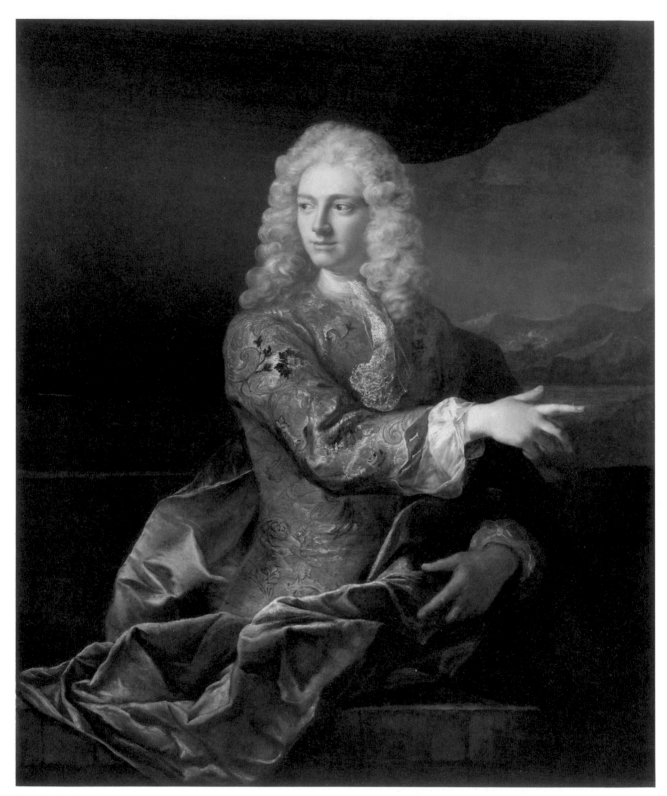

Portrait of a Gentleman

Robert Levrac, called Tournières

Caen 1668-1752 Caen

Robert Levrac's family was originally from Tournières (near Bayeux), a name he assumed in Paris. While still very young he studied in Caen under a mediocre teacher, the Carmelite friar Delahaye. Perhaps as a result of this early training by a monk, his portraits retain a characteristic austerity and intensity of expression. In 1685 he met Bon de Boullongne, who had come to decorate the Château de Balleroy near Caen and who soon appreciated his talent. He returned to Paris with Boullongne and entered his studio; there he was trained in all schools, including Flemish and Dutch, in accordance with the astonishingly eclectic tastes of this too-little-known master. In 1693 Tournières married Françoise Dauvin, the widow of the king's postilion Le Moyne, and the mother of François Le Moyne, whose vocation as a painter was undoubtedly determined by Tournières.

Tournières began his career by making copies after Rigaud, who noted his payment to Tournières in his account book. As a result of this training, Tournières acquired a singular talent for portraiture and was made an associate by the Royal Academy of Painting and Sculpture in 1701. He was elected to membership the following year with portraits of *Pierre Mosnier* (Château de Versailles) and *Michel Corneille* (lost). This bias for portraiture was apparent at the Salon of 1704, where he exhibited only one history painting and nineteen portraits, some clearly derived from the Dutch (*Nicolas de Launay and His Family*, Musée des Beaux-Arts, Caen). It was not until about 1716 that this skillful craftsman was able to create more original work. Ambition inspired him to attempt history painting, and he was elected by the Academy to the grade of history painter in 1716 with *Origin of Painting* (Ecole des Beaux-Arts, Paris), obviously influenced by the art of Rembrandt. He was appointed counselor in 1721, then adjunct professor in 1725, a post from which he resigned in 1737 during an outburst of temper.

Tournières remained, first and foremost, a portraitist. A protégé of Duc d'Orléans well before the Regency, Tournières painted his portrait and those of his mistresses, exhibited regularly at the Salon, and received his only official commission in 1745 for a votive picture of Saint Geneviève (lost) by which the city of Paris wished to commemorate the recovery of Louis XV. In 1749 Tournières abruptly quit Paris for Caen, leaving behind obscure students, Romagnesi and Huilliot, who seem to have inherited only his meticulous manner of painting flowers and animals. He died forgotten three years later.

It should be noted that large paintings, such as *Portrait of a Family in a Salon* (1724, Musée des Beaux-Arts, Nantes) and *Portrait of François de Bruny and His* *Two Children* (1733, Musée des Beaux-Arts, Marseille), are relatively rare in Tournières's work. Dezallier d'Argenville writes:

Encouraged by the success of his smaller paintings, Tournières abandoned larger ones and devoted himself entirely to painting small historical portraits or capricci in the manner of Schalken or Gérard Dou. His aim was to imitate their beautiful colors, appealing highlights, and that perfect finish that cannot be too highly esteemed.[1]

Marie-Louise Bataille's study on Tournières has not been replaced.[2]

1. A.-J. Dezallier d'Argenville, *Abrégé de la vie des plus fameux peintres . . .*, 2d ed., 4 vols. (Paris: De Bure l'Aîné, 1762), 4:363.
2. Marie-Louise Bataille, in Dimier 1928-1930, 1:218-243.

Portrait of a Gentleman (*attributed to Tournières*)
Portrait d'un gentilhomme
Oil on canvas, 58½ × 44 in. (148.5 × 111.5 cm)
Museum purchase, Archer M. Huntington Fund. 1937.1
(CPLH)

Provenance Sale, Brussels, Galerie Fievez, 10 December 1928, no. 75, pl. 32 (as Tournières); Mabel Gerry Drury and F. Saxham Drury; Drury estate sale, New York, American Art Association, Anderson Galleries, Inc., 3 December 1936, no. 74, repr. (as J.-F. de Troy); [Siegfried Aram, Aram-Erhardt Galleries, New York, 1936]; acquired by the CPLH, 1937 (as J.-F. de Troy).

References *Illustrated Handbook* 1942, 43, repr.; *idem*, 1944, 47, repr.; Bénézit 1976, s.v. "J.-F. de Troy."

Attributed to Tournières on the art market in 1928, and then to J.-F. de Troy in a 1936 sale, it seems reasonable today to reattribute this portrait to Tournières.[1] While Tournières's work, as well as that of other artists of the period, includes a large number of portraits of men in half-length poses placed behind a piece of furniture or a balustrade, the handling of this painting is much like his *Portrait of the Engraver Audran* (Musée des Beaux-Arts, Caen) and *Portrait of Chancellor d'Aguesseau* (Musée des Arts Décoratifs, Paris). In *Portrait of a Man* (Musée Central, Metz), Tournières depicts the drapery with the same nervous strokes of the San Francisco painting, sometimes with white highlights trailing off the breaks in the pigment. An excessively meticulous and precise treatment of the lace and embroidery that makes it possible to follow the course of each thread can be observed in both paintings. Such realism matches the keen perception of the Dutch masters.

Perhaps the painting in San Francisco, if not a fragment of a larger painting, was conceived as a pendant to the sitter's wife or children. For example, in the two portraits presumed to be of Chancelier d'Aguesseau and his wife, one figure points to a statue, the other to a landscape background.[2] The practice of linking portraits by use of the same architectural setting or landscape, or by the gestures and the poses of the sitters, was widespread in France during the first half of the eighteenth century.

This painting can be dated around 1710-1720, based on the style of the powdered wig and the gold patterned brocade dressing gown stitched in gold with red and green. The overall harmony of the composition relates it less to the Flemish and Dutch painters of the period than to French artists like Rigaud and Largillierre.

The gentleman in this portrait possesses an elegant and noble demeanor and is undoubtedly of aristocratic origin. Although his identity remains unknown, the painter's considerable skill can be admired. The palette is of utmost refinement, with striking contrast between the gold brocade of the dressing gown and the blue velvet mantle. The skillful brushwork is at once minutely descriptive without intruding upon the general effect of the whole, and the sitter's features are carefully and soberly brought to life. There is nothing spontaneous about Tournières's work, but in spite of this, his portraits faithfully if not discreetly record the features of his sitters. The artist himself once remarked, "a painter's skill does not lie in convincing those who see his works that he has spirit: above all he must make them feel that they have it."[3]

1. Dominique Brême, letter, 21 April 1984, still favors the de Troy attribution.
2. Sale, Paris, Galerie Charpentier, 26 June 1951.
3. M.-L. Bataille, in Dimier 1928-1930, 1:233.

Pierre-Henri de Valenciennes

Toulouse 1750-1819 Paris

When first a student at the Academy of Toulouse, Pierre-Henri de Valenciennes studied under the history painter Despax and the miniaturist Bouton. Apparently he then traveled in the Pyrenees, Catalonia, Languedoc, and Provence, visiting Italy in 1769 for the first time. He arrived in Paris in 1771, two years later entering the studio of Doyen. He often went to Chanteloup and liked to sketch in Touraine as well as in the countryside around Paris. He returned to Italy in 1777, remaining there until 1784-1785, visited Sicily in 1779, returning temporarily to France in 1781 via Switzerland and Savoy. After 1785-1786 he remained in France. A series of landscapes, which appeared on the Parisian art market about ten years ago, prove that Valenciennes also traveled in Britain. The extensive sketches and studies on paper that he brought back from his journeys (Musée du Louvre and BN, Paris) indicate that Valenciennes was essentially a self-taught landscape painter.

Presented by Demachy, Valenciennes was made an associate by the Royal Academy of Painting and Sculpture in March 1787 and was elected as an academician in July with *Cicero Having the Trees Cut Down Concealing the Tomb of Archimedes* (Musée des Augustins, Toulouse). He exhibited regularly at the Salon from 1787 to 1819, and in 1789 executed two large decorative paintings for Comte d'Artois at the Château de la Muette, *Cascade* and *Stone Bridge* (private collection, New York). From 1796 to 1800 he taught courses on perspective and in 1799-1800 assembled his ideas in a book.[1] In 1812 he succeeded Dandrillon as professor of perspective at the Ecole Impériale des Beaux-Arts and obtained great satisfaction with the creation in 1816 of a special *Prix de Rome* for historical landscape, a prize that existed until 1863.

Valenciennes wished to raise landscape painting to the level of history painting. As was Poussin, he was more concerned with uniting an idea to nature than with reproducing visual impressions, often using figures and themes from classical mythology. His large paintings, unlike his oil sketches (of which there are nearly one hundred thirty in the Musée du Louvre), are filled with humanist ideals aided by a fresh sensibility. A first-rate teacher and theoretician, Valenciennes formed an entire generation of landscape painters, including Bertin and A.-E. Michallon, who became Corot's masters. It is not surprising that Valenciennes's oil sketches and drawings after nature now appear to anticipate Corot. Above all, he wanted to be the *David du paysage* (the David of landscape painting) and to idealize and ennoble nature, based on his studies of the paintings of Poussin and the Bolognese school and the works of Greek and Latin authors.

The complexity of his art perhaps explains why he has not been the subject of a monograph or catalogue raisonné. In addition to an exhibition catalogue compiled by Robert Mesuret,[2] there have been several important articles, such as the one by Geneviève Lacambre,[3] and *Le petit journal*, which she edited for the 1976 exhibition *Les paysages de Pierre-Henri de Valenciennes 1750-1819*.[4]

1. Pierre-Henri de Valenciennes, *Eléments de perspective pratique à l'usage des artistes: Suivis de réflexions et conseils à un élève sur la peinture et particulièrement sur le genre du paysage* (Paris: privately published, Resenne and Duprat, year VIII [1800]; 2d ed., enlarged 1820).

2. Robert Mesuret, exh. cat., 1956-1957 Toulouse.

3. Geneviève Lacambre, "P.-H. de Valenciennes en Italie: Un journal de voyage inédit," *BSHAF 1978*, 1980:139-172.

4. Geneviève Lacambre, ed., *Le petit journal des grandes expositions* (Paris: Editions de la Réunion des Musées Nationaux, 1976) no. 11.

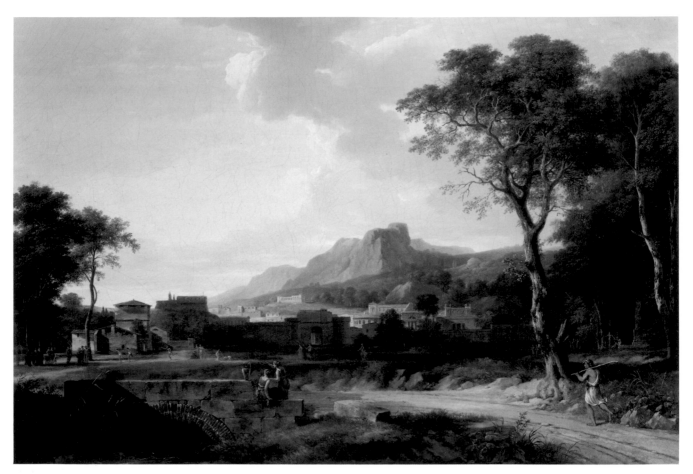

A Capriccio of Rome with the Finish of a Marathon

A Capriccio of Rome with the Finish of a Marathon

Paysage représentant une ville antique
Oil on canvas, 32 × 47 in. (81 × 119 cm)
S.d. lower center, on the rock: *P. de Valenciennes pinxit 1788*, fig.1
Museum purchase, Roscoe and Margaret Oakes Income
Fund and Art Trust Fund. 1983.28

Provenance Marquis Jean-Baptiste-Charles-François de Clermont-d'Amboise; sale of the Cabinet de M. le Marquis de C+++ [Clermont-d'Amboise], Paris, Hôtel de Bullion, 20 May 1790, no. 35; acquired by Desmarest for 1,200 *livres*, according to the annotated sale catalogue, library of the Akademie der Bildenden Künste, Vienna (E Dep. 7566); Emerich Joseph, duke of Dalberg, Herrnsheim, ca. 1790-1833; Marie-Louise Pellini (only child of the duke of Dalberg), wife of Sir Ferdinand Richard Edward Dalberg-Acton, 1833-1837; John Emerich Edward, first baron Acton, 1837-1884 (?); Cornelius van Heyl, Herrnsheim, ca. 1884(?); sale, London, Sotheby's, 15 March 1983, no. 2 (repr. in color); [Stair Sainty Matthiesen, New York]; acquired by TFAMSF, 1983.

References Bellier and Auvray 1979, 4:609; R. Mesuret, exh. cat., 1956-1957 Toulouse, mentioned on 11, 31.

Exhibition Salon of 1789, no. 120.

Related Work

DRAWING
Classical Landscape, fig.2
Black chalk heightened with white, 7 ¼ × 8 ⅞ in. (185 × 225 mm)
Matthiesen Gallery, London

The *livret* of the Salon of 1789 describes no. 120 as "landscape representing an ancient city; peasants in the middle distance train for a race, and two women in the foreground are watching them with interest. 2 *pieds* 6 *pouces* high by 3 *pieds* 9 *pouces* wide" [ca. 81 × 121 cm], and belonging to "M. le Marquis de Clermont d'Amboise." As the painting is dated 1788, it was either executed for Marquis de Clermont or he was the first owner. The second son of Marquis Jean-Baptiste-Louis de Clermont d'Amboise (1702-1761) and Henriette de Fitz-James (1705-1739), Jean-Baptiste-Charles-François was baptized 6 August 1728 and first called Chevalier de Clermont-Gallerande. He inherited the title in October 1746 after the accidental death of his older brother, Jacques-Louis-Georges, marquis de Clermont d'Amboise and colonel of the regiment of Brittany. Named ambassador to the Court of Portugal in 1767, two years later the marquis married Mlle de Moustiers, daughter of Philippe-Xavier, marquis de Moustiers, and Louise de Bournel.[1] The date of his death is unknown, but in the sale catalogue of his cabinet on 20 May 1790 no. 35 is described in exceptional terms:

fig.1 (detail with signature)

fig.2

A beautiful landscape with structures, composed in the distinguished style of Poussin, and executed with such perfection that it renders the illusion of nature. This piece is finished in every detail . . . amateurs of perfect works in the landscape genre cannot find a more beautiful or agreeable piece; to the charm of the composition is added masterful brushwork and a fresh and natural palette in its various planes.[2]

The painting was not a total success when it was exhibited at the Salon. Comte de Mende Maupas in *Remarques sur les ouvrages exposés au Salon* states simply that "almost all of M. de Valenciennes's landscapes are charming"[3]; and the author of *Elèves au Salon ou l'Amphigouri* exclaims, "As for M. Valenciennes, my friend, his talent is miraculous,"[4] but an

anonymous critic writing in the *Journal de Paris* treats the subject with greater precision and nuance:

This artist's works are generally of great merit, especially the quality of style and distinctness of the different planes. However, I would criticize the yellowish tone that gives them all a similar physiognomy. Another painting, depicting an ancient city where peasants train for a race in the middle distance, is striking, especially in the background. The road in the foreground seems to me to be too even in tone.[5]

A more unfavorable opinion is given by the author of *Entretien entre un amateur et un admirateur*, for whom the painting lacks originality:

L'Amateur:
His landscape depicting an ancient city should please you because of its beautiful composition and style.
L'Admirateur:
Yes, but this is executed after Poussin and other Masters who worked in this genre, and it lacks aerial perspective. The middle ground is as vigorous as the foreground, the sky is crudely treated, the mountains in the background are much too uniform in tone, and what is good in this painting is not of his own inspiration. I prefer his other paintings, at least they are his own compositions; he should consult nature and true Artists. In this genre he could become a good painter.[6]

The historical, composed landscape was clearly defined by the artist himself in his famous *Eléments de perspective pratique à l'usage des artistes:*

There are two ways to consider Nature. . . . The first is to take Nature as it is and represent it as faithfully as possible. . . . The second is to see Nature as it could be, viewed through the imagination of the man of genius who has seen much and carefully compared, analyzed, and reflected on the choice that must be made; who knows all its beauties and all its flaws; who is excited and inflamed and identifies with the famous poets who have described and sung the praises of beautiful Nature; who sees the places in poetic descriptions, who distinguishes the customs and costumes of the works of Homer, Xenophon, Diodorus, Pausanias, and Plutarch. . . . This manner of viewing and studying Nature is certainly much more difficult than the first. One must be born with genius, have traveled extensively and even more extensively have meditated on one's travels; one must have fed one's mind through the reading of ancient and modern authors; have familiarized oneself with the works of the great Painters; in a word, one must have developed the creative faculties with which to give birth to those masterpieces of art which interest the philosopher and the educated man.[7]

This theory explains Valenciennes's choice of a race to animate almost imperceptibly the scene outside the walls of this ancient city. Numerous ancient authors describe the frequency with which their contemporaries exercised their bodies, sanctioned by a tradition that considered physical exercise necessary to develop beauty and dexterity, and above all to harden future soldiers to fatigue. Foot races, which did not need any specific location or equipment, with wrestling, jumping, and swimming constituted one of the most common physical disciplines practiced by the peoples of antiquity. The rules of perspective in Valenciennes's treatise are applied to the landscape itself as well as to the figures:

If the composition requires several figures, in order to position them correctly in the Painting, one must necessarily make small clay or wax models, and group them on a terrain of proportional size. . . . Then one steps back a distance of three times the width of the painting; one draws the whole composition without changing the position of the eye to gain a feeling for where the figures should be placed, in order to execute separate studies and later unite them again in the Painting.[8]

Similarly, the harmonious succession of planes is detailed as follows:

Since the forms of the different objects are composed only of lines, it is clear that their rhythms can be only the result of the felicitous choice the Artist must make from the beautiful variety of forms found scattered in Nature, and which he will combine in his composition so that they contrast without clashing with each other through the junction of lines which create right angles.[9]

The realistic depiction of trees finds its source in the following principle: "In order to know exactly the shape of a tree and its branches, one must draw it during winter when it is stripped of its leaves; then one can grasp the structure and comprehend the whole."[10] More examples could easily be given, but Valenciennes's opinions as they relate to the right half of this canvas should be mentioned: "Statues in the middle of trees or by the water yield a very good effect when they are artistically positioned. . . . It is through these arrangements that an artist is found to have good judgment and taste, whether or not he knows how to use the field to his advantage."[11]

It is tempting to look for prototypes for the structures of the imaginary city among the mass of drawings after nature left by the artist. Most of this ambitious composition seems to derive from what the painter himself called his *ressouvenirs* (recollections). However, it is possible that the rotunda with its dome visible on the flanks of the mountain is a variation on the Pantheon in Rome; that the building on the right with the conical roof and portal with columns, surmounted by a semicircular arch with a sculpture inside, appears with some modifications in a sketch "drawn from nature after the Villa Medicis"[12]; that the curious architecture of the barn with an open gable on the left is very common in Valenciennes's Italian sketchbooks; and that the neighboring tower covered with a four-sided sloping roof is very close to one in the drawing "De la Villeneron."[13]

The entire composition, clearly inspired by the great seventeenth-century tradition of classical landscape, is masterfully set between two masses of foliage on the sides and in front of a mountainous horizon lost in the haze. This sun-drenched vision is rendered in subtle colors, playing on the harmony of the green of the foliage, the blue-gray of the background, and the azure blue of the sky underlined with light gray clouds. Except in the costumes of the figures, there are few touches of bright color. The sharply drawn silhouettes in the middle ground and the beautiful pink tonality of the building above the bridge, brightly lit by the sun, show the measure of the artist's delicate touch. There is no doubt that this painting, previously unpublished, should be considered along with *Ancient City of Agrigento* (1787, Musée du Louvre, Paris) as one of Valenciennes's masterpieces. It is an exceptional manifestation of a thoughtful and deliberate art that delighted the *amateurs* of the neoclassical period.

1. De la Chenaye-Desbois and Badier, *Dictionnaire de la noblesse,* s.v. "Clermont d'Amboise."

2. Sale, Cabinet de M. le Marquis de C+++, Paris, Hôtel de Bullion, 20 May 1790, no. 35.

3. Collection Deloynes 16, 12, no. 413.

4. Collection Deloynes 16, 35, no. 416.

5. Collection Deloynes 16, 310, no. 421.

6. Collection Deloynes 16, 25, no. 412.

7. P.-H. de Valenciennes, *Eléments de perspective pratique à l'usage des artistes*. . . (Paris, 1820), 380-382.

8. Valenciennes, *Eléments*, 203-204.

9. Valenciennes, *Eléments*, 213.

10. Valenciennes, *Eléments*, 226.

11. Valenciennes, *Eléments*, 355.

12. Cab. des Est., Vf 31c Rés., pet. fol., *Rome*, pl. 30.

13. Cab. des Dess., R.F. 12967, fol. 35.

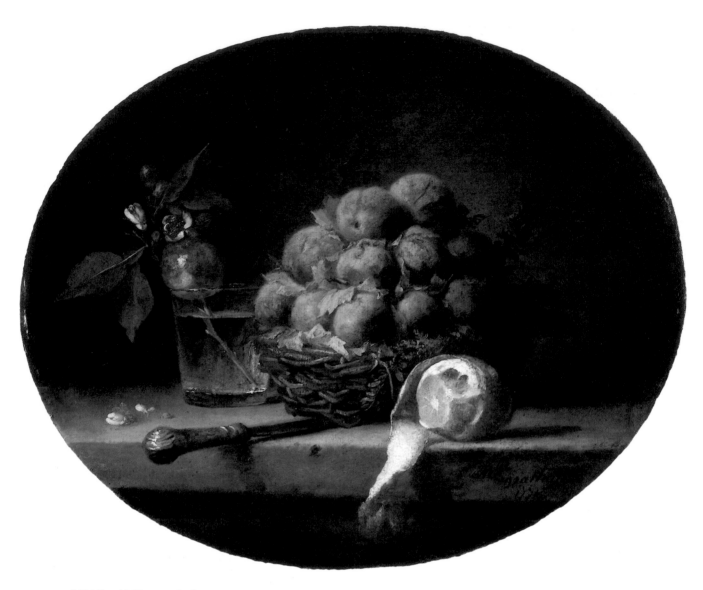

Still Life with Plums and a Lemon

Anne Vallayer-Coster *Paris 1744-1818 Paris*

The daughter of a goldsmith for the Gobelins, Anne Vallayer-Coster was one of the most celebrated female painters of eighteenth-century France. While little is known about her early training, she was elected to membership in the Royal Academy of Painting and Sculpture in 1770 with *Attributes of Music* and *Attributes of Painting, Sculpture, and Architecture* (Musée du Louvre, Paris). A prolific painter who left an oeuvre of four to five hundred paintings, she obtained lodgings at the Louvre in 1780. The next year she married Jean-Pierre-Silvestre Coster, a parliamentary lawyer and tax collector for tobacco in Domfront. She painted pictures for the queen and the royal family and participated in all the Salons from 1771 to 1789, when her royalist convictions forced her to take refuge in the provinces until 1796. Under the Revolution and then the Empire she gradually lost her place among first-rank painters, perhaps because only occasionally did she try to adapt to the new aesthetic. She exhibited again at the Salon from 1800 to 1817.

Her work consists primarily of portraits and still lifes (flowers, foodstuffs, the hunt, and the arts). Vallayer-Coster drew on Chardin for inspiration for her portraits, both in the study of figures and in the sober handling of details (*Portrait of Joseph-Charles Roettiers*, Salon of 1777, Château de Versailles). Perhaps using Largillierre as intermediary, she took a Dutch iconographical repertory for her still lifes. However, as an heiress of the sober French tradition of the painters of silence, she often used a neutral background and delicate brushwork. After J.-B. Oudry, and especially Chardin, she is one of the best and most appealing painters of still life in the second half of the eighteenth century. She continued to work in the same vein until the dawn of romanticism (*Table with Lobster, Different Fruits, and Game*, 1817, Musée du Louvre, Paris).

Works by Vallayer-Coster are found in French museums, of course, as well as in major museums in such cities as Geneva, Berlin, Ottawa, Toledo, and New York. Marianne Roland Michel's excellent monograph (1970) has done justice to the sometimes underestimated merits of this painter.

Still Life with Plums and a Lemon
Nature morte avec des prunes et un citron
Oil on canvas (oval), 16⅜ × 18⅝ in. (41.5 × 47.5 cm)
S.d. lower right: *Mlle Vallayer/1778*, fig.1
Gift of Mr. and Mrs. Louis A. Benoist. 1960.30 (CPLH)

Provenance A. Weinberger; [Harry G. Sperling, New York, October 1958]; acquired by the CPLH, 21 July 1960.

References Roland Michel 1970, 145, no. 138, repr. on 144; Roland Michel 1973, 57; Bellier and Auvray 1979, 4:295; Lee 1980, 222, fig.19 on 221.

Exhibitions Perhaps Salon of 1779, no. 105, as 13 × 15 *pouces* [ca. 35 × 40 cm]; San Francisco, CPLH, *Women Artists: Review and Recognition*, 11 October-25 December 1975, no cat.; 1976-1977 United States, no. 55, repr.; 1978-1979 Denver-New York-Minneapolis, no. 38.

Variant
PAINTING
Plums, a Lemon, a Knife, autograph replica, not signed, of the painting in San Francisco
Oil on canvas (rectangle), 13¾ × 17¾ in. (35 × 45 cm)
Collection John Lowenthal, New York
PROV: Galerie Cailleux, Paris, before 1980.
REFS: Roland Michel 1970, 154, no. 182, repr.; Roland Michel 1973, 57-58, fig.11.

fig.1 (detail with signature)

This beautiful painting is a perfect example of the small still life, close in inspiration to the work of Chardin, for which Vallayer-Coster is well known. Plums perfectly stacked in a rustic wicker basket, a glass of water containing a branch of orange blossom with leaves, another sprig with barely perceptible small red flowers, a knife arrested in the act of peeling a lemon with its rough skin uncurling in the foreground, and a few almonds on the table are the elements of this visual poem.

Such a painting is not a spontaneous creation of this eighteenth-century French artist. This type of still life originated in the early seventeenth century in the United Provinces (the future Netherlands). The French artists Moillon and Baugin first showed an interest in it around 1630. After the middle of the century and under the influence of painters such as Belin de Fontenay, Monnoyer, still-life compositions became larger, more complex, and more decorative. It was Chardin who in the 1730s returned to the initial formula. Chardin's austere treatment of still life greatly influenced Vallayer-Coster, who resorted to it repeatedly throughout her career to satisfy the demands of a clientele that had acquired a taste for still lifes and small floral compositions through the massive importation of such works from the north.

Chardin painted several versions of baskets of plums, notably *Basket of Plums with Glass of Water, Two Cucumbers, and a Bottle of Wine* (The Frick Collection, New York), *Basket of Plums with Cherries, Almonds, and a Glass of Water* (Sammlung Oscar Reinhart, Winterthur; another signed version in the Musée des Beaux-Arts, Rennes, exhibited at the Salon of 1759), or *Basket of Plums with Nuts, Berries, and Cherries*, exhibited at the Salon of 1765.[1] Anne Vallayer-Coster herself treated this motif even more frequently and with little variation. The *Basket of Plums* (1769), acquired in 1971 by the Cleveland Museum of Art, is probably the painting exhibited in the Salon of 1771, no. 147.[2] The fruit basket and the glass found also in the San Francisco canvas are accompanied here by two Savoy biscuits. In 1772 the artist placed two peaches beside one of her baskets of plums.[3] The following year at the Salon, under no. 143 she repeated the subject,[4] and later at an unknown date presented the composition of San Francisco's painting in a rectangular format (John Lowenthal collection, New York). At the sale of Marquis de Ménars (formerly Marquis de Marigny and Mme de Pompadour's brother) in March-April 1782, under no. 111 was listed a canvas by Vallayer-Coster depicting plums in a porcelain dish next to two lemons and a basket of peaches. Finally, she also combined a basket of plums with almonds (Newhouse Galleries, Inc., New York), a composition that provided the model for a tapestry by the Savonnerie factory (Musée Nissim de Camondo, Paris).

Comparison of similar paintings by Chardin with Vallayer-Coster's is particularly interesting. The artist has the same manner of placing her objects on a small table tilted in the foreground to emphasize the depth of the field with succeeding zones of shadow and light. Like Chardin, she also rigorously determines the relationship of the objects themselves in the third dimension, notably through the use of accessories that, like the knife, extend out of the canvas and deepen the space. Their pictorial treatment of the objects is rather different. Where Chardin is more synthetic and less analytical, painting the feeling of the objects more than the objects themselves, Vallayer-Coster concentrates instead on the outline of each object. In this sense her painting is less mysterious, more materialistic, and closer to the northern tradition of the seventeenth century. These elements combine to make this painting an exceptional work of art—the transparence of the glass, the brilliance of the silver handle of the knife, the smooth and slightly shimmering skin of the plums, the contrast of the juicy pulp of the lemon with its thick, rough skin, the choice of a somber palette that subtly juxtaposes the deep purple of the plums and the pale gold of the lemon, and a minute observation of the highlights. The handling of the paint is exquisitely refined and the composition is the result of careful reflection. Before such a work it is easy to understand how enlightened minds of the time could advance the revolutionary notion that the subject of a painting was of little importance compared to the manner in which it was treated.

San Francisco's painting could be the picture exhibited in the Salon of 1779, no. 105, as "a basket of plums, a lemon, and others. Oval painting, 13 *pouces* high and 15 *pouces* wide" [ca. 35 × 40.5 cm]. However, the difference of about 3 inches in dimensions, although that might include the frame, precludes a sure identification. In any case, the works Vallayer-Coster exhibited at the Salon of 1779 were generally well received. Only the author of *Encore un rêve, suite de la prêtresse* appeared somewhat critical. After writing that "Mlle Vallayer masterfully renders still life," he continued, "It appears that as a member of the fair sex she should give more life to everything that breathes; but there are some unfortunate times when the brush cannot translate the most beautiful ideas, unless it is for lack of study."[5]

Others showed more enthusiasm, writing, "Mlle Vallayer, known for a long time as an excellent Painter, reinforces her reputation with her Paintings of fruit and flowers"[6] and "It is not really possible to create more illusion in this genre."[7] Finally, the author of the "Exposition des peintures, sculptures & gravures" in the *Année littéraire* of 1779 wrote, "In ending this article on the paintings, I should not fail to discuss the charming works of Mlle Vallayer-Coster; she alone can console us in a genre abandoned by MM. Chardin and Roland de La Porte."[8]

1. Rosenberg 1983, nos. 27, 154, 154A, 173.
2. Roland Michel 1973, 53-54.
3. Roland Michel 1970, no. 131.
4. Roland Michel 1970, no. 135.
5. Collection Deloynes 11, 14-15, no. 207.
6. Collection Deloynes 11, 29, no. 201.
7. Collection Deloynes 11, 18, no. 208.
8. Collection Deloynes 50, 79, no. 1336.

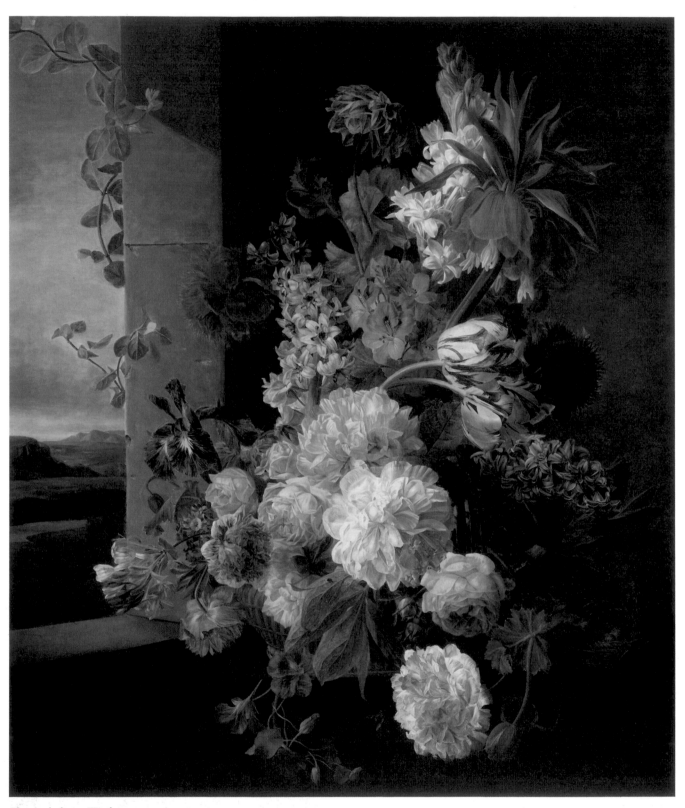

Flowers before a Window

Jans-Frans Van Dael *Antwerp 1764-1840 Paris*

With the Spaendonck brothers and Redouté, Jans-Frans Van Dael was among the most famous of the northern artists who came to Paris at the end of the eighteenth century to perpetuate the great Dutch tradition of flower painting. He was trained by the Academy in Antwerp, winning prizes for architecture in 1784 and 1785. He arrived in Paris in 1786 and began his career as a decorator of buildings, executing trompe l'oeil decors for the châteaux of Chantilly, Saint-Cloud, and Bellevue. Influenced particularly by G. van Spaendonck, he found and achieved success in his specialty, the painting of flowers and fruit.

In 1793, the year he first exhibited at the Salon, Van Dael began to paint his most famous works and received lodgings at the Louvre. He later resided at the Sorbonne from about 1806 to 1817. *Offering to Flora* (lost) earned him an incentive prize of 4,000 francs at the Salon of 1799. Its pendant, the superb *Tomb of Julie* exhibited at the Salon of 1804, is now at the Château de Malmaison. At the Salon of 1810 he won a gold medal with *Flowers on a Windowsill*.[1] Following the taste of Josephine, who had five Van Daels in her collection, Empress Marie-Louise bought two paintings, as did the duchesse de Berry. Louis XVIII acquired *Flowers in an Agate Vase on a Marble Table* at the Salon of 1817 (1816, Château de Fontainebleau) and *Fruits on a Marble Table* at the Salon of 1819 (Musée des Beaux-Arts, Auxerre). This painting won another gold medal for Van Dael. The king purchased a third Van Dael in 1819 (1810, Musée du Louvre, Paris) and a fourth in 1820 (Château de Compiègne). Charles X bought *Flowers on a Marble Console with Pineapple* (1823, Château de Fontainebleau) at the Salon of 1824 and decorated the artist with the Legion of Honor. Van Dael was a member of several foreign academies, including those of Antwerp, where he exhibited in 1807, and Amsterdam. He was decorated near the end of his life by King Leopold of Belgium, but he was never honored by admission to the Institute of France. He participated in the Salons until 1833 and the Galerie Lebrun showed his works in Paris in 1826.

It is interesting to note how much this northern artist, who enjoyed considerable favor in France and received high prices for his canvases, remained faithful to the pictorial tradition of his country. Little influenced by the French school, he taught his method to numerous students (Millet de Caux, Bruyère, Nepveu, Richer, Pilon, and Knip)—a precise, linear, yet decorative style and flawless facture, anticipating much of nineteenth-century art. Drawing directly on the work of van Huysum, Van Dael produced canvases that differ greatly from the more contained and somber French style of a painter such as Vallayer-Coster.

There is no monograph dedicated to this artist, but an interesting entry was written by Jacques Foucart for the catalogue of the exhibition *French Painting 1774-1830: The Age of Revolution*.[2]

1. Now lost, this work was no. 1 in the catalogue for Van Dael's estate sale, Paris, 19-20 May 1840.
2. 1974-1975 Paris-Detroit-New York, 642-643.

Flowers before a window
Fleurs devant une fenêtre
Oil on canvas, 36 3/8 × 31 1/4 in. (92.5 × 79.5 cm)
S.d. lower right, on the edge of the table: *J. Van Dael f. 1789*, fig. 1
Mildred Anna Williams Collection. 1952.79 (CPLH)

Provenance [Frank Partridge, London, before 1924]; [M. Knoedler & Co., Inc., London, July 1924]; C. S. Carstairs, New York, 1925; Charles Tower (on consignment to Knoedler, 1952); acquired by the CPLH, 1952.

References Howe 1953, n.p., fig. 8; J. Foucart, exh. cat., 1974-1975 Paris-Detroit-New York, 635-636 (Fr. ed.), 642-643 (Am. ed.), erroneously mentioned at Knoedler, New York, 1962.

Exhibition 1958 Santa Barbara, no. 23, repr.

fig. 1 (detail with signature)

This painting is one of Van Dael's earliest extant works. The painter arrived in Paris in 1786, having painted mostly trompe l'oeil decorations for building interiors (as did Sauvage, with whom he may have collaborated). Nevertheless, this work by a man only twenty-five years old reveals the mastery and compositional technique that Van Dael retained until the end of his career. These principal components are found again in a painting dated 1832, sold with the painter's estate in May 1840: "Roses, tuberose, peony, a branch of lilacs, and poppies composing a most beautiful flower arrangement, and presented in a most elegant manner; a bird's nest placed on a marble shelf."[1]

This brilliant bouquet is depicted with extraordinary precision, a scientific knowledge of plant life, and great diversity: roses, peonies, poppies in full bloom and in bud, tulips, hyacinths, dahlias, nasturtiums, iris, rhododendron, tuberose, and even a honeysuckle vine climbing along the window ledge. Interestingly, different species have been gathered together that do not bloom at the same time: hyacinths bloom in April, iris in the summer, and dahlias at the end of the season or even in early fall. Since it is unlikely that Parisian gardeners were capable of such wonders, Van Dael, like his contemporary flower painters, composed his bouquets from previous studies. An artificial structure has been used for the arrangement; some flowers hang low in front of the basket while others create a powerful diagonal extending from the lower left to the upper right.

The bouquet is admirably composed and the colors have been very skillfully distributed. Two similar tones, a pale pink peony and a white peony, are juxtaposed in the center of the canvas. Near the window Van Dael contrasts a yellow rose with its complementary, an indigo iris. The bouquet is brightly lighted from the left through a window so that the flowers in the right background are plunged into semi-darkness. The arrangement is controlled by subtle relationships of dissonance and consonance that complement and reinforce each other. This symphony of colors is heightened by its contrast with a brownish background and even with the table, covered with red velvet trimmed with a fringe of braid.

The unglazed window embrasure admits light, accentuates the verticality of the composition, and probably serves a more ambitious intention. Through it a bare and mountainous landscape can be seen with a river in the field below. Interestingly, Van Dael executed only a few landscapes of which *House of the Artist* (Boymans-Van Beuningen Museum, Rotterdam) is an excellent example. The presence of the nest with eggs (a blackbird's?) and the almost imperceptible representation of a few insects, such as a bee and a ladybug, indicate that Van Dael may have wished to symbolically represent the three kingdoms governing nature—animal, vegetable,

and mineral. Later, he limited himself to compositions that were simpler and more restricted, in the spirit of van Huysum if not in imitation of his style. A work such as this is a pertinent reminder that still life, appreciated primarily for the quality of its execution and decorative effect, can sometimes have deeper significance and acquire overtones of history painting.

1. Van Dael sale, Paris, 19-20 May 1840, no. 3.

Charles-André (Carle) Vanloo

Nice 1705-1765 Paris

Charles-André Vanloo, called Carle, is the most famous member of a dynasty of painters of Dutch origin. He was the grandson of Jacob, son of Louis-Abraham, brother of Jean-Baptiste, uncle of Louis-Michel and Charles-Amédée, and the father of Jules-César-Denis. As early as 1712 Carle joined his brother Jean-Baptiste in Turin, then followed him to Rome where he studied under Luti and the sculptor Legros. When he returned to Paris in 1719 he painted his first religious composition, *Presentation in the Temple* (1725, Church of Saint-Jean, Lyon), and in 1724 won the *Grand Prix*. He arrived at the French Academy in Rome in 1727, as did Boucher, and remained until 1732, primarily painting a ceiling representing the apotheosis of the saint for the Church of San Isidoro. Between 1732 and 1734 in Turin he executed eleven scenes from *Jerusalem Delivered* for the Palazzo Reale (1733) and *Repose of Diana* for the Castle of Stupinigi (1733), as well as various commissions for religious orders.

He returned to Paris in 1734 and was elected to membership by the Royal Academy of Painting and Sculpture the following year with *Apollo Having Marsyas Flayed* (Ecole des Beaux-Arts, Paris). He soon had a brilliant official career: adjunct professor in 1736, professor in 1737, adjunct rector in 1752, rector in 1754, *premier peintre du roi* in 1762, and director of the Academy in 1763. In 1749 he became governor of the Ecole des Elèves Protégés, where he exercised an important pedagogical role over his students—among them Brenet and Fragonard. He was ennobled in 1751.

Carle Vanloo worked for the king (*The Bear Hunt*, 1736, Musée des Beaux-Arts, Amiens; *Allegories of the Arts*, 1745, BN, Paris), for the Gobelins, for private individuals—executing decorations for the Hôtel de Soubise in 1737 (today the Archives Nationales), and especially for churches (four paintings from *The Life of the Virgin*, 1746-1751, Church of Saint-Sulpice, Paris; six paintings from *The Life of Saint Augustine*, and *The Vow of Louis XIII*, 1748-1753, Church of Nôtre-Dame-des-Victoires, Paris). He painted all categories: religion, history, mythology, portraiture, allegory, and genre scenes (*Pasha Having His Mistress Painted*, 1737, Wallace Collection, London, and *Spanish Reading*, 1761, Hermitage, Leningrad). His fame was immense; Grimm called him "the greatest painter in Europe"[1] and Voltaire compared him to Raphael.[2] Shortly before his death he undertook the decoration of one of the chapels in the Invalides with *The Life of Saint Gregory*.

Esteemed by his students (Doyen, N.-B. Lépicié, and Lagrenée), the rival of Boucher, who was named the *premier peintre du roi* only after his death, Carle Vanloo was one of the most gifted history painters of the eighteenth century. Today he is one of the most unappreciated and scorned artists of his era. To compare him to Boucher is somewhat cruel, but his work has confidence, conscientiousness, power, and a sense of composition that one cannot help but admire. He may not move the viewer, but he compels respect.

For a long time the study of Carle Vanloo was limited to Dandré-Bardon's eulogy and catalogue raisonné (1765), as well as Louis Réau's poorly illustrated monograph (1938). Fortunately, Marie-Catherine Sahut compiled a complete catalogue with reproductions of Vanloo's oeuvre for the 1977 (France) exhibition.

1. *Correspondance 1877-1882*, 2:280.
2. *Correspondance 1877-1882*, 6:322.

Allegories of the Arts:
Painting
La peinture
Signed lower left, on the chest: *Carle Vanloo*, fig.1

Sculpture
La sculpture
Signed lower right, on the box: *Carle Vanloo*, fig.2

Architecture
L'architecture
Signed lower center: *Carle Vanloo*, fig.3

Music
La musique
Signed lower center: *Carle Vanloo*, fig.4
Oil on canvas (previously curved at the top),
34½ × 33¼ in. (87.5 × 84 cm)
Mildred Anna Williams Collection. 1950.9,10,11,12
(CPLH)

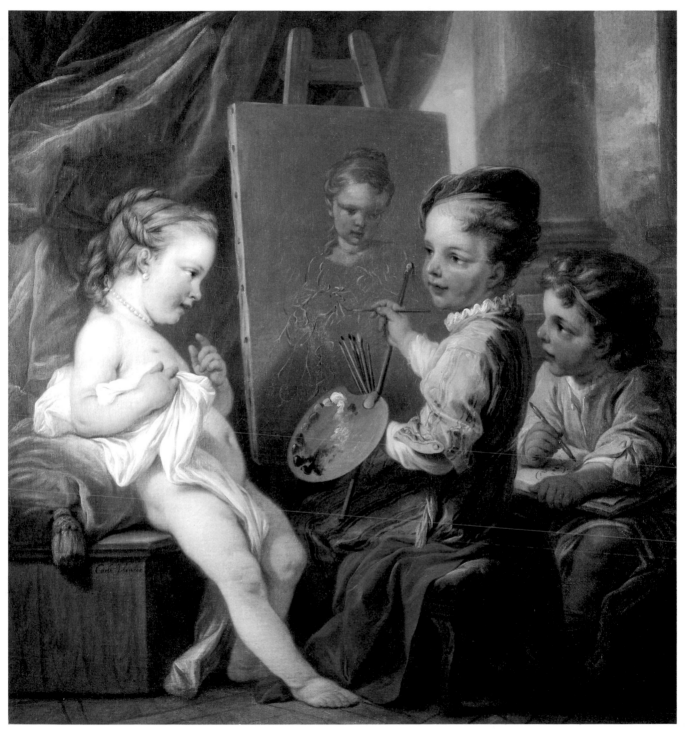

Painting

fig.1 (detail with signature)

fig.3 (detail with signature)

fig.2 (detail with signature)

fig.4 (detail with signature)

Provenance These paintings (*trumeaux*) were executed in 1752-1753 for Mme de Pompadour for the Salon de Compagnie, Château de Bellevue. On 6 August 1752, two canvases were sketched; the following 17 October, the entire suite was worked out (Furcy-Raynaud 1904, 21 and 27). 800 *livres* were paid for each (see "le mémoire des deux dessus-de-porte et des quatre peintures de trumeau," AN, O^1 1922B, *pièce* 10), which was published with some variations by Engerand. This document indicates payment for work in 1752 that does not appear in the payment records of the Bâtiments du Roi of that date. The paintings were removed after 1757 (Biver 1933, 145); mentioned in the vestibule of the first floor, Hôtel de Pompadour, Paris (now the Palais de l'Elysée), and valued at 1,800 *livres* in the inventory after the decease of the marquise, 26 July 1764, no. 86 (Nolhac, August 1903, 403; and Cordey 1939, 91, no. 1238); inherited by Marigny, brother of the marquise de Pompadour; estate sale of Marquis de Ménars (formerly Marigny), Paris, 18 March 1782, no. 124 ("ronds. D. O,81"); acquired for 3,100 *livres* by Basan; perhaps these are the four paintings in the collection of Frank Hall Standish, England (*Catalogue of the Paintings . . . Standish Collection . . .* (1842), 42, nos. 227-230, 88 × 84 cm?); bequeathed to King Louis-Philippe of France, 1842; King Louis-Philippe sale, London, Christie's, 28-30 May 1853, nos. 190-193; acquired by Samuel Wheeler, who exhibited them in London at the British Institution, 1864, nos. 66-67 (*Sculpture* and *Architecture*), and 73-74 (*Painting* and *Music*; A. Graves, *A Century of Loan Exhibitions* [London, 1913-1915], 1545); Wheeler sale, London, Christie's, 29 July 1871, no. 118; bought by "G. Smith"; perhaps anonymous sale, London, Christie's, 21 July 1888, no. 57; bought by "Speakman"; perhaps anonymous sale, London, Christie's, 1 December 1888, no 66; bought by "Radley"; perhaps Sir Hume Campbell sale, London, Christie's, 16 June 1894, nos. 13-14; probably collection of Baron Nathaniel de Rothschild, Vienna (cat. 1903, no. 18, 78 × 82 cm); confiscated by the Nazis in World War II and placed in the salt mine at Alt-Aussee, Austria; returned to his nephew, Alphonse de Rothschild, 1946; [Rosenberg and Stiebel, Inc., New York, 1950]; acquired by the CPLH, 1950.

References Dezallier d'Argenville 1762, 31; Dandré-Bardon 1765, 59; Piganiol de la Force 1765, 9:42; Thiéry 1788, 316; Blanc 1862-1863, 2:11, s.v. "Vanloo"; Engerand 1900, 486-487; Nolhac 1902, 567, and August 1903, 403, 407 (note 1), 409, 619; Furcy-Raynaud 1904, 21, 27, 56; Maumené and d'Harcourt 1931, 412-413, no. 373 (*Sculpture*); Biver 1933, 30-33, 145, 167; Réau 1938, 60-61, nos. 73-76; Cordey 1939, 91, no. 1238; Howe, November-December 1950, repr.; *Handbook* 1960, 63 (*Architecture*, repr.); W. Davenport et al., *Art Treasures of the West* (Menlo Park: Lane, 1966), 155; P. Rosenberg, exh. cat., 1972-1973 Toronto-Ottawa-San Francisco-New York, 217-218; A. Frankenstein, "A Reassessment of French Masters . . . at the Legion," *San Francisco Sunday Examiner and Chronicle*, 21 January 1973, 42-43 (*Painting*, repr. on 42); Kauffmann 1973, 1:284; Mirimonde 1975, 27-28 (*Music*, pl. 14); Henry 1976, nos. 74, 76, 82, 88, pls. 35, 36, 40, 42; P. Rosenberg and M.-C. Sahut, exh. cat., 1977 France, nos. 125, 126, 127, 128, repr.; G. Glueck, "San Francisco's French Art Museum Flowers with New Permanent Show," *New York Times*, 5 July 1980, 9 (*Painting*, repr.); Savill 1980, 306, 309 (note 12); "A Look into the Artist's Studio," *Westart*, 12 February 1982, 14; Near 1983, 25, fig.14; T. Lefrançois, "Les peintures provençales anciennes des Fine Arts Museums de San Francisco," *Bulletin Mensuel de l'Académie de Vaucluse*, January 1985, 4.

Exhibitions Salon of 1753, no. 180 (presented several days after the opening); 1954 New York, nos. 18 (*Music*), 19 (*Painting*); 1959 Baltimore, no. 22 (*Music*); 1964 Cleveland, no. 16 (*Sculpture*, repr.); 1975-1976 Toledo-Chicago-Ottawa, no. 107 (*Painting*, pl. 83); 1978-1979 Denver-New York-Minneapolis, nos. 39-42; San Francisco, CPLH, *The Studio of the Artist*, 2 December 1981-27 February 1982 (*Sculpture*), no cat.; 1982 Florida, no. 87 (*Painting*, repr.).

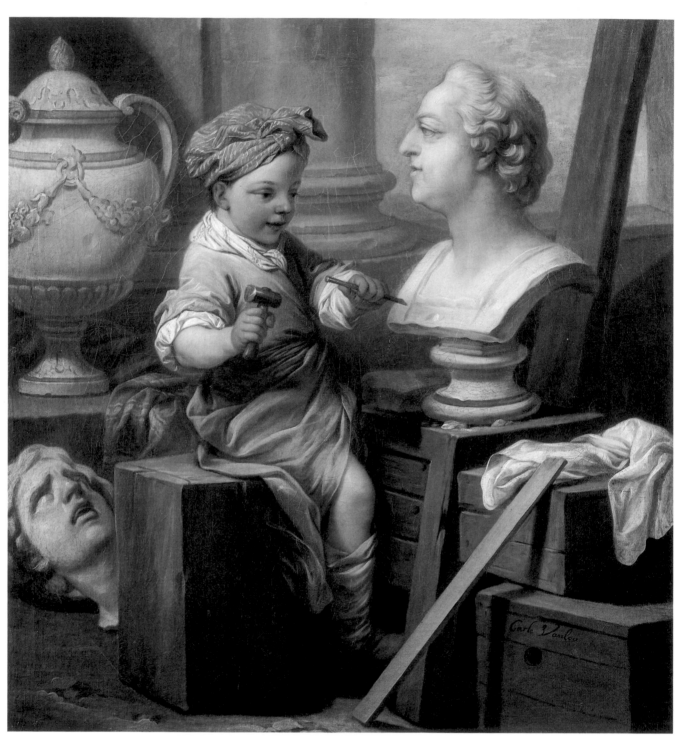

Sculpture

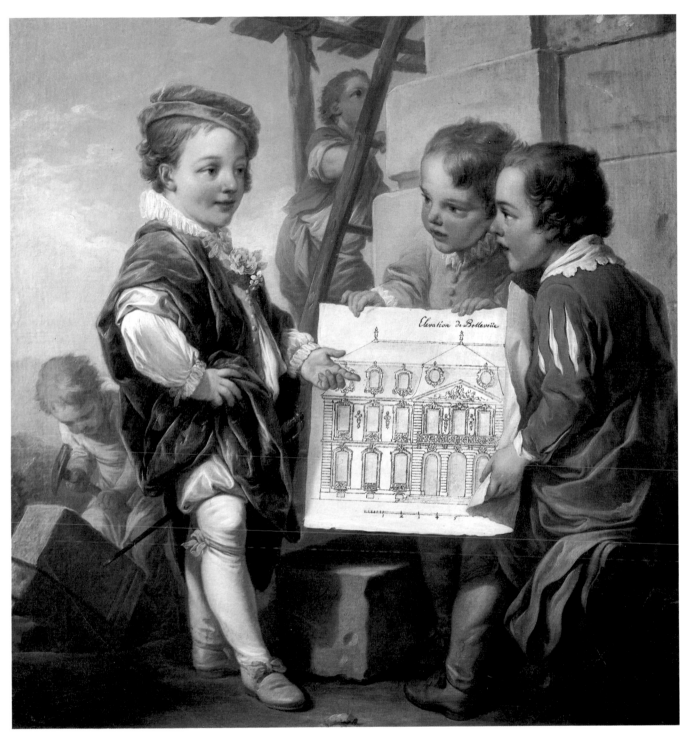

Architecture

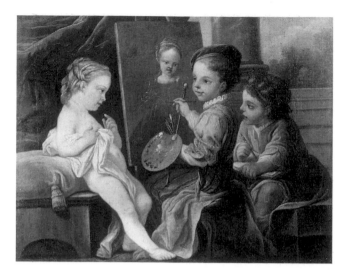

fig. 5

fig. 6

fig. 7

Variants

PAINTINGS

While innumerable copies exist in various sizes, there is little likelihood that Vanloo himself executed any replicas. Some of the versions listed below may actually be the paintings belonging to TFAMSF.

Sets of Four Paintings

Painting, Inv. 550-1882, **fig. 5**
Sculpture, Inv. 552-1882, **fig. 6**
Architecture, Inv. 553-1882, **fig. 7**
Music, Inv. 551-1882, **fig. 8**
Oil on canvas, 30 × 38⅝ in. (76 × 98 cm)
Victoria and Albert Museum, London, Bequest of John Jones. 1882
REF: Kauffman 1973, nos. 349-353, repr.

Sources for the following descriptions are the sale catalogues cited:

"Attributed to Boucher"
Round canvases, each diam. 43¼ in. (110 cm)
PROV: Perhaps Galerie Charles Brunner, Paris; Asher Wertheimer sale, London, Christie's, 9 March 1923, no. 93.

"Rectangular canvases"
PROV: Durlacher sale, London, Christie's, 8 July 1938, no. 83.

Oil on canvas, each 43¼ × 35½ in. (110 × 90 cm)
PROV: Baron Louis de Rothschild, Everett W. Pervers, and others, sale, New York, Parke-Bernet, 4 May 1955, nos. 67-70 (*Painting* and *Music*, repr.).

(No description provided)
PROV: J. K. Weddeburn sale, London, Christie's, 3 June 1892, nos. 77-79 (*Sculpture* and *Architecture* under the same number); acquired by Mainwaring.

Oil on canvas, each 51⅝ × 57⅛ in. (131 × 145 cm)
PROV: Paul Chevalier, Château de X and other *amateurs*, sale, Galerie Jean Charpentier, Paris, 20 March 1956, nos. 60-63.

"French School, 18th Century"
Oil on canvas, each 34⅝ × 31½ in. (88 × 80 cm)
PROV: Sale, Versailles, Hôtel des Chevau-Légers, 7 March 1976, nos. 84-87.

"After Vanloo"
Oil on canvas (oval), diam. each 43¼ in. (110 cm)
PROV: Sale, Paris, Hôtel Drouot, salle 6, 18 February 1946, nos. 105-108.

"Set of four copies"
Oil on canvas (oval), each 43¼ × 37 in. (110 × 94 cm)
PROV: De Boulogne sale, Paris, 22 November 1787 and following days, no. 49.
NOTE: Perhaps these are the same four paintings sold 18 February 1946.

"Set of four overdoors in the Salon de Compagnie of the Hôtel de Tessé, quai Voltaire, Paris"
REF: J. Vacquier, *Les vieux hôtels de Paris* (1920), 4:12, pl. 36-38.
NOTE: *Architecture* shows the facade of Hôtel de Tessé.

"Set of four paintings"
PROV: Hôtel Count E. Frisch de Fels, Paris, at the beginning of the twentieth century.
REF: Marquet de Vasselot 1902, 181.

M. H. Descours, executed in blue *camaieu*, 1770
Ernest Masselier collection, Bernay
REF: Exh. cat., 1977 France, 71.

"Van Loo, The four arts represented by the games of children"
REF: Mentioned in the inventory of the Château de Chanteloup,
drawn up by Rougeot, 1794 (Orliac 1929, 239).

"Vanloo (after Carle)"
Each 40½ × 61 in. (103 × 155 cm)
PROV: Château de M[ouchy] sale, Paris, Hôtel Drouot, 31 May 1923,
nos. 28-31.

"After Vanloo"
Oval, each 43¼ in. (110 cm)
PROV: Sale, Paris, Hôtel Drouot, 18 February 1946, nos. 105-108.

Partial Sets

Painting and *Sculpture*
Oil on canvas, each 34½ × 49½ in. (87.5 × 125.5 cm)
PROV: Sale, London, Christie's, 27 January 1928, no. 98.

"After Carle Vanloo," *Music* and *Sculpture*
Oil on canvas, each 34⅝ × 53⅛ in. (88 × 135 cm)
PROV: Sale, Paris, Hôtel Drouot, salle 10, 13 March 1947, nos. 79-
80.

Music, 35 × 47½ in. (89 × 120.5 cm) and *Sculpture*, 31 × 39 in.
(78.5 × 99 cm)
PROV: Lord Airedale sale, London, Sotheby's, 2 April 1952, nos. 133-
134.

Music and *Architecture*
Oil on canvas (ovals), each 34¼ × 39¾ in. (87 × 101 cm)
PROV: Frederick E. Sotheby sale, London, Sotheby's, 12 October
1955, no. 37.

Painting, *Sculpture*, and *Architecture*
Oil on canvas, each 33 × 56 in. (84 × 142 cm)
PROV: Sale, London, Christie's, 21-22 July 1960, no. 102.

Painting and *Architecture*
Oil on canvas (curved), each 39 × 56 in. (99 × 142 cm)
PROV: Sir Arthur Elton sale, London, Sotheby's, 21 February 1962,
no. 128.

Painting and *Sculpture*
PROV: Sale, Versailles, 13 July 1974, no. 92, repr.

Music, 38¾ × 54⅜ in. (98.5 × 138 cm) and *Painting*, 38¼ × 54¼ in.
(97 × 137.5 cm)
PROV: Eugène Fischof sale, New York, Fifth Avenue Galleries, 23
February 1906, nos. 33-34.

Single Examples of *Painting*

Hermitage, Leningrad
REF: Museum cat. 1958, I:265, no. 7467.

Musée Jacquemart-André, Paris. Inv. 321
REF: Summary cat. 1967, 57.

Oil on canvas, 40⅛ × 54⅜ (102 × 138 cm)
PROV: Soviet Union sale (Hermitage Collection), Berlin, Rudolph
Lepke, 6-7 November 1928, no. 393, pl. 17; second sale, Soviet

fig.8

Union, Berlin, Lepke, 4 June 1929, no. 64 (?).
REF: Copy mentioned by Réau 1938, 61, under no. 76.

Oil on canvas, 38¼ × 54¼ in. (97 × 137.5 cm)
PROV: Eugène Fischof sale, New York, Fifth Avenue Galleries, 17-18
March 1909, no. 106; acquired by W. D. Sheppard.
REF: Henry 1976, no. 83.

Oil on canvas, 37⅜ × 51⅝ in. (95 × 131 cm)
PROV: Louis Sherry sale, New York, Fifth Avenue Galleries, 4 April
1919, no. 712.
REF: Henry 1976, no. 84.

"Attributed to Vanloo, *The Youthful Artist*"
Oil on canvas, 26 × 38 in. (66 × 96.5 cm)
PROV: Sale, New York, Christie's, 9 January 1981, no. 210, repr.

Single Examples of *Sculpture*

"Atelier of Carl Vanloo (copy)"
PROV: Professor Singer, London, 1941; sold successively: London,
Sotheby's, 12 December 1979, no. 209, repr.; Monaco, Sotheby's, 26
May 1980, no. 546, repr.; New York, Sotheby's, 18 February 1981,
no. 59, repr.

"School of Vanloo"
Oil on canvas, 36¼ × 28¾ in. (92 × 73 cm)
PROV: Sale, Versailles, Palais des Congrès, 27 February 1972, no. 47,
repr.

Oil on canvas, 36¼ × 48½ in. (92 × 123 cm)
PROV: Leo Spik sale, Berlin, 18-19 October 1972, no. 329, repr.
NOTE: Probably a part of the suite Durlacher sold in London, 1938,
framed by garlands forming festoons.

"After Vanloo, *The Child Sculptor*"
32¼ × 50 in. (82 × 127 cm)
PROV: Sale, Paris, Hôtel Drouot, salle 6, 18 December 1946, no. 33.

Frick Art Reference Library, New York, has a photograph of a version
(509g) belonging to Sam Hartveld, dealer in Antwerp until 1940, then
in New York.

Music

Single Examples of *Music*

"Copy"
Oil on canvas, 16 ⅛ × 27 ⅛ in. (41 × 69 cm)
Musée du Louvre, Paris. R. F. 3070

Pastel, 29 ⅜ × 32 ½ in. (74.5 × 82.5 cm)
Clarice Henry, New York
Annotated lower right: CARLE VANLOO
REF: Henry 1976, no. 77.

Oil on canvas, 41 × 64 in. (103 × 162.5 cm)
PROV: M. X . . . , London, Christie's, 7 May 1909, no. 117 ("R. G. Behrens to Shepherd").

Oil on canvas (oval), 26 ½ × 21 in. (67.5 × 53.5 cm)
PROV: Sir J. M. Scott sale, London, Christie's, 27 June 1913, no. 126; acquired by Andrade.

Oil on canvas, 38 ¾ × 54 ⅜ in. (98.5 × 138 cm)
PROV: Eugène Fischof sale, New York, Fifth Avenue Galleries, 2 February 1923, no. 33; acquired by George Hurd.
REF: Henry 1976, no. 79.

Oil on canvas, 43 × 35 ½ in. (109 × 90 cm)
PROV: Weinmuller sale, Munich, 7 December 1960.
REF: A. P. de Mirimonde, *La Revue du Louvre*, 1968, no. 3, 133, fig. 18.

Single Examples of *Architecture*

Oil on canvas, 32 ¾ × 41 in. (83 × 104 cm)
PROV: Baron de Beurnonville sale, Paris, 3 rue Chaptal, 9-16 May 1881, no. 131. The children hold the elevation of the facade of the Château d'Orly; acquired for 850 francs by de Clerg, according to the annotated catalogue, Bibliothèque Doucet (1881/172).

Oil on canvas, rectangle with composition extended at the sides, ca. 30 × 68 ⅞ in. (ca. 76 × 175 cm)
Hotel San Pietro, Positano, in 1984

Version reproduced in "Pour des week-end en Ile-de-France," *Plaisir de France*, nos. 356-357 (June-July 1968):38, repr.

DRAWINGS
Painting and *Music*
Two preparatory drawings in black chalk, heightened with white gouache on tinted paper, 15 × 15 in. (38 × 38 cm)
Inscribed on the curved frames. Signed lower left: *Carle Vanloo*
REF: Exh. cat., 1977 France, nos. 356-357, repr.

Head of Girl Looking to Right (for *Painting*), **fig.9**
Preparatory drawing in black and white chalk with pastel, uneven format, 9 × 6 ⅝ in. (23 × 17 cm)
The Art Institute of Chicago. 59.529
REF: Exh. cat., 1977 France, no. 358, repr.

Head of Girl Looking to Left (for *Music*), **fig.10**
Preparatory drawing in black and white chalk with pastel and touches of graphite, irregular format, 9 ⅛ × 7 ⅛ in. (23 × 18 cm)
The Art Institute of Chicago. 59.528
REF: Exh. cat., 1977 France, no. 359, repr.

Portrait of a Child Wearing a Cap (for *Architecture*)
Preparatory drawing in colored chalk and pastel, 8 ¼ × 6 ¾ in. (21 × 17 cm)
PROV: Georges Bourgarel sale, Hôtel Drouot, 15-16 June 1922, no. 231, repr. on 156.

fig.9

fig.10

fig.11

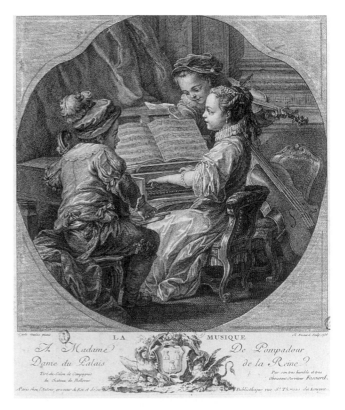

fig.13

fig.12

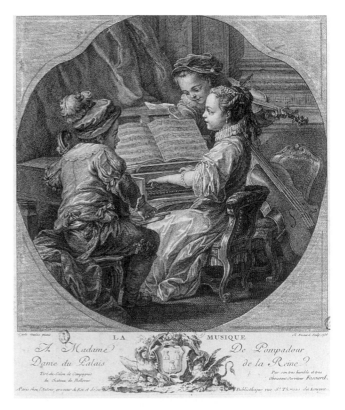

fig.14

Painting and *Architecture*
"After Vanloo"
Watercolors, 10⅝ × 11¾ in. (27 × 30 cm)
PROV: Estate sale, Henri Lacroix, Paris, Hôtel Drouot, 18-23 March
1901, nos. 284-285.
NOTE: Perhaps the same as those in the J.[ean] G.[igoux] sale, Paris,
Hôtel Drouot, salle 5, 20-23 March 1882, no. 754.

Mongenor (?), *Painting*
Drawing, reversed and with an extra figure
REF: Savill 1980, 309 (note 13).
NOTE: Reproduced in a two-volume set of snuffbox designs, Victoria
and Albert Museum, London, E.168-1938, 1:305.

ENGRAVINGS
Etienne Fessard, after Vanloo, 1756, figs.11-14
REFS: *Mercure de France*, September 1756, 228; Le Blanc 1854-
1890, 2:226, nos. 35-38; Portalis and Béraldi 1880-1882, 2:131, 145,
no. 26; Roux et al. 1931-1977, 9:73-74, nos. 364-367.

DECORATIVE ARTS
Noël Hardivilliers, snuffbox, 1757-1758 (*The Arts*), figs.15-18
Enamel on gold, 1⅜ × 2¾ × 2 in. (3.5 × 7 × 5 cm)
Wallace Collection, London. Inv. no. XVIII A 86
REFS: A. V. B. Norman, *Gold Boxes* (London: Wallace Collection,
1975), G 24, repr. in color; Savill 1980, 306, fig. 1 on 304.

"Another square gold box, decorated in enamel in eight compartments
representing the different aspects of artistic genius as children."
PROV: Estate sale, Marquis de Ménars, Paris, February-March 1782,
no. 714.
REF: Savill 1980, 309 (note 14).

French snuffbox, 1773 (*Music*)
PROV: Sale, Hermann Ball and Paul Graupe, Berlin, 25 September
1930, no. 71.
REF: Savill 1980, 309 (note 13).

Porcelain cup, Sèvres, 1778 (*Music*)
Bears the stamps of the painter Dodin, and of the gilder Chauveaux,
the elder.
PROV: Sale, London, Sotheby's, 13 July 1976, no. 20, repr. (Savill
1980, 309 [note 13]); another in a sale, London, Sotheby's, 12 June
1984, no. 189, repr.

English or French watch case, coarsely enameled (*Music*)
Tuck Collection
Petit Palais, Paris
REF: Savill 1980, 309 (note 13).

fig.15

fig.16

fig.17

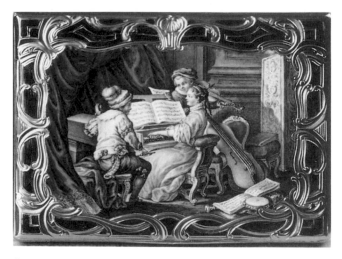

fig.18

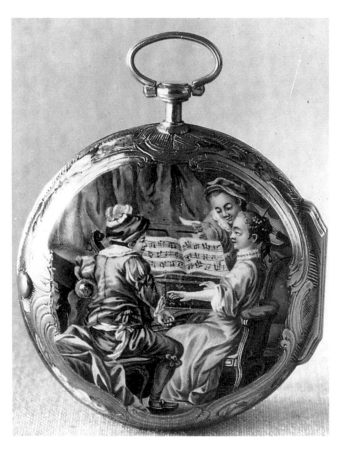

fig.19

Watch (*Music*), fig.19
D. 1⅞ in. (4.8 cm)
Signed: *Pierre le Roy à Paris*
Musée du Louvre, Paris. OA 8345

Studio of Cozette, after Vanloo, armchair with Gobelins tapestry panel (*Painting*)
Oval, 33¼ × 26 in. (13¼ × 10¼ cm)
EXH: 1959 Baltimore, no. 158.

Small enameled plaque, French, eighteenth century (*Sculpture*)
Victoria and Albert Museum, London. Inv. 866-1873

Oval miniature on enamel in a frame of silver gilt decorated with marcasite, eighteenth century (*Music*)
PROV: Sale, Paris, Hôtel Drouot, salle 1, 24 January 1964, no. 65.

The history of this important suite by Vanloo raises a number of questions. The identification of these four paintings as the originals commissioned by Mme de Pompadour rests upon the judgment that they are not only the best of the known versions, but are the only ones that are signed (figs.1-4). At one time they had rounded upper corners, very much like the shape of the engravings Fessard (figs.11-14) dedicated to Mme de Pompadour, taken from models in the Salon de Compagnie of the Château de Bellevue. Both the engraving and the San Francisco painting of *Architecture* show an elevation of the Château de Bellevue, but other versions do not. It should be noted, however, that the exhibition catalogue for the sale by Pompadour's brother, Marquis de Ménars (1782), specified "paintings in round shape . . . of thirty *pouces* in diameter" (ca. 81 cm). These dimensions do not correspond with those of the San Francisco paintings or with the size suggested by the Fessard engravings. In their original format the paintings were larger both in height and width than they are today. Perhaps the dimensions given in 1782 were only approximate or the canvases were reduced in size at a later date.

In any case, there are a few obvious discrepancies between the paintings and the engravings. The placement of the figures in relation to the objects is not quite the same. The tree in the background of the print *Painting* is different, and the perspective indicated in the parquet is not exactly the same as in the painting here. The numerous cracks in the crate in the right foreground of the print *Sculpture* are absent in the painting. In *Architecture* the young worker chisels at a stone at left that has been cropped in the engraving. It is possible, of course, that the engraver was responsible for these modifications. Although engravings usually are printed in reverse of their model, their direction does not necessarily prove authenticity of either work.

The results of X-rays of the four paintings are extremely positive, as they show evidence of alterations in format as well as *pentimenti*. The bust of the king

was initially higher and in three-quarter profile in *Sculpture*. In *Music* the chair of the young harpsichordist was originally higher and less curved, and the head of the violinist was at a slightly different angle. Numerous revisions were made in *Architecture* in the stones, the sheet showing the elevation of the château, the hands that hold it, and the drapery and direction of the sword worn by the architect. Interestingly the canvases for *Painting* and *Architecture* are placed on the stretcher-frames slightly askew.

These four pictures may then be considered as paintings intended as pairs, *Painting* and *Sculpture* on one hand and *Architecture* and *Music* on the other. Along with the overdoors *Comedy* and *Tragedy*, they were commissioned around 1752 by Mme de Pompadour for the Salon de Compagnie on the ground floor at Bellevue.

Louis XV in 1748, wishing to please his favorite, decided to have the architect Lassurance (1695-1755) construct Bellevue on the hills near Meudon. The small château was decorated by the greatest artists of the age and the spacious gardens were designed by d'Isle. Work was completed in January 1751, paid indirectly by the king through the income of Mme de Pompadour. This explains why no order of payment can be found in the accounts of the Bâtiments du Roi, although the correspondence of this administration follows in part the progress of the work. Bernard Lépicié wrote from Paris on 6 August 1752 to M. de Vandières, the future Marquis de Marigny and de Ménars, that "M. Vanloo has finished the paintings of *Tragedy* and *Comedy*; he has sketched out two others which he will finish soon. The artist desires no more than to repay your kindness to him, and forever to merit your good will and protection."[1] In a letter of 17 October in Paris, he adds, "Monsieur has certainly not forgotten that M. Vanloo promised to finish all the paintings that will decorate the Salle de Compagnie of the Château de Bellevue during the trip to Fontainebleau (the autumn journey); he is presently working on them and will not leave them."[2]

At the Salon of 1753 the four paintings received much critical attention, Baron Grimm noting that they were "very pleasing."[3] E.-C. Fréron observes that they were "treated with all possible finesse,"[4] and Jacques Lacombe notes that they were "of pleasing composition, the brush being guided by the gods of taste and talent," Vanloo being "the Rubens of our academy."[5] "These four pretty pieces," wrote Abbé Laugier, "are conceived with spirit, composed with clarity, drawn with elegance, and gracefully colored."[6] Abbé Leblanc wrote that *nature has been portrayed with striking fidelity in the four overdoors executed for the Château de Bellevue representing Painting, Sculpture, Architecture, and Music, embodied by children. M. Vanloo knows how to enliven all these little figures. The Sculptor working on the bust of the king is full of fire and genius. The little girl playing the harpsichord and the one posing for the Painter are the most naive of figures, the most ingenuous, and the most pleasing that one could hope to see. These four paintings are executed with lightness of spirit, but the elegance and nobility that predominate are indicative of the playful spirit of a great man.*[7] Estève was nearly as enthusiastic, remarking that *these paintings combine grace and power. . . . Geniuses [are] in action representing what they want to express. We can only praise M. Vanloo for having rejected the allegorical figures that traditionally have almost always been employed in these subjects. To resort to the mechanics of Art is genius become sterile and not a true understanding of one's metier. We might only have wished for a little more variety in the physiognomies of these small figures.*[8]

The hint of criticism perceived here, while not unfounded, pales compared to the indictment by Lafont de Saint-Yenne, who was an unconditional partisan of history painting of the highest order:
These arts are represented by children who are too dressed up, making them appear a little heavy and stuffed, even though their costumes are elegant and clever. Their physical features are not sufficiently varied and seem to have come from the same model. It is moreover unlikely that five- and six-year-old brats could seriously practice the arts; that their small and weak hands could hold sledgehammers and chisels to work the marble; that they would paint from nature, and similar occupations that are apt to give a more childlike character to the arts rather than dignity and respect. This reflection was prompted by the bad joke made by several people who upon seeing these paintings remarked "that the arts in our country have regressed to infancy," a ridiculous criticism and far from the truth.[9] Abbé Garrigues de Froment, while reiterating other critics' reactions to these paintings, remarked, "But, even if they are right, what does criticism matter to one who has succeeded in winning the acclaim of all?"[10]

The four paintings enjoyed enormous success. This was in no small part due to the established reputation of Vanloo. The allegorical subjects that he treats here are certainly less novel than his way of handling them. The two overdoors, *Tragedy* and *Comedy* (Pushkin Museum, Moscow), are more conventional in composition, as were the "two oval paintings representing Painting and Sculpture" that he exhibited two years later in the Salon of 1755 (no. 16). These latter came from the cabinet of Marquis de Marigny and were described in the catalogue of his estate sale (1782, no. 124) as allegories "represented by the busts of two women, one of whom holds a large head." The novelty in the four paintings from San Francisco, as the critics of the day observed, comes from the use of children in the allegories. This was a motif that soon became popular, as in

the six pictures of the Arts and Sciences that Boucher executed for Mme de Pompadour (The Frick Collection, New York), which in turn served as the models for a group of tapestries manufactured at the Gobelins (now in The Huntington Library and Art Collections, San Marino, California).

What is really surprising here is the unusual attitude Vanloo brings to these time-worn subjects. His young actors wear costumes of the most extravagant fancy, some in Louis XIV coats trimmed with ribbon, others in Renaissance costume with slashed velvet sleeves, lace ruffs, and feathered caps. Such costumes had a precedent in the work of Grimou and would soon be taken up by Fragonard.

It has been traditionally surmised that the faces of the painter's model and the young harpsichordist were inspired by the features of Mme de Pompadour. *Painting* is in many respects similar to Vanloo's *Appelles Painting Campaspe before Alexander* and *Pasha Having His Mistress Painted* (1737, Virginia Museum of Fine Arts, Richmond)[11] and is particularly interesting for the skill with which the idea of a painting within a painting is presented. Even more unusual is the personification of *Sculpture* by the young boy in the knotted kerchief who uses a mallet and a chisel on the bust of Louis XV, although the bust appears already completed and mounted on a pedestal. As Michèle Beaulieu has remarked, it would be a mistake to identify this bust, *à l'antique* but without a laurel crown, as a work of Jean-Baptiste Le Moyne, the official portraitist to the king.[12] At best, the busts in the painting are simply plaster casts commonly used as studio models. The representations of *Architecture* and *Music* are just as fanciful. No master builder ever worked solely from a simple elevation of the facade of his building, and while *Music* does show a violin and a cello, the keyboard of the harpsichordist is abbreviated and the sheet of music lacks key and time signature.

All these inconsistencies stem from Vanloo's chief preoccupation, which was to please and amuse the viewer. Without pretension but with charm, color, and imagination, he succeeds in doing just that.

1. Letter from N.-B. Lépicié to M. de Vandières, 6 August 1752, AN O[1] 1925[B]; Furcy-Raynaud 1904,21, no. 22.

2. Letter, 17 October 1752, AN,O[1] 1907; Furcy-Raynaud 1904,27, no.29.

3. *Correspondance* 1877-1882, 2:281.

4. Collection Deloynes 47, 15, no. 1240.

5. Collection Deloynes 5, 12-15, no. 55.

6. Collection Deloynes 5, 21, no. 59.

7. Collection Deloynes 5, 12, no. 63.

8. Collection Deloynes 5, 22-23, no. 56

9. Collection Deloynes 6, 31–33, no. 69.

10. Collection Deloynes 5, 12, 30, no. 58.

11. Near 1983, 18-19, repr.

12. Letter, 14 March 1978.

Claude-Joseph Vernet *Avignon 1714-1789 Paris*

Claude-Joseph Vernet, son of a modest coach painter from Avignon, was the father of Carle Vernet and grandfather of Horace Vernet. He studied with Vialy in Aix-en-Provence, probably after having been a student of Sauvan in Avignon. He arrived in Rome in 1734 as a protégé of the marquis de Caumont. There he was greatly influenced by Panini and received lessons from Manglard, a landscape painter from Lyon, who may have encouraged him to specialize in that genre. Vernet made numerous studies after nature at Tivoli, by the banks of the Tiber, and around Naples. By 1740 he was famous and received commissions from artists such as Conca and Costanzi, French dignitaries such as the duc de Saint-Aignan, French ambassador to Rome, and English tourists. He was elected a member of the Academy of Saint Luke in 1743 and successfully exhibited at the Salon from 1746. In 1750 he made the acquaintance of the marquis de Vandières, the future superintendent of the Bâtiments du Roi, who played an important role in Vernet's return to France in 1753. By that time Vernet had a considerable reputation in his own country. He was elected to membership by the Royal Academy of Painting and Sculpture in 1753 with *Sunset on the Sea* (lost) and was immediately commissioned by the king for fifteen paintings depicting the *Ports of France* (Musée du Louvre and Musée de la Marine, Paris).

The execution of this series, his most important work, kept him away from Paris for ten years. During this time his style evolved noticeably. In the first phase, the influence of his Roman studies is apparent, as well as a concern for animating his figures and for the color harmonies of aerial perspective (port views of *Marseille*, 1754, and *Toulon*, 1756, Musée du Louvre, Paris). In its next phase Vernet created an appealing view of port life in which he contrasted the elements of nature in dark and golden tones (*La Rochelle*, 1763, Musée de la Marine, Paris). Eventually, however, Vernet placed too much emphasis on details, thus weakening the overall composition of his works (*Dieppe*, 1765, Musée de la Marine, Paris). *Ports of France* quickly became famous and were engraved by Cochin the Elder and Le Bas beginning in 1760. Upon his return to the French capital Vernet was universally acclaimed and given lodgings at the Louvre. Diderot went so far as to prefer him to Claude, over whom he had the advantage of an ability to paint figures.[1]

Vernet's repertory is limited to views of ports or cities, landscapes, and especially imaginary seascapes at sunrise or sunset, moonlight scenes, fog, storms, and shipwrecks. At the beginning of his career Vernet modeled his art after Claude, Rosa, and the seventeenth-century Dutch painters, but he soon acquired his own highly personal style that was realistic while anticipating romanticism. Unfortunately, far too many imitators have helped foster the image of an aged Vernet, lacking inspiration and cold in his handling of the brush.

Florence Ingersoll-Smouse's catalogue raisonné (1926) has not been replaced, although Philip Conisbee prepared an excellent catalogue for the 1976-1977 exhibition.[2] Vernet, however unjustly, no longer has the reputation he held during his lifetime. Nonetheless, a genuine Vernet is often an authentic masterpiece and can be compared with the most perfect Venetian, Roman, or English paintings of the eighteenth century.

1. Diderot 1957-1967, 4:no. 41.
2. Philip Conisbee, *Claude Joseph Vernet 1714-1789*, exh. cat. (London: Kenwood, 1976; and Paris: Musée de la Marine, 1976-1977).

The Bathers

The Bathers

Les baigneuses
Oil on canvas, 22½ × 32½ in. (57 × 81 cm)
S.d. lower right, on the rock: *J. Vernet/f. 1786,* **fig.1**
Gift of Mrs. Georgia Worthington. 76.29 (de Young)

Provenance Sale of the cabinet of M. M+++, Paris, 20 March 1787,
no. 214; Jean-Baptiste-Pierre LeBrun sale, Paris, 2-11 February 1813,
no. 299 (not sold, according to the annotated catalogue, Bibliothèque
Doucet, Paris, 1813/2); Ravel collection, Lyon; sale, London, Sothe-
by's, 12 December 1973, no. 108, repr.; acquired by "R. Green" for
9,000 pounds; [Gerlach & Co., Amsterdam, 1973-1976]; acquired for
the de Young, 7 January 1976.

References Ingersoll-Smouse 1926, 2:40, no. 1151; Lee 1980, 221,
fig.13 on 218; T. Lefrançois, "Les peintures provençales anciennes des
Fine Arts Museums de San Francisco," *Bulletin mensuel de l'Acadé-
mie de Vaucluse,* January 1985, 3-4.

Exhibition 1978-1979 Denver-New York-Minneapolis, no. 43.

Related Works

PAINTING
The Bathers, 1753, **fig.2**
Oil on canvas, 25¼ × 31⅛ in. (64 × 79 cm)
Musée des Beaux-Arts, Nîmes. Gift of Louis Fournier, 1862
REFS: Ingersoll-Smouse 1926, 1:no. 696, pl. 81, fig.160; museum cat.
1940, no. 183.

ENGRAVING
J.-J. Balechou, after Vernet, *Les baigneuses,* 1762, **fig.3**

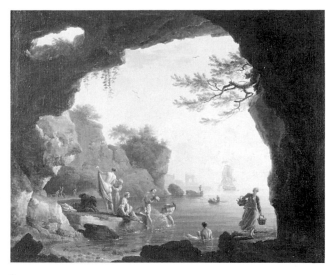

fig.2

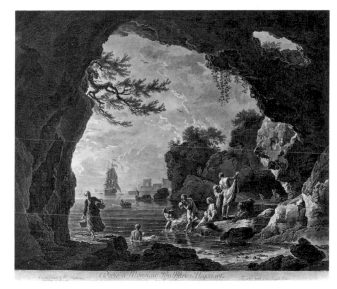

fig.3

fig.1 (detail with signature)

Less than a year after its execution, this canvas was described in the sale catalogue of 20 March 1787 as "a capital painting and a beautiful composition in which this artist [Joseph Vernet] appears to have wanted to produce a second version of *The Bathers*, in a new composition of a very different genre." The work derives directly from *The Bathers*, probably the canvas in the Musée des Beaux-Arts, Nîmes (fig.2), commissioned in 1753 by M. Poulhariez of Marseille and engraved by Balechou (fig.3). The composition met with great success, as evidenced by the engravings it inspired[1] as well as the copies made after it.[2] These pictures use the same device—a rocky arch that opens onto a vast marine view animated with ships and harbor activities. In the foreground on the left, the sea forms a small cove in which several women are bathing, protected by a projection of rock. However, the works are similar only in composition, with different details in the figures and landscape.

Florence Ingersoll-Smouse (1926) identified thirty-three paintings of *The Bathers* by Vernet, their locations in many cases currently unknown. Vernet mentions two pendants in his personal account books—*Bathers in a Grotto by the Sea (Morning)* and *Bathers at a River's Edge (Sunset, Landscape)*.[3] The Musée du Louvre has an important painting entitled *The Bathers: Morning* (s.d. 1772), which was commissioned as an overdoor by Comtesse de Barry as part of a series illustrating the four times of the day for her Pavillon de Louveciennes.[4] This picture presents several of the details in the San Francisco painting in reverse: the standing bather slipping on the sleeve of her dress, the one seated next to her pulling on her stocking, and the young woman in the water leaning on a stick. Similarly, *Summer Evening: Italian Landscape* (1773, formerly in the Henry Lapauze collection, Paris) shows the bather pulling on her stocking and a young woman seated in the water, splashing very much like the one in the San Francisco canvas.

The constancy with which Vernet more or less copied himself, especially after 1770, suggests it would be futile to try to identify the sites that inspired each composition. These landscapes were composed of previously used themes and motifs that were bathed in the soft warm light of Vernet's native Provence and executed in his studio. The rocky arch in the foreground with deep fissures and sparse vegetation is a feast for the artist's skillful brush, one that offers a striking contrast to the light haze of the background. The sharp contrast here is one to which an artist from the Midi of France may be especially sensitive, with its opposition of scorching summer heat and the cool, fresh shade. By juxtaposing the scene with the bathers against a second plane, animated by ships, sailors, fishermen, and their ladies (one is seated; the other stands silhouetted against the light),

Vernet evokes and places in apposition the themes of rest and labor.

It would be a mistake to believe Vernet's repetitions were motivated only by commercial reasons; his emotional commitment remained intact and his sensitivity exquisite. The editor of the sale catalogue (1787) observed, "This very precious piece dated 1786 will at the same time astonish and charm *amateurs* of our school to whose benefit M. Vernet becomes day-by-day more perfect in his work."[5] On the eve of the Revolution Vernet was still considered one of the best French landscape painters. Many artists would in turn take up the preromantic effects of the play of light and water that had been espoused by this untiring emulator of Claude Lorrain.

1. An anonymous engraving, unreversed, was no. 105 in the 1771 compendium of the cabinet of the duc de Choiseul.
2. Sale, Paris, Hôtel Drouot, 4 March 1931, no. 115, pl. 25; Ingersoll-Smouse 1926, 1:no. 697.
3. Commissioned by M. de la Borde in 1768, paid for by 4,800 *livres* on 20 September 1770, and shown in the Salon of 1771, no. 43. [C.-J. Vernet, Account Books, MS, 20 September 1770, library of the Musée Calvet, Avignon]; Ingersoll-Smouse 1926, 2:nos. 911-912; Philip Conisbee (letter, 11 March 1985) points out that the first of these paintings was put up for sale in London at Christie's on 12 December 1980, no. 81, repr. The second is certainly the version now in The Ashmolean Museum, Oxford.
4. Ingersoll-Smouse 1926, 2:no. 973, pl. 111, fig.244.
5. Sale, cabinet of M. M+++, Paris, 20 March 1787, no. 214.

Elisabeth Louise Vigée Le Brun *Paris 1755-1842 Paris*

Elisabeth Louise Vigée Le Brun was one of the most successful women painters of eighteenth-century France. The daughter of Louis Vigée, a professor at the Academy of Saint Luke who was a known portraitist and pastelist, she received advice from Doyen and Claude-Joseph Vernet in her father's studio. She completed her training by studying the collection of Flemish paintings belonging to Randon de Boisset, the works by Rubens in the Palais du Luxembourg, and the Italian masterpieces in the duc d'Orléans's collection at the Palais-Royal.

At fifteen she began a brilliant career as a portraitist. The virtuosity of her talent, the elegance of her draperies, her delicate brushwork, and the flattering manner in which she depicted her sitters soon attracted a large aristocratic clientele. In 1778 she executed her first portrait of Queen Marie-Antoinette (Kunsthistorisches Museum, Vienna), whom she portrayed more than twenty times, alone or accompanied by her children (1787, Château de Versailles). Because she was a woman and, in addition, married to the famous art dealer J.-B.-P. Le Brun, she endured violent opposition from a faction led by Pierre before being elected to membership by the Royal Academy of Painting and Sculpture in 1783 with the presentation of *Peace Bringing Prosperity* (1780, Musée du Louvre, Paris). Her studio attracted a succession of celebrities, society women (*Mme Grant*, 1783, The Metropolitan Museum of Art, New York), government figures (finance minister *Charles Alexandre de Calonne*, 1784, Windsor Castle), collectors (*Comte de Vaudreuil*, 1784, Virginia Museum of Fine Arts, Richmond), and artists (*Hubert Robert*, 1788, Musée du Louvre, Paris). She exhibited regularly at the Salon from 1783 to 1791.

With the commencement of the Revolution in 1789, however, Vigée Le Brun was compromised by her connections with the court and took refuge in Italy. Her reputation preceded her and she was welcomed among the academicians in Rome, Parma, and Bologna. After a sojourn in Naples she left Italy for Vienna (1793-1794) and then established herself in Saint Petersburg from 1795 to 1802, where she continued to portray court figures and political exiles. She returned to Paris in 1802, but loyalty to the Bourbons persuaded Vigée Le Brun to go to England from 1802 to 1805. There she met Benjamin West and admired the works of Sir Joshua Reynolds. She also traveled to Holland in 1805 and Switzerland from 1808 to 1809 where she was received by Mme de Staël at the Château de Coppet. Napoleon commissioned *Portrait of Caroline Bonaparte, Queen of Naples* (Château de Versailles). After the Restoration she found favor at court again, but her art, linked to the lost world of the ancien régime, soon became unfashionable. She died in Paris after writing her memoirs, an important document of the era to which she had been a privileged witness.[1]

A prolific portraitist who claimed to have executed over six hundred sixty-two portraits, fifteen history paintings, and close to two hundred landscapes, she frequently combined the delicate craftsmanship of eighteenth-century art with the new sensibility shared by some of her foreign contemporaries such as Batoni and Kauffmann (*The Artist and Her Daughter*, 1786, Musée du Louvre, Paris).

A catalogue raisonné is being prepared by Joseph Baillio, who organized a successful exhibition of Vigée Le Brun's work in 1982.[2]

1. Vigée LeBrun 1907.
2. Joseph Baillio, exh. cat., 1982 Fort Worth.

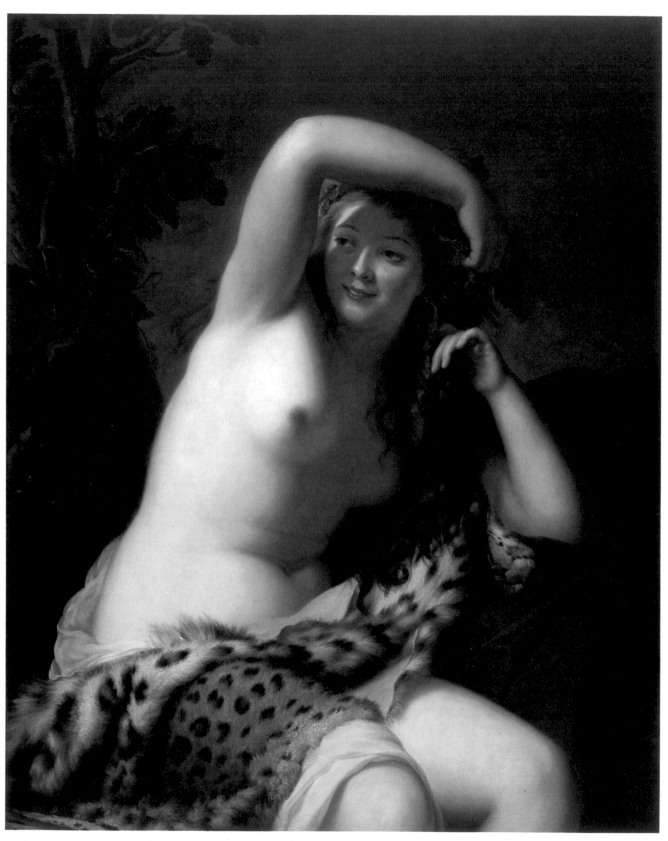

Bacchante

Bacchante (*copy after Vigée Le Brun*)

Oil on canvas, 44 × 35 in. (112 × 89 cm)
Mildred Anna Williams Collection. 1956.20 (CPLH)

Provenance Lady Eliza Rolleston, London; [The Hallsborough Gallery, London, ca. 1955]; acquired by the CPLH, 1956.

References *The Connoisseur*, March 1955, 50, no. 6, repr. (also color repr., advt.); *The Art Quarterly*, Autumn 1956, 305, repr. on 307; Howe 1957, 11, repr.; *Handbook* 1960, 63, repr.; W. Davenport et al., *Art Treasures of the West* (Menlo Park: Lane, 1966), 155; Rose 1975, 68, repr.; Petersen and Wilson 1976, 54, fig.IV-17; Baillio 1980, 168, note 26; W. Wilson, *California Museums* (New York: Abrams, 1985), 73, pl. 61 (color); J. Baillio, exh. cat., 1982 Fort Worth, mentioned on 7.

Exhibitions San Francisco, CPLH, *Women Artists: Review and Recognition*, 11 October-28 December 1975, no cat.; 1976 Washington, no. 246, repr.

Variants

PAINTINGS

Bacchante, 1785, **fig.1**
Oil on panel, 43 × 30¾ in. (109 × 78 cm)
Musée Nissim de Camondo, Paris. Inv. 277
PROV: Comte de Vaudreuil.
REFS: Vigée Le Brun 1907, 227; mus. cat. 1985, no. 113.
EXH: Salon of 1785, no. 86.

Bacchante, copy
Oil on canvas
Baron Edmond de Rothschild, Château de Prégny (near Geneva)
NOTE: According to Joseph Baillio (letter, 26 November 1980), this painting is incorrectly attributed to Vigée Le Brun.

DECORATIVE ARTS

Jacques Thouron, after Vigée Le Brun, miniature, **fig.2**
Enamel, 3⅝ × 3 in. (9.5 × 7.5 cm)
Cab. des Dess., Musée du Louvre, Paris. Inv. 35726
PROV: Seized 25 Messidor, year V [13 July 1797] at the Temple, Paris, with the collections of the comte d'Artois, *émigré*.

Vieux Paris plate, ca. 1810, **fig.3**
Painted in sepia monochrome; the gilded rim with a burnished foliate border, inscribed in gold script with an incised mark: *Darte ainé à Paris*
D. 9¼ in. (23 cm)
PROV: Sale, New York, Sotheby's, 4 May 1985, no. 127, repr.; acquired by Edward Sheppard, New York.

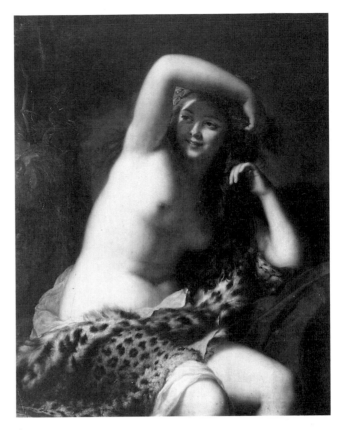

fig.1

fig.2

fig.3

This is a faithful copy of very fine quality after the original panel in the Musée Nissim de Camondo (fig.1), which was executed for Joseph-François de Paule, comte de Rigaud de Vaudreuil (1740-1817), one of the great *amateurs* of the day and a habitué of the salon of the artist with whom he maintained a sincere friendship.

The original *Bacchante* is not a self-portrait, in spite of earlier suggestions. Vigée Le Brun did not include it in her list of portraits, but, as *Bacchante with a Tiger Skin*, among the fifteen history paintings she executed during the course of her career.[1] (Later in Naples the artist painted a portrait of Lady Hamilton as a reclining bacchante and another portrait of "the same bacchante, dancing with a Basque tambourine."[2]) This *Bacchante* was conceived as a history painting, however, and must be judged accordingly.

If we can believe Chompré's classic *Dictionnaire de la fable*, a work frequently consulted by artists of the day, [bacchantes] *were the women who followed Bacchus to the conquest of the Indies, everywhere proclaiming his victories. During the Ceremony of Bacchanals and Orgies, they ran about dressed in tiger skins, completely disheveled, carrying thyrsi* [staffs tipped with a pine cone and twined with ivy] *and torches, and howling frightfully.*[3] Pierre Grimal makes the distinction between human and divine bacchantes, or maenads, the latter being the personification of orgiastic spirits of nature. Possessed by a god who inspired them with mystical madness, maenads wandered around the country, drawing water from springs and imagining it was milk and honey. In addition, they held power over wild animals.[4] This sort of violent creature is far from the gracious subject depicted here, leaning against a vivid red drape, with a background of reddish vegetation and a steel-blue sky.

This fact did not escape critical attention when the original painting was shown in the Salon of 1785. In *Journal de Paris*, Villette wrote:
The mark of great talent is not to embellish everything, but to express character. Should a bacchante look like a nymph? Should her bacchic hilarity resemble the smile of a pretty girl? Should she not retain something of the robust and uncouth? If, under the tiger skin that covers her, I divine delicate contours or admire a satiny skin where it seems the most masterful hand has blended lilies and roses, I forget the bacchante and see only the model [dressed] in lawn.[5]

Nevertheless, some of the critics were not content to focus on the painting's subject but attacked the execution as well. For *L'Aristarque Moderne au Sallon*, *the expression of the bacchante, which should be virile and savage, is here inane and unpleasant, the rendering of the knees repulsive. This artist, who shows much promise of talent and announces a certain facility, would do well to change her style and, above all, her*

palette. Whatever deference we might have for the fair sex, truth is still more dear to us.[6]

The author of *L'avis important d'une femme sur le Sallon de 1785* does not spare the artist any less:
This history subject called for vigor, anatomical knowledge, and an ability to paint on a large scale. Severe masters will always be astonished that a young woman of charm and a delicate constitution could have conceived such a bold undertaking: its execution is another matter which must finally be discussed. This history figure is no better than the Junoes and Venuses all familiar to this artist; she is, however, less insipid, but just as mannered, almost grimacing, poorly seated, raises her arm without motive, unless it is to amuse herself by producing bits of shadow on her face. Her thighs are short, badly angled, and show no contrast, and the colors are of no help. The execution is listless, sporadic, the palette is not the same tone throughout, the half-tone of the raised arm is certainly not among the series of colors employed for the rest of the body; in a word, although the choice of this figure gives the intention of showing us voluptuousness in a sharp and lively way, one could look at this figure all day without reproaching her in the least for her nudity. This figure is definitely not up to the standard of the portraits painted by this fashionable artist.[7]

A very favorable opinion was expressed by the writer in the *Mercure de France* for whom the painting was *gay, seemly in expression, in the form of the bacchante, and skillful in the manner in which she is lit. . . . Mme Le Brun knows equally well how to paint all tones. She is the master of her style, she divides it, she heightens it or reduces it in proportion to what is needed. Her color is strong, varied, local; a quality quite rare and too little appreciated. Despite the observations of some Critics, we dare to advance that this artist is one of the most skillful colorists of our century.*[8]

The vigorous accord of colors, treatment of the fur, juxtaposition of rosy flesh against it, and luxuriant vegetation irresistibly evoke Flemish painting of the seventeenth century, an influence important in the artist's formation. In addition, the painter has embellished the hair of her bacchante with a red ribbon with great subtlety, and the colors of the grapes and foliage blend well with the color scheme of the whole.

1. Vigée Le Brun 1907, 227.
2. Helm 1915, 201.
3. Chompré, *Dictionnaire de la fable* (1833 ed.), 75.
4. Pierre Grimal, *Dictionnaire de la mythologie grecque et romaine* (1969 ed.), 288.
5. Collection Deloynes 14, 810, no. 350.
6. Collection Deloynes 14, 14, no. 340.
7. Collection Deloynes 14, 26-27, no. 344.
8. *Mercure de France*, 1 October 1785, 32.

Jean-Antoine Watteau *Valenciennes 1684-1721 Nogent-sur-Marne*

Jean-Antoine Watteau was apprenticed by his father to Gérin in Valenciennes, then came to Paris at the beginning of the eighteenth century. He frequented the shop of the art dealers and print collectors Pierre Mariette and his son Pierre-Jean, where he became acquainted with the works of Callot, Picart, and Simpol, as well as Titian and Rubens. In the studio of Gillot he began working with popular and theatrical themes. He subsequently entered the studio of Claude III Audran, the concierge of the Palais du Luxembourg, where from 1708 to 1709 he had the revelatory experience of studying Rubens's *Marie de' Medici* cycle (Musée du Louvre, Paris). Under Audran he worked primarily on the decoration of the Château de la Muette (the king's cabinet), creating one of the first ensembles reflecting contemporary taste for chinoiserie and exoticism, as well as on the Hôtel de Nointel, where his painted panels represented a fantastic combination of gallant personages, grotesques, and arabesques. In 1709 Watteau tried in vain to win the *Prix de Rome*, losing to an obscure artist named Grison. Three years later he presented several paintings to the Royal Academy of Painting and Sculpture and was made an associate.

He returned to Valenciennes in 1710, where he treated military subjects in a more realistic fashion than his predecessors (*Bivouac*, Pushkin Museum of Fine Arts, Moscow). Upon his return to Paris he lived in the house of Pierre Sirois, the father-in-law of Gersaint, where he painted masquerades in the style of Gillot. He also worked diligently on his landscape technique. He soon made the acquaintance of Pierre Crozat and perfected his craft while studying Crozat's immense collection of drawings. It was for this famous *amateur* that Watteau painted *The Seasons* (ca. 1715), of which only *Summer* survives (National Gallery of Art, Washington). This painting is representative of his new, mature style, a personal synthesis of an aesthetic originally derived from the second School of Fontainebleau, Rubens, the colorists of the age of Louis XIV, as well as Venetian painting, and executed with the most delicate palette, bold luminous effects, and rare poetic sensitivity to atmosphere.

In 1717 Watteau was made an academician as a painter of *fêtes galantes*, a genre created for him by the Academy, with *Pilgrimage to the Island of Cythera* (Musée du Louvre, Paris). After a journey to England from 1719 to 1720, where he met some French artists and received several commissions, he went to live in the house of Gersaint, for whom he executed the famous *Shop Sign* (Schloss Charlottenburg, Berlin). Watteau retired to Nogent-sur-Marne in 1721 where he died in

Gersaint's arms at the age of only thirty-seven. Gersaint has left us the following portrait of Watteau: "Restless and moody, . . . self-willed, free in spirit, but morally wise, impatient, shy, . . . always unhappy with himself and others."[1]

In the eighteenth century Watteau enjoyed a widespread reputation not only for his paintings, but also for his admirable drawings and the engravings that Jullienne had made after his works (*Recueil Jullienne*).[2] The regard that was accorded him during his lifetime, however, was far less important than the esteem in which he has been held in the history of European painting for more than a century.

His complete oeuvre has been the subject of many studies.[3] The exhibition *Pèlerinage à Watteau*[4] and another devoted to the master's drawings[5] testify to the great interest this seminal figure still holds for the public. The catalogue by Pierre Rosenberg and Margaret Morgan Grasselli for the 1984-1985 Washington-Paris-Berlin exhibition commemorating the tercentenary of Watteau's birth has shed new light on several problems and enhances the body of literature on this artist.

1. Pierre Rosenberg, *Vies anciennes de Watteau* (Paris: Hermann, 1984), 39.

2. See Dacier et al. 1921-1929.

3. For important bibliography see exh. cat., 1984-1985 Washington-Paris-Berlin, *Watteau: 1684-1721*.

4. Exh. cat., *Pèlerinage à Watteau* (Paris: Hôtel de la Monnaie, 1977).

5. Exh. cat., *Watteau: Drawings in the British Museum* (London: British Museum, 1980-1981).

fig.1 (detail with inscription)

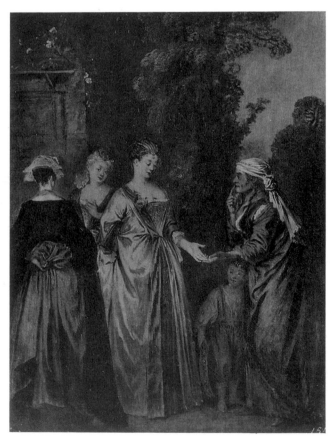

fig.2

The Fortune Teller

La diseuse d'aventure or *La diseuse de bonne aventure*
Oil on walnut panel, 14⅝ × 11 in. (37 × 28 cm)
Inscribed lower left: *Wateau*, **fig.1**, and on the back
stretcher: *Wottot* and *Mde de Tricaud* (?)
Roscoe and Margaret Oakes Collection. 68.4 (de
Young)

Provenance Collection of "M. Oppenort" [Gilles-Marie Oppenordt],
1727, probably until his death in 1742 (M. Rambaud, *Documents du
Minutier Central concernant l'histoire de l'art 1700-1750*, vol. 2,
[Paris, 1971]). ("Fortune Tellers" attributed to Watteau are listed in
Related Works, but the provenance of the San Francisco panel
between 1742 and 1954 is unknown.) Restoration by William Suhr,
New York, 1954); private collection, France (according to Rudolf J.
Heinemann and Walter Heil, former director of the de Young
Museum, letter, 9 June 1961); Mr. R. E. Hornsby, Pulford Publicity,
Ltd., 1957 (according to Sir Francis Watson, letter, 10 January 1968);
[Rudolf J. Heinemann, New York, before 1959]; [on consignment
with Thos. Agnew & Sons, Ltd., London, 1967]; acquired by the de
Young, 1968.

References A. Fried, "California Gets a New Art Treasure," in *Cali-
fornia Living, San Francisco Sunday Examiner and Chronicle*, 21
April 1968, 22-23, repr. in color; J.-P. Cuzin, exh. cat., 1977 Paris, no.
110, repr.; M. C. Stewart, "16 Paintings in Search of an Artist," *Trip-
tych*, October-November 1982, 10-11, repr.; Roland Michel 1984
(*Watteau*), 276; Roland Michel 1985, 916.

Exhibitions San Francisco, de Young, *16 Paintings in Search of an
Artist*, 28 August-14 November 1982, no cat.; 1984-1985
Washington-Paris-Berlin, no. 8, repr. in color.

Variants
PAINTINGS

Reversed from the Engraving

The Fortune Teller, copy, **fig.2**
Oil on canvas, 29½ × 22¹³⁄₁₆ in. (75 × 58 cm)
PROV: Léon Michel Lévy, Paris; sale, Galerie Georges Petit, 17-18
June 1925, no. 161, repr.; lost(?).
REFS: Zimmermann 1913, pl. 92; Emile Dacier, "Les premiers ama-
teurs de Watteau en France," *Revue de l'art ancien et moderne*, July-
August 1921, 121; Dacier et al. 1921-1929, 1:259, and 3: under no.3.

Sources for the following descriptions are the sales catalogues cited:

"A follower of Lancret"
Oil on canvas, 25¼ × 25⅝ in. (64 × 65 cm)
PROV: Sale, Versailles, 26 February 1978, no. 57, repr.

"Attributed to 'Antoine Watteau und sein Atelier'"
PROV: Sale, Zurich, Koller Gallery, 16-17 May 1980, no. 5183,
pl. 46.

"Signed: *Anne Bricoller 1798*," **fig.3**
PROV: Brought into the de Young for examination in 1968; private
collection, northern California, 1985.

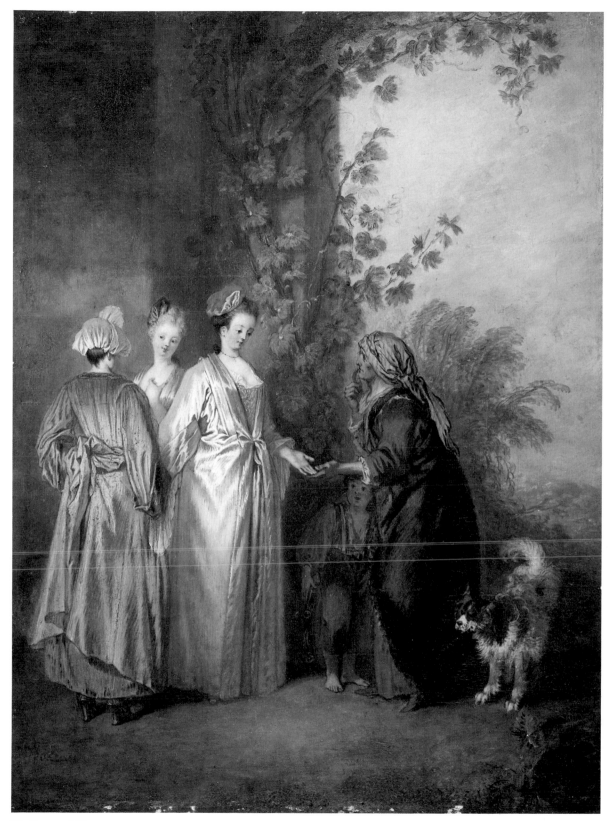

The Fortune Teller

fig.3

fig.4

Same Direction as the Engraving

The Fortune Teller, fig.4
Oil on canvas, 23½ × 21 in. (59.5 × 53.5 cm)
PROV: The New-York Historical Society; sale, New York, Parke-Bernet, 2 December 1971, no. 153; Jules Szawas, New York, in 1972.
REF: F. Monod and L. Einstein, "Le musée de la société historique de New York," *GBA*, September 1906, 250-251.

Horizontal Version
PROV: Sale, Versailles, 14 March 1976, no. 2, repr.

NOTE: For the works of Lancret and Pater that were inspired by Watteau's painting or the engraving after it, see Wildenstein 1924, no. 524, fig.200; Ingersoll-Smouse 1928, nos. 505-518, figs.7, 147, 150, 152; J.-P. Cuzin, exh. cat., Paris 1977; and Eidelberg 1977.

Versions that Have Appeared in Public Sales

"The Fortune Teller of Watteau"
PROV: M. Barbier (deceased), former Captain of the Regiment of Orléans . . . , sale "rue des Ursulines in Saint-Germain-en-Laye 31 July 1752 (. . .)"
REF: *Annonces, affiches et avis divers*, 31 July 1752, 467.

"A Young Fortune Teller Telling a Young Lady Her Fortune"
PROV: Dr. Bragge sale, London, 24-25 January 1754, no. 36.
REF: Raines 1977, 57, 62, no. 51.

"Gypsies Telling Fortunes"
31 × 24 in. (79 × 61 cm)
PROV: Cardinal Mazarin and Prince de Carignan sale, London, 28 February 1765.
REF: Raines 1977, under no. 51.

"The Bohemian of Watteau, subject composed of four figures"
Oil on canvas, 2 *pieds* 4 *pouces* × 22 *pouces* [ca. 76 × 59.5 cm]
PROV: M. de Merval sale, Paris, 9 May 1768, no. 130; acquired by Langlier.

"A Landscape with the Fortune Teller"
PROV: Le Brun sale, London, 18 March 1785, no. 75.

"Fortune Teller"
PROV: Foxall sale, London, Christie's, 10 February 1786, no. 37; acquired by Tassaert.

"Fortune Teller"
Oil on canvas, 33 × 29 in. (84 × 73.5 cm)
PROV: Desenfans sale, London, 8 April 1786, no. 298.

"Fortune Teller, this painting has been engraved"
PROV: Fossard sale, Paris, 24 April 1838, no. 73.

"The Bohemian, engraved by Cars"
REF: P. Hédouin, "Watteau," *L'Artiste*, 16-30 November 1845, no. 64: "A painting of very small dimensions was recently bought in 1845 in the countryside near Paris [for] 25 francs by M. Malinet who then sold it for 1,500 francs."

No details known
PROV: Stevens sale, 1-4 March 1847, no. 319.

"The Fortune Teller, engraved"
Oil on canvas, 23⅝ × 19¹¹⁄₁₆ in. (60 × 50 cm)
PROV: Dr. Gaston Gaudinot sale, Paris, Hôtel Drouot, 15-16 February 1869, no. 119.

"The Fortune Teller"
Oil on canvas, 29 ½ × 22 ¹³/₁₆ in. (75 × 58 cm)
PROV: Sale, Paris, Hôtel Drouot, 26 February 1880, no. 12.

"The Fortune Teller"
10 × 7 in. (25.5 × 18 cm)
PROV: The Bohn [Henry G.] Collection, sale, London, Christie's, 19 March 1885, no. 63.

"The Fortune Teller, attributed to Watteau"
Oil on canvas, 12 ⅝ × 9 ⅞ in. (32 × 25 cm)
PROV: E. May sale, Paris, Galerie Georges Petit, 4 June 1890, no. 131.

"French School, The Fortune Teller"
Oil on canvas, 28 × 35 ⅞ in. (71 × 91 cm)
PROV: Eugène Kraemer sale, Paris, Galerie Georges Petit, 2-5 June 1913, no. 81.

ENGRAVING
Laurent Cars, after Watteau, *La diseuse d'aventure*, **fig.5**
PROV: Announced in the *Mercure de France*, December 1727, 2677. The caption fixes the name of the owner of the painting, Gilles-Marie Oppenordt, and adds that the original painting was "of the same size" as the print, which measures 339 × 274 mm, very close to the dimensions of the San Francisco panel.
REFS: Roux et al. 1931-1977, 3:462, no. 11; P.-J. Mariette, "Notes manuscrites sur les peintres et graveurs," in vol. 9, fol. 192, MS, 1740-1770, BN; Dacier et al. 1921-1929, 3:no. 30 and 4:pl. 30.

Related Works

DRAWINGS
Doubled-sided drawing with studies for the painting. Recto shows a study for the gypsy; verso has a study of the entire composition.
Private collection, Paris
REFS: K. T. Parker and J. Mathey, *Watteau: Catalogue complet de son oeuvre dessiné*, 2 vols. (Paris: F. de Nobele, 1957), nos. 33, 142; Eidelberg 1977, 226-232 and 258-259.

Two Groups of Comedians, **fig.6**
Counter-proof from red chalk, 6 ½ × 8 ½ in. (165 × 215 mm)
Nationalmuseum, Stockholm. NM H 2833/1863

Comedians Traveling, **fig.7**
Counter-proof from red chalk, 6 ⅜ × 8 ½ in. (162 × 215 mm)
Nationalmuseum, Stockholm. NM ANCK 491
REF: K. T. Parker and J. Mathey, cited above, nos. 130-131; Eidelberg 1977, 228-229; P. Bjurstrom, *Drawings in Swedish Public Collections: French Drawings. Eighteenth Century. Nationalmuseum* (Stockholm, 1982), nos. 1285-1286, repr.

DECORATIVE ARTS
Chelsea Gold Anchor vase with cover, ca. 1770, **fig.8**
Reverse painted with figures in the style of Watteau, possibly by Donaldson
H. 14 in. (35.5 cm)
Klaber and Klaber, London
REF: *Grosvenor House Antiques Fair Catalogue* (London, 1984), 68, repr.

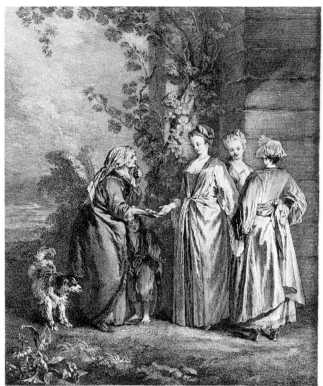

LA DISEUSE DAVENTURE. FUTURORUM PRÆNUNTIATRIX.
Gravée d'apres le Tableau original Peint par *Sculpta juxtà Exemplar Ejusdem magnitudinis*
Watteau, de mesme grandeur. *à Watteaus Depictum.*
à Paris chez F. Chereau graveur du Roy rue St Jacques aux deux pilliers d'or.

fig.5

fig.6

fig.7

Gilles-Marie Oppenordt, architect and decorator, owned works by Watteau, among them *The Fortune Teller* and *Jealous Harlequin*.[1] Oppenordt frequented the same circle as Watteau and his patron Pierre Crozat, and Watteau was influenced by Oppenordt's decorative designs.[2] However, the inventory taken upon the death of Oppenordt, 9 May 1742, is troubling because of the confusion it casts on the provenance of the Museums' work.

Drawn up at his residence, "a house situated in the rue de Richelieu belonging to Monsieur Crozat, Marquis du Chatel," the inventory mentions a "soothsayer of good fortune." The picture was said to be on "wood, a copy after Vateau, partially damaged" and was estimated at 24 *livres*.[3] A number of interpretations of this document are possible. Oppenordt may have sold the original and kept a copy, or perhaps the agent who drew up the inventory in 1742 was unable to tell the difference between an original Watteau and a replica. This extremely low estimated value, which supports the statement that the work was a copy, might again reflect the agent's inexperience; the other Watteau, presuming *Jealous Harlequin* was confused with the "history subject" given in the inventory, is appraised at only 60 *livres*. What cannot be accounted for is the "partially damaged" state of the painting. Although the varnish was removed rather brutally, the San Francisco panel seems to be in relatively good condition.

Thus there was some risk in attributing this panel to Watteau in the 1984-1985 exhibition. With the exception of Sir Francis Watson, Claus Virch, and Alexander Fried,[4] scholars were skeptical. However, as a result of intensive examination and exhibition with Watteau's works of the same period, the painting appears to be an original early work by this artist and most reviewers of the exhibition accepted this attribution. It is certainly the best by far of all the many known versions of this composition. The trees and the grapevine in the middle ground and the mongrel spaniel are executed by a sure hand. Moreover, the thin, dark lines that outline the face and hands of the gypsy and delineate the eyes and mouth of the child with the Basque tambourine, and the manner of describing the folds and bows of the women's gowns and of capturing the shifting reflections of light in the silks and satins seem much in keeping with Watteau's style.

A few uncharacteristic features—the tiny hands and heads, some rather sharp coloring, and somewhat static composition, for example—may be ascribed to the inexperience of the youthful Watteau. The bow on the woman dressed in yellow with her back to the viewer is almost identical to a figure in *Halt* (Thyssen-Bornemisza collection, Castagnola, Switzerland), confirming the early date of this picture. The Gillotesque preparatory drawings, which are a bit clumsy and uncertain,

probably can be dated slightly before 1710, as can the painting.

The theme of the fortune teller in painting was explored by Jean-Pierre Cuzin in a 1977 exhibition highlighting the famous Caravaggio in the Louvre. It is a subject that remained popular throughout the eighteenth century although the protagonist was no longer portrayed in half-length as in previous epochs, thus undercutting the disturbing and mysterious element in such compositions. More than a genre scene taken from life, *The Fortune Teller* provided Watteau with the opportunity for tonal contrasts, playing the coppery complexion of the gypsy with her hand at her mouth against the clear flesh tones of the young woman and her companions.

The painting is in fact a series of contrasts between the realism of the right half of the composition and the idealism of its left side, between town and country, and between the savage world represented by the gypsy's bare feet and civilized society symbolized by the slippers worn by the elegant women. Innovative color combinations in the silver and cherry pink dress, humorous touches like the four coiffures in white, lavender, pink, and ochre, and the pensive expressions of the two young women announce the great Watteau of the following decade. Even at this early date Watteau was capable of creating the particular and affecting ambience for which he was to become renowned.

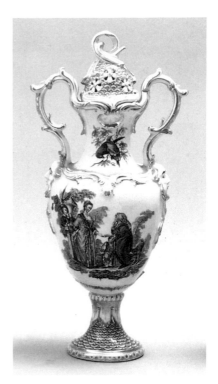

fig.8

1. Dacier et al. 1921-1929, 3:77, Camesasca and Sunderland 1968, Fr. ed., no. 83.

2. M. P. Eidelberg, "Watteau, Lancret, and the Fountains of Oppenort," *BM* 110, no. 785 (August 1968): 447-456.

3. M. Rambaud, AN, *Documents du Minutier Central concernant l'histoire de l'art 1700-1750* (Paris, 1964-1971), 2:907.

4. Sir Francis Watson, letter, 20 January 1968; Claus Virch, letter, 18 June 1972; A. Fried, "California Gets a New Art Treasure, in *California Living, San Francisco Sunday Examiner and Chronicle*, 21 April 1968, 22-23.

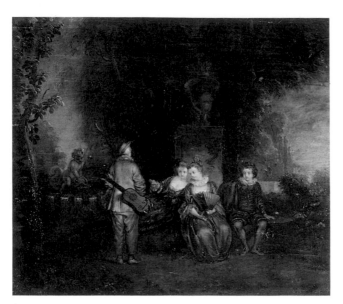
fig.1

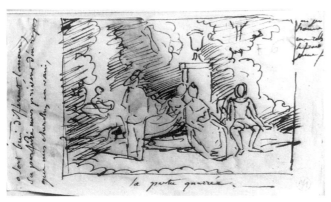
fig.2

The Foursome
La partie quarrée
Oil on canvas, 19½ × 24¾ in. (49.5 × 63 cm)
Mildred Anna Williams Collection. 1977.8 (CPLH)

Provenance The original owner is unknown; the painting may have been taken to England early in the eighteenth century; possibly "A Partie Quaré" in the sale of Dr. Robert Bragge, London, 17 March 1758, no. 77; acquired for 9 pounds by Roger Harenc (or Harene);[1] probably in the sale, "Cabinet d'amateur du midi de la France" (Bondon), Paris, 30 May-1 June 1839, no. 114 ("In a charming grove embellished with spouting fountains, Pierrot, his guitar on his back, and a sort of Crispin, talking with their sweethearts"); erroneously identified (as the text of the catalogue proves) with a painting in the Aubert de Trucy sale, Paris, 13 March 1846, no. 59 ("Conversation in a park. A Pierrot, a Harlequin, and a sort of Crispin talking with their sweethearts in a park, near a statue"); perhaps in the collection of Baron Llangattock, ca. 1907; (see Willoughby, "Lord Llangattock's Monmouth Seat, The Hendre and Its Art Treasures," *The Connoisseur*, March 1907, 155); 2d Baron Llangattock sale, London, Christie's, 28 November 1958, no. 79; [Galerie Cailleux, Paris, 1958-1977]; acquired by TFAMSF, 1977.

1. Dr. Bragge sold Watteaus several times in 1748-1749 and 1754-1755, and owned a version of *The Fortune Teller* (p. 319). Roger Harenc was a collector or dealer whose name is often found in eighteenth-century English sale catalogues.

References Dacier et al. 1921-1929, 3: under no. 169 (mentioning the two Paris sales in the nineteenth century); L. Réau, in Dimier 1928-1930, 1:42, no. 133 (the nineteenth-century sales); Adhémar 1950, no. 66 ("lost since 1846"); Cailleux 1962, i-v, pl. 1; Châtelet and Thuillier 1964, 262; Camesasca and Sunderland 1968, no. 82, repr.; *idem*, Ital. ed. 1968, no. 82, repr.; *idem*, Fr. ed. 1970, no. 82, repr.; Ferré 1972, A. 11; Boerlin-Brodbeck 1973, 194; Raines 1977, 58, 63, no. 77 and note 44; Jean-Richard 1978, mentioned under no. 148; Lee 1980, 218, fig.8 on 215; J. D. Morse, *Old Master Paintings in North America* (New York: Abbeville Press, 1980), 297, repr. on 299; Roland Michel 1982, no. 114, repr.; Posner 1984, 9-10, 20, 57, 69, 243, repr. in color; Roland Michel 1984 (*Watteau*), 35, 69, 115, 177, 211, 212, 215, pl. 10, fig.175; Roland Michel, "Watteau," *Paris Match*, 26 October 1984, 108, repr. in color on 108-109; Whittingham 1984, 342; W. Wilson, *California Museums* (New York: Abrams, 1985), 73, pl. 62 (color); Schwartz 1985, 108; Roland Michel 1985, 916; *Antoine Watteau: The Great Artists* (London: Marshall Cavendish Ltd., 1986), 3: part 61, repr. in color on 1934; Rosenberg 1987, 10, fig.10 on 106, pl. 30; B. Allen, exh. cat., 1987 London, fig.44 on 102.

Exhibitions 1962 London, no. 41, pl. 31; 1968 Paris, no. 35, repr.; 1970 Aix-en-Provence, no. 24; 1978-1979 Denver-New York-Minneapolis, no. 45; 1984-1985 Washington-Paris-Berlin, no. 14, repr. in color, fig.23 on 511, 535 (detail).

Variants
PAINTINGS
Pierrot and Three Other Figures in a Park, copy, **fig.1**
Oil on canvas, 25⅝ × 27⁹⁄₁₆ in. (65 × 70 cm)
Musée des Beaux-Arts, Nîmes. Inv. 223
REF: Mus. cat. 1940, 12, no. 223.

Copies, Same Direction as the Engraving

"Ecole de Nicolas Lancret"
Oil on canvas, 25 ⅝ × 32 ¼ in. (65 × 82 cm)
PROV: Sale, Comte de R . . . , Angers, 23-24 June 1976, no. 404, repr.

PROV: Sale, Brussels, November 1900, no. 33, fig.4 (photograph in the Witt Library, London).

PROV: Sale, Paris, Hôtel Drouot, salle 13, 3 February 1984, no. 19, with a copy of *Jealousy*.

"A foursome of Pierrot and Colombine, four subjects very entertaining which appear to have been commissioned for the decoration of a salon. Brought from Spain by Count de S . . ."
Oil on canvas (88 × 104 cm)
PROV: Sale, Dubois, Paris, 7-11 December 1840, no. 131.

"Attributed to Lancret"
REF: Wildenstein 1924, no. 183, repr.

DRAWING
J.-A.-D. Ingres, after the engraving of Moyreau, **fig.2**
Musée Ingres, Montauban. Inv. MI 867.4075

ENGRAVINGS
Jean Moyreau, after Watteau, *La partie quarrée*, **fig.3**
A print is held by AFGA, TFAMSF, 1983.1.33.
The name of the first owner is not included in the caption on the print, which states the painting from which it was engraved measured 51 × 64.8 cm.
REFS: Announced by Gersaint in the *Mercure de France*, June 1731, 2:5564; P.-J. Mariette, *Notes manuscrites* (Cab. des Est., Ya²4 pet. fol., 9:fol. 193,[53]). The copper plate was included in the Chereau sale catalogues of 1770 and 1778.

Boucher, after a lost drawing by Watteau for *Figures de différents caractères*, *Gilles en pied, une guitare en bandoulière dans le dos*, **fig.4**
REF: Jean-Richard 1978, no. 148, repr.
NOTE: There is a counter-proof after this print by Dubosc with the addition of landscape.

TAPESTRIES
Aubusson
9 ft. 8 ¼ in. × 8 ft. 3 ¼ in. (2.95 × 2.53 m)
PROV: Sale, Paris, Palais Galliera, 17 June 1970, no. 69.

Aubusson
REF: *Art et Curiosité*, September 1971, 18, repr.

Fragment
8 ft. 10 ⅜ in. × 6 ft. 3 ⅝ in. (2.7 × 1.92 m)
PROV: Sale, Italy, Casa d'Arte Michelangelo, Villa Rivara, 16-28 September 1980, no. 1146, repr. in color.

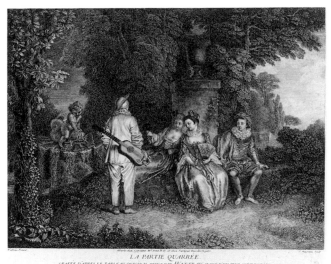

fig.3

fig.4

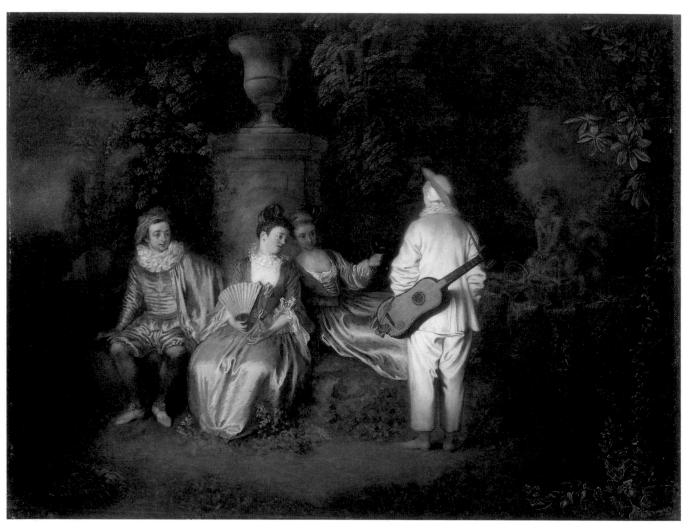

The Foursome

Related Works

DRAWINGS

Three sheets, **figs. 5, 6, 7**

Cab. des Dess., Musée du Louvre, Paris. Inv. 33368 (fig. 5), 33383 (fig. 6), 33384 (fig. 7)

REF: K. T. Parker and J. Mathey, *Watteau: Catalogue complet de son oeuvre dessiné*, 2 vols. (Paris: F. de Nobele, 1957), nos. 720, 729, 741.

NOTE: These studies could have been used for the head of the heroine in *La partie quarrée*.

Studies for the hand holding a fan and for the head and the hand holding a mask (of the second woman), **fig. 8**

REF: Parker and Mathey, cited above, no. 802.

fig. 6

fig. 5

fig. 7

fig. 8

A handwritten note by Pierre-Jean Mariette makes clear that Watteau was made an associate of the Royal Academy of Painting and Sculpture upon the presentation of his painting *Jealousy* (now lost).[1] This took place on 30 July 1712 when, according to the official minutes of the Academy, Antoine Watteau presented some of his works.[2] *Jealousy* has always been associated with three other paintings with a parallel theme, all preserved by engravings in the *Recueil Jullienne*: *Jealous Harlequin* (lost),[3] *Pierrot Content* (Thyssen-Bornemisza collection, Castagnola, Switzerland), and *The Foursome*. The latter is the largest of these four works, the most finished, and probably the latest. The earliest date it may have been painted is 1713, a probability reinforced by the style of the preparatory drawings. An X-ray shows that Watteau hesitated before deciding on the graceful carriage of the head of his heroine, for which there exist several sheets of drawings (**figs.** 5, 6, 7).

The composition of *The Foursome* is both simple and strictly controlled. Four characters converse in a park at twilight with the last rays of the sun giving the silks and satins of their costumes a brilliant sheen. Watteau is at his most dramatic in the figure of Pierrot, seen from behind, slightly off-center to the right, his face hidden as he turns toward Mezzetin and their two elegant companions. This figure in white foreshadows the celebrated *Pierrot* (formerly called *Gilles*) in the Musée du Louvre.

Scholars may not have sufficiently addressed what actually occurs in the painting or the exact meaning of the title of the engraving. If the title *La partie quarrée* did not originate with Watteau, it was surely assigned to the picture within ten years of his death. In the 1690 edition of the *Dictionnaire universel*, a *partie quarrée* or foursome is defined as "that which is composed of two men and two women for the purpose of a few promenades or meals only."[4] However, the innuendo of this expression has not changed since the eighteenth century. The Cupid astride a dolphin in the painting might refer to the impatience of love,[5] as it does in another Watteau composition, *The Delights of Summer*.[6] The mask is an emblem of love as commerce, and it might be concluded that Watteau's two couples are on an amorous adventure were it not for the way he painted them. The heroine, whom Watteau portrayed later in a similar attitude in *The Pleasures of the Ball* (The Dulwich Picture Gallery, London), seems to be encouraging Pierrot to play the guitar slung on his back. While they still wear theater costumes, the four have left the stage for the countryside, and behave like human beings rather than actors, with all the moods, passions, desires, and insecurities of humanity. In the end Watteau lets the viewer interpret the scene.

Another famous French painting that has invited a flood of interpretation once was also called *La partie quarrée*. This was the name Manet gave in a manuscript inventory of 1872 to *Luncheon on the Grass*.[7]

The ambiguity of its content, its delicate touch, and refined colors that recall the splendors of Venetian painting make this an exceptional work and one of the jewels in the Museums' collection.

1. P.-J. Mariette, "Notes manuscrites sur les peintres et graveurs," in vol. 9, fol. 193, MS, 1740-1770, BN; Dacier et al. 1921-1929, 3:127; Camesasca and Sunderland 1968, Fr. ed., no. 80.

2. *Procès-verbaux* 1875-1892, 4:150.

3. Dacier et al. 1921-1929, 3:77.

4. A. Furetière, *Dictionnaire universel*, 1690 ed., s.v. "partie quarrée."

5. A. P. de Mirimonde, "Statues et emblèmes dans l'oeuvre de Watteau," *La revue du Louvre et des musées de France*, no. 1 (1962):11-20.

6. Dacier et al. 1921-1929, 3:102; Camesasca and Sunderland 1968, Fr. ed., no. 110.

7. Exh. cat., *Manet* (Paris: Grand Palais; New York: The Metropolitan Museum of Art, 1983), 172 (provenance).

Unknown Artist *Eighteenth Century*

Portrait of a Miniaturist
(*formerly attributed to Fragonard*)
Portrait d'un miniaturiste
Oil on canvas, 18 × 14¾ in. (45.5 × 37.5 cm)
Gift of Mr. and Mrs. Louis A. Benoist. 1959.24 (CPLH)

Provenance Perhaps in the sale of Coll. de M. R.⁺⁺⁺, Paris, Hôtel Drouot, salle 8, 25 March 1875, no. 53 ("Portrait of a Painter"); Jean Dollfus, Paris, by 1885; Jean Dollfus sale, Paris, Galerie Georges Petit, 20-21 May 1912, no. 27 ("French School. Portrait of a Miniaturist"); [acquired for 26,000 francs by Wildenstein & Co., Inc., according to the annotated catalogue at the Bibliothèque Doucet]; Baron Maurice de Rothschild, Paris; Judge Elbert H. Gary, New York, before 1928; Elbert H. Gary sale, New York, American Art Association, Inc., 20 April 1928, no. 26, pl. 22 ("Fragonard. Selfportrait"); acquired for $52,000 by Charles Haydon, New York; J. W. Willard Haydon, brother of the preceding, Boston; Mrs. Daniel C. Jackling, San Francisco, ca. 1952; Mrs. Robert F. Gill, niece of Mrs. Jackling, San Francisco; acquired by the CPLH, 1959 (as Fragonard, *Self-Portrait*).

References Portalis 1889, 267; Alexandre 1904, 4, repr.; Réau 1956, 174; Howe 1959, 3, repr.; "Reflection of Youth," *Time*, 23 March 1959, 66, repr.; GBA, "La Chronique des Arts," May-June 1959, 6-7; Vaughan 1959, 66-67, repr.; *Handbook* 1960, 60, repr. in color; Wildenstein 1960, 307, no. 486, pl. III; GBA, "La Chronique des Arts," February 1961, 42, no. 125, repr.; Colombier 1962, 67, repr.; W. Davenport et al., *Art Treasures of the West* (Menlo Park: Lane, 1966), 160, repr.; E. Christensen, *A Guide to Art Museums in the United States* (New York: Dodd, Mead, 1968), no. 467, repr.; *American Heritage Dictionary*, 1982 ed., s.v. "Fragonard," repr.; Hess and Ashbery 1971, 87, repr.; Wildenstein and Mandel 1972, 108, no. 515, repr.; Bordeaux 1977, 39, repr.; Neugass 1978, 580, repr.; N. Hale, "The Solid Comfort of French Paintings," *Art World*, 16 March-16 April 1979, 13, repr.; J. Russell, "A Fragonard Festival at the Frick," *New York Times Magazine*, 15 April 1979, 31, repr.; Frankenstein 1979-1980, 108, repr.; Lee 1980, 219, fig.12 on 216; J. D. Morse, *Old Master Paintings in North America* (New York: Abbeville Press, 1980), 128, repr.; M. Morris, *European Paintings of the Eighteenth Century* (London: Frederick Warne, 1981), 22; "A Look into the Artist's Studio," *Westart*, 12 February 1982, 14; "The Studio of the Artist," *Bay Area Antiques*, December 1981, 5; W. Wilson, *California Museums* (New York: Abrams, 1985), 76, pl. 66 in color (as Fragonard); P. Rosenberg, exh. cat., 1987-1988 Paris-New York, mentioned under no. 287.

Exhibitions 1885 Paris, no. 190; 1916 Paris; 1963 Cleveland, no. 59, repr.; 1965 Indianapolis, no. 6, repr.; 1977 New York, no. 41, fig.47; 1978-1979 Denver-New York-Minneapolis, no. 17; 1980 Japan, no. 80, repr.; San Francisco, CPLH, *The Studio of the Artist*, 2 December 1981-27 February 1982, no cat.

The traditional attribution of this painting to Fragonard has been challenged over the years and should be reconsidered. Pierre Rosenberg, Jacques Thuillier,[1] and Jean Cailleux[2] have all expressed doubts as to the artist, and Jean Massengale[3] and Eunice Williams[4] have also questioned the identity of the sitter. Jean-Pierre Cuzin in a recent article judiciously noted that because the painter from Grasse had been

forgotten, then celebrated again, it has been only too easy, after long neglect, mingled with the profits of commerce, and the authority of the printed word, to attribute to Fragonard any painting with rapid brushwork....[5]

In this article Cuzin suggests that several works attributed to Fragonard's maturity are in fact works by the young François-André Vincent, executed about the time of his sojourn at the French Academy in Rome (1771-1775). These include the famous oval portrait from the Musée Fragonard, Grasse, formerly considered a *Self-Portrait* of Fragonard, which Cuzin considers a *Self-Portrait* by Vincent dating from 1769-1770.[6] In addition there are striking stylistic similarities between the San Francisco portrait and *Bust of a Man Reading* (fig.1), often identified as a portrait of Hubert Robert. Both works possess the same powerful impasto and the same roughness in the treatment of the face and the hands. While Cuzin believed for a time that both portraits were by Vincent, the question remains open, and the artist of the San Francisco painting, unfortunately, remains unknown.

fig.1 Attributed to Fragonard, *Bust of a Man Reading*, oil on canvas, 16¾ × 13⅜ in. (42.5 × 34 cm), Siftung Sammlung E. G. Bührle, Zurich.

Portrait of a Miniaturist

Is San Francisco's canvas truly a portrait of Fragonard ca. 1770-1775, as has been the tradition for the past fifty years? We know that Fragonard worked occasionally in miniature, but how can a man whose head is bowed, his features distorted by perspective, be identified with certainty? In addition to three charcoal self-portraits formerly in the Huot-Fragonard collection (now Musée du Louvre, Paris) only a few certain images of Fragonard by other artists exist.[7] None of these shows any real similarity to the sitter in the San Francisco picture. The hair is different, the face is squarer, the eyebrows are thicker, the eyesockets are deeper, and the bridge of the nose is not straight and narrow like the one seen in the Museums' painting.

It has been proposed that this might be a portrait of François Boucher.[8] However, comparison with his portrait by Roslin, engraved in 1761 by Carmona for his reception piece at the Royal Academy of Painting and Sculpture, does not allow this identification. Boucher had a strong and fleshy nose, hollow cheeks, and a round chin. His face, already worn by that date, is very different from the Museums' sitter.

Certainly, this is the portrait of a miniaturist. Here is an artist bent studiously over his work, drawing (perhaps on vellum) with a very thin brush and preparing his colors on a small palette. Eunice Williams hypothesized that these are the features of the Swedish artist P.-A. Hall,[9] who arrived in Paris in 1766 and in 1769 bore the title of Painter of the Children of France. His *Self-Portrait* (ca. 1780, private collection, Stockholm) displays some physical similarity to our sitter,[10] but is not conclusive. The possibility of other miniaturists of the later eighteenth century, such as van Blarenberghe, who was in Paris in the 1750s and was introduced at court, or Naudin, a member of the Academy of Saint Luke, cannot be considered at this time because of insufficient historic and iconographic evidence.[11]

This canvas is distinguished by its great pictorial qualities. It reappeared only in 1875 in an anonymous sale, and was not owned by Eduardo de Los Reyes, as suggested by Georges Wildenstein, who was unaware that only half of the catalogue of the 25 March 1875 sale was devoted to Reyes's collection.[12] The artist is bold in his use of color. Against a warm brown tonality, the bright red of the sitter's dressing gown is contrasted to the strong green of his collar, cuffs, and the drapery in the foreground. The white highlights of the powdered wig and the sealed letter lying on the table, the brilliance of the flesh tones where the same juxtaposition of red, green, and white is brightly lit from the right, and the modeling of the figure accentuate the depth of the composition and introduce a human element. The surprising accents of carmine in the face and the tirelessly energetic brushstrokes announce the powerful, rapid handwriting of an extraordinarily innovative artist who it is hoped will be identified some day.

1. Conversation with M. C. Stewart, May 1977.
2. Conversation with M. C. Stewart, May 1977.
3. Letter, 13 January 1984.
4. Letters, 16 February and 24 August 1984.
5. J.-P. Cuzin, "De Fragonard à Vincent," BSHAF 1981, 1983: 103-124.
6. Cuzin, "Fragonard," 104, repr.
7. See P. Rosenberg, exh. cat., 1987-1988 Paris-New York, nos. 287, 288, 289, 290, repr.
8. Jean Massengale, conversation with M. C. Stewart, July 1980.
9. Letter, 16 February 1984.
10. Karl Asplund and P. A. Hall, *Sa correspondance de famille* (Stockholm: Nationalmuseum, 1955), no. 2, repr.
11. Pierre Lespinasse, *La miniature en France au XVIIIᵉ siècle* (Paris: Van Oest, 1929), 109-113.
12. Wildenstein 1960, 307, no. 486.

Presentation of a Young Girl to the Empress Josephine

Unknown Artist *Early 19th Century*

Presentation of a Young Girl to the Empress Josephine

La Présentation d'une fillette à l'Impératrice Joséphine
Oil on canvas, 64½ × 84½ in. (163.5 × 214.5 cm)
Gift of the M. H. de Young Endowment Fund. 55196
(de Young)

Provenance Gordon W. Batchelor (letter, 8 December 1983) confirms that this painting was part of the interior decoration of Bedgebury Park near Goudhurst, Kent, England, from the middle of the nineteenth century. Therefore the following provenance prior to 1919 is proposed: Viscount William Carr Beresford (1768-1854), Bedgebury Park, Kent, 1836-1854; Alexander James Beresford-Hope (1820-1887), Bedgebury Park, Kent, 1854-1887; Isaac Lewis, Bedgebury Park, Kent, 1899-1919; Bedgebury sale, 12-19 May 1919, no. 64, repr. (attributed to Gérard); acquired for 367 pounds 10 by "Harper"; [Siegfried Aram, New York]; acquired for the de Young, 1938 (as Baron A.-J. Gros, but subsequently re-attributed to H.-F. Riesener).

This work was purchased as *The Empress Josephine at Malmaison*, but despite careful research the story of this curious painting remains unknown. The woman seated in the armchair is presumably the empress Josephine (1763-1814), identified particularly by comparison with a portrait miniature by Isabey (**fig.1**). The woman standing at the far right presumably is her daughter, Hortense de Beauharnais (1783-1837), wife of Louis-Napoleon Bonaparte, king of Holland, specifically identified from a marble bust of Queen Hortense by Bosio (**fig.2**). However, there is no basis for assuming the setting is a room at Malmaison.[1] The frieze-like composition, the costumes, the furnishings, and the cold, purely neoclassical facture date the execution of this painting no later than 1815.

The other three persons behind Josephine undoubtedly are members of her retinue, two ladies-in-waiting and a chamberlain. The young women might be identified as Mme de Rémusat, although she was rarely present at court at that time, Mme Ségur de Colbert, Mlle de Mackau (frequently present), Mme Gazani, or guests such as Mlle Louise de Castellane, and Mme and Mlle Ducrest. The young man in court dress cannot be Eugène de Beauharnais, viceroy of Italy, as undoubtedly he would be portrayed wearing his decorations. Possibly he is Comte Lancelot Théodore Turpin de Crissé or even Baron Louis-Désiré de Montholon. However, no certain portraits of these personages permit verification.

This painting probably represents a *présentation* similar to the one described by Valérie Mazuyer (1797-1878), the goddaughter of Dame Josephine-Rose Tascher Delapagerie (at that time still the wife of General Bonaparte), who met her godmother on 6 January 1810 at Malmaison. Unfortunately, this date as well as the circumstances of the meeting[2] do not correspond to this composition.

The attribution of the work is a problem. The skillful execution of the figures and the costumes contrasts with faults in perspective (the table and the fireplace), and with the naive quality of the bouquet at left, which X-rays prove was not a later addition. An artist of the first rank might have resorted to help for the decorative elements, but he never would have accepted such weaknesses in execution.

The painting was probably executed by a minor artist –perhaps not French–or by an *amateur* in commemoration of the event depicted. A souvenir more than a work of art, its value would have been primarily to the family being honored here.[3]

1. Gérard Hubert, letters, 2 February and 31 March 1977.
2. A. Leflaive, *Sous le signe des abeilles, Valérie Mazuyer, dame d'honneur de la reine Hortense* (Paris, 1943), 39-42.
3. Hal Opperman, conversation with M. C. Stewart, 12 November 1986.

fig.1 J. B. Isabey, *Empress Josephine*, crayon and watercolor, 9⅞ × 7⅞ in. (25 × 20 cm), Musées d'Angers.

fig.2 François-Joseph Bosio, *Queen Hortense*, 1810, marble bust, 22⅞ × 16¹⁵⁄₁₆ in. (58 × 43 cm), Musée National du Château de Malmaison. Gift of Mariano de Unzue, 1929.

Pastoral Landscape

Unknown Artist *Ca. 1800*

Pastoral Landscape
Paysage pastorale
Oil on canvas, 50½ × 76½ in. (128 × 194 cm)
Mildred Anna Williams Collection. 1977.7

Provenance Dr. Joachim Carvallo, Château de Villandry (Indre-et-Loire), ca. 1920-1936; inherited on the death of his wife by his daughter, Mme C. de Bodman, November 1940, but remained at Villandry; sale, Tours, Hôtel des Ventes, 19 November 1953, no. 71; Le Peletier, Paris, 1954; Walter P. Chrysler, Jr., New York, 1956; [M. Knoedler & Co., Inc., New York, April 1972]; acquired by the CPLH, 1977 (as Louis-Gabriel Moreau).

Reference GBA, "Chronique des Arts," March 1978, no. 224, repr.

Exhibitions 1956-1957 United States, no. 68, repr.; 1963 New York, no. 35; 1966 New York, no. 11, repr.; 1972 South Bend, no. 64, repr.; 1978-1979 Denver-New York-Minneapolis, no. 31.

This superb painting is also a supremely difficult one to attribute to a specific artist. Traditionally considered the work of Louis-Gabriel Moreau, called Moreau the Elder, the painting bears some similarities to his *View of the Château de Vincennes* and *The Hills of Bellevue* (both Musée du Louvre, Paris). However, Moreau's vision is less grandiose than the artist of the present picture, and his manner is generally more in the tradition of eighteenth-century painting. While no known work by Moreau is in such large format, Eric Turquin remains convinced that this painting is consistent with Moreau's style.[1]

The possibility of Claude-Joseph Vernet as the artist has been explored and received some support. Philip Conisbee, who knows the painting only from a photograph, finds it very similar in style to *A View of the Waterfalls at Tivoli* (fig.1), and suggests that it might be an early work by this artist, perhaps from the late 1730s.[2]

Another possible artist is J.-J. Bidauld, who lived in Italy for five years, and is celebrated for his historical landscapes—vast panoramas with picturesque elements that were popular well into the nineteenth century. Occasionally he asked other artists, such as Vernet, to paint his figures. The San Francisco landscape can be compared in particular with *Roman Landscape* (1788, Kunstmuseum, Basel) in terms of composition, architectural elements, and figural treatment.[3]

Pierre Rosenberg does not believe the painting is by any of the above artists, but by an unknown French artist, ca. 1800, or even later, and suggests the site is real, not imaginary. He questions whether the landscape is French, perhaps Jura or Doubs, or if the mountain scenery more nearly resembles Switzerland, Italy, Bavaria, or the Tyrol. While the monastery, with its pitched roof

and unusual bell tower (fig.2), is reminiscent of the border region around northern Italy, it should be noted that Moreau never traveled outside France, although both Vernet and Bidauld did.

Whatever the case, this painting is of exceptional quality. The balance of the composition is stunning. The artist opposes a foreground area of shadow against the brilliantly lighted cliffs on the left, the two zones sharply divided by a diagonal in space. No less remarkable is the delicate execution, the subtle range of colors and values, and the light, transparent handling of the sky. It is to be hoped that some day an artist can be assigned to this important work.

1. Letter from T. D. Llewellyn, 4 November 1986.
2. Letter, 6 November 1986.
3. See exh. cat., 1974-1975 Paris-Detroit-New York, no. 4, pl. 84.

fig.1 Claude-Joseph Vernet, *A View of the Waterfalls at Tivoli*, oil on canvas, 47½ × 67 in. (121 × 170 cm), Cleveland Museum of Art, 84.175.

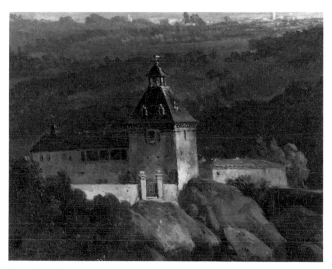

fig.2 (detail)

Reserve

Portrait of a Child (*style of Louis-Léopold Boilly*)

Portrait d'enfant
Oil on canvas, 18 × 14¾ in. (45.5 × 37.5 cm)
Mildred Anna Williams Collection. 1941.23 (CPLH)

Provenance George Lutz, Paris, by 1893 (?); Lutz sale, Paris, Galerie
Georges Petit, 26-27 May 1902, no. 16 ("Portrait of the son of the
painter"); Mme J. Brasseur, Lille; Brasseur sale, Paris, Hôtel Drouot,
13 March 1920, no. 11, repr. ("Presumed portrait of a son of the art-
ist"); C. Picard, Paris; [Jacques Seligmann, Paris, 1922]; Mrs. Henry
Walters, Baltimore; Walters sale, New York, Parke-Bernet, 30 April
1941, no. 976; gift of H. K. S. Williams to the CPLH, 1941.
References Harrisse 1898, no. 665 ("Portrait of a little boy"); Mar-
mottan 1913, 231; *Illustrated Handbook* 1942, 47, repr.; *idem*, 1944,
51, repr.; *idem*, 1946, 56, repr.; *Handbook* 1960, 65, repr.; W. Daven-
port et al., *Art Treasures in the West* (Menlo Park: Lane, 1966), 156.
Exhibitions 1893 Paris, no. 102; 1900 Paris; 1950 Detroit, no. 12;
1961 Los Angeles, 31, repr.; 1966 Milwaukee, no. 14, repr.; San Fran-
cisco, de Young, *16 Paintings in Search of an Artist*, 28 August-14
November 1982, no cat.

*Previously attributed to Boilly, this portrait was presumed to be of his
son, Edouard, a musician (1799-1854). Comparison with the Louvre
portrait (**fig.1**) suggests that this is not the same child.*

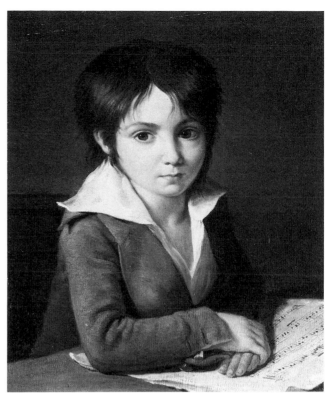

Portrait of a Child

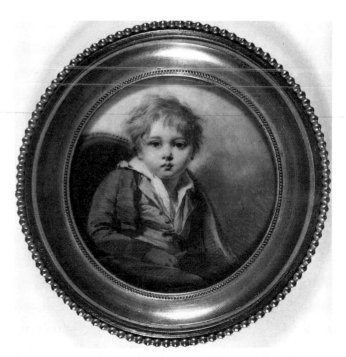

fig.1 Louis-Léopold Boilly, *Edouard Boilly*, grisaille on porcelain, oval,
2¾ × 2½ in. (7 × 6.5 cm), Musée du Louvre, Paris, Inv. R.C. 30.666.

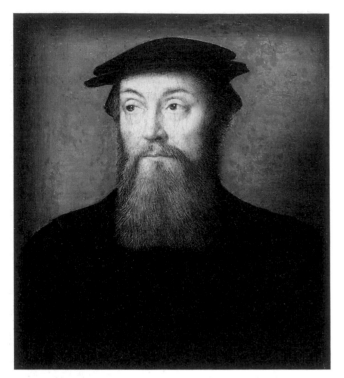

Portrait of a Man

Portrait of a Man (*style of Corneille de Lyon*)

Portrait d'un homme
Oil on oak panel, 7 ⅛ × 6 in. (18 × 15 cm)
Mr. and Mrs. E. John Magnin Gift. 75.18.5 (de Young)

Provenance [F. Kleinberger Galleries, Inc., New York]; Mr. and Mrs. E. John Magnin, New York, 1928; gift to TFAMSF, 1975.
This portrait has been completely repainted and is impossible to attribute to Corneille or his workshop.

Head of a Young Boy (*style of Jean-Baptiste Greuze*)

Tête d'un garçon
Oil on canvas, 16 ½ × 13 in. (42 × 33 cm)
Gift of Mr. and Mrs. William M. Greve. 1957.138 (CPLH)

Provenance Felix Wildenstein, New York; Wildenstein sale, New York, Parke-Bernet, 7-8 November 1952, no. 268, repr.; acquired by Mr. and Mrs. William M. Greve; gift to the CPLH, 1957.

Variants

PAINTINGS

Style of Greuze, *Portrait of a Child Dressed in Pink*
Oil on canvas, 15 ¾ × 12 ¾ in. (40 × 32 cm)
Present location unknown
PROV: Formerly in Hermitage, Leningrad; sale of art treasures from the Castles of Leningrad, Berlin, Lepke Galleries, 6-7 November 1928, no. 384, pl. 107a; Mrs. Ralph K. Robertson, New York; Robertson sale, Parke-Bernet, 21-22 January 1944, no. 346, repr.; [acquired by N. Acquavella, New York].
REFS: Hermitage, mus. cat. 1839, no. 183; Mauclair [1906], no. 981; Hermitage, mus. cat. 1920, no. 47.

Style of Greuze, *Portrait of a Little Boy*
Oil on canvas, 16 × 13 in. (39.5 × 31.5 cm)
Present location unknown
PROV: Van Diemen sale, Berlin, 1930; [Parish-Watson & Co., New York]; Mrs. A. N. Benedict, New York; Benedict sale, New York, Parke-Bernet, 14 March 1951, no. 46, repr.; [Newhouse Galleries, Inc., New York]; Mr. and Mrs. Kay Kimbell, Fort Worth, Texas; Kimbell sale, New York, Sotheby's, 9 June 1983, no. 50, repr.
None of these three versions, showing only slight variations in details such as hair style and clothing, could have been executed by Greuze. All reveal the same heavy handling of fabrics and awkwardness in the rendering of hands and treatment of face, indicating that the author was undoubtedly one of Greuze's imitators. These works belong to a very familiar type whose sentimental character was designed to appeal to a specific clientele. Their primary advantage is that they testify to the success of a genre and an artist.

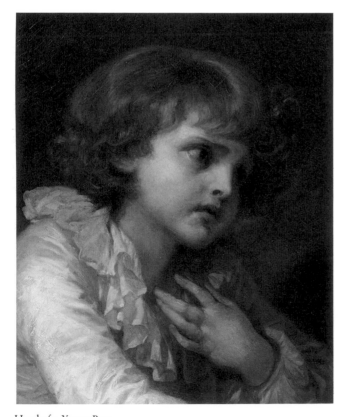

Head of a Young Boy

Portrait of Louis XV (*school of Jean-Gaspard Heilmann*)

Portrait de Louis XV
Oil on canvas, 21¾ × 18 in. (55 × 45.5 cm)
Gift of André J. Kahn-Wolf. 1965.35 (CPLH)

Reference Howe 1958, repr.
This is one of the hundreds of portraits of Louis XV (1710-1774) executed during the eighteenth century after major prototypes by L.-M. Vanloo (1762, Musée de Versailles) and M.-Q. de La Tour (1748, Cab. des Dess., Musée du Louvre, Paris).

Portrait of Louis XV

Harbor Scene (*style of Georges Michel*)

Scène du port
Oil on oak panel, 16⅜ × 21¾ in. (41.5 × 55.5 cm)
Jacob Stern Family Loan Collection. 1928.32 (CPLH)

References Quinton and Quinton 1928, no. 11; *Illustrated Handbook* 1942, 46, repr.; *idem*, 1944, 50, repr.
This is probably a pastiche in the style of Michel, who himself copied the Dutch masters.

Harbor Scene

Country Party

Country Party (*style of Jean-Baptiste-Joseph Pater*)

Fête champêtre
Oil on oak panel, 6 × 8 in. (15.5 × 20.5 cm)
Jacob Stern Family Loan Collection. 1928.31 (CPLH)

References Quinton and Quinton 1928, no. 10; *Illustrated Handbook* 1942, 46, repr.; *idem*, 1944, 50, repr.; *idem*, 1946, 54, repr.; *Handbook* 1960, 54, repr.
Exhibitions 1934 San Francisco, no. 44; Richmond, Virginia Museum of Fine Arts, *Les fêtes galantes*, 20 January–5 March 1956, no cat.; 1961 Los Angeles, 12, repr.
The painting is badly damaged and is probably a pastiche in the style of Pater from the nineteenth century.

Musicians in an Archway

Musicians in an Archway (*style of Hubert Robert*)

Musiciens sous une arche
Oil on canvas, 30 × 25 in. (76 × 63.5 cm)
Bequest of Grace Hamilton Kelham. 1978.3.2 (CPLH)

Provenance Grace Spreckels Hamilton, ca. 1920; Grace Hamilton Kelham, 1936; gift to the CPLH, 1978.
Exhibition 1958 Los Angeles–San Francisco, no. 21, repr.
This is not convincing as a painting by Robert.

The Triumph of Love (*style of Piat Joseph Sauvage*)

Le triomphe de l'Amour
Oil on canvas, 11⅜ × 27 in. (30.3 × 68.6 cm)
Museum purchase, Benoist Fund. 1961.9 (CPLH)

Provenance [F. Kleinberger & Co., New York]; acquired by the
CPLH, 1961 (as J.-B.-S. Chardin).
*This canvas was attributed erroneously to Chardin when acquired by
the Museums. It appears to be a copy after or a pastiche in the style of
Sauvage.*

The Triumph of Love

Flowers (*unknown artist, French, 17th century?*)

Fleurs
Oil on canvas, 19 × 14¼ in. (48 × 36 cm)
Gift of Edward W. Carter. 1958.97 (CPLH)

*Given to the Museums as a work by Jean-Baptiste Belin de Fontenay,
this painting's attribution cannot be supported.*

Flowers

Portrait of a Boy

Portrait of a Boy (*unknown artist, French, 18th century?*)

Portrait d'un garçon
Oil on canvas, 18 ¼ × 15 ¼ in. (46.5 × 38.5 cm)
Museum purchase, M. H. de Young Art Trust Fund. 50.35.4 (de Young)

Provenance [Alex Popoff & Cie, Paris]; [Thos. Agnew & Sons, Ltd., London, July 1929]; [Mrs. Isabella Barclay, New York, September 1929]; Mrs. Gordon Dexter, Massachusetts and New York; [French & Company, New York]; acquired by the de Young, 1950 (as Michel-Nicolas-Bernard Lépicié).
References *International Studio*, March 1930, 1, repr. in color on cover; *Art Digest*, July 1953, 28.
Acquired as a portrait by Lépicié as pendant to Portrait of a Little Boy *(p. 222), this attribution is not convincing.*

Italian Landscape

Italian Landscape (*school of Pierre-Henri de Valenciennes*)

Paysage italien
Oil on canvas, 16 ½ × 22 in. (42 × 56 cm)
Gift of Patrick Matthiesen. 1985.101

Provenance [Matthiesen Fine Art Limited, London]; gift to TFAMSF (as Louis Gauffier).
Although attributed to Louis Gauffier when acquired by the Museums, the artist of this small neoclassical landscape remains unidentified. Pierre Rosenberg and Geneviève Lacambre have discussed the possibility of Valenciennes, with whose work this canvas shares many stylistic affinities. In the absence of any documentation to support this attribution, however, we can assume only that the artist may have been a student or follower of Valenciennes.

Duke Ferdinand Maria Innozenz von Bayern

Duke Ferdinand Maria Innozenz von Bayern
(*copy after Joseph Vivien*)

Portrait du Duc Ferdinand Maria Innozenz von Bayern
Oil on canvas, 78 × 40 ⅛ in. (121.5 × 62 cm)
Gift of the M. H. de Young Endowment Fund. 45.20.1 (de Young)

Provenance Acquired from Mrs. Amely Richter, New York, 1945.
Reference *European Works* 1966, 186, repr. (Wespien Room).

Related Works

PAINTINGS

Elector Karl Albert of Bavaria (1697-1745), **fig.1**
Oil on canvas, 78 ⅜ × 50 ⁷⁄₁₆ in. (199 × 128 cm)
PROV: Former collection Kurt Rote, Breslau, 1935 (according to Dr.
Johann Georg von Hohenzollern, letter, 19 May 1982).
NOTE: The pose and costume are identical to the San Francisco version, but the face is of another man.

Duke Ferdinand Maria Innozenz von Bayern (1699-1734), **fig.2**
Oil on canvas, 52 × 39 in. (132 × 99 cm)
Hessisches Landesmuseum, Darmstadt. GK 152
NOTE: This appears more likely to be our sitter.
The identity of the sitter is unresolved. The portrait was acquired as
Count Preysing. *Dr. Barbara Grotkamp (letter, 5 September 1978)*
says this is not Preysing's portrait (see exh. cat., Kurfurst Max Ema-
nuel, Bayern und Europa um 1700, [Munich, 1976], 593, 594). Dr.
Peter Volk (letters, 23 September 1982 and 20 October 1982) believes
the gentleman is Ferdinand Maria Innozenz von Bayern, as does Dr.
Loring Seelig (letter, 5 May 1985). The artist Franz Joseph Winter,
who often copied Vivien, has been suggested as a possible attribution.

fig.1

fig.2

Paintings Formerly Considered French

Dutch
Gerrit Cornelisz. van Haarlem
Formerly attributed to François Clouet, and then to unknown artist,
Franco-Flemish school, late 16th century
Portrait of a Danish Nobleman
(formerly called *Portrait of Cosme Pascarengis*)
Oil on white oak panel, cradled, 14¼ × 10¾ in. (38 × 27.5 cm)
Gift of Osgood Hooker. 1964.13

English (?)
Unknown artist
Formerly attributed to Henri-Pierre Danloux
Man in a Brown Coat
Oil on canvas, 29⅜ × 23¾ in. (74.5 × 60.5 cm)
Gift of Grover Magnin. 1956.87

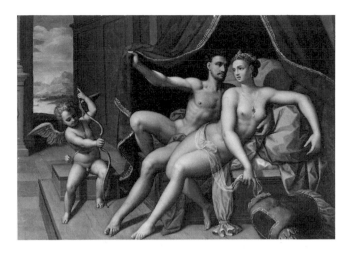

Flemish
Unknown artist
Formerly School of Fontainebleau
Venus and Mars
Oil on panel, 30½ × 42½ in. (77.5 × 107.5 cm)
Mildred Anna Williams Collection. 1962.11

Flemish
Attributed to Jan Baptiste Lambrechts
Formerly attributed to an unknown artist, 18th century
Tavern Scene with Five Boors
Oil on canvas, 14½ × 11⅞ in. (37 × 30 cm)
Catherine D. Wentworth Collection. 1949.26

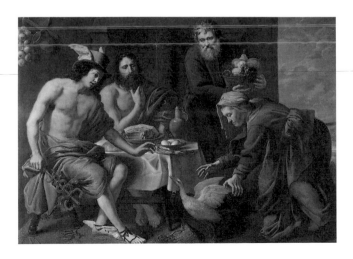

Flemish
Jacob van Oost
Formerly attributed to Mathieu Le Nain
Mercury and Jupiter in the House of Philemon and Baucis
Oil on canvas, 65⅜ × 92¼ in. (166 × 234 cm)
Gift of Dr. Rudolf J. Heinemann. 46.14

Flemish
Unknown master
Formerly attributed to a southern French artist, ca. 1505, and/or to
Juan de Flandes
Christ Carrying the Cross
Oil on panel, 18½ × 19½ in. (47 × 49.5 cm)
Gift of Mr. and Mrs. George T. Cameron. 47.8

 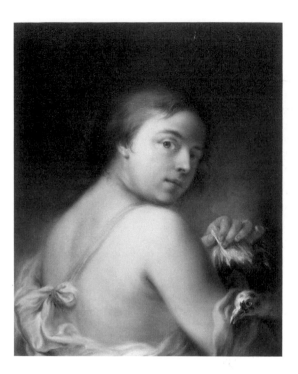

Hungarian
Attributed to Adam de Manyoki
Formerly attributed to Robert Levrac, called Tournières
Countess Wiatinska
Oil on canvas, 30 × 24¼ in. (76 × 61 cm)
Gift of André J. Kahn-Wolf. 1966.64

Italian
Unknown artist
Formerly attributed to Jeanne-Philiberte Ledoux
Portrait of a Young Lady
Oil on canvas, 21¾ × 17¾ in. (55 × 45 cm)
Gift of Mr. and Mrs. Alfred Romney. 61.46

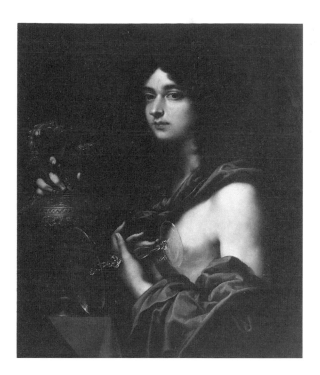

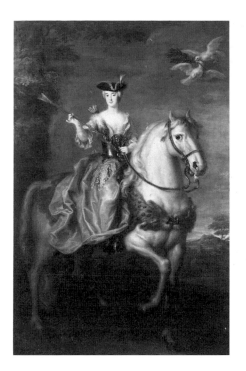

Italian
Copy after Baldassare Franceschini, called Il Volterrano
Formerly attributed to Pierre Mignard
Ganymede
Oil on canvas, 28 ½ × 23 ½ in. (72.5 × 59.5 cm)
Museum purchase, Sidney M. and Florence H. Ehrman and
T. B. Walker Funds. 1962.14

Italian
Unknown artist
Formerly attributed to Carle Vanloo
Lady on Horseback
Oil on canvas, 117 × 77 ½ in. (297 × 197 cm)
Gift of Arthur M. Huntington. 1927.201

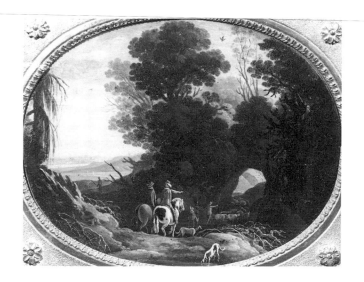

Italian (?)
Unknown artist
Formerly attributed to Simon Mathurin Lantarat, called Lantara
Landscape
Oil on copper (oval), 7 ⅜ × 9 ½ in. (18.5 × 24 cm)
Gift of André J. Kahn-Wolf. 1964.117

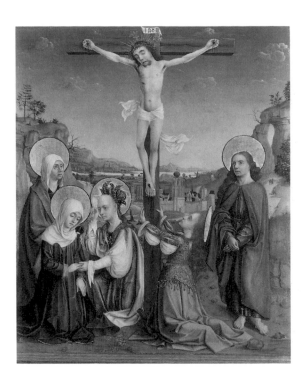

Northern
Unknown artist (fake or pastiche?)
Formerly attributed to unknown French artist
Christ on the Cross
Oil on panel transferred to composition board and cradled,
27½ × 22¾ in. (70 × 58 cm)
Mildred Anna Williams Collection. 1961.21

Spanish
Unknown artist
Formerly attributed to Michel-Ange Houasse
Infante of Spain
Oil on canvas, 40¾ × 27½ in. (103.5 × 70 cm)
Gift of Mrs. Herbert Fleishhacker. 49.9

Spanish
Unknown artist, active in Aragon, early 15th century
Formerly attributed to unknown French artist, early 15th century
Christ Appears to Mary Magdalene
Mixed media on panel transferred to masonite, 40½ × 19½ in.
(103 × 50 cm)
Gift of the Samuel H. Kress Foundation. 61.44.28

Spanish
Unknown artist, active in Aragon, early 15th century
Formerly attributed to unknown French artist, early 15th century
Resurrection of Christ
Mixed media on panel, transferred to masonite, 40½ × 19½ in.
(103 × 50 cm)
Gift of the Samuel H. Kress Foundation. 61.44.27

Exhibitions

1860 Paris, Galerie Martinet, *Tableaux de l'école française, principalement du XVIII^e siècle, tirés de collections d'amateurs: Deuxième exposition au bénéfice de la Caisse de secours des artistes-peintres.*

1874 Paris, Hôtel de Lassay, *Explication des ouvrages de peinture exposés au profit de la colonisation de l'Algérie par les Alsaciens-Lorrains: Société de protection des Alsaciens et Lorrains demeurés français,* 22 June.

1874 Paris, Ecole des Beaux-Arts, *Exposition Prud'hon,* May.

1885 Paris, Musée du Louvre, Salle des Etats, *Exposition de tableaux, statues et objets d'art au profit de l'oeuvre des orphelins d'Alsace-Lorraine.*

1888 Paris, Hôtel de Chimay, nouvelle annexe de l'Ecole Nationale des Beaux-Arts, *Exposition de l'art français sous Louis XIV et sous Louis XV au profit de l'oeuvre de l'hospitalité de nuit.*

1893 Paris, *Exposition des portraits du siècle.*

1900 Paris, *Exposition universelle de 1900: L'art français d'origines à la fin du XIX^e siècle.*

1902 London, Art Gallery of the Corporation of London (Guildhall), *Exhibition of a Selection of Works by French and English Painters of the Eighteenth Century.*

1902 London, The Royal Academy of Arts, *Works by Old Masters,* Winter.

1904 Paris, Palais du Louvre and Bibliothèque Nationale, *Exposition des primitifs français,* April-July.

1907 Paris, Galerie Georges Petit, *Exposition Chardin et Fragonard,* June-July.

1910 Berlin, Académie Royale des Arts, *Exposition d'oeuvres de l'art français au XVIII^ème siècle.*

1910 London, Burlington Fine Arts Club, *Catalogue of a Collection of Pictures Including Examples of the Works of the Brothers Le Nain and Other Works of Art.*

1912 St. Petersburg, Institut Français, *Exposition centennale de l'art français, 1812-1912.*

1913 Paris, Palais des Beaux-Arts (Petit Palais), *David et ses élèves,* 7 April-9 June.

1913 Paris, Galerie Philipon, *Exposition de tableaux anciens principalement de l'école française du XVIII^e siècle de la Galerie Wildenstein,* 18 June-1 July.

1916 Paris, Wildenstein & Co., Inc., *Fragonard peignant une miniature: Portrait de l'artiste par lui-même.*

1920 The San Francisco Museum of Art, *Loan Exhibition of Paintings by Old Masters.*

1922 Paris, Petit Palais, *Exposition Prud'hon,* May-June.

1923 New York, Wildenstein & Co., Inc., *Portraits of the French 18th Century,* April.

1923 Paris, Galerie Louis Sambon, *Exposition Le Nain: Louis Le Nain (1593-1648), Mathieu Le Nain (1607-1677), au profit de l'oeuvre de la préservation contre la tuberculose à Reims,* 15-30 January.

1923 City Art Museum of St. Louis, *French Art of the XVIII Century,* January.

1924 London, Thomas Agnew & Sons, Ltd., *Pictures by Old Masters.*

1928 Paris, Petit Palais, *Exposition N. de Largillierre,* May-June.

1929 Paris, Galerie Pigalle, *Exposition des oeuvres de J.B.S. Chardin (1699-1779) au bénéfice de la Maison de Santé des gardiens de la paix.*

1931 Cambridge, Massachusetts, Fogg Art Museum, *Loan Exhibition of Eighteenth Century French Art,* 16 February-9 March.

1931 New York, The Union League Club, *Eighteenth Century French Paintings,* 9-15 April.

1933 Paris, Musée de l'Orangerie, *Exposition Hubert Robert à l'occasion du deuxième centenaire de sa naissance.*

1934 San Francisco, CPLH, *French Painting from the Fifteenth Century to the Present Day,* 8 June-8 July.

1935-1936 New York, The Metropolitan Museum of Art, *French Painting and Sculpture of the XVIII Century,* 6 November 1935-5 January 1936.

1936 New York, M. Knoedler & Co., Inc., *Loan Exhibition of Paintings by Georges de La Tour and The Brothers Le Nain,* 23 November-12 December.

1937 Los Angeles Art Association, *International Art Show,* 11 October-15 December.

1937 New York, Wildenstein & Co., Inc., *David-Weill Pictures,* 10 November-31 December.

1939 San Francisco, Golden Gate International Exposition, *Masterworks of Five Centuries,* 18 February-29 October.

1940 Los Angeles County Museum of Art, *The Development of Impressionism,* 12 January-28 February.

1940 New York World's Fair, *Masterpieces of Art: Catalogue of European and American Paintings 1500-1900,* May-October.

1940 New York, Durlacher Brothers Gallery, *Loan Exhibition of Works by Poussin,* March.

*1940 New York, Wildenstein & Co., Inc., *The School of Fontainebleau,* 31 October-30 November.

1942 New York, Parke-Bernet Galleries, Inc., *French and English Art Treasures of the XVIII Century,* 20-30 December.

1942 San Francisco, CPLH, *Vanity Fair: An Exhibition of Styles in Women's Headdress and Adornment through the Ages,* 16 June-16 July.

1943 New York, Duveen Galleries, Inc., *Exhibition of Boucher Paintings.*

1943 New York, Wildenstein & Co., Inc., *The French Revolution,* December.

1946 New York, M. Knoedler & Co., Inc., *Washington Irving and His Circle,* 8-26 October.

1946 New York, Wildenstein & Co., Inc., *A Loan Exhibition of French Painting of the Time of Louis XIIIth and Louis XIVth,* 9 May-1 June.

1947 Detroit, The Detroit Institute of Arts, *A Loan Exhibition of French Paintings XVII-XX Centuries,* 6-30 March.

1947 City Art Museum of St. Louis, *40 Masterpieces: A Loan Exhibition of Paintings from American Museums,* 6 October-10 November.

1948 Baltimore Museum of Art, *Themes and Variations in Painting and Sculpture,* 15 April-23 May.

1948 London-Manchester, *David 1748-1825.* London, Tate Gallery; Manchester, City Art Gallery.

1948 New York, Wildenstein & Co., Inc., *French Eighteenth Century Paintings*.

1948 Paris, Musée de l'Orangerie, *David: Exposition en l'honneur du deuxième centenaire de sa naissance*, June-September.

1948-1949 Paris, Galerie Charpentier, *Danse et divertissements*, December 1948-January 1949.

1950 The Detroit Institute of Arts, *French Painting from David to Courbet*, 1 February-5 March.

1950 New York, Wildenstein & Co., Inc., *The Woman in French Painting: XVIth to XXth Century*, Summer.

1950 Paris, Galerie Charpentier, *Cent portraits de femmes*, February.

1950-1951 Philadelphia Museum of Art, *Diamond Jubilee Exhibition, Masterpieces of Painting*, 4 November 1950-11 February 1951.

1951 Dallas Museum of Fine Arts, *Four Centuries of European Painting*, 6-31 October.

1951 Pittsburgh, Carnegie Institute, *French Painting (1100-1900)*, 18 October-2 December.

1951 Pomona, Los Angeles County Fair, *One World of Art*, 4-30 September.

1951 Santa Barbara Museum of Art, *Old Master Paintings from California Museums*, August.

1951-1952 Ann Arbor-Grand Rapids, *Italian, Spanish, and French Paintings of the 17th and 18th Centuries*. Ann Arbor, The University of Michigan Museum of Art, 1-28 November 1951; The Grand Rapids Art Gallery, 14 December 1951-9 January 1952.

1952 The Minneapolis Institute of Arts, *Great Portraits by Famous Painters*, 13 November-21 December.

1952 New York, Duveen Galleries, Inc., *French Art in Painting and Sculpture of the Eighteenth Century*, 23 October-22 November.

1952 Paris, Galerie Bernheim-Jeune, *Peintres de portraits*, 17 May-28 June.

1952 Vancouver Art Gallery, *Baroque Art*, 16 April-4 May.

1952-1953 Palm Beach, Society of the Four Arts, *Eighteenth Century Masterpieces*, 12 December 1952-4 January 1953.

1953 Reims, Musée des Beaux-Arts, *Les Le Nain*, 30 May-1 August.

1954 Fort Worth Art Center, *Inaugural Exhibition*, 8-31 October.

1954 New York, Wildenstein & Co., Inc., *French Eighteenth Century Painters*, 16 November-11 December.

*1955 Amsterdam, Rijksmuseum, *Le triomphe du maniérisme européen de Michel-Ange au Greco*, 1 July-16 October.

1955 Sarasota, The John and Mable Ringling Museum of Art, *Director's Choice*, 6 February-4 March.

1955 San Francisco, M. H. de Young Memorial Museum, *The Samuel H. Kress Collection*.

1955 Zurich, Kunsthaus, *Schönheit des 18. Jahrhunderts, Malerei, Plastik, Porzellan, Zeichnung*, 10 September-6 November.

1956 Kansas City, Missouri, The William Rockhill Nelson Gallery of Art and Mary Atkins Museum of Fine Arts, *The Century of Mozart*, 15 January-4 March.

1956 Richmond, Virginia Museum of Fine Arts, *Les fêtes galantes*, 20 January-5 March.

1956-1957 United States, *Paintings from the Collection of Walter P. Chrysler, Jr.* Portland Art Museum, 2 March-

15 April 1956; Seattle Art Museum, 27 April-27 May 1956; San Francisco, CPLH, 12 June-11 July 1956; Los Angeles County Museum of Art, 26 July-26 August, 1956; The Minneapolis Institute of Arts; City Art Museum of St. Louis; Kansas City, Missouri, William Rockhill Nelson Gallery of Art; The Detroit Institute of Arts; Boston, Museum of Fine Arts.

1956-1957 Rome, Palazzo delle Esposizioni, *Il Seicento Europeo, realismo, classicismo, barocco*, 15 November 1956-31 January 1957.

*1956-1957 Toulouse, Musée Paul Dupuy, *Pierre-Henri de Valenciennes*.

1957 Buffalo, Albright Art Gallery, *Trends in Painting 1600-1800*, 2 October-3 November.

1958 London, Royal Academy of Arts, *The Robinson Collection*.

1958 Los Angeles-San Francisco, *California Collects: North and South*. Los Angeles, University of California Art Galleries, 20 January-23 February; San Francisco, CPLH, 7 March-6 April.

1958 Montpellier, Musée Fabre, *Des primitifs à Nicolas de Staël: Belles peintures de collections privées de la région montpelliéraine*, 19 April-19 May.

1958 Santa Barbara Museum of Art, *Fruits and Flowers in Painting*, 12 August-14 September.

1959 Baltimore Museum of Art, *Age of Elegance: The Rococo and Its Effect*, 25 April-14 June.

1959 Cape Town, South African National Gallery, *The Sir Joseph Robinson Collection*.

*1959 Toledo-Minneapolis, *Nicolas Poussin*. The Toledo Museum of Art, 4 January-2 February; The Minneapolis Institute of Arts, 11 February-10 March.

1960 Paris, Musée du Louvre, *Exposition Nicolas Poussin*, May-July.

1961 University of California at Los Angeles Art Galleries, *French Masters: Rococo to Romanticism*, 5 March-18 April.

1961 New York, Wildenstein & Co., Inc., *Masterpieces*, 6 April-7 May.

1961-1962 Canada, *Heritage de France: French Painting 1610-1760*. The Montreal Museum of Fine Arts, 6 October-6 November 1961; Le Musée de la Province de Québec, 16 November-16 December 1961; Ottawa, The National Gallery of Canada, 4 January-4 February 1962; The Art Gallery of Toronto, 16 February-18 March 1962.

1961-1962 Washington, D.C., National Gallery of Art, *Exhibition of Art Treasures for America from the Samuel H. Kress Collection*, 10 December 1961-4 February 1962.

1962 Atlanta, Art Association Galleries, *Landscape into Art*, 6-25 February.

1962 London, Victoria and Albert Museum, *International Art Treasures Exhibition*.

1962 Seattle World's Fair, *Masterpieces of Art*, 21 April-4 September.

1962 Zurich, Kunsthaus, *Sammlung Sir Joseph Robinson (1840-1929)*, 17 August-16 September.

1963 Cleveland Museum of Art, *Style, Truth, and the Portrait*, 1 October-10 November.

1963 New York, Finch College Museum of Art, *French Masters of the Eighteenth Century*.

1963 Oberlin College, Allen Memorial Art Museum, *Youthful Works by Great Artists*, 10-30 March.

1964 Cleveland Museum of Art, *Neo-Classicism, Style and Motif*, 21 September-1 November.

1964 Paris, Galerie Cailleux, *François Boucher: Premier peintre du roi*, May-June.

1965 Art Association of Indianapolis, Herron Museum of Art, *The Romantic Era, Birth and Flowering 1750-1850*, 21 February-11 April.

1965 Riverside, University of California, The Art Gallery, *Problems in Connoisseurship*, 22 March-15 April.

1966 Bordeaux, Musée des Beaux-Arts, *La peinture française: Collections américaines*, 13 May-15 September.

1966 Milwaukee Art Center, *The Inner Circle*, 15 September-23 October.

1966 The Hague-Paris, *In the Light of Vermeer*. The Hague, Mauritshuis, 25 June-5 September. *Dans la lumière de Vermeer: Cinq siècles de peinture*. Paris, Musée de l'Orangerie, 24 September-28 November.

1966 New York, Finch College Museum of Art, *French Landscape Painters from Four Centuries*.

1967 New York, Finch College Museum of Art, *Vouet to Rigaud: French Masters of the Seventeenth Century*, 20 April-18 June.

1968 London, Colnaghi & Co., Inc., *Paintings by Old Masters*, 7-24 May.

1968 Paris, Galerie Cailleux, *Watteau et sa génération*, March-April.

1968-1969 Providence-Riverside, etc., *Baroque Painting: Italy and Her Influence*. Providence, The Rhode Island School of Design; Riverside, University of California, The Art Gallery, 20 April-18 May 1969; and elsewhere.

1969 Buffalo, Canisius College, *Works from the Hanley Collection at Canisius College*, 23 November-23 December.

1969 Kansas City, Missouri, The William Rockhill Nelson Gallery of Art and Mary Atkins Museum of Fine Arts, *The Taste of Napoleon*, 2 October-16 November.

1969-1970 Florida, *The Age of Louis XIII*. Jacksonville, Cummer Gallery of Art, 29 October-7 December 1969; St. Petersburg, The Museum of Fine Arts, 5 January-8 February 1970.

1970 Aix-en-Provence, Pavillon Vendôme, *De la commedia dell'arte au cirque*.

1970 San Francisco, de Young, *The Dr. T. Edward and Tullah Hanley Memorial Collection*, 21 October-6 December.

*1971 Paris, Musée du Louvre, Cabinet des Dessins, *Boucher: Gravures et dessins du Cabinet des Dessins et de la Collection Edmond de Rothschild*, May.

1971-1972 Cleveland Museum of Art, *Caravaggio and His Followers*, 27 October 1971-2 January 1972.

1972 South Bend, University of Notre Dame Art Gallery, *Eighteenth Century France: A Study of Its Art and Civilization*, 12 March-15 May.

1972 Paris, Musée de l'Orangerie, *Georges de La Tour*, 10 May-25 September.

*1972-1973 Toronto-Ottawa-San Francisco-New York, *French Master Drawings of the 17th & 18th Centuries in North American Collections*. Toronto, Art Gallery of Ontario, 2 September-15 October 1972; Ottawa, The National Gallery of Canada, 3 November-17 December 1972; San Francisco, CPLH, 12 January-11 March 1973; New York City, The New York Cultural Center, 4 April-6 May 1973.

*1972-1973 Paris, Grand Palais, *L'Ecole de Fontainebleau*, 17 October 1972-15 January 1973.

*1973 Paris, Musée du Louvre, "La Mort de Germanicus de Poussin." *Les dossiers du Département des peintures*, no. 7.

1973 Ottawa, The National Gallery of Canada, *Fontainebleau: Art in France, 1528-1610*, 1 March-15 April (2 vols.).

*1973-1974 Rome-Paris, *I Caravaggeschi Francesi*, Rome, Accademia di Francia, Villa Medici, 1973; *Valentin et les Caravagesques français*, Paris, Grand Palais, 13 February-15 April 1974.

*1973-1974 Washington-Chicago, *François Boucher in North American Collections: 100 Drawings*. Washington, D.C., National Gallery of Art, 23 December 1973-17 March 1974; The Art Institute of Chicago, 4 April-12 May 1974.

1974 Santa Barbara Museum of Art, *The Horse in Art: Paintings-Sculpture 17th-20th Century, Graphics 15th-20th Century*, 22 June-21 July.

1974-1975 Paris-Detroit-New York, *De David à Delacroix: La peinture française de 1774 à 1830*. Paris, Grand Palais, 16 November 1974-3 February 1975. *French Painting 1774-1830: The Age of Revolution*. The Detroit Institute of Arts, 5 March-4 May 1975; New York, The Metropolitan Museum of Art, 12 June-7 September 1975.

1975 Paris, Eurohal, *Maestrict Paysages*, 29 November-7 December.

1975 London, Somerville & Simpson, *Paintings by Old Masters*, 26 November-19 December.

*1975 London, Thos. Agnew and Son Ltd., *Master Paintings*, 29 May-4 July.

1975-1976 Toledo-Chicago-Ottawa, *The Age of Louis XV: French Painting 1710-1774*. The Toledo Museum of Art, 26 October-7 December 1975; The Art Institute of Chicago, 10 January-22 February 1976; Ottawa, The National Gallery of Canada, 21 March-2 May 1976.

*1976 The Art Institute of Chicago, *Selected Works of 18th Century French Art in the Collections of The Art Institute of Chicago*, 24 January-28 March.

1976 Washington, National Gallery of Art, *The Eye of Thomas Jefferson*, 3 June-6 September.

1976-1977 Hartford-San Francisco-Dijon, *Jean-Baptiste Greuze 1725-1805*. Hartford, Wadsworth Atheneum, 1 December 1976-23 January 1977; San Francisco, CPLH, 5 March-10 May 1977; Dijon, Musée des Beaux-Arts, 4 June-31 July 1977.

1976-1977 United States, *Women Artists 1550-1950*. Los Angeles County Museum of Art, 21 December 1976-13 March 1977; Austin, The University of Texas, University Art Museum, 12 April-5 June 1977; Pittsburgh, Carnegie Institute, 14 July-4 September 1977; New York, The Brooklyn Museum, 4 October-27 November 1977.

1976-1977 San Francisco, CPLH, *Five Centuries of Tapestry*, 20 November 1976-30 January 1977.

1977 Cincinnati, The Taft Museum, *The Best of Fifty*, 22 March-8 May.

*1977 Florence, Palazzo Pitti, *Pittura francese nelle collezioni pubbliche fiorentine*, 24 April-30 June.

1977 New York, Wildenstein & Co., Inc., *Paris-New York: A Continuing Romance*, 3 November-17 December.

*1977 France, *Carle Vanloo: Premier peintre du roi (Nice, 1705-Paris, 1765)*. Nice, Musée Chéret, 21 January-13 March; Clermont-Ferrand, Musée Bargoin, 1 April-30 May; Nancy, Musée des Beaux-Arts, 18 June-15 August.

*1977 Paris, Musée du Louvre, "La diseuse de bonne aventure de Caravage," *Les dossiers du Département des peintures*, no. 13.

*1978 London, Artemis, David Carritt, Ltd., *18th Century French Paintings, Drawings and Sculpture*, 6 June-7 July.

*1978 London, Wildenstein & Co., Inc., *Twenty Masterpieces from the Natale Labia Collection*, 26 April-26 May.

1978 London, Thomas Agnew & Sons, Ltd., *Old Master Paintings: Recent Acquisitions*, 31 May-28 July.

*1978 Marseille, Musée des Beaux-Arts, Palais Longchamps, *La peinture en Provence au XVIIe siècle*, July-October.

1978 New York, Wildenstein & Co., Inc., *Romance and Reality*, 18 October-22 November.

1978-1979 Denver-New York-Minneapolis, *Masterpieces of French Art: The Fine Arts Museums of San Francisco*. Denver Art Museum, 26 December 1978-18 February 1979; New York, Wildenstein & Co., Inc., 14 March-27 April 1979; The Minneapolis Institute of Arts, 24 May-1 July 1979.

1978-1979 Paris, Grand Palais, *Les frères Le Nain*, 3 October 1978-8 January 1979.

*1980 New York, Wildenstein & Co., Inc., *François Boucher: A Loan Exhibition for the Benefit of The New York Botanical Garden*, 12 November-19 December.

1980 Japan, *Fragonard*. Tokyo, The National Museum of Western Art, 18 March-11 May; Kyoto, Municipal Museum, 24 May-29 June.

1981 San Francisco, CPLH, *Fans in Fashion*, 23 May-13 August.

1981 Montreal Museum of Fine Arts, *Largillierre and the Eighteenth-Century Portrait*, 19 September-15 November.

*1982 New York, Maurice Segoura Gallery, *From Watteau to David: A Century of French Art*, 21 April-25 June.

*1982 Fort Worth, Kimbell Art Museum, *Elisabeth Louise Vigée Le Brun, 1755-1842*, 5 June-8 August.

1982 Paris-New York-Chicago, *La peinture française du XVIIe siècle dans les collections américaines*. Paris, Grand Palais, 29 January-26 April. *France in the Golden Age: Seventeenth Century French Painting in American Collections*. New York, The Metropolitan Museum of Art, 26 May-22 August; The Art Institute of Chicago, 18 September-28 November.

1982 Florida, *Exotic Kingdoms: China and Europe in the 18th Century*. St. Petersburg, Museum of Fine Arts, 24 January-28 February; Palm Beach, Society of the Four Arts, 12 March-18 April.

*1983 Atlanta, The High Museum of Art, *The Rococo Age: French Masterpieces of the Eighteenth Century*.

*1984 Langres, Musée du Breuil de Saint-Germain, *Diderot et la Critique de Salon 1759-1781*, 2 June-16 September.

*1984 Los Angeles County Museum of Art, *Selections from The Armand Hammer Collections*, 22 May-26 August.

*1984 Manchester, City Art Gallery, *François Boucher, Paint-ings, Drawings, and Prints from the Nationalmuseum, Stockholm*, 27 June-1 September.

*1984 Orléans, Musée des Beaux-Arts, *Peintures françaises du Museum of Art de la Nouvelle Orléans*, 9 May-15 September.

*1984-1985 Cleveland-Fort Worth-Naples, *Bernardo Cavallino of Naples 1616-1656*. The Cleveland Museum of Art, 14 November-30 December 1984; Fort Worth, The Kimbell Art Museum, 26 January-24 March 1985; Naples, Museo Pignatelli Cortes, 24 April-26 June 1985.

1984-1985 Washington-Paris-Berlin, *Watteau: 1684-1721*. Washington, National Gallery of Art, 17 June-23 September 1984; Paris, Grand Palais, 23 October 1984-28 January 1985; Berlin, Schloss Charlottenburg, 22 February-26 May 1985.

*1985-1986 New York-New Orleans-Columbus, *The First Painters of the King: French Royal Taste from Louis XIV to the Revolution*. New York, Stair Sainty Matthiesen, 16 October-22 November 1985; New Orleans Museum of Art, 10 December 1985-19 January 1986; Columbus Museum of Art, 8 February-26 March 1986.

*1986-1987 New York-Detroit-Paris, *François Boucher 1703-1770*. New York, The Metropolitan Museum of Art, 17 February-4 May 1986; The Detroit Institute of Arts, 27 May-17 August 1986; Paris, Grand Palais, 19 September 1986-5 January 1987.

1986-1987 Houston, The Museum of Fine Arts, *A Magic Mirror: The Portrait in France 1700-1900*, 10 October 1986-25 January 1987.

1987 Rochester-New Brunswick-Atlanta, *La Grande Manière: Historical and Religious Painting in France, 1700-1800*. Memorial Art Gallery of the University of Rochester, 1 May-16 August; New Brunswick, Jane Voorhees Zimmerli Art Museum, Rutgers University, 6 September-8 November; Atlanta, High Museum, 7 December 1987-29 January 1988.

*1987 Paris-Rome, *Subleyras 1699-1749*. Paris, Musée du Luxembourg, 26 February-26 April; Rome, Accademia di Francia, Villa Medici, 18 May-19 July.

*1987 London, Iveagh Bequest, Kenwood, *Francis Hayman 1708-1776*, 24 June-30 September.

*1987-1988 Paris-New York, *Fragonard*. Paris, Grand Palais, 24 September 1987-4 January 1988; New York, The Metropolitan Museum of Art, 2 February-8 May 1988.

References

This list includes publications on paintings in TFAMSF, major monographs on artists in their collection, and pertinent sources for seventeenth- and eighteenth-century engravings.

ABROMSON, Morton C. "Portrait of a Gentleman by Aimée Duvivier." *The William Benton Museum of Art Bulletin*, no. 9 (1981):5-15.

ADHEMAR, Hélène, and René HUYGHE. *Watteau: Sa vie, son oeuvre*. Paris: Tisné, 1950.

ALEXANDRE, Arsène. "La collection de M. Jean Dollfus." *Les Arts*, no. 26 (February 1904):2-12.

ANANOFF, Alexandre. *L'oeuvre dessiné de Jean-Honoré Fragonard*. 4 vols. Paris: F. de Nobele, 1961-1970.

——. "François Boucher et l'Amérique." *L'Oeil*, no. 251 (June 1976):18-23.

ANANOFF, Alexandre, with Daniel WILDENSTEIN. *François Boucher*. 2 vols. Paris: La Bibliothèque des Arts, 1976.

——. *L'opera completa di Boucher*. Milan: Rizzoli, 1980.

ARCHIVES DU MUSEE DES MONUMENTS FRANÇAIS: *Inventaire général des richesses d'art de la France*. 3 vols. Paris: Henri Plon, 1883-1897.

BACHAUMONT, Louis Petit de. *Lettres sur les peintures, sculptures et gravures de Mss. de l'Académie Royale, exposées au Sallon du Louvre depuis MDCCLVII jusqu' en MDCCLXXIX*. London: John Adamson, 1780.

BADIN, Jules. *La manufacture de tapisserie de Beauvais depuis ses origines jusqu' à nos jours*. Paris: Société de Propagation des Livres d'Art, 1909.

BADT, Kurt. *Die Kunst des Nicolas Poussin*. 2 vols. Cologne: Du Mont Schauberg, 1969.

BAILLIO, Joseph. "Identification de quelques portraits d'anonymes de Vigée Le Brun aux Etats-Unis." *GBA* 96, no. 1342 (November 1980):157-168.

BARRET, André. *Fontainebleau le miroir des dames*. Paris: Robert Laffont, 1984.

BAZIN, Germain. "Duplessis." In *Kindlers Malerei Lexikon*, vol. 2, 185-187. Zurich: Kindler, 1965.

BEGUIN, Sylvie. *L'Ecole de Fontainebleau: Le maniérisme à la Cour de France*. Paris: Editions d'Art Gonthier-Seghers, 1960.

——. "Le Maître de Flore de l'Ecole de Fontainebleau." *Art de France* 1 (1961):301-305.

BELLAIGUE, Geoffrey de. *The James A. de Rothschild Collection at Waddesdon Manor: Furniture, Clocks, and Gilt Bronzes*. 2 vols. Fribourg: Office du Livre, 1974.

BELLEUDY, Jules. *J.-S. Duplessis, peintre du roi (1725-1802)*. Chartres: Durand, 1913.

BELLIER, Emile de La Chavignerie, and Louis AUVRAY. *Dictionnaire général des artistes de l'Ecole française depuis l'origine des arts du dessin jusqu' à nos jours*. 2 vols. 1882-1885. Reprint, ed. Robert Rosenblum. 5 vols. New York: Garland Publishing, 1979.

BENEZIT, Emmanuel. *Dictionnaire critique et documentaire des peintres, sculpteurs, dessinateurs et graveurs de tous les temps et de tous les pays par un groupe d'écrivains specialistes français et étrangers*. Paris: Librairie Gründ, 1976.

BENISOVICH, Michel N. "Duplessis in the United States. Addenda: Benjamin Franklin at the White House, a Letter and a Drawing." *GBA* 29, no. 91 (May 1946):285-292.

BERTIN-MOUROT, Thérèse. "Addenda au catalogue de Grautoff depuis 1914." *Bulletin de la Société Poussin* 2 (December 1948):44-53.

BIVER, Paul. *Histoire du château de Bellevue*. Paris: Librairie Gabriel Enault, 1933.

BLANC, Charles. *Histoire des peintres de toutes les écoles: Ecole française*. 3 vols. Paris: Vve Jules Renouard, 1862-1863.

BLOCH, Vitale. "Louis Le Nain and His Brothers." *BM* 75, no. 437 (1939):50-59.

——. "The Le Nains, on the Occasion of the Exhibition at Reims." *BM* 95, no. 608 (November 1953):366-367.

——. "Georges de La Tour Once Again." *BM* 96, no. 612 (March 1954):81-82.

——. *Louis Le Nain*. Milan: Fratelli Fabbri, 1966; *Le Nain*. Paris: Hachette, 1968.

BLUM, Jerome. *Our Forgotten Past: Seven Centuries of Life on the Land*. London: Thames Hudson, 1982.

BLUNT, Anthony. "Poussin Studies. II: Three Early Works." *BM* 89, no. 535 (October 1947):266-270.

——. *Nicolas Poussin. The Adoration of the Golden Calf*. London: National Gallery, 1951.

——. *Art and Architecture in France, 1500 to 1700*. London: Penguin Books, 1953, 1957, 1973.

——. *Nicolas Poussin*. The A. W. Mellon Lectures in the Fine Arts. 2 vols. Washington, D.C.: National Gallery of Art, 1958. Reprint. New York: Bollinger Foundation, dist. Pantheon Books, 1967.

——. "La première période romaine de Poussin." In *Colloque Nicolas Poussin [1958]*, vol. 1, 163ff. Paris, 1960.

——. "Poussin Studies. XI: Some Addenda to the Poussin Number." *BM* 102, no. 690 (September 1960):396-405.

——. "Poussin et les cérémonies religieuses antiques." *Revue des Arts* 10 (1960):56-66.

——. *The Paintings of Nicolas Poussin: A Critical Catalogue*. London: Phaidon Press, 1966.

——. "Georges de La Tour at the Orangerie." *BM* 114, no. 833 (August 1972):516-525.

——. "Poussin's 'Death of Germanicus' Lent to Paris." *BM* 115, no. 845 (August 1973):533.

——. "The Complete Poussin." *BM* 116, no. 861 (December 1974):760-763.

——. "Paintings from the Samuel H. Kress Collection: European Schools Excluding Italian." *Apollo* 105, no. 183 (May 1977):392-393.

——. "The Le Nain Exhibition at the Grand Palais, Paris: Le Nain Problems." *BM* 120, no. 969 (1978):870-875.

——. *The Drawings of Poussin*. New Haven: Yale University Press, 1979.

——. "French Seventeenth-Century Painting: The Literature of the Past Ten Years." *BM* 124, no. 956 (November 1982):705-711.

BOERLIN-BRODBECK, Yvonne. *Antoine Watteau und das Theater*. Basel: Universitätsbibliothek, 1973.

BOISCLAIR, Marie-Nicole. *Gaspard Dughet: Sa vie et son oeuvre (1615-1675)*. Neuilly-sur-Seine: Arthéna, 1986.

BOLOGNA, Ferdinando. "A New Work from the Youth of La Tour." *BM* 117, no. 868 (1975):434-440.

BORDEAUX, Jean-Luc. "Un musée français en Californie." *Connaissance des Arts*, no. 299 (January 1977):32-41.

———. *François Le Moyne and His Generation, 1688-1737*. Neuilly-sur-Seine, Arthéna: 1985.

BREJON DE LAVERGNEE, Arnauld. "Nouvelles toiles d'Andrea di Lione: Essai de catalogue." In *Scritti di storia dell'arte in onore di Federico Zeri*, vol. 2, 656-680. Milan: Electa Editrica, 1984.

BROOKNER, Anita. *Greuze: The Rise and Fall of an Eighteenth-Century Phenomenon*. London: Paul Elek, 1972.

———. *Jacques-Louis David*. London: Chatto and Windus, 1980.

BURGER, W. "Exposition des tableaux de l'Ecole française ancienne, tirée des collections d'amateurs (XVIIᵉ-XVIIIᵉ siècles)." *GBA* 1st ser. 7 (1 September 1860):257-277; (15 September 1860):333-358; (November 1860):228-240.

BUROLLET, Thérèse. *Catalogue des peintures et dessins, Musée Cognacq-Jay*. Paris, 1980.

CAILLEUX, Jean. "L'art du dix-huitième siècle: A Rediscovered Painting by Watteau 'La partie quarrée'." *BM* 104, no. 709, suppl. 16 (April 1962):i-iv.

CAMESASCA, Ettore, and John SUNDERLAND. *The Complete Paintings of Watteau*. New York: Abrams, 1968; Giovanni MACCHIA and E. C. MONTAGNI. *L'opera completa di Watteau*. Milan: Rizzoli, 1968; Ettore CAMESASCA and Pierre ROSENBERG. *Tout l'oeuvre peint de Watteau*. Paris: Flammarion, 1970.

CANTINELLI, Richard. *Jacques-Louis David, 1748-1825*. Paris: G. Van Oest, 1930.

CATTAUI, Georges. "L'exposition du 'seicento' à Rome." *GBA* 49 (April 1957):239-248.

CHATELET, Albert, and Jacques THUILLIER. *French Painting from Le Nain to Fragonard*. Geneva: Skira, 1964.

CHOBAUT, Hyacinthe. "Documents inédits sur les peintres et peintres-verriers d'Avignon, du Comtat et de la Provence occidentale de la fin du XIVᵉ siècle au premier tiers du XVIᵉ siècle." *Mémoires de l'Académie de Vaucluse 1939* 4, 3d-4th quarters (1940):83-145.

CLEMENT, Charles. *Prud'hon: Sa vie, ses oeuvres et sa correspondance*. Paris: Didier, 1872.

COCKE, Richard. "A Note on Mola and Poussin." *BM* 111, no. 801 (December 1969):712-719.

COHN, Marjorie B., and Susan L. SIEGFRIED. *Works by J.-A.-D. Ingres in the Collection of the Fogg Art Museum*. Cambridge: Fogg Art Museum-Harvard University, 1980.

COLLECTION DELOYNES. Ed. Georges Duplessis, *Catalogue de la collection de pièces sur les Beaux-Arts imprimées et manuscrites, recueillie par P. J. Mariette, Ch. Nic. Cochin et M. Deloynes*. 64 vols. [1675-1808]. Paris, 1881. Cab. des Est., BN, Paris.

COLOMBIER, Pierre du. "Nouvelle jeunesse pour Fragonard." *Connaissance des Arts*, no. 120 (February 1962): 66-73.

COMPIN, Isabelle, and Anne ROQUEBERT. *Catalogue sommaire illustré des peintures du Musée du Louvre et du Musée d'Orsay, Ecole française*. 3 vols. Paris: Editions de la Réunion des Musées Nationaux, 1986.

COMSTOCK, Helen. "The Connoisseur in America: De Young Museum, Gifts from Kress." *The Connoisseur* 136, no. 547 (September 1955):71-72.

———. "The Connoisseur in America." *The Connoisseur* 138, no. 555 (September 1956):74.

———. "The Connoisseur in America: Paintings by Georges de La Tour." *The Connoisseur* 140, no. 563 (September 1957):70-71.

CONSTANS, Claire. *Catalogue des peintures du Musée National du Château de Versailles*. Paris: Editions de la Réunion des Musées Nationaux, 1980.

COOK, Herbert. "La Collection de Sir Frederick Cook." *Les Arts*, no. 44 (August 1905).

———. *A Catalogue of the Paintings at Doughty House, Richmond and Elsewhere in the Collection of Sir Frederick Cook*. Ed. Herbert Cook. 3 vols. London: privately printed, 1915.

———. *Abridged Catalogue of the Pictures at Doughty House, Richmond, Surrey, in the Collection of Sir Herbert Cook, Bart.* London: privately printed, 1932.

CORDEY, Jean. *Inventaire des biens de Madame de Pompadour rédigé après son décès*. Paris: F. Lefrançois, 1939.

CORRESPONDANCE LITTERAIRE, PHILOSOPHIQUE ET CRITIQUE. Friedrich Grimm, Denis Diderot et al. 16 vols. Paris: Garnier Frères, 1877-1882.

CORTISSOZ, Royal. *Decorations by François Boucher*. New York: The William Bradford Press, 1944.

COUPIN, P.-A. *Essai sur J.-L. David, peintre d'histoire* Paris: J. Renouard, 1827.

COURVILLE, X. de. *Un apôtre de l'art du théâtre au XVIIIᵉ siècle, Luigi Riccoboni dit Lélio*, vol. 1; *L'expérience française, 1716-1731*, vol. 2; *La leçon, 1732-1753*, vol. 3. Paris: Librairie Théâtrale, 1943-1958.

CUZIN, Jean Pierre. "Les frères Le Nain: La part de Mathieu." *Paragone*, nos. 349-351 (1979):58-70.

———. "New York, French Seventeenth-Century Paintings from American Collections." *BM* 124, no. 953 (August 1982):526-530.

DACIER, Emile. *Catalogues de ventes et livrets de Salons illustrés et annotés par Gabriel de Saint-Aubin*. Vol. 1, *Catalogue de la collection Crozat (1755)*. Vol. 2, *Livret du Salon de 1769*. Paris: La Société de Reproduction des Dessins des Maîtres, 1909.

———. "Portrait de jeune fille: Gravure au burin de M. Chiquet d'après Greuze." *Revue de l'Art Ancien et Moderne* 29 (10 April 1911):259-260.

DACIER, Emile, Albert VUAFLART, and Jacques HEROLD. *Jean de Jullienne et les graveurs de Watteau au XVIIIᵉ siècle*. 4 vols. Paris: La Société pour l'Etude de la Gravure Française, 1921-1929.

D'AGEVILLE, M. *Eloge historique de Michel-François d'André Bardon* Marseille: Jean Mosy, 1783.

DANDRE-BARDON, Michel-François. *Vie de Carle Vanloo*. Paris, 1765.

DAVID, Jacques-Louis-Jules. *Le peintre Louis David (1748-1825): Souvenirs et documents inédits*. 2 vols. Paris: Victor Havard, 1880-1882.

DAVIES, Martin. *French School*. 2d ed. London: The National Gallery, 1957.

DAVISSON, Gay D. "Portrait of Citizen Dubard: Painting by Jean-Baptiste Greuze." *Bulletin CPLH* 1, no. 12 (March 1944):98-100.

———. "The Mildred Anna Williams Collection." *Bulletin CPLH* 4, nos. 3-4 (July-August 1946):26-31.

———. "Portrait of the Marquis de Montespan: Painting by Nicolas de Largillièrre." *Bulletin CPLH* 4, no. 12 (April 1947):98-103.

———. "Two Portraits by Jean-Baptiste Perronneau." *Bulletin CPLH* 5, no. 4 (August 1947):26-31.

DAYOT, Armand, and Léandre VAILLAT. *L'oeuvre de J. B. S. Chardin et J. H. Fragonard*. Paris: Frédéric Gittler [1907].

DES BOULMIERS [Jean-Augustin Jullien]. "Exposition des peintures, sculptures & gravures de MM. de l'Académie royale, dans le salon du Louvre 1769." *Mercure de France* 1, October 1769, 177-203. Vol. 97, 274-281, Geneva: Slatkine Reprints, 1971.

D[EZALLIER D'ARGENVILLE, Antoine-Nicolas]. *Voyage pittoresque des environs de Paris, ou description des maisons royales, châteaux & autres lieux de plaisance, situés à quinze lieues aux environs de cette ville.* Paris: De Bure l'Aîné, 1755; 2d ed., 1762; 3d ed., 1768; 4th ed., 1779.

DIDEROT, Denis. *Salons*. Ed. Jean Seznec and Jean Adhémar. 4 vols. Oxford: Clarendon Press, 1957-1967; 2d ed., 1975-1983.

DIMIER, Louis. *Les peintres français du XVIIIᵉ siècle.* 2 vols. Paris: G. Van Oest, 1928-1930.

DRUART, René. "Les Le Nain au Musée de Reims." *Annales des amis belges du vieux Laon*, 1952-1953 (1953):7-10.

DUCHESNE, Henri-Gaston. *Le Château de Bagatelle (1715-1908) d'après les documents inédits des Archives Nationales, des Archives de la Seine et des mémoires manuscrits ou imprimés.* Paris: Jean Schemit, 1909.

DU SEIGNEUR, Jean. "Appendice à la notice de P. Chaussard sur L. David." *Revue Universelle des Arts* 18 (1863-1864):359-369.

DUSSIEUX, Louis. "Nouvelles recherches sur la vie et les ouvrages de Le Sueur." *Archives de l'Art Français* 2 (1852-1853):1-124.

EIDELBERG, Martin P. *Watteau's Drawings, Their Use and Significance.* New York: Garland Publishing, 1977.

EISLER, Colin. *Paintings from the Samuel H. Kress Collection: European Schools Excluding Italian.* New York: Phaidon Press, 1977.

ELLER, Irvin. *The History of Belvoir Castle.* London: R. Tyas, 1841.

ENGERAND, Fernand. *Inventaire des tableaux commandés et achetés par la Direction des Bâtiments du Roi (1709-1792).* Paris: Ernest Leroux, 1900.

ENGGASS, Robert. "Review of Caravaggio and His Followers." *Art Bulletin* 55, no. 3 (September 1973):460-462.

ESCHOLIER, Raymond. "Le secret des Le Nain." *Le Figaro. Supplément Littéraire*, no. 199 (28 January 1923).

EUROPEAN WORKS OF ART IN THE M.H. DE YOUNG MEMORIAL MUSEUM. San Francisco: Diablo Press, 1966.

FAHY, Everett. *The Wrightsman Collection: The Metropolitan Museum of Art.* 5 vols. New York: New York Graphic Society, 1973.

FARE, Michel, and Fabrice FARE. *La vie silencieuse en France: La nature morte au XVIIIᵉ siècle.* Fribourg: Office du Livre, 1976.

FELIBIEN, André. *Entretiens sur les vies et sur les ouvrages des plus excellens peintres anciens et modernes.* 5 vols. Paris, 1666-1688; 6 vols. Paris: Trevous, 1725.

FENAILLE, Maurice. *François Boucher.* Paris: Nilsson, 1925.

FERRE, Jean. *Watteau.* 4 vols. Madrid: Editions Artistiques Athéna, 1972.

FIERENS, Paul. *Les Lenain.* Paris: Floury, 1933.

———. "La vie paysanne au XVIIᵉ siècle: Louis Le Nain." *Le Jardin des Arts*, no. 33 (July 1957):547-554.

FIOCCO, Giuseppe. "Due quadri di Georges de La Tour." *Paragone* 5, no. 55 (July 1954):38-48.

FISCHER, Wolfgang. "Claude Vignon (1593-1670)." *Nederlands Kunsthistorisch Jaarboek* 13 (1962):105-148; 14 (1963):137-182.

FLORISOONE, Michel. "Chronique de l'art ancien et moderne: Sur quelques récents problèmes de la peinture des XVIIᵉ et XVIIIᵉ siècles." *Revue des Arts*, no. 4 (December 1954):247-256.

FOREST, Alfred. *Pierre-Paul Prud'hon, peintre français (1758-1823).* Paris: Ernest Leroux, 1913.

FOSTER, Joshua James. *French Art from Watteau to Prud'hon.* London: Dickinsons, 1906.

FRANKENSTEIN, Alfred. "Portrait: San Francisco." *Portfolio* 5, no. 1 (December 1979-January 1980):106-112.

FRANKFURTER, Alfred M. "383 Masterpieces of Art." *Art News* 38, no. 34 (25 May 1940):16-43.

———. "The Kress Gift to San Francisco." *Art News* 54, no. 2 (April 1955):40-44, 58.

FRAPPART, A. "Chronique des ventes." *Les Arts*, no. 18 (June 1903):34.

FRIEDLAENDER, Walter. "America's First Poussin Show." *Art News* 38, no. 23 (9 March 1940):7-14, 24.

———. *Nicolas Poussin.* New York: Abrams, 1964.

———. "The Domestication of Cupid." In *Studies in Renaissance and Baroque Art: Presented to Anthony Blunt on His 60th Birthday*, 51-52. London: Phaidon Press, 1967.

———. *The Drawings of Nicolas Poussin.* London: The Warburg Institute, University of London, 1968.

FRIEDLAENDER, Walter, and Anthony BLUNT. *The Drawings of Nicolas Poussin: Catalogue raisonné.* 3 vols. London: The Warburg Institute, University of London, 1939-1953.

FURCY-RAYNAUD, Marc. *Correspondance de M. de Marigny avec Coypel, Lépicié, et Cochin.* 2 vols. Vol. 1, 1903. *Nouvelles Archives de l'Art Français* 3d ser. 19 (1904). Reprint. Paris: F. de Nobele, 1973.

GABILLOT, Claude. *Les Huet: Jean-Baptiste et ses trois fils.* Paris: L. Allison, 1892.

———. *Hubert Robert et son temps.* Paris: Librairie de l'Art, 1895.

GASTON-DREYFUS, Philippe. "Catalogue raisonné de l'oeuvre de Nicolas-Bernard Lépicié," *BSHAF 1922* (1923):134-283.

GEBELIN, François. *L'époque Henri IV et Louis XIII.* Paris: Presses Universitaires de France, 1969.

GENDEL, Milton, "Rome and Baroque Europe." *Art News* 56, no. 2 (April 1957):24-27.

GERARD, Baron Henri. *Oeuvre du Baron François Gérard, 1789-1836: Gravures à l'eau-forte.* 3 vols. Paris: Vignières et Rapilly, 1852-1857.

———. *Lettres adressées au Baron François Gérard, peintre d'histoire, par les artistes et les personnages célèbres de son temps.* 2 vols. Paris: A. Quentin, 1886.

GIRODIE, André *Jean-Frédéric Schall*. Strasbourg: A. and F. Kahn, 1927.

GONCOURT, Edmond de. *Catalogue raisonné de l'oeuvre peint, dessiné et gravé de P. P. Prud'hon*. Paris: Rapilly, 1876.

GONCOURT, Edmond de, and Jules de GONCOURT. *L'art du dix-huitième siècle*. 2 vols. 1873-1874. Enlarged ed. Paris: Charpentier-Fasquelle, 1894-1895.

———. *French XVIII Century Painters*. Trans. Robin Ironside. New York: Phaidon Press, 1948. Reprint. Ithaca, New York: Cornell University Press, 1981.

GRAPPE, H. *Fragonard: Peintre de l'amour au XVIIIᵉ siècle*. 2 vols. Paris: H. Piazza, 1913.

GRIGAUT, Paul L. "A Crucifixion from Provence." *Bulletin of The Detroit Institute of Arts* 29, no. 3 (1949-1950):90-93.

GRONKOWSKI, Camille. "L'exposition Largillierre au Petit Palais." *Le Figaro. Supplément Artistique* 5, no. 193 (10 May 1928):467.

———. "L'exposition N. de Largillierre au Petit Palais." *GBA* 6, no. 2 (June 1928):321-338.

GROSSMANN, F. "A Painting by Georges de La Tour in the Collection of Archduke Leopold Wilhelm." *BM* 100, no. 660 (March 1958):86-91.

———. "Some Observations on Georges de La Tour and the Netherlandish Tradition." *BM* 115, no. 846 (September 1973):576-583.

GUIFFREY, Jean. "L'exposition Chardin-Fragonard." *Revue de l'Art Ancien et Moderne* 22 (1907):93-106.

———. *Catalogue complet de l'oeuvre du maître*. In Armand Dayot, *J.-B. Siméon Chardin*. Paris: H. Piazza, 1908.

———. "L'oeuvre de Pierre-Paul Prud'hon." *Archives de l'Art Français*, n.s. 13 (1924).

———. "Musée du Louvre. Peintures et dessins: Deux nouveaux Prud'hon." *Bulletin des Musées de France* 5, no. 1 (January 1933):2-5.

GUIMBAUD, Louis. *Fragonard*. Paris: Editions d'Histoire et d'Art, 1947.

HALL, Samuel Carter. *Gems of European Art. The Best Pictures of the Best Schools*. London: privately printed, 1843-1845.

HANDBOOK OF THE COLLECTIONS: *California Palace of the Legion of Honor*. San Francisco: CPLH, 1960.

HARRISSE, Henry. *L.-L. Boilly*. Paris: Société de Propagation des Livres d'Art, 1898.

HATTIS, Phyllis. *Four Centuries of French Drawings in The Fine Arts Museums of San Francisco*. San Francisco: TFAMSF, 1977.

HAUTECOEUR, Louis. *Louis David*. Paris: La Table Ronde, 1954.

HELD, Julius S. "Flora, Goddess and Courtesan." In *De Artibus Opuscula 40: Essays in Honor of Erwin Panofsky*, vol. 1, 201-218. New York: New York University Press, 1961.

———. "Caravaggio and His Followers." *Art in America* 60, no. 3 (May-June 1972):40-47.

———. "The Emergence of Georges de La Tour." *Art in America* 61, no. 4 (July-August 1973):82-87.

HELM, W. H. *Vigée-Lebrun, Her Life, Works and Friendships*. Boston: Small, Maynard and Company, 1915.

HENRIOT, Gabriel. "La collection David Weill." *L'Amour de l'Art* 1, no. 6 (January 1925):1-23.

———. *Collection David Weill*. 2 vols. Paris: Braun, 1926.

HENRY, Clarice. "The Works of Carle Van Loo in North American Collections." Thesis, Queens College, The City University of New York, 1976.

HESS, Thomas B., and John ASHBERY, eds. "Fragonard: Painterly Painting." *Art News Annual* 27 (1971):77-88.

HOLMA, Klaus. *David: Son évolution et son style*. Paris: P. LeJay, 1940.

HONOUR, Hugh. "17th-Century Art in Europe." *The Connoisseur* 139, no. 559 (March 1957):34-35.

HOWE, Thomas C. "Henry K. S. Williams. In Memoriam." *Bulletin CPLH* 2, no. 3 (June 1944):18-23.

———. "Georges de La Tour." *Bulletin CPLH* 4, no. 5 (September 1946):34-43.

———. "A Painting by Jacques-Louis David." *Bulletin CPLH* 5, no. 2 (June 1947):10-13.

———. "A Landscape by Claude Lorrain." *Bulletin CPLH* 5, no. 12 (April 1948):94-97.

———. "Two Recent Accessions." *Bulletin CPLH* 8, no. 1 (May 1950):2-7.

———. "Four Recent Acquisitions." *Bulletin CPLH* 8, nos. 7-8 (November-December 1950):n.p.

———. "Recent Acquisitions." *Bulletin CPLH* 10, no. 12 (April 1953):n.p.

———. "Recent Acquisitions." *Bulletin CPLH* 12, no. 11 (March 1955):n.p.

———. "Annual Report of the CPLH for the Year 1956." *Bulletin CPLH* 14, nos. 9-10 (January-February 1957):n.p.

———. "The André J. Kahn Gift." *Bulletin CPLH* 16, no. 6 (October 1958):n.p.

———. "A Self-Portrait by Jean-Honoré Fragonard." *Bulletin CPLH* 17, no. 4 (August 1959):n.p.

———. "Six Recent Accessions." *Bulletin CPLH* 19, nos. 3-4 (July-August 1961):n.p.

———. "A Recent Gift to the Museum." *Bulletin CPLH* 22, no. 6 (October 1964):n.p.

———. "'Vertumnus and Pomona' by François Boucher." *Bulletin CPLH* 1, no. 5 (March-April 1968):n.p.

ILLUSTRATED HANDBOOK OF THE COLLECTIONS: *California Palace of the Legion of Honor*. San Francisco: CPLH, 1942; 1944; 1946.

ILLUSTRATIONS OF SELECTED WORKS: *M. H. de Young Memorial Museum*. San Francisco: de Young, 1950.

INGERSOLL-SMOUSE, Florence. "Quelques tableaux de genre inédits par Etienne Aubry," *GBA* 5th ser. 11 (February 1925):77-85.

———. *Joseph Vernet, peintre de marine (1714-1789): Etude critique suivie d'un catalogue raisonné de son oeuvre peint*. 2 vols. Paris: Etienne Bignou, 1926.

———. *Pater*. Paris: Les Beaux-Arts, 1928.

ISARLO, Georges. "Les trois Le Nain et leur suite." *La Renaissance*, no. 1 (March 1938):1-58.

———. "A Rome: L'exposition du XVIIᵉ siècle." *Combat-Art*, 4 February 1957, 2.

———. "Le prétendu 'Siècle de Louis XIV' à Londres." *Combat-Art*, 3 May 1958, 2.

JAL, Auguste. *Dictionnaire critique de biographie et d'histoire*. Paris: Henri Plon, 1867. Rev. ed. Paris, 1872.

JAMOT, Paul. "Sur les frères Le Nain: II. Essai de classement de l'oeuvre des Le Nain." *GBA* 5th ser. 5 (April 1922):219-233; (May 1922):293-308.

———. "Sur quelques oeuvres de Louis et de Mathieu Le Nain: A propos d'une exposition." *GBA* 5th ser. 7 (January 1923):31-40.

———. "Essai de chronologie des oeuvres des frères Le Nain." *GBA* 5th ser. 7 (March 1923):157-166.

———. *Les Le Nain.* Paris: Henri Laurens, 1929.

———. "Antoine, Louis, et Mathieu Le Nain." *Pantheon* 4, no. 8 (August 1929):356-362.

JEAN-RICHARD, Pierrette. *L'oeuvre gravé de François Boucher dans la collection Edmond de Rothschild au Musée du Louvre.* Paris: Editions des Musées Nationaux, 1978.

JOHNSTONE, J. H. "An Early Picture by Nicolas Poussin." *BM* 35, no. 198 (September 1919):91.

KAUFFMANN, C. M. *Catalogue of Foreign Paintings, Victoria and Albert Museum.* 2 vols. London: Eyre & Spottiswood Ltd., Manet Press, 1973.

KENNEDY, I. G. "Claude Lorrain and Topography." *Apollo* 90, no. 92 (October 1969):304-309.

KITSON, Michael. "Claude Lorrain: Two Unpublished Paintings and the Problem of Variants." *Studies in Renaissance and Baroque Art: Presented to Anthony Blunt on His 60th Birthday.* London: Phaidon Press, 1967.

———. *Claude Lorrain: Liber Veritatis.* London: British Museum, 1978.

KROHN, Mario. *Frankrigs og Danmarks kunstneriske forbindelse i det 18. Aarhundrede.* 2 vols. Copenhagen: Henrik Koppels Forlag, 1922.

LABANDE, L.-H. *Les primitifs français: Peintres et peintres verriers de la Provence occidentale.* 2 vols. Marseille: Tacussel, 1932.

LACLOTTE, Michel. *L'école d'Avignon: La peinture en Provence aux XIV^e et XV^e siècles.* Paris: Gonthier-Seghers, 1960.

LACLOTTE, Michel, and Dominique THIEBAUT. *L'école d'A-vignon.* Paris: Flammarion, 1983.

LAFENESTRE, Georges. "L'exposition des primitifs français." *GBA* 3rd ser. no. 32 (1904):130-139.

LARSEN, Erik. "The Samuel H. Kress Collection at the M. H. de Young Memorial Museum, San Francisco." *Apollo* 61, no. 364 (June 1955):172-177.

LASTIC, Georges de. "Le Brun et Largillierre autour d'un 'Autoportrait'."*BSHAF* 1977 (1979):154-160.

———. . "Portraits d'artistes de Largillierre." *Connaissance des Arts*, no. 9 (1979):17-24.

———. "Largillierre et ses modèles: Problèmes d'iconographie." *L'Oeil*, no. 323 (June 1982):24-31, 78-79.

———. "Largillierre à Montréal." *GBA* 102 (July-August 1983):35-38.

———. "Propos sur Nicolas de Largillierre en marge d'une exposition." *La Revue de l'Art*, no. 61 (1983):73-82.

LATREILLE, Alain. "Catalogue raisonné des portraits peints par le baron François Gérard (1770-1837)." Paris: Mémoire de l'Ecole du Louvre, 1973.

LAVIN, Marilyn Aronberg. *Seventeenth-Century Barberini Documents and Inventories of Art.* New York: New York University Press, 1975.

LE BLANC, Charles. *Manuel de l'amateur d'estampes.* 4 vols. Paris: Chez P. Jannet, 1854-1890.

LEE, Thomas P. "Recently Acquired French Paintings: Reflections on the Past." *Apollo* 111, no. 217 (March 1980):212-223.

LEYMARIE, Jean. *Le Nain.* Paris: Braun, 1950.

———. *French Painting: The Nineteenth Century.* Geneva: Skira, 1962.

LIVRETS DES SALONS. Ed. Jules Guiffrey, *Collection des livrets des anciennes expositions depuis 1673 jusqu' en 1800.* Paris: Liepannssohn et Dufour, 1869.

LOCQUIN, Jean. "Catalogue raisonné de l'oeuvre de Jean-Baptiste Oudry, peintre du roi." *Archives de l'Art Français* n.s. 6 (1912):1-209.

———. *La peinture d'histoire en France de 1747 à 1785.* Reprint. Neuilly-sur-Seine: Arthéna, 1978.

LOUGH, John. *An Introduction to Seventeenth-Century France.* 8th ed. New York: David McKay Company, 1969.

LUNA, Juan J. "Precisiones sobre las pinturas de Claudio de Lorena en el Museo del Prado." *Boletin del Museo del Prado*, no. 5 (May-August 1981):99-110.

LUNDBERG, Gunnar W. *Roslin Liv och Verk.* 3 vols. Malmo: Allhems Förlag, 1957.

MACAGY, Jermayne. "Endymion and Selene: Painting by Michel François d'André-Bardon." *Bulletin CPLH* 1, no. 11 (February 1944):90-93.

MACFALL, Haldane. *Boucher: The Man, His Time, His Art and His Significance.* London: The Connoisseur, 1908.

MAHON, Denis. "Poussin's Early Development: An Alternative Hypothesis." *BM* 102, no. 688 (July 1960):288-304.

———. "Poussiniana: Afterthoughts Arising from the Exhibition." *GBA* 60 (July-August 1962):1-129.

MAI, Ekkehard. "Ausstellung: La peinture française du XVII^e siècle dans collections américaines." *Pantheon* 40, no. 2 (April-June 1982):153.

MALLETT, Donald. *The Greatest Collector: Lord Hertford and the Founding of the Wallace Collection.* London: Macmillan, 1979.

MARANDEL, J. Patrice. "A Portrait by Duplessis." *Bulletin of The Art Institute of Chicago* 70, no. 1 (January-February 1976):2-3.

MARET, Jacques. *David.* Monaco: Les Documents d'Art, 1943.

MARGUILLIER, Auguste. "Collections de feu M. Maurice Kann." *Les Arts*, no. 88 (April 1909):1-32.

MARIETTE, P.-J. *Abecedario et autres notes inédits de cet amateur sur les arts et les artistes.* Ed. Ph. de Chennevières and A. de Montaiglon. 6 vols. Paris: Dumoulin, 1851-1860. Reprint. Paris: F. de Nobele, 1967.

MARILLIER, H. C. *Christie's 1766-1925.* London: Constable & Company Ltd.; Boston: Houghton Mifflin Company, 1926.

MARMOTTAN, Paul. *Le peintre Louis Boilly.* Paris: H. Gateau, 1913.

MARQUET DE VASSELOT, J.-J. "Comptes rendus critiques: Inventaire des tableaux commandés et achetés par la Direction des Bâtiments du Roi (1709-1792), rédigé et publié par Fernand Engerand. . . ." *Revue Historique* 79, no. 157 (May-June 1902):180-182.

MARTINET, Suzanne. "Les frères Lenain." MS 1971. Bibliothèque Laon.

MARZOLA, Maria. "Jean Le Clerc." Thesis, Istituto di Storia dell' Arte, Padua, 1949-1950.

MAUCLAIR, Camille. *Jean-Baptiste Greuze*. Includes *Catalogue raisonné de l'oeuvre peint et dessiné de Jean-Baptiste Greuze, suivi de la liste des gravures exécutées d'après ses ouvrages* by J. Martin and Ch. Masson. Paris: H. Piazza [1906].

MAUMENE, Charles, and Louis D'HARCOURT. "Iconographie des rois de France: Seconde partie. Louis XIV, Louis XV, Louis XVI." *Archives de l'Art Français* 16 (1931).

MAXON, John. "J. L. David's Portrait of the Marquise de Pastoret." *Art News* 66, no. 7 (November 1967):45-46.

MEMOIRES INEDITS sur la vie et les ouvrages des membres de l'Académie Royale de Peinture et de Sculpture. . . . 2 vols. Published from manuscripts in the Ecole Impériale des Beaux-Arts by L. Dussieux, E. Soulié, Ph. de Chennevières, P. Mantz, and A. de Montaiglon. Paris: J.-B. Dumoulin, 1854.

MEROT, Alain. "Eustache Lesueur et ses graveurs (1635-1655): Un ensemble incomplet." *Nouvelles de l'Estampe*, no. 69 (May-June 1983):6-13.

————. *Eustache Le Sueur 1616-1655*. Neuilly-sur-Seine: Arthéna, 1987.

MICHEL, André. *François Boucher*. Includes *Catalogue raisonné de l'oeuvre peint et dessiné de François Boucher, suivi de la liste des gravures executées d'après ses ouvrages* by L. Soullié and Ch. Masson. Paris: H. Piazza, 1906.

MICHEL, Edouard. "A propos des frères Le Nain." *Gand Artistique* (14 July 1923):167-169.

MIRIMONDE, Albert Pomme de. *L'iconographie musicale sous les rois Bourbons: La musique dans les arts plastiques XVIIe-XVIIIe siècles*. 2 vols. Paris: Editions A. et J. Picard, 1975.

MOLLER, Tyge. "L'exposition de l'art français du XIXe siècle à Copenhague." *GBA*, no. 686 (August 1914):158-163.

NEAR, Pinkney L. "Carle Van Loo, 'A Pasha Having his Mistress's Portrait Painted'." *Arts in Virginia* 23, no. 3 (1983):18-27.

NEUGASS, Fritz. "Diamantenes Jubiläum von Wildenstein in New York." *Die Weltkunst* 48, no. 6 (15 March 1978):580-581.

NEUMEYER, Alfred. "The Samuel H. Kress Collection of the M. H. de Young Museum in San Francisco." *The Art Quarterly* 18, no. 3 (Autumn 1955):272-282.

NICOLSON, Benedict. "The 'Candlelight Master,' A Follower of Honthorst in Rome." *Nederlands Kunsthistorisch Jaarboek* 11 (1960):121-164.

————. "Un caravagesque aixois, le Maître à la chandelle." *Art de France* 4 (1964):116-139.

————. "The Rehabilitation of Trophime Bigot." *Art and Literature* 4 (1965):66-105.

————. "Caravaggesques at Cleveland." *BM* 114, no. 827 (February 1972):113-117.

————. *The International Caravaggesque Movement: Lists of Pictures by Caravaggio and His Followers throughout Europe from 1590 to 1640*. London: Phaidon Press, 1979.

NICOLSON, Benedict, and Christopher WRIGHT. *Georges de La Tour*. London: Phaidon Press, 1974.

NOLHAC, Pierre de. "Mme de Pompadour et les arts." *L'Art*, no. 756 (October 1902):564-579; no. 766 (August 1903):393-410; no. 770 (December 1903):619-636.

————. *Nattier: Peintre de la cour de Louis XV*. Paris: Goupil, 1905; 1910; 1925.

————. *J.-H. Fragonard: 1732-1806*. Catalogue raisonné by Georges Pannier. Paris: Goupil, 1906.

————. *François Boucher: Premier peintre du roi*. Catalogue raisonné by Georges Pannier. Paris: Goupil, 1907.

————. *Madame Vigée Le Brun: Peintre de la reine Marie-Antoinette 1755-1842*. Paris: Goupil, 1908.

————. *Hubert Robert: 1733-1808*. Paris: Goupil, 1910.

OPPERMAN, Hal N. *Jean-Baptiste Oudry*. 2 vols. New York: Garland Publishing, 1977.

ORBAAN, J. A. F. *Documenti sul barocco in Roma: Miscellanea della R. Società Romana di Storia Patria*. Rome: Nella Sede della Società, 1920.

ORLIAC, J.-D. *La vie mystérieuse d'un beau domaine français: Chanteloup du XIIIe au XXe siècle*. Paris, 1929.

OSBORN, Max. *Die Kunst des Rokoko*. Berlin: Propyläen, 1929.

OULMONT, Charles. *J.-E. Heinsius (1740-1812): Peintre de Mesdames de France*. Paris: Hachette, 1913. Reprint. Strasbourg: Istra, 1970.

PACE, Claire. *Félibien's Life of Poussin*. London: A. Zwemmer Ltd., 1981.

PARISET, François-Georges. "Mise en point—provisoire—sur Georges de La Tour." *Cahiers de Bordeaux, Journées Internationales d'Etudes d'Art* (1955):79-89.

————. "Georges de La Tour." In *Encyclopedia of World Art*. New York: McGraw-Hill Book Company, 1959.

————. "Y a-t-il affinité entre l'art espagnol et Georges de La Tour?" *Velázquez, son temps, son influence: Actes du Colloque tenu à la Casa de Velázquez (7-10 December 1960)*. Paris: Arts et Métiers Graphiques, 1963, 53-64.

————. "L'exposition de Georges de La Tour à l'Orangerie, Paris." *GBA* 80, no. 1245 (October 1972):207-211.

————. "L'exposition Georges de La Tour." *Le Pays Lorrain*, no. 2 (1973):59-86.

PASCAL, Georges. *Largillierre*. Paris: Les Beaux-Arts, 1928.

PETERSEN, Karen, and J. J. WILSON. *Women Artists' Recognition and Reappraisal from the Early Middle Ages to the Twentieth Century*. New York: Harper & Row, 1976.

PIGANIOL DE LA FORCE, Jean-Aymar. *Description historique de la Ville de Paris et de ses environs*. Rev. and aug. Lafont de Saint-Yenne. 10 vols. Paris: G. Desprez, 1765.

PORTALIS, Roger. *Honoré Fragonard: Sa vie et son oeuvre*. Paris: J. Rothschild, 1889.

PORTALIS, Roger, and Henri BERALDI. *Les graveurs du dix-huitième siècle*. 3 vols. Paris: Damascene Morgand et Charles Fatout, 1880-1882.

POSNER, Donald. *Antoine Watteau*. Ithaca, New York: Cornell University Press, 1984.

PROCES-VERBAUX DE L'ACADEMIE ROYALE DE PEINTURE ET DE SCULPTURE 1648-1793. Ed. Anatole de Montaiglon. 10 vols. Paris: Bauer et Charavay, 1875-1892.

PUYCHEVRIER, Sylvain. *Le peintre Etienne Jeaurat: Essai historique et biographique sur cet artiste*. Paris, 1862.

QUINTON, C. B., and W. W. QUINTON. *Catalogue of the Jacob Stern Loan Collection*. San Francisco: CPLH, 1928.

RAINES, Robert. "Watteaus and 'Watteaus' in England before 1760." *GBA* 89 (February 1977):51-64.

RAMBO, J. I. "A Recently Acquired Painting by Jacques de Lajoue." *Bulletin CPLH* 18 (2 June 1960):n.p.

REAU, Louis. "Les influences flamandes et hollandaises dans l'oeuvre de Fragonard." *Revue Belge d'Archéologie et d'Histoire de l'Art*, April 1932, 97-104.

———. "Carle Vanloo (1705-1765)." *Archives de l'Art Français* 19 (1938):7-96.

———. *Fragonard: Sa vie et son oeuvre*. Paris: Elsevier, 1956.

REDFORD, George. *Art Sales: A History of Sales of Pictures and Other Works of Art*. London: privately printed, 1888.

REY, Robert. "Une exposition de peintures des frères Le Nain." *Beaux-Arts*, no. 1 (15 January 1923):5.

———. "La femme dans la peinture française." *La Renaissance* 22, no. 4 (August 1939):10-18.

RICHARDSON, John, ed. *The Collection of Germain Seligman*. New York: privately printed, 1979.

RIDDER, André de. *J.-B.-S. Chardin*. Paris: Floury, 1932.

RING, Grete. *A Century of French Painting, 1400-1500*. London: Phaidon Press, 1949.

ROBERT-DUMESNIL, A.-P.-F. *Le peintre-graveur français ou catalogue raisonné des estampes gravées par les peintres et les dessinateurs de l'Ecole française*. 11 vols. Paris: Mme Huzard, 1835-1871. Reprint. Paris: G. Waree, 1967.

ROBINSON, D. M. "Current Notes and Comments." *Art and Archaeology* 11, no. 3 (March 1921):113-122.

ROBIQUET, Jean. *La femme dans la peinture française XVᵉ-XVIᵉ siècle*. Paris: Les Editions Nationales, 1938.

ROETHLISBERGER, Marcel. *Claude Lorrain: The Paintings*. 2 vols. 1961. Reprint. New York: Hacker Art Books, 1981.

———. *Claude Lorrain. The Drawings*. 2 vols. Berkeley and Los Angeles: University of California Press, 1968.

———. "Quelques tableaux inédits du XVIIᵉ siècle français: Le Sueur, Claude Lorrain, La Fosse." *Revue de l'Art* 2 (1971):75-84.

ROETHLISBERGER, Marcel, with Doretta CECCHI. *L'opera completa di Claude Lorrain*. Milan: Rizzoli, 1975; *Tout l'oeuvre peint de Claude Lorrain*. Paris: Flammarion, 1977.

ROLAND MICHEL, Marianne. *Anne Vallayer-Coster 1744-1818*. Paris: Comptoir International du Livre, 1970.

———. "Basket of Plums." *The Bulletin of the Cleveland Museum of Art* 60 (February 1973):52-59.

———. *Antoine Watteau*. Berlin: Ullstein Kunst Buch, 1981; *Tout Watteau: La peinture*. Paris: Flammarion, 1982.

———. *Lajoue et l'art rocaille*. Neuilly-sur-Seine: Arthéna, 1984.

———. *Watteau: Un artiste au XVIIIᵉ siècle*. Paris: Flammarion, 1984; London; Trefoil Books, 1984.

———. "Watteau: After the Exhibitions," *BM* 127, no. 993 (December 1985), 915-917.

ROSE, Barbara. "Self-Portraiture: Theme with a Thousand Faces." *Art in America* 63, no. 1 (January-February 1975):66-73.

ROSENBERG, Pierre. "L'exposition Le Nain: Une proposition." *La Revue de l'Art*, no. 43 (1979):91-100

———. "La peinture française du XVIIᵉ siècle dans les collections des Etats-Unis." *La Revue du Louvre*, no. 1 (1982):72-74.

———. "Le siècle d'or." *Connaissance des Arts*, no. 360 (February 1982):76-83.

———. *L'opera completa di Chardin*. Milan: Rizzoli; *Tout l'oeuvre peint de Chardin*. Paris: Flammarion, 1983.

———. "France in the Golden Age: A Postscript." *Metropolitan Museum Journal*, no. 17 (1984):23-45.

———. *Vies anciennes de Watteau*. Paris: Hermann, 1984.

———. "Répétitions et répliques dans l'oeuvre de Watteau," *Antoine Watteau (1684-1721) le peintre, son temps et sa légende* (Paris: Champion-Slatkine, 1987), 103-110.

ROSENBERG, Pierre, and François MACE DE LEPINAY. *Georges de La Tour: Vie et oeuvre*. Fribourg: Office du Livre, 1973.

ROSENBERG, Pierre, Nicole REYNAUD, and Isabelle COMPIN. *Musée du Louvre: Catalogue illustré des peintures Ecole française XVIIᵉ et XVIIIᵉ siècles*. 2 vols. Paris: Editions de la Réunion des Musées Nationaux, 1974.

ROSENFELD, Myra Nan. "Largillierre: Problèmes de méthodologie." *La Revue de l'Art*, no. 66 (1984):69-74.

ROSENTHAL, Léon. *Louis David*. Paris: Librairie de l'Art Ancien et Moderne, 1905.

ROUCHES, Gabriel. *Eustache Le Sueur*. Paris: Alcan, 1923.

ROUX, Marcel, et al. *Inventaire du fonds français: Graveurs du XVIIIᵉ siècle*. 14 vols. Paris: Cab. des Est., BN, 1931-1977.

SAMBON, Arthur. "Exposition Le Nain." *Bulletin des Experts d'Art* (31 July 1934):13-16.

———. "Les Le Nain." *Bulletin Trimestriel de la Chambre Internationale des Experts d'Art*, no. 7 (April-June 1936).

SANDOZ, Marc. *Jean-Baptiste Deshays 1729-1765*. Paris: Editart-Quatre Chemins, 1978.

———. *Gabriel Briard (1725-1777), avec des remarques liminaires sur . . . Jean-Baptiste Deshays. . . .* Paris: Editart-Quatre Chemins, 1981.

SAPIN, Marguerite. "Précisions sur l'histoire de quelques tableaux d'Eustache Le Sueur," *BSHAF* 1984 (1986):53-88.

SAUNIER, Charles. *Louis David*. Paris: H. Laurens, [1903].

———. "David et son école au palais des Beaux-Arts de la ville de Paris." *GBA*, no. 671 (May 1913):271-290.

SAVILL, Rosalind. "Six Enamelled Snuff-Boxes in the Wallace Collection." *Apollo* 111, no. 218 (April 1980):304-309.

SCHARF, Alfred. "The Robinson Collection," *BM* 100, no. 666 (September 1958):299-304.

SCHLEIER, Erich. "Un chef d'oeuvre de la période italienne de Simon Vouet." *Revue de l'Art*, no. 11 (1971):65-73.

———. *Georges de La Tour (1593-1652): Essendes Bauernpaar Neuerwerbung*. Berlin: Gemäldegalerie Staatliche Museen, 1976.

———. "Georges de La Tour: Essendes Bauernpaar, Zu einer Neuerwerbung der Gemäldegalerie." *Jahrbuch Preussischer Kulturbesitz*. Berlin: Gebrüder Mann, 1976.

———. "Die Le Nain Ausstellung in Paris." *Kunstchronik*, May 1979, 176-195.

SCHNAPPER, Antoine. *David, témoin de son temps*. Fribourg: Office du Livre, 1980.

SCHWARTZ, Sanford. "The Art World: A Stranger in Paris," *The New Yorker* (September 1985):102-113.

SELIGMAN, Germain. *Merchants of Art: 1880-1960. Eighty Years of Professional Collecting*. New York: Appleton-Century-Crofts, 1961.

SHIPP, Horace. "Treasures of the Robinson Collection: Some Problems of Attribution." *Apollo* 68, no. 402 (August 1958):39-43.

SLATKIN, Regina Shoolman. "The New Boucher Catalogue." *BM* 121, no. 911 (February 1979):120.

SMITH, Joan Van Renssalaer. "Nicolas Largillierre, A Painter of the Régence." Thesis, University of Minnesota, 1964.

SMITH, John. *A Catalogue Raisonné of the Works of the Most Eminent Dutch, Flemish, and French Painters*. London: Smith and Son, 1837. Suppl. 1842.

SMITH, Martha Kellogg. "Georges de La Tour's 'Old Man' and 'Old Woman' in San Francisco." *BM* 121, no. 914 (May 1979):288-294.

SPEAR, Richard E. *Caravaggio and His Followers*. New York: Harper & Row, 1975.

STANDEN, Edith A. "Some Notes on the Cartoons Used at the Gobelins and Beauvais Tapestry Manufactories in the Eighteenth Century." *J. Paul Getty Museum Journal* 4 (1977):25-28.

———. "*Fêtes Italiennes*: Beauvais Tapestries after Boucher in The Metropolitan Museum of Art." *Metropolitan Museum Journal*, no. 12 (1978):107-139.

———. *European Post-Medieval Tapestries and Related Hangings in The Metropolitan Museum of Art*. 2 vols. New York: The Metropolitan Museum of Art, 1985.

———. "The *Fragments d'Opéra*: A Series of Beauvais Tapestries After Boucher." *Metropolitan Museum Journal*, no. 21 (1986):123-137.

STEIN, Henri. "Etat des objets d'art placés dans les monuments religieux et civils de Paris au début de la Révolution française." *Nouvelles Archives de l'Art Français* (1890):1-131.

STERLING, Charles. "Two XV Century Provençal Painters Revived." *GBA* 22 (October 1942):9-16.

———. "Observations sur Georges de La Tour, à propos d'un livre récent." *La Revue des Arts* (1951):147-158.

———. *A Catalogue of XV-XVIII Centuries: The Metropolitan Museum of Art*. Cambridge: Harvard University Press, 1955.

———. "La peinture française et la peinture espagnole au XVIIᵉ siècle: Affinités et échanges." In *Velázquez, son temps, son influence: Actes du Colloque tenu à la Casa de Velázquez (7-10 December 1960)*. Paris: Arts et Métiers Graphiques, 1963.

———. "Une oeuvre de Pierre Villate enfin retrouvée?" *Chronique méridionale: Arts du Moyen Age et de la Renaissance*, no. 1 (1981):3-14.

SUIDA, William E. *The Samuel H. Kress Collection*. San Francisco: de Young, 1955.

SUMMARY ILLUSTRATED CATALOGUE OF PICTURES. London: The Trustees of the Wallace Collection, 1979.

SZIGETHI, Agnes. *Georges de la Tour*. Budapest: Corvina Kiado, 1971.

TANAKA, Hidemichi. "L'oeuvre de Georges de La Tour." Thesis, Université de Strasbourg, 1969.

———. "The Exhibition of Georges de La Tour in Paris." *Mizué*, no. 813 (November 1972):80-84.

THIEME, Ulrich, and Felix BECKER. *Allgemeines Lexikon der bildenden Künstler von der Antike bis zur Gegenwart*. Leipzig: Wilhelm Engelmann, 1907-1950.

THIERY, Luc-Vincent. *Guide des amateurs et des étrangers voyageurs à Paris, ou description raisonnée de cette ville et de tout ce qu'elle contient*. 2 vols. Paris: Hardouin & Gattey, 1786-1787.

———. *Guide des amateurs et des étrangers voyageurs dans les maisons royales, châteaux, lieux de plaisance, établissements publics, villages et séjours les plus renommés. Aux environs de Paris*. Vol. 1. Paris: Hardouin & Gattey, 1788.

THIIS, Jens. "De tre brodre Le Nain. Notater og iagttagelser om deres Billeder." *Kunstmuseets Aarskrift 1921-1923* (1924):273-304.

THOME DE GAMOND, Aimé. *Vie de David*. Paris: Les Marchands de Nouveautés, 1826.

———. *Vie de David, premier peintre de Napoléon*. Brussels: Grignon, Baudouin Frères and H. Tarlier, 1826.

THUILLIER, Jacques. "Georges de La Tour: Between Yesterday and Tomorrow." *Art News* 71, no. 4 (Summer 1972):24-27.

———. *L'opera completa di Georges de La Tour*. Milan: Rizzoli; *Tout l'oeuvre peint de Georges de La Tour*. Paris: Flammarion, 1973.

———. *L'opera completa di Poussin*. Milan: Rizzoli; *Tout l'oeuvre peint de Poussin*. Paris: Flammarion, 1974.

———. "Les frères Le Nain et l'inspiration réaliste à Paris au temps de Louis XIII et de Mazarin." *Annuaire du Collège de France* (1978-1979):649-662.

———. "Le Nain: Leçons d'une exposition." *La Revue du Louvre et des Musées de France*, no. 2 (1979):158-166.

THUILLIER, Jacques, and Claude MIGNOT. "Collectionneur et peintre au XVIIᵉ siècle: Pointel et Poussin." *La Revue de l'Art*, no. 39 (1978):39-58.

TOWNSEND, Gertrude. "A Pastoral by François Boucher." *Bulletin of the Museum of Fine Arts* (Boston), no. 230 (December 1940):85-86.

VAILLAT, Léandre. "Une famille de peintres français du XVIIᵉ siècle: Une exposition d'oeuvres des frères Le Nain." *L'Illustration*, no. 4168 (20 January 1923):58-61.

VAILLAT, Léandre, and Paul RATOUIS DE LIMAY. *J.-B. Perronneau (1715-1783): Sa vie et son oeuvre*. 1909. 2d ed. rev. and enl. Paris: G. Van Oest, 1923.

VAUGHN, Malcolm. "The Connoisseur in America: Strong Self-Portrait by Fragonard." *The Connoisseur* 144, no. 579 (September 1959):66-67.

VIGEE LE BRUN, Elisabeth. *Souvenirs de Madame Louise-Elisabeth Vigée Le Brun*. 3 vols. Paris: H. Fournier, 1835-1837. Trans. Lionel Strachey. New York: Doubleday, Page & Company, 1907.

WAAGEN, G. F. *Treasures of Art in Great Britain*. 4 vols. London: John Murray, 1854. Suppl. 1857.

WALKER, John. "The Kress Collection and the Museum." *Arts Digest* 29, no. 11 (1 March 1955):17-23.

WALLACE COLLECTION CATALOGUES: *Pictures and Drawings*. 16th ed. London: Wallace Collection, 1968.

WEHLE, Harry B. "A Painting of the Fontainebleau School." *Bulletin of The Metropolitan Museum of Art* 37, no. 2 (February 1942):27-30.

———. *The Metropolitan Museum of Art Miniatures*. New York: The Metropolitan Museum of Art, 1957.

WEIGERT, Roger-Armand. *Inventaire du fonds français: Graveurs du XVIIe siècle*. 5 vols. Paris: Cab. des Est., BN, 1939-1968.

WEISBACH, Werner. *Französische Malerei des XVII. Jahrhunderts im Rahmen von Kultur und Gesellschaft*. Berlin: Heinrich Keller, 1932.

WESCHER, Paul. "Etienne Jeaurat and the French Eighteenth Century 'Genre de Moeurs'." *The Art Quarterly* 32, no. 2 (Summer 1969):153-165.

WHITTINGHAM, Selby. "Watteau's 'l'Isle Enchantée': From the French Régence to the English Regency," *Pantheon* 42, no. 4 (October-December 1984), 339-346.

WILD, Doris. *Nicolas Poussin*. Zurich: Orell Füssli, 1980.

WILDENSTEIN, Georges. *Lancret*. Paris: Les Beaux-Arts, 1924.

———. *Chardin*. Paris: Les Beaux-Arts, 1933.

———. "An Unknown Portrait of Mme de Staël by J. S. Duplessis in the de Young Museum." *The Pacific Art Review* 3 (1944):1-15.

———. *The Paintings of Fragonard*. London: Phaidon Press, 1960.

———. *Chardin*. 1963. Rev. and enl. by Daniel Wildenstein. Greenwich, Connecticut: New York Graphic Society, 1969.

WILDENSTEIN, Georges, and Gabriele MANDEL. *L'opera completa di Fragonard*. Milan: Rizzoli, 1972.

WILENSKI, R. H. *French Painting*. Boston: Hale, Cushman & Flint, Inc., 1936; Boston: Charles T. Bradford Co., 1949. Reprint. New York: Dover Publications, 1973.

WILSON, Peter. "Une vente que fera date (Collection Fribourg)." *L'Oeil*, no. 101 (May 1963):20-31.

WRIGHT, Christopher. *Georges de La Tour*. London: Phaidon Press, 1977.

———. "The 'Choirboy' by Georges de La Tour." *BM* 126, no. 975 (June 1984):351.

———. *The Art of the Forger*. New York: Dodd, Mead, 1985.

———. *The French Painters of the Seventeenth Century*. Boston: Little Brown and Company, 1985.

———. *Masterpieces of Reality: French 17th Century Painting*. Leicester: The Leicestershire Museum and Art Gallery, 1985.

———. *Poussin Paintings: A Catalogue Raisonné*. London: Harlequin Books, 1985.

YOUNG, Mahonri Sharp. "The Ruin of Painting." *BM* 95, no. 119 (January 1972):60-62.

———. "The Last Time I Saw Paris." *Apollo* 106, no. 189 (November 1977):411-416.

YRIARTE, Charles. "Mémoires de Bagatelle." *La Revue de Paris* 5 (September-October 1903):380-414.

ZIMMERMAN, Ernest H. *The Work of Antoine Watteau*. New York: Brentano, 1913.

Index of Artists

All of the painters, sculptors, and engravers mentioned in the catalogue entries are listed here, together with the titles of paintings by artists in TFAMSF collection in the order in which they appear.

French Paintings 1500-1825 *was produced by the* *Publications Department of The Fine Arts Museums of* *San Francisco. Editorial and production management by* *Ann Heath Karlstrom. Edited by Karen Kevorkian.*

The book was designed by Jack Werner Stauffacher of *The Greenwood Press, San Francisco, California.* *Display type is Kis-Janson, hand set at The Greenwood* *Press. Text type is Sabon, designed by Jan Tschichold.* *Digital composition and production by Wilsted &* *Taylor Publishing Services, Oakland, California. Printed* *by Balding + Mansell Limited, England. Text paper is* *Huntsman Velvet, 135 gsm.*